ART INFORMATION

W9-BPW-836

RESEARCH
METHODS
AND RESOURCES

Third Edition

Lois Swan Jones

University of North Texas

Foreword by
Caroline H. Backlund

WITHDRAWN

KENDALL/HUNT PUBLISHING COMPANY
2460 Kerper Boulevard P.O. Box 539 Dubuque, Iowa 52004-0539

Copyright © 1990 by Kendall/Hunt Publishing Company

Library of Congress Catalog Card Number: 89–64325

ISBN 0–8403–5713–3

All rights reserved. No part of this publication may be reproduced,
stored in a retrieval system, or transmitted, in any form or by any
means, electronic, mechanical, photocopying, recording, or otherwise,
without the prior written permission of the copyright owner.

Printed in the United States of America
10 9 8 7 6 5 4 3 2

ARTS

N
85
)64
1990
cop 3

Dedication

Art Information: Research Methods and Resources is dedicated to my friends and colleagues in the Art Libraries Society/North America. Thank you for your assistance and encouragement.

Photo Credits

Example 19, *On the Europe Bridge,* Kimbell Art Museum, Fort Worth, Texas. Back Cover: Detail of Eadweard Muybridge's *Horse Galloping,* Courtesy Amon Carter Museum, Fort Worth. Other photographs taken by the author.

Contents

SECTION A: METHODOLOGY

PART I: BEFORE RESEARCH BEGINS

PART II: BASIC RESEARCH METHODOLOGY

SECTION B: A BIBLIOGRAPHY OF RESEARCH SOURCES

PART IV: GENERAL ART RESEARCH TOOLS

PART VI: ICONOGRAPHICAL RESOURCES

SECTION C: RESEARCH CENTERS

List of Examples

Foreword

The many readers who have found Lois Jones's *Art Research Methods and Resources: A Guide to Finding Art Information* (1st edition, 1984; 2nd revised edition, 1984) an invaluable tool for developing efficient art research techniques and for locating a wide variety of bibliographic references will have reason to welcome this third edition. With its new title, *Art Information: Research Methods and Resources*, it is, in fact, an almost completely rewritten book, covering not only the latest art resources but a greater range and depth of subjects. The book contains about 19,000 bibliographic citations, an increase of more than 400 items from the previous edition.

Methodology continues to be one of the strongest features of the book with its focus on the application of new technologies, such as online databases, CD ROM, computerized subject access to visual resources, video documentaries, and computer-generated bibliographies. Bibliographic listings throughout have been strengthened by the inclusion of early published works not previously listed and numerous foreign-language items. Important new publications in all subject areas have been systematically added to make this edition an up-to-date resource of special value.

An experienced and skilled teacher, bibliographer, and researcher, Jones effectively leads her readers through the different steps of art research methodology, always keeping in mind the broad range of users for whom she has written this book. In the introduction she defines her audience and explains how she organized material to meet their varying needs. A useful new addition is the section on "Using This Book" in which Jones provides specific guidance to readers at their different levels of research capabilities.

Another strength of the book is the placement, within each chronological and geographical bibliographic listing, of subject-related topics. These include dictionaries, art historical surveys, bibliographies, documents and sources, indices, serials, video documentaries, cultural/historical surveys, etc. This material, expanded and pulled together on specific subjects, provides easier access of information and makes for more efficient utilization of the book.

Readers will appreciate Jones's detailed suggestions in the use of complex reference tools such as *SCIPIO*, *Iconclass*, and the *Illustrated Bartsch*. The Chapter on "Database Searches" provides helpful guidance on choosing a database and formulating and conducting a search. A new feature is the outline of the five major art indices with an explanation of their different subjects and dates of coverage, special features and availability in both book and computer format. The inclusion of 275 serials, in appropriate subject areas, is another welcome addition.

Regional listings in Asian studies (with special emphasis on China and Japan), as well as those of Canada, Latin America, the South Pacific, and Africa have all been expanded. Another feature is the bringing together of resources from different disciplines and media. These include prints and the art of the book, architecture, photography, decorative arts and crafts, fashion and costume, film and video, commercial design, and museum studies.

In the preparation of this book, the author consulted professional colleagues in the United States, Canada, and abroad. She visited many libraries and carefully studied their resources. As professor of art history and art bibliographer at the University of North Texas, she maintains an awareness of developments in the field and of new publications in a constantly expanding subject area. Alert to changing information needs, Jones dedicates herself to facilitating the research process at every step of the way. This book testifies to the success of her mission.

Caroline H. Backlund
National Gallery of Art Library

Acknowledgements

The revision and expansion of this book was made possible by the assistance of numerous people. First I would like to thank Caroline H. Backlund, Collection Development Librarian of the National Gallery of Art, Washington, D.C., who went over and beyond the call of friendship to read the entire manuscript, certain chapters not once but several times, to edit, to cajole, and to encourage the development of this manuscript. In addition, there were ten other librarians, whom I called the Board of Directors, who each read and commented on three or four chapters. Thanks goes to Sarah S. Gibson, Head Librarian, Clark Art Institute; Milan Hughston, Head Librarian, Amon Carter Museum; Nancy S. Allen, Head Librarian, Museum of Fine Arts, Boston; Ray Anne Lockard, Head, Frick Fine Arts Library, University of Pittsburgh; Margaret Culbertson, Art and Architecture Librarian, University of Houston; Alexander D. Ross, Head Art Librarian, Stanford University; Jack Robertson, Fine Arts Librarian, Kimball Fine Arts Library, University of Virginia; Kenneth Chamberlain, Head Librarian, Emily Carr College of Art; Betty Jo Irvine, Head, Fine Arts Library, Indiana University; and Jeffrey L. Horrell, Assistant University Librarian, E. S. Bird Library, Syracuse University.

Other colleagues were also gracious with their time and expertise, checking specific sections of the manuscript and offering valuable suggestions: Mary F. Williamson, Fine Arts Bibliographer, Scott Library, York University; Maryhelen Garrett, Off-Campus Librarian, Central Michigan University; Eileen Markson, Head of Library, Art & Archaeology Library, Bryn Mawr College; Robert W. Ott, Professor of Art Education, Penn State University; Christine L. Sundt, Slide & Photo Collection, Architecture and Allied Arts Library, University of Oregon; Larry A. Gleeson, Associate Professor of Art, Susan Noyes Platt, Associate Professor of Art, and Myra Walker, Assistant Professor of Art, University of North Texas; Mary Lampe, Audiovisual Coordinator, Amon Carter Museum; Mary M. Schmidt, Head Librarian, Marquand Library, Princeton University; Maurice Fortin, Head of Reference, and Valerie Brown Pinkney, Art Department Slide Librarian, University of North Texas; Chia-Chun Shish, Head Librarian, Kimbell Art Museum; Evelyn K. Samuel, Former Director of Libraries, Institute of Fine Arts Library; Jane S. Peters, Professor of Art, University of Kentucky; Librarian William R. Treese and Head Librarian Lynette M. Korenic, Arts Library, University of California, Santa Barbara; and Kristin L. Buckwalter, Managing Editor of RILA.

During the past two years, research was done in the following North American institutions with special cooperation from these librarians: Ruth Philbrick, Curator, Photographic Archives, National Gallery of Art Library; Christine M. Hennessey, Coordinator, Inventory of American Paintings, National Museum of American Art; Linda Thrift, Deputy Keeper, Catalog of American Portraits, The National Portrait Gallery; Jenni M. Rodda, Curator, Slide Collection and Photographic Archive, Institute of Fine Arts; Eleanor McD. Thompson, Librarian in Charge, Printed Book & Periodical Collection, and Bert Denker, Librarian Decorative Arts Photographic Collection, Winterthur Museum and Gardens; Adelaide Bennett Hagens, Computer Subject Indexer, Index of Christian Art; and Paula Baxter, Head Librarian, Art & Architecture Division, New York Public Library.

A trip was also made to London, where the following graciously gave their assistance: Director J. F. van der Wateren and Chief Reference Librarian Gillian Varley, National Art Library; Acting Director Ruth Kamen, British Architectural Library, Royal Institute of British Architects; Director J. B. Trapp as well as Warburg Computer Directors Brendan Cassidy and Ruth Rubinstein, Warburg Institute Library; Cathie Gordon, Witt Computer Index, Courtauld Institute of Art; and Ian Jacobs, Manager Macmillan Encyclopedia of Art.

In addition, I would like to thank the following for their invaluable suggestions and extensive assistance while working in their libraries: at the Metropolitan Museum of Art—William B. Walker, Chief Librarian, Thomas J. Watson Library; Ross Day, Librarian, The Robert Goldwater Library; and Robert C. Kaufmann, Librarian, Lewisohn Costume Library. At the Museum of Modern Art: Clive Phillpot, Director of Library, and Janis Ekdahl, Assistant Director of Library. At the Fashion Institute of Technology, James A. Findlay, Library Director, and at the Art Gallery of Ontario, Karen McKenzie, Chief Librarian, E. P. Taylor Reference Library.

In conclusion, I would like to thank my graduate assistant, Betty Carruth Siber, for all of her help and Elizabeth Ann Hecker for assistance in the proofreading. And I would like to thank my family for their patience, understanding, and assistance, especially my sister and brother-in-law—Phyllis Swan Dorsey and Robert Treat Dorsey—and my sons, Robert Preston Jones and Jeffrey Carl Jones.

Introduction

Doing research is hard work, but inexperienced researchers often make it even more difficult, because they do not know the hows, whys, and wherefores of basic research: how to find pertinent data, why to use certain kinds of references, and where to locate the needed materials. To be effective, researchers must know how to find and use the reference materials available to them. In order to answer simple questions, all that may be needed are a few books and articles that discuss the subject, so that necessary information can be located and studied. Usually, however, the questions are more complicated requiring an in-depth study to find a solution. Like detectives who unearth every clue, researchers must check each lead in order to discover the existence of resources that can help answer questions. This necessitates the use of numerous publications from various sections of the library, since art research requires a systematic, diligent inquiry into many types of materials. *Art Research Methods and Resources: A Guide to Finding Art Information,* second edition, 1984, was written to assist researchers in this search.

In the past six years, the number and variety of reference tools have greatly expanded. Some types of resources—vertical files, picture collections, periodicals, sales and exhibition catalogues—are now published on microforms making them available to a larger audience. Databases have proliferated and become more economical making interlibrary loans often a necessity. There have been modifications of some basic art publications, such as the merger of *RILA* and *Répertoire d'art et d'archéolog*ie. Subject indexing projects, which are gradually altering the types of questions that can be answered, are being developed. Although these changes have made some material more accessible, the alterations have not necessarily made research easier. For all these reasons, a third edition was deemed appropriate.

Two years ago when research and writing began in earnest, the decision was made not only to update the resources and text but also to take a critical look at the book as a whole. As a result, radical changes occurred. The scope and depth of the book was increased. Resources were reorganized to facilitate research. Subject access was provided to reference works by historical cultures, styles, geographic locations, media, and disciplines. Annotations were expanded for more difficult resources or ones that needed detailed explanations to ensure their efficient use. Unnecessary comments were deleted. Serials, cultural/historical surveys, and video documentaries were added. The methodological discussions were revised and amplified. Two years later, a different book evolved. And with the new contents, came a different title, *Art Information: Research Methods and Resources.*

Although the name has changed, the book's contents and emphasis are still on methodology, including the many ways reference tools can be used to find art information. The book was written to aid those involved in art research:

Beginners who know little about methodology or art resources

Intermediate researchers—such as upper-level or graduate students or art collectors—who need to be guided through the labyrinth of art reference material

Advanced researchers or established scholars who want to be apprised of the latest tools as well as new uses for older ones

Professional art and visual resource librarians who want to help the other three groups in using the library

A brief section, "Using This Book," has been appended to outline the various sections designed for different types of readers.

Art Information: Research Methods and Resources has three major divisions. "Section A: Methodology" provides definitions and details the methods by which research projects can be conducted. "Section B: A Bibliography of Research Sources" contains bibliographical entries for about 1,900 diverse resource tools, including microforms, online databases, and computer projects. In addition, there are 275 serials listed with their first date of issue and some of their various title changes. "Section C: Research Centers" provides a representative list of North American and European art libraries. The appendices include (1) three brief dictionaries of frequently used French, German, and Italian words with their English equivalents;

(2) a multilingual glossary of terms, including selected proper nouns—both geographical locations and surnames of artists and saints—plus terms denoting time, numbers, and animals; (3) the names of the Greek and Roman gods; (4) definitions of terms of attribution, time, shape, dimension, and monetary abbreviations; (5) a comparison of the Catholic and Protestant Bibles and the *Apocrypha;* and (6) a subject index to databases accompanied by a list of vendors.

Because research consists of studying both primary and secondary data, viewing the actual art object or artifact is essential. Therefore, a few museums with significant collections of specific styles or periods are mentioned. Some institutions have extensive encyclopedic collections with outstanding works of art in many fields; others concentrate on one particular kind or period of art. Whenever possible, these institutions should be visited to study and analyze primary data. Publications of museums with significant collections in a particular culture or geographic area often provide scholarly information. Their exhibition catalogues, museum collection catalogues, journals, and serials should be consulted. In addition, learn to be an efficient researcher, become familiar with the library and its tools. For like a successful sleuth, the researcher will find that the more one searches, the easier the search becomes.

Using This Book

The following outline provides guidance to the users of this book.

For beginners:

1. How to plan a research project and how to utilize the library, see Chapters 1 and 2.
2. Details on basic research methods used to formulate bibliographies and chronologies, see Chapter 3. Throughout these chapters, pertinent examples of actual research studies clarify methodological points; salient facts are provided in outline form. Chapter 3 refers to the bibliographical entries recorded in Chapters 10 through 16, these references should be examined at the same time.
3. Searching an online database is explained in Chapter 4.
4. Lists of encyclopedias and biographical dictionaries, see Chapter 10; information on exhibitions, Chapter 15; the major art indices, Chapter 16.
5. To make subject access easier, Chapters 11 and 12 are organized according to artistic styles and historical periods of Western Art—from prehistoric to the contemporary. Chapters 13 and 14 provide resources for various geographical locations: American and Canadian studies as well as those of Latin America, Asia, Africa, and the Pacific area.
6. Data on different media and disciplines are located in specific chapters, including architecture, prints, photography, decorative arts and crafts, fashion and costumes, film and video, commercial design, art/museum education, and museum studies. See Part V.
7. Art history surveys that provide overviews of subjects and serials pertinent to the subject are cited. English-language books are emphasized. To furnish additional background on these subjects, video documentaries and cultural/historical surveys have been included.
8. Art terms are defined throughout the text as well as in Appendix E.

For intermediate researchers:

1. Review how to develop a research plan for a term paper or a thesis, the latest methods used in libraries, interlibrary loans, and changes in some basic reference tools, such as *ARTbibliographies MODERN, RILA,* and the databases by reading Chapters 1 through 4.
2. Discussions of more specialized and complex tools—art bibliographies; indices for items such as dissertations, *Festschriften,* newspapers, and book reviews; sales information resources; archival material; vertical files; critics' reviews and interviews; visual resources; and subject indexing projects—are included in Chapter 5.
3. Methodology for research projects on individual works of art—such as finding reproductions, analyzing form and style, understanding catalogue entries, and evaluating monetary values—as well as iconographical studies, including data on the literature which influenced the subjects and symbols, is discussed in Chapters 6 and 7.
4. Material on how to find information on difficult-to-locate artists, authors, art collectors and critics is explained in Chapter 8; architecture, in Chapter 9.
5. Annotated lists of specific resources are located in Section B which consists of Chapters 10 through 29. Complete bibliographical entries are recorded; more difficult tools are accompanied by details on how to use them effectively. To assist readers, numerous cross references have been added.

Both simpler and more complex texts are recorded. Some references furnish an overview of the subject; the specialized bibliographies provide access to more scholarly material. Moreover, certain unique works are included in order that readers might have a fuller knowledge of the variety and types of research tools available in some libraries.

Although few monographs or museum and exhibition catalogues are cited, there are discussions on how to find these essential materials.

Collections of art criticism as well as documents and sources that translate and reprint primary data such as artists' remarks and writings are reported.

Several important archives and vertical files are discussed as well as references which locate these important sources.

Because it is essential for students to read the professional literature of their discipline, the serials and addresses of the appropriate associations have been added.

6. Methodology for completing bibliographical citations is detailed in Chapter 17; for locating data on serials, in Chapter 20.

7. The English equivalents of certain French, German, and Italian terms frequently used in art catalogues and reference works are recorded in the foreign-language dictionaries in the Appendices.

8. A concordance of proper names, geographic locations, and terms denoting time, numbers, and animals comprises Appendix D which is a glossary of French, English, German, Italian, and Spanish terms.

9. For iconographical studies, explanations are provided for the *Apocrypha* and *Apocryphal New Testament;* a comparison of the Catholic and Protestant Bibles is in Appendix E.

10. A subject index for online databases is recorded in Appendix F.

For advanced researchers:

1. The latest reference tools—both recently issued and forthcoming publications, such as the new biographical dictionary that updates *Thieme-Becker* and the cumulative index planned for *Worldwide Art Exhibition Catalogues*—are reported in the appropriate chapters.

2. The latest changes in art research materials, such as the RILA/RA merger, are recorded.

3. Information has been included on such items as archival material, resources for research grants, indices for early twentieth-century publications, and sources for monetary conversion rates.

4. Detailed annotations are added for difficult or underused resources, such as newspaper indices and the *Illustrated Bartsch.*

5. Visual Resources and subject-indexing projects constitute Chapter 19. Included is information on how to use *Iconclass* and some microform picture collections, such as the *Marburger Index* and *Alinari Photo Archive.* Also detailed are a number of unique subject-indexing projects, such as the *Iconclass Indexes,* Warburg Institute Census of Antique Works of Art Known to Renaissance Artists, Index of British Art at Yale Center for British Art, The Index of Christian Art, and Inventory of American Painting Executed Before 1914.

6. A representative list of North American and European art centers is provided.

For art reference and visual resource librarians:

1. This guide brings all of the latest resources into one book, providing complete bibliographical data to expedite acquisitions.

2. Because most librarian's need to cover the entire field of art, separate chapters on all art media and disciplines—including prints, photography, fashion, the decorative arts, commercial art, film, museum studies, and art/museum education—are included.

3. Since many studies are interdisciplinary, cultural/historical surveys have been added.

4. Answering reference questions should be facilitated by such items as the list of marketing aids, database vendors' addresses, and the numerous publications cited.

5. Lists professional publications pertinent to the library field.

6. Includes difficult-to-find information, such as title changes, methods of romanizing Chinese and Japanese names, the difference between such terms as iconography and iconology.

7. Provides a review of methodology and reference tools which may not be used frequently, such as those for hagiography and non-Christian iconography.

8. *Art Information* will also assist in the training of librarians who do not have an art background.

SECTION A
Methodology

This section, which consists of three parts, is the core of this book; everyone should read it.

"Part I: Before Research Begins" discusses how to plan a project and how to utilize the library.

"Part II: Basic Research Methodology" introduces simple reference tools and database searching.

"Part III: Methodology: Beyond the Basics" has chapters on specialized sources for more involved research and explains the methodology for discovering information on individual works of art, subjects and symbols, lesser-known artists, and architecture.

The references cited in "Section B: A Bibliography of Research Sources" are utilized in various types of research; therefore, they are separated from the following methodological discussions. As resources in the following chapters are studied, consult their bibliographical entries in Section B. The brackets placed after a title refer to the main entry for that work. For example, *Modernism in the 1920s* [12:154.6] indicates that additional information can be located in Chapter 12, entry 154, the sixth publication.

PART I

Before Research Begins

This section provides discussions of essential information that every student should know: (1) how to plan and carry out a research project and (2) the ways various libraries are organized. Even if most of this material is familiar, this section should be read, since there have been a number of changes in how library materials are classified.

Planning a Research Project

Need to know more about Notre Dame Cathedral? What influence the German Expressionists had on American twentieth-century paintings? How Pablo Picasso's sculptures are doing in the art market? Whether Degas was influenced by Muybridge's photographs? No matter what the question happens to be, there are certain basic reference tools which can be consulted to answer them. But before research begins, the project must be clearly defined. The following need to be decided:

1. Why is it being done, the purpose of the research and the depth to which it is to be examined.
2. What is to be done, a concise, clear statement of the study.
3. How much is to be done, deciding on the basic resource material that needs to be compiled.
4. How is it to be accomplished, developing a research plan or methodological approach.
5. Where will the research be done?
6. When should the project be started?

This chapter discusses the first four steps for planning a research project. But the last two steps, the where and the when, are also important. Where researchers go to find material depends upon their geographical location and the type of project. Two major resource centers are libraries and art museums, local as well as distant ones. When the study is begun is also important. Since research takes time, only an early start will allow illustrative material to be gathered, letters to be written, and interlibrary loans to be made. The time to begin is now.

Purpose of the Research

To define the purpose of a research project is to explain why the study is being conducted. Most research has an end product: a term paper, a presentation accompanied by slides, a thesis or dissertation, or a gallery talk. The purpose of the project determines the kinds of resource tools needed. For each research project, the following items must be known prior to beginning the investigation: (1) the exact form of the end product, (2) the depth of the study, and (3) the audience who will read or view it. These three items should be considered together.

Once the form of the end product is established, the depth of the study, can be determined. For a speech or paper supplemented by visual aids, the proper illustrative materials must also be obtained. Photographs, slides, or good photocopies will have to be collected as the research progresses. If the paper or speech is to be presented to an audience, it is necessary to have visual materials that coincide with the available equipment: slide or overhead projectors or videotape machines. For oral presentations, the correct pronunciation of names, titles, and foreign words is essential. The level of the audience—children, peers, the paying public— helps determine the level and form of the presentation. If the project was well done and if the subject has a continuing interest, more research may allow the material to be expanded and revised at a later date. Scholars keep a photocopy of their papers and speeches in addition to retaining their reference notes.

Statement of the Problem

The topic to be studied must be defined and stated as succinctly as possible. Anyone reading the project proposal must understand exactly what research is to be conducted. Care must be taken in formulating this statement. If a subject is too broad, it can become unmanageable; it must be narrowed to an aspect that can be handled. If a computer online database search, which is explained in Chapter 4, is to be utilized, a vague topic or one incorrectly stated will cost the researcher not only time, but money. As a study progresses, the focus of the subject may need to be changed or limited, or the emphasis may shift.

Defining the research problem might seem simple to do, but it can be extremely difficult. For example, wanting to find out about the artist, Gustave Caillebotte, is an ambiguous statement. If just

knowing his nationality, the dates when he lived, and the titles of one or two of his paintings is all that is needed, reading an entry in an art encyclopedia may suffice. But after some initial study, the problem might be altered to an interest in the artist's bequest to the French nation. In this case, the readings would focus on the works the French artist had collected, rather than those he painted. If the study is curtailed to Caillebotte's *On the Europe Bridge,* a good color reproduction of the work of art—plus details of this painting as well as illustrations of any preliminary studies and derivations—would be necessary additions. Writing a catalogue entry for the work would assist in the organization of essential data.

The following examples of problem statements may help beginning researchers:

This study will investigate whether or not the works of art in the Caillebotte Bequest influenced the French artist's own paintings.

The problem will ascertain whether or not Muybridge's photographs influenced Edgar Degas's depictions of running horses.

This study is concerned with the iconography of Robert Campin's *Mérode Altarpiece.*

Compiling Basic Resource Materials

For most research, the following are required before the actual writing begins: (1) bibliographies of articles, books, and catalogues in order to document pertinent data on the topic; (2) chronologies of people and of specific monuments and buildings that will place them in historical perspective; (3) catalogue entries for particular works of art which organize and document salient aspects of the work; and (4) visual materials, such as reproductions, drawings, floor plans, and elevations. This section is subdivided into definitions and brief discussions of bibliographies and chronologies. Due to their complexity, visual resources are discussed in Chapter 5, catalogue entries in Chapter 6.

Bibliographies

All in-depth research begins with a review of the literature that has already been written on the subject. This requires the formation of a *working bibliography,* a compilation of books, articles, and catalogues that are cited in the various publications which are consulted. With this list, the reader can then locate and study the references, so that

the latest theories and the accepted facts can be learned. Formal papers require the inclusion of a *selected bibliography,* a list of pertinent resources derived from the working bibliography; see Examples 11 and 12. When formulating bibliographies, be sure to adhere to the following procedures:

1. Use 3″ × 5″ cards to record all references that are mentioned.

An easy way to organize what could be a vast amount of material is to record all bibliographical information for each reference on a separate 3″ by 5″ card. Include for all references: the name of the author or authors, the complete title, the translator, the edition, name of the series, number of volumes, and publishing data, consisting of city, firm, and date. For multivolume works, add the total number of volumes that have been published in the set as well as the number of the particular volume studied. For serials, also record volume and page numbers. The cards have space for annotations, call numbers, and names of libraries where the references are located. These cards will facilitate later alphabetizing and organizing as well as provide essential information in case the material needs to be rechecked or ordered through an interlibrary loan.

If a reference work mentions a pertinent book or article, but does not cite all of the necessary bibliographical data, the details provided should still be recorded, since additional information may be discovered later. There are certain resources which will aid researchers in deciphering incomplete entries; for a discussion of this process, see Chapters 17 and 20. Not all works listed in the working bibliography, however, will be found. Moreover, how hard and how long one searches will depend upon the depth of the study as well as the importance of the material. The working bibliography will also probably contain citations for more publications than can possibly be located and read. But until the search is begun, it is impossible to determine just which works will or will not be found. Therefore, careful researchers record all references.

2. Choose the manual of style which is preferred by your discipline and follow it consistently.

There are a number of correct methods of writing bibliographical entries. Researchers must decide on a specific style guide, since this will determine the sequence and punctuation used to record publication data. The difference may be slight, but whichever method is chosen, it must be used consistently.

There are a number of style guides available. Some university administrators publish a special book to be used by their students. Many serial editors record the style which authors are expected to follow. Art educators prefer the style recommended by the American Psychological Association [20:11]; art historians often utilize Turabian's *Manual for Writers* [20:19], which is based upon *The Chicago Manual of Style* [20:15]. There is no one best system. Consistency of style is the goal.

3. Annotate the references as they are obtained and studied.

Annotation involves the addition of a few sentences or phrases that briefly state the contents and merits of each particular article or book in relation to the research subject, as for example:

Scharf, Aaron. *Art and Photography.* London: Penguin Press, 1968.
Discusses photography's influence upon Caillebotte's painting.

In some situations, as in college courses where the working bibliography is to be submitted, researchers may need to provide longer, fuller annotations for entries in order to indicate the extent to which they have analyzed the material. For instance, in the Scharf example, the annotation might state:

Well-illustrated book on invention of photography and photography's influence on 19th- and 20th-century art. Includes brief discussion of Caillebotte's *Un refuge, boulevard Haussmann*, 1880, and *Boulevard, vue d'en haut*, 1880.

In a working bibliography, any important data about a particular reference work should be included in the annotation, even before that resource is located and read. If the material is never obtained, this fact should also be recorded. Moreover, every reference should be annotated, even if the information is repetitive. As seen in Example 11, an annotation indicating that an article was a news release acted as a reminder that an item did not merit inclusion in the selected bibliography. Annotations, abstracts, and reviews multiply the usefulness of any material, for this type of data can often provide enough information to allow a preliminary judgment as to whether or not the resource should be procured.

4. Add to the bibliography only works that have information on the subject, not the tools used to find the references.

Only references that have data on the subject are recorded, not the sources from which they were derived. Thus *Art Index* [16:1] and *Worldwide Art Catalogue Bulletin* [15:13] are not added to the bibliography, but the pertinent articles or exhibition catalogues they report are included.

5. Attach a qualifying paragraph that explains exactly what is not included in both a working and selected bibliography.

Since not all works that were read are included in a bibliography, a qualifying paragraph is a necessary adjunct to both working and selected bibliographies. A *qualifying paragraph* relates what additions and deletions were made, giving any particulars that would make it clearer to the prospective reader how and why the works were chosen. This statement of criteria determines what is cited in the bibliography. For instance, in Examples 11 and 12, the qualifying paragraphs explain that all sales catalogues, newspaper articles, exhibition reviews, and general literature on the nineteenth century were excluded. For examples of different ways to organize bibliographies and to compose qualifying paragraphs, students might study the methods used to organize some of the bibliographies in the various books in the *Pelican History of Art Series* [11:80].

6. Organize the material of a selected bibliography in a logical way.

A selected bibliography is derived from the working bibliography, requiring researchers to: (1) select the pertinent entries from the working bibliography and (2) classify the material by types of references—encyclopedias, books, articles, or exhibition catalogues. An extensive selected bibliography might have various subject headings for periods of time, artistic styles, and individual artists. Most bibliographies are arranged in alphabetical order by the surname of the author or editor, but they can also be arranged in chronological order with the oldest publication cited first. Having each reference on a separate bibliographical card facilitates this organizational process.

Sometimes students confuse a selected bibliography with a chapter bibliography. The latter is a listing of the references quoted or referred to in a specific chapter or in a brief paper. Placed at the end of a chapter or term paper, a chapter bibliography is a method of noting material without having to type footnotes at the bottom of each page. The bibliographic entries are usually provided numbers which correspond to the footnote references in the text of the paper.

Chronologies

Another important aspect of research is the formation of a chronology which helps illustrate the chosen topic's relationship to events of the period. Example 1 at the end of this chapter is a chronology based upon the life, works, and bequest of Gustave Caillebotte. Because Caillebotte was famous for his gift to the French nation, the works of art in the bequest are listed separately. Example 20 is a chronology of Jefferson's home, Monticello.

A chronology should be compiled at the same time as the working bibliography, since many of the identical research tools are used. This process is outlined in Chapter 3. When developing a chronology, follow these procedures:

1. Choose a format and use it consistently.

A chronology can be written in the past or present tense, but whichever tense is chosen, it must be used consistently. Some researchers add significant world or local events to illustrate the topic's relationship to the historic occurrences of the period. In this type of chronology, the first entry of Example 1 might state:

1848 Born in Paris on August 19th, Gustave was the son of wealthy bourgeois parents, Martial and Celeste Daufresne Caillebotte. His father was a judge in the Commercial Tribunal of the Seine. After Louis Philippe abdicated the throne of France on February 24th of that year, Paris experienced turmoil and revolution.

2. Report all noteworthy biographical data.

A chronology states all of the significant events concerning a subject and lists the accurate dates when these events occurred. For an artist this should include a brief description of such salient episodes as birth, death, education, travel, influences, relationships, prizes, honors, and writings. The medium the artist favored is also meaningful.

3. Record all major works of art accompanied by their present locations and the dates they were created.

The titles of significant works should be reported, accompanied by the years the pieces were created and their present locations, when known, placed in parentheses. For instance, Example 1 states:

1878 Moved from the family home after his mother's death that year. Began painting a greater number of canvases; works were more loosely structured in the style of Claude Monet and Auguste Renoir. Painted Madame Renoir's portrait and *Toits sous la neige* (Musée d'Orsay, Paris)

4. Include major retrospective and contemporary exhibitions as well as extraordinary sales prices, since a chronology does not end with the subject's death.

Chronologies are formulated in order to ascertain exactly how an artist's career progressed; it does not end with the artist's life. Because works of art continue to live, the chronology is extended into the present. Retrospective exhibitions are cited to illustrate changes in the artist's reputation. For example, the important 1976/77 exhibition of Caillebotte's work is noted as is the first major English-language monograph and the latest sale price for one of his paintings.

5. Footnote significant discrepancies.

If meaningful dates are in conflict, the authorities who differ should be noted. For instance, several authors state that there were sixty-five paintings in the Caillebotte bequest, but Berhaut, who has written extensively on Caillebotte, lists sixty-nine works: one drawing, one watercolor, seven pastels, and sixty oils. This discrepancy is explained in a footnote.

Developing a Research Plan

Research means a systematic search or investigation of a specific topic. *True* or *pure research* brings new knowledge into existence or analyzes previous theories in view of additional information or recently obtained data. But most studies are not pure research; papers written to synthesize the ideas of others or to state facts already known are simple research. Term papers may be undertaken on this easier level; theses or dissertations require that

graduate students engage in the more exhaustive inquiry. There are various kinds of scholarly investigations, each requiring different kinds of study. Although not all scholars list the same number and types, John W. Best in his *Research in Education* [28:88] cites three: historical, descriptive, and experimental. Historical inquiry reports what occurred in the past. A descriptive study relates what is happening at the present, the *status quo*. Experimental research is concerned with what might transpire, if certain conditions were to occur or be changed. All three studies require observation, description, and analysis.

Since research requires a review of the literature previously published on the chosen topic, it is essential that all data on the subject be gathered and studied prior to reporting any conclusions. *Data* are the facts—or identifiable information—that are derived from research of an historical, descriptive, or experimental study. The phrase, *primary data,* means first-hand information, such as eyewitness accounts, the letters and diaries of an individual, and personal interviews as well as original drawings and works of art. The phrase, *secondary data,* means subordinate or indirectly derived information which is provided by authors who have examined the subject and have come to certain conclusions concerning it. These sources are important, because research, by necessity, is built upon other scholars' work. Remember that not everything published is correct. An essential part of research is to gather and to study as many of the facts as possible and then to try to ascertain which are correct or reliable.

Obviously, as much primary data as possible must be studied. Fortunately, a researcher does not always have to travel to some out-of-the-way place to obtain this material. Facsimile copies of some primary source materials are available for students to examine first hand. For example, Delacroix's diaries and Vincent van Gogh's letters have been translated and published. For scholars interested in American creative works, the Archives of American Art, described in Chapter 13, has much of its extensive holdings of archival material on microfilm, which can be borrowed through an interlibrary loan.

Art is a visual medium. Researchers must scrutinize numerous works of art, original as well as reproductions. Essential visual material should be collected during the research process. Not only may this material be difficult to locate, but it may need to be ordered. Good color reproductions of paintings are indispensable; details of more complicated works will be necessary. Sculpture, which was carved in the round and expected to be viewed from all angles, requires multi-viewed reproductions for proper understanding. Two works of art can hardly be compared unless they are near each other in the same museum or adequate visual materials are available. There are also problems of reproductions which have been cropped and visual deceptions created by erroneous color density or tone. Moreover, since reproductions of works of art usually give no indication as to the scale of the object, catalogue entries may be needed to learn the dimensions. Not all art—such as altarpieces and statuary—is still *in situ;* drawings or photographs depicting the work of art where the artist expected it to be displayed may be essential to the study.

After collecting and reading all of the published literature on the subject and scrutinizing the significant visual materials, the researcher is ready to write. Care must be taken (1) to check and verify the data; (2) not to plagiarize—to quote exactly or to use the ideas of another person without giving credit to the original author; and (3) to edit, rewrite, and proofread all material before submitting or presenting it. There are several guides which will aid researchers in learning how to write a paper: Henry Sayre's *Writing About Art* [20:18] and Sylvan Barnet's *A Short Guide to Writing About Art* [20:12].

A CHRONOLOGY OF GUSTAVE CAILLEBOTTE, 1848–1894: HIS LIFE, WORKS, AND BEQUEST

1848 Born in Paris on August 19th, Gustave was the son of wealthy bourgeois parents, Martial and Celeste Daufresne Caillebotte. His father was a judge in the Commercial Tribunal of the Seine and headed the family textile business.

1869 After pursuing an education in law, received his Diplôme de Bacheher en droit.

1870–71 During the Franco-Prussian War, served as an officer in the Garde Mobile of the Seine.

1872 Traveled in Italy; began his studies with Leon Bonnat.

1873 Sponsored by Bonnat, entered Ecole des Beaux-Arts.

1874 Father died leaving him and his brothers well-off financially for the remainder of their lives. About this date met Edgar Degas, probably through Bonnat. First Impressionist Exhibition, Nadar's Studio, Paris; Caillebotte did not exhibit.

1875 One of his paintings—probably Les raboteurs de parquet (Musée d'Orsay, Paris)—rejected by the Salon.

1876 Second Impressionist Exhibition; displayed eight paintings, including Les raboteurs de parquet and Jeune homme à sa fenêtre (Private Collection, Paris). Drafted his first will which bequeathed his Impressionist collection to the French state with provisions to finance group Impressionist exhibitions.

1877 His genre paintings indicate a knowledge, and probably some use, of the camera. Helped organize and finance the Third Impressionist Exhibition; displayed six paintings, including Les peintres en bâtiment (Private Collection, Paris); Portraits à la campagne (Musée Baron Gerard, Bayeux, France); Madame Godard et Madame Davoye (Musée du petit Palais, Geneva); Madame Martial Caillebotte, mere de l'artiste (Private Collection, New York); Madame Martial Caillebotte, mere de l'artiste (Private Collection, Paris); and Paris, a Rainy Day (Originally entitled Rue de Paris, temps de pluie; also called Umbrellas in the Place de l'Europe. Upon being transferred to the Art Institute of Chicago in 1964 renamed Place de l'Europe on a Rainy Day; in 1971 changed to Paris, A Rainy Day.)

1878 Moved from the family home after his mother's death that year. Began painting a greater number of canvases; works were more loosely structured in the style of Claude Monet and Auguste Renoir. Painted Madam Renoir's portrait and Toits sous la neige (Musée d'Orsay, Paris).

1894 Died suddenly of a pulmonary infection on February 2, at age forty-five years. Painted 332 works in oil and pastel during his lifetime. From June 4–16, the Galerie Durand-Ruel in Paris held the Exposition rétrospective d'oeuvres de G. Caillebotte, displaying 122 works. In his will left the French government his collection of sixty-seven works[1] Cézanne, Degas, Manet, Monet, Pissarro, Renoir, and Sisley. Renoir was named executor. Due to the importance of the Caillebotte Bequest, a complete list of the works are cited at the end of this chronology.

1896 During February, the 38 works that had been accepted by the government were exhibited at the Palais du Luxembourg. Later two works by Millet were offered and accepted.

1929 The Caillebotte Bequest moved from the Palais du Luxembourg to the Musée National du Louvre.

1951 Rétrospective Gustave Caillebotte, Galerie Wildenstein, Paris, May 25–July 25.

1965 Caillebotte et ses amis impressionnistes, Musée de Chartres, Chartres, June 28–September 5.

1966 Gustave Caillebotte Exhibition, Wildenstein Gallery, London, June 15–July 16.

1968 Gustave Caillebotte Exhibition, Wildenstein Gallery, New York City, September 18–October 19; his first American show.

1976–77 Gustave Caillebotte: A Retrospective Exhibition, The Museum of Fine Arts, Houston, October 22, 1976–January 2, 1977 and the Brooklyn museum, Brooklyn, February 12–April 24, 1977.

1975–87 Selling price of work climbs 1,400 percent.[2]

1987 Voiliers au mouillage sur la Seine a Argenteuil, signed and dated, sold for $300,000. First major English-language monograph: Kirk Varnedoe's Gustave Caillebotte (Yale University Press)

[1]Bernac states that there were sixty-seven paintings; Rewald repeats this number. Bazin lists sixty-seven pictures. Berhaut, who has written extensively on Caillebotte, includes the drawing and watercolor by Jean-Francois Millet that was not cited by the other authors and lists a total of sixty-nine works; one drawing, one watercolor, seven pastels, and sixty oils. The confusion may be over whether or not some of the Degas pastels were considered completed works of art.

[2]Duthy, Robin, "Investor's File," Connoisseur 217 (May 1987): 145–54.

Example 1: A Chronology of Gustave Caillebotte, 1848–1894: His Life, Works and Bequest (first and last pages).

Example 1:—(continued)

THE CAILLEBOTTE BEQUEST

The sixty-nine works of art listed by Marie Berhaut as being in the Caillebotte Bequest included seven pastels by Degas, a drawing and a watercolor by Millet, and sixty oil paintings. The asterisks denote the forty works accepted by the French government and exhibited at the Musée du Luxembourg. Most of these works were displayed at the Musée du Jeu de Paume until 1986 when the entire collection was moved to the Musée d'Orsay, Paris. The titles of the accepted works and the dates they were painted are those recorded in the 1973 catalogue, Musée du Jeu de Paume. If the work is also known by another title, it is given in the parentheses beside the official title listed by the museum where they are now located or the title found in Calillebotte the Impressionist by Berhaut.

I. Probably acquired before the Caillebotte will of 1876:
Cézanne, Vase de fleurs, 1876 (National Gallery, Washington, D.C.).
*Manet, Angélina (Une dame à sa fenêtre), 1865, Exposition de 1867 (Musée d'Orsay).
*——, Die Croquetpartie (La partie de croquet), 1873 (Staedelsches Kunstinstitut, Frankfurt).
*Monet, Le déjeuner, 1872-74, Second Impressionist Exhibition, 1876 (Musé d'Orsay).
*——, Régates à Argenteuil, ca. 1872 (Musée d'Orsay).
*——, Un coin d'appartement, 1875, Third Impressionist Exhibition, 1877 (Musée d'Orsay).
*Pissarro, Le Lavoir, Pointoise, 1872 (Musée d'Orsay).
*Renoir, La Liseuse, 1874 (Musée d'Orsay).
*——, Torse de femme au soleil, ca 1876, Second Impressionist Exhibition, 1876 (Musée d'Orsay).
*Sisley, Les régats à Molesey, près de Hampton Court, 1874 (Musée d'Orsay).[1]
*——, Une rue à Lauveciennes, ca 1873 (Musée d'Orsay).[1]

II. Probably acquired during 1877:
Cézanne, Baigneurs au repos, 1875-76, Third Impressionist Exhibition, 1877 (Barnes Foundation, Marion, Pennsylvania).
*Degas, Femmes à la terrasse d'un café (Un café, boulevard Montmartre), 1877, Third Impressionist Exhibition, 1877 (Musée d'Orsay).[2]
*——, Femme sortant du bain, 1877, Third Impressionist Exhibition, 1877 (Musée d'Orsay).[2]
*——, Les Choristes, les frigurants, 1877 (Musée d'Orsay).

IV. Probably acquired between 1880 and 1888 (cont'd):
*Pissarro, Chemin montant à travers champs, Cote des Grouettes, Pontoise, 1879 (Musée d'Orsay).
*——, La brouette, verger, 1881 (Musée d'Orsay).
*Renoir, Pont du chemin de fer à Chatou, 1881 (Musée d'Orsay).
*Sisley, Lisière de forêt au printemps, 1880 (Musée d'Orsay).
*——, Saint-Mammès (La Seine à Saint-Mammès), 1885 (Musée d'Orsay).
*——, Cour de ferme à Saint-Mammès (Seine-et-Marne), 1884 (Musée d'Orsay).

V. Works whose whereabouts are unknown as well as the date they were painted:
Cézanne–Scène champêtre
Manet–Les coures
Monet–Le mont Riboudet, à Rouen
Le plaine d'Argenteuil
Le Seine entre Vétheuil et La Roche-Guyon
Pommiers
Chrysanthèmes rouges
Poirier en fleurs
Pissarro–Louveciennes
Paysage avec rochers
Les choux, coin de village
Le labour
Le jardin fleuri
Sous-bois avec personnages
Vallée en été
Les orges
Clairière
Sous-bois
Travailleurs des champs
Renoir–La place Saint-Georges
Soleil couchant à Montmartre
Sisley–Effet du soir, bord de Seine
Station de bateaux à Auteuil
Pont de Billancourt

[1]Berhaut places it in the Musée National du Louvre, but it is not included in the Musée du Jeu de Paume catalogues. All of the works in the Musée du Jeu de Paume were transfered to the Musée d'Orsay in 1986.

[2]Listed in the Musée du Jeu de Paume catalogue of 1958 but not the 1973 publication.

Utilizing the Library

Material in a library is usually grouped by subject—art, music, literature—as well as by type—books, periodicals, microforms. Because patrons must be able to retrieve this material, an inventory system, which utilizes both a classification and catalogue scheme, must be devised. Although the trend is toward greater uniformity, not all institutions use the same system. Since researchers will need to obtain material from all areas of the library as well as to study at more than one institution, a brief discussion of the following practices has been included. These are (1) library classification systems, (2) library catalogues and their formats, (3) bibliographic database services, and (4) interlibrary loan service.

Library Classification Systems

Two basic classification systems—the Library of Congress or LC and the Dewey Decimal—are widely used. Some libraries have a split system in which some works are arranged under the older Dewey scheme and more recent acquisitions have LC numbers. If this is the case, all LC classified books will be separate from those with Dewey Decimal numbers. The Library of Congress developed the LC system by which letters are used to represent specific subject areas. Instead of being confined to ten sequences—000s for General Works to 900s for History—provided by Dewey, twenty-one letters of the alphabet are used to increase the basic number of topics. The Fine Arts are represented by the Ns; the NAs for architecture; NBs for sculpture; NCs for drawing, design, and commercial art; NDs for painting; NEs for prints; and NKs for decorative arts. The classification for photography is TR; fashion and costumes, GT; and archaeology, CC.

Under the Dewey system, the three beginning numbers state the general topic of the work. After the principal subject indicator, there is a decimal followed by other numbers that denote a narrower field. For example, the 700s are used for the Arts. The 720s represent architecture; 723. means that the work is concerned with medieval architecture.

The addition of .4 to 723.4 indicates that the architecture is Romanesque or Norman. Each number beyond the decimal point provides a more specific aspect of the primary subject.

The call number of a work is the complete set of letters and numbers which are placed on the spine of the book, inside the book, and on the library's catalogue entry. The top row of indicators follows the L.C. or Dewey Decimal system. The second line, called the Cutter number, usually refers to the entry, which is the body—author, editor, creator, society, or museum—that wrote, edited, or had the work compiled. *Gothic Architecture* by Paul Frankl has an LC call number of NA440, F683. The NA refers to architecture, the 440 to Gothic, and the F to Frankl. Sometimes the Cutter number begins with the letter that represents the artist or title of the work, rather than the author or corporate body responsible for the published material. Not all libraries adhere to the LC or Dewey classification systems; some use a modified version.

Library Catalogues

Once material is classified and shelved, access to it is provided by placing its bibliographical entry into a location catalogue: card, online public access, or COM. Because not all institutions use the same format, researchers must understand each one. In addition, the method by which entries are filed into these systems determines the accessibility of the material. Knowing how to use these catalogue systems is essential to the success of any research project, for they are one of the most valuable tools available to students and scholars. This section discusses these two aspects of library catalogues: (1) their formats and (2) methods and procedures for retrieving information from them.

Catalogue Formats

Containing the records of the library's collection, catalogue systems usually consist of the following, either singly or in combination: (1) card catalogue, (2) online public access catalogue

(OPAC), or (3) computer output microform (COM) catalogue. All three have assets and liabilities; all are subject to human error.

Card Catalogues

The oldest system, the card catalogue is arranged alphabetically, either as a dictionary or as a divided catalogue. In the former, all entries—subject; title; and author, creator, or corporate entry—are filed in one alphabetical sequence. In the latter, they are separated into more than one alphabetical sequence; subject entries in one section and author/title entries in another is a common division. Usually a good cross-reference network is provided. Acquisitions can be readily added to this flexible system.

Descriptive material on catalogue cards is generally standardized. A card contains, such information as author or corporate entry, title, publication data, call number, subject headings, number of pages, translator, foreign title, inclusion of bibliographies and illustrations, and whether or not the book is part of a series. Under "Caillebotte, Gustave," the subject card catalogue has an entry for an exhibition catalogue from the Museum of Fine Arts, Houston and the Brooklyn Museum. Example 2 illustrates this card. In addition to the above data, the dates of the exhibition and a reference to the bibliography are included. Arabic numbers identify other subject headings under which this card can be filed; Caillebotte being the only one in this case. Roman numerals report the entries to be placed in the Author/Title Catalogue. There is an LC call number of *ND* for painting and a Cutter number of *C* for Caillebotte. The artist's name is used because he is the creator of the works of art which are a major part of the catalogue. The bottom line on the card records data needed by the library administrators.

In the subject file, the cards are organized in an alphabetical hierarchical arrangement of which the researcher should be aware. For example, if searching for books to discover the influence on art of the French medieval theater, the correct sequence must be followed when checking a library's card catalogue. For LC cards, it is "Theater-History-Medieval." Only this linear progression will find the desired references. Since familiarity with the terminology of L.C. subject headings is essential for successful searches, the *Library of Congress Subject Headings (LCSH)* [17:21] should be consulted. Knowing the exact

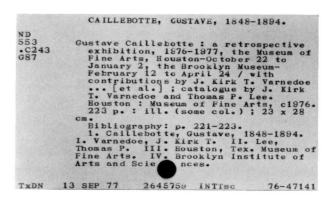

Example 2: Subject Card for Gustave Caillebotte: A Retrospective Exhibition.

wording to use for a subject search is one of the problems encountered in all library catalogues, especially if there are no, or few, cross references.

Online Public Access Catalogues

The online public access catalogue (OPAC), contains computer records in machine-readable form. Online means that the user interacts with the computer to retrieve records of the library's collection. Written instructions are usually placed near each terminal. Because computer catalogues differ, data on the main entries varies according to the way the system has been developed. Although computers are capable of searching a subject by key words placed in any order, rather than a hierarchical arrangement, many online computer catalogues have no subject access at all. Often, even those which have the ability to search for material by subject do not have the necessary cross references to make efficient and productive searches. The more cross references, the greater the expense, but the easier it is to discover material. Moreover, many systems have added no retrospective data. If this is the case, researchers need to search both the computer and the older card catalogue.

COM Catalogues

The COM catalogue, which is a microform printout, is an inexpensive, inflexible system in which entries cannot be readily added or corrected. The microfiches—thin microfilm cards that contain extensive text which must be magnified to be read—have the disadvantage that they can be misfiled or lost. In a COM catalogue, entries are filed by author, title, and subject headings. Only abbreviated entries are used; cross references are kept to a minimum. Since every time a new entry is added, all of the cards must be reproduced, updating of

the material is infrequent. The COM catalogue is unsatisfactory for effective research.

Retrieving Information

In cataloguing material, librarians follow certain international rules that frequently cause students trouble in locating material. Moreover, libraries differ as to the regulations that are followed; some have used several systems. For effective searching, researchers must be familiar with these variations. This section discusses (1) author and corporate entries, (2) proper names, and (3) cataloguing rules.

In most library catalogues, a book that contains mainly reproductions of an artist's creative work is listed in the Author File under the person's name, since he or she is the creator of the works of art reproduced in the book. This is difficult for many students, since the words artist and author are not synonymous. Because entries in the Author File are usually not repeated in the Subject File, books may not be found by beginning students. This may or may not be the case in an OPAC system.

Under AACR2, the latest international cataloguing rules that most libraries now follow, the name by which a person or institution is commonly known is the form used. Some changes have made research easier, such as the shift from the Latin "Augustinus, Saint" to "Augustine, Saint" and "Degas, Hilaire Germain Edgar" to "Degas, Edgar." Other name changes have proved more confusing. Take the case of one fourteenth-century Italian painter. Although known as Fra Angelico in most art history books, his entries are now classified under "Fiesole, Giovanni da, called Fra Angelico." Yet, in some OPAC systems, both names are still being used, and there are no cross references to warn students. If unaware of this situation, researchers will not realize the full extent of the library's collection.

Another concern for researchers is the way a museum's name is entered into the catalogue system. Prior to AACR2, the organizational entry was usually by location followed by the name of the institution. Now the institution's name is entered directly: "Museum of Fine Arts, Boston" rather than "Boston. Museum of Fine Arts." One confusing issue stems from the rule that the name of the government which administers an agency must be used first, if this corporate body is likely to be used for another agency. Instead of "Musée archéologique, Dijon" the entry will be "Dijon. Musée

archéologique." This requires researchers to determine when an institution is governmentally managed. The only solution to this problem is to keep on searching.

The idiosyncracies of the library catalogue system are many and varied. Reference librarians who assist students in retrieving information usually have little voice in how a particular work is classified and catalogued. Most LC numbers are assigned at the Library of Congress, and most institutions accept this designation. Sometimes books are virtually hidden, because their classification numbers and subject headings do not make them easy to locate. The best information specialists on the library catalogue system are the reference librarians; ask their advice.

Bibliographic Database Services

There are several types of bibliographic databases prevalent in libraries. In this guide, they have been organized into the following categories: (1) online public access catalogues discussed above, (2) specialized databases, detailed in Chapter 4, and (3) online cataloguing and bibliographic database systems, such as OCLC and RLIN.

Since about 1968 the U.S. Library of Congress [17:21] librarians have been putting the records of the material they catalogue onto magnetic computerized tape by means of a system termed MARC, an acronym for machine-readable cataloguing. The LC MARC tapes provide similar information to the LC card which is illustrated in Example 2. Purchased by online cataloguing and bibliographic database services, these tapes are made available to libraries for a fee. The services have supplementary records added to their files which are used by librarians for cataloguing materials, bibliographic control, and interlibrary loans. Students and researchers should be familiar with these services, because some of them affect the library patron. In addition, with the proliferation of personal computers, in the future, these systems may be used by a wider audience. The most prevalent online cataloguing and bibliographic database services are OCLC, RLIN, and UTLAS.

Founded in 1967 by the Ohio College Association, OCLC originally was an acronym for Ohio College Library Center. In 1981, the organization name was officially changed to Online Computer Library Center. The acronym remained the same. The OCLC files consist of LC MARC tapes from

about 1968 plus records that are added by participating libraries. Since many records have been augmented by the participating institutions, some of which have put their entire records into the system, OCLC records contain many bibliographical entries from before 1968. This system is used by the majority of U.S. libraries; in 1989, there were approximately 6,000 member institutions and 4,000 institutions which participated in some OCLC programs, such as the serial union list.

RLIN, an acronym for Research Libraries Information Network, is owned by The Research Libraries Group, called RLG. Established in 1974 by the universities of Harvard, Yale, and Columbia with the New York Public Library, RLIN contains the LC MARC files from 1968 plus records from participating libraries, which in 1989 consisted of thirty-six governing member libraries, seven associates, and fifty-three special members. The level of membership depends upon participation in RLG's various programs. Although the membership is small, the libraries whose scholarly research materials have been recorded into RLIN have some of the oldest and most outstanding art resources in the U.S. Moreover, RLIN has the advantage of being capable of subject searches. There are a number of special files in RLIN, such as the Eighteenth-Century Short Title Catalog (ESTC), the RLG Conspectus Online (RIPD), the Research-in-Progress Database (RIPD), and the Library of Congress Subject and Name Authority File. Although not readily available to students, RLIN does have search-only accounts accessed through The Cooperative Library Agency for Systems and Services, known as CLASS. These special files include the *Online Avery Index to Architectural Periodicals* [21:127] and *SCIPIO* [18:48]—both of which are discussed later.

UTLAS, the University of Toronto Library Automation Systems, is a Canadian bibliographic utility that has services similar to OCLC but differs from it in its file organization. All of these bibliographic utilities are constantly refining and improving their systems. It is their development which has computerized library procedures.

Interlibrary Loan Service

Since no library can have every book and serial that might be needed, it is fortunate that many necessary works can be obtained through the interlibrary loan service most libraries have. The search may take a two-to-three-week period, but if the material can be found in a participating library, the book will be sent to the researcher's institution for a period varying from two to three weeks. Usually, there is no charge. Through the same service, a photocopy of a serial article is often available; however, there may be a fee of ten to fifty cents per page plus a small service charge.

This exchange between libraries has been in effect on a small scale since the latter half of the nineteenth century. During the past decade due to budgetary constraints of individual libraries, the proliferation of all materials, and an increase in art scholarship, these interlibrary loans have multiplied. The use of photocopy machines, the teletype, and computers has improved this important cooperative effort. Because of the cost of interlibrary loans, some libraries restrict them.

All interlibrary loans must be written on a requisition form and submitted to the interlibrary loan service, which is a separate department in most large libraries. The form differs from institution to institution, but all forms require certain basic information for a book: complete name of author; correct title; translator, if any; publishing data, including city, firm, and date; particular edition if other than the first one; and, sometimes, a verification reference. In addition, each book has an ISBN number, a unique number that distinguishes a specific work from other publications as well as paperback and later editions of the same book. A serial has an ISSN number. These numbers are internationally accepted and can be used in ordering and obtaining interlibrary loans. If this number is known, add it to the interlibrary loan form.

When using the interlibrary loan service, researchers should realize that some works are difficult, if not impossible, to locate and borrow. This is especially true of Russian and Eastern European works, proceedings of conferences, and masters' theses. Many libraries do not lend serials or dissertations, as the former are available through photocopies and the latter through University Microfilms. Other works that usually cannot be borrowed include rare books or those issued prior to the nineteenth century; multivolume reference works, encyclopedias, and dictionaries; and recent publications. Since the 1978, U.S. Copyright Law has a number of stipulations concerning photocopying, the librarian will have certain guidelines which must be followed. Although not all items can be obtained, the large percentage that can represent a tremendous service for students and scholars.

PART II

Basic Research Methodology

This section explains the basic methodology of solving simple research problems: Chapter 3 gives a step-by-step description of how a working bibliography and chronology are compiled; Chapter 4 discusses database searching. Because beginning research topics are often on a particular artist or specific artistic style, a number of artists will be used as examples, especially the nineteenth-century French Impressionist painters Gustave Caillebotte and Edgar Degas. But remember this is just the start; after this section is mastered, Part III, which discusses methodology for more complicated subjects, should be consulted.

Tools for Compiling Bibliographies and Chronologies

Research begins with a review of the literature, the published material on the subject or as much of it as is appropriate for the depth of the study. This requires the compilation of a bibliography. Another important step is developing a chronology of the topic to be investigated in order to be able to place it in the context of time; this should be done as the material is collected. Since these two items require similar procedures, they are discussed together in this section. To begin these compilations, four basic types of references need to be consulted. Although they do not have to be checked in a particular order, all of them must be studied to obtain accurate and recent data.

1. Art encyclopedias and dictionaries furnish broad overviews of subjects; concise definitions of terms, styles, and historical periods; and examples of works of art that depict various themes. Biographical dictionaries usually provide correct names and nicknames of artists, important dates, bibliographical citations, lists of works of art and their present locations, some sales prices, and sometimes facsimiles of artists' signatures.
2. Art history surveys—including such studies as monographs, catalogues raisonnés, and corpora—place subjects within the context of historic periods and art styles, record previously published research, contain lengthy bibliographies, and include numerous illustrations.
3. Museum collection and exhibition catalogues locate works of art, report recent research, provide detailed information on works of art, reproduce significant illustrative material, and have special essays on various aspects of the included art works.
4. Scholarly articles contain research on sharply-focused aspects of a subject and report both retrospective and current information, much of which is never published elsewhere. Abstracts and indices of periodical literature access this material and provide brief data concerning the contents.

No bibliography is ever complete or current. There are always new articles and books being published as well as references which were never indexed by any of the various indices. As a consequence, other people's bibliographies and footnotes must be scrutinized for possible additions to help formulate a better, more inclusive working list. Most of the references annotated in this guide include bibliographies. These should also be studied. Some of the books cited will be repetitive; thus the major resources will become evident.

During the research process, the library's catalogue should be checked at various times in order to discover whether or not any of the mentioned works are available. To ensure a successful search, students must be aware that the method for alphabetizing family names varies from reference work to reference work. The library catalogue may use one system, the biographical dictionaries another, and the abstracting and indexing services yet a third. Since certain names present particular difficulties, researchers must check different possibilities. For instance, there maybe no one correct way to alphabetize the following:

1. names that have no one correct spelling, such as Hans Memling's surname which can also be written Memlinc
2. umlauted letters, such as the German ä, ö, and ü which may be interfiled as if there were no umlauts on the vowels; placed at the end of the a's, o's, u's; or respelled with ae, oe, and ue as replacements. For instance, the umlauted vowel in Otto Müller's name is sometimes spelled Otto Mueller
3. baptismal or first names without a surname or when there is no family name, for example, Leonardo da Vinci
4. name variations, double names, and married names, such as Paolo Caliari, called Veronese
5. the placement of prefixes such as de, du, le, and la in French; da and di in Italian; von in German; and van, de, and ter in Dutch and Flemish, for example, Herri Met de Bles

6. the interfiling of certain letters, such as I and J in Italian-language references, since there are only twenty-one letters in the Italian alphabet
7. the method of filing or interfiling M, Mc, and Mac

Students who are writing on artists or subjects for which there is a tremendous amount of available material will probably not be able to locate and read the majority of the references that are accessible to them. For instance, if Edgar Degas, who has generated masses of material, is the topic, the subject must be narrowed or the bibliography curtailed. Focusing the subject on his bronzes or his depictions of horses would greatly limit the study. In order to restrict their bibliographies, some researchers include only publications written in certain languages, for instance, English, French, and German. Others delete all brief reviews of exhibitions. But if the bibliography is curtailed, how and why must be clearly stated in the qualifying paragraph. And even if a bibliography is to be condensed, each of the following categories must be searched.

Art Encyclopedias and Dictionaries
Also See Chapter 10

For overviews of topics or definitions of terms, encyclopedias and dictionaries should be consulted. The latter provide succinct statements on terms, styles, and artists. The former are illustrated multivolume sets that include signed articles and bibliographical data on various phases of art from different periods and cultures as well as provide general art historical background essential to research. Example 3, the Caillebotte entry from the *Praeger Encyclopedia of Art* [10:4], typifies the information that can be gleaned from these resources. Cited are the artist's nationality, dates, types of paintings, and bequest of Impressionist works, plus one bibliographical reference to M. Berhaut's *Gustave Caillebotte,* Paris, 1951. Since Caillebotte is called an Impressionist, the encyclopedia's entry on this artistic style should also be examined. Other major art encyclopedias and dictionaries may provide additional material. For instance, *McGraw-Hill Dictionary of Art* [10:3] has an informative concise article that refers to three books on the subject. One is J. Rewald's *The History of Impressionism* [12:85], a work most li-

CAILLEBOTTE, Gustave (1848, Paris—1894, Gennevilliers, Seine), French painter, best known as one of the principal patrons of the Impressionists. Although he was a minor painter, his work shows some talent. From 1876 to 1882 he took part in five of the exhibitions of the Impressionist group. His portraits (*Henri Cordier,* 1883; Paris, Louvre) and landscapes may have been influenced by Degas, but his views of Paris (*Snowy Rooftops,* 1878; Louvre) and realistic scenes of working-class life (*Workmen Planing a Floor,* 1875; Louvre) are highly personal in expression. In his will Caillebotte left his collection, comprising no less than 65 Impressionist works, to the State, which, however, rejected it. After three years of negotiations and a campaign in the press, 38 of the pictures were accepted. It was not until 1928 that these works—including Renoir's *Swing* and *Moulin de la Galette,* and Pissarro's *Red Roofs*—finally entered the Louvre.

BÉRHAUT, M. *Gustave Caillebotte.* Paris, 1951.

Example 3: From *Praeger Encyclopedia of Art,* Vol. 1, p. 331, 1971. Reprinted by permission of Praeger Publishers, Inc., a Division of Holt, Rinehart and Winston.

braries own and a good beginning to the research study. Although it has no entry for Caillebotte, *The Encyclopedia of World Art* [10:2] has a lengthy article and an extensive bibliography on Impressionism.

Research should begin with broader, general terms and concepts and move to more specific ones. Unless a term or artist is difficult to find, one or two encyclopedias will prove adequate. Publishing an encyclopedia is a major project taking many years to complete. Notice that most of the ones annotated in Chapter 10 were issued in the 1960s and 70s. In 1994, these references will be joined by *The Dictionary of Art* [10:1], which is being compiled by The Macmillan Publishers of London. Written by international experts, this projected thirty-volume reference work will expand and update information in the other encyclopedias.

If research on an individual artist is being conducted, the biographical dictionaries should be consulted. These tools often provide variations on artists' names, succinct chronologies, early bibliographical references, titles and locations of works of art, sales prices, and facsimiles of artists' signatures. Frequently, the references have representative works of art and report medium, size, probable date, and present location for them. Checking several of these research tools may help in the compilation of the artist's chronology.

Some of the most highly esteemed biographical dictionaries are written in German, French, and Italian. The references to countries and cities are written in the vernacular of that particular dictionary. For instance, the Belgian city of Gent would be spelled Gand in a French reference and Ghent in most English and American works. For assistance, consult the multilingual glossary of geographic locations in Appendix D as well as the lists of commonly used German, French, and Italian words found in various appendices. Students who are just beginning research often shy away from important foreign-language works. But it is best to make as complete a working list as possible, including all publications no matter what the language, because these references often provide essential information on the research topic even for those who can not read the language.

One of the most highly regarded biographical dictionaries is *Allgemeines Lexikon der bildenden Künstler von der Antike bis zur Gegenwart* [10:47] by Ulrich Thieme and Felix Becker, frequently referred to as *Thieme/Becker*. This thirty-seven volume German work covers painters, sculptors, architects, engravers, and some decorative artists. Because of its comprehensiveness, it is a good source for minor artists. It does not, however, include many twentieth-century artists. The signed articles include data on artists' lives, locations of some of their works, and multilingual bibliographical citations. For instance, in Example 4, there is a list of eight publications issued between 1876 to 1906. Most of these citations are abbreviated to the point that they are hard to decipher. Even so, record them in the bibliography; Chapters 17 and 20 have discussions on how to complete bibliographical entries. Presently, a new dictionary, *Allgemeines Künstler Lexikon* [10:25], is being published; it will incorporate material from *Thieme/Becker* as well as Vollmer's *Allgemeines Lexikon* [10:49] and will broaden the coverage, particularly for twentieth-century artists.

Caillebotte, G u s t a v e, Maler, geb. 1848 in Paris, † am 2. 3. 1894 in Gennevilliers; studierte in Paris und trat früh in Beziehungen zu den Impressionisten Monet, Renoir, Pissaro, Sisley, Cézanne, denen er sich von ihrer zweiten Ausstellung an, 1876, endgültig anschloß, in der er mit dem noch in dunklen Tönen gehaltenen Bilde „Les raboteurs du parquet" debütierte. Claude Monet gewann besonderen Einfluß auf ihn, leitete ihn an, im Freilicht zu malen und seine Palette aufzuhellen. Als Maler steht Caillebotte unter den

daß von 8 Manets 2, von 16 Monets 8, von 9 Sisleys 6, von 18 Pissaros 9, alle 7 Degas', von 4 Cézannes 2, von 8 Renoirs 6 und 2 Bilder von Caillebotte („Les Raboteurs du parquet" und „Toits sous la neige") für das Luxembourg ausgewählt wurden. Die ausgewählten Bilder wurden schon 1894 auf 400 000 Francs geschätzt.

Caillebotte hat sich auch als Radierer betätigt, von seinen Blättern seien genannt: „Die Ruderer", „Alte Frau mit Haube" und ein Porträt Storelli's.

D u r a n t y, La nouv. Peinture (1876). — C h. E p h r u s s i in Gaz. d. B.-Arts 1880 I 487 f. — D u r e t, Critique d'Avantgarde (1885); Les Peintres Impressionistes (1906). — F é n i e r, Les Impressionistes en 1886 (Paris, publ. De la Vogue). — Le Temps v. 3. 3. 1894. — Chron. des Arts 1894 p. 71, 85. — J. B e r n a c in The Art Journ. 1895 p. 230 f., 308 f., 358 f. *O. Grautoff.*

Example 4: Thieme, Ulrich and Becker, Felix. *Allgemeines Lexikon der bildenden Künstler von der Antike bis zur Gegenwart.* Leipzig: E. A. Seemann, 1907–50. Volume 5, page 361.

Another major biographical dictionary is the French ten-volume work by Emmanuel Bénézit, *Dictionnaire critique et documentaire des peintres, sculpteurs, dessinateurs, et graveurs* [10:27], illustrated in Example 5. This publication covers about 300,000 painters, sculptors, designers, and graphic artists of Eastern and Western art from 5 B.C. to the present. Included are biographical information, sometimes brief bibliographies, locations of some works of art, and facsimiles of artists' signatures. Under the section entitled "*Prix,*" a few representative sales prices for art works are provided. These major biographical dictionaries should be consulted, as each reference may record an additional clue to the puzzle being solved.

The ease with which information on artists is discovered depends upon their reputation. World-renowned artists are easily located. But finding biographical data on contemporary artists who do not have international reputations can be a challenge. Although there are some dictionaries on contemporary artists, most of them provide only brief data. Some which should be consulted are *Contemporary Artists* [10:31], *Contemporary Architects*

et Antiphonaires), enrichis de miniatures de Cailleau, à la Bibliothèque de Douai.

CAILLEBOTTE (Gustave), *peintre, né à Paris le 19 août 1848, mort à Gennevilliers le 21 février 1894* (Ec. Fr.). *G Caillebotte*

Elève de Bonnat, reçu en 1873, à l'Ecole Nationale des Beaux-Arts où il ne fit que passer pour se joindre aux impressionnistes alors réprouvés. Il s'occupa des expositions du groupe, rendant notamment la troisième possible. Il exposa avec ses amis en 1876, 1877, 1879, 1880, 1882. G. Caillebotte n'a été longtemps connu du public que par son tableau *Les raboteurs de parquets* figurant avec les œuvres impressionnistes léguées par lui, au Musée du Luxembourg, dans la petite salle portant son nom, toutes œuvres devant entrer au Louvre, condition que l'Etat n'accepta qu'en partie et sous la pression de Clémenceau. En 1894, Caillebotte passait pour un amateur. Riche, il s'était fait le Mécène de ses amis Monet, Renoir, Sisley, Pissarro dont la correspondance révèle ses générosités. Il a peint des scènes réalistes de la vie des travailleurs, de nombreuses vues de Paris, notamment *Le Pont de l'Europe* qui figura à l'Exposition impressionniste de 1877, et, note dans une copieuse étude Marie Berhaut : « certaines vues plongeantes des boulevards, prises des fenêtres de son appartement annonçant les compositions analogues que Pissarro exécutera une vingtaine d'années plus tard ». L'art de G. Caillebotte n'est pas non plus sans liens avec celui de Degas. Il a été un excellent peintre des bords de la Seine où il s'était établi, devenant maire-adjoint de Gennevilliers, partageant son temps entre la peinture, le yachting et l'administration généreusement paternelle de sa commune.

C'est dans ce temps qu'il peignit l'une de ses toiles les plus remarquables : *La Seine à Argenteuil*. En léguant à l'Etat sa collection de chefs-d'œuvres impressionnistes, G. Caillebotte précisa que ces tableaux ne devaient aller « ni dans un grenier, ni dans un Musée de province, mais bien au Luxembourg et plus tard au Louvre ». Devant le sacrilège, que représentait l'entrée des Impressionnistes au Louvre, Gérome et les professeurs de l'Ecole des Beaux-Arts menacèrent de démissionner. Renoir, l'exécuteur testamentaire, tint bon, néanmoins l'Etat tergiversa et.... ne prit qu'une partie du legs, dont la moitié seulement des Monet et des Cézanne. Quand vint l'heure du transfèrement au Louvre aucune difficulté ne se présenta, car l'esprit des dirigeants des Beaux-Arts n'était plus, en 1928, celui de 1894.

PRIX. — LA HAYE. 1889, Vte Van Gogh : *Les bouleaux blancs* : 1.260 fr. — *Paysage aux environs d'Amiens* : 810 fr. — PARIS. Vte X..., 28 avril 1894 : *Le verger* : 780 fr. — Vte Sisley, 1899 : *Boulevard Haussmann, effet de neige* : 620 fr. — Vte Blot, 1900 : *L'allée des marronniers* : 450 fr. — *Le hangar* : 150 fr. — Vte X..., 23 juin 1900 : *Les bleuets* : 240 fr. — Vte du 5 décembre 1901 : *Le Pont de fer* : 55 fr. — Vte du 17 mars 1904 : *Bords de la Seine* : 125 fr. — Vte Depeaux, 1er juin 1906 : *Boulevards de Paris, neige* : 140 fr. — *Nature morte* : 250 fr. — Vte du 22 mars 1907 : *Pommiers en fleurs* : 820 fr. — Vte X..., 28 mars 1919 : *Banlieue parisienne* : 305 fr. — Vte Hazard, 1-3 décembre 1919 : *Trois poules faisanes* : 420 fr. — Vte X..., 25 octobre 1920 : *Maison au bord de l'eau* : 540 fr. — Vte X..., 4 avril 1924 : *Le Jour des Régates à Trouville* : 650 fr. — Vte X..., 5 et 6 juin 1925 : *Moret* : 500 fr. — Vte Théodore Duret, 1er mars 1928 : *Sur le banc* : 2.200 fr. — Vte X..., 2 mars 1929 : *Colons dirigeant des yoles* : 4.010 fr. — Vte S. G. et divers, 27 avril 1929 : *La plage de Trouville. Vue prise de la Corniche* : 7.000 fr. — Vte Eugène Blot, 2 juin 1933 : *Le pont d'Argenteuil* : 2.600 fr. — Vte X..., 22 février 1936 : *Portrait d'homme* : 600 fr. — Vte M. de Saint-M., 29 et 30 novembre 1937 : *Voiliers sur la Seine à Argenteuil au printemps* : 1.720 fr. — Vte X..., 13 décembre 1937 : *Sur le pont* : 650 fr. — Vte X..., 21 mars 1938 : *Voiliers sur la Seine à Argenteuil au printemps* : 1.300 fr. — Vte X..., 30 octobre 1940 : *Bords d'un canal* : 910 fr. — Vte X..., 8 novembre 1940 : *Les voiles blanches* : 1.600 fr. — Vte X..., 27 novembre 1940 : *Les Pommes* : 680 fr. — *Bords de mer* :

Example 5: Bénézit, *Dictionnaire critique et documentaire des peintres, sculpteurs, dessinateurs, et graveurs.* Paris, Librairie Grund, 1976, Tome II. Reproduced by the kind permission of the editor. Selection from the Caillebotte entry.

[21:49], *Contemporary Designers* [10:32], *Who's Who in American Art* [10:50], the *Guide to Exhibited Artists Series* [10:38], and *Current Biography Yearbook* [10:33]. More material can frequently be located through the exhibition catalogues and serials, which are discussed later.

Everyone appreciates a short cut to a long tedious job. Indices to biographical information—such as the *Artist Biographies: Master Index* [10:70] and Havlice's *Index to Artistic Biography* [10:73]—pinpoint in which specialized dictionaries a particular artist is cited. The former covers 275,000 artists who were discussed in ninety volumes of *Current Biography Yearbook* [10:33]. The latter lists 70,000 artists indexed in sixty-four different dictionaries; its supplement, 44,000 artists in seventy additional works. These resources save students from having to check individually all the references covered. For more difficult to find artists, specialized research tools, discussed in Chapters 5 and 8, need to be consulted.

Art History Surveys
Also See Chapters 11 through 14

Art history books are essential reading for everyone interested in art. For coverage of well-known artists and subjects, these resources are frequently the best tools for beginning research. Depending upon their focus, they furnish:

1. substantial information on artistic styles, periods, and cultures
2. biographical data on artists
3. the titles and present locations of the more famous works in an artist's *œuvre*

4. numerous black-and-white and some color reproductions plus drawings of elevations and floor plans
5. extensive bibliographies
6. glossaries, chronologies, and synoptic tables— *synoptic tables* provide, in outline form, a general view of the important events and achievements that occurred about the same period of time in either certain countries or in different disciplines, such as art, music, literature, and science

In the early part of this century, multivolume art history reference works, such as Max J. Friedlander's fourteen-volume *Early Netherlandish Painting* [12:14], were especially popular. These were written on one subject and by one person. Care must be taken in assessing the currency of the research in these works. For instance, In *Volume 2: Rogier van der Weyden and the Master of Flemalle,* Friedlander provides a lengthy discussion on Robert Campin and the Master of Flemalle controversy. Although the English translation was issued in 1967, the original version was published between 1924 and 1937. Since the latter date, additional research has been done. Friedlander, remember, did not have knowledge of these perceptions and thus based his conclusions on different data than later scholars.

The trend now is to divide a subject into workable parts, inviting experts in each field to write on various sections, with an editor-in-chief to oversee the whole project. Thus, the highly regarded *Pelican History of Art Series* [11:80] under the guidance of Nikolaus Pevsner has produced more than forty volumes, some in several editions. Surveying art from the prehistoric period to contemporary times, these important studies contain informative texts and extensive bibliographies. Presently, many individual volumes are being revised. Although Fritz Novotny's *Painting and Sculpture in Europe 1780–1880* [12:84.1] in this series provides an overview of this period of art history, only one chapter is on French Impressionism. There is a brief discussion of Degas, but Caillebotte has only one sentence. Obviously, a book on Impressionism will be needed for fuller information on these artists.

For an over-view of art periods as well as some good illustrative material and extensive bibliographies, the textbooks for upper-level college courses should be examined. For instance, John Rewald's *The History of Impressionism* [12:85], which provides an excellent discourse on the style, has a lengthy discussion of both Caillebotte and Degas, numerous reproductions of their art, and an extensive bibliography. Many upper-level textbooks are listed under "Art Historical Surveys" in the appropriate chapters of this guide. Non-academic researchers may also profit from these books which can usually be located at the bookstores of the local university or college.

It would be impossible to include the titles of all of the numerous art history surveys in this guide. But to assist researchers, several chapters record some of the more important resources. The references in Chapters 11 and 12 cover artistic styles, periods, and cultures of Western Europe and North America; Chapters 13 and 14, works from various geographic origins. Where appropriate, each section lists

1. term and biographical dictionaries that cover that period of time or geographic location
2. pertinent art history survey books
3. bibliographies
4. documents and sources that report the actual words spoken or written by artists
5. references on art criticism
6. video documentaries
7. special indices
8. serials which cover predominantly that subject
9. cultural/historical surveys that provide background for the art

Because many art surveys are written about a specific medium, Part V of this guide consists of chapters on resources for various media. Most research projects will overlap; several sections of this guide will have to be examined.

There are three types of reference tools written on individual artists and their works of art: a monograph, œuvre catalogue, and a catalogue raisonné. An artist *monograph* is a treatise on one individual artist which usually provides some historical or biographical material and some information on the artist's works. French for production or work, œuvre can be used to denote either the complete artistic output of an artist or all works in a specific medium. Often appended to a monograph on the artist, an œuvre catalogue systematically lists and illustrates each work of art in the artist's œuvre. The œuvre catalogue may or may not give a full citation on each art piece; sometimes it provides only a check list of the works.

More scholarly is the catalogue raisonné, which also can be appended to a monograph. In French, *raisonné* means ordered, rational, or analytical. Therefore, a *catalogue raisonné* is a critical or descriptive study of an artist's œuvre or all an artist's artistic endeavor in one medium. In a *catalogue raisonné*, each entry cites title, dimensions, medium, probable date completed, and current location. Other items are included, such as exhibitions in which the work has been displayed, the provenance or list of former owners, literature that has referred to the piece, and any additional significant information. Problems of authentication are discussed. Often samples of fakes, forgeries, and studio works are reproduced. Catalogues raisonnés published today include an illustration of each work of art.

Because it takes years of research before a catalogue raisonné or an œuvre catalogue is produced, most artists have not been the subject of this type of study. But for artists who have, these references are essential research tools. To discover them, consult Wolfgang Freitag's *Art Books: A Basic Bibliography of Monographs on Artists* [10:72]. This 1985 reference work provides more than 10,500 titles for publications on about 1,870 painters, architects, sculptors, graphic designers, and photographers from all historical periods and countries. The CR in Freitag's book indicates a catalogue raisonné. Some prolific artists have generated a large body of literature; this is evident in Freitag's book. For instance, Peter Paul Rubens who painted well over a thousand canvases, with or without the help of his studio assistants, has seventy-three entries. Pablo Picasso, who was reported as stating that he hoped to finish 10,000 works of art before he died, has ninety-five entries.

Exhibition Catalogues and Museum Publications
See also Chapter 15

Basically there are two kinds of museum and exhibition catalogues: (1) a checklist or summary catalogue and (2) a scholarly catalogue. *A summary catalogue* provides some fundamental data on each listed work of art, such as artist's name, the work's title, medium, and measurements. At times, acquisition data and the approximate date of the piece are included. An illustration of the object may or may not be reproduced.

On the other hand, each entry for a work of art in a *scholarly catalogue* traditionally provides:

1. artist's name, title of work, medium, dimensions, and any signature and date found on the work
2. acquisition data and present location
3. approximate date completed
4. condition of work, if known or unusual
5. provenance, a list of all known owners and sales in which it figured
6. literary references or scholarly publications on the object
7. previous exhibition history
8. related works, such as sketches or prints
9. additional information
10. a black-and-white or color reproduction

Included within the ninth category might be attribution data, a facsimile of the artist's signature, and information concerning the subject of the work, such as location of the landscape, identification and history of person portrayed, and symbolism. See Appendix E for the definitions of terms of attribution, time, shape and dimension, as well as other words pertinent to catalogues.

Scholarly catalogues sometimes provide special indices and supplementary materials which greatly aid researchers. There may be several kinds of indices:

1. subjects or iconography—often subdivided into religious, historic, profane and secular, topographical subjects, and portraits
2. previous owners
3. coats of arms and seals
4. locations of works
5. donors
6. accession numbers
7. changes in attributions
8. media

Exhibition Catalogues

Art exhibitions come in all kinds and sizes. The works exhibited may be of any medium or from any period of time. Only a few art objects may be displayed, or the exhibition may assemble a vast collection of works providing visitors with an encyclopedic view of the subject. There are numerous kinds of exhibitions, such as retrospective, competitive, invitational, one-person, educational, and historical. Exhibition catalogues not only provide

permanent documentation of these temporary displays but frequently disseminate the most current research on the subject. Moreover, they have become excellent sources for reproductions of works that have not been previously reproduced. And because some exhibitions cover subjects rarely examined, their catalogues can remain the most significant research on that subject for years, or even decades.

Originally, international traveling exhibitions had a distinct, separate catalogue for each country in which the works of art were displayed. For example, there was a different exhibition catalogue in each country where the archaeological finds of the People's Republic of China were placed on view during the 1970s when the art traveled throughout Europe and the United States. These catalogues not only differed as to the language in which they were written but as to the content of the material included. Now, the tendency is for one catalogue to be written by scholars and translated for the countries where the art will be displayed. For instance, the 1988 monumental catalogue, *The Art of Gauguin,* was written by seven American and French scholars. In Paris, there was a French catalogue; in the U.S., an English one.

All works of art cited in an exhibition catalogue are not necessarily displayed at all museums to which the exhibition travels. For example, *El Greco of Toledo*—the 1980s catalogue for an exhibition in Madrid, Washington, D.C., Toledo, and Dallas—cited sixty-six works of art. The exhibition, which was four years in the making, had one catalogue. Although each painting was displayed in at least one museum, none of the four institutions showed all of the pieces. The Prado displayed fifty-eight paintings; Washington and Toledo, fifty-seven; and Dallas, fifty-one. Conservation concerns and the length of borrowing time influenced these decisions. Scholars must take these points into consideration, especially when assigning influence from specific exhibitions on contemporary artists' works.

No one knows exactly how many exhibition catalogues are produced each year, but the estimates range from 6,000 to 8,000. Because of their importance, researchers must search diligently to discover any exhibition catalogues on their subjects. The easiest to locate is a catalogue centered around one artist. For instance, *Degas,* the 1988 catalogue for the exhibition held in Paris, Ottawa, and New York City is an excellent reference work and is

readily found in a library's catalogue. But some artists are the subject of a profuse number of exhibitions—for instance, in one year there were more than sixty exhibition catalogues for Pablo Picasso's art—while the works of other artists are rarely documented. Consequently, it sometimes is a real challenge to discover the catalogues that will further the research project.

One difficulty in locating these important resources is the lack of standardization in listing an exhibition catalogues. They may be indexed under:

1. authors or compilers
2. exhibiting institutions
3. cities or states in which the exhibiting institutions are located followed by the names of the exhibitors
4. exhibition titles
5. the catalogues' subjects

Online library catalogues facilitate finding these references, if they are processed as books and given classification numbers. But brief, small catalogues can be treated as ephemeral material, placed in folders, and organized in vertical files. There may be no notation as to the existence of either the exhibition catalogues or the vertical files in the library's catalogue system. Due to the various ways these references can be treated, researchers should ask the reference librarian for assistance in locating them.

For discovering the titles and subjects of major exhibition catalogues, there are three widely used sources: *RILA* [16:7] discussed below, the *Art Exhibition Catalogs Subject Index: Collection of the Arts Library, University of California at Santa Barbara,* and *The Worldwide Art Catalogue Bulletin.* On microfiche, the University of California, Santa Barbara reference work [15:12] indexes more than 67,000 catalogues. For each catalogue, it provides authors, names and cities of exhibiting institutions, catalogue titles, subject terms used to describe or clarify the contents, exhibition years, and data such as number of pages and illustrations and inclusion of bibliographies, chronologies, and bibliographical footnotes. Access is through names of exhibiting institution and subjects. Up to five artists' names per catalogue are added to the subject category. Many catalogues are available for interlibrary loans.

THE NEW PAINTING: IMPRESSIONISM, 1874-1886
National Gallery of Art, January 17-April 6, 1986; and M.H. de Young Memorial Museum, Fine Arts Museums of San Francisco, April 19-July 6, 1986. Organized in association with Fine Arts Museums of San Francisco. Published by Richard Burton SA, Publishers, Geneva. Distributed in the U.S.A. and Canada by University of Washington Press, Seattle. Preface by Ian McKibbin White and J. Carter Brown. Introduction by Charles S. Moffett. Essays by Moffett, Stephen F. Eisenman, Richard Shiff and others. Reprinted essays by Stéphane Mallarmé and Louis Emile Edmond Duranty (1876; also in French). Complete entries with bibliographies. Extensive bibliography. Index of artists. Excellent reproductions. Portraits of some of the artists. 512 pp. with 279 ills. (213 col.) and 146 reference ills. 29 x 24 cm. LC 85-24537 ISBN 0-295-96367-0
Highlighting the aesthetic diversity of the movement now labeled Impressionism, this exhibition of 160 landscapes, portraits, figure studies, still lifes and views of Parisian society presented a narrow cross-section of the nearly 1800 works actually displayed in the eight original Impressionist shows. Assembled from more than 70 international collections, the exhibited works represented 28 artists, including such celebrated figures as Degas, Monet, Pissarro, Renoir, Cassatt, Cézanne, Gauguin, Seurat, Signac and Sisley along with a number of lesser-known painters.
The sumptuous catalogue is organized into eight central chapters, each corresponding to a single show held between 1874 and 1886. Included in each section are beautiful color reproductions of the exhibited paintings from the featured show, accompanied by complete entries and excerpts from contemporary critiques; an annotated facsimile of the original catalogue; and an illustrated, well-researched essay outlining the importance of the show and assessing the stature of the exhibiting artists. In his introduction Moffett examines the historical record in order to underscore the divergent aims of the original participants, who were united only in their resistance to the official Salon. Eisenman discusses the source and various connotations of the term Impressionist as applied to these artists, and Shiff points out the subjective attitude that links the Impressionists to later Symbolist concerns. In important reprinted critical essays of 1876, Mallarmé stresses Manet's role as a leader of the group and Duranty defends the validity of a new art based on modern life. One useful

bibliography cites contemporary reviews of the original exhibitions, while another updates John Rewald's substantial 1973 bibliography for The History of Impressionism.
•20132 Hardcover $60.00

NA 7620 H37
THE ARCHITECT AND THE BRITISH COUNTRY HOUSE, 1620-1920
The Octagon, November 5, 1985-April 6, 1986; National Academy of Design, New York, May 8-June 15, 1986; High Museum of Art, Atlanta, July 27-September 7, 1986; and Farish Gallery, Rice University, Houston, October 19-November 30, 1986. Organized by American Institute of Architects Foundation, Washington, D.C. Published in association with Trefoil Books, London. Text by John Harris. Complete entries. Index. Excellent reproductions. 264 pp. with 409 ills. (30 col.). 26 x 27 cm. ISBN 0-913962-75-9
Complementing the National Gallery of Art's "The Treasure Houses of Britain" (see this Bulletin, 20069), this exhibition featured 95 original architectural drawings, plans and sketches of exterior and interior views that reflected the development of the British country house from the Stuart through the Edwardian era. Chosen primarily from the collection of the Royal Institute of British Architects, the drawings represented the work of 62 architects, including Inigo Jones, Christopher Wren, John Vanbrugh, James Wyatt, William Chambers and William Kent. The exhibition's selective overview offered an illuminating survey of milestones in the evolution of a significant tradition in British architectural history.
The well-produced catalogue presents fine reproductions of all the exhibited pieces, arranged chronologically and supplemented with more than 300 illustrations of related works. Harris, Curator of the Royal Institute of British Architects Drawings Collection, contributes a scholarly and profusely illustrated examination of the history of British country house design, discussing the styles of the Stuart, Restoration, Baroque, Neo-Palladian, Neoclassical, Picturesque, Victorian and Edwardian periods. He also assesses the achievements of several major architects, including Robert Smythson (the "genius of the Tudor Renaissance"), Inigo Jones (who in fact never built a country house) and Christopher Wren (whose real contribution to country house design is still a matter of speculation).
•20096 Hardcover $35.00

THE NEW PAINTING: IMPRESSIONISM, 1874-1886
National Gallery of Art, January 17-April 6, 1986; and M.H. de Young Memorial Museum, Fine Arts Museums of San Francisco, April 19-July 6, 1986. Organized in association with Fine Arts Museums of San Francisco. Published by Richard Burton SA, Publishers, Geneva. Distributed in the U.S.A. and Canada by University of Washington Press, Seattle. Preface by Ian McKibbin White and J. Carter Brown. Introduction by Charles S. Moffett. Essays by Moffett, Stephen F. Eisenman, Richard Shiff and others. Reprinted essays by Stéphane Mallarmé and Louis Emile Edmond Duranty (1876; also in French). Complete entries with bibliographies. Extensive bibliography. Index of artists. Excellent reproductions. Portraits of some of the artists. 512 pp. with 279 ills. (213 col.) and 146 reference ills. 29 x 24 cm. LC 85-24537 ISBN 0-295-96367-0
Highlighting the aesthetic diversity of the movement now labeled Impressionism, this exhibition of 160 landscapes, portraits, figure studies, still lifes and views of Parisian society presented a narrow cross-section of the nearly 1800 works actually displayed in the eight original Impressionist shows. Assembled from more than 70 internation-

Example 6: *Worldwide Art Catalogue Bulletin.* Christine James, editor. Ithaca: Worldwide Books, Inc., 1986. Volume 22, Number 3.

The Worldwide Art Catalogue Bulletin [15:13], a quarterly with an annual index, provides detailed reviews for about 700 to 900 international exhibition catalogues culled from about 3,500 different museums and galleries around the world. Each issue contains indices to

1. catalogue titles
2. artists whose work is displayed
3. a chronological arrangement by century and style
4. media represented
5. specialized topics, such as American, Canadian, Near and Far Eastern, primitive, political, and religious art plus surveys of current trends and women artists

In 1990, a cumulative index for 1963–1987 will be published.

Example 6, for *The New Painting: Impressionism, 1874–1886,* illustrates the extensive information that can be gleaned from the *Worldwide Art Catalogue Bulletin.* The review provides not only data concerning the catalogue but details the focus and content of the articles. There are numerous essays, an extensive bibliography, and 279 illustrations, 213 of which are in color. After reading the review, researchers will realize that this catalogue addresses each of the eight Impressionist Exhibitions, reproducing the actual *livret* or pamphlet from each show. Because the *Worldwide Art Catalogue Bulletin* uses only broad subject categories, there was no subheading for Impressionism and no listing under Caillebotte or Degas. But the catalogue was located through the Chronology Index under "Eastern and Western European Art, 1800–1900, Painting." Remember, it often takes creative searching to find needed material.

Publications on Museums and Private Collections

A long standing and reliable source for information concerning a work of art is the owner—either a museum or private collector. Some museums have consistently published detailed data concerning their objects. Some are written for a popular audience; others, for scholars. But even the booklets for museum visitors can be erudite and informative. For example, Carol Andrews's *Egyptian Mummies* [11:71.2] and Julian Reade's *Assyrian Sculpture* [11:71.5], which are seventy-page publications written by the British Museum curatorial staff, are scholarly readable books providing an overview of the subject.

Museum collection catalogues have a lengthy history. For instance, the Ashmolean Museum of Oxford University was opened to the public in 1683, and by 1713 the administration was requested to inventory the collection and write a catalogue in Latin. Some institutions have had a continuous history of producing catalogues, although most of the earlier ones are very brief and ambiguous as to which works of art are cited. The National Gallery in London is an excellent example of a museum which publishes a series of quality catalogues that are periodically revised. Other examples are the Metropolitan Museum of Art and the Frick Collection, New York City; the Samuel H. Kress Collection at the National Gallery of Art, Washington, D.C.; Yale University Art Gallery, New Haven, Connecticut; and the Rijksmuseum, Amsterdam. Information on new acquisitions, changes in attribution, deaccessioning, and recent conservation of specific items can sometimes be found in catalogue supplements, museum serials, annual reports, or separate publications, such as *The Metropolitan Museum of Art: Notable Acquisitions*.

Most private collectors and many museums publish brief inventory lists for their works of art. But even lists providing little information can be essential to research. Because many art works have changed ownership as well as location over the centuries, inventory lists can assist scholars in determining the provenance of a work and in authenticating it. Sometimes numerous versions exist of a particular painting by a famous artist. One may be the first work; the others, later copies by the master, his or her studio, followers, imitators, or forgers. In the case of a Raphael painting which was known

to have been in the Borghese Collection, the inventory number on the work discovered from the Italian collector's inventory helped determine its authenticity. See Cecil Gould, "The Millionaire and the Madonna," *Connoisseur* 214 (December 1984): 98–101.

Because items from private collections may be donated to museums, studies of collectors can be meaningful. For instance, Caillebotte, who was also a patron of the arts, amassed a group of sixty-nine works, which he bequeathed to the French nation. Research on how and why the works were chosen provides greater insight into the collection. The role of patronage—whether private collector or museum—has become increasingly important in art history, as museum curators try to authenticate works and to establish provenance. This research also deals with the study of changes in taste, a topic explored by Francis Haskell in several of his books: *Rediscoveries in Art: Some Aspects of Taste, Fashion, and Collecting in England and France* [12:112], *Past and Present in Art and Taste* [12:81], and *Patrons and Painters: Art and Society in Baroque Italy* [12:65].

During the research process, when works of art are located as being in a specific museum, the museum collection catalogues should be consulted. A number of references mentioned institutions that own Caillebotte's paintings. If catalogues of these collections exist and are available, they will provide essential data for the study. Most museums, however, have not compiled scholarly collection catalogues.

There are a few resources that under specific artists' names cite which museums own their works. For instance, *Paintings in Dutch Museums* [19:34] indicates the location of about 30,000 paintings—by 3,500 artists who were born prior to 1870—in about 350 Dutch institutions. Under Caillebotte's name, there is a citation for his *Pool in a Wood* at the Stedelijk Museum 'Het Catharinagasthuis' in Gouda. Other similar reference works are the *Census of Pre-Nineteenth-Century Italian Paintings in North American Public Collections* [19:23], *Old Master Painting in Britain* [19:33], and *Paintings in German Museums* [19:35]. Once the institution that owns the work is known, its collection catalogue, if any exists, needs to be located, since it may have more recent and comprehensive data.

Serials and Their Indices
Also See Chapter 16

It often takes from one to three years from the beginning of a research project to its publication in a periodical and from two to five years to be issued in book form. Up to 10 years or more can be required before new data will be included in a multivolume reference work. Thus, some of the most recent information on a subject is published in magazines and journals. Furthermore, much of this material is never published in book form. The articles, which usually discuss some narrow aspect of a subject, often become the only publication source. To discover pertinent material, both recent and retrospective, indices of periodical literature must be used.

Art-Related Serials

A *serial* is a term for any publication that is issued at more or less regular intervals and numbered consecutively. Because serials are notorious for changing titles, volume numbers, and frequency of publication, they can be difficult to locate. In most libraries, bound periodicals are separated from the books, although some annuals are provided classification numbers and shelved with other book material. Significant serials have been listed under the appropriate chapters in this guide.

Once the author or title of an article is discovered, the publication that contains it must be found. Researchers should ask the reference librarian concerning the best approach for that particular institution. The following methods can be used to determine the location of specific serials:

1. the computer print-out serials list or the catalogue file which institutions maintain of their holdings
2. the computer files of such utilities as OCLC or RLIN
3. a union list of the serial collections of area libraries

A *union list,* which is a compilation of specific materials available in a particular group of libraries, uses a variety of abbreviations, symbols, and marks. For instance, // indicates that the serial has ceased publication; *n.s.,* that the magazine began a new series with the volume numbers beginning once again with the number one. An + or − after an entry signifies that the serial is still being published. Brackets usually mean an incomplete entry

or an incomplete holding of that particular volume. Moreover, every serial has a unique, internationally accepted, number; called an *ISSN number;* it can be used in ordering and in obtaining interlibrary loans.

Of special importance to researchers is the quality of the articles printed in a serial. A scholarly article contains footnotes and usually a bibliography. To cite an article from *Art Bulletin* carries more prestige than to quote from a popular journal. Care must be taken to check the abstracts and indices that cover the serials most likely to contain the type of articles needed. Most of the indices include numerous foreign-language periodicals, some of which print articles in English or provide English summaries. Do not shy away from these important resources.

Five Major Art Indices

In order to locate articles on a specific topic, an indexing or abstracting service should be consulted. An *index* of periodical literature is an alphabetically arranged reference work that lists material published in serials under various subject categories. Sometimes contents of the articles are indicated, and an author index is provided. These indices cover articles in a particular number of different magazines on a regular basis. The number and selection of serials, however, may change over the years.

Whereas most indices provide brief data on the articles, *abstracting resources* furnish summaries of the material supplying additional, often essential, information. Abstracting resources may index more serials, but not necessarily all issues of each publication on a regular basis. Some entries are submitted by the authors of the articles; consequently, the contents may not depend entirely upon a consistent number of serials, but rather on who submits what material. Thus, the type, kind, and number of references included may vary with each issue. The length of the abstract or summary of the material, remember, is no indication of its importance. Although there is a difference between an abstracting resource and an index, the general term, index, often represents both types of works. It is so used in this guide.

The indices of periodical literature, which are annotated in Chapter 16, provide access to some of the following different kinds of information:

1. articles on specific subjects or by certain authors

2. exhibition and sales catalogues
3. reports and essays included in symposia, corpora, and *Festschriften*
4. book, film, and exhibition reviews
5. titles of illustrated works of art
6. obituary notices

Indices often report articles that were published one or two years prior to the issue date. This is not unusual, for it takes time for foreign serials to be indexed in American references. Also important is the frequency with which indices themselves are published.

Throughout the years of publication, the abstracting and indexing services will change methods of organizing the material as well as some of their subject headings. Although the alterations may be minor, they must be take into account for effective research. Even if two indexing tools cover similar material, both should be examined, since significant material may not appear in both. Not only does this require the use of a number of different indices and abstracting sources, but every volume of those references must be checked. It is this tedious job which database searches eliminate.

Indices of periodical literature provide only abbreviated or incomplete bibliographical entries. This information must be translated into an accepted form before it can be added to the bibliography. For instance, in Example 7, the abbreviated entry means an article, "Concerning Symbolism and the Structure of Surface," by R. Heller, published in *Art Journal (Art J)*, volume 45, Summer 1985, on pages 149 and 151. The *bibl f* indicates bibliographic footnotes are included. *Mme Dietz-Monnin: Portrait after a Costume Ball* is illustrated. Full titles for the publications cited in periodical indices are usually found in the front of each volume.

There are five major indices and abstracting resources for periodicals on general art subjects: *Art Index* [16:1], *RILA* [16:7], *ARTbibliographies MODERN* [16:2], *Répertoire d'art et d'archéologie* [16:6], and the new *BHA* [16:3]. All include foreign-language material and are available through online databases, which are discussed in Chapter 4. Because each index has particular strengths and emphases, it is especially important for researchers to scrutinize all of the indices that might include their specific topics. Using entries on Edgar Degas for the year 1986, the following is an analysis of these research tools.

about
Domus interviews: Paolo Deganello. R. M. Rinaldi. por *Domus* no655:32-3 N '84
Degas, Edgar, 1834-1917
about
Concerning Symbolism and the structure of surface. R. Heller. bibl f il *Art J* 45:149, 151 Summ '85
il: Mme Dietz-Monnin: portrait after a costume ball
La Danseuse de quatorze ans de Degas, son tutu et sa perruque. L. Relin. il *Gaz B-Arts* ser6 v104:173-4 N '84
Degas [works in the Philadelphia Museum of Art and John G. Johnson Collection] J. S. Boggs. bibl f il (pt col with cov) *Bull Phila Mus Art* 81:2-48 Spr '85
Degas at the Hayward Gallery [London; exhibit] R. Pickvance. *Burlington Mag* 127:474-6 Jl '85
il: Actresses in their dressing rooms; Au bord de la mer; Nude standing, drying herself; Les blanchisseuses
Degas in the Art Institute of Chicago [Art Institute of Chicago; exhibit] L. Silver. *Pantheon* 42:391-3 O/D '84
il: Self-portrait; The Morning bath; Ballet at the Paris Opéra

painting—Impressionism, 1874-1886: National Gallery of Art, Washington, D.C; traveling exhibit] N. Broude. col il *Art News* 85:84-9 My '86
Reproductions
L'attente (pastel)
Burlington Mag 127:268 Ap '85
Au théâtre, femme a l'éventail (pastel and charcoal, 1880)
Burlington Mag 127:[back] 42 S '85 (col)
Conversation (ca 1885-95)
Yale Univ Art Gallery Bull 39:37 Fall '84
Dancer (charcoal and pastel, ca 1880)
Antiques 129:344 F '86
Danseuse au repos (pastel, 1897-1900)
Apollo ns 121:[front] 49 Ap '85 (col)
Burlington Mag 127:xxiii My '85 (col)
Danseuses (pastel, ca 1896)
Connaiss Arts no400:126 Je '85
Danseuses bleues
Connaiss Arts no401/402:11 Jl/Ag '85 (col)
Deux danseuses sur scène (ca 1880)
Connaiss Arts no396:27 F '85 (col)
L'Oeil no356:41 Mr '85 (col)
Femme sortant du bain (pastel, ca 1886-90)
Archit Dig 43:100 F '86 (col)
Jeune homme assis: Ferdinand Bol? (engr after Rembrandt;

Example 7: *Art Index:* November 1985–October 1986, Page 295–296, selections. Copyright c 1987 by the H. W. Wilson Company. Material reproduced by permission of the publisher.

Art Index

Issued: in 1930 indexing began with 1929 material; quarterly with annual cumulation
Scope: all styles and periods of art, including Egyptian, classical Greece and Rome, Islam, the Orient, Asia, and primitive societies
Covers: about 235 serials
Hints: has not always indexed the same serials continuously; includes titles of works of art illustrated
Database: *Art Index Database,* WILSONLINE, coverage from October 1984, updates twice a week; has no immediate plans for including the other fifty-five years of material which has been covered by *Art Index*. Available on CD-Rom

Because of its broad subject coverage, *Art Index* is one of the first references to which most art researchers turn. Example 7 illustrates the type of entries for Degas for November 1985 through October 1986; there were sixteen entries plus two reviews, one of which was for an exhibition. Of the sixteen entries, three were dated May 1986; nine, 1985; and four, 1984. In addition, under "Reproductions," there was a listing of forty-nine works of art illustrated in the covered serials.

RILA

Issued: begun in 1974, semi-annual abstracting service; demonstration issue published in 1973

Scope: from late antiquity of the fourth century to the present; excludes prehistoric, ancient, Far Eastern, Indian, Islamic, African, Oceanic, and ancient and native American Art.

Covers: about 400 serials; includes books, museum and exhibition catalogues, *Festschriften,* congress reports, and dissertations

Hints: uses broad categories many of which are artistic styles of the Western tradition. to enable browsing for material within a specific area; most efficient way to find information is through the indices to authors and subjects and by using the two cumulative indices, for 1975–1979 and for 1980–1984. Henceforth, will merge with *Répertoire d'art d'archéologie* and be called *BHA;* see below. Publication will cease with Volume 15 (1989); a cumulative index for 1986–89 will be issued

Database: *Art Literature International (RILA) Database,* DIALOG, File 191, coverage from 1973; updates semi-annually

Due to its extended coverage of pertinent material, such as exhibition catalogues, dissertations, and *Festschriften, RILA* is one of the most important abstracting services for art. Example 8 illustrates the kind of data which *RILA* provides. Entry number 3856 reports *Degas et son oeuvre: a supplement* compiled by Philippe Brame and Theodore Reff. Recorded are publication information, the number of pages and illustrations, the inclusion of a bibliography and index, the ISBN number, and the language of the book. The abstract states that this is a supplement to a previous publication and that 150 paintings and pastels are illustrated and catalogued. The next entry is for the exhibition catalogue, *Edgar Degas: "Hélène Rouart in Her Father's Study."* Note the inclusion of works by Corot and Millet which were from Henri Rouart's collection. This is a citation for an exhibition catalogue, not a serial article.

3856 [DEGAS, H. G. E.] LEMOISNE, Paul-André. **Degas et son oeuvre: a supplement.** Comp. by Philippe BRAME and Theodore REFF; with the assistance of Arlene REFF. New York; London: Garland, 1984. 189 p. *163 illus., bibl., index, 0-8240-5525-X.* In English.
A supplement to *Degas et son oeuvre.* (Paris: P. Brame et C.M. de Hauke, aux Arts et métiers graphique [1947-48, c.1946]). Publishes some 150 paintings and pastels which were omitted from the earlier edition. Each work is illustrated and fully catalogued, including information on date, provenance, exhibition history, bibliography, and location. *(Publisher)*

3857 [DEGAS, H. G. E.] LONDON (GBR), National Gallery. **Edgar Degas: *Hélène Rouart in Her Father's Study.*** Exh. 11 Apr-10 June 1984. By Dillian GORDON. 20 p. (Acquisition in focus). *22 illus. (1 col.), bibl., biogs., 13 works shown, 0-901791-92-X.* In English.
On the painting, ca.1886, purchased by the museum in 1981. Traces the evolution of Degas's ideas and his relationship with the Rouart family. Discusses the inclusion in the portrait of items from Henri Rouart's collection: Corot's *Bay of Naples with the Castel dell'Ovo,* 1828 (private collection); Millet's drawing *Peasant Girl Seated by a Haystack,* ca. 1851-52 (Musée du Louvre, Cabinet des Dessins,

Example 8: *RILA: Répertoire international de la litterature de l'art,* a bibliographic service of the Getty Art History Information Program of the J. Paul Getty Trust, 1986. Volume 12, Number 1, page 220.

But because *RILA* is dependent upon authors for many of its abstracts, its coverage is often not consistent, and indexing of some issues is delayed. For instance, for Degas in the 1986 issues, there were seven citations and five book reviews. Of the seven, two were dated 1983; five, 1984. None were for 1985 or 1986 articles.

ARTbibliographies MODERN

Issued: begun in 1974; semi-annual abstracting service

Scope: from 1974–1988, coverage began with 1800. In 1989 coverage narrowed to art from 1900, although artists and movements of the late nineteenth century that influenced or were important to the twentieth century are also included. Architecture was dropped; concentration is now on all aspects of art, design, and photography

Covers: about 330 serials plus dissertations and exhibition catalogues

Hints: abstracts are placed alphabetically under more than 150 subject classification headings; study the list of these headings to obtain correct term. Has indices to author and museums and galleries. Cross references are interfiled with the abstracts. Use the cumulative index, 1969–1974

Database: *ARTbibliographies MODERN Database,* DIALOG, File 56, coverage from 1974; updates twice a year

From 1974 through 1988, *ARTbibliographies MODERN* covered material on nineteenth- and twentieth-century art. But in 1989, the emphasis was changed to art of the twentieth century, although artists and movements of late nineteenth

5406 Edgar Degas: Pastelle, Ölskizzen, Zeichnungen (Edgar Degas: pastels, oil sketches, drawings). Tübingen, G.F.R.: Kunsthalle (14 Jan.-25 March 1984)/Berlin, G.F.R.: Nationalgalerie, Staatliche Museen, Preussischer Kulturbesitz (5 April-20 May 1984). G. Adriani. 408pp. ISBN 3-7701-1552-X. 276 illus. biog. bibliog.

Catalogue to an exhibition of 227 pastels, oil sketches and drawings by Degas, some of which are published for the first time. In the introduction, it is stressed that drawing for Degas was an important means of clarifying images through precise, formal analysis, never a form of recreation, and that Degas had a deep knowledge of drawing, as well as being one of its greatest exponents. In an essay, the author traces the evolution of Degas's artistic career and the place of drawing within it, from the early portraits of 1853-55 and the works of the 1860s, when his themes were history and the horse, and he first attempted pastels. After the Franco-Prussian war, in which he served in the artillery, Degas became interested in scenes of city life and the social milieu of Paris, its women (models, nudes, dancers, socialites) forming a central theme in his work. His use of different drawing and monotype techniques and his interest in photography are discussed in relation to the development of his work from the 1870s and his Impressionist years to his last drawings of 1906-08. The annotations give details of title, date, medium, size, signature, collection, provenance and bibliographical references, together with explanatory and descriptive notes.

see 4469 Paris cafés: their role in the birth of modern art
see 4709 The camera in painting
see 6530 Musée d'Orsay: 'Le Voyageur' de Meissonier (Orsay Museum: 'The Traveller' by Meissonier)
see 6990 Prostitution and the art of later nineteenth century France: on some differences between the work of Degas and Duez
see 6991 From the real to the unreal: religious painting and photography at the salons of the Third Republic
see 6996 On the ascendancy of modern painting
see 7351 Purpose and practice in French avant-garde print-making of the 1880s

Example 9: *ARTbibliographies MODERN,* 1986, Volume 17, Number 21, pages 131–32. Reprinted by permission of Clio Press Ltd, Oxford, England, 1986.

century that influenced or were important to this later period are also included. Architecture was dropped; concentration is now on all aspects of art, design, and photography. As Example 9 illustrates, its annotations provide extensive access to information. In the two issues for 1986, *ARTbibliographies MODERN* had ten entries for Edgar Degas and fourteen cross references to related material. Of the ten, six were dated in 1985; two, 1984; one, 1981; and one, 1980. Particularly pertinent to the research were the cross references, which included articles such as "Paris Cafes: Their Role in the Birth of Modern Art" and "Prostitution and the Art of Later Nineteenth Century France: On Some Differences Between the Work of Degas and Duez." This type of material can be difficult to find.

Répertoire d'art et d'archéologie

Issued: since 1910, quarterly abstracting resource with an annual cumulated index to the abstracts

Scope: from about 200 A.D. to the present; excludes Islamic, Far Eastern, and primitive art as well as post-1940 works of art and artists born after 1920

Covers: about 420 serials plus exhibition catalogues; in 1981 began listing *Festschriften* and reports of Congresses

Degas, Edgar, 9502, 9679, 9731, 9736, 9737, 9804.
 Dessins, 9730, 9736, 9738.
 Danseuses, 9732.
 Gravures, 9679, 9733, 9734, 9735, 9736.
 Influence
 Ivanov, Aleksandr, 9738.
 Monotypes, 9736.
 Pastels, 9730.
 Pastels peints sur monotype, 9733.
 Peintures
 Danseuses, 9732.
 Esquisses peintes, 9730.
 Fille de Jephté, 9738.
 Jeunes filles de Sparthe s'exerçant à la lutte, 9738.

9679. *CLAYSON (H.)* Avant-garde and pompier images of 19th century french prostitution : the matter of modernism, modernity and social ideology. In : *BUCHLOH (B. H. D.)* ed. *GUILBAUT (S.)* ed. *SOLKIN (D.)* ed. Modernism and modernity. *Vancouver conference papers* (1981, printemps). Vancouver. Halifax : Press of the Nova Scotia college of art and design, 1983. *(The Nova Scotia series, 14. Source materials of the Contemporary arts),* 43-64. — BD.

Comparaison du traitement du thème de la prostitution chez un peintre « pompier », Henri Gervex et chez un artiste d'avant-garde Edgar Degas : étude située dans le contexte sociologique des années 1870-1890 alors que la prostitution à Paris était soumise à la loi dite de « réglementation »; démonstration de la force critique et sans fard de Degas par rapport à la mystification académique et conventionnelle de Gervex.

Example 10: *Répertoire d'Art et d'Archéologie,* Maryse Bideault, editor. Under direction of Comité Francais d'Histoire de l'Art, Paris: Centre National de la Recherche Scientifique, Institut de l'Information Scientifique et Technique, 1986. Number 4, from "Index des articles," page 156; entry, page 132.

Hints: format similar to *RILA;* uses subject and author indices. Early issues difficult to use and not readily accessible in most libraries. In 1973, became computerized and easier to search. Publication will cease with Volume 25 (1989) when it is merged with *RILA* and called *BHA;* see below

Database: *Repertory of Art and Archaelology Database,* QUESTEL, Francis-H, Chapter 530, coverage since 1973; updates quarterly

Example 10 reproduces the analytical entry for Degas in the "Index des artistes," as well as one of the cited entries. The article, "Avant-Garde and Pompier Images of 19th Century French Prostitution: The Matter of Modernism, Modernity, and Social Ideology," was published in *Modernism and Modernity,* the 1981 Vancouver Conference Papers which were not published until 1983. Although *Répertoire* has no annual cumulation, there is an extensive annual index, *tables annuelles,* which provides a number of indices for all of the year's entries.

As to its currency, *Répertoire d'art et d'archéologie* does better than some of the American indexing services. In the four 1986 issues, there were eleven Degas entries for books and articles plus six reviews of books and exhibitions. Of the eleven, one was dated 1986; six, 1985; two, 1984; and one each for 1983 and 1982. Although no titles of illustrated works of art were reported, the fact that much of the material dated from as recently as 1985 is very important for scholars.

BHA

Issued: first volume mid-1990, quarterly with annual cumulation

Scope: format similar to *RILA* from late antiquity to the present

Covers: upwards to 4,000 serials; will be twice the size of *RILA*; also publications concerning the collections and activities of various museums, books, *Festschriften,* congress reports, and dissertations

Hints: *BHA: Bibliographie d'Histoire de l'Art/Bibliography of the History of Art* is the merger of the two abstracting references—*RILA* and *Répertoire d'art et d'archéologie*—which were discussed above.

Although the indices and subheadings will be printed in both languages, the abstracts will be in the language of the person who writes the entry. Be sure to search *BHA* and the two indices it replaces.

Database: Will be available on DIALOG

Remember, compiling a bibliography is only the first step in solving a research problem. Other steps might include such items as discovering data on specific works of art or obtaining reviews of books written about the artist. In addition, studying a famous individual presents one set of challenges. Other subjects require slightly different approaches and references. When students have mastered the four types of reference works discussed in this section, they are ready to advance to more sophisticated tools, such as the database searches discussed next and the more specialized references detailed in Chapter 5. Be sure and consult the Table of Contents and study the various subjects in the later chapters in order to determine exactly which sections are pertinent to the information needed.

GUSTAVE CAILLEBOTTE:
AN ANNOTATED WORKING BIBLIOGRAPHY

The following bibliography includes works that specifically discuss Gustave Caillebotte, his life, works, and bequest. Sales catalogues, newspaper articles, and general literature of the nineteenth century have been excluded. Museum and gallery catalogues are alphabetized under the name of the institution. Abbreviations for the libraries where the references are located are as follows: UNT, University of North Texas, Denton; KAM, Kimbell Art Museum, Fort Worth; and DMA, Dallas Museum of Art, Dallas.

Bataille, H. "Enquete." Journal des Artistes, 1894.

Bazin, Germain. French Impressionists in the Louvre. Translated by S. Cunliffe-Owen. New York: Harry N. Abrams, 1958. (UNT, 759.4, B348r).

 Discusses the Caillebotte Bequest; reports that 38 of the 67 pictures offered were accepted. Mentions that Leonce Benedite was curator of the Palais du Luxembourg museum during the controversy over the bequest.

Bénédite, Leonce. "La Collection Caillebotte au Musée du Luxembourg." Gazette des Beaux-Arts 17 (1897): 249-58.

Bénézit, Emmanuel. Dictionnaire critique et documentaire des peintres, sculpteurs, dessinateurs, et graveurs. 10 vols. Paris: Librairie Grund, 1976. (UNT, N40, B48)

 Facsimile of Caillebotte's signature; gives sales prices of a few of his works over a span of 84 years, 1889-1974.

Berhaut, Marie. Caillebotte the Impressionist. Translated by Diana Imber. New York: French and European Publications, 1968. (Interlibrary, Bowling Green University).

 Includes sections on Caillebotte's life, oeuvre, critics, and collection. Provides list of French titles of the art works of the Caillebotte Bequest accompanied by indication of works accepted. Contains 28 color reproductions of Caillebotte's paintings, a list of retrospective exhibitions, and a brief bibliography.

___. Caillebotte: sa vie et son oeuvre: Catalogue raisonné des peintures et pastels. Paris: Foundation Wildenstein, 1978. (KAM, N44, C1346, B36).

 Catalogue of 477 works, 31 of which are reproduced in color. Rest of works have small black-and-white identification photograph. Includes 18 illustrations of Caillebotte and his residences. Reproduces 46 letters, mailed either to or from Caillebotte. Reprints documents concerning the bequest and critical reviews of Caillebotte's work. Includes a bibliography, a list of museums owning Caillebotte's work, and indices to titles of paintings, subjects, and people.

Werner, Alfred. "Caillebotte: A Rediscovery." Arts Magazine 43 (September/October 1968): 42-45. (UNT).

 Discusses Caillebotte's life and friendships with other Impressionist Painters. Reports that Caillebotte posed for Renoir's The Luncheon of the Boating Party and Boating Party at Chatou.

Wildenstein Gallery, London. Gustave Caillebotte 1848-1894: A loan Exhibition in Aid of the Hertford British Hospital in Paris. Compiled by Denys Sutton. London: Wildenstein and Company, 1966. (Personal Copy)

 Illustrated catalogue of an exhibition, held June 15-July 16, 1966, which consisted of 51 of his paintings. Includes the artist's biography plus an analysis of some of his works. Reproduces four letters from Degas to Caillebotte and Jean Bernac's article, "The Caillebotte Bequest to the Luxembourg," which was originally published in 1895 in The Art Journal.

Wildenstein Gallery, New York. Gustave Caillebotte: A Loan Exhibition. New York: Wildenstein and Company, 1966. (Personal Copy)

 Exhibition held June 15-July 6, 1966; text by Denys Sutton and Jean Bernac. The 35-page catalogue includes letters by Edgar Degas to Caillebotte.

___. Gustave Caillebotte 1848-1894: A Loan Exhibition of Paintings for the Benefit of The Alliance Française de New York. New York: Wildenstein and Company, 1968. (Personal Copy).

 An 8-page pamphlet listing the 70 paintings-their dimensions and owners-which were exhibited September 18-October 19, 1968.

___. One Hundred Years of Impressionism: A Tribute to Durand-Ruel. Forward by Florence Gould. New York: Wildenstein and Company, 1970. (Interlibrary, University of Texas at Arlington).

 Catalogue of exhibition held at Wildenstein Gallery, New York City, April 2-May 9, 1970; reproduces La Seine à Argenteuil, 1888. Includes extracts from The Memoirs of Paul Durand-Ruel.

Wykes-Joyce Max. "Maecenas at Work: Gustave Caillebotte." Arts Review 18 (June 11, 1966): 269.

Young, Mahonri Sharp. "The Detached Observer." Art News 76 (May 1977): 114. (UNT)

 News item on exhibition at Brooklyn Museum.

Example 11: Gustave Caillebotte: An Annotated Working Bibliography (first and last pages).

GUSTAVE CAILLEBOTTE:
A SELECTED BIBLIOGRAPHY

Only publications that specifically discuss in detail Gustave Caillebotte, his life, works, or bequest are included. All sales catalogues, newspaper articles, exhibition reviews, and general literature of the nineteenth century have been excluded. Arranged alphabetically, the bibliography is divided into three categories: encyclopedias and books, articles, and catalogues. All museum and gallery catalogues are alphabetized under the institution's name.

Encyclopedias and Books

Bazin, Germain. French Impressionists in the Louvre. Translated by S. Cunliffe-Owen. New York: Harry N. Abrams, Inc., 1958.

Bénézit, Emmanuel. Dictionnaire critique et documentaire des peintres, sculpteurs, dessinateurs, et graveurs. 10 vols. Paris: Librairie Grund, 1976.

Berhaut, Marie. Caillebotte the Impressionist. Translated by Diana Imber. New York: French and European Publications, Inc., 1968.

———. Caillebotte: sa vie et son oeuvre. Paris: Bibliotèque des arts, 1978.

Faberman, Hilarie. "Gustave Caillebotte 1875-1880." Unpublished M.A. thesis, Queen's College, 1975.

Isaacson, Joel. The Crisis of Impressionism 1878-1882. Ann Arbor: The University of Michigan Museum of Art, 1979.

Praeger Encyclopedia of Art. 1971 ed. S. v. "Caillebotte, Gustave."

Rewald, John. The History of Impressionism. 4th ed. revised. New York: The Museum of Modern Art, 1973.

Scharf, Aaron. Art and Photography. London: Allen Lane, 1968.

Thieme, Ulrich and Becker, Felix. Allgemeines Lexikon der Bildenden Künstler von der Antike bis zur Gegenwart. 37 vols. Leipzig: E. A. Seemann, 1907-50.

Varnedoe, Kirk and Peter Galassi. Gustave Caillebotte. New Haven, CT: Yale University, 1987.

Articles

Berhaut, Marie. "Musées de Province: trois tableaux de Caillebotte." Musées de France. July 1948, pp. 144-7.

Bernac, Jean. "The Caillebotte Bequest to the Luxembourg." The Art Journal, 1895, pp. 230-32, 308-10, 358-61.

Bodelson, Merete. "Early Impressionist Sales 1874-1894 in the Light of Some Unpublished 'Proces-l'erbaux'," The Burlington Magazine, CX. No. 783, June 1968, pp. 331-48.

Glueck, Grace. "Art: An Impressionist Re-emerges," New York Times, 11 February 1977.

Rosenblum, Robert. "Gustave Caillebotte: The 1970s and the 1870s," Artforum, March 1977.

Varnedoe, J. Kirk T. "The Artifice of Candor: Impressionism and Photography Reconsidered," Art in America, January 1980.

———. "Caillebotte's Pont de l'Europe: A New Slant," Art International 18 (April 20, 1974): 28-29, 41, 58.

———. "Gustave Caillebotte in Context." Arts Magazine 50 (May 1976): 94-99.

Werner, Alfred. "Caillebotte: A Rediscovery." Arts Magazine 43 (September/October 1968): 42-45.

Museum and Exhibition Catalogues

Musée de Chartres. Caillebotte et ses amis impressionnistes. Forward by Georges Besson. Chartres: Syndicat d'initiative de Chartres, 1965.

Musée des Beaux-Arts de Rouen. Catalogue des peintures du Musée des Beaux-Arts de Rouen. Compiled by Olga Popovitch. Paris: Arts et Metiers Graphiques, 1967.

Musée du Jeu de Paume, Paris. Musée du Jeu de Paume. Revised ed. Paris: Editions des Musees Nationaux, 1976.

Musée National du Louvre, Paris. Catalogue des peintures, pastels, sculptures impressionnistes. Paris: Musées Nationaux, 1958.

Museum of Fine Arts, Houston. Gustave Caillebotte: A Retrospective Exhibition. Houston: Museum of Fine Arts, Houston, 1976.

The Toledo Museum of Art: European Paintings. University Park, Pennsylvania: Pennsylvania University Press, 1976.

Wildenstein Gallery, London. Gustave Caillebotte 1848-1894: A Loan Exhibition in Aid of the Hertford British Hospital in Paris. Compiled by Denys Sutton. London: Wildenstein and Company, Ltd., 1966.

Wildenstein Gallery, New York. Gustave Caillebotte 1848-1894: A Loan Exhibition of Paintings for the Benefit of The Alliance Francaise de New York. New York: Wildenstein and Company, 1968.

———. One Hundred Years of Impressionism: A Tribute to Durand-Ruel. Forward by Florence Gould. New York: Wildenstein and Company, Inc., 1970.

Example 12: Gustave Caillebotte: A Selected Bibliography

Database Searches

Computer technology has extended the ability to access a greater part of the world's storehouse of knowledge. By utilizing specialized bibliographic databases, either online or through compact discs, research is faster and more efficient. Although medicine and the other sciences were the first major users, the humanities have enough computer sources to enable art researchers to utilize this latest tool effectively. This chapter discusses (1) computer and CD-ROM technology, (2) choosing a database, and (3) formulating and conducting a database search.

Computer and CD-ROM Technology

During the 1960s some abstracting and indexing services changed to a computer system for typesetting their citations. A decade later, the material stored on these tapes was compiled into databases and made accessible to the public for online searches. Most databases are available through vending firms which standardize the databases as to search procedures and language. The vendors represent various producers—such as RILA of the J. Paul Getty Trust—who are responsible for the information on the computer tapes. Some companies have also converted their data to separate compact discs, called CD-ROM. Because searching most computer databases is not free, either the library or the patron bears the expense, researchers need a thorough understanding of what these computerized projects can and cannot do.

Most libraries provide some online database services for their patrons. Access is usually through vending firms, frequently DIALOG and BRS, which cover a broad scope of disciplines. Within each vending firm, all databases use the same basic commands. Some libraries also provide access to such online networks as OCLC or RLIN, which were discussed in Chapter 2, as well as such specialized computer files as *ArtQuest: The Art Sales*

Index Database [18:7] and *SCIPIO (Sales Catalog Index Project Input Online) Database* [18:48]. The reference librarian may do the actual search, although researchers should be present in order to control the direction of the inquiry. Many libraries charge for the actual time spent online with the computer, and some institutions add a surcharge. In this system, the cost of searching is usually borne by the patron. Still another technology is CD-ROM, which means compact disc, read only memory. Although they can be expensive for the library, discs are becoming more prevalent. Once purchased, discs can be searched continuously without additional monetary concerns, although some libraries charge for printing. Due to their popularity, students may have to make appointments to use certain discs during peak periods.

There are several types of bibliographical databases. Some contain citations identical to those in a corresponding printed abstract or reference work, such as *ARTbibliographies MODERN* [16:2], which is available both in a printed and computer form. Others provide entries which correspond to a printed index, but also include additional material, such as *Dissertation Abstracts Online Database* [16:9]. This database includes entries from *Dissertation Abstracts International* plus *American Doctoral Dissertations, Comprehensive Dissertation Index,* and *Masters Abstracts.* Moreover, in 1988, the database began including British dissertations. Another type of database accesses information that has never appeared in printed form, and, therefore, is available only through the computer format. An example is *SCIPIO* [18:48], which was begun in 1981 for auction catalogues. In addition, there are some databases which are closed, no additional data will be added, for example, *Bible (King James Version) Database* [29:93].

After the results of the search are known, the material can be (1) typed onto the library's printers, called online printing; (2) issued from the computer site and mailed to the patron, a process called

offline printing; or (3) downloaded onto a computer disc, making the data available to be manipulated later through word processing software. Because of the speed of the electronic machines, the first system can be relatively inexpensive, depending upon the number of citations. Offline printing frequently takes three to five days. In addition, some databases, such as the ones through NEXIS [16:50], are capable of providing full-text citations by which the entire article or entry can be printed.

Choosing A Database

Two kinds of database services are prevalent: (1) Selective Dissemination of Information or SDI Services by which researchers provide a profile of their interests and the vending firm automatically sends pertinent material as it is made available, a system used especially in medicine and the sciences, and (2) retrospective searches by which patrons utilize the computer to find data on specific subjects. It is the latter service that most humanities researchers use.

Because there are more than 3,000 publicly accessible international databases, no library could subscribe to them all. But care must be taken in choosing the databases which are available. The following should be considered:

1. the availability and cost of the service
2. the subjects and historic time periods covered
3. the kinds and dates of serials and source documents included
4. the date of the earliest files within the database
5. the frequency of updating

Two popular vending firms are DIALOG and BRS. The former has more than 320 individual databases, the latter, about 160. Their popularity is partly due to the fact that once an account is established, monetary payment is only for the actual computer connect time plus a small fee per citation printed. This is not true of all companies. Some charge a monthly or annual amount. Obviously, the fee structure greatly determines the services an institution provides. Not only does the library have to consider expense, but researchers must also. If all of the hardbound copies of *Dissertation Abstracts International* [16:9] are available, an online computer search may not warrant the price. But if the printed volumes are not owned by the user's institution, a database search might be cheaper than traveling to another library to use them. The expense of an online database search must be weighed against the time and effort required for obtaining the information elsewhere.

Each database covers certain subjects and specific time periods. For the indices with hardbound copies, these can be discovered by consulting the printed version. Obviously, *ARTbibliographies MODERN* is a good source for a twentieth-century subject, but not for a sixteenth-century one. It is important that researchers understand what kinds of data are in the files before they decide which database to search. Not only must the topics covered be known, but the types of serials most likely to publish articles on the subject must be considered. For the value of a computer file is determined by the number and kinds of serials and source documents—books, catalogues, reviews, *Festschriften*—that are included. But discovering which serials are covered by databases that either have no printed index or provide additional resources is not always easy. A list must be obtained from the database producer. Ask the reference librarian for the latest edition of the vendor's catalogue which provides the names and addresses of the individual producers. Or write the vendor for a catalogue; the addresses of some vending firms are provided in Appendix F.

Besides the databases that cover general art subjects, there are other computer files which are important to art. For example, architectural researchers use *The Architecture Database* [21:126] and the *On-Line Avery Index to Architectural Periodicals Database* [21:127]. Art educators utilize the *ERIC Database* [28:117], which covers both *Resources in Education* and *Current Index to Journals in Education*. Appendix F is a list of online databases organized by subjects. Each database has a bibliographical entry in Section B of this guide; this information is provided in brackets.

Another consideration in choosing a database is the earliest date covered by the computer files. If information on an event in 1978 is needed, it would be useless to search a database which did not have data covering that time period. Of the major art indexing and abstracting services—*Art Index* [16:1], *RILA* [16:7], *ARTbibliographies*

MODERN [16:2], *Répertoire d'art et d'archéologie* [16:6], and *BHA* [16:3]—all have online databases. *Art Index* is also available on CD-ROM. But not all computer files are equivalent to the cumulative hardbound copies. Both *ARTbibliographies MODERN Database* and *Art Literature International (RILA)* contain all back files; the former since 1974, the latter since 1973. But neither *Repertory of Art and Archeology Database* nor *Art Index Database* have complete files. The former has files from 1973, the later only since October 1984. But databases can be expanded almost magically. For instance, *Avery Index* [21:127] had some of their older printed files converted, added to their database, and expanded their files backwards from 1980 to 1977.

One of the assets of bibliographic online databases is that the files are usually updated frequently, and the data is available faster than the arrival on the shelf of the published work. As a consequence, the latest citations can be promptly obtained. For instance, *ArtQuest: The Art Sales Index Database* [18:7] updates continuously. CD-ROM discs are usually updated quarterly or annually. Obviously, if the most recent material is important, this fast service is far superior to waiting for the bound copy.

Researchers should be cautioned about online database searches. They are usually similar in function to an abstract or indexing service. The indices and abstracts which cover pertinent serials, but which, for one reason or another, are not yet available in an online database, will still need to be examined in printed form. Online database searches are not the end of a research problem; they are only one tool used to facilitate finding data. If used with care, they can assist researchers in becoming more efficient. But expense will be incurred, especially if extreme caution is not taken to define and refine the study problem.

Formulating and Conducting the Search

There are a number of reasons for conducting database searches. They can be used to:

1. locate data fast and efficiently
2. discover current material

3. uncover information not available elsewhere
4. most importantly, link two or more ideas

But the computer locates only data it is directed to find. Students must have a clear idea of what they wish to discover prior to beginning the search; a process detailed in Chapter 1. If the search statement is too broad, the number of entries may be astronomical. If the statement is too narrow, nothing may be found. It takes time and practice to become an efficient searcher. The keys to success are knowing how to formulate problems and how to use the computer commands.

The simplest database search is for material on a specific person. If a student wished to locate the London exhibition which displayed the work of Canadian artist Jean Paul Riopelle and was not sure whether or not there was a final *e* on his name, the command to expand can be given. Using *Art Literature International (RILA)* [16:7], as seen in Example 13, the star indicates that "Riopell" was typed. The computer expanded the word providing the next two names above and nine below. For "Riopelle" and "Riopelle, Jean Paul, Canadian Painter, Sculpto" sixteen citations were reported. Once the correct name was known the following command was given

?SS S3 AND LONDON

As Example 13 illustrates, there were 7,604 citations for London, but only one entry that included both London and Riopelle. Since the computer assigns numbers for each set, the statement does not have to be retyped. Example 14 is a copy of the citation. The computer provided similar data to that found in the hardbound copies of *RILA* [16:7]. The computer online time for the search and the printing of the abstract took about five minutes and cost under three dollars. This eliminated the manual checking of numerous volumes and the cost of photocopying the page.

Online databases can be used to discover current information. For instance, to search for gallery exhibitions in New York City, the *New York Times* can be searched. NEXIS Service [16:50], which updates its files daily, has provided access to this newspaper since 1980. Moreover, this is a full-text computer file by which either the bibliographical entry or the entire article can be printed. NEXIS

```
?e RIOPELL

Ref            Items       Index-term
E1             3           RIONE
E2             1           RIONI
E3             0          *RIOPELL
E4            16           RIOPELLE
E5            16           RIOPELLE, JEAN PAUL, CANADIAN PAINTER, SCULPTO
E6             4           RIOPELLE'S
E7             2           RIORDAIN
E8             1           RIORDINAMENTI
E9             3           RIORDINAMENTO
E10            1           RIORDINO
E11            1           RIORGANIZZAZIONE
E12            8           RIOS

          Enter P or E for more
?SS E4 OR E5
     S1        16 RIOPELLE
     S2        16 RIOPELLE, JEAN PAUL, CANADIAN PAINTER, SCULPTO
     S3        16 'RIOPELLE' OR 'RIOPELLE, JEAN PAUL, CANADIAN PAINTER,
                  SCULPTO'
?SS S3 AND LONDON
               16 S3
     S4      7604 LONDON
     S5         1 S3 AND LONDON
?T/5/ALL
```

Example 13: Selections from a DIALOG® search completed through *Art Literature International (RILA) Database,* a bibliographic service of the Getty Art History Information Program of the J. Paul Getty Trust.

covers a number of newspapers, such as the *Boston Globe, Chicago Tribune, Los Angeles Times,* and *Washington Post.*

Another important use of online database searches is to locate information not readily available elsewhere. For instance, until a building is completed, most national newspapers and magazines do not mention it. Only the local papers will provide data on the building project. In searching for material on the Meyerson Symphony Hall—designed by I. M. Pei—which was still under construction in Dallas, the *DataTimes Database* [16:49] was used. This database indexes numerous newspapers, but not the major ones covered by NEXIS. The material was easily found in *The Dallas Morning News,* which *DataTimes* has covered since 1984. The simple search statement was

1/ FIND "MEYERSON SYMPHONY"

There were 228 articles on the subject; one was for an article which appeared in the paper two days before the search.

One of the advantages of a database search is that two or more ideas can be linked. Instead of having to investigate a single subject unilaterally, one word at a time, a concept or group of related items can be combined. In order to link multiple ideas, the problem must be stated in Boolean logic. This is the method of using certain words—AND, OR, and NOT—in algebraic-like sentences. For example, if information on Susanna and the Elders was searched in *Art Literature International (RILA),* the statement formulated in Boolean logic might state

SU?ANNA AND (ELDER? OR OLD(W)MEN)

The AND indicates that the two ideas must be linked, both Susanna and the Elders or old men must be found. The OR means that either of two or more words are acceptable. A truncated word uses a symbol, such as a ? or a $, to indicate that any words which have the typed letters are to be chosen. Since Susanna can also be spelled Suzanna, the ? allows for both names. ELDER? allows

```
5/5/1
0090680      9 8207 (1983)
Canadian art in Britain; contemporary works from collections in Britain
   EXHIBITION SHOWN: London, GBR, Canada House Gallery, 3 Feb-9 Mar 1982
   EXHIBITION YEAR(S): 1982
   SHEPHERD, Michael
   CONTRIBUTOR(S): Introd. by: Michael SHEPHERD
   56 p. 10 illustrations, color; exhibition list; 95 works shown
   PUBLICATION YEAR(S): 1982
   LANGUAGE(S): In English
   DOCUMENT TYPE: exhibition catalogue
   Paintings, graphic work and sculpture, post 1940. Artists represented by
      more than one work include Sybil Andrews, Edward Bartram, Maxwell
      Bates, Paul Emile Borduas, Jack Bush, Kosso Eloul, Paterson Ewen,
      Gerald Gladstone, Eli Ilan, Jean Paul Riopelle, Henry Saxe. (Staff,
      RILA, UK)
   DESCRIPTORS: Andrews, Sybil, Canadian printmaker, painter, b.1898/
      exhibitions
   Bartram, Edward John, Canadian printmaker, b.1938/exhibitions
   Bates, Maxwell Bennett, Canadian painter, architect, 1906-1980/
      exhibitions
   Borduas, Paul Emile, Canadian painter, 1905-1960/exhibitions
   Bush, Jack, Canadian painter, 1909-1977/exhibitions
   drawing, Canadian/20th c./(1940-1982)
   Eloul, Kosso, American sculptor, b.1920/exhibitions
   Ewen, William Paterson, Canadian painter, b.1925/exhibitions
   Gladstone, Gerald, Canadian sculptor, b.1929/exhibitions
   prints, Canadian/20th c./(1940-1982)
   Ilan, Eli, Israeli sculptor, b.1928/exhibitions
   London (GBR), Canada House Gallery/exhibitions/Canadian art in Britain;
      contemporary works from collections in Britain
   painting, Canadian/20th c./(1940-1982)
   Riopelle, Jean Paul, Canadian painter, sculptor, printmaker, b.1923/
      exhibitions
   Saxe, Henry, Canadian artist, b.1937/exhibitions
   sculpture, Canadian/20th c./(1940-1982)
   SECTION HEADING(S): 80—MODERN ART—miscellanea and new media; 97—
      COLLECTIONS AND EXHIBITIONS—exhibition list
   SUBJECT NATIONALITY: Canadian
   SUBJECT PERIOD: 1940-1982
   SUBJECT STYLE, MEDIUM, FORM: painting; drawing; graphic arts; sculpture
```

Example 14: Selections from a DIALOG® search completed through *Art Literature International (RILA) Database,* a bibliographic service of the Getty Art History Information Program of the J. Paul Getty Trust.

for elder and/or elders. Moreover, a symbol can be placed between two or more words that must be used in combination. For the DIALOG databases, the symbol is (w), standing for with. For example, OLD(W)MEN would mean that these two words must be adjacent and in that specified order. If the statement was BOOK(1W)HOURS, the (1W) would indicate that one word, and only one, can be between the two terms. This would allow for the phrase, book of hours.

Another example of the linking of multiple concepts would be if the problem is to discover titles of references on depictions of woman in 19th-century English art. The search statement might be:

WOM?N AND (ICONOGRAPH?
OR SUBJECT) AND ((19 OR NINETEEN?)
(1W) CENTURY OR 1800?)
AND ENGLISH/DE

The truncated WOM?N will find either woman or women; ICONOGRAPH?, iconography or inconographic. Using *Dissertation Abstracts Online* [16:9], a search brought forth the following entries:

S1	17,802	WOM?N
S2	639	ICONOGRAPH?
S3	19,587	SUBJECT
S4	5,008	((19 OR NINETEEN?) (1W) CENTURY OR 1800?)
S5	8,081	ENGLISH/DE.
S6	14	WOM?N AND (ICONO-GRAPH? OR SUBJECT) AND ((19 OR NINETEEN?) (1W) CENTURY OR 1800?) AND ENGLISH/DE.

The /DE signifies descriptors; ENGLISH/DE would have to be in the list of descriptive terms that were assigned to the article by the computer indexer. In the combination of terms, as requested in the search statement, there were fourteen citations.

In the above search, notice that the computer reports how many records there are for each word or phrase before it indicates the number of citations for the combined terms. By carefully checking these numbers, researchers can obtain ideas as to which terms are most frequently used in that particular database. There were 19,587 records for the word, subject, but only 639 for iconograph?. To locate all relevant articles, both terms need to be used. It is important to use synonyms in the search statement, because researchers do not know which terms were used by the authors or computer indexers.

Some databases have an astronomical number of records; for instance, *Magazine Index* [16:21] has more than 2,785,000. For databases with extensive files, the search may need to be narrowed and refined. There are a number of options, such as (1) entries can be viewed in an abbreviated form, (2) the statement can be limited by such items as dates and language, or (3) the term NOT can be added to the search statement. There are several ways bibliographical entries can be printed or displayed on the screen. As seen in Example 15 at the end of this chapter, under "Output Options," *Art Literature International (RILA)* has eight methods for typing or displaying citations. For instance, a full record can be displayed, with or without the abstract, or the title and accession number may be all that is needed. The more information requested, the longer the computer takes, the more expense is incurred. By having brief bibliographical entries displayed, researchers usually have enough data to choose the most pertinent material. Once evaluated, the complete records of the relevant articles can be printed. This saves time and money.

Both descriptors and suffixes limit and refine a search. For instance, *ERIC Database* [28:117] was used to locate information on students and school visits to museums. The ERIC computer file, which dates from 1966, has more than 660,000 citations. The search statement read:

STUDENT?/DE AND MUSEUM?/DE

There were 102,740 references to STUDENT?/ DE, 591 to MUSEUM?/DE, and fifty-seven to the terms combined. In this database, the search can be narrowed further. By using major descriptors— STUDENT?/MAJ AND MUSEUM?/MAJ— which characterize the most substantive contents of articles, the number of citations was curtailed to fifteen.

By adding the suffixes /ENG or /NONENG to a search only English or non-English language articles will be chosen. Years can also be used as suffixes in order to confine the search between specific dates. For instance, 1970:1980 would indicate that the material between these decades are to be located. But care must be taken when using dates as they can be confusing. Computer indexers may use a number of methods for stating the same thing: 19c, 1800–1899, 1800H, or nineteenth()century. Descriptors and suffixes vary from database to database; to discover which ones are available for a specific file, ask the reference librarian for assistance or consult the vendor's user manual or guide sheets.

Another method for limiting searches is to add the word NOT to the Boolean statement. For instance, in the following search

PHOTOGRAPH? AND MEXICO
NOT NEW()MEXICO

the NOT ensures that only the country will be located. But care must be taken in using this limiting word. For example, a search for a California graphic artist who worked in 1945 might state

CALIFORNIA? AND (PRINT? OR
GRAPHIC()ART?)
AND 1945 NOT PHOTOGRAPH?

The NOT PHOTOGRAPH? would narrow the search by directing the computer to ignore citations with photography, photographic or photographers. But an article on "California Photographic Images Converted into Prints During 1945" could be pertinent, yet it would not be reported.

Various files within a database can be investigated by searching individual fields or the Basic Index. The individual fields may include:

1. titles
2. authors
3. descriptors
4. the abstract
5. serial name
6. publication years of the serial
7. the ISBN number
8. depending upon the database, the type of document, museum names, the language of the articles, or the country where the magazine was published.

Because titles are not always good indicators of the subject matter in an article, a subject search which is by title alone will seldom be adequate. In many bibliographic databases, the Basic Index includes titles of articles, abstracts, and descriptors. But this varies with the database. Since this information, which in DIALOG is published on Blue Sheets, is available from the vending firms, researchers must ask the reference librarian for details. Example 15 reproduces the DIALOG Blue Sheet for *Art Literature International (RILA);* study it carefully, it illustrates the terms which can be used for searches.

By having the computer search the Basic Index, more citations will probably be reported, but the relevancy rate will be lower. This is due to the fact that the computer pulls out matching terms, regardless of their meaning. For instance, in a Basic Index search for information on German Biedermeier furniture, the computer would report any citations that included these terms, regardless of their position in the record. This can produce a number of irrelevant citations. For example, an article on the Asiatic furniture of a German diplomat living in Biedermeier would probably not be pertinent to the study, although it would fit the search statement and thus be reported. Students must realize that not all titles which the computer locates will be relevant to the topic. The tighter the statement, the higher the percentage of hits—a computer term meaning pertinent citations.

The quickest method for obtaining germane citations is to employ the same terms the indexer used. Some companies have issued a thesaurus to aid patrons in choosing the correct words or subject headings. For example, there are *The New York Times Thesaurus* [16:56] and the *Thesaurus of Eric Descriptors* [28:119]. If no thesaurus exists, researchers should study the indexing terms used in the corresponding hardbound version. Many vending firms have hand books, workshops, and videos to assist students in learning the refinements of database searching. Moreover, some—such as DIALOG—have special classroom instruction programs by which most databases are available at special rates for academic instruction. Take advantage of any of the searching aids that may be in the library or media center. If the library provides CD-ROM databases, use them as often as possible. For it is only through communicating with computers that students will learn how to manipulate them.

ART LITERATURE INTERNATIONAL 191 (RILA)
ONTAP℠ ART LITERATURE INTERNATIONAL (RILA) (176)

Information Retrieval Service

FILE DESCRIPTION

ART LITERATURE INTERNATIONAL abstracts and indexes current publications in the history of art. The database is produced by RILA, the International Repertory of the Literature of Art, and corresponds to the printed publication, *RILA*. More than half of the records have informative abstracts.

File 176, ONTAP℠ ART LITERATURE INTERNATIONAL, is available for **ON**line **T**raining **A**nd **P**ractice and contains records from 1984 through 1986.

SUBJECT COVERAGE

ART LITERATURE INTERNATIONAL covers literature on all aspects of Western art from Late Antiquity (4th century) to the present. Topics include:

- Sculpture
- Architecture
- Painting
- Drawing
- Prints
- Decorative Arts
- Manuscripts and Illumination
- Books and Illustration
- Photography
- Industrial Design
- Scenography
- Landscape Architecture and Gardens
- City Planning
- Conceptual Art and New Media
- Iconography
- Collecting and Patronage
- Exhibitions
- Art Theory and Criticism
- Artist, Movements, and Schools
- Techniques
- Conservation and Restoration
- Museums and Galleries

ART LITERATURE INTERNATIONAL also covers related subjects including politics and art, psychoanalysis and art, and law and art.

SOURCES

ART LITERATURE INTERNATIONAL cites a wide array of documents including: books, collected essays, festschriften, conference proceedings, museum publications, exhibition catalogs, dissertations, and periodical articles. Book and exhibition reviews, obituaries, interviews, and published lectures are included. Individual essays are included as separate abstracts.

DIALOG FILE DATA

	File 191	**File 176**
Inclusive Dates:	1973 to the present	1984 through 1986
Update Frequency:	Semiannual (approximately 4,500 records per update)	Not applicable — special file
File Size:	104,100 records as of December 1988	10,000 records

ORIGIN

The ART LITERATURE INTERNATIONAL database is sponsored by the College Art Association of America and the Art Libraries Society of North America and is produced by RILA, a bibliographic service of the Getty Art History Information Program of the J. Paul Getty Trust. Questions concerning file content should be directed to:

Marshall Lapidus or Darlene Bonner
RILA
c/o Sterling and Francine Clark Art Institute
Williamstown, MA 01267

Telephone: 413/458-8260

Database copyrighted by the J. Paul Getty Trust - RILA.

©Dialog Information Services, Inc., 1989. All rights reserved. DIALOG is the Servicemark of Dialog Information Services, Inc. Reg. U.S. Patent and Trademark Office. Dialog Information Services, Inc. is a Knight-Ridder company.

Example 15: A DIALOG Blue Sheet for *Art Literature International (RILA) Database*, a bibliographic service of the Getty Art History Information Program of the J. Paul Getty Trust.

Example 15:—*(continued)*

FILE 191

ART LITERATURE INTERNATIONAL
(RILA)

SAMPLE RECORDS

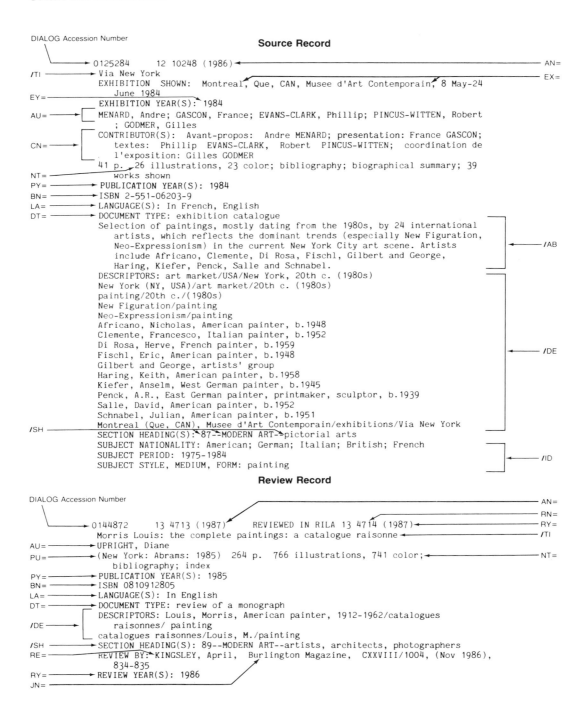

Source Record

DIALOG Accession Number

AN= ← 0125284 12 10248 (1986)

/TI → Via New York

EX= EXHIBITION SHOWN: Montreal, Que, CAN, Musee d'Art Contemporain, 8 May-24 June 1984

EY= EXHIBITION YEAR(S): 1984

AU= MENARD, Andre; GASCON, France; EVANS-CLARK, Phillip; PINCUS-WITTEN, Robert ; GODMER, Gilles

CN= CONTRIBUTOR(S): Avant-propos: Andre MENARD; presentation: France GASCON; textes: Phillip EVANS-CLARK, Robert PINCUS-WITTEN; coordination de l'exposition: Gilles GODMER

NT= 41 p. 26 illustrations, 23 color; bibliography; biographical summary; 39 works shown

PY= → PUBLICATION YEAR(S): 1984

BN= → ISBN 2-551-06203-9

LA= → LANGUAGE(S): In French, English

DT= → DOCUMENT TYPE: exhibition catalogue

/AB ← Selection of paintings, mostly dating from the 1980s, by 24 international artists, which reflects the dominant trends (especially New Figuration, Neo-Expressionism) in the current New York City art scene. Artists include Africano, Clemente, Di Rosa, Fischl, Gilbert and George, Haring, Kiefer, Penck, Salle and Schnabel.

/DE ← DESCRIPTORS: art market/USA/New York, 20th c. (1980s)
New York (NY, USA)/art market/20th c. (1980s)
painting/20th c./(1980s)
New Figuration/painting
Neo-Expressionism/painting
Africano, Nicholas, American painter, b.1948
Clemente, Francesco, Italian painter, b.1952
Di Rosa, Herve, French painter, b.1959
Fischl, Eric, American painter, b.1948
Gilbert and George, artists' group
Haring, Keith, American painter, b.1958
Kiefer, Anselm, West German painter, b.1945
Penck, A.R., East German painter, printmaker, sculptor, b.1939
Salle, David, American painter, b.1952
Schnabel, Julian, American painter, b.1951
Montreal (Que, CAN), Musee d'Art Contemporain/exhibitions/Via New York

/SH SECTION HEADING(S): 87--MODERN ART--pictorial arts

/ID ← SUBJECT NATIONALITY: American; German; Italian; British; French
SUBJECT PERIOD: 1975-1984
SUBJECT STYLE, MEDIUM, FORM: painting

Review Record

DIALOG Accession Number

AN=
RN=
RY= ← 0144872 13 4713 (1987) REVIEWED IN RILA 13 4714 (1987)

/TI → Morris Louis: the complete paintings: a catalogue raisonne

AU= → UPRIGHT, Diane

PU= → (New York: Abrams: 1985) 264 p. 766 illustrations, 741 color; NT= bibliography; index

PY= → PUBLICATION YEAR(S): 1985

BN= → ISBN 0810912805

LA= → LANGUAGE(S): In English

DT= → DOCUMENT TYPE: review of a monograph

/DE → DESCRIPTORS: Louis, Morris, American painter, 1912-1962/catalogues raisonnes/ painting
catalogues raisonnes/Louis, M./painting

/SH → SECTION HEADING(S): 89--MODERN ART--artists, architects, photographers

RE= REVIEW BY: KINGSLEY, April, Burlington Magazine, CXXVIII/1004, (Nov 1986), 834-835

RY= → REVIEW YEAR(S): 1986

JN=

Example 15:—(continued)

ART LITERATURE INTERNATIONAL
(RILA)

SEARCH OPTIONS

BASIC INDEX

SEARCH SUFFIX +	DISPLAY CODE	FIELD NAME	INDEXING	SELECT EXAMPLES
/AB	AB	Abstract[1]	Word	S NEO(W)EXPRESSIONISM/AB
/DE	DE	Descriptor[2]	Word & Phrase	S KIEFER(1N)ANSELM/DE S NEW FIGURATION?/DE
/ID	ID	Identifier[3]	Word & Phrase	S GERMAN//ID S 1975-1984/ID
/SH	SH	Section Heading and Code	Word & Phrase	S 87/SH S MODERN ART/SH
/TI	TI	Title	Word	S VIA(W)NEW(W)YORK/TI

+ If no suffix is specified *all* Basic Index fields are searched.
[1]Abstracts present for over half of the records.
[2]Also /DF.
[3]Also /IF.

ADDITIONAL INDEXES

SEARCH PREFIX	DISPLAY CODE	FIELD NAME	INDEXING	SELECT EXAMPLES
AN=	AN	RILA Number (Main)	Phrase	S AN=12 10248
AU=	AU	Author	Phrase	S AU=MENARD, ANDRE
BN=	BN	International Standard Book Number (ISBN)	Phrase	S BN=2551062039
—	CI	Citation		
CN=	CN	Contributor	Word	S CN=(FRANCE(W)GASCON)
CS=	CS	Degree-Granting Institution	Phrase	S CS=NEW YORK UNIVERSITY
—	DG	Degree		
DN=	DN	Dissertation Number[4]	Phrase	S DN=DA8421557
DT=	DT	Document Type	Phrase	S DT=EXHIBITION CATALOGUE
DY=	DY	Year Degree Granted	Word	S DY=1984
EX=	EX	Exhibition Sponsor and Location	Word	S EX=MONTREAL S EX=(MUSEE(2W)CONTEMPORAIN)
EY=	EY	Exhibition Year	Word	S EY=1984
—	FN	File Name		
JN=	JN	Journal Name	Phrase	S JN=BURLINGTON MAGAZINE
LA=	LA	Language	Word	S LA=FRENCH
LC=	LC	Library of Congress Card Number	Phrase	S LC=82-84621
NT=	NT	Notes	Word	S NT=ILLUSTRATIONS
—	PL	Page Length		
—	PR	Price		
PU=	PU	Publisher Name:Location	Word	S PU=(WEIDENFELD(1W)NICOLSON) S PU=LONDON
PY=	PY	Publication Year	Word	S PY=1985
RE=	RE	Reviewer Name	Phrase	S RE=KINGSLEY, APRIL
RN=	RN	RILA Number (Reviews)	Phrase	S RN=13 4714
RY=	RY	Publication Year (Reviews)	Word	S RY=1986
SE=	SE	Series	Word	S SE=(MODERN(W)MASTERS)
SL=	SL	Summary Language	Word	S SL=ENGLISH
—	SN	International Standard Serial Number (ISSN)		
UD=	—	Update	Phrase	S UD=9999

[4]Present only for U.S. dissertations.

ART LITERATURE INTERNATIONAL
(RILA)

LIMITING

Sets and terms may be limited by Basic Index suffixes, i.e., /AB, /DE, /DF, /ID, /IF, /SH, /TI (e.g., S S5/TI), as well as by the following features.

SUFFIX	FIELD NAME	EXAMPLES
None	Publication Year	S S2/1987
/ENG	English Language	S S3/ENG
/NONENG	Non-English Language	S S3/NONENG

SORTING

SORTABLE FIELDS	EXAMPLES
Online (SORT) and offline (PRINT) AU, JN, PY, RY, TI	SORT S3/ALL/AU/TI PRINT S5/5/1-24/AU

OUTPUT OPTIONS†

USER-DEFINED FORMAT OPTIONS

User-defined formats may be specified using the display codes indicated in the Search Options tables, e.g., TYPE S3/TI,PY/1-5.

PRE-DEFINED FORMAT OPTIONS

NUMBER	RECORD CONTENT
Format 1	DIALOG Accession Number
Format 2	Full Record except Abstract
Format 3	Bibliographic Citation
Format 4	Full Record[1] with Tagged Fields
Format 5	Full Record[1]
Format 6	Title, DIALOG Accession Number, RILA Number (Main), and RILA Number (Reviews)
Format 7	Bibliographic Citation and Abstract[1]
Format 8	Title, Indexing, RILA Number (Main), and RILA Number (Reviews)
Format K	KWIC (Key Word In Context) displays a window of text; may be used by itself or with other formats

DIRECT RECORD ACCESS

FIELD NAME	EXAMPLES		
DIALOG Accession Number	TYPE 0125284/5	DISPLAY 0144872/EX,EY	PRINT 0125061/5

†TAG may be used for tagged fields, e.g., TYPE S2/3/1-5 TAG.

PART III

METHODOLOGY
Beyond the Basics

This section discusses the methodology for using specialized resources to develop more detailed bibliographies and chronologies, to research specific works of art and iconography, and to locate sales information and reproductions of works of art. Chapter 5 is concerned with these additional research tools; Chapter 6, individual works of art; Chapter 7, subjects and symbols; Chapter 8, information on people; and Chapter 9, architecture. Parts IV through VI, which contain annotations for research tools to which these discussions refer, should be consulted while reading this section.

Specialized Art Research Resources

Because of the many resources that are now available to scholars, in-depth research has become both easier and more complex. Access to pertinent materials can be more involved, since they appear in a variety of forms—such as books, serials, microforms, photographs, and databases. Students and scholars have a tendency to utilize the tried and the familiar, but some recent publications may have made this mode of operation inefficient and cumbersome. This chapter discusses several types of resources which are frequently underused, because students are not sure how to utilize them. Sources—which can be consulted to create more current and detailed bibliographies and chronologies, learn about the value of an artist's work, and locate illustrative material—are organized into (1) art bibliographies; (2) additional indices and databases; (3) sales information; (4) archival material (5) vertical files and scrapbooks; (6) documents, critics' reviews, and interviews; (7) visual resources; and (8) subject indexing projects. For architectural bibliographies, indices, and published archives, see Chapter 9.

Art Bibliographies
Also See Chapter 17

The importance of bibliographies cannot be overemphasized. They are a great hidden resource, for they reflect the cumulative research of scholars, research which should be built upon, not repeated. Providing access to various publications over a wide range of materials, bibliographies list titles of pertinent books, catalogues, and articles on specific subjects. A concerted effort must be made to discover and use these valuable tools. This section discusses (1) specialized bibliographies and (2) the multivolume catalogues that have been published on the holdings of some libraries.

Specialized Art Bibliographies

There are two important general art bibliographies: Mary Chamberlin's 1959 *Guide to Art Reference Books* [17:4] and the 1979 book that updates it, Etta Arntzen and Robert Rainwater's *Guide to*

Literature of Art History [17:1], shortened to *Arntzen & Rainwater*. These bibliographies—which have extensive annotations for dictionaries, art-history references, specialized bibliographies, and serials—provide access to a core of established scholarly material. Especially useful for foreign-language resources, they cite reference works that will lead researchers to other tools. For instance if Islamic art was the subject, by consulting *Arntzen & Rainwater* students would find seventy-six entries for encyclopedias and general histories as well as books on Islamic architecture, decorative and applied arts, painting, and sculpture. Mentioned are two serials with detailed data on dates of suspended publications, title changes, and special subject bibliographies. This extensive analytical coverage is typical throughout the book. Although they lack currency, these two references can be updated through the indices to periodical literature. It is well to remember, however, that *Arntzen & Rainwater* does not include references on individual artists; see Freitag's *Art Books* [10:72], discussed in Chapter 3, for that type of material.

The most efficient way to begin the compilation of a bibliography is to find a scholarly annotated bibliography on the research subject. With this data, other sources can be used to update and augment the material. The annotated volumes of the *G.K. Hall Art Bibliographies Series* [17:6] are written on (1) individual artists, (2) artistic and historical periods, (3) styles, and (4) media. These bibliographies include articles as well as books, catalogues, dissertations, and *Festschriften*. Presently there are about twenty-four volumes, individual titles of which are cited in the appropriate sections of this book.

In Barbara G. Lane's *Flemish Painting Outside Bruges, 1400–1500* [12:29.6], one of the *G.K. Hall Art Bibliographies Series,* two sections are on the Flemish artist Robert Campin: one on Campin and Van der Weyden, the other on Campin and the School of Tournai. The former records forty-two entries; the latter, 132. In addition, the book's introduction has a discussion on the Campin-Flemalle controversy. The annotations not only help in the

1 SCHABACKER, PETER H. "Notes on the Biography of Robert
 Campin." Mededelingen van de Koninklijke academie voor weten-
 schappen, letteren, en schone kunsten van België, Klasse der
 schone kunsten (Brussels) 41, no. 2 (1980):1-14.
 Reviews Tournai documents relating to the period in which
 Campin worked. Concludes that he was not a leading participant
 in the 1423 revolt in Tournai, and that he was a successful
 chief of a workshop there. Offers evidence that Rogier van der
 Weyden, his pupil and nephew by marriage, received his mastership
 on August 1, 1432, probably as a direct result of Campin's second
 condemnation and possibly "to ensure the continued operation of
 the workshop" (since Campin was to be banished for a year).

Example 16: *Flemish Painting Outside Bruges,* 1400–1500: An Annotated Bibliography by Barbara G. Lane. Boston: G. K. Hall and Company, 1986, Page 70. Reprinted with the permission of G. K. Hall & Co., Boston.

decision as to which references should be obtained, but also provide additional insight into the life of these artists. For instance, in Example 16 which is one of the entries in Lane's bibliography, the annotation mentions the 1423 Tournai revolt as well as the probable reasons for Rogier van der Weyden's receiving his mastership. Notice that the English-language article is in a Belgium annual. These annotations can be added to the student's bibliography as long as quotation marks are used and credit is given to the source.

Specialized annotated bibliographies have been compiled on relatively few subjects. In order to obtain a list of the most significant reference works for a subject, most researchers will have to compile their own by utilizing numerous and varied research tools. A systematic approach is required. For instance, most of the resources cited in this guide include bibliographies; where relevant, they should be consulted. Moreover, most of the bibliographies annotated in Chapter 17 are important sources for this type of compilation. In addition, some serials publish separate bibliographies on narrow topics. The indices to periodical literature frequently report them. For instance, *RILA* [16:7] and *ARTbibliographies MODERN* [16:2] have special sections for these important resources; *Art Index* [16:1] lists them under the subdivisions of various subjects.

Published Catalogues of Major Libraries

Other important sources for bibliographical material are published catalogues of the holdings of major libraries, such as the *Library Catalog of the Metropolitan Museum of Art* [17:12] and the *Catalogue of the Harvard University Fine Arts Library* [17:11]. The special strengths of these publications are their outstanding coverage which reflects the collection policies of their institutions.

Most of these catalogues provide subject access to bibliographical material. Some have annual updates; some, online databases. The catalogues assist researchers in:

1. developing more extensive and better bibliographies
2. locating titles of small pamphlets, ephemera, and foreign-language material
3. learning books that have pertinent chapters on a topic
4. finding annotations for exhibition and sales catalogues
5. verifying or completing bibliographical data
6. ascertaining the birth and death dates of authors
7. learning of exisiting vertical files and scrapbooks

The published catalogues for general art libraries are annotated in Chapter 17, but the publications of libraries with specialized interest—such as *Dictionary Catalog of the Library of the Freer Gallery of Art* [14:81], which has its emphasis on Asiatic art—are listed in the appropriate chapters.

A few published library catalogues contain analytical cataloguing, supplying information that can be obtained nowhere else. A notable example is the MoMA—Museum of Modern Art in New York City—catalogue, which has, under a particular artist's name, subdivisions that enable researchers to pinpoint needed references more accurately. For instance, under Degas's name, the *Catalog of the Library of the Museum of Modern Art* [12:96] has 187 entries subdivided into thirteen subject categories, such as dancers, draftsman, exhibitions, pastels, photographer, portraits, and sculptor. MoMA's catalogue has entries for books, articles, and exhibition catalogues as well as references that include important discussions on Degas. One entry—Ambroise Vollard's *Recollections of a Picture Dealer,* 1936—reports that Vollard's book has an account of Degas and his use of models. No less impressive is the information provided for contemporary artists. Larry Rivers has twenty-three entries divided into three categories—general references, draftsman, and exhibitions. Here too is a valuable entry: James Thrall Soby's *Modern Art and the New Past,* 1957, which has an account of an interview with Larry Rivers.

Several of these library catalogues—*Catalog of the Library of the Museum of Modern Art* [12:96], the *Dictionary Catalog of the Art and Architec-*

ture Division of the New York Public Library [17:13], and the *Catalogue of the Library of the National Gallery of Canada* [13:94]—have notations for ephemera material which is available in the library's vertical files or scrapbooks. This has become more important since some of these vertical files and scrapbooks are being published on microforms, a subject discussed below.

Additional Indices and Databases
See Also Chapter 16

One object of thorough research is to find all pertinent material that has been written on a particular subject. Additional abstracting and indexing services—other than the four major ones discussed in Chapter 3—will be needed. Some are very specialized, such as *The Concordia University Art Index to Nineteenth-Century Canadian Periodicals* [16:26]; others are of a general nature, such as *Reader's Guide to Periodical Literature* [16:23]. Many have online databases that provide current information; most are rewarding for some types of research. This section details indices that cover: (1) dissertations, (2) corpora, (3) symposia and conferences, (4) *Festschriften,* (5) newspaper and popular magazine articles, (6) serials published prior to the 1970s, (7) book reviews, and (8) citations. Read the annotations in Chapter 16 carefully, in order not to omit any of these important resources. Architecture is discussed separately in Chapter 9.

Dissertations

The valuable work of graduate students should not be overlooked. This research, much of which is never published in any other form, can not only provide insight and detailed information into a subject, but the bibliographies and footnotes can be invaluable. These contributions can be located in *Dissertation Abstracts International* [16:9]. Using the *Comprehensive Dissertation Index, 1861–1972* and its annual supplements or the *Comprehensive Dissertation Index Abstract Database* will facilitate finding pertinent information. Many U.S. dissertations are published as monographs by UMI Press and Garland Press; the latter also has a series that publishes British dissertations and theses, which can be hard to find. One of their greatest assets is the peripheral subjects and ideas which are addressed. For instance, there have been at least eight dissertations written on Degas's art, focusing on such aspects as his reputation, his dance compositions, and his Russian Dancers Series.

Corpora

Because of the recurring need to bring together the research of international scholars, corpora have resulted. Providing exhaustive material on a specific subject, media, or type of monument, the multivolume corpus, which is issued in individual volumes sometimes called *fascicles,* includes complete documentation, extensive bibliographical and archival data, plus every important known fact concerning the subject. For example, *A Corpus of Spanish Drawings,* by Diego Angulo and Perez Sanchez is a multivolume work which, when completed, will contain all of the drawings made in Spain from 1400 to 1800.

Due to its magnitude, a corpus must be organized in some rational manner. For instance, the *Corpus della scultura altomedievale* [11:114] includes illustrations and documentation on Italian sculpture. Because the material is divided according to ecclesiastical districts—such as, la diocesi di Lucca—in which the art is located, researchers must be familiar with this information prior to using this resource. Corpora can be located through other researcher's bibliographies, specialized art bibliographies, and abstracting resources, such as *RILA* [16:7].

Symposia and Conferences

Papers read at symposia and conferences are chosen for their scholarly content and their relation to a specific topic. Some symposia papers are only available as abstracts; others are combined and issued as documentation of the meetings. For example, the British Archaeological Society publishes the transactions of their annual conferences. The Society published *Medieval Art and Architecture at Wells and Glastonbury* in 1981 and *Medieval Art and Architecture at Canterbury Before 1220* in 1982. *RILA* [16:7] included a listing of the papers accompanied by the names of the presenters. These papers can also be located through *Répertoire d'art et d'archéologie* [16:6].

Festschriften

A *Festschrift* is a collection of scholarly essays written in honor of a well-known person or institution. For instance, *Scritti di storia dell'arte in onore di Federico Zeri* is a two-volume work honoring Federico Zeri. The eighty-five essays are

written in Italian, French, English, and German by such noted scholars as Charles Sterling, Marcel Roethisberger, and John Pope-Hennessy. Usually *Festschriften* are cited in bibliographies and footnotes under a shortened title giving only the honored person's name, such as *Festscrift Zeri.* This can make them difficult to locate in some library catalogue systems, since older cataloguing rules put the editor's name and the title of the book as entries not the honored person. Moreover, no cross reference or access is provided to the honored person. But researchers need to search diligently for these valuable tools, because *Festschriften* can provide (1) material which is international in scope, (2) essays on narrow topics that are not published elsewhere, and (3) biographical data on the honored person.

To find *Festschriften,* consult (1) Betty Lincoln's *Festschriften in Art History, 1960–1975: Bibliography and Index,* and (2) *RILA* and *Répertoire d'art et d'archéologie.* The Lincoln index [16:11] includes 344 *Festschrifen* written by more than 3,000 authors and covering the period of art history since the beginning of Christianity. Under the name of the honored person, the book provides a complete bibliographical citation and a list of contributors. There are indices to subjects, essay authors, and honored persons.

RILA [16:7] provides access to *Festschriften* under the honored persons' names. Under "General Works: Collected Works," the 1986 issue has an entry for "*Zeri, F. Festschrift.*" Reported are title, editor, bibliographical data, and a complete listing of titles and authors of all eighty-five essays. The numbers in parentheses refer to the separate entries for individual articles cited in the abstract section. Authors are listed in the index. Another source is *Répertoire d'art et d'archéologie* [16:6] which under "*Liste des recueils collectifs*" provides access to the individual essays. A quick way to find current *Festschriften* is through a database search.

Newspapers and Popular Magazines

Most biographical references and indices of periodical literature only include artists who have been included in important exhibitions or have had a number of one-artist shows in a cosmopolitan city, such as New York or Los Angeles. But material can be located on exhibitions outside the major art centers. For pertinent data on current events and exhibitions as well as contemporary artists, regional newspapers and magazines are often excellent sources. The indexing of these regional publications is through databases, such as *Magazine Index* [16:21] which covers 400 popular American magazines—including *American Artist, American Art Review, Art News, Current Biography*—plus a number of regional periodicals—*Boston Magazine, Los Angeles, New York, Philadelphia,* and *Texas Monthly. DataTimes Database* [16:49] provides access to numerous regional newspapers as well as *The Times* and the *Daily Telegraph* of London. NEXIS [16:50] also provides access to regional U.S. papers which cover local artists. Many of these databases have full-text capabilities by which researchers can have entire newspaper articles printed.

Before databases began indexing them, newspaper items were difficult to find. Although *The Times* of London and the *New York Times* have published hardcopy indices for over a century, they are not readily available or easy to search. Formerly newspaper material could only be located in a vertical file of the local library. But all this has changed with the reprint of some of the more extensive vertical files, discussed below, and the development of databases that index material from some of the larger newspapers. For instance, *Newspaper Abstracts Database* [16:52] has files since 1984 for such publications as the *Atlanta Constitution, Boston Globe, Chicago Tribune, Denver Post, Detroit News, Houston Post, Los Angeles Times, New York Times, San Francisco Chronicle, Wall Street Journal,* and *Washington Times.*

For current or recent events, databases should be used, since most of them update their files daily. Indices to newspapers and popular magazines are major sources for locating:

1. times, dates, and reviews of exhibitions
2. data on forthcoming sales as well as unusual auction prices
3. critical reviews and interviews
4. book reviews
5. announcements of awards
6. articles in the news and magazine sections
7. obituaries

Serials Published Prior to the 1970s

All detailed studies must consider not only current information but also retrospective research. The material may not be pertinent and it may be

dated, but until it is examined, researchers will not know its value. Most articles published since the 1970s are fairly easy to find; it is the older material which is usually harder to locate. For publications prior to this date, use the printed volumes of *Art Index* [16:1], *The Frick Art Reference Library Original Index to Periodicals* [16:28], *The Courtauld Institute of Art Periodicals Subject Index* [16:27], and the *Index to Art Periodicals Compiled in Ryerson Library, The Art Institute of Chicago* [16:29]. There are also several nineteenth-century indices, but often the subject categories are so broad that they are difficult to search. Individual indices for serials, such as *Art Bulletin* and *Burlington Magazine* are useful sources. Moreover, some biographical dictionaries, such as *Thieme/ Becker* [10:47], report older bibliographical data. In addition, articles can frequently be located in the vertical or artists' files discussed below.

Book Reviews

Although it may present varying viewpoints or question the accuracy of the material, a good book review should give an objective critical analysis of the material. Sometimes a review becomes an important essay on the subject and provides additional insight into the discipline. Often the book review itself can be judged by the quality of the serial in which it is published. For example, a critique printed in *Art Bulletin* would most likely be written by an expert in the same art field as the reviewed book covers. Book reviews assist researchers in:

1. discovering how much research authors have done and how authoritative they are considered by their peers
2. understanding books that are confusing or difficult to comprehend
3. deciding whether or not specific books warrant being used as textbooks or as references to be studied extensively
4. staying informed of current publications

And since a book review is also someone's opinion, it too must be judged. Is the reviewer nit-picking or do the comments and criticisms discussed deserve merit?

When checking indices to book reviews, annotated in Chapter 16, scrutinize the volume covering the year when the first edition of the book was issued, plus the following three years, as well as the volumes that include the periods during which later editions were published. This is necessary, because a review is often written only for the first edition or for an enlarged and revised work. Moreover, not all books are reviewed, and some may have reviews that are difficult to find. Remember that sometimes books are issued under one title in the U.S. and under a different title when published in a foreign country. For instance, the American edition of Peter Mitchell's *European Flower Painters* was called *Great Flower Painters* [10:43].

Citations

Issued three times a year with an annual cumulation, the *Arts & Humanities Citation Index* [16:59], abbreviated *A&HCI*, indexes citations found in the text, footnotes, or bibliographical references in about 1,300 journals plus about ninety books, *Festschriften,* and proceedings. Begun in 1976, *A&HCI,* assists researchers in locating:

1. reproductions and references to specific works of art
2. discussions of particular artists or ideas
3. whether or not a scholar is frequently quoted
4. articles from serials not covered by the major art indices

The primary advantage to *A&HCI* is in locating references to specific works of art. But the researcher needs to remember that the works are recorded in the language of the article; *L'Adoration des Bergers, La Adoracion de los Pastores,* and *Adoration of the Shepherds* may all be the same painting. Moreover, a comparison of the speed with which material is published in relationship to the major art indices is particularly interesting. Checking the 1986 volumes under "Degas E," it was found that *A&HCI* included material before either *Art Index* [16:1] or *RILA* [16:7]. A disadvantage to *A&HCI* is its lack of an authority name file; nor are first names provided. Thus there could be citations for Master of Flemalle, Campin, and Campin, R. Moreover, the print is exceedingly hard to read due to its reduced size. Although it can be expensive, the *A&HCI Database* [16:59], with files dating since 1980, is easier to use.

Sales Information
Also See Chapter 18

Sales information is scattered and sometimes difficult to collect because of its international nature, its extensive coverage, and the wide range of its literature. For instance, the *International Art & Antiques Yearbook* [20:44] lists approximately 200

auctioneers and salerooms throughout the world. Historically, the two major auction houses are Sotheby's and Christie's, both of which have been in existence for more than 200 years. Sales information is usually gleaned from the sales catalogues that most auction houses publish and the indices that cover them. Beginning researchers seldom use these resources, and yet they can be used to:

1. establish the value of an artist's work at a given time
2. determine the provenance of a work of art, since the names of sellers and buyers may be reported, thus enabling the genealogy of the work to be traced
3. discover information on little-known artists or ones whose work has recently been sold but for whom insufficient documentation exists
4. locate rarely published illustrations, sometimes in color, of an artist's works or on a particular subject
5. compile a catalogue entry for a specific work of art, a subject discussed in the next chapter, because data—such as dimensions, and probable date of completion—are provided
6. extend a bibliography from the literary references that may be included
7. evaluate the auction market
8. trace artistic taste and trends, since sales prices are an indicator of the market's reaction to works of art and artists

Auction Catalogues

In order to advertise their forthcoming sales, most auction houses place advertisements in local newspapers and serials such as *Apollo, Burlington Magazine,* and *Connoisseur.* In addition, auction houses issue publicity brochures or newsletters, annual summaries that detail some of the outstanding items sold, and catalogues of forthcoming sales. Both Christie's [18:1] and Sotheby's [18:2] publish annuals; these include all categories of art sold during the year, lavish illustrations, and essays by experts in different fields.

Prior to a sale the objects are examined and appraised by the auction house's experts, grouped with similar works of art, provided an estimated presale value, and advertised in catalogues of forthcoming sales. Available approximately one month prior to the auction, the sales catalogues may be purchased either individually or by annual subscription. After the auction takes place, a list of postsale prices may

be published; in libraries, this is attached to the sales catalogue. Until the early 1970s, Sotheby's and Christie's included buyers' names in their postsale price lists; this was especially beneficial for scholars tracing provenance.

The estimated 5,000 sales catalogs published annually cover all kinds of art, such as French furniture, pre-Renaissance paintings, prints, contemporary art, and Americana. They can be for one specific work of art, for an individual collection, or a number of items grouped together for the auction. As would be expected, they can be expensive. Only those libraries that need them, buy them. Because a curatorial staff, collectors, and dealers must have current knowledge of the art market, most museum libraries, as well as large public libraries, purchase sales catalogues in some categories. These catalogues are frequently shelved separately, organized by auction houses, subdivided by category, and chronologically arranged. The catalogues are not always entered into the library's catalogue system. Ask the reference librarian for assistance in finding this material.

Some auction houses have traditionally listed artists' names in a particular way to indicate the auctioneer's opinion as to the piece's authenticity or the degree of the artist's involvement with the work of art. If the complete given names and surname are provided, it means that the work of art is considered to be by that person. If surname and first initial are stated, the work of art, in the auctioneer's opinion, is of the appropriate period and might be wholly or partly the artist's work. When only the surname is printed, the art is thought to be of the school or by a follower or is in the artist's style. Some auction houses use the terms—*attributed, circle of, studio of, school of, manner of,* and *after*—to indicate this descending order of involvement. Although some sales terms are defined in Appendix E, it is prudent to check the definitions published in the sales catalogue.

The auction world uses abbreviations and terms of which the reader should be aware; for instance, a *hammer price* is the highest bid. The minimum price for which the owner is willing to sell the piece is called the *reserve price,* an amount which is always confidential, known only to the seller and auction house. If this monetary value is not met, the auction ceases rather than allow the object to be sold below the reserve. The price at which the auction was stopped is called a *Bought In* or *B.I.* price. *Vte.*—for *Vente*—means sale or selling; *Vte.*

X or *Vente X* indicates an anonymous sale or one where the auction was not limited to one individual collection.

Because of the importance of catalogues, certain ones have been reprinted. Some are actual reprints of the entire catalogue; some are photographs of the auction house files or pages from their catalogues. Access to most of these reprinted catalogues is by auction house and date of sale. For the London auction house of Sotheby's, there are microfilm reprints of the actual catalogues [18:2] from the first brochure of 1734 through those of 1970, a total of more than 15,000 sales catalogues. Organized chronologically, the catalogues are filmed from the auctioneers' copies, which usually include annotations of sales prices and buyers' names.

The New York art gallery, Knoedler [18:42], has reproduced its collection of sales catalogues from various international auction houses. This microfiche set covers 13,000 auctions in fourteen countries. Although the earliest catalogue dates from 1744, the strength of the collection is in late nineteenth- and early twentieth-century publications, especially those of France and the U.S. The Knoedler collection includes Christies's of London and Parke Bernet of New York, but not catalogues from Sotheby's of London. Many of the entries have added notes provided by the Knoedler staff who attended the auctions; sales prices and names of buyers are usually included.

A source for reprints of American sales catalogues published between 1785 and 1960 is The Archives of American Art [18:39], which has filmed about 15,000 of them. This material is available through interlibrary loans. There is no index to the collection. Therefore, researchers must write to request specific catalogues citing the numbers in Lancour's *American Art Auction Catalogues* [18:46], which is discussed below.

Christie's Pictorial Archive [18:41] is a microfiche publication of photographs from the auction house's files or pages from its catalogues. Under broad subject categories—such as Impressionist & Modern Art, Dutch and Flemish School, and New York 1977–1985—there are reproductions of works of art organized under artists' names. Although the first set indexed more than 5,000 artists, it deleted essential information concerning sales dates and prices. Later publications have included these items. Access is through individual artists.

In 1980, a database was formed to help researchers identify the vast number of auction catalogues that have been published. *SCIPIO* [18:48], acronym for *Sales Catalog Index Project Input Online,* is a cooperative project initiated by the Metropolitan Museum of Art, the Cleveland Museum of Art, and the Art Institute of Chicago. Later other libraries joined the project. Information taken from a catalogue's title page or cover is placed in the *SCIPIO Database.* Reported are the title, sale year and date, auction house, and collectors' names. The contents of the catalogue are not analyzed. *SCIPIO,* which is a union list of the holdings of the participating libraries, is a tool for locating specific catalogues which either (1) are devoted to particular subjects—such as Art Deco, the Hudson River School, or French landscape painting—or (2) provide information on collectors who have sold their works. Occasionally, *SCIPIO* can be used to locate material on individual artists, but their names must appear on the cover of the sales catalogues to be included in the database.

Two other valuable union lists are Frits Lugt's *Répertoire des catalogues de ventes* [18:47] and Harold Lancour's *American Art Auction Catalogues* [18:46]. The former provides an international chronology of auctions for all types of media—including paintings, drawings, miniatures, sculptures, tapestries, ceramics, and furniture. There are four volumes covering the period from 1600 to 1925. Lugt reports dates and locations of sales, names of collectors or owners, the contents of the sales, the auction houses, and the international libraries that have copies of the catalogues. Access is through collectors' names and dates of the sales. Lancour's *American Art Auction Catalogues 1785–1942* [18:46], which reports only American sales, is a union list for 150 institutions, which also has an index to collectors. In addition, a supplement to Lancour is available through the Archives of American Art. The numbers in Lugt and Lancour are frequently used for identification; both the Archives of American Art and *SCIPIO* utilize them. Additional sources for titles of auction catalogues are the catalogues of major libraries, such as those of the Metropolitan Museum [17:12], Harvard University [17:11], and Winterthur Museum [13:55]. These library catalogues often provide a subject approach to sales catalogues as well as access to collectors.

Indices to Sales Information

The long history of auctions is inadequately covered, but for more recent sales there are certain tools which provide limited access to this data. For works of art recently sold at auction, consult such works as *The Annual Art Sales Index* [18:7], *Gordon's Print Price Annual* [18:16], *Leonard's Index of Art Auctions* [18:10], and Mayer's *International Auction Records* [18:12]. Issued annually, these reference tools organize entries under artists' names. Although the different indices vary as to the types of information, they often include (1) titles, media, and dimensions; (2) whether or not the items were signed and dated; (3) auction houses plus sales dates and lot numbers; and (4) sales prices stated in the currencies of the countries where the auctions took place. Some indices include only sales of drawings and paintings or prints; others are more inclusive in their coverage.

Example 17, an entry for the 1985/86 *Art Sales Index* [18:7], illustrates the type of information recorded in these indices. Under Caillebotte's name, thirteen paintings are listed. The sales prices are reported in both English pounds and U.S. dollars. Given are the dates, abbreviations for the auction houses, and catalogue numbers; an *R* indicates color illustrations. Next comes titles, sizes in metric and English dimensions, media, and signature and date data. For instance, the last work, *Voiliers au mouillage sur la Seine a Argenteuil,* signed and dated in 1883, was sold on May 13, 1986 at Sotheby Parke Bernet in New York City. For a fuller explanation, researchers must obtain this specific catalogue. Not all indices to sales information will contain identical dimensions and monetary value for the same works of art. This is due to the rounding off of numbers, variations in the rates of exchange, and whether or not the auction house's commission is included in the sale price. Read the fine print to determine the methods used by each individual index.

Finding sales information on earlier auctions usually requires a little sleuthing. This data can frequently be located through resources listed in Chapter 18. For instance, Bénézit's *Dictionnaire critique et documentaire* [10:27], which reports only a few sales dates, lists the names of collectors but not auction houses. Under Caillebotte's name in Example 5, the *"Prix"* or price section lists *"Vte. Theodore Duret, ler mars, 1928: Sur le banc, 2,200 fr,"* meaning the Theodore Duret sale, March 1,

Example 17: *Art Sales Index.* Weybridge, Surrey, England: Art Sales Index, Ltd., 1986. Page 218.

1928, *Sur le banc* sold for 2,200 francs. By checking the chronologies in Lugt's *Répertoire des catalogues de ventes* [18:47], the correct auction house was located. The actual sales brochure— *Catalogue des Peintures: Aquarelles, Dessins, Gravures of the collection of Theodore Duret*— reported the size and signature data. The copy of the sales brochure was obtained from the Knoedler *Library Sales Catalogues* [18:42] and had an annotation that indicated the sale price and the purchaser.

For locating nineteenth-century sales information for paintings, there is the *Index of Paintings Sold in the British Isles During the Nineteenth Century* [18:29]. Also called the *Getty Provenance Index,* this extensive project will annually publish one volume covering a five year period; the first one covered 1801 through 1805. Because of the unrest caused by the 1789 French Revolution, England became the major art market. Thus the sales included in this scholarly project cover most of the major nineteenth-century European auctions. This is a detailed compilation with three sections: a chronological index of sales, an index to individual paintings listed under artists' names, and an index of owners and buyers. A database, not yet available to the public, is being formed with additional information, such as the painting's subject and, when known, its subsequent provenance.

Archival Material

Libraries are frequently depositories for original documents and records, personal diaries and letters, architectural drawings and plans, and sketchbooks, as well as ephemera. The main purpose of these archives is to conserve the material for posterity. But how to organize the material and provide access to it is a continuing problem. The word, archive, can be used to designate: (1) collections of

unique papers and letters relating to the past history of a person, family, firm, institution, or association; (2) any collection of original works of art, such as prints, etchings, and photographs; and (3) reproductions of original works of art in which the photograph is used for study purposes. At one time, archival material was defined as unpublished documents. But today, this is misleading, since some archival material has been published on microfiche and made available to the public. A differentiation is sometimes made between archives and manuscripts. The latter, which are frequently solicited or purchased by libraries, are usually single documents—letters, diaries, and personal papers. Both archival material and documents are usually located in a rare book room or a special archive department.

There are a number of types of special archives. Some preserve architectural drawings, such as The Archives of Frank Lloyd Wright at Taliesin West in Scottsdale, Arizona. Some architecture archives have been published, such as the Mies van der Rohe's drawings at the Museum of Modern Art [21:117.3]. The International Museum of Photography at George Eastman House in Rochester has an historical photographic archive. For American art, the most extensive collection is the Archives of American Art, discussed in Chapter 8. One of their publications, *The Card Catalogue of the Manuscript Collections* [13:61] provides access to individuals, such as Louise Nevelson who donated her correspondence and papers from 1922 through 1965. To locate archives in the U.S. and Canada, there are several directories available; they are annotated in Chapter 13.

Vertical Files and Scrapbooks
See Also Chapter 13

Libraries are the regular recipients of ephemera; some librarians save it, others do not. But the institutions that collect this material can prove to be storehouses of information. Vertical files—which may be organized by such subjects as artists, architectural monuments, and local museums and galleries—hold small pamphlets, usually under fifty pages, and are open-ended in that material can be added continually. Also included are clippings from local publications and such newspapers as the *New York Times*. Some museums use scrapbooks to keep the historical records of the institution.

Many libraries, especially in museum and public institutions, preserve vertical file material. Art schools often have extensive collections of illustrative material—on such subjects as depictions of animals, insects, automobiles, and costumes—to which artists refer for ideas. Fashion institutes maintain files on such topics as designers, business firms, and types of dress. These files are not entered into the library's catalogue system. Students usually hear about them through their professors and other students. Due to this lack of access, some organizations have compiled union lists of regional vertical file collections. In addition, some libraries have commenced writing entries for individual items within their files and adding them to the RLIN files. But this computer system, available at a limited number of libraries, is frequently restricted to the institution's staff.

Two U.S. libraries that have abundant material on international artists—the New York Public Library and MoMA—now have their vertical files or scrapbooks available on microfiche. The *New York Public Library: The Artists File* [13:71] contains ephemera for about 90,000 individuals: artists and designers, architects, collectors, historians, museum directors, dealers, and others associated with art. Artists from all geographic locations and historical periods are included. The earliest published material dates around 1895, but the bulk of the items are from the 1930s through the 1970s.

Artists Scrapbooks: Museum of Modern Art [13:69] consists of photographs of material from scrapbooks of forty-two major late nineteenth- and early twentieth-century artists. Moreover, a project is underway to publish MoMAs extensive vertical files that cover between 25,000 and 30,000 international contemporary artists. For those working on Canadian artists, there are extensive artists' files at the National Gallery of Canada Library [13:100]. Some of the material has been filmed and made available to other libraries.

Because local libraries tend to concentrate on regional topics, they usually are the best source for data concerning artists, architects, and monuments of a particular geographical area. These collections may include:

1. small, sometimes rare, brochures and magazines, usually less than twenty-five or thirty pages
2. articles clipped from local magazines and newspapers which are infrequently indexed

3. gallery and exhibition notices, invitations, reviews, and even entire small catalogues, usually under fifty pages
4. sales announcements and pages from auction catalogues
5. information on works in progress
6. obituaries
7. brief award notices
8. letters to and from artists
9. illustrations of works of art
10. old photographs of monuments
11. architectural blueprints
12. advertisements

Finding a pertinent vertical file on a specific artist, building, or monument can be a challenge. One way is to write the library where the artist lives or lived or where the building or monument was constructed. A few geographical areas have issued vertical file directories of these collections; one such publication is the bilingual *Directory of Vertical File Collections on Art and Architecture Represented by ARLIS M/O/Q* [13:101], compiled by members of Art Libraries Society/ North America of Montreal, Ottawa, and Quebec. Information is provided on the locations of the files, the types of documents, how the collections are organized, and the kinds of periodicals clipped. There are also indices to subjects and names.

Documents, Critics' Reviews, Interviews

In order to have a better understanding of art, researchers need to study (1) documentation of the period being studied, (2) the opinions of artists and critics, and (3) the writings or interviews by artists themselves. These can frequently be discovered by consulting:

1. one of the various books containing collections of artist's writings or critical reviews
2. one-person exhibition catalogues and monographs that occasionally reprint letters, diaries, significant correspondence, and reviews
3. video or audio tapes or discs that record interviews with artists and critics
4. newspaper and magazine articles
5. the material on deposit with the Archives of American Art

Throughout Chapters 11 and 12, there are lists of some works which have been compiled on the

first point. For instance, *Artists on Art: From the XIV to the XX Century* [11:12] provides quotations from over 140 artists. The works edited by Elizabeth G. Holt, such as *The Triumph of Art For the Public: The Emerging Role of Exhibitions and Critics* [12:105], and the individual volumes of the *Sources and Documents in the History of Art Series,* cited in the appropriate sections, are especially good references. *The Documents of 20th-Century Art Series* [12:151] publishes separate books which record specific artists' writings. In addition, there are indices for this material, such as Jack Robertson's *Twentieth-Century Artists on Art: An Index to Artists' Writings, Statements, and Interviews* [12:152], which covers about 5,000 artists.

Every now and then, an exhibition catalogue may reprint some archival material. An English translation of Caillebotte's will which provided for his Bequest to the French nation was included in *Gustave Caillebotte: A Retrospective Exhibition.* Eugene Delacroix's diary and Vincent Van Gogh's letters to his brother Theo have been translated and published. For local contemporary artists, some researchers conduct their own interviews. Sometimes these are taped and form part of an oral history program. Problems with this type of material are the quality of the taping, the importance of the questions, and the difficulty in locating and obtaining the tapes. One extensive project is the Video Data Bank at The School of the Art Institute of Chicago [26:51], which has numerous videos of interviews, performances, documentations, and experimental forums.

For current quotations by contemporary artists, an online search of newspaper databases is an efficient method, giving the fastest results. One of the most extensive collections of documents is The Archives of American Art, which collects primary and secondary research material on American painters, sculptors, and craftsmen. In addition, the Archives has an oral-history program of taped interviews. Most of the microfilmed material is available through an interlibrary loan. This vast collection is of prime importance to anyone studying an American artist; see "Archives" in Chapter 13.

Some letters and papers of artists are maintained in U.S. library archives. To locate them, check the *The National Union Catalog of Manuscript Collections* [13:67], which is published annually. It can also be used to locate architectural

drawings in archival collections. For efficient searching, use *Index to Personal Names in the National Union Catalog of Manuscript Collection 1959–1984* [13:68]. In addition, RLIN has an Archives and Manuscripts Control File which gives locations of manuscript collections; ask the reference librarian if this is available.

Visual Resources
Also See Chapter 19

Visual resources encompass a wide range of formats, such as slides, videotapes, photographs, microform collections, and some new technologies, such as videodiscs and digitized images. Although they have great potential, videodiscs and digitized images are not yet feasible for most art research. They are expensive, labor-intensive projects, and few libraries have adequate computer access and viewing machines for them. But by reading articles in *Visual Resources: An International Journal of Documentation,* students can keep informed of the latest developments in these technologies.

Some visual resources will be located in the institution's media center, others in the microform section. While still others, such as many slide libraries, are part of an art department and available only to faculty and, perhaps, graduate students. The challenge is to find exactly what is needed in the desired format with acceptable quality of color, clarity, and resolution. If the artist's name and the title of a work of art are known, the subject-indexing tools, discussed below, may help locate the institution owning the work. If a museum is the owner, researchers can then obtain its collection catalogue, if one exists, or write the institution for a reproduction and additional information. This sections discusses (1) slides, (2) videotapes, and (3) picture collections.

Slides

Good quality color slides of complete views as well as details of works of art are essential for teaching; they are also significant reference tools. Slides can be used to determine details and to compare more than one work of art. Many people take their own pictures; cameras, slide projectors, and screens are readily available. Slide libraries are usually arranged by media followed by some order of historical period, country, and artist. On the slides as well as in the card or computer file for the collection, information concerning titles and locations of works of art are usually recorded. In the file, other data may also be provided, such as dimensions and probable date of the work of art. Over the past decade, slide quality has improved. Even so, most European and American museums have been negligent in the number and caliber of slides that they sell to the public. Few of these institutions have even a small fraction of their collections available in this format.

Although there is usually no subject access other than broad art historical classifications for slide collections, several indices are now being compiled to provide this important dimension. For instance, Helene Roberts's *Iconographic Index to Old Testament Subjects Represented in Photographs and Slides of Paintings in the Visual Collections, Fine Arts Library, Harvard University* [19:37] can be used by researchers who do not have access to the slide collection at Harvard University. Roberts's book includes artists' names, painting titles, and usually the museums that own the works.

Videotapes

One technology that is becoming more valuable to researchers is the video documentary. Many researchers own video recorders; the technology is no problem. Video documentaries include visual interviews of artists, movies changed to this format, and documentaries adapted from television. The subjects run the gamut from prehistoric art to the contemporary period. The Video Data Bank Study Center at the School of the Art Institute of Chicago, for instance, has more than 200 programs listed in its *On Art and Artists* [26:51]. Moreover, a number of videos have been produced by museums for special exhibitions, such as "The Eighteenth Century Woman," made for the Metropolitan Museum of Art. This videotape illustrates how the French, English, and American fashions during that century were influenced by society. One measure of the acceptance of these documentaries is the fact that *Visual Resources: An International Journal of Documentation,* a publication of the Visual Resources Association, has regular video reviews.

Videos can provide unusual views and perspectives not available through other visual resources, such as (1) a sense of the scale and dimensions of a work, (2) overall views of three dimensional works which are difficult to achieve in still photography,

(3) how a costume moves with the body, and (4) a person's mannerisms and speaking voice. Many video cassettes can be rented; some are shown on public broadcasting or cable stations. Since they are being produced at a rapid rate, only a sampling of available video documentaries are cited under the appropriate chapters of this guide. For locating other videos, see Chapter 26. Do not forget to utilize these significance research tools.

Picture Collections

A picture collection, also called a picture archive or study collection, contains various types of reproductions of fine art. Any photograph—small or large, black and white or color, good or bad—may be saved. Collected from magazines, museum and sales catalogues, and, sometimes, books, they are (1) mounted and identified insofar as possible, (2) placed in vertical files or archival boxes, and (3) arranged according to media, geographic location, subjects, periods of time, and/or artists or designers. Often located in a separate visual-resource department, some include art in all media; others, specific disciplines. Indices for artists' names, Christian iconography, topography, mythology, secular subjects, and portraits are sometimes compiled; for a few, computer indexing projects are being developed.

For European and American paintings, there are several outstanding picture collections, such as the National Gallery of Art, The J. Paul Getty Center for the History of Art & The Humanities, The Frick Art Reference Library, The Witt Library, and the Rijksbureau voor Kunsthistorische Documentatie. The extensiveness of these collections is illustrated by the National Gallery of Art, which has approximately 1,194,000 photographs of Western European and American paintings and drawings, architecture, and sculpture. There are other collections that cover only art from a particular country—such as the Yale Center for British Art and the National Museum of American Art—or a specific type of art, such as the National Portrait Gallery.

Some study collections, which have been reproduced on microfiche, are extensive, such as the *Marburger Index: Photographic Documentation of Art in Germany* [19:7] and its supplements, which consists of about 930,000 black-and-white photographs, taken between 1850 and 1976, illustrating architecture, painting, sculpture, and arts and crafts from the classical to modern times. This is a photographic collection of German art as well as art from other countries owned by German institutions. Arranged topographically according to geographic site, most monuments have numerous views; for example, one Gothic reliquary has more than sixty-five details. There were hundreds of photographs for the city of Frankfurt-Am-Main: ancient city maps, views of the city's many buildings and churches, and individual paintings and sculpture in the collections of the various art museums. In addition, this microfiche collection has indices for artists, portraits, topography, and subjects organized by *Iconclass* [19:14], which is discussed below.

Microfiche picture collections have both assets and liabilities. Because some of the photographs were taken in the late nineteenth or early twentieth century, monuments and objects that no longer exist or have been altered extensively can still be studied. Each photograph is usually dated, thus making it possible to compare buildings or works of art as they appeared prior to wars or natural disasters as well as to view monuments which have since been destroyed. Moreover, copies of individual photographs in some published versions may be purchased through the institution. Often issued over a number of years, the microform sets have the advantage of rarely going out of print. But their greatest asset is the large body of images which are reproduced. No book publication could ever come close to this tremendous number.

On the debit side, the visual quality varies greatly, from excellent to poor. In some, the typed text is difficult to read; in others, the illustrations are too dark to distinguish details. Furthermore, pertinent research data may have been excluded, such as the exact measurements or sales dates. And as in many visual resources, a work's scale may be difficult, if not impossible, to determine. Remember, too, that artists' attributions may represent nineteenth-century scholarship and connoisseurship, which may have changed. Microfiche sets published over a period of years are not always interfiled, necessitating looking in different places for the information. Entries may be on the next fiche but not so indicated. Moreover, unfamiliar abbreviations and idioms are often a problem.

The language of the indices will be that of the country which owns the picture collection. For instance, the term, chastity, would be *Pudicizia* in

Alinari Photo Archive [19:1] and *Keuschheit* in the *Marburger Index* [19:7]. To circumvent the linguistic problem, some indices utilize *Iconclass* [19:14], a classification system described below. In some collections, works are organized by typography, requiring researchers to know the geography of the area. Nor are photocopies made from this media always satisfactory. But because they conserve material, store it in a compact space, and make it available to a larger audience, microforms are here to stay.

Because of their expense, few libraries will have extensive holdings of these important art research tools. Write or call prior to making a trip to distant institutions. Since microforms are not always cited individually in the library's inventory catalogue system, request information from the art reference librarian. Picture collections can be used to:

1. study reproductions of an artist's work
2. observe details of monuments and works of art
3. locate works of art which are reproduced nowhere else
4. investigate how a building, monument, or even painting may have changed over time
5. find sales and exhibition information
6. compare works of art on a particular subject done by various artists or during certain periods
7. browse for ideas
8. discover works of art owned by specific museums

Subject Indexing Projects

Most picture collections are accessed by specific geographic locations or by individual artists, in a linear method by which researchers must check the city or artist and then look at every image until the desired object is located. For efficient searching, detailed analytical subject-indexing is needed. Although this is labor-intensive, expensive work, some librarians are developing such indices. A few projects are computerized, thus allowing questions, which formerly would have consumed a prodigious amount of time, to be answered. For instance, how many sixteenth-century paintings depict the Dutch landscape around Utrecht? Who are the artists? Which paintings contain windmills? Most computer projects can presently be used only at the institution developing the program, but in time this may change, making them more accessible to researchers.

Because of the wealth of material in the extensive picture collections that have been published on microfiche, many of the computer projects are centered around them. One problem encountered was that each foreign-language reference utilized its own vernacular, and since few students and scholars are proficient in many languages, using these tools was difficult. One solution is afforded by the international classification system, *Iconclass,* which provides numbers for complex ideas that would otherwise require a lengthy text. Because it utilizes letters and Arabic numbers, it is language neutral and presents few translation difficulties. *Iconclass* [19:14] is a method for organizing highly divergent material into nine main divisions: (1) religion and magic, (2) nature, (3) man, (4) society, (5) abstract ideas or concepts, (6) history, (7) the Bible, (8) literary subjects, and (9) classical mythology and antiquities. These are then subdivided into detailed headings. For instance, the mythological love story between Paris and Helen has been assigned the number *94 C 1* with various scenes within the story adding numbers to that stem. For example, the Judgement of Paris is indicated by *94 C 11 3;* the dream of Paris, *94 C 11 32;* and the abduction of Helen, *94 C 13 3.* By checking the subject indices of some photographic archives, such as the *Marburger Index* [19:7], researchers will find reproductions of works of art that pinpoint aspects of the life of Paris. Because *Iconclass* outlines a subject by providing numbers for the topic's various scenes and depictions, it can be used to give direction to the organization of subject material. Moreover, this publication has an additional subject approach to the literature in its list of articles and books that discuss the various themes. For a detailed discussion on *Iconclass,* see 19:14

Because scholars of Renaissance art need to determine which antique objects were known at what time, the Warburg Library [19:15] has undertaken a census of classical art studied by artists between 1400 and mid-sixteenth century. Utilizing and augmenting the photograph collection at the Warburg Institute, the Census is based upon specifically known works of art. The computer database includes information found in a catalogue raisonné as well as additional documentation—such as the state of the object during the Renaissance and the reasons it was known. In 1981 the project scope was increased to include architecture from the photograph collections at the Bibliotheca Hertziana and

extended in time to mid-sixteenth century. Presently, there are about 12,000 photographs in Rome and the same number in London. It is estimated that there will be about 30,000 by the time the computer project is finished. Phyllis Bober and Ruth Rubinstein's *Renaissance Artists and Antique Sculpture* [12:9], which includes 200 ancient sculptures, is based upon the Warburg Census.

There are a number of major picture collections organized by artists, but the most extensive is The Witt Library of London's Courtauld Institute of Art. Paintings, drawings, and graphics of all European and American schools are collected. About 65,000 artists who lived from the thirteenth century to the present are represented. Acquired from many sources—exhibition, museum, and sales catalogues; articles; original photographs—they are mounted and filed in boxes under the artist's name. The boxes are then organized by schools of art. Each year, approximately 40,000 illustrations are added. Most new reproductions are for works by artists not previously represented in the collection, especially nineteenth- and twentieth-century artists. The filing of entries from sales catalogues receives top priority, but no verification of the material is made. Even though not all of the photographs are clear, dated, labeled correctly, or authenticated, this collection provides researchers with an enormous amount of visual material on one artist.

A microfiche photocopy of this collection was begun in 1978 and finished in 1981. The *Witt Library Photo Collection* [19:13] comprises more than 1,200,000 separate photographs and reproductions of some 50,000 artists. Copies are owned by several libraries: National Gallery, Washington, D.C.; J. Paul Getty Museum, Malibu; Frick Art Reference Library, New York City; National Gallery of Canada, Ottawa; and Yale Center for British Art, New Haven, which has only the British School.

A Checklist of Painters c. 1200–1976 Represented in the Witt Library, Courtauld Institute of Art [19:13] is available in many libraries as a guide to the artists represented in the microfiche publication.

A subject-indexing computer project has recently been devised for this collection. The pilot program, which indexed paintings from the American School, was finished in 1989. The British School is now being indexed. For each illustration, there is an individual computer record that reports, from the information on the reproduction, the data that a catalogue raisonné would include. The work of art is then coded for subject matter using *Iconclass* [19:14]. If there is more than one iconographical interpretation for the work of art, all are included. There is no limit for subject classifications; all recognizable details are recorded.

The extensiveness of the program can be illustrated by the *Iconclass* number for architectural representations: *48 C 14*. For John Singer Sargent's *Orange Trees,* a painting of the Villa Bonfils, the subject classification was *48 C 14 (Villa Bonfils) 1,* where the last number means that the painting is an exterior view. Each illustration, even if similar to others in the file, is provided a separate record. Detailed documentation is provided for each American work of art represented in the Witt collection. Scholars can ask the computer to locate all paintings with various combinations, such as works depicting orange trees, the Villa Bonfils, the exterior of a building, or a combination of all of these terms. Presently, it is not known exactly how the index will be made available to scholars. It is hoped that libraries owning the *Witt Library Photo Collection on Microfiche* [19:13] would also have a copy of its computer index. The research possibilities are formidable.

Research on Individual Works of Art

The end product of an artistic endeavor is an individual object. Works of art may be discussed in a number of different ways: (1) intrinsic or mainly derived from observing the object and (2) extrinsic necessitating gleaning from outside sources data which explains or clarifies the work. Intrinsic methods are concerned with discussions of materials and techniques, the work's physical condition and style, formal analysis of elements and composition, and subject matter. Extrinsic studies require additional information, including such items as the artist's biography, critics' reviews, the work's historical context, patronage, and iconology.

Students new to this approach should read the essay on "Historiography"—a term that means the methods by which the discipline of art history has been approached, the theories and techniques used for critical examination and evaluation of art objects—in the *Encyclopedia of World Art* [10:2]. References annotated in Chapter 28 under "Analysis of Works of Art" should also be consulted. Another excellent source, W. Eugene Kleinbauer's *Modern Perspectives in Western Art History* [11:29] provides essays by famous scholars that illustrate different ways in which art has been analyzed and discussed.

When researching a specific work of art, several steps might be considered: (1) viewing the original object and locating reproductions of it, especially details; (2) analyzing its form and style; (3) compiling a catalogue entry for it; (4) studying its subject matter and symbolism; (5) estimating its monetary value; and (6) investigating various influences—artistic, literary, religious, theatrical, historical, geographical, and scientific—that might have affected it. Except for the study of subjects and symbols, which is treated separately in the next chapter, this section discusses these concerns for all kinds of art except architecture, which is detailed in Chapter 9.

Reproductions of Works of Art

Artists, researchers, and critics need to look at great quantities of art in order to study and analyze it. There is no substitute for personally examining this primary data. The original object provides spectators with information that can be gathered no other way. Only by seeing the work *in situ*—in the place for which it was planned—can the effect of the surroundings, the work's scale, the patina of a bronze, the color-tone of an original photograph, or the artist's handling of the medium be discerned. Unfortunately, most art is no longer *in situ,* and if it is, the environment has been altered. In addition, many works of art are:

1. located in museums which are difficult and expensive to visit
2. owned by private collectors and not available to the public
3. no longer in existence, because they have been destroyed by wars, fires, or other catastrophes
4. lost or stolen with no clues as to what happened.

In spite of these difficulties, researchers must make every effort to study the original work of art.

Even if researchers were personally able to view all of the art they need to examine, reproductions would still be needed for detailed and comparative studies. There are five main ways of obtaining this essential visual material:

1. visiting the place where the work of art is located and photographing it
2. purchasing what the owner of the object offers in the way of photographs, slides, or postcards
3. consulting publications that illustrate the collections
4. studying the picture collections that some museums and libraries maintain or which have been published and sold to other institutions
5. locating a reproduction in a published work, such as a catalogue raisonné, book, article, or exhibition or sales catalogue

Acquiring visual material requires time; begin early in the research process to locate and obtain it.

The first method cited above allows the actual object to be studied, but may not be practical. For instance, because many of Caillebotte's paintings

are in private European collections, a visit to see each of them would be impractical, if not impossible. There is also the problem that most owners do not allow photographing of their works of art.

Museum bookstores usually sell color reproductions, in the form of either 35 mm. slides or postcards, of the most popular objects in the collection. Unfortunately, not all museum administrators have accepted the responsibility for ensuring that scholars and students have adequate visual materials of the art works in their collections. Few institutions offer the variety of good slides that the National Gallery, London, does. Due not only to the inadequate supply but to the poor quality of many color reproductions, some scholars prefer the black-and-white glossy photographs that institutions sell through the registrar's office. Obtaining them entails a considerable amount of time: inquiring as to what is available, negotiating the sale, and receiving the desired illustration. Moreover, foreign museums usually require payment in their currency. Although large metropolitan banks have an International Department which will supply a bank draft in most currencies, there is a service fee. Remember too that buying the photograph does not include the right to publish it. In order to reproduce it in an article or book, written permission must be obtained from the owners of both the art depicted and the photograph.

Museum publications, discussed in Chapter 3, are prime sources for illustrations of the masterpieces of a museum's collection. If no collection catalogue exists, any well-illustrated book on the institution should be located. Tremendous aids in locating works by specific artists are the indices to museum collections in specific countries, annotated in Chapter 19. For instance, *Paintings in Dutch Museums* [19:34] has a citation for Caillebotte's *Pool in a Wood* at the Stedelijk Museum in Gouda. *Paintings in German Museums* [19:35] records his *Bootshafen bei Argenteuil* at the Kunsthalle in Bremen.

The picture collections, discussed in Chapter 5, have extensive reproductions of art works. Some collections are owned by special libraries which researchers must visit. Other collections have been reproduced on microfiche and are available at a number of art centers. Some published collections also have a printed index. For instance, *A Checklist of Painters c. 1200–1976* [19:13], which may be in the researcher's library, indexes the more than 50,000 European and American artists in the *Witt Library Photo Collection on Microfiche*. Check this book prior to making a trip to a library which owns the microfiche set.

Some references for locating reproductions of works of art in books and periodicals, such as Patricia Havlice's *World Painting Index* and its supplement [19:27], were published a decade or more ago. They frequently index reproductions which researchers may not be able to obtain or which are not prime quality. But because they include lesser-known artists and sometimes provide broad subject access, these indices are still useful.

These references that index illustrations in specific books and articles require two steps: discovering where the work of art is reproduced and then finding the book or article that has the illustration. Although some works were published many years ago and index material that either may be difficult to obtain or may have inferior reproductions, they sometimes report important illustrations.

Other sources for this research are the major art indices. For instance, under "Reproductions," *Art Index* [16:1] provides titles of works of art. *RILA* [16:7], which includes the titles of reproductions within the abstracts, does not record a date for the work but often reports its present location. Because the artist and title of the work can be linked, database searches are the most efficient method for locating articles and books that reproduce specific works of art. For instance, in a search for Caillebotte's *On the Europe Bridge* in *Arts & Humanities Citation Index Database* [16:59], there were three entries for this specific work: one called it by its present name, two by its former title, *Pont de L'Europe*.

Form and Style of Works of Art

An individual work of art can be analyzed by (1) its elements—such as line, shape, contrast, and color—and their organization, which creates balance, rhythm, proportion, and unity, and (2) the artistic style which the piece may display. There are several widely used texts that will assist students in learning about art elements and methods for analyzing a work's form. Many of the books—such as Gilbert and McCarter's *Living with Art* [28:3] and Feldman's *Varieties of Visual Experience* [28:2]—are used in college courses.

Stylistic terms—such as Expressionism, Realism, and Minimalism—are words that are applied to groups of art works in order that objects can be classified. Scholars are not always in total agreement as to the exact definition of stylistic terms, much less the objects which should be included within a classification or the dates when a style begins and ends. Defining a specific style is made even harder by the many nuances and variations within it. There is also the problem of an artist's individual style. Moreover, all works of art in an artist's œuvre are not necessarily in one specific style, nor are all works of art easily classified. An innovative work may be predominantly of one style and yet possess the seeds of a later one. Since art historians and critics do not agree on specific definitions, students frequently have trouble understanding artistic styles.

Although the classification of styles is complex, there are several reference works which will help students in understanding the different periods and styles:

1. art history surveys and textbooks usually provide overviews of styles with numerous examples and illustrations, glossaries, sometimes chronologies, and extensive bibliographies
2. the *Encyclopedia of World Art* [10:2] and its two supplements include discussions of recent research and lengthy bibliographies
3. the series—"The State of Research" published in *Art Bulletin,* is written for scholars and is more detailed
4. specialized serials that cover the particular style

By perusing the various serials that cover the particular art style or period, students can learn a great deal about the subject. Although the articles may be essays on individual works, the illustrative material, informative texts, and scholarly footnotes will be invaluable. Unless otherwise noted, these types of references are listed under the style or culture to which they pertain in Chapters 11 through 14.

One professional who must have an in-depth knowledge of how to analyze the form and style of objects is the connoisseur. To be an authority in the authentication of works of art, this person must be concerned with materials and techniques—the way the medium is handled and the details that might indicate the hand of a specific artist. Although technology has proved a wonderful asset, experts must still know how objects look and feel. Connoisseurship is the ability to judge an object as well as the time period and the country in which it was made and the probable artist who executed it. This demands a thorough knowledge of media, artistic and individual styles and techniques, plus a fine aesthetic sense. Years of studying and experience are required. Although no book can teach this process, there are several references which will provide a better understanding of it, such as B.B. Berenson's *Rudiments of Connoisseurship* [11:18]; most of these books are annotated in Chapter 28, under "Analysis of Works of Art."

Catalogue Entries

Whether a work of art is studied *in situ* or from a reproduction, researchers will need additional information concerning it. For instance, the size and medium must be ascertained. The best method for organizing this essential data is to compile a catalogue entry, which may vary from a few facts on the physical aspects of the piece to a scholarly citation. Chapter 3 provides definitions of museum and exhibition catalogues; Appendix E, some terminology.

In compiling a catalogue entry, the researcher should record all of the pertinent data that can be found concerning the object. This information includes:

1. artist's name and dates
2. title of the piece
3. approximate date it was made
4. medium
5. dimensions
6. specific data on the object, such as signature and date information, casting mark, or watermark
7. condition of work, if known or unusual
8. present location and, where applicable, acquisition number
9. provenance
10. various exhibitions in which it has been displayed
11. literary references which discuss the piece
12. related works of art, such as studies or sketches, engravings, or graphics
13. additional pertinent information
14. an illustration

Not all fourteen categories will be used for every work of art; for instance, some pieces have never been displayed in an exhibition. Furthermore, because a catalogue entry is a compilation of known information, the entry will never be absolutely complete. As more data are uncovered, the catalogue entry will change. Example 19 at the end of this chapter is a catalogue entry for Caillebotte's *On the Europe Bridge.*

In order to complete the first category—the artist's name and dates—biographical dictionaries should be consulted, since these references will help sort out names and nicknames as well as establish the artist's dates. For monograms or hallmarks, the facsimiles of designations should be studied; see Chapter 10 for a list of resource tools. If the artist or artisan cannot be determined, information on any style or school whose presence or influence is discerned in the work of art should be included.

Discovering the correct title, the second category, may be a challenge, because (1) the work may have no definite name or (2) the title may have been altered, modified, or translated. Many art works have no official titles, but are known by descriptive terms, such as *Ibex Handle, Greek Amphora with the Death of Orpheus,* and *Egyptian King Amenhotep III.* Obviously, descriptions are easily altered. Even if a work of art has received an official title, it may have been changed. Owners of art objects, remember, have the right to name and rename any of the works they own. For instance, Caillebotte's painting at The Art Institute of Chicago has had numerous titles: *Paris, A Rainy Day; Rue de Paris, temps de pluie; Umbrellas in the Place de l'Europe;* and *Place de l'Europe on a Rainy Day.*

Another problem is that the title of the work of art may have been translated into the language used by the reference work which is being studied. For instance, in Bénézit's *Dictionnaire critique et documentaire* [10:27], all titles are in French; in *Kindlers Malerei Lexikon* [10:39], in German. A still-life painting owned by a museum in Germany would be called *Stilleben;* in France, *Nature Morte;* and in Italy, *Natura Morta.* Care must be taken to try to record the correct title. The name in a museum catalogue will usually be in the language of that country and should be so listed. Nevertheless, frequently the title by which a work has been known will be retained by a new collector.

For most catalogue information, the work's owner must be ascertained. The institution or person who possesses the work can often be discovered through:

1. biographical dictionaries
2. catalogues raisonnés or *œuvres* catalogues
3. indices of periodical literature
4. indices to reproductions of works of art
5. exhibition, museum, and sales catalogues

Once the owner is known, the catalogue of the institution or private collector that owns the object should be consulted. Unfortunately, few museums have published scholarly catalogues for their entire collections. Details concerning the work might also be located in one of the series of books that have been published on art collections of famous museums, such as the *Newsweek Great Museums of the World Series* [15:7] and the *World of Art Library Galleries Series* [15:8]. Although not official museum catalogues, these books are usually well illustrated and contain scholarly data.

If the information can not be located or needs corroboration, a letter requesting assistance can be written to the registrar, who will often send a photocopy of data recorded in the museum's files. Any knowledge regarding the price or monetary value, however, is always withheld. One exception is the Wallace Collection, London, whose catalogue entries often report the prices for which some of the objects in the collection were purchased. For addresses of museums, see the latest edition of the American Association of Museum's *Official Directory of Museums* [20:34], *American Art Directory* [20:1], *The World of Learning* [20:42], or *International Directory of Arts* [20:39].

The information needed for the next six categories must come from the owner, for the work of art must be inspected and measured. These facts include date, medium, size, data on piece, condition of work, and acquisition number. The date is sometimes signed on the work of art. If not, the compiler may have to research this question by using the same resource tools utilized in compiling a chronology of the artist. If the exact date is not known, an approximation or range of dates should be provided. This is often preceded by a *c.* for *circa* which means *about.*

The medium of an art object should be defined as accurately as possible; for instance, a fresco should have a specific designation, such as *buono fresco* or *fresco secco*. In English-language catalogues, dimensions are reported in both centimeters and inches; otherwise, only the metric system is used. Most measurements are written with the height of the object preceding the width. Moreover, the overall measurements of the actual painting are usually recorded. For information on measuring works of art, see *Museum Registration Methods* [28:41]; for metric conversion, Appendix E.

Any data on the work can prove to be of the utmost importance. A signature designation can be used to ascertain both the authenticity and the probable date of an object. For example, the *Royal Museum of Fine Arts Catalogue of Old Foreign Paintings* (Statens Museum for Kunst, Copenhagen, 1951) reproduces a number of signature facsimilies. The three illustrations of Ferdinand Bol's signature reveal how the seventeenth-century Dutch painter changed his handwriting, as well as the actual way he signed his name, during the period from 1644 to 1669. He signed his name *F.Bol-fecit* in 1644, *Bol* in 1656, and *Bol fecit* in 1669. Sometimes used in artist's signatures, *Fecit* is Latin for "he or she made it."

If there is a signature on a particular work that the researcher would like to compare with other known signatures by the artist, the following references may be of assistance:

1. Jackson's *Concise Dictionary of Artists' Signatures* [10:79]
2. biographical dictionaries such as, *Kindlers Malerei Lexikon* [10:39] and Bénézit's *Dictionnaire critique et documentaire* [10:27]
3. books on monograms, such as Nagler's *Die Monogrammisten* [10:81] and Goldstein's *Monogramm Lexikon* [10:78]
4. scholarly catalogues of such museums as the Frick Collection, New York City; the Rijksmuseum, Amsterdam; the Statens Museum for Kunst, Copenhagen; the Bayerische Staatsgemaldesammlungen, Munich; and the Hamburger Kunshalle, Hamburg

Specific data found on the object obviously varies with the form of art. For instance, in the case of a piece of metal-cast sculpture, this might include the name of the casting firm or founder's mark plus the number and size of the edition. An important inclusion for drawings or prints is whether or not the paper contains a watermark. Impressed or incorporated into sheets of paper at the time of their manufacture, *watermarks* are used to designate their makers or manufacturers. This kind of design or pattern first began to appear in Europe around the end of the thirteenth century. Due to their distinctive characteristics, watermarks help determine locations and approximate dates of works of art; see Chapter 22.

The work's physical condition should be included in the catalogue entry, especially if it has recently been cleaned, damaged, or restored. The technical bulletins which a few institutions publish can provide essential data for understanding certain works of art. For instance, the 1983 London's *National Gallery Technical Bulletin* discusses four of the museum's paintings, among which is Edouard Manet's *The Waitress*. With the scientific analysis of this work in relationship to Manet's *Au Cafe* (Oskar Reinhart Collection, 'Am Romerholz', Winterthur, Switzerland) and *La Serveuse de Bocks* (Musée d'Orsay, Paris), the scholars were able to determine which works had been altered as well as how and where. Although few works of art have been scientifically analyzed, researchers must be cognizant of those that have.

The present location or owner should also be included in the catalogue entry. The acquisition number is the one the owner gave to the object upon receiving it into the collection. As illustrated in Example 19, Caillebotte's painting has an acquisition number of AP82.1, indicating that it was the first item received for the museum's collection by the registrar of the Kimbell Art Museum in 1982.

The ninth category, the work's provenance, requires tracing the movements of the piece from the time it left the artist's studio to its present location. In collecting data on changes of ownership and auctions in which it might have figured, researchers are able to obtain information that will assist them in determining authenticity and attribution. But the provenance of a work of art is often elusive, and may be impossible to establish. The following should be investigated: (1) auction catalogues and indices that cover them; (2) any existing catalogues, inventories, or lists of collections; and (3) artists vertical files, which might include sales information. All are discussed in Chapter 5. Establishing provenance is sometimes made more difficult, because it is hard to decide whether or not various references to a work are one and the same.

The titles and dimensions can be confusing. For instance, depending upon the translation and conversion of dimensions, the following may all be the same painting: (1) *Paysage,* 2.7 m. × 3.7 m.; (2) *Die Landschaft,* 273.5 cm. × 365.8 cm.; (3) *Paesaggio,* 3 m. × 4 m.; and (4) *Landscape,* 9 ft. × 12 ft.

One of the best methods for discovering provenance is to investigate the sales in which the work of art might have figured. If it was sold at a public auction, there may be a sales catalogue that indicates the seller and, in some instances, the buyer. The indices of auction sales, listed in Chapter 18, should be used. An outstanding example is the *Index of Paintings Sold in the British Isles During the Nineteenth Century* [18:29]. This ambitious publication project contains detailed analyses of paintings sold in Britain. But for other years and media, additional resources must be used. And because each sales catalogue covers somewhat different auction houses and various kinds of art, several may need to be studied.

If a past owner of the piece is known, a search can be made for (1) auctions at which the collector might have sold works of art and (2) any inventories or listings that may have been made of the collection. By checking for the collectors' name in such resources as the *SCIPIO Database* [18:48], Lugt's *Répertoire des catalogues de ventes* [18:47], and Lancour's *American Art Auction Catalogues* [18:46], a sale of the collection may be discovered. These union lists report institutions that own the individual auction catalogue, which must then be studied. If the auction catalogue has the names of buyers and previous owners, the steps can be repeated to find other former collectors who owned that specific work of art. It is only by careful research and a lot of elbow grease that, little by little, a provenance can be established.

Finding an inventory or listing of a private collection, if one was compiled, can be difficult, if not impossible. Often a source for establishing the existence of such archival material is in other scholar's bibliographies or footnotes. For example, Francis Haskell's *Patrons and Painters* [12:65] has references for inventories of art collections in Baroque Italy. Susan Foster's "Paintings and Other Works of Art in Sixteenth-Century English Inventories" [15:9] provides data for that particular period. Listings of private collections are elusive materials; they are laborious to find. Inquiries may need to be made as to whether or not one of the major art-research centers—such as the National Gallery of Art, the Metropolitan Museum, and the J. Paul Getty—have such inventories, if indeed, they do exist.

Some collectors have marked or impressed their personal seals or stamps on the edges or margins of the works of art they possess. The mark of a well-known collector may provide a means of tracing an object's provenance, since there are references that help in identifying designations, such as Frits Lugt's *Les marques de collections de dessins et d'estampes* [10:80]. In addition, investigating a family crest or coat of arms found on the object might provide a valuable lead to its past ownership.

The tenth section of a catalogue entry lists all of the exhibitions, accompanied by the location and dates of the shows, in which the object has been displayed. The entries usually are placed in chronological, rather than alphabetical, order to facilitate adding names of later exhibitions in which the item might appear. If the exhibition catalogue had no illustration of the work, there may be difficulty in deciding whether or not a work of art is the same object as the one being researched. This is due to variations in titles caused by translated titles, changes in the titles by different owners, and the use of generic titles, such as *Madonna and Child.*

It is not easy to establish the exhibition record for a work of art. First a notation that it was displayed in a specific exhibition needs to be discovered, then the catalogue has to be consulted in order to verify the citation. Some of the resources available for this type of research are (1) *Worldwide Art Catalogue Bulletins* [15:13] and *Art Exhibition Catalogs Subject Index* [15:12] (2) indices to periodical literature, (3) vertical files and scrapbooks, and (4) indices to past exhibitions. The first two are discussed in Chapter 3, the third in Chapter 5; for more information consult those sections.

Past exhibitions can often be discovered through the references annotated in Chapter 15 under "Indices to Past Exhibitions." Most of these works provide data on artists who displayed works in famous exhibitions, such as The Royal Academy, The Royal Society of British Artists, The Academy of Fine Arts, The National Academy of Design, and The Pennsylvania Academy of Fine Arts. For British exhibitions the indices compiled by Algernon Graves are valuable but not always accurate. For instance, his *Dictionary of Artists* [15:16], directs researchers to individual exhibitions but does not cite specific titles of works of art. In this

book, Graves reports that Augustus Leopold Egg, R.A., exhibited from 1837 to 1860: twenty-eight times at the Royal Academy, nine at the British Institution, and nine at the Suffolk Street Exhibitions. In his *Royal Academy of Arts* [15:18], Graves states that Egg exhibited in twenty shows, a figure that does not correspond to the number cited in his *Dictionary of Artists.* It must be remembered that this is secondary material, not primary data. In order to ascertain the exact number and titles of the works, the individual exhibition catalogues must be located and studied.

The Royal Academy of Arts presently holds two exhibitions annually. The Winter Exhibition is a special show of various kinds of art. For instance, in 1962, the show was Primitives to Picasso; in 1987/88, the Age of Chivalry. During the Summer Exhibitions, the Royal Academy academicians display their art. It is the academician exhibitions that concerned Graves. In addition to the official exhibition catalogues, there are other important references which will assist researchers studying British art. *Royal Academy Illustrated,* which began publication in 1884, and *Academy Notes,* published between 1875 and 1902, reproduce illustrations for some of the displayed works. Other sources for exhibitions are the critical reviews published in such serials as *The Magazine of Art* and the two-volume illustrated exhibition catalogue, *Royal Academy of Arts Bicentennial Exhibition 1768–1968,* compiled by St. John Gore in 1968. For documentation of American exhibitions, see Chapter 15. But not all major exhibitions have been provided this type of analytical indexing. Information on the Paris Salons and the numerous exhibitions of the various French independent artists groups of the nineteenth century have yet to be published in a similar form.

Once a reference to a specific exhibition catalogue is discovered, the original catalogue or a copy of it must be obtained to verify the information. Remember not all published reports are true. Checking and corroborating data are an integral part of all research. A few libraries have extensive holdings of original exhibition catalogues, with complete or near complete runs, of the various French, English, and American academies and societies. This is not true of most libraries. Fortunately, the reprints of earlier exhibition catalogues, often on microforms, have made them available to a greater audience.

CAILLEBOTTE (Gustave)
31, boulevard Haussmann.

7 — Canotiers.

8 — Partie de bateau.

9 — Périssoires.

10 — Périssoires.

11 — Vue de toits.
 Appartient à M. A. C...

12 — Vue de toits. (Effet de neige.)
 Appartient à M. K...

13 — Canotier ramenant sa périssoire.

14 — Rue Halévy, vue d'un sixième étage.
 Appartient à M. H...

15 — Portrait de M. F...

16 — Portrait de M. G...

17 — Portrait de M. D...

18 — Portrait de M. E. D...

19 — Portrait de M. R...

20 — Portrait de Mme C...

Example 18: Catalogue de la 4me exposition de peinture, **1879.** Livret of the Fourth Impressionist Exhibition. *Impressionist Group Exhibitions,* Garland Publishing, Inc., 1981, page 6.

Not all data collected on Caillebotte stated that he had exhibited at the same specific Impressionist exhibitions. One art museum catalogue reported that he had participated in all except the second and last. This conflicted with other references. By actually studying the *livrets* or pamphlets of the eight Impressionist Exhibitions, it was evident that Caillebotte displayed his work in all but the first, sixth, and eighth. Example 18 of the fourth exhibition in 1879 illustrates the type of information which can be extracted from older catalogues: artists' addresses, titles and dates of works, sometimes names of owners, and subjects of portraits. By examining Example 18, readers can understand why it is often impossible for scholars to provide positive identification for displayed works. Because photography was not yet an integral part of an exhibition catalogue and because the titles are often ambiguous, the researcher's job can be extremely difficult. For instance, notice there are two paintings

entitled *Perissoires.* Moreover, the names of the persons whose portraits were painted are identified only by initials. In *Portrait de M. F . . . ,* the M stands for Monsieur. All that is revealed concerning the painting is that the sitter was a Mr. F. The meaning of "Appartient a M. A. C." is that the painting, *Vue de toits,* belonged to Mr. A. C. The initials can sometimes be used to trace the ownership of works of art.

Bibliographic references to literature in which the object is discussed is the eleventh category in a catalogue entry. Discretion must be used in formulating such a list, since some famous works may be mentioned in almost all general art history books. For instance, Edouard Manet's *Le déjeuner sur l'herbe* has been the subject of so many discussions that a definitive list of literary references would be so extensive as to be meaningless. The catalogue entry should list only the literary references that are historically important or that discuss the work from an innovative approach or from some information that has just been discovered. These references should also be recorded in chronological, rather than alphabetical, order, so that any fluctuation in the interest given the work may be illustrated and later additions to the list can be easily made.

The twelfth category—the listing of any drawings, similar works of art, and engravings or graphics based upon the work—is usually one of the hardest sections on which to find material. Studying a book of the artist's drawings or prints may be profitable. A number of large drawing collections have been catalogued, illustrated, and published, such as the Musée du Louvre in Paris and the British Museum in London. Exhibition catalogues often include preliminary drawings. If a specific engraver is noted for having used the artist's creative endeavors, consult the pertinent volumes of *Illustrated Bartsch* [22:27]. Unless there is a famous work of art that is similar or based upon the work being catalogued, the search for such an item may be fruitless. Information for all categories of a catalogue entry, remember, may not be found.

A catalogue entry includes any data known about the work. In a scholarly entry, this thirteenth section is often the longest and the most revealing. It can include any of the following:

1. a discussion of the subject and symbolism depicted

2. any special or different perspective, angle, or medium used

3. data on animals, birds, and objects represented in the work, such as furniture, decorative arts, costume and dress, ships, or wagons

4. facts concerning any discernable location which is illustrated, especially for a landscape or cityscape

5. for a portrait, interesting facts concerning the sitter's life

6. other works of art which influenced or were the bases for depictions within the work

7. data on the style or form of the specific work or any innovations by the artist

8. statements by the artist concerning the work

9. any unusual or important criticism of the art

10. the environment or original placement of the work

To discover this information, the art itself must be carefully studied. What the work depicts must be noted prior to beginning this research for additional data. Various scholar's accounts of the work of art may be important to this section. For instance, in Example 19, Varnedoe's opinion is repeated. Moreover, a quotation from the artist's brother recounting how Caillebotte painted the bridge from a carriage and a description of the geographic location of *Le Pont de l'Europe* are meaningful additions.

This section, if well researched and written, is the most stimulating part of any catalogue entry. Be sure to do it justice. To discover applicable data takes time and creativity, for the reference tools will be scattered throughout the library. For example, if the work is a portrait, information on the sitter will be needed. If the subject is wearing a fashionable dress of a particular period, the fashion and jewelry references recorded in Chapter 25 may assist in finding pertinent material. Other critical aspects are to discover how people perceived or reacted to the work and to read the artist's comments and critics' reviews; see Chapter 5, "Documents, Critics' Reviews, Interviews." For data on discovering the subject or symbolism, see Chapter 7.

Some works were done for particular places or types of locations, for instance, a small living room, a large entrance of a business office, or a church altar. If possible, try to examine similar places. For example, portraits painted in Virginia during the American Colonial period might have been displayed in houses similar to George Washington's

Mount Vernon or Stratford Hall. Visiting these estates and viewing their interiors will help students understand where and how art was seen. Some museums have period rooms, complete temples, or chapels; study the displays and the original works of art.

An illustration of the object is the fourteenth and last section of a catalogue entry. Consult sources for reproductions as each reference is read. Catalogues raisonnés and œuvres catalogues as well as museum collection, exhibition, and sales catalogues are all excellent sources. If no reproduction can be located, a written description of the object should be included.

Monetary Evaluations

Art has value, not only aesthetically, but monetarily. Curators and collectors must know this value for purposes of acquistion and insurance. But students and scholars can learn a great deal about the fluctuations in an artist's reputation and stature by evaluating some of the artist's works and learning more about the art market. Some books, such as Gerald Reitlinger's *The Economics of Taste, 1961–1970* [18:34] and *American Art Analog* [18:15], edited by Michael David Zellman, provide brief evaluations of the art market for specific artists. But for most artists, researchers will need to utilize the books annotated in Chapter 18—those for auctions both prior-1970s and post-1970s.

One of the biggest difficulties with this type of research is in comparing the prices paid for works; currency fluctuations and the value of money are difficult, if not impossible, to measure. In the front of Volume I of Bénézit's *Dictionnaire critique et documentaire* [10:27], there is a chart—based upon the *Annuaire Statistique de la France,* 1975—which provides, for most years between 1901 and 1973, the average number of French francs per one U.S. dollar and one English pound. Another source is the *Statistical Abstract of the United States* [18:53], published by the U.S. Department of Commerce, Bureau of Census. Several volumes will need to be consulted; for instance, the 108th edition of 1988 contained the monetary exchange rates for 1970 through 1988. In his book, *100 Years of Collecting in America: The Story of Sotheby Parke Bernet* [18:5], Thomas Norton contrasts prices in different years using for comparison the dollar value of one bushel of wheat, one ounce of silver, and the

Consumer Price Index, measured against the base year of 1967. He obtained the data from the *Statistical Abstract of the United States* [18:53]. For abbreviations of foreign money, see Appendix E.

Social History and the Influences on Art

Art was not created in a vacuum. Upon each work of art there were many influences: artistic, educational, literary, religious, musical, theatrical, historical, political, economical, social, geographical, and scientific. In addition, pressure on the artist could be exerted by the patron who commissioned or purchased the work. These factors have impact on the form as well as the subject of art. Patrons have frequently dictated their wishes; for instance, J. Paul Getty wanted his Malibu museum to be built to resemble a Herculaneum villa. Some of the best discussions of the influence of various patrons have been written by Francis Haskell in *Patrons and Painters: A Study in the Relations Between Italian Art and Society in the Age of the Baroque* [12:65] and *Rediscoveries in Art: Some Aspects of Taste, Fashion, and Collecting in England and France* [12:112].

The art around artists—the objects they actually viewed, studied, and admired—obviously affected the artists' own works. For instance, *Renaissance Artists & Antique Sculpture* [12:9], discusses which antique pieces were known during this period. If a statue was not known, it could not have influenced a fifteenth- or sixteenth-century artist.

Especially influencial in certain periods of history were illuminated manuscripts, print collections, and illustrations in such works as emblem books. Exhibitions which artists viewed can have an impact upon their work. But care must be taken not to assume that just because an exhibition was held in a certain city where the artist lived that the artist viewed a specific work reproduced in the exhibition catalogue. Not all works included in an exhibition catalogue, remember, travel to all of the museums where a show is displayed. As mentioned in Chapter 3, not one of the four sites for the El Greco Exhibition were able to display all sixty-six paintings listed in the catalogue.

Where and for whom artists have exhibited their works has sometimes made a tremendous difference in what was created. The judges of exhibitions, then as now, often chose pieces which

resembled or were in accord with their own philosophical and aesthetic views. For example, the 1863 Salon des Réfuses was held to display the works refused by the French Salon judges, because Emperor Napoleon III wanted the public to realize that the rejected art was not worthy to be part of the official French Salon.

Education, not only that of the artists, but of the audience, is a major influence on art. If most viewers could not read or write, artists added an attribute, something that would distinguish that specific person, such as the flail and crook for the Egyptian deity Osiris. Although most people think of a cuddly, white bunny as something pure, people of the Renaissance knew more about the promiscuity of rabbits, which were symbols for lust. Because the subject of some art today is difficult to decipher, viewers may not be able to understand its subtle references.

Literary influence cannot be overemphasized. The literature that artists and patrons read was important, as was any work illustrated by artists. Some of the symbolism in Christian art came from noncanonical sources, not the Bible. And in art depicting classical mythology, the stories came from a number of writers, such as Ovid, Virgil, and Homer. Chapter 7 includes a discussion of various sources for Christian art and classical mythology.

Religion, music, and theater have been major influences on art. Ecclesiastical officials have often dictated what can and cannot be depicted. For instance, the Ecumenical Councils sometimes altered the emphasis of Christian art, such as in 692 when the Quinisext Council decreed that art should show Christ in human form rather than as a lamb. Music is also important to art. The need for excellent acoustics dictated certain changes in church architecture. The theatrical world and the fine arts influence each other. Jacques Louis David's interest in the theater is well documented. Other art historical periods were also partial to dramatic depictions. Two works which illustrate theatrical influence are Jean Fouquet's *Book of Hours of Etienne Chevalier* and the Italian sculptor Bernini's *Ecstasy of St. Theresa* in the Church of Santa Maria della Vittoria, Rome.

History—political, economic, and social—has always played a role in art. Napoleon was a master at using it for propaganda purposes. Hitler wanted art created which would glorify the German Third Reich. The subjects which artists are allowed to paint in Communist Russia are dictated by party line. But art has also depicted politicians—such as the satirical works by Englishman William Hogarth and Frenchman Honoré Daumier. The wars of history have been both glorified—Meissonier's *Campagne de France 1814*—and vilified—Picasso's *Guernica*. Politics is a motivating factor in T.J. Clark's *The Absolute Bourgeois: Artists and Politics in France, 1848–1851* [12:78].

Economics will always affect art, if only by determining who can afford to buy and sell it. The power that comes from wealth is sometimes more motivation for rich collectors than aesthetic judgment. Art production also depends upon supply and demand. This not only affects the object as a whole, but the media used. When the price of gold escalated, gold leaf was replaced with paint. When printing became feasible and inexpensive, the illumination of manuscripts died out.

One of the greatest impacts on art has been society itself, especially such items as (1) manners, mores, and customs; (2) recreation and sports; and (3) fashion in dress and the decorative arts. These have been not only the subject of art but also an influence on it. The seventeenth-century genre painter Jan Steen was a master at illustrating the social concerns of his fellow Dutchmen. The popularity of tea in eighteenth-century England created a desire for tea services and tea tables. Even recreation and sports can be important to art. The Olympic Games and the emphasis on athletics were glorified in Greek art.

Dress and fashion, in both its presence and absence, influence art by providing (1) the type of clothing that is depicted—high fashion in portraiture, peasant dress in rural genre scenes; and (2) the reasons for changes and the popularity of certain types of furniture and other decorative items. The first can be used in dating paintings and in discerning the artist's intentions to illustrate the social status of the figures represented. The enormous skirts worn in eighteenth-century France, as well as the new vogue for comfort, necessitated the development of the wide cushioned chair, called a *bergère*. Because Queen Elizabeth I adorned her dresses with small ornaments and miniatures, these tiny portraits were especially popular in sixteenth-century England. Some fascinating reading will be found in the social history books listed in Chapter 25.

Science and geography have also exerted an influence on art. The former, for instance, has had a resounding impact on art, not only in the materials

which artists could use but also in the reality of art. Nineteenth century artists could not paint out of doors until tube paints were invented. Photography's influence, discussed in Aaron Scharf's *Art and Photography* [23:33], was made possible by scientific inventions. Geography has affected not only the media used in certain areas but also the kind of architecture that is built. Because of the lack of ingredients to produce bronze, few statues were made of this metal in ancient Mesopotamia. Studying some of the cultural/historical surveys and atlases listed in pertinent chapters and the topographical guides cited in Chapter 21 will make this geographical influence clearer.

For several decades, one of the few resources for social history has been the volumes of the *Everyday Life Series* published by Dorset Press, such as Marjorie and C. H. B. Quennell's *Everyday Life in Roman and Anglo-Saxon Times* and Marjorie Rowling's *Everyday Life in Medieval Times.* Although helpful, these slender volumes have no footnotes and only brief bibliographies. But they describe important social history, and for this reason are cited in Chapter 25. Recently, several scholarly resources have been issued, such as the three-volume *Civilization & Capitalism 15th–18th Century* by Fernand Braudel [12:35] and the five-volume *A History of Private Life* [11:101, 11:153, and 12:40]. Due to the importance of cultural/historical surveys, they have been included in the appropriate sections of Chapters 11 through 14.

To find additional pertinent references for interdisciplinary subjects, check the library's catalogue system as well as such resources as Eugene P. Sheehy's *Guide to Reference Books* [17:10] and the *Bibliographic Index* [17:3]. Although *The Encyclopedia Britannica* will provide more material on medieval French theater than *The Encyclopedia of World Art,* both should be studied. A search of some of the specialized bibliographic databases may prove productive, depending upon the wording of the problem and the computer files consulted. Because it covers all subjects, *Dissertation Abstracts International* [16:9] often provides valuable leads as do the catalogues of holdings of famous libraries. The resource tools for interdisciplinary studies may be scattered throughout the library or available only at other institutions. Ask the reference librarian to help you find these materials.

ON THE EUROPE BRIDGE
A CATALOGUE ENTRY

ARTIST & DATES:

Caillebotte, Gustave, 1848-1894

TITLE:

On the Europe Bridge. Originally entitled Le Pont de l'Europe.
Later called Sur le Pont de l'Europe. When transferred to the
Kimbell Art Museum in 1982, it was renamed.

DATE:

1876-1880

MEDIUM:

Oil on Canvas

SIZE:

105.3 × 129.9 cm (41 1/2″ × 51 1/8″)

DATA ON OBJECT:

Stamped in blue ink, lower right: G. Caillebotte

CONDITION:

Excellent. Unlined original canvas; the paint film in 1982 was
nearly pristine.

PRESENT LOCATION AND ACQUISITION NUMBER:

Kimbell Art Museum, Ft. Worth, Texas AP82.1

PROVENANCE:

Martial Caillebotte (Gustave's brother), Paris
Descendents of M. Caillebotte
Extended loan, National Gallery of Ireland, Dublin, 1964-71
Private Collection, Paris by 1976
1982 sold to the Kimbell Art Museum

EXHIBITIONS:

Rétrospective Gustave Caillebotte, Galerie Beaux-Arts, Paris, May
25-July 15, 1951, catalogue number 10.
Gustave Caillebotte, A Loan Exhibition, Wildenstein, London,
June-July, 1966, catalogue number 5.
Gustave Caillebotte: A Retrospective Exhibition, Museum of Fine
Arts, Houston, and the Brooklyn Museum, October 1976-April
1977, catalogue number 22.

LITERARY REFERENCES:

Wildenstein Gallery, New York. Gustave Caillebotte: A Loan
Exhibition. New York, Wildenstein & Company, 1966, pp. 12,
23.

Varnedoe, J. Kirk T., "Caillebotte's Pont de l'Europe: A New
Slant." Art International 18 (April 20, 1974): 28-29, 41,
58. Extensive discussion of Geneva painting.

Museum of Fine Arts, Houston. Gustave Caillebotte: A
Retrospective - Exhibition. Houston: Museum of Fine Arts,
Houston, 1976, pp. 105-107; see Varnedoe's "Caillebotte's
Space," pp. 60-73.

Berhaut, Marie. Caillebotte sa vie et son oeuvre: Catalogue
raisonné des paintures et pastels. Paris: Foundation
Wildenstein, 1978, p. 94, catalogue number 46.

Kimbell Art Museum. In Pursuit of Quality. Fort Worth: Kimbell
Art Museum, 1987, pp. 286-287.

Varnedoe, Kirk. Gustave Caillebotte. New Haven, CT: Yale
University Press, 1987, pp. 80-82.

RELATED WORKS:
Sketch for On the Europe Bridge:

Esquisse pour Le Pont de l'Europe, variant, 1876-77, oil sketch
on canvas, 64 × 80 cm. (25 1/4 × 31 1/2 in.). Collection
of Richard M. Cohen, Los Angeles (Berhaut's catalogue
raisonné, 1976, No. 45).

Variations and studies of the bridge theme:

Le Pont de L'Europe, 1876, oil on canvas, 131 × 181 cm. (51 5/8
× 71 1/4 in.), Musée du Petit Palais, Geneva (Berhaut's
catalogue raisonné, 1976, No. 44).

Esquisse pour Le Pont de L'Europe, 1876, oil sketch on canvas,
82 × 120 cm. (32 3/4 × 48 1/2 in.), Albright-Knox Art
Gallery, Buffalo (Berhaut's catalogue raisonné, 1976, No.
38).

Esquisse pour Le Pont de L'Europe, 1876, oil sketch on canvas,
54 × 73 cm. (21 1/4 × 28 3/4 in.), Private Collection,
Paris, (Berhaut's catalogue raisonné, 1976, No. 40).

Esquisse pour Le Pont de L'Europe, 1876, oil sketch on canvas,
32 × 46 cm. (12 5/8 × 18 1/8 in.), Musée des Beaus-Arts,
Rennes (Berhaut's catalogue raisonné, 1976, No. 39).

Etude pour Le Pont de L'Europe-les poutres en fer, 1876, oil
study on canvas of iron girders, 55.5 × 44.7 cm. (22 × 18
in.), Private Collection, Paris, (Berhaut's catalogue
raisonné, 1976, No. 42).

Example 19: On the Europe Bridge: A Catalogue Entry for the Caillebotte Painting at the Kimbell Art Museum,
Ft. Worth, Texas.

Example 19:—(continued)

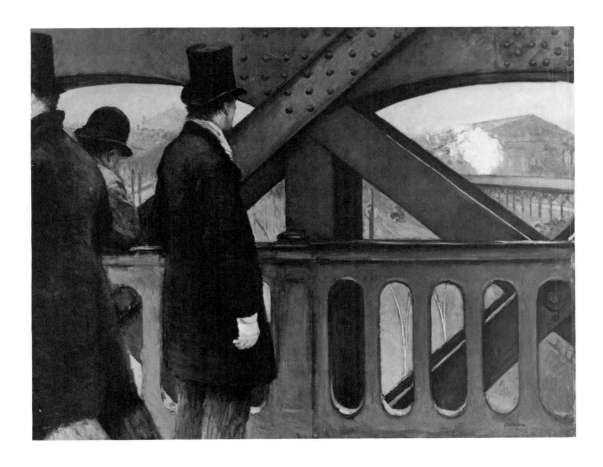

ADDITIONAL INFORMATION:

In the 1966 Wildenstein exhibition catalogue, On the Europe Bridge is described as a study for part of the larger painting, Le pont de l'Europe, 1876, which is now in the Musée du Petit Palais, Geneva. In his catalogue, Varnedoe states that the Kimbell's highly finished work, which is preceded by its own sketch, is a variant of a bridge theme, rather than a study for the Geneva painting. The fact that both works have had the same title adds to the confusion. Varnedoe suggests that the two paintings might be a pair, with the Geneva work's sunny view contrasting with the wintery blue greys in the Kimbell painting. These may be "separate considerations of the same basic motif, we can perhaps see them, too, in the context of the kind of series paintings Monet did throughout his life, taking essentially the same subject under different conditions of weather and light." In his 1987 book, Varnedoe adds a question mark to the painting's dates and states in the narrative that the work may have been painted closer to 1880. Varnedoe clarifies his point: "The palette, brushwork, figure scale, spacial closure and mood would all be consistent with Caillebotte's work of c. 1880–82."[1] The Kimbell Art Museum publication gives a range of dates: 1876–80.

The Pont de l'Europe is an enormous bridge which spans the Gare St.-Lazare, not too far from Caillebotte's former home in the residential district, Quartier de l'Europe. For a bird's eye view of the bridge, see the print from the Paris Nouveau Illustré, which is reproduced on page 72 of Varnedoe's book. The area reflects the growth and changes that transformed the city of Paris under Baron Georges Haussman during the Second Empire. Caillebotte's brother recounted to his family that in order to work in all kinds of weather, Gustave painted his views of the Pont de l'Europe from a carriage.[2] No figure in the painting is full length and totally seen; all are cropped. The gentleman wearing the top hat and looking through the iron girders is thought to be Caillebotte himself.

[1]Varnedoe p. 80 of his book.

[2]Quoted in Berhaut, 1951 and repeated in Museum of Fine Arts, Houston, 1976, pp. 98–99.

Subjects and Symbols: Methodology and Literature

Although not all twentieth-century art depicts a theme, most of the artistic creations of the past have imparted some message or subject to the viewer. Within a work of art, symbols—objects or emblems that represent a person, idea, or concept— are often used in order to assist observers in understanding the subject, ideas, or meaning which the artist wishes to portray. A work of art can have a subject that is also a symbol. For example, a painting of Christ seated at a table with twelve men depicts the subject of the Last Supper. The scene is also a symbol for the Eucharist, the Christian sacrament of Holy Communion.

Symbols do not necessarily have the same interpretation during all periods of history. For instance, the swastika which is found in many ancient and primitive cultures probably had a number of meanings, one of which involved the four directions of the compass. But in the twentieth century, the swastika became the emblem for a particular political party—the Nazis of Germany. Many subjects and symbols are no longer intelligible to audiences. Frequently, such art has lost its meaning for the viewer.

Two important terms in understanding discussions on the subjects depicted in art are iconography and iconology. *Iconography* is the study of the meaning of a work's subjects and symbols and of any literary references from which they derive. Covering a broader, more in-depth scope, *iconology* provides a deeper meaning for themes in relation to the history, religion, mores, customs, and social concerns of a particular milieu at a specific time. This requires multidisciplinary research on the influences on the work of art, a subject discussed in Chapter 6. For an instructive essay on these two terms, read "Iconography and Iconology" in the seventh volume of *The Encyclopedia of World Art* [10:2], which quotes extensively from Erwin Panofsky. Although not the originator of the distinction between these words, Panofsky provided one of the best discussions on their differences in his introduction to *Studies in Iconology,* a section reprinted in his *Meaning in the Visual Arts* [29:118]. Panofsky's essay should be read by everyone working on an iconographical study. In addition, the student who wishes to read some analytical studies of specific works of art should consult the *Art in Context Series* [28:9].

Because various types of iconographical research need different kinds of references, this section is divided into (1) the basic iconographical research which should be read no matter what the particular theme happens to be, (2) Christian subjects, which answers some of the questions encountered with this topic, (3) non-Christian religious subjects, (4) classical mythological subjects, and (5) secular subjects. Although the discussions will not answer all questions, it is hoped that they will point the direction for students to follow. Some of the basic iconographical resources are annotated in Chapter 29. In addition, since iconographical research requires many of the tools discussed in previous chapters, these should be read first.

Eight Basic Steps for Iconographical Research

All iconographical studies depend upon a correct description of what the art illustrates. It is particularly important to inspect the work closely in order to discern exactly what figures, subjects, or events are being depicted. In some cases, an obscure, inconspicuously placed item may be of the greatest importance. For instance, a rose near a mother and child is usually a symbol for the Virgin Mary, who was called the rose without thorns. Researchers must not only observe the flower, but know that it is a rose. If neither the title nor the subject of the work of art is known, the challenge is to discover what the scene represents. But by checking the clues the artist has provided plus some detective work, the riddle can frequently be resolved. Since it is always easier to follow an example, this section takes the study of paintings and sculpture that represent Susanna and the Elders.

The eight basic steps to follow in iconographical research are as follows:

1. Describe exactly what subjects, events, or objects are depicted or illustrated in the work.
2. Consult both the broader and narrower terms in iconographical references as well as art and, if pertinent, religion encyclopedias in order to obtain the first clues as to the interpretation of the piece and an overall view of the topic.
3. If the subject or symbol was derived from a literary work, read the material—in a version as close to what the artists would have known as possible—to determine derivations between the written and artistic concept.
4. Develop a bibliography of the topic, utilizing a database search which facilitates the process; start with general articles and proceed to more specific material.
5. If apropos, compile a chronology on any real or fictitious persons who are represented or on changes in the way the subject has been depicted.
6. Study as many works of art incorporating the subject as possible to determine the years it was popular and any changes in meaning which might have occurred.
7. If specific artists frequently used the symbol, research them and the particular works of art, studying with care footnotes and bibliographies of scholarly publications.
8. Study interdisciplinary texts and pertinent history books to provide background for understanding the historic period and the country from which the art object comes.

In any iconographical study, these eight basic steps should be followed. If a work of art shows a slightly clothed woman either bathing or preparing to do so and two elderly men watching her, this is most probably Susanna and the Elders. But if the student does not know what is represented, reference tools will need to be used to discover the subject. *Iconclass* [19:14] would help in this identification; for in the general index under "bathing" and "elders," there are cross references to this heroine. The two concise, single-volume books—Hall's *Dictionary of Subjects and Symbols in Art* [29:10] and Metford's *Dictionary of Christian Lore and Legend* [29:59]—include this story. Hall has a cross reference to Susanna under "Woman observed"; Metford, under "Woman bathing." Both relate the story of this Old Testament Apocryphal heroine.

Early in the research project, the student should read the essays on the subject found in *The Encyclopedia of World Art* [10:2] and, if apropos, the *New Catholic Encyclopedia* [29:105]. The former has articles that provide an orientation to topics. If the research is on monsters, read "Monstrous and Imaginary Subjects"; if on the everyday life of the people, see "Genre and Secular Subjects." Two other pertinent essays are "Symbolism and Allegory" and "Christianity." Although there is no text entry for Susanna, the *Encyclopedia of World Art* does index fourteen works of art depicting her story. The *New Catholic Encyclopedia* has a good discussion of the subject including folklore elements of the theme and ten bibliographical citations.

Two sources for more detailed information are Réau's *Iconographie de l'art chrétien* [29:61] and Kirschbaum/Braufel's *Lexikon der christlichen Ikonographie* [29:58]. Under "La Chaste Suzanne et les vieillards," Réau discusses literary sources and symbolic interpretations as well as relates various scenes which artists through the ages have depicted, such as Susanna at the bath and the Judgment of Daniel. Reported are the artists and titles of more than fifty specific works of art, dating from the second to the nineteenth centuries, illustrating these scenes. Under "Susanna," *Lexikon der christlichen Ikonographie* has a listing of some of the early Christian writings, a discussion of the various scenes of her life, numerous titles of works of art illustrating the story, and a list of eleven literary references. This scholarly reference utilizes German abbreviations which are hard to decipher. Iconographical studies are often difficult, partly because the interpretations are complex and the material is published in so many languages. Therefore, the footnotes and bibliographies of all articles and books which are examined should also be studied. These are prime iconographical sources for material.

In iconographical research, if a literary source for the subject exists, it should be consulted. Not only should the reference be read, but researchers should try to discover whether or not the artist could have had access to it. Several references referred to Susanna as an Apocryphal heroine; consequently, students must know something about this literature. When St. Jerome (c. 340–420 A.D.) translated the Bible into Latin, the version called the Vulgate, he based some of his work on the *Septuagint,* an early Greek translation of Hebrew

writings which contained fourteen pieces of literature that were later not incorporated into the official Hebrew Scriptures. In the sixteenth-century when he translated the Bible into German, Martin Luther decided that only the writings contained in the canonical Hebrew Scriptures should be included. In Luther's Bible, the fourteen literary pieces, called the *Apocrypha,* meaning doubtful, were placed between the Old and the New Testaments. The seventeenth-century English translation, entitled the King James Version of the Bible, retained this format. Later to save printing costs, the *Apocrypha* was often deleted. In most Protestant Bibles, it is missing, but the *Apocrypha* is still incorporated into the text of the Roman Catholic Bible. Numerous stories depicted in art—such as Susanna and the Elders, Judith and Holofernes, and Tobias and Tobit—derive from the *Apocrypha.* Remember, these stories will not be found in the Protestant Bible. For a listing of the titles of the various books of the Bible in both the Protestant and Catholic versions, consult Appendix E.

The fourth step, compiling an iconographical bibliography requires many of the same tools discussed in Chapters 3 through 5. For pertinent articles, consult the major indexing services as well as *Dissertation Abstracts International* [16:9], which records the research of nascent scholars. All of these reference tools have databases. When Susanna and the Elders, which was used as an example in Chapter 4, was searched in *Art Literature International (RILA) Database* [16:7], there were sixteen entries. Although most of the articles pertained to individual works of art that depict this theme, several discussed the changes in the story during various periods of history. In addition, *Art Index* [16:1] and *RILA* [16:7] have listings under "Iconography," a term which is subdivided by chronological periods and styles, such as Christian or medieval. *Répertoire d'art et d'archéologie* [16:6] has a similar subdivision, "Iconographie." For frequently depicted subjects, there is usually a wealth of material.

In addition to the general reference tools, there are two special ones: *Iconclass* [19:14] and the *Catalog of the Warburg Institute Library* [11:87]. The former, which was discussed in Chapter 5, provides an overview of the scenes in which Susanna figures, the correct biblical book and verse, and a bibliography of thirty-two books and articles. There is a notation that Susanna praying could be a typological or prefigurative symbol for Christ praying in the Garden of Gethsemane, which might become part of the research.

The twelve-volume *Catalog of the Warburg Institute Library* is an excellent source for bibliographical data on broad subjects. Concerned with the significance of classical civilization on cultural history, the collection of the Warburg Institute Library is arranged in four areas: (1) political and social history; (2) religion, history of science, and philosophy; (3) literature; and (4) art and archaeology, which includes numerous works on iconography. One of the most valuable aspects of the Warburg material, much of which is in foreign languages, is that at this London library offprints of articles are filed with the books. Although there is no specific section for Susanna, there is a listing of thirty-nine references concerning Old Testament apocryphal stories.

The fifth step—which is to formulate a chronology of the subject or person—is not pertinent to this particular study, since outside of the Apocrypha and religious writings, there is no later mention of Susanna's life. Because it would indicate the fluctuation in interest in this theme, a chronology of the years in which the story was popular in art, however, could be essential for certain studies.

Researchers always need to locate and examine various works of art on their particular theme, the sixth step in iconographical research. This illustrative material is required in order to observe, among other things, the symbol or subject as to (1) how it is depicted in art, (2) which countries and in what periods of history it was popular or prevalent, and (3) how it may have altered over the years. For some hints on how to find reproductions, consult Chapters 5 and 6. Since they include subject categories, indices to reproductions can be used to discover the names of specific artists who depicted a theme. Armed with data gleaned from these references, works of art can be tracked down through other means. For instance, Havlice's *World Painting Index* [19:27] and its 1982 supplement have entries for forty-six artists who depicted Susanna and various aspects of her story.

There are also specialized iconographical indices that provide titles to specific types of art. Fredericksen/Zeri's *Census of Pre-Nineteenth-Century Italian Paintings in North American Public Collections* [19:23] reports fourteen titles for Italian works of art that illustrate Susanna.

Helene Roberts's *Iconographic Index to Old Testament Subjects* [19:37], organizes the paintings depicting Susanna into nine scenes and then subdivides these into various schools. The total number of paintings cited is 178; the locations of these works are usually reported. Roelof van Straten's *Iconclass Indexes* [19:39] is a series of works that index prints using *Iconclass* [19:14]. The first three volumes, which cover Italian prints, are based upon Arthur M. Hind's *Early Italian Engravings* [22:16] and certain volumes of Adam von Bartsch's *Le Peinture-Graveur* [22:9]. Although there were not many prints for Susanna, the *Iconclass Indexes* provide both the Bartsch number and the *Illustrated Bartsch* [22:27] volume number as well as the artists who created the image upon which the print is based.

Pigler's *Barockthemen* [29:60] covers art from the seventeenth and eighteenth centuries, although there are often citations for much earlier and later periods. Under "Susanna und die beiden Alten," Pigler reports the book and verse of the biblical passage and cites a total of 358 drawings and paintings: sixty-three from the sixteenth century, 132 Italian works from the sixteenth through the eighteenth century, two Spanish paintings, eighty-six Netherlandish works, fifty-four French, two English, plus a nineteenth-century French painting. In his *Illuminated Manuscripts: An Index to Selected Bodleian Library Color Reproductions* and supplement [19:41], Ohlgren indexes about 1,872 manuscripts and printed books, mostly dating from the eleventh to the fifteenth centuries. Susanna has only two entries, an indication that this Apocrypha heroine was not as popular either in this medium or during this period. Some scholarly museum catalogues have subject indices which will assist researchers in locating titles of works of art on specific subjects. Some of the museums which have catalogues containing iconographical indices are the National Gallery, Washington, D.C.; the National Gallery, London; the Samuel H. Kress Collection; and the Yale University Art Gallery.

Although there are a number of picture collections, only a few have subject indices. The *Marburger Index* [19:7], which was discussed in Chapter 5, has forty-six black-and-white reproductions of Susanna. Although all of them are owned by German museums, the works of art are international in scope: nineteen of the artists are Netherlandish; thirteen, German; twelve, Italian; one, Austrian; and one, Hungarian. The *Index Iconologicus* [19:28] provides subject access to prints, most of which date from the sixteenth and seventeenth centuries. For Susanna and the Elders, there were eleven prints reproduced. For Susanna, *DIAL* [19:25]—a set of post-card size, black-and-white reproductions of Dutch and Flemish sixteenth- and seventeenth-century art—has thirty-two works of art illustrated: twenty-five paintings, six drawings, and one engraving.

The Index of Christian Art [19:20], an open-ended system to which entries are continuously being added, consists of a Subject File, which has almost 700,000 cards that index and describe the subject matter of Early Christian and Medieval works of art up to the year 1400 as well as record bibliographical data for the art. For many of the works, there are small black-and-white illustrations. For Susanna, there are twenty-eight listings to frescoes, glass works, illuminated manuscripts, and sculptures. One entry is for the *Crystal of Lothar* in the British Museum. Provided are data on the provenance, the inscription on the crystal, and a listing of eighteen articles on this work of art. In addition, there are three photographs of the piece. In North America, the complete photographic copy of the index is available at Princeton University, the Art Library of the University of California at Los Angeles, and Dumbarton Oaks Research Library, Washington, D.C.

The seventh step, researching specific artists who frequently depicted the subject, should be used for any in-depth study. For Susanna, such artists as Tintoretto and Altdorfer might be investigated. The footnotes and bibliographies should be carefully studied. The eighth and last step is to study interdisciplinary texts and pertinent history books to provide background for understanding the art and the subjects depicted. In addition, in order to understand the popularity of illustrations of this story, research will need to be done on the different influences: historical, legal, and artistic. Cultural/historical surveys are cited in the appropriate sections of this guide; social history books are listed in Chapter 25.

Christian Subjects

Because there are various aspects to Christian studies, this section discusses (1) the literature that influenced Christian art, (2) Christian iconographical research, (3) hagiographical—study of the Christian saints—studies, and (4) reformation

themes. Remember, research on Christian subjects follows the eight basic steps for iconographical research explained above.

Literature That Influenced Christian Art

When researching subjects concerning the Christian Holy Family care must be taken to discover the specific literary references which influenced that particular work of art. Of the many manuscripts written during the formation of the Christian Church, twenty-seven books were accepted as canonical to form the New Testament. But many of the early Christian writings which were not endorsed by the ecclesiastical authorities also had an impact on art. Some of these have been collected, translated, and dubbed *The Apocryphal New Testament* or the *Christian Apocrypha* [29:83]. This collection of stories—many of which are incomplete—consists of three main groups of works: *The Infancy Gospels,* which recount stories of the Christian Holy Family; *The Gospel of Nicodemus,* also called the *Acts of Pilate,* which recounts Christ's trial and crucifixion; and *The Apocrypha Acts of the Apostles,* which relate the adventures and deaths of some of the Christian Apostles. *The Infancy Gospels,* which were particularly popular, contained two important works: (1) *The Protevangelium of James,* probably written in the second century, and (2) *The Gospel of Pseudo-Matthew,* which was composed during the eighth or ninth century and which was based upon the earlier work. Such symbols as the proverbial ox and ass illustrated in Nativity scenes and the midwives, who are often included in these depictions, derive from the *Infancy Gospels,* not the New Testament. Some of the episodes described in these apocryphal works, which were subsequently rejected by the ecclesiastical authorities, were later included in Jacobus de Voragine's *The Golden Legend* [29:73].

From the fourteenth through the sixteenth century, depictions concerning the Holy Family were influenced by a number of non-biblical writings, especially *The Golden Legend, Meditations on the Life of Christ,* and *Revelations* of St. Bridget. One of the most important early non-biblical books was *The Golden Legend* which was compiled in the thirteenth century by Jacobus de Voragine on the lives of the saints, the Holy Family, and some important Christian feast days. Due to its great popularity, *The Golden Legend* was published in more than 150 editions and translations between 1450

and 1550. The first comprehensive compilation of oral legends and traditions on the saints, this work is the one artists would have known.

Mystical writings of those who believed that they saw the events in the life of Mary and Christ were also published during this period. The thirteenth-century work once attributed to Pseudo-Saint Bonaventura, *Meditations on the Life of Christ* [29:85], describes the Virgin Mary as standing erect against a column during the birth of Jesus and after the event, kneeling to adore her child. And in the visions seen by the fourteenth-century Swedish saint, called Birgitta or Bridget, which were published under the title *Revelations* or *Visions* [29:89], the Virgin Mary wore a white mantle and had long golden hair. These scenes and others which derive from mystical writings are often portrayed in art.

Throughout Christianity, the Old Testament episodes were considered allegorical prefigurations for New Testament events. These typological symbols were prevalent in art. For example, Abraham's willingness to sacrifice his only son, Isaac, was seen as a symbol of the Crucifixion—God's sacrifice of his son Jesus. The heroine Susanna praying was seen as a typological symbol for Jesus as he prayed at the Garden of Gethsemane. Some of these parallels were later published in the *Biblia Pauperum* [29:80], a widely circulated, popular, fifteenth-century printed book which was issued in various editions and illustrated by woodcuts. For researchers who need to find typological parallels, the general index of *Iconclass* [19:14] is an excellent source.

In researching Christian stories, the translation closest to the one that would have been known at that historic period should be consulted. For instance, the seventeenth-century Douay-Rheims Bible is probably the most faithful translation of the Latin Vulgate, the official Roman Catholic Bible known during the Middle Ages. But for English Protestant artists during the seventeenth and eighteenth centuries, the King James version would have been read. Although popular biblical studies might prove helpful in understanding the Bible, they cannot be used for art historical research. Remember, it was often the lack of details that allowed the imagination of the artists to create varied depictions of a theme. By consulting the literary references, the innovative additions of the artists can be differentiated from details inspired by literature.

Christian Iconographical Research

Most of the same tools used in the eight basic steps are needed for Christian subjects. For instance, the *New Catholic Encyclopedia* [29:105] has some very informative articles on the iconography of such religious concepts as the Holy Trinity, God the Father, the Holy Spirit, Jesus Christ, the Virgin Mary, the Last Supper, Pentecost, and the Apocalypse. This reference also includes discussions on symbols for Christ, the Virgin, Saints, and the Church. Since some of these terms are discussed within various essays, use the general index.

There is another superior scholarly publication: Gertrud Schiller's four-volume *Iconography of Christian Art* [29:62]. Volume I covers Christ's birth through his ministry; Volume II, the Passion or death of Christ. Each of these extensively illustrated volumes has an index to the biblical and legendary texts cited. The "Thematic Index" to the first two publications, which is printed only in the second volume, allows readers to locate quickly the text that refers to certain objects or scenes. Under "column," there are citations for its use in the miraculous birth, the Crucifixion, the Denial of Peter, the Flagellation, and the Baptism. This is one of the best references for discovering the literary sources that influenced the various scenes and symbols used in works of art concerning Christ. The last two volumes in the series have yet to be translated into English: Volume 3: *Die Auferstehung und Erhöhung Christi* on the Resurrection and Ascension; Volume 4, Part I: *Die Kirche* (The Church) and Part II: *Maria* (the Virgin Mary).

Hagiographical Studies

Researchers are frequently confronted by a work that seems to depict a saint, whose identity is not known. For instance, the work of art might be a fifteenth-century Venetian statue of a young girl adorned by a halo, wearing a crown, and with a broken wheel at her feet. The first puzzle to be solved is who is the woman? Since a halo is indicative of many Christian saints, and a crown is not an unusual headdress, the best object to investigate is the wheel. To answer the question, consult *Iconclass* [19:14], Metford's *Dictionary of Christian Lore and Legend* [29:59], and Hall's *Dictionary of Subjects and Symbols in Art* [29:10]. All have cross references from the term, wheel, to St. Catherine. One of the best one-volume hagiographical references is Farmer's *The Oxford Dictionary of Saints* [29:71], which explains Catherine's story

and gives her attributes, the reasons the faithful prayed for her intercession, and the people for whom she was the patron saint. This dictionary also includes a bibliography of literary references and a list of works of art that depict her.

From the wheel, there are a number of sources which would have led the researcher to St. Catherine. But not all attributes are as easily traced. Two of the best sources for locating the names of saints when only the attributes are known are Drake's *Saints and Their Emblems* [29:70] and *Iconclass* [19:14]. If all that was needed was the identity of the woman, these dictionaries would have sufficed. But for a more detailed study, the eight basic steps, explained earlier, should be followed.

The earliest printed book on the lives of the saints was Jacobus de Voragine's *Golden Legend* [29:73]; this is the literature which Renaissance artists would have consulted. Later hagiographical publications, such as Butler's eighteenth-century four-volume *Lives of the Saints* [29:68], provide data on the saints and will often lead the reader to other publications which earlier artists might have used. For instance, Butler's work gives a citation to a Greek tenth-century mention of St. Catherine in Migne's *Patrologiae Cursus Completus, Series Graeca* [29:88]. Catherine's history is vague, ambiguous, and differs slightly depending upon the translations and sources consulted. It must be remembered that in the early Christian Church, local authorities could proclaim sainthood. The earliest official canonization record dates from about 993 with the first Roman Catholic Papal Canonization of St. Ulrich. In the twelfth century, Pope Alexander III forbade reverence to any person not authorized by the Papal See.

In tracing Catherine's legend, as many iconographical and hagiographical references as possible should be consulted, since each may supply different clues. The *New Catholic Encyclopedia* [29:105] relates that after the tenth century the cult of St. Catherine was especially popular in Italy and that she was the patroness for about thirty groups, such as students and teachers. Holweck's *A Biographical Dictionary of the Saints* [29:72] reports that Catherine was the patroness of jurists, philosophers, students, millers, wagonmakers, and teachers. Drake's *Saints and Their Emblems* [29:70] repeats the philosophers and students, but adds ropemakers, schools, science, and spinsters. Drake also states that St. Catherine was invoked for diseases of the tongue and by those who desired

eloquence, presumably of speech. Réau's *Iconographie de l'art chrétien* [29:61] details her legend, cult, and patronage plus scenes in which she was depicted. In addition, Réau cites specific works of art that represent St. Catherine from the twelfth through the eighteenth centuries, often the locations of the objects are included. The *Handbook of Legendary and Mythological Art* [29:17] mentions that Catherine was the patron saint of the Italian city of Venice. This was especially pertinent to the study, since the statue was Venetian.

Bibliographies on saints consist mainly of hagiographical references which detail their lives. For additional material, consult (1) *Iconclass* [19:14], which lists six bibliographical entries for Catherine and (2) either do a database search or check the volumes of *Art Index* [16:1], *RILA* [16:7], and *Répertoire d'art et d'archéologie* [16:6]. A search of *Art Literature International (RILA) Database* [16:7] resulted in ninety-eight entries; many were discussions of specific altarpieces in which she was one of the saints depicted. To find more general data on saints, check the "Subject Index" and scan the citations listed in *RILA* under "GENERAL WORKS, Iconography." The articles do not have to be specifically on St. Catherine to be relevant. For instance, "Aureola and Fructus: Distinctions of Beatitude in Scholastic Thought and the Meaning of Some Crowns in Early Flemish Painting," by Edwin Hall and Horst Uhr (*Art Bulletin,* Volume 60, June, 1978) provides a discussion of the use of halos and crowns. The footnotes and bibliographical references as well as the text are significant.

Biographical data on St. Catherine will be found in the hagiographical references, annotated in Chapter 29. Many of these list holy persons under their feast days, which are the days they died, were canonized, or that their relics were moved. It should be remembered that in Europe the date is written with the day preceding the month. For instance, 22 juillet, 22.7, and July 22 are the same day. In using foreign-language references, the name of the saint in that language must be used. For Catherine, this is simple; the variations are Katharina, German; Caterina, Italian; and Catalina, Spanish. For some saints, there are radical differences. St. James is Saint Jacques in French, hl. Jakobus in German, San Giacomo in Italian, and Santiago in Spanish. The *hl.* in German is an abbreviation for *heiliger,* meaning saint. Appendix D, which is a multilingual glossary, provides these name variations.

To locate works of art, researchers need lists of the various scenes and ways by which St. Catherine was depicted. If Reau and *Iconclass* have been consulted, the list is already formed. To discover works of art on St. Catherine, follow the methodology outlined in the eight basic steps. For hagiographical studies there is an important reference for Italian art. Kaftal's *Iconography of the Saints in Italian Painting* [29:77] covers the iconography of the saints in paintings from various sections of Italy. Profusely illustrated with black-and-white reproductions, Kaftal's four-volume work frequently includes inscriptions that are associated with depictions of the saint as well as a list of the literary references for these inscriptions.

In order to understand the background of a period and section of Italy, the following types of books should also be consulted: (1) general humanities surveys, (2) specific works on the country where the work of art was made, and (3) general books that discuss saints and their popularity. For an iconological interpretation of the anonymous Venetian fifteenth-century statue of St. Catherine, a study might include important items, such as (1) the history of Venice in relationship to the saint; (2) the religious importance of nunneries whose inhabitants aspired to emulate the virgin martyr as to humility, chastity, and poverty and who were also brides of Christ; (3) the new fifteenth-century emphasis on learning, erudition, and earthly justice; and (4) the importance of Catherine of Siena who has a story with many parallels to that of Catherine of Alexandria.

Reformation Themes

In order to understand the historic period of time in which Reformation art was produced, researchers should read the history of the Reformation. One source might be the three-volume, *Encyclopedia of the Lutheran Church* [29:98]. The ideas of Martin Luther, John Calvin, and other Protestant leaders changed art during the Reformation, just as the seventeenth-century Council of Trent had its effect on the art of the Counter-Reformation. The religious views of the artists and their patrons must be considered when studying iconography.

Works of art, such as depictions of the Man of Sorrows, frequently represent theological concepts. For instance, a German painting of Christ wearing the crown of thorns with his wounds showing, but not bleeding, may represent Reformation ideas.

These are not always easily located in the iconographical dictionaries; often there are entries on the subject but not enough cross references to lead the researcher to them. Réau [29:61] and Kirschbaum [29:58] have little to say about the subject. As with most studies on Christ, see Schiller's *Iconography of Christian Art* [29:62]. In the "Thematic Index," under both "Crown of Thorns" and "Man of Sorrows," there are references to the forty-two-page discussion of the subject.

For a detailed study, a bibliography must be compiled. *Iconclass* [19:14] provides insight into other depictions which might be researched and a list of forty-three bibliographical entries. A search for *Man(1w)Sorrows* in several databases brought forth a wealth of material. *Art Literature International (RILA)* [16:7] reported twenty-eight citations, most of which were for works of art that incorporate this theme. *Religion Index Database* [16:24] had two entries: for a 1980 book on the origin of the theme and its development in trecento Florentine painting and a 1979 symposium on the subject at Dumbarton Oaks, Washington, D.C.

But by far the best bibliographical source was *Art and the Reformation: An Annotated Bibliography* [12:29.2], by Linda and Peter Parshall. This bibliography includes numerous references on such subjects as Reformation religious iconography, artists and Reformation imagery, and the iconography of the Reformers. Although the index does not include the Man of Sorrows, the annotations provide information on a number of pertinent references works.

For illustrations of works of art depicting the theme, the best and most accessible source is Schiller's *Iconography of Christian Art* [29:62], which has more than 130 black-and-white reproductions for the Man of Sorrows. *Marburger Index* [19:7] has photographs and catalogue entries for sixty-seven works; *Index Iconologicus* [19:28], fifty-six prints; and The Index to Christian Art [19:20], a total of 371 works, including paintings, sculptures, frescoes, and illuminated manuscripts.

It is not always easy to obtain the literary source from which the title of paintings derive. But a book of familiar quotations can sometimes be helpful. In the third edition of *The Oxford Dictionary of Quotations* in the index under "Sorrows, man of" is an entry to Isaiah 53:2: *He is despised and rejected of men: a man of sorrows, and acquainted with grief. . . . Surely he hath borne our griefs and carried our sorrows.* A search of the *Bible (King James Version) Database* [29:93] also produced the correct verse.

Non-Christian Religious Subjects

Most dictionaries on subjects and symbols are concerned only with classical mythology and western Christian art. For other religious symbolism, students must turn to different tools. If the term is not known, it should first be checked in an unabridged dictionary. For example, in researching the Shiva figure, the second edition of the *Random House Dictionary of the English Language* related that Shiva or Siva is a Hindu god who is known as the Destroyer and in Sanskrit means the auspicious. Knowing that it is Hindu allows the researcher to check such resources as *The Hindu World* [29:179]; *Harper's Dictionary of Hinduism: Its Mythology, Folklore, Philosophy, Literature, and History* [29:188]; and *A Dictionary of Non-Christian Religions* [29:43]. Although the last reference has only a short entry, it does cite some of the god's other manifestations and literary references that include him. *Harper's Dictionary of Hinduism* has footnotes and provides the titles of Hindu writings in which Siva is mentioned. The most detailed discussion is in the two-volume *The Hindu World*, which has a three-page discourse that includes how the god appeared in art and a listing of some of his 1008 names or epithets. In addition, encyclopedias usually have articles that provide an over-view on this type of subject. For instance, the *Encyclopedia of World Art* [10:2] has twenty-four entries, such as the Cult of Saivism, cosmic symbolism, masks, terror and the malign, and representations of the lord of the dance.

In compiling a bibliography, *Iconclass* [19:14] should be consulted. Under *12 H*—which is the broad number for Hinduism, Buddhism, and Jainism—there is a listing for both general literature and for single deities. The former contains thirty-three literary citations, sixteen of which are in English. For the narrower term, Shiva, *Iconclass* has references to ten articles in various issues of *Arts asiatiques.*

Worldwide Art Catalogue Bulletin [15:13], which has an index to non-western art that includes Near and Middle Eastern Art, has an extensive

review for the *Manifestations of Shiva*. This 1981 scholarly exhibition catalogue was written by one of the experts in the field, Stella Kramrisch, and contains photographs and data on 190 pieces of monumental sculpture, altarpieces, and paintings. The illustrations are accompanied by the work's present location. Students can then follow through on this information. By checking the catalogues of museums—such as the British Museum, Brooklyn Museum, and the Asian Art Museum of San Francisco—that loaned these objects, more data can be collected. Furthermore, consulting other publications of the persons responsible for the catalogue will frequently lead to additional material. For instance, Kramrisch also wrote *Presence of Siva* (Princeton University Press, 1981). And there is a book on her essays, *Exploring Indias' Sacred Art: Selected Writings of Stella Kramrisch* (University of Pennsylvania Press, 1983), which contains a bibliography of her books and articles.

Dissertation Abstracts International Database [16:9] has thirty entries in which the abstracts use the words Siva or Shiva. Not all of the dissertations were germane to the study, as the computer picked up entries for anyone with that name, not just references to the Hindu god. But even allowing for the extraneous citations, more than half of these references were pertinent. Because Shiva has so many manifestations, it would be difficult to compile a chronology. But a chronology as to the known dates when various forms of the god were known and popular, would assist students in obtaining an overview of the subject. The material collected from the above resources also provide data on literary works that refer to Shiva. These should be perused; how many and at what depth, depends upon the study.

There is no good index to illustrations of non-Christian religious subjects. Consulting the catalogues of the various museums that have Oriental collections is one method of locating these essential reproductions. In addition, general books on Hindu art and religion will assist in the understanding of Shiva. Such works as Alain Daniélou's *Hindu Polytheism* (*Bollingen Series,* Princeton University Press, 1964) provides data on the Indian gods and philosophy. Books on mythology, such as Joseph Campbell's *The Mythic Image* (*Bollingen Series,* Princeton University Press, 1974), will furnish an over-view of the subject. These are easily located in the library's catalogue system or through a database search.

Classical Mythological Studies

As in other specialized iconographical studies, working on classical mythology requires subject-related tools. But the same eight basic steps, discussed earlier, are applicable. In studying the Judgement of Paris as used in Renaissance art, begin by referring to (1) Hall's *Dictionary of Subjects & Symbols in Art* [29:10], to study the outline of the myth and, perhaps, to discover literary references from which the story derived; (2) "Myth and Fable" in the *Encyclopedia of World Art* [10:2] for information on how different historic periods viewed this subject; and (3) one of the many mythological encyclopedias, some of which are listed in Chapter 29, to collect data on the principal characters—Paris, Athena, Hera, Aphrodite, and Eris, the Goddess of Strife. Remember that some of the mythological names are different, while others vary slightly in spelling—Athene, Athena, Pallas Athena, and Minerva are all the identical goddess. Appendix D lists the equivalent names of the Greek and Roman gods.

Just like the Christian Saints, the Greek and Roman gods had attributes. Researchers not familiar with the particular god or hero, should check Hall's dictionary [29:10] or *Iconclass* [19:14] to discover the correct mythological character. From the term, apple, both publications have cross references to the Judgement of Paris. Moreover, *Iconclass* provides an overview of the various ways this scene has been depicted in art. In addition, there are special dictionaries and references for mythology; see Chapter 29.

Usually originating as an oral tradition, myths were told and retold by the bards and poets. Only later were these tales transcribed, and, naturally, there are differences in the way authors perceived the events. Consequently, there is not one correct myth, which can be told in one and only one way. There are variations. For this reason, researchers must study myths as recorded by various writers. Although works, such as Lucian's *Dialogues of the Gods* and the dramatist Aeschylus' trilogy, *Oresteia,* are important, the following list is restricted to just three well-known authors who wrote about Greek and Roman myths.

The most famous Greek poet was Homer, who probably lived in the ninth century B.C. Thought to be both blind and poor, Homer is an illusive historical character about whom little is known, but much is written. His *Illiad* [29:46] is the tale of

the Trojan War, which was won by the Greeks after ten years of fighting. The final destruction of Troy is variously dated, some texts put it about 1193 B.C. The *Odyssey* [29:47] recounts the ten-year adventures of Odysseus, known as Ulysses in Roman mythology, as he returns from Troy to his home in Greece.

The Latin poet Virgil (Publius Vergilius Maro, 70 B.C.–19 B.C.) wrote the *Aenied* [29:49], an epic poem that relates the adventures of Aeneas, as he escapes the destruction of Troy after the Trojan War. Although there were stories concerning this demigod prior to the *Aenied,* Virgil is the one who created this literary masterpiece which won immediate fame and was for many centuries a popular textbook.

Latin poet, Ovid (Publius Ovidius Naso, 43 B.C.–17 A.D.) wrote the fifteen-volume, *Metamorphoses* [29:48], in which all of the characters—who are drawn from classical mythology—undergo some kind of transformation. His poetic descriptions were later depicted in well-known paintings and sculpture.

For a bibliography on the Judgement of Paris, use *Iconclass* and either a database search or check the volumes of *Art Index, RILA, Répertoire d'art et d'archéologie,* and *Dissertation Abstracts International. Iconclass* [19:14] lists twenty-seven entries, one of which is for Pigler's *Barokthemen* [29:60]. This could be important since Pigler gives the scene its German title, "Das Urteil des Paris." A chronology of Paris's life might provide some insight as to his involvement with Helen and the Trojan war.

For illustrations, see Havlice's *World Painting Index* [19:27] and Pigler's *Barokthemen.* Havlice lists a total of thirty-eight artists who depict scenes of Paris; Pigler, 250 works of art. Both books provide only the names of artists; reproductions must still be located. With the *Iconclass* number, works reproduced in the *Marburger Index* [19:7] can be investigated. There are a total of forty. The *Index Iconologicus* [19:28] has thirty entries for prints; the *DIAL* [19:25], fifty-two entries for Dutch and Flemish works on the subject. If the classical art or sculpture of the Renaissance was part of the study, Bober/Rubinstein's *Renaissance Artists and Antique Sculpture* [12:9], discussed in Chapter 5, should also be perused.

Because any thorough study requires the reading of history and interdisciplinary texts, there are several books which students should consult; a few of these are recorded in Chapter 29 under "Subjects in Art." After reading the annotations carefully, the books by Wind and Panofsky would appear promising, because they discuss Renaissance themes. Wind's *Pagan Mysteries in the Renaissance* [29:124] states that the Italian philosopher Ficino wrote to Lorenzo de'Medici that there were three kinds of life: contemplative, exemplified by the wisdom of Minerva (Pallas Athena); active, by the power of Juno (Hera); and pleasurable, by Venus (Aphrodite). In the contest, Paris had chosen Venus, just as Hercules had decided on heroic virtue and Socrates, wisdom. All three men were punished. To Marsilio Ficino, man must neglect none of the goddesses, but by honoring each according to her merits, will receive the attributes which she has to bestow. Wind's book provides additional mythological references for researchers to examine. In order to achieve a more complete understanding of Ficino and his influence, the student should read Panofsky's "The Neoplatonic Movement in Florence and North Italy" in *Studies in Iconology* [29:117]. The subject section of the library's catalogue system should be checked under "Ficino" for a list of his writings, translations of his works, and books that discuss his philosophy.

Secular Subjects

There is a growing interest in secular subjects. Although a broad field, only three specific types are discussed here: (1) emblem books, (2) nineteenth- and twentieth-century topics, and (3) objects illustrated in art.

Emblem Books

Emblem books were often used as source material by artists from the sixteenth through the nineteenth centuries. During the Renaissance in Italy, the Humanists became interested in the Egyptian hieroglyphics. They did not want to translate them, but to emulate their symbolic images. Using a variety of sources—the Bible, classical mythology, fables, bestiaries, and legends—scholars wrote descriptions of allegorical devices that represented abstract ideas, such as patriotism, liberty, charity, peace, and death. Later these ideas were (1) provided pictorial form; (2) accompanied by a motto plus an explanatory, and often moralistic, text; and (3) printed in books. Andrea Alciati's *Emblemata* of 1531 was one of

84

the most influential references which inspired artists as books increased in popularity, especially in Western Europe during the seventeenth and eighteenth centuries.

Related to the emblem books, Cesare Ripa's *Iconologia* [29:128] was originally published in 1593 without illustrations. By the early 1600s, Ripa's book had expanded to a three-volume, multilingual illustrated work, in which the text was of prime importance. Including more devices than the emblem books, Ripa described allegorical and personification figures as well as symbols and emblems. In his later editions, the illustrations were still secondary to the lengthy text. Published repeatedly throughout Europe, emblem books and Ripa's *Iconologia* had various editions and translations, some of which added supplementary visual material and often deleted or shortened the texts. *The Renaissance and the Gods: A Comprehensive Collection of Renaissance Mythographies, Iconologies, and Iconographies* [29:128] consists of fifty-five volumes, many of which are reprints of the various emblem books and different versions of Ripa's *Iconologia*.

Most emblem books were written in the sixteenth and seventeenth centuries, chiefly in Dutch, German, Italian, and Latin. For beginning students, there are two English-language versions available: Richardson's *Iconology* [29:128] and *Cesare Ripa: Baroque and Rococo Pictorial Imagery*. The former, written in the eighteenth century by the London architect George Richardson, is a translation of Ripa's descriptions accompanied by illustrations designed by William Hamilton. There are 424 subjects included. Some of Ripa's text was shortened; more figural representations were added. This was the form of Ripa's work by which late eighteenth-century English artists knew the *Iconologia*.

Cesare Ripa: Baroque and Rococo Pictorial Imagery [29:129] differs markedly from Ripa's original work. A translation of the 1758–60 German edition published by Johann Georg Hertel, the text is accompanied by full-page scenes designed by Gottfried Eichler, the Younger. The two hundred allegories, personifications, and symbols were chosen from various editions of Ripa's works. The long descriptive text is deleted; the illustrations are used as the major component of the book. Each scene consists of (1) the main allegory which derived from Ripa's text and (2) a small historic, literary, or mythological event, called *fatto*, placed in the background to serve as an example for the principal figure. The *fatti* provided additional material for artists, but were never part of Ripa's *Iconologia*. To help explain the allegories, the German edition also had a Latin inscription and a German couplet accompanying each scene. Remember this is an English translation of a German edition which greatly altered Ripa's work; it must be used with care.

In *Iconclass* [19:14], the fifth division—abstract ideas and concepts—includes 800 of Ripa's descriptions and has a special index coordinating *Iconclass* and Ripa's concepts. For the person studying this period, two other excellent references are (1) "Emblems and Insignia, Medieval through Modern West" by Mario Praz in the fourth volume of *The Encyclopedia of World Art* [10:2] and (2) "Humanist and Secular Iconography, 16th to 18th Centuries: Bibliographic Sources: A Preliminary Bibliography" by Sarah Scott Gibson [29:192].

Nineteenth and Twentieth-Century Subjects

If a work of art has a discernible narrative or theme, one of the best methods of obtaining insight into the piece is to read articles and books written about the same theme for works from the same milieu and time period. By studying the footnotes and bibliographies, a list of essential references can be compiled. Because research on social themes requires the use of multidisciplinary materials, the quickest method for finding pertinent data is through a database search, since this allows ideas and concepts to be linked.

Take, for instance, art which depicted the plight of women in English art of the nineteenth century. The computer files of *Art Literature International (RILA) Database* [16:7], *Art Index Database* [16:1], *ARTbibliographies MODERN Database* [16:2], and *Dissertation Abstracts International* [16:9] were searched. The statement read: fallen(w)wom?n OR plight(lw)women AND (19 or nineteen?) (1w) century or 1800?). Numerous pertinent articles were located; an important one is the article by T. J. Edelstein, "Augustus Egg's *Triptych*: A Narrative of Victorian Adultery," *Burlington Magazine*, April 1983.

Edelstein's article discusses some of the symbols in Egg's 1858 triptych, currently entitled *Past and Present*, which is composed of three separate paintings that, in sequence, depict the dissolution of a

Victorian family. But Edelstein does not just discuss this triptych and its symbolism, he provides an iconological meaning for the work. Having researched the position of women and the changing laws of Victorian England, he comes to the conclusion that the paintings reflect some of the then current social debates on the 1857 Matrimonial Causes Act, which altered Victorian laws by allowing Civil Courts to grant divorces, and on the 1839 Infant's Custody Act, which banned divorced or separated women from seeing their children. Edelstein also mentions Egg's close association with Charles Dickens, whose 1848 *Dombey and Son* used the theme of adultery as a subsidiary plot.

This type of study requires knowledge not only of Egg and his *œuvre* but also of Victorian history, laws, literature, mores, and social concerns. Edelstein's article provides citations for a number of interesting references, to name just two—*The Substance or the Shadow: Images of Victorian Womanhood,* 1982, and *Victorian Treasure House,* 1973. In addition, some of the references on the status of women and children, annotated under Cultural/Historical Surveys—such as Priscilla Robertson's *An Experience of Women: Pattern and Change in Nineteenth-Century Europe* [12:113] and The *History of Childhood,* edited by Lloyd de Mause [11:42]—will provide insight into the problems of this period. Twentieth- century social and psychological issues are similarly traced, some of these are published in serials and symposium papers.

Objects Illustrated in Art

Even if one specific symbol or item is being investigated, the eight basic steps, explained earlier, should be followed. Unfortunately, for most objects illustrated in art, such as sausages, the iconographical indexes provide too little data. But *Iconclass* [19:14] comes once again to the rescue. Under the correct number, there is a reference to one article. But there are also bibliographical citations for such peripheral ideas as slaughtered ox or pig and fat or lard. And surprisingly, the *Marburger Index* [19:7] reproduces five works of art that include sausages as the primary part of the painting.

For those who have access to the *Index of Christian Art* [19:20] , a cross reference will be found under "sausage-making," to see "scene: occupational, Sausage-making." One illuminated manuscript is listed. There are also two full drawers of cards for illuminated manuscripts depicting the seasons of the months. Under sausage, the *Index Iconologicus* [19:28] has cross references to the triumph of the sausage and to a mock ceremony of kingship. Both have one illustrated print. The latter is a caricature of a king who has sausages for a scepter and a wine jug for a globe. Under the term "slaughtering," *Index Iconologicus* has a cross reference to December and one image of an engraving after Guilio Romano. The entry "December" has a quote from Francis Bond's *Wood Carvings in English Churches,* 1910, which explains how during this month most of the animals had to be slaughtered, because there was not enough hay to keep them alive over the winter. In *DIAL* [19:25], a single painting, *Woman Making Sausages with Erotic Implications* by G. Schalcken, is illustrated. A database search brought forth no pertinent material. But frustratingly, by searching "ham," the computer kept reporting articles on Ham House in London. It takes much patience and digging to meet the challenge of research on individual objects depicted in art.

Research on People: Special Reference Tools

The basic methodology for formulating bibliographies and chronologies on artists was outlined in Chapter 3. Additional research tools needed for more advanced studies were detailed in Chapter 5. Building upon those discussions, this chapter suggests methodology for discovering material on (1) difficult-to-find artists, (2) authors, (3) collectors, and (4) art critics. For architects, see Chapter 9.

Difficult-to-Find Artists

There are many specialized research tools available for the person who is ready to dig, and that is what it usually takes to discover material on little-known artists. Although these artists may seem obscure today, they may have been prominent during their own lifetime. Consequently, data may be located in some earlier publications. But other artists have fallen into oblivion, never to recover. Even after years of searching, the information may continue to be fragmentary. This type of research takes time and patience.

To meet this challenge, consult the following types of reference tools:

1. the biographical dictionaries, especially the indices to them
2. exhibition, salon, and museum-collection catalogues and their indices
3. vertical files and scrapbooks
4. auction catalogues and their indices
5. visual resources, such as picture collections, especially those with indices to artists
6. art inventories or a census on artists
7. specialized bibliographies
8. archives or indices to manuscript collections or oral history projects
9. indices to periodical literature, including newspapers
10. art history surveys
11. city directories

Several artists are used to illustrate these steps: American painter William P. Babcock (1826–99), Englishmen William Henry Bartlett (1809–54) and Henry B. Baynton (1862–1926), and Guatemalan printmaker Rodolfo Abularach (1933–).

First check the general biographical dictionaries as well as the indices to specialized ones. It is essential to establish the person's correct name and dates. Remember that artists from all countries—including U.S. and Canada—are included in the foreign-language biographical dictionaries. Frequently these works provide the best clues for locating other pertinent data. For instance, in searching for material on Boston painter, William P. Babcock, citations were found in the dictionaries by Bénézit [10:27] and Thieme/Becker [10:47]. Both articles mentioned that he displayed his works at the Royal Academy in London and at the Salons of Paris from 1868 to 1878 and that he was associated with the Boston Athenaeum.

Although material on Babcock was found in these biographical dictionaries, the entries were brief—five or six sentences. With so little data, it is best to check *Biography Master Index Database* [10:70] and Havlice's *Index to Artistic Biography* [10:73] for titles of specialized biographical dictionaries. The former cited Babcock as being in Baigell's *Dictionary of American Art* [13:4]; Havlice added Mitchell's *Great Flower Painters* [10:43]. The former reported that Babcock lived in Barbizon, France, and that the Museum of Fine Arts in Boston has a number of his paintings. Mitchell's dictionary provided information on the subject matter of some of this artist's work and reproduced one of his paintings.

Armed with these facts, researchers will know which exhibitions to pursue. Both Bénézit and Thieme-Becker reported Babcock's association with the Boston Athenaeum. *The Boston Athenaeum Art Exhibition Index 1827–1874* [15:27] had entries for the eight years when he displayed his work. Although no reference mentioned that Babcock exhibited his work in New York, due to the proximity

of the cities, *A History of the Brooklyn Art Association with an Index of Exhibitions* [15:29] was consulted. A citation was found for his 1872 *Love and Reason*. Other exhibitions, such as those for the Montreal Museum of Fine Arts [15:30], might also be examined. Remember, artists from all nationalities were represented in various exhibitions. And because it was reported that Babcock had his paintings displayed at the London Royal Academy, the indices of British exhibitions should also be perused.

For early American exhibitions, consult *National Museum of American Art's Index to American Art Exhibition Catalogues: From the Beginning through the 1876 Centennial Year* [15:33]. This six-volume index provides access to 900 U.S. and Canadian exhibition catalogues, excluding the exhibitions which have previously been the subject of publication, such as the American Academy of the Fine Arts [15:24], the Boston Athenaeum [15:27], the Brooklyn Art Association [15:29], the National Academy of Design [15:31], and the Pennsylvania Academy of Fine Arts [15:28]. These should be searched separately. The *National Museum of American Art's Index* lists a number of entries for the name Babcock. There are seven for "Babcock, W."; four "Babcock, William"; two "Babcock, Wm."; one "Babcock, W.P.," and one "Babcock, Wm. P." Entries report titles of works, names and years of exhibition catalogues, art works' catalogue numbers, and the owners of the art. More thorough research will be needed to determine which are entries for the correct artist.

Indices to exhibition catalogues are good sources for locating artists whose work has recently been displayed. Some of these can be located by checking the artist's indices of such works as *Worldwide Art Catalogue Bulletin* [15:13] or the *Art Exhibition Catalogs Subject Index* [15:12]. But remember, not all artists whose work is displayed are listed in these reference works. But if the medium, style, and subject favored by the artist is known, a pertinent exhibition catalogue might be located. For instance, if a fifteenth-century painter is Sienese, his work may have been included in *Painting in Renaissance Siena 1420–1500*, the 1988 catalogue for the exhibition at the Metropolitan Museum of Art. Check the catalogue; even if the specific artist's work was not displayed, the scholarly text will provide further insight into artists of this period. It often takes ingenuity to find a specific resource.

Whenever a reference is discovered to a specific institution that owns one of the artist's works, check to see if a museum collection catalogue has been published. For instance, due to the mention that one of Babcock's works was in Boston, the *American Paintings in the Museum of Fine Arts, Boston* was consulted. Seven entries and one reproduction of his work were discovered. Other museum catalogues revealed supplementary data. In addition, the indices to museum collections, such as *Paintings in Dutch Museums* [19:34], might bring forth information on the location of the artist's works. Remember that indices to museum collections document all kinds of art; the only stipulation for inclusion is that the work is owned by a specific institution.

The vertical files that some libraries maintain are excellent sources for material on artists, past and present. For example, although the Dallas Public Library has a collection which was started only about twenty-five years ago, its Fine Arts Department has vertical files containing material—clippings from the local newspapers as well as the *New York Times* and the *Christian Science Monitor*, exhibition catalogues and announcements, gallery and museum notices, plus other ephemera—on approximately 6,500 artists who not only work in the region but in other geographical locations. No differentiation is made on the stature of the artist; everything is saved. The material in a library's vertical files is available to visiting researchers and sometimes, for a small fee, the material will be photocopied and sent.

With the publication of the New York Public Library's *Artists File* [13:71], this type of material is being made available to a larger audience. These vertical files can save researcher's time, since they contain the actual newspaper clippings, auction catalogue entries, or small exhibition catalogues. The *Artists File* contains ephemera for 90,000 people associated with art; all geographical locations and periods of art are covered. For instance, in looking for information on Englishman William Henry Bartlett, the *Artists File* had material under both William Bartlett and William Henry Bartlett. These are two different artists. This is why establishing the dates of an artist is so important. The *Artists File* also had data on William P. Babcock as well as eight other people with this last name, some of which may be related to the artist; there

was also a file for the Babcock Galleries in New York. And what was more remarkable, there was information on the Guatemalan printmaker, Rodolpho Abularach.

One of the most extensive vertical files on contemporary artists is at the Museum of Modern Art. Emphasizing living persons, the files contain rare material on approximately 25,000 to 30,000 international artists, and the files grow yearly. There are references to this vertical file information in the *Catalog of the Library of the Museum of Modern Art* [12:96]. Presently, the material is available to those who visit the MoMA Library, but since these files are being photographed, they will soon be accessible at other libraries as well. There are also extensive files at the National Gallery of Canada; *Artists in Canada* is not just Canadian artists, but those who worked in this country. There is a directory [13:100] to the material, some of which is available on microfiche. Sometimes, gallery directors save similar material for the artists whom they represent. If data are needed, researchers should write the director of the gallery which represents the artist. To discover these galleries, consult the *Guide to Exhibited Artists Series* [10:38] and the summer issue of *Art in America*.

Good sources for finding information on little-known artists are the auction information indices, which are discussed in Chapter 5. For instance, Englishman, Henry Baynton, 1862–1926, had four citations in *Art Sales Index* [18:7] for works which sold between 1974 and 1981. Prices ranged from $324 to $623, paltry sums on the international art market. Only one of the sales catalogues illustrated the sold painting. Some of the catalogues were difficult to locate, since they included the auction houses of Grant Stourport and Galerie Dobiashofsky, as well as the more familiar Sotheby Belgravia and Christie's in London. The notation of four of Baynton's works—their titles, dimensions, plus signature and date—provided additional material on this artist, who, up to this point, had brief entries only in *Dictionary of British Watercolour Artists* [10:41] and *Dictionary of Victorian Painters* [12:75], but no where else. If the sales catalogues cannot be located, the auction houses can be contacted to request a photocopy of the entry and any additional information that they might have. For these addresses, consult either *International Art and Antiques Yearbook* [20:44] or *International Directory of Arts* [20:39].

Sometimes detective work can be rewarding. With a notation of a sale of an artist's work, more data can be collected by checking an annotated sales catalogue which might record the name of the buyer. For example, in researching William Henry Bartlett, a reference was discovered in Bénézit's biographical dictionary [10:27] to a sale date for January 23, 1936. Because Bénézit does not report auction houses, all catalogues of sales held on that date had to be examined. Lugt [18:47], Lancour [18:46], and *SCIPIO* [18:48] are resources that can help in the discovery of what firm held an auction on a specific date. When the correct auction catalogue from the American Art Association Anderson Galleries was located, the entry for *View of Stevens Castle Point, Hoboken* included a photograph, the work's measurements, plus exhibition and provenance information. The auction catalogue that was examined was from the Knoedler Collection [18:42], whose catalogues have handwritten annotations. This one added that in 1934 the painting sold for $160.00 to someone named Sperling and that in 1936 it had been purchased for $155.00 by M.A. Linch. The researcher would then need to examine the 1934 auction catalogue. Unfortunately, there was no specific date provided. Once again Lugt, Lancour, or *SCIPIO* can be used to resolve this dilemma. Under the index to owners in Lancour's book [18:46], there was a reference provided to a sale of objects owned by Hiram Burlingham for January 11, 1934. The correct catalogue had an entry for *Landscape View of Stevens Castle Point Hoboken*. Notice the slight title change; similar facts were printed. Because there is no one source that covers all auction information, this detective work is necessary. Little by little, data can be collected.

Other sources for locating lesser-known artists are visual resources, detailed in Chapter 5, especially extensive collections which have indices to artists. Remember, the original works of art may be scattered throughout the world. For instance, In *A Checklist of Painters c. 1200–1976 Represented in the Witt Library, Courtauld Institute of Art, London* [19:13], Babcock's name is included as are citations for "Bartlett, William H., British, 1809–1854" and "Bartlett, William Henry., British, 1858– ." Researchers can view the reproductions of the works by these artists either at the Witt Library in London or one of the several microfiche copies which have been made of this valuable picture collection.

Some libraries have picture collections which reflect their collecting interests, such as the Fashion Institute of Technology or the Avery Architectural & Fine Arts Library. Some of these can be extensive. For instance, the National Gallery of Art and The J. Paul Getty Center have large collections of photographic images, many of which are on microfiche. The Frick Art Reference Library has a vast collection of mostly European and American master artists' works for which the librarians have done additional research. For William Henry Bartlett, the Frick Library had forty-seven catalogued reproductions of paintings and drawings plus eighteen more unmounted illustrations of his work. The bibliographic entries on the back of the reproduction cardboards reported two articles, one in a 1941 issue of *New York History,* the other in the 1936 *Bulletin of the Detroit Institute.* Although there are 269 photographs of Bartlett's work in the microfiche Witt Library Collection [19:13], which the Frick Library owns, most of them provide only the name of the artist. Researchers must utilize more than one picture collection, for each institution will have different works of art illustrated and varying degrees of data recorded.

Any special inventory or census on artists should be investigated, since they are frequently the best source for facts on little-known artists. For instance, the Yale Center for British Art has (1) a photograph archive which includes reproductions of British artists from the Witt Library plus photographs of about 15,000 works in U.S. and Canadian museums; (2) a separate British Artists Biography File, which includes records of about 5,000 artists who worked in Great Britain—medieval illuminators, architects, and interior designers are excluded; and (3) a computerized index, started in 1977, to British Art from about 1500 to the 20th century. The computer files can be searched by subject, such as landscape, seascape, portrait, or genre. Although the files are only available at Yale University, written and phoned enquiries are answered. When information on William Henry Bartlett was requested, a printout of twenty landscape paintings, drawings, and sketches plus a work attributed to the artist was sent. Where known, entries provided titles, media, dimensions, signature data, locations and accession numbers, the institutions that owned the photographs' negatives, subject categories, and availability of illustrations at the Yale Center for British Art.

For researchers studying American art, there are two unpublished inventories, both in Washington, D.C.: (1) The Inventory of American Painting Executed Before 1914 [19:29] at the National Museum of American Art and (2) The Catalog of American Portraits [19:52] at the National Portrait Gallery. The former was a bicentennial project begun in 1976, which presently includes information on about 230,000 paintings in a computer file and almost 45,000 photographic reproductions of these works. There are three indices to the paintings: artists, owners or locations, and subject classification. Babcock is represented by twenty documented paintings. The titles of the works, their dimensions, present owners, and last known sales are reported.

The Catalog of American Portraits contains photographs and documents on 80,000 historically important Americans. Paintings, sculpture, drawings, miniatures, and silhouettes are included. Organized by sitters' names, there are cross references to the artists who did the likenesses. Babcock was listed as having painted a miniature of the Marquis de Lafayette, owned by the Metropolitan Museum. Although this same data was reported by the The Inventory of American Painting Executed Before 1914, the portrait index provided more details, even giving a place where the work was exhibited. Both of these files have a photograph for most listed works. Researchers have access to both of these resources by visiting the museum or, for simple requests, by mail.

Specialized bibliographies often report material on artists who are not esteemed today. For instance, E. James Mundy's *Painting in Bruges, 1470–1550: An Annotated Bibliography* [12:29.8] has material on more than 100 artists working during that time; nineteen are noted only by the title Master. Published transcriptions of documents relevant to the painters are reported; each artist listed in the documents is included. In addition, under the sections "Genealogies" and "Guilds and Artists," there is information on numerous obscure artists.

In addition, the catalogues of holdings of famous libraries have entries for thousands of artists, many of whom are lesser known. For instance, the *Library Catalog of the Metropolitan Museum of Art* [17:12] has eight entries for William Henry Babcock and a notation that he was a draughtsman and

illustrator. With this information, some of the indices to illustrators, annotated in Chapter 22: "Prints and the Art of the Book," might provide additional data. In addition, some library catalogues, such as *Catalogue of the Library of the National Gallery of Canada* [13:94], have notations to their artists' files. Some of this material might be available on microfiche or the reference librarian may photocopy some essential items.

For American art there is one essential bibliography, which not only details exceedingly difficult to find data but also is full of marvelous little tidbits which so delight researchers. *Arts in America: A Bibliography* [13:44] is a collection of twenty-one separate annotated bibliographies written by various experts. Many of the bibliographies have references for individual artists. "Sculpture" by William B. Walker, for instance, provides bibliographical citations for about 365 sculptors; "Photography" by Beaumont Newhall, for approximately 170 photographers. Because it provides references to persons mentioned in the annotations as well as those for whom there are citations, the general index should be consulted. For instance, Babcock has two entries in "Painting: Nineteenth Century" by J. Benjamin Townsend. But by using the index, another reference was found. The citation was for Marchal Landgren's article, "The Two Worlds of Robert Loftin Newman," in *Antiques,* December 1975. The annotation discusses Newman's association with fellow artists, such as Babcock. Unless the index was examined, this entry would not have been located.

The two principal citations for Babcock in Townsend's bibliography were for a 1970 exhibition catalogue, *American Pupils of Thomas Couture,* and *The Great American Nude: A History of Art,* 1974. References to these books were not discovered elsewhere. Townsend's bibliography also provides access to thematic categories—such as seascapes, religious art, still life, and genre—as well as works concerned with regional sections of the United States—New England, The South, and the Middle West. In using *Arts in America,* researchers should not just study the specific bibliography which fits their artists; other essays may also have pertinent material. For example, Walker's "Sculpture" has citations for works concerned with the International Expositions and the World's Fairs from 1876 to 1970, including European and

Japanese, as well as North American expositions. "Design: Nineteenth Century," by Demtra Pulos, includes bibliographical data on the major Industrial Exhibitions from London in 1851 to Chicago in 1893. Anyone studying American art needs to become familiar with this four-volume reference.

One of the most extensive collections of primary research material on U.S. painters, sculptors, and craftsmen is the Archives of American Art. Containing 5,000 collections consisting of six million items on artists, the material is photocopied and available through interlibrary loans. *The Manuscript Collections of the Archives of American Art* [13:61], a ten-volume work which reproduces the library's inventory card file, is organized by collections of papers and individual items or series of items. The filing is under the proper names of individual artists, collectors, and organizations. The collection includes varied and different types of material, such as exhibition brochures, letters, photographs, sketchbooks, business records, and even diaries. Under William P. Babcock, there is a notation that some clippings among the Mary Bartlett Cowdrey File refer to him. In addition, for contemporary artists, there is an oral history program [13:62] of taped interviews with more than 1,200 people in the arts. At the Archives of American Art, there has been an aggressive campaign to photocopy other existing archival material on American art. For instance, the Pennsylvania Academy of Fine Arts owns twenty letters dating from 1866 to 1906 which Thomas Eakins wrote. The Archives of American Art photographed them in 1964. Thus scholars can find copies of this material at more than one site.

Sometimes an artist can be located through indices to manuscript collections or oral history projects. For instance, Jack Robertson's *Twentieth-Century Artists on Art: An Index to Artists' Writings, Statements, and Interviews* [12:152], which covers 5,000 artists, had a notation for the Guatamalan Rodolfo Abularach. *The Index to Personal Names in the National Union Catalog of Manuscript Collection 1959–1984* [13:68] helps pinpoint specific people who are represented in that archive.

The general indices to art periodicals are usually unproductive sources for lesser-known artists, but they should still be checked. Database searches are the most efficient method of discovering whether or not the person is included in these numerous publications. Sometimes, even the remotest name will

appear. Also check the newspaper indices, especially for the year of the artist's death. For contemporary artists, some of the databases—such as *Magazine Index* [16:21] which covers a number of regional periodicals—such as *Boston Magazine, Los Angeles, New York, Philadelphia,* and *Texas Monthly*—may help in locating material. Although most art history survey texts focus on master artists and innovators, sometimes references to harder to find people will be included. This is especially true for older publications or for surveys covering a brief historical period. But unless a citation is found to a specific monograph, checking surveys of the period could be a fruitless search.

For lesser-known American artists, locating an address in a city directory can establish a person's place of residence. With this information, the library and museum of the community can be contacted to inquire as to whether or not any vertical files or exhibition data might be available on the artist. *City Directories of the United States* [20:52] is a microform reprint of these reference tools. Each city directory provides such information as a list of city residents for that year, a list of people by professions, an indication of business firms, advertisements for household goods, and a city map. These city-directory reprints can be purchased by segments for individual states. Few libraries will have extensive holdings. Remember, for artists who have not displayed works of art in major exhibitions or whose works are not in great demand, it may be impossible to collect much data concerning them. But take it as a challenge. For clue by clue, piece by piece, the puzzle may fit together.

Authors

Before quoting books extensively, researchers should know how other scholars evaluate these works. The authors' credentials should be checked and reviews of their books studied. This will also keep researchers informed of current publications. Reading several reviews may shed light on the author's ideas and may foster the understanding of certain points. To discover book reviews of the author's works, consult the sources annotated in Chapter 16 and read the section on the subject in Chapter 5. In order to compile biographical information, consult the indices of biographical dictionaries, such as *The Biography and Genealogy Master Index* [10:70] and the *Marquis Who's Who Publications: Index to All Books* [10:75]. For

death notices, *The New York Times Obituaries Index 1858–1968* [16:56] curtails checking individual volumes of the *New York Times Index.*

Most indices do not include the various who's who books published in other countries; these should also be consulted. In obtaining material relating to the author's expertise, facts concerning a dissertation topic and titles of various books by the author should be located. Check *Comprehensive Dissertation Index, 1861–1972* [16:9] or search the online database. For book titles, the many catalogues published by the Library of Congress and the catalogues of famous libraries, all of which are described in Chapter 17, may have pertinent entries. Another source is the annual publication, *Books in Print* [20:55], which lists all books published in the U.S. in a given year. Other countries have equivalent annual listings.

Art Collectors

During the past decades, there has been considerable interest in art collectors and individual taste. This has resulted in museum exhibitions and the publication of books on the subject. *The Vatican Collections: The Papacy and Art*—the 1982 catalogue of the exhibition held at the Metropolitan Museum of Art of New York City, The Art Institute of Chicago, and the M. H. de Young Memorial Museum in San Francisco—discusses the art collected by various Roman Catholic Popes, from the fourth century to the present. Other exhibitions have been held in order to recreate part of a specific collection. For example, in 1966 the National Gallery of Stockholm displayed some of the art that Queen Christina removed from Sweden upon her abdication in 1654. In addition, there has been a continuous interest in the extensive collections of rulers, such as Napoleon and Hitler. Illustrating the artistic taste of kings, queens, and dukes, are such books as, J. H. Plumb's *Royal Heritage: The Treasures of the British Crown* [28:60] and Hugh Trevor-Roper's *Princes and Artists: Patronage and Ideology at Four Habsburg Courts, 1517–1633* [28:66].

Some collectors have built a special museum for their art, such as the J. Paul Getty Museum at Malibu, California, and the Kimbell Art Museum in Ft. Worth, Texas. Other patrons have donated their art to one or more museums, such as Samuel Kress and Paul Mellon. Books, such as Francis Henry Taylor's *The Taste of Angels* [28:64] and

Aline Saarinen's *The Proud Possessors* [28:61] relate the stories of some of the famous collectors of history.

Researching material on prominent collectors requires the following:

1. developing a bibliography including references on the person's life and data on each object and artist represented in the collection
2. formulating a chronology relating to the person's life; dates of purchases of collected works; any sales which occurred; dissolution of the collection, if this happened; and any later exhibitions of the collection
3. obtaining reproductions and compiling catalogue entries for as many of the works as possible

Follow the basic steps outlined in Chapters 3 through 5. For American collectors, refer to the Archives of American Art, see above.

Due to the problems of locating inventories, this type of research can be time consuming, depending upon the patron and the period when the collection was formed, and whether or not the art objects have been dispersed. Especially important are the museum catalogues that have indices to former owners of the works of art now in their collections and the compilations of Lugt [18:47], Lancour [18:46], and *SCIPIO* [18:48] which provide access to references on collectors who have disposed of some of their art. While compiling this data, remember there may be discrepancies. For example, Caillebotte was a collector of Impressionist art. As illustrated in Example 1, some sources report sixty-five paintings in his bequest; others cite sixty-seven or sixty-nine.

Art Critics

Art criticism has had a tremendous influence on art. During the French Impressionist exhibitions, the fact that the art critics castigated the works helped set the climate by which the French government officials refused many of the paintings in the Caillebotte Bequest. The role of the critic can be especially important in understanding certain artists and periods of art. George Heard Hamilton's *Manet and His Critics,* 1954, is an excellent example of an analytical study that examines the influence of French writers on the nineteenth-century painter, Edouard Manet.

In order to discover what critics have had to say about an artist's works and to assess the quality of the critic's artistic judgment, consult

1. references of collected writings that discuss art and criticism
2. books and articles written on or by the critic
3. magazines and newspapers for which the critic wrote and the indices that cover them
4. one-artist exhibition catalogues and monographs that may reprint evaluative critiques
5. biographical dictionaries that provide data on critics in order to determine their credentials

Elizabeth Gilmore Holt's *The Triumph of Art for the Public: The Emerging Role of Exhibitions and Critics* [12:105] details public art exhibitions in France, England, Italy, and Germany from 1785 to 1848. A brief historical essay describes each exhibition followed by English translations of some of the critical assessments of the displayed works of art. In *The Art of All Nations, 1850–73* [12:106] and *The Expanding World of Art 1874–1902* [12:107], Holt continues this format. Gerd Muehsam's *French Painters and Paintings from the Fourteenth Century to Post-Impressionism* [12:33] reproduces selections from criticisms and writings concerning the works of about one hundred French artists. *Arts Criticism Series* [12:154] has separate books on different critics.

It should also be remembered that in assessing the influence or effect of criticism on artists and their works, one must gauge the nature, domicile, and extent of the audience who read the critiques. For instance, Denis Diderot (1713–84) wrote at great length, often in minute detail, on nine of the biennial Paris Salons between 1759 and 1781. These readable articles were printed in *Correspondence litteraire, philosophique et critique de Frederic Melchior Grimm,* a newsletter which was circulated to an exclusive list of subscribers, most of whom never saw the French Salon exhibitions. Many of the patrons, such as Catherine the Great of Russia, lived outside of France. The effect of Diderot's critiques—which were only published many years after his death—on the Parisian Salon viewer was probably nil, but these comments undoubtedly influenced the foreign market for French art as well as the method and style of writing used by later art critics.

CHAPTER 9

Architectural Research

Although there are many different ways of approaching architectural research, the methods described here are divided into (1) architects, (2) monuments and buildings, (3) construction and building materials, (4) historic preservation, and (5) business and technology. Although Chapter 21 lists references pertinent to architectural studies, many resources cited in Part III also cover the subject. This section supplements the basic research methodology explained in the previous chapters.

Architects, Present and Past

For research on architects, data must be collected concerning their names, nationality, and dates as well as the architectural firms with which they are associated. For instance, information on Charles-Edouard Jeanneret-Gris, the twentieth-century Swiss architect, is often located under his trade name, Le Corbusier. It must also be determined which part of the name—individual or firm—may be used. For example, Ludwig Mies van der Rohe is indexed under *M* for Mies. Eero Saarinen and Associates is usually listed under "Saarinen, Eero." But Kevin Roche is usually entered under K for the firm's name—Kevin Roche, John Dinkeloo and Associates. For famous architects who are members of companies that do not contain their names, the listings may be under either. Gordon Bunshaft of Skidmore, Owings and Merrill is placed under B for Bunshaft in *Art Index* [16:1], but under the firm's name in some of the other indices. Although there are cataloguing rules which explain these types of listings, students should remember that several approaches must often be tried in order to find all entries.

One of the best biographical references is the four-volume *Macmillan Encyclopedia of Architects* [21:50], which has 2,450 comprehensive biographies of architects, past and present. Under Thomas Jefferson, there is a nine-page, illustrated, signed article which contains a list of architectural works with their dates and a bibliography of fourteen entries. Two other references for living Americans are *Pro File: Professional File Architectural*

Firms [21:48] and *Contemporary Architects* [21:49]. The former, published by the American Institute of Architects (AIA), is an AIA membership directory that has indices for firms and principals allowing researchers to obtain data regardless of whether or not the name of the architect or firm is known. Covering 575 professionals, *Contemporary Architects* includes chronologies, publications by and on the architects, and short essays on their works. In addition to biographical data, an integral part of research on architects is viewing their works and studying the floor plans, elevations, and drawings for their projects. This methodology is detailed below.

Monuments and Buildings

Various types of architectural research have their own resources and challenges. In addition to knowing how to use the tools described in Chapters 3 through 5, students will need other types of resources. This section describes (1) the basic steps for architecture research, which should be read by all students; (2) special problems pertinent to archaeology and classical works; (3) the study of historic architecture; and (4) how to discover data on contemporary and future buildings.

Basic Architectural Monuments Research

Prior to studying a specific building, the exact location—city, state or province, and country—must be determined, since citations may be listed under any one of these. For an architectural monument, information must be collected on such items as:

1. function and style of the building
2. preliminary designs and plans
3. pertinent specifications, rules, regulations, or codes
4. construction site and building plans and method
5. construction materials
6. the topography of the surrounding area

7. reactions to the finished building
8. any restoration or preservation

While collecting and organizing this data, researchers should:

1. formulate a bibliography and chronology
2. visit the site and obtain visual material to study the building
3. investigate various influences which affected the design, planning, and restoration of the work

This section discusses these three items. Monticello, Thomas Jefferson's home which he designed and built outside of Charlottesville, Virginia, is used as an example.

Bibliographies and Chronologies

Separate chronologies for the building and for the architect should be compiled. In the case of Example 20, at the end of this chapter, on Monticello, because this was not Jefferson's primary profession, pertinent facts concerning his career were included in the one chronology. Remember, a chronology does not end with a person's death or with the finished building. Information on resales, changes of ownership, alterations, and restoration is especially important to the chronology of a building.

This section discusses some special architectural resources, most of which are listed in Chapter 21. Research methodology for compiling bibliographies is detailed in Chapters 3 through 5; a similar order will be followed: dictionaries and encyclopedias, art-history surveys, exhibition catalogues, serials and their indices, databases, specialized bibliographies, vertical files, and picture collections. In addition, architectural research frequently uses other types of resources: (1) travel books, maps, and personal reactions to the monument, (2) trade literature and data on the construction materials used, and (3) specifications, rules, and regulations concerning the building.

The easiest method of conducting this type of research is to start with the architect, if the person is prominent. But for buildings which are also well known, check under both architect and building, since the citations may be different under each. Of the general art encyclopedias, *McGraw Hill Dictionary of Art* [10:3] is an especially good source for architecture. There are a number of architectural term and biographical dictionaries, many

cover only one continent or a specific style. Check the listings in Chapter 21. One of the best is the *Macmillan Encyclopedia of Architects* [21:50], which has already been discussed.

Architecture has some very specialized bibliographies which have been compiled by the staffs of the Avery Architectural Library of Columbia University and the Royal Institute of British Architects, known as RIBA. Both have important print and computer references. For major architects and monuments, these will provide a wealth of material. For Avery, these include:

1. *Avery Index to Architectural Periodicals* [21:127] and its database
2. *Catalog of the Avery Memorial Architectural Library* [21:98]
3. *Avery Obituary Index to Architects and Artists* [21:59]

For RIBA, there are

1. *Architectural Periodicals Index* [21:126] and its database
2. *Catalogue of the Royal Institute of British Architects Library* [21:101]
3. *Catalogue of the Drawings Collection* [21:114]

Closely check the coverage of the four general art indices; for instance, *ARTbibliographies MODERN* [16:2] dropped coverage of architecture in 1989 and *Art Index* [16:1] is the only one which covers classical Greece. Using *Architectural Index* [21:125], an annual covering only about ten serials, often provides quick access to pertinent articles but is hardly adequate for more detailed research. *Architecture Periodicals Index* [21:126] and *Avery Index to Architectural Periodicals* [21:127] are important indices to this pertinent material. Because of the numerous citations in these files, a database search is the most efficient research method.

Not all of the pertinent information will be found in art and achitectural indices. A search of *America: History and Life* [16:15] brought forth forty-five entries on Monticello and Jefferson. The articles included such diverse serials as *Early American Life, Smithsonian, Eighteenth-Century Life, Historic Preservation,* and *Daughters of the American Revolution Magazine.* The subjects and serials covered a wide range: "The Levys and the Restoration of Monticello" in the *American Jewish Historical Quarterly* and "The Hennings Family of Monticello" in the *Virginia Cavalcade.*

Architectural research encompasses many aspects, such as how people experience the enclosure of space. Other databases will often provide bibliographical references to these other considerations. Several searches brought forth articles published in the *Journal of the Society of Architectural Historians:* (1) "Monticello: 1856," providing a nineteenth-century visitor's reaction to the finished building, and (2) "Mr. Jefferson as Revolutionary Architect." For additional material, consult the catalogues of the large general art libraries, such as the Metropolitan Museum [17:12], Harvard University [17:11], and the New York Public Library [17:13].

Retrieving information concerning architectural styles is particularly easy, since this subject has been well researched. There are several series on historical architecture, such as the *History of World Architecture* [21:68] and the *Pelican History of Art* [11:80]. Although some of these were published decades ago, they are still useful reference tools, since many contain floor plans, elevations, and illustrations. Individual volumes of the *Pelican Series* along with other architectural surveys are annotated under the specific style, culture, or country in Chapters 11 through 14.

Information on building types—such as museums, hospitals, or stadiums—is more scattered. Nikolaus Pevsner's *A History of Building Types* [21:69] provides a brief history of the development of a number of kinds of buildings. For each chapter, there is a detailed bibliography. Other sources are dissertations, which have research reports for places of worship, palaces, libraries, schools, hospitals, museums, theaters, prisons, and commercial buildings. Searches of the special architectural databases, such as those of *Avery* [21:127] and *RIBA* [21:126] will bring forth additional bibliographical information.

There have recently been a number of important exhibitions that have spotlighted specific architects, buildings, or architectural materials. *Worldwide Art Catalogue* [15:13] has a special heading for Architecture under "Index of Media." A review located in the *Worldwide Art Catalogue* indicated that the exhibition catalogue, *The Eye of Th. Jefferson,* reproduced drawings, prints, maps, books, furniture, and other decorative materials owned by the Virginia statesman. Although no specific mention was made of Monticello, the review reported that the scholarly essays discussed (1) the inhabitants and topography of Virginia; (2) British life

under George III; (3) scientific, exploratory, and archaeological activities in the Age of Enlightenment; and (4) Jefferson's architectural designs. The exhibition catalogue reproduced numerous important preliminary drawings of Monticello, material that is not readily available.

There are numerous architectural bibliographies of varying size and quality. The American Institute of Architects, called AIA [21:87], has more than 300 available on an assortment of subjects, as does *Vance Architectural Bibliographies* [21:96]. The annotated volumes of the *G.K. Hall Art Bibliographies Series* [21:90] presently includes *Chartres Cathedral;* more will be published in the future.

All scholars know that archival material is important for research; the challenge is to find it. Usually this material is not included in the library's catalogue. In some instances, archival material is being published, especially for contemporary architects. For instance, there are *The Le Corbusier Archive* [21.117.1], *The Mies van der Rohe Archive of the Museum of Modern Art* [21:117.3], and *The Louis I. Kahn Archive* [21:117.2]. Remember, these are photographs of material owned by one institution; they may or may not cover the buildings which the researcher is studying.

For most archival material, the researcher should consult the *National Union Catalog of Manuscript Collections* [13:67], a series of publications consisting of (1) annual catalogues that list archival records and provide descriptions of the contents and the locations and (2) indices that provide access to the records by names of persons, firms, associations, and location sites. In the example used in this chapter, the cumulative index for 1975–79 of the *National Union Catalog of Manuscript Collections* [13:67] had two references under Jefferson's name. The entry indicated that the Southern Historical Collection of the University of North Carolina at Chapel Hill has 530 items plus one reel of microfilm of architectural and archaeological data pertaining to the restoration and preservation of Monticello. These records include field notes, drawings, photographs, and slides. Because numerous historical collections report their holdings, this Library of Congress publication can be a rich source for information on archival material.

Because there are so many architectural records tucked away in unlikely places, some organizations have decided to encourage the preservation of these

materials and to assist scholars and students in locating them. COPAR, the acronym for Cooperative Preservation of Architectural Records, was founded in 1973. The Library of Congress Prints and Photographs Division—which is discussed in Chapter 22—has promoted certain aspects of COPAR, especially the development of state committees. COPAR has published or encouraged several important surveys on the cities of New York, Boston, Philadelphia, Chicago, San Francisco, and Washington, D. C. These references list institutions that have preserved architectural documents, such as drawings, blueprints, photographs, and records. See "Indices to Research Materials" in Chapter 21.

In addition, COPAR has a "National Union Index to Architectural Records," a computerized file of more than 5,000 entries which was begun in 1973. All of the material published on the cities of New York, Boston, Philadelphia, Chicago, and Washington, D.C. plus comparable material supplied by individuals and institutions is in this bibliographic database. The main access point is by architect's name. Other access points include the personal names important to the record being described; the building's name, location, type, and construction date; and the owner and location of the record. Presently information concerning the architectural records in the "National Union Index" can be obtained by writing or telephoning COPAR, Prints & Photographs Division, Library of Congress, Washington, D.C. 20540, (202)–707–8867.

Libraries and historical societies often have vertical files on local buildings in their area. This material can usually be located by writing these institutions. Another source is to write the director or curator of the building being studied. For instance, the Thomas Jefferson Memorial Foundation's 1984 *Report of the Curator* included a chronology of the house since 1955 and the titles of the various publications on Monticello issued during each year. This type of publication is exceedingly hard to locate except at a library in the building's area.

An integral part of architectural research are personal accounts, travel books, and maps—both historical and current. These works often provide information about the site on which the building was constructed. Personal accounts of visits to the building—such as the description provided by two visitors which was reprinted in the article, "Monticello: 1856"—are ways to learn about any alterations that might have been made. Travel books usually describe how the area looked in a certain period of time. By reading these references, changes in the building and its environment may be discerned. In Chapter 21, there is a list of both historical and current travel books, many of which include detail maps. Historical atlases define the changing boundaries over the centuries, modifications which sometimes result in new nations or different political alliances. Maps of states, cities, and even specific districts may provide essential data on the site and the surrounding environment. An historical atlas with a map of Virginia in the early nineteenth century indicates that Monticello was isolated from much of the newly formed state. Only larger libraries have an adequate supply of this type of reference material.

Topographical information is needed in order to understand the surroundings of the building, both the general environment as well as the immediate area. Many nations have funded or encouraged national surveys. For instance, the Royal Commissions on Historic Monuments in England, Scotland and Wales has records for many shires in these countries. Begun in 1910, the inventories were for all notable buildings completed before 1850, which was the final terminal date. Divided by parishes, entries are subdivided by prehistoric monuments, Roman monuments, ecclesiastical buildings, secular architecture, and unclassified monuments. There are detailed descriptions, photographs, line drawings, maps, and floor plans. Although not all shires were inventoried, all of the sixty-five volumes which have been published are available on microfiche [21:122].

One of the great U.S. architectural projects is the Historic American Buildings Survey. Begun in 1933, and greatly facilitated by the Historic Sites Act of 1935, the HABS—as the survey is abbreviated—was conducted by the National Park Service in consultation with the American Institute of Architects. Although the survey ceased between 1941 and 1956, the historic collection has continued to increase measurably since that date. With the 1966 National Historic Preservation Act, the National Park Service in cooperation with state and local governments has continued the inventorying of historic structures. The survey includes about 31,000 measured drawings, 45,000 photographs,

and 15,000 additional records. Now one of the largest collections of architectural records in the world, the material is deposited in the HABS Archives in the L.C. Division of Prints and Photographs. Much of the material can be purchased through the Photoduplication Service, Library of Congress, Washington, D.C. 20540. Some HABS archival material has been published in books by Garland Press [21:121] and on microforms by Chadwyck-Healey [21:120].

In addition, there are the extensive Sanborn maps. The Sanborn Map Company, which has been in operation for more than a century, has mapped every U.S. city and town with a population of more than 2,500 people. The maps, which date from 1867 to the present, cover commercial, industrial, and residential districts of 12,000 municipalities in the United States, Canada, and Mexico. The updating of *Sanborn Maps* [21:47] differs with the agreement between various municipal governments and the company. About sixty large cities have a lease agreement by which the Sanborn Map Company updates their maps on an annual basis. Other municipal governments purchase the maps and negotiate a revision every five to ten years. Some small towns have never had their maps updated. The maps provide street-by-street information concerning street names, general shapes and sizes of structures, and sometimes building materials and approximate measurements. By studying the maps over a number of years, major additions or deletions can be discerned as well as alterations in the neighborhoods. These maps can be extensive. For instance, the maps of all five boroughs of New York City are contained in seventy-nine volumes which have about 6,000 maps. These are updated annually. Researchers can usually discover the cities for which maps have been made, as well as for which years, by consulting *Fire Insurance Maps in the Library of Congress* [21:47], a checklist of some 11,000 volumes of Sanborn maps owned by the U.S. Library of Congress. Since many of these maps can be purchased on microfilm, researchers should ask as to their availability.

For historical buildings, trade literature may also be needed. This is composed of actual sales catalogues of firms, including manufacturers of such items as hardware and bricks and the people who supply services, such as stone masons or designers. In order to discover the types of materials available at certain periods of history, some of the trade literature should be consulted. *The Guide to American Trade Catalogs: 1744 through 1900* [24:87] is a bibliography for these reference tools. Other sources are *American Architectural Books* [21:92]—which lists builders' guides, pattern books, and other architectural books published in America before 1895—and Helen Park's "A List of Architectural Books Available in America Before the Revolution." (*Journal of the Society of Architectural Historians,* 23 (October 1961):115–130). Most of the books cited in the above bibliographies have been reprinted on microfilm by Research Publications.

There are also a number of reprints of some late nineteenth- and early twentieth-century trade literature. Two extensive microfiche publications are (1) *Trade Catalogues at Winterthur* [24:96], of 1,885 catalogues, and (2) *Architectural Trade Catalogues from Avery Library* [24:93], of 2,300 catalogues. Advertisements published in nineteenth-century newspapers and serials are other sources. There are also articles, especially those in magazines such as *Historic Preservation,* that discuss the hardware and building materials available during historical periods.

Throughout the research, there will be some information on the construction materials used in the work being studied. For an understanding of how these materials affected the building, research must be done on that specific type of brick, stone, marble, wood, or whatever kinds of materials were used. This can lead to a study of engineering and construction problems; these are discussed later in this chapter.

Most cities today have building codes that limit what can be constructed. This has not always been the case. Jefferson probably had few limitations—other than money, accessibility of materials, lack of skilled labor, and time. However, in the twentieth century, there are specifications and regulations concerning the restoration of the building. These rules and regulations should be considered. This often entails a trip to the site and an extensive search through archival records of primary source material.

Visual Materials

In any art research, it is essential to view the actual artistic creation. For architecture, which is three dimensional, it is even more important. There is no substitute for personally experiencing the

structure in space. If possible, the building or monument should be personally visited, as often as possible, in order to study:

1. all sides, angles, and details
2. the scale of the building
3. the effect of the construction materials
4. the environment surrounding the work

Each time the site is viewed, some new facet will be observed. When visiting the building remember to purchase or gather any pamphlets or written information which the building's owners might have. It is difficult, if not impossible, to find these types of small brochures later. Even after visiting the building, numerous reproductions will be needed. Personally photographing the work can be less expensive but may be impractical. Commercially produced illustrations usually must be used.

Because buildings are such complex structures, numerous plans and blueprints had to be made prior to their construction. Researchers must understand how to read these architectural records. For assistance, see one of the architectural dictionaries, such as Cyril Harris' *Dictionary of Architecture and Construction* [21:6]. Until the use of reproductions on microforms, scholars had to do their own photographing, spend time locating any extant architectural plans, and visit various North American and European photographic archives. Now some of these collections, discussed in Chapter 5, are being reproduced on microforms. But they are expensive; not all libraries will have them. Be sure to inquire if such resource material is available before traveling to a distant library.

One of these architectural resources was published by the Dunlap Society, formed in 1974 to produce a visual documentation of all American art. The organization's name derives from William Dunlap, who in 1834 published *The Rise and Progress of the Arts of Design in the United States* [13:28], probably the first American art history book. Among the society's projects, two studies have been published on microfiche: *Architecture of Washington, D.C.* and *County Court Houses of America* [21:116]. The images are also available as 35 mm. slides or as photographs. Each publication consists of a looseleaf binder which has storage for the microfiche plus a printed table of contents and factual data on each structure. The visual material consists of multiple views of the building's exterior and interior, preliminary drawings, photographs taken during construction, and views of the site, both before and after the monument was erected.

Influences on Architecture

The discussion on the influences on art in Chapter 6—which every student should read—is pertinent to architectural buildings and monuments as well as to individual works of art. This material is not repeated here, however, a few examples will be provided to emphasize the importance of influence on any historical study.

Obviously, other art has always influenced artists. This is especially evident in architecture. The Gothic churches that copied aspects of Notre Dame in Paris are documented. Many of the skyscrapers in large, international cities have such a similar look that it is difficult to distinguish one from another. The literary effect of the writings of such famous architects as Vitruvius, Alberti, and Palladio is apparent. But there is other literature, not by architects, which has also had a tremendous impact. This is especially true of the literature of a theological and religious nature. In *The Mass of the Roman Rite: Its Origins and Development* [29:101], Jungmann relates the changes in the Roman Catholic rites and rituals to the alterations in ecclesiastical needs, including architecture. Certain religious ideas have dictated building requirements. Because the Carthusian monks wished to live in small separate cells, monasteries had to be designed to accommodate this community of hermits. To remind Moslems that it is time for worship, tall minarets were added to mosques, thus allowing the muezzin's call to be heard by the faithful.

Especially important to architecture are the influences created by geographical conditions, such as weather, site, location, and availability of materials and transportation. These conditions had more of an impact before engineers and scientists had the ability to develop materials and construction methods which could overcome some of these geographical limitations. For example, without the seasonal flooding of the Nile River, the Egyptians could not have floated the quarried limestone to the pyramids. Because of the cold inclement weather, English Decorated Gothic churches usually had a long rectilinear plan which allowed people to congregate, and even to hold meetings, in the first nave

without disturbing the religious services in the rest of the building. The history of architecture is closely related to scientific developments. The inventions of concrete, iron, and steel had tremendous impact on construction. For instance, before the invention of the elevator, most apartment houses and offices were curtailed to a height of four or five stories. Without the present engineering knowledge, skyscrapers could never have been constructed.

Enormous building programs are often used by political dictators to demonstrate their benevolent effects on the country. Caesar Augustus, Napoleon, and Hitler all commissioned numerous buildings. Versailles was created to glorify the French monarch, Louis XIV. Economic factors often decide what can and can not be built and at what cost in money, power, and people. Because the French government coffers were depleted following the Hundred Years War with England, churches in the Flamboyant Gothic Style were relatively small compared with those designed earlier. Social changes also bring architectural alterations. After Louis XIV's death, members of the French Court, who were weary of life at Versailles, had town houses, called hôtels, built in Paris. Dramatic productions influenced the construction of theaters as well as the decorative effects on other buildings. The Palazzo dei Conservatori in Rome was redesigned in the sixteenth-century, partly by Michelangelo, to provide a dramatic setting.

Studying architecture and its influences requires a multi-faceted search strategy. For example, to discern if there is any influence of the medieval theater on the sculpture of the French Romanesque Church of Saint-Gilles-du-Gard, there are two general starting points—medieval theater and Romanesque churches—as well as the specific example, Saint-Gilles-du-Gard. Database searches can link the two principal concepts. Not only will a bibliography need to be compiled but footnotes found in relevant articles and books must be studied. Finding the exact information one is seeking is in part dependent on the researcher's creativity in conducting a bibliographic search.

Archaeology and Classical Antiquities

Research on archaeological and classical antiquities follows the basic resources just described. All of the names—past and present and sometimes in various languages—by which the work and the site on which it was built must be learned prior to

beginning the study. Specialized dictionaries will help establish these facts. For example, if the Altar of Zeus and Athena which once was at Pergamum in present-day Turkey is the project, the *Illustrated Encyclopaedia of the Classical World* [11:50] might be one of the first references to be consulted. This book would indicate that Pergamum can also be spelled Pergamon and that it is today called Bergama. The entry records some of the ancient history of the area, refers to three English-language books, and provides cross references to other related terms.

It must be remembered that the countries whose scientists and historians have done the excavations and restorations will usually publish the most scholarly reports. If the monument, or parts of it, have been moved, this compounds the problems. For instance, the Altar of Zeus and Athena excavated at Pergamum in Asia Minor was relocated in 1930 to the Pergamon Museum in East Berlin. Research would involve data on the Asia Minor site, the nineteenth-century excavations, the restoration of the temple in Germany, the damage done by bombing during World War II, and the present condition of this Hellenistic temple.

For the excavation site, articles in *The Princeton Encyclopedia of Classical Sites* [11:60] and *Paulys Real-Encyclopädie der classischen Altertumswissenschaft* [11:59] should be consulted. For information on the temple, the catalogues of holdings of famous libraries in Chapter 17 and the index and abstracting services in Chapter 16 should be checked. In these references the material is listed under various headings: (1) "Pergamum, Altar," (2) "Pergamon, Altar of Zeus," (3) "Pergamus-Archaeology," (4) "Berlin Museen-Pergamon Museum," and (5) "Staatliche museen zu Berlin, Pergamonmuseum" with a cross reference to this entry from "Pergamonmuseum, Berlin." There are numerous entries in the catalogues for the libraries at Columbia University [21:98], Metropolitan Museum [17:12], and Harvard University [17:11]. *Art Index* [16:1] has a wealth of material. Most articles are on the excavations, past and present; a few are on the altar. At least 80% of the titles cited are in some language other than English.

One of the most important aspects of architectural research is to find varied views of the buildings. The published picture collections, annotated in Chapters 19 and 21, may provide the illustrations required. But it must be kept in mind that some of these collections have photographs taken

in countries other than their own and that some of them include the objects owned by museums. For instance, the Altar of Zeus and Athena was excavated from its site at Pergamum in Asia Minor and was relocated to the Pergamon-Museum in East Berlin. Photographs could be in the *Marburger Index* [19:7], the *Conway Library* [19:3], or the *Index of Ancient Art & Architecture* [19:5].

Historic Architecture

Because the example used in describing the basic steps to be followed in architectural research was Jefferson's Monticello, most of the important historical resources have already been discussed. But buildings located in non-English speaking countries often have additional challenges, as the example of the twelfth-century French church of St-Pierre at Aulnay of the ancient feudal district of Poitou will illustrate.

For historical works, all of the names for the building and the location site—past as well as present—may be needed. One of the better sources is *McGraw-Hill Dictionary of Art* [10:3]. However, even in this reference, some buildings are entered under their popular name—such as the two Pantheons, one of which is in Paris, the other being in Rome—while some monuments are listed under the city or town in which they were built, such as "Aulnay St. Pierre." Popular usage is usually the key factor, but students must remember to look under more than one type of entry—city, name of building, or architect. Moreover, not all architectural terminology has remained constant. For clarification of various historical terms, consult *Illustrated Dictionary of Historic Architecture Sourcebook* [21:65] or the *Illustrated Dictionary of Architecture, 850–1914* [21:66]. In addition, a geographical dictionary will help find specific locations, such as Italian or French provinces.

Choosing a specialized reference tool will more likely produce pertinent data. For French churches, there is an especially detailed reference, *Dictionnaire des Eglises de France* [21:2]. This five-volume work includes even small French ecclesiastical buildings, regardless of historic period. The entries are under broad geographical locations—such as north, west, or south-eastern—and an atlas or travel book may be needed to pinpoint the location. Remember that for centuries the nation now known as France consisted of feudal regions—such as Normandie, Anjou, and Bourgogne—which

changed boundaries and political allegiances numerous times over the centuries. All of this was altered with the 1789 French Revolution. In order to unify the country, the ancient divisions were reapportioned into ninety-five districts, utilizing the names of natural geographical boundaries, such as mountains and rivers. Reference material on French architecture can use either the ancient feudal divisions or the present French departments.

In the *Dictionnaire des Eglises de France* in the volume of Sud-Ouest under "Poitou, Saintonge, Angoumois," an entry was located for the Church of St. Pierre at Aulnay. There was a one-page discussion, four illustrations, a small floor plan, and four bibliographical references. This provided information that the town, which is sometimes referred to as Aulnay-de-Saintonge—meaning the town of Aulnay of the Saintonge district—was originally part of the feudal region of Poitou, located near the border of the Saintonge area, hence the misnomer. It also provided the modern geographical department in which the town is now located, the Charente-Maritime. The *Répertoire d'art et d'archéologie* [16:6] had information under three terms—Aulnay, Poitou, and Charente-Maritime. This data was also necessary to locate any entries for Aulnay in the Romanesque ecclesiastical monuments series, published by the European Zodiaque Company [11:122], which had discussions of the church in two books—*Poitou roman* and *Haut-Poitou roman*. Additional information was located under "Saintonge," because the architecture in this district influenced the builders of St. Pierre.

In certain artistic periods, sculpture was such an integral part of the architecture that references that discuss one usually contain data on the other. Such is the case with medieval art. For Aulnay, *French Romanesque Sculpture: An Annotated Bibliography* [11:138.4] has thirty entries, many of which include detailed information on the church building. The abstracts also provide additional data on the area. Another difficulty with researching buildings in a non-English speaking country is that of locating and obtaining the articles once the titles are discovered. Some material on St. Pierre at Aulnay was published in *Congrès archéologique de France* and the *Bulletin de la Société des Antiquaries de L'ouest et des Musées de Poitiers,* references not readily available in most North American libraries.

In order to view as many reproductions of the building being studied as possible, researchers may need to study some of the photographic archives reprinted on microforms. Under "Aulnay" in *Index Photographique de l'Art en France* [19:6], there were 189 photographs—mostly taken in 1925/26 and 1940/44—of the exterior and interior of the church. Usually, it is only through these extensive photographic archives that sufficient views and details of a building can be located.

Contemporary and Future Buildings

For architectural projects which have been recently completed, the correct building title, exact location, and architectural firm need to be known, because any of these may be used by the various references. The quickest method for finding data is through researching the architect, a process discussed above. If the architect is not known, the index and abstracting services, especially a database search of newspapers local to the building project, will assist in discovering data, since these resources provide access to the latest material. For completed projects, databases that cover magazines may be searched, since serials usually report only finished works. When the name of a contemporary building is known, but not the architectural firm nor the exact city, several sources may have to be used. For instance, in seeking data on the Sears Building, a cross reference was found in *RILA Cumulative Index, 1975–1979* [16:7] under "Sears Bank and Trust Company" to "Chicago, Illinois." With the city established, *Architecture Index* [21:125] was consulted. Under "Illinois, Chicago, Office Building-High Rise," a reference to the Sears Building reported the architectural firm of Skidmore, Owings and Merrill. With these facts, the search became easier.

For announced projects which are not yet completed, the best method is to try a database search, especially in a file that covers local newspapers or regional magazines of the town where the project is to be built; see the example used in Chapter 4. Large major projects are usually easy to find. For smaller projects, the search will be less productive. The best resource is usually the vertical files of the city's public library, which may have clippings from the local newspapers. For a small fee, copies of this material is usually available to people who write the Fine Arts Librarian.

Another resource is the owner of the building. Often the building plans and pertinent material concerned with the construction can be located through writing those in charge of the actual structure. The material is sometimes made available to researchers. The person to contact is usually the Director of Public Relations, who can channel the inquiry to the correct department. Personally interviewing those concerned with the planning and construction of the work will also add to the knowledge of the building. The researcher can inquire at the tax office of the local city hall concerning the availability of any plans and papers which were deposited with the city government in order to obtain the building permit. If specific questions arise, a letter to the architect may receive a reply.

Construction and Building Materials

When seeking information on building materials, it is important that an exact statement of the study, as well as synonyms of some of the terms, be developed. "I need something on concrete?" must be refined before the project begins. The changes created by weather on the strength of reinforced concrete is, naturally, a more specific query. *Engineering Index* [21:128], which covers about 2,000 serials has numerous entries for this subject. Synonyms and alternate terms for building materials should be compiled, since various references use different words than the ones the researcher is using. For example, travertine might also be termed limestone or Italian marble. There are references which define architectural vocabulary, both for current and historic terminology. The *International Dictionary of Building Construction* [21:23] defines terms used in English, French, German, and Italian. For synonyms used by the abstracting and indexing services, the thesaurus that a few of these companies publish may be of assistance.

If the architect or interior designer is considering a terrazzo floor, there are a number of books that provide details on this non-structural covering. Two particularly good references are *Construction Glossary* [21:24] and *Construction Materials and Processes* [21:25]. Both report data on the properties, types, uses, applications, and history of terrazzo. For additional information, the technical indices and abstracts cited above can be used. And for the most recent material, or for information on

some specific aspect, the *COMPENDEX Database* [21:128] should be consulted. In a search of this computer file for <u>terrazzo/MAJ AND resistan?/ MAJ</u>—where the truncated <u>?</u> allowed for resistant or resistance and only major descriptors were sought—two publications were discovered. The computer printout reported both as being in the *Natl Bur Stand Spec Publ,* an abbreviated title for *National Bureau of Standards Specifications Publications,* a pamphlet issued by the United States Government and usually kept in loose-leaf binders or vertical files. Since most printed versions of a database have a list of the serials covered, if the student does not know the translation of an abbreviated title, these hardbound copies can be consulted. For *COMPENDEX Database,* this is *Engineering Index.* If in doubt, ask the reference librarian for assistance.

Historic Preservation

In 1895, the National Trust—an independent, nonprofit society—was founded to safeguard England's heritage from industrialization, destruction, and neglect. Receiving no subsidy from the government, the National Trust [21:37] protects manor houses, historic buildings, and land in England, Wales, and Northern Ireland. Included are villages, the remains of part of Hadrian's Roman Wall, nearly 300 miles of unspoilt coastline, and more than 200 houses of historic importance. In 1907, an Act of Parliament incorporated the National Trust and empowered it to declare its property inalienable, thus ensuring that such property can never be given away or sold. By an Act of 1934, the National Trust was allowed to accept a house, with or without its furnishings, as a gift and in return to allow owners and their descendants to continue living in the house rent free. In this manner, the crippling death-duty taxes can be circumvented.

The National Trust of England was modelled on the Charter of the Massachusetts Trustees of Public Preservations, which was established in 1891. The National Trust for Historic Preservation, however, was not chartered by the U.S. Congress until 1949. A nonprofit educational organization, the American society, the National Trust for Historic Preservation, publishes books, the monthly *Preservation News,* and the quarterly *Historic Preservation.* The U.S. government is also involved in the saving of national monuments. The National Park Service, created in 1916 under the direction of the U.S. Department of Interior, is responsible for such projects as the Historic American Buildings Survey [21:118–121] and the National Register of Historic Places [21:36]. See Charles Hosmer's *Preservation Comes of Age* [28:36] and Arnold Markowitz's *Historic Preservation: A Guide to Information Services* [28:38].

The preservation of architectural monuments is important at all levels—national, state, county, and local. In 1858 the Mount Vernon Ladies Association purchased George Washington's Virginia home. This was the first of many U.S. tax-exempt foundations and societies to be formed to preserve individual homes. At the historic sites, there are often repositories of archival material, which researchers may use. Some societies publish material on architectural monuments. Knowledge of these pamphlets and books may not be available except through writing the society. In 1940, the American Association for State and Local History [28:35], known as AASLH, was established in order to develop programs and activities to help communities preserve significant historical resources. This association publishes a monthly magazine, *History News,* and numerous books and technical pamphlets on a vast array of topics.

Business and Technology

Practicing architects need references to aid them (1) in meeting the standards and regulations set by various governmental agencies—federal, state, and local—and (2) in calculating the costs of projects. For the former, an online database search may be profitable. For the latter, check the resources located in the library's business and technology division. Such materials as the *Dodge Building Cost Calculator and Valuation Guide* [21:79], *Dodge Manual for Building Construction Pricing and Scheduling* [21:80], and *Architectural Graphic Standards* [21:74], published by the American Institute of Architects, will help students understand the problems encountered with the business end of architecture, an area beyond the scope of this book.

CHRONOLOGY OF MONTICELLO: THE VIRGINIA HOME
DESIGNED AND BUILT BY THOMAS JEFFERSON

1735 Tract of land on which Monticello would later be built obtained by Peter Jefferson, a land surveyor and County Lieutenant of Albemarle County, Virginia.

1743 On April 13, Thomas Jefferson was born at Shadwell, the family's Virginia tobacco plantation, to Peter Jefferson and Jane Randolph.

1757 Upon Peter Jefferson's death, his son Thomas received the tract of 1052 3/4 acres of mountainous land on which Monticello will later be built.

1760-62 Jefferson attended the College of William and Mary.

1767 After studying law for five years, Jefferson admitted to the bar. First mention of estate in Jefferson's Garden Book, a chronicle he kept from 1766 to 1824: entry of August 3, "Inoculated common cherry buds at Monticello."

1768 The top of the estate leveled.

1769 First road to estate constructed from Charlottesville, which was about two miles away. The south pavilion of Monticello was begun. Jefferson's first known study of Monticello shows a square wooden house having rectangular rooms and little axial relationship. There are no stairs or chimneys.

1770 By this date Jefferson's library probably contained Palladio's Four Books of Architecture and James Gibbs' Rules for Drawing the Several Parts of Architecture. Before February, several plans for the house had been designed: a cruciform with wooden walls and loggia and a cruciform plan of brick construction without loggia. Notes on these two drawings indicate they were made before the final position of the house was determined. Numerous studies for the auxiliary buildings were drawn. One shows a single two-story building with stables and a chariot room on the lower level and a suite for the owner above. The lack of windows in the rear of the lower level and the presence of a door on that side of the upper story indicates Jefferson's intention to build the stables on the side of the mountain. A drawing marked "summer" has the earliest general lay out of the mountain top. By autumn a design was completed for the main dwelling, utilizing the general arrangement and form of a Palladio villa. Other drawings indicate that two buildings were intended to form balancing wings on either side of the arcades. By September there were drawings of the slave quarters which were planned for the estate. After the family home at Shadwell burned, Jefferson moved to Monticello on November 28.

1771 Small pavilion, in which Jefferson lived completed.

1826 On July 4th, Jefferson died at Monticello; buried in the family plot on the estate. Monticello, its furnishings and surroundings, were bequeathed to his daughter, Martha Jefferson Randolph. Due to indebtedness, Monticello advertised for sale for $26,000.

1827 In January, the household furnishings sold at public auction. Vandalism led to the closing of Monticello to visitors.

1829 The last of the Jefferson family moved from Monticello.

1831 House and 552 acres of the estate purchased for $7,000 by James T. Barclay of Albemarle County, Virginia.

1834 Monticello sold for $2,500 to Uriah Phillips Levy, a native of Philadelphia.

1836 Levy moved to Monticello.

1862 Levy died in New York City. Monticello seized by the Confederate government.

1863 Levy's heirs broke his will in which he had bequeathed Monticello to the United States government for an agricultural school for orphans of American seamen.

c. 1881 Jefferson Monroe Levy bought out other heirs and began repairing Monticello.

1882 U.S. Congress appropriated $10,000 for a monument to be placed over Jefferson's grave and for its maintenance.

1916 Fiske Kimball published Thomas Jefferson's drawings, which had been collected by Jefferson's great-grandson, Thomas Jefferson Coolidge, who had deposited them with the Massachusetts Historical Society, Boston. Many of the drawings are of Monticello.

1923 On December 1st, the Thomas Jefferson Memorial Foundation, which had been organized on April 13, 1923, purchased Monticello by paying 1/5 of the $500,000 sale price. Restoration program initiated.

1940 Virginia Garden Club provided $10,000 plus skilled supervision for the restoration of some of the gardens.

1954 House structurally renovated at a cost of over $250,000.

1959 The Thomas Jefferson Memorial Foundation began an annual $5,000 grant to the Alderman Library of the University of Virginia to purchase documents and manuscripts relating to Jefferson and Monticello. The grant made possible the assembling of more than 3/4 of the titles in Jefferson's original library.

1960 Doveton Nichols compiled a definitive checklist of Jefferson's drawings from U.S. collections.

1976 The Eye of Jefferson, an exhibition at the National Gallery, Washington, D.C. focused on Jefferson as an artist and architect.

1983 Monticello featured in Architectural Digest, Volume 40 (August 1983): 116f, "Historic Home: Monticello" by William Howard Adams; book by William Howard Adams entitled Jefferson's Monticello published by Abbeville Press, New York, 1983.

Example 20: A Chronology of Monticello: The Virginia Home Designed and Built by Thomas Jefferson (first and last pages).

SECTION B

A Bibliography of Research Sources

While reading the discussion in "Section A: Methodology" on how research tools are used, references are continuously made to the bibliographical entries in this section, which consists of the following divisions:

"Part IV: General Art Research Tools" records basic reference works covering a wide range of media
"Part V: Specialized Resources for Different Media and Disciplines"
"Part VI: Iconographical Resources"

For information on the contents of this section, see "Using This Book," the introduction, and the table of contents. Since it would be impossible to list all relevant art resources in this guide, only some significant or representative ones are recorded. Although specific titles for artists monographs, catalogue raisonnés, and *Festschriften* as well as museum collection and exhibition catalogues are mostly excluded, the methodology for finding these important refernces is provided. Many of the cited works were published many years ago; this does not diminish their usefulness. Often they are the best sources on the subject.

To increase the usefulness of this book, add other appropriate resources and the call numbers and libraries owning them. Brackets indicate main entries; 11:138.2 refers to Chapter 11, the 138th entry, the second publication. The bibliographical citations do not follow any one style guide but are an abbreviated form. Except in the main bibliographical entry, shortened titles are used.

PART IV
General Art Research Tools

This section lists various types of resources essential to art research. Chapter 10 covers generalized art encyclopedias and both term and biographical dictionaries. Chapter 11 has resources for artistic styles, periods, and cultures from prehistoric art through the Gothic period; Chapter 12, from the Renaissance to the Contemporary. Chapter 13 cites reference tools for American and Canadian studies. Chapter 14 covers other geographical areas, such as Latin America, Asia, Africa, and the Pacific, including Australia and New Zealand. Chapter 15 discusses how to locate museum collection catalogues and exhibition information. Chapter 16 has annotations for indexing and abstracting services and most databases. Chapter 17 discusses general bibliographies; Chapter 18, sales information; Chapter 19, visual resources and subject indexing. Chapter 20 lists reference directories. For specialized resources on particular media and disciplines, see the appropriate chapters of Part V.

Art Dictionaries

Some of the following dictionaries are illustrated. All provide short summaries of terms and styles; a few include biographies of artists.

10:8 Adeline, Jules. *The Adeline Art Dictionary: Including Terms in Architecture, Heraldry, and Archaeology.* New York: Frederick Ungar, 1966.
> Based upon *Lexique des termes d'art;* first English translation was in 1891.

10:9 *Artist's Manual: Equipment, Materials, Techniques.* New York: Mayflower, 1980.
> Pictorial dictionary of terms.

10:10 Hill, Ann, ed. *A Visual Dictionary of Art.* Greenwich, CT: New York Graphic, 1974.

10:11 Mayer, Ralph. *The Artist's Handbook of Materials and Techniques.* 4th ed. rev. New York: Viking, 1982.

10:12 ———. *A Dictionary of Art Terms and Techniques.* New York: Thomas Y. Crowell, 1969.

10:13 Mollett, John William. *An Illustrated Dictionary of Art and Archaeology, Including Terms Used in Architecture, Jewelry, Heraldry, Costume, Music, Ornament, Weaving, Furniture, Pottery, Ecclesiastical Ritual.* New York: American Archives of World Art, 1966.
> Reprint of 1883 London edition of *Illustrated Dictionary of Words Used in Art and Archaeology.*

10:14 Murray, Peter and Linda Murray. Rev. ed. *Dictionary of Art and Artists.* New York: Penguin, 1984.

10:15 Osborne, Harold, ed. *The Oxford Companion to Art.* Oxford: Clarendon, 1970.

10:16 Quick, John. *Artists' and Illustrators' Encyclopedia.* 2nd ed. New York: McGraw-Hill, 1977.

10:17 Read, Herbert, ed. *Encyclopaedia of the Arts.* New York: Meredith, 1966.

10:18 Runes, Dagobert David and Harry G. Schrickel, eds. *Encyclopedia of the Arts.* London: P. Owne, 1965; reprint of 1946 ed. Gale Research 1982. 2 vols.

10:19 Savage, George. *The Art and Antique Restorers' Handbook: A Dictionary of Materials and Processes Used in the Restoration and Preservation of All Kinds of Works of Art.* Rev. ed. New York: Frederick A. Praeger, 1967.

10:20 Verhelst, Wilbert. *Sculpture: Tools, Materials, and Techniques.* 2nd ed. Englewood Cliffs, New Jersey: Prentice-Hall, 1987.

Foreign-Language Art Term Dictionaries

10:21 Apelt, Mary L. *German-English Dictionary: Art History-Archaeology/Deutsch-Englisches Worterbuch: Für Kunstgeschichte und Archäologie.* Berlin: E. Schmidt, 1982.

10:22 *Glossaire des termes techniques à l'usage des lecteurs de la nuit des temps,* by Dom Melchior de Vogue and Dom Jean Neufville, rev. by Raymond Oursel. 3rd ed. Paris: Zodiaque, 1983.
> French medieval terms.

10:23 Masciotta, Michelangelo. *Dizionario di termini artistici.* Florence: Le Monnier, 1967.

10:24 Réau, Louis. *Dictionnaire polyglotte des termes d'art et d'archéologie.* Paris: Presses Universitaires de France, 1953; reprint, Osnabruck, Zeller Verlag, 1974.
> Includes most Western European languages plus Latin.

Biographical Dictionaries

Research on artists or authors begins with biographical dictionaries. This section lists general biographical dictionaries—divided into works that cover (1) artists: all media, (2) illuminators and miniaturists, (3) sculptors, and (4) authors. Specialized biographical dictionaries are cited in the appropriate chapters. Biographical dictionaries for special types of paintings, such as marine or landscape painters, can be extensively illustrated and be good sources for lesser-known artists. Consult the indices to biographical information, listed below, for difficult-to-locate artists. Remember that some dictionaries were published long ago and represent 19th-century scholarship.

Artists: All Media

10:25 *Allgemeines Künstler Lexikon.* Leipzig: Seemann, 1983+
> Ambitious new publication is updating and expanding *Thieme-Becker* [10:47], one of the most scholarly biographical dictionaries published, and Vollmer [10:49], which covers 20th century artists. Like *Thieme-Becker*, this dictionary gives data on

painters, sculptors, architects, engravers, and some decorative artists plus locations of some of their works. Lists abbreviations reporting German terms and abbreviations used for bibliographic entries. Provides an English explanation of how to use the book. Be sure to read this section, for it gives information on how certain names are alphabetized and romanized. Under "Benutzungshinweise," there is an English explanation of symbols for such items as works of art, locations, one-person exhibitions, and the bibliographies. Entries are longer and more comprehensive than either *Thieme-Becker* or Vollmer. In 1986, volume 2 (*Alexander through Andrea di Zanetto*) was issued.

10:26 Archibald, E. H. H. *Dictionary of Sea Painters*. Woodbridge, England: Antique Collectors' Club, 1980.
Entries for about 800 artists. Often reports current ownership and location. Includes depictions of European historic maritime flags and essays on ships.

10:27 Bénézit, Emmanuel. *Dictionnaire critique et documentaire des peintres, sculpteurs, dessinateurs, et graveurs*. Paris: Librairie Grund, 1976. 10 vols.
Biographical dictionary covering about 300,000 painters, sculptors, designers, and graphic artists of Eastern and Western art from 5 B.C. to the present. Includes brief biographical data, sometimes a short bibliography, locations of some art works, and frequently the facsimiles of artists' signatures. Under category "*Prix,*" there are a few recorded prices for which works sold. At end of each letter of alphabet are biographical entries for artists known only by monograms. Volume I has chart—based upon the *Annuaire Statistique de la France*—providing for most years between 1901 and 1973, the average number of French francs per one U.S. dollar and one English pound.

10:28 Brewington, Dorothy. *Dictionary of Marine Artists*. Poughkeepsie, NY: Apollo, 1982.
Covers 3,074 American, European, and Asian artists.

10:29 Bryan, Michael. *Bryan's Dictionary of Painters and Engravers*. Enlarged and rev. by George C. Williamson. New York: Macmillan, 1926-34; reprint, New York: Kennikat, 1964. 5 vols.

10:30 Champlin, John Denison, Jr., ed. *Cyclopedia of Painters and Paintings*. New York: Scribner, 1885-87; reprint ed., Port Washington, NY: Kennikat, 1969. 4 vols.

Includes some works of art, providing titles, dates when painted, locations, and some signatures.

10:31 *Contemporary Artists*. New York. St. Martin's. 3rd ed., 1989.
For more than 1,000 artists, includes exhibitions, bibliographies, galleries representing them, signed critical essays, and sometimes original artists' statements.

10:32 *Contemporary Designers*. Ann Lee Morgan, ed. Detroit: Gale Research, 1984.
International coverage of designers of interiors and fashion as well as commercial designers, photographers, and film art directors.

10:33 *Current Biography Yearbook*. New York: H. W. Wilson. Volume 1 (1940)+
Published 11 times per year, with annual cumulation, has 16 to 18 profiles per issue. Entries appear in only one volume, necessitating use of index, such as *Artist Biographies: Master Index* [10:70] or *Biography Master Index Database* [10:70]. Indexed both by names and by professions, such as architecture, art, education, fashion, motion pictures, photography, and television. Photographs and subject's own opinions often provided. Correct name pronunciations sometimes included.

10:34 *Dictionary of Italian Painting*. New York: Tudor, 1964.
About 250 painters from 13th to end of 18th century.

10:35 *Dizionario Enciclopedico Bolaffi dei pittori e degli incisori italiani: Dall' XI al XX secolo*. Turin, Italy: Giulio Bolaffi, 1972-76. 11 vols.
Italian painters and graphic artists. Includes some recent sales prices and facsimiles of artists' signatures.

10:36 Gaunt, William. *Marine Painting: An Historical Survey*. New York: Viking, 1976.

10:37 Grant, Maurice Harold. *A Chronological History of the Old English Landscape Painters from the XVIth Century to the XIXth Century: Describing More than 800 Painters*. Rev. and enlarged. Leigh-on-Sea, England: F. Lewis, 1957-61. 8 vols.

10:38 *Guide to Exhibited Artists Series*. Santa Barbara, CA: Clio, 1985.
.1 *Craftsmen*
.2 *European Painters*
.3 *North American Painters*
.4 *Printmakers*
.5 *Sculptors*
Organized by artist, gives dates, address, exhibitions (group and one person), and

galleries representing the artist accompanied by addresses, often for both galleries and artist. Data derived from information solicited from artists and material in *ARTbibliographies MODERN* [16:2], Fall 1982–Fall 1983.

Clio Press has 3 earlier dictionaries which are all very similar. They are not cumulative, but have different information. *Dictionary of Contemporary Artists* (1981) covered material from *ARTbibliographies MODERN*, Fall 1979-Fall 1980. *International Directory of Exhibiting Artists*, the 1982 issue covered Fall 1980-Fall 1981; the 1983 issue, Fall 1981-Fall 1982. Both are 2 vols. These earlier publications include not only the 5 categories above but also photographers, performance artists, and video artists. They also have an index to media which is subdivided into nationality, making it easier to find references when the name is not clear or fully known. The 1985 books cover fewer countries; there are no Australian or South American painters, nor are there indices by media or geography.

10:39 *Kindlers Malerei Lexikon.* Zurich: Kindler Verlag, 1964–71; reprint, Hanover: Max Buchner, 1976. 6 vols.
Illustrated articles on painters giving locations, media, and dimensions of many art works plus bibliographical references. Includes 1,000 facsimiles of painters' signatures. Vol. 6 contains dictionary of terms, styles, and techniques; list of literary references; and artist index.

10:40 *Larousse Dictionary of Painters.* New York: Larousse, 1981.

10:41 Mallalieu, H.L. *Dictionary of British Watercolour Artists up to 1920.* Poughkeepsie, NY: Apollo, 1986. 2 vols.

10:42 Marks, Claude. *World Artists 1950–1980.* New York: H.W. Wilson, 1984.
Covers 312 artists.

10:43 Mitchell, Peter. *Great Flower Painters.* Woodstock, NY: Overlook Press , 1973.
English edition published by Adam & Charles Black as *European Flower Painters.* Biographical information on 320 artists who worked from 17th through 20th centuries.

10:44 Myers, Bernard S., ed. *Encyclopedia of Painting.* 4th rev. ed. New York: Crown, 1979.

10:45 Pavière, Sydney. *A Dictionary of Flower, Fruit, and Still Life Painters.* Leigh-on-Sea, England: F. Lewis Publishers, 1962. 3 vols in 4 books.

Vol. 1: 15th-17th Centuries, Vol. 2: 18th Century, Vol. 3: Part 1: 19th Century: Artists Born 1786–1840, Vol. 3: Part 2: 19th Century: Artists Born 1841–1885.

10:46 Simon, Robin. *The Portrait in Britain and America: With a Biographical Dictionary of Portrait Painters 1690–1914.* London: Phaidon, 1987.

10:47 Thieme, Ulrich and Felix Becker. *Allgemeines Lexikon der bildenden Künstler von der Antike bis zur Gegenwart.* Leipzig: E. A. Seemann, 1907–50; reprint ed., Leipzig: F. Allmann, 1964. 37 vols.
One of the most scholarly biographical dictionaries. Signed articles give data on painters, sculptors, architects, engravers, and some decorative artists plus locations of some of their works. Contains indispensable bibliographical information on older publications. Good source for minor artists; does not include many from 20th century. Last volume contains entries on anonymous artists known by monograms or nicknames. *I* and *J* are alphabetized together; umlauted words are spelled with the vowel plus an *e*. True name, not anglicized version, of artist must be used. For instance, there is no entry for Titian under this anglicized version of the Italian painter's name. Under Tiziano there is a cross reference to Vecellio where a lengthy entry is found. Frequently called by short title of *Thieme/ Becker.* Supplemented by Hans Vollmer [10:49], who covered artists born after 1870. Valerie D. Meyer's brief, but useful, work, *Index of the Most Common German Abbreviations Used in Thieme-Becker's Künstler-Lexikon* was compiled in 1972 for the University of Michigan Fine Arts Library. For a new publication which is updating *Thieme/Becker* and including artists covered by Vollmer, see *Allgemeines Künstler Lexikon* [10:25].

10:48 Tufts, Eleanor. *Our Hidden Heritage: Five Centuries of Women Artists.* London: Paddington, 1974.
Covers 22 women, 16th century to the present.

10:49 Vollmer, Hans. *Allgemeines Lexikon der bildenden Künstler des XX. Jahrhunderts.* Leipzig: E. A. Seemann, 1953–62. 6 vols.
Artists born after 1870; same format as *Thieme-Becker [10:47]*, which it supplements. Signed articles and bibliographical data. Vols. 5 and 6 are supplements to initial 4-volume work. For updated version, see 10:25.

10:50 *Who's Who in American Art: A Biographical Directory.* New York: R. R. Bowker. Volume 1(1936/37)+
 Now published biennially. Biographical sketches of over 10,500 artists, collectors, scholars, art administrators, art historians, and critics. Brief bibliographies; lists awards and names of exhibitions; geographical and professional indices. Companion volume to *The American Art Directory* [20:1]; from 1898 through 1952 both volumes appeared as part of the *American Art Annual* [13:1].

10:51 *Who's Who in Art: Biographies of Leading Men and Women in the World of Art Today: Artists, Designers, Craftsmen, Critics, Writers, Teachers, Collectors, and Curators With an Appendix of Signatures.* Havant, Hantsford, England: Art Trade Press, 1927+
 Published erratically; majority of biographies are people in England.

10:52 Zampetti, Pietro. *A Dictionary of Venetian Painters.* Leigh-On-Sea, England: F. Lewis, 1969–79. 5 vols.
 Vol. 1: 14th and 15th Centuries, Vol. 2: 16th Century, Vol. 3: 17th Century, Vol. 4: 18th Century, Vol. 5: 19th and 20th Centuries.

Illuminators and Miniaturists

10:53 Aeschlimann, Erardo and Paolo d' Ancona. *Dictionnaire des miniaturistes du Moyen Age et de la Renaissance dans les différentes contrées de l'Europe.* 2nd ed., rev. Milan: Ulrico Hoepli, 1949; reprint, Nendeln, Liechtenstein: Kraus, 1969.
 Some bibliographical data and artists' works with their locations. Index of artists by stylistic periods.

10:54 Bradley, John William. *A Dictionary of Miniaturists, Illuminators, Calligraphers, and Copyists: From the Establishment of Christianity to the Eighteenth Century.* London: Quaritch, 1887–89; reprint, New York: Burt Franklin, 1973. 3 vols.
 Lists artists' patrons.

10:55 Foskett, Daphne. *A Dictionary of British Miniature Painters.* New York: Praeger, 1972. 2 vols.
 Artists active between 1520 and 1910.

10:56 Foster, Joshua James. *A Dictionary of Painters of Miniatures (1525–1850) with Some Account of Exhibitions, Collections, Sales, etc. Pertaining to Them.* Edited by Ethel M. Foster. London: P. Allan, 1926; reprint, New York: Burt Franklin, 1968.

10:57 Long, Basil S. *British Miniaturists.* London: G. Bles, 1929; reprint, London: Holland Press, 1966.

Miniaturists working in Great Britain and Ireland, 1520–1860. Lists provincial towns accompanied by names of miniaturists who worked there.

10:58 Schidlof, Leo R. *The Miniature in Europe in the 16th, 17th, 18th and 19th Centuries.* Graz, Austria: Akademische Druck- U. Verlagsanstalt, 1964. 4 vols.

Sculptors

10:59 Berman, Harold. *Encyclopedia: Bronzes, Sculptors, and Founders 1800–1930.* Calne, England: Hilmarton Manor, 1974- 80. 4 vols.
 Extensively illustrated; useful for identification. Vol. 1 has introduction and definitions plus a list of foundries. Other volumes provide data on sculptors, founders, and seals. Facsimile of some signatures.

10:60 Gunnis, Rupert. *Dictionary of British Sculptors 1660–1851.* Rev. ed. London: Abbey Library, 1968.
 Includes titles and dates of important works, some price and bibliographical data, plus exhibitions in which works were displayed.

10:61 Horswell, Jane. *Bronze Sculpture of "Les Animaliers": Reference and Price Guide.* Woodbridge, England: Antique Collectors' Club, 1971.
 Covers 19th-century sculptors; illustrations of works, essays on founding practices and methods of casting, artists' signatures, and titles of exhibition pieces displayed in French Salons.

10:62 Lami, Stanislas. *Dictionnaire des sculpteurs de l'école française.* Paris: Champion, 1898–1921; reprint, New York: Kraus, 1970. 8 vols.
 Tome 1: Du Moyen Age au règne de Louis XIV, Tome 2: Sous le règne de Louis XIV, Tomes 3–4: Au dix-huitième siècle, Tomes 5–8: Au dix-neuvième siècle. Extensive documentation on sculptors' works of art; includes Salons and exhibitions in which works were displayed and, frequently, their provenance and present location. For 19th-century art, there is a subject index; see 19:44.

10:63 Maillard, Robert, ed. *New Dictionary of Modern Sculpture.* Trans. by Bettina Wadia. New York: Tudor, 1971.

10:64 Opitz, Glenn B. *Dictionary of American Sculptors 18th Century to the Present.* Poughkeepsie, NY: Apollo, 1984.
 More than 5,000 sculptors.

10:65 Souchal, François. *French Sculptors of the 17th and 18th Centuries: The Reign of Louis XIV.* Trans. by Elsie and George Hill. Oxford: Bruno Cassirer, 1977–87. 3 vols.

Covers from Middle Ages to late 19th century; includes bibliographies, all known works accompanied by scholarly catalogue entries, photographs, and drawings. Index to artists, sites, titles of works, and collections. Reproduces some genealogical trees.

10:66 Wasserman, Jeanne, ed. *Metamorphoses in Nineteenth-Century Sculpture.* Cambridge, MA: Fogg Art Museum, Harvard University, 1975.
Informative section on the technical aspects of sculpture.

10:67 Watson-Jones, Virginia. *Contemporary American Women Sculptors.* Phoenix, AZ: Oryx, 1986.
Data on 328 artists; includes artists' statements.

Authors

For biographical data on authors, see *Current Biography Yearbook* [10:33], *Who's Who in American Art* [10:50], *Who's Who in Art* [10:51], as well as the indices to biographical information cited above.

10:68 *Contemporary Authors.* Detroit: Gale Research. Volume I(1962)+
Entries are in one volume and not repeated in subsequent ones; this necessitates using the cumulative indices. Since 1981 issued bimonthly.

Indices to Biographical Sources

Under the person's name, these resources cite books and articles that provide biographical data. See Karpel's *Arts in America* [13:44], *New York Times Obituaries* [16:56], and *Biographical Index of American Artists* [13:53].

10:69 Bachmann, Donna G. and Sherry Piland. *Women Artists: An Historical, Contemporary, and Feminist Bibliography.* Metuchen, NJ: Scarecrow, 1978.
Covers 161 artists from Middle Ages to 20th century.

10:70 *Biography and Genealogy Master Index.* 2nd ed. Detroit: Gale Research, 1980. 8 vols. Frequent supplements.
Indexes biographical information in hundreds of reference works, including *Current Biography Yearbook* [10:33] and who's who books. Entries for more than 2 million people.

Biography Master Index Database, DIALOG, File 287: A-L, File 288: M-Z, irregular updates. Covers all data from printed edition plus supplements.

Artist Biographies: Master Index. Detroit: Gale Research, 1986. Quick access to more than 275,000 artists; data derived from *Biography and Genealogy Master Index,* above.

10:71 *Biography Index: A Cumulative Index to Biographical Material in Books and Magazines.* New York: H. W. Wilson. Volume I (January, 1946-July, 1949)+
Published every three years until 1974 when it changed to quarterly with annual cumulation. Regularly scans 2,600 serial and works of collective biography. Indexed by surnames and professions, including painters, sculptors, designers, architects, art historians, critics, art collectors, art teachers, artists, and museum directors. Replaces biographical entries found in other Wilson publications before 1946.

Biography Index Database, WILSONLINE. Files from July 1984, updates quarterly. Available on CD-ROM.

10:72 Freitag, Wolfgang. *Art Books: A Basic Bibliography of Monographs on Artists.* New York: Garland, 1985.
Lists international monographs for about 1,870 artists. Includes biographies, exhibition catalogues, œuvres catalogues, and catalogues raisonnés (signified by CR). Over 10,500 titles on artists from all historical periods and countries. Although majority are painters and draftsmen (64%), there are also sculptors (11%), architects (11%), graphic artists (8%), and photographers (5%). Lists international biographical dictionaries.

10:73 Havlice, Patricia Pate. *Index to Artistic Biography.* Metuchen, NJ: Scarecrow, 1973. 2 vols. *First Supplement,* 1981.
Guide to 64 biographical dictionaries published 1902–1970 in 10 languages; contains about 70,000 artists. Supplement covers about 44,000 artists in 70 more books. Variant spellings and alternate names of each artist are given in parentheses following artist's name. Indexes all kinds of artists.

10:74 Mallett, Daniel Trowbridge. *Mallett's Index of Artists: International-Biographical Including Painters, Sculptors, Illustrators, Engravers, and Etchers of the Past and the*

Present. New York: R. R. Bowker, 1935; reprint, New York: Peter Smith, 1948. *Supplement to Mallett's Index of Artists,* 1940; reprint, 1948.

Covers about 27,000 artists cited in 24 general art-reference books and 957 selected ones, some of which are monographs. Supplement covers about 78 more references and includes list of early American silversmiths. Necrology, 1935–1940, lists artists deceased since 1935 edition.

10:75 *Marquis Who's Who Publications: Index to All Books.* Chicago: Marquis Who's Who, 1974.

Index to more than 200,000 names found in 10 biographical dictionaries published by Marquis; such as *Who's Who in America* and *Who's Who in the World.*

Marquis Who's Who Database, DIALOG, File 234, current issue, updates quarterly.

10:76 Meyer, George H., ed. *Folk Artists Biographical Index: A Guide to Over 200 Published Sources of Information on Approximately 9,000 American Folk Artists from the, Seventeenth Century to the Present Including Brief Biographical Information; a Full Bibliography of Sources; Art Locator, Ethnicity, Geographic, Media, and Type of Work Indexes; and a Directory of Nearly 300 Institutions Where the Works of the Artists Are Located.* Detroit: Gale Research, 1987.

Provides names, dates, types of work, museums owning their works, bibliographical sources.

Designations and Signatures of Artists and Collectors

Facsimiles of artists' signatures can often be located in museum catalogues, both exhibition and museum collection. For a discussion, see Chapter 6. Consult Bénézit's *Dictionnaire* [10:27], Champlin's *Cyclopedia of Painters* [10:30], Contag's *Seals of Chinese Painters and Collectors* [14:39], *Dizionario Enciclopedico* [10:35], Horswell's *Bronze Sculpture* [10:61], *Kindlers Malerei Lexikon* [10:39].

10:77 Caplan, H.H. *Classified Directory of Artists' Signatures, Symbols, and Monograms: American Artists with New UK Additions.* New and enlarged ed. London: Grahame, 1987.

Covers over 5,000 items divided into artists' names, monograms, illegible or misleading signatures, and symbols.

10:78 Goldstein, Franz. *Monogramm-Lexikon: internationales Verzeichnis der Monogramme bildender Künstler seit 1850.* Berlin: Verlag Walter de Gruyter, 1964.

Alphabetized by monograms; entries cite artists' names, nationalities, dates, and media used. Includes index to names and section on artists who used figures, signs, or symbols. Covers artists active since 1850, thereby supplementing Nagler [10:81].

10:79 Jackson, Radway. *The Concise Dictionary of Artists' Signatures: Including Monograms and Symbols.* New York: Alpine Fine Arts, 1981.

Index to artists' signatures and visual index to monograms and pictorial devices. Includes about 8,000 such items.

10:80 Lugt, Frits. *Les marques de collections de dessins et d'estampes: marques estampillées et écrites de collections particulières et publiques. Marques de marchands, de monteurs et d'imprimeurs. Cachets de vente d'artistes décèdes. Marques de graveurs apposées après le tirage des planches. Timbres d'édition. Etc. Avec des notices historiques sur les collectionneurs, les collections, les ventes, les marchands et éditeurs, etc.* Amsterdam: Vereenigde Drukkerijen, 1921. *Supplément.* Den Haag: Martinus Nijhoff, 1956; reprints, San Francisco: Alan Wofsy Fine Arts, *First ed.,* 1975; *Supplément,* 1988.

This important resource reproduces identification marks placed on drawings and prints. Marks are grouped into (1) names, inscriptions, and monograms; (2) figures; (3) marks difficult to decipher and Japanese marks; (4) numbers; and (5) specimens of writings. Extensive sales information and index to names of collectors, artists, dealers, and publishers.

10:81 Nagler, Georg Kaspar. *Die Monogrammisten und diejenigen bekannten und unbekannten Künstler aller Schulen* Munich: G. Franz, 1858–79. 5 vols. *General-index zu dr. G. K. Nagler Die Monogrammisten.* Munich: G. Hirth Verlag, 1920. One vol. Reprint of all 6 vols. Nieuwkoop, Holland: De Graaf, 1966.

Over 30,000 facsimiles of monograms. Alphabetized by chief initials in monograms or by symbols used by artists active before middle of 19th century. Includes painters, sculptors, architects, engravers, lithographers, gold- and silver-smiths, and ceramists. Brings together work by such men as Adam von Bartsch and A.P.F. Robert-Dumesnil. Vol. 4 finished by Andreas Andresen; Vol. 5 by Andresen and Carl Clauss. Last volume has general index and bibliography. Updated by Goldstein [10:78].

10:82 Ris-Paquot, Oscar Edmond. *Dictionnaire en-cyclopédique des marques et monogrammes, chiffres, lettres, initiales, signes, figuratifs, etc.* Paris: Henri Laurens, 1893; reprint, New York: Burt Franklin, 1963. 2 vols.

Over 12,000 monograms and marks. Vol. 2 has indices to names and geographic locations.

Heraldry, Medals, and Decorations

A coat of arms or decoration can frequently be used to trace ownership or persons represented.

10:83 Brooke-Little, John Philip. *An Heraldic Alphabet.* London: Macdonald, 1973.

Covers history, development, grammar, and law of heraldry.

10:84 Brusher, Joseph Stanislaus. *Popes Through the Ages.* Princeton, NJ: Van Nostrand, 1959.

Popes from St. Peter through John XXIII; entries include reproductions of personal coats of arms.

10:85 Burke, John Bernard. *A Genealogical History of the Dormant, Abeyant, Forfeited, and Extinct Peerages of the British Empire.* London: Harrison and Sons, 1883; reprint, London: William Clowes and Sons, 1969.

Illustrations of coats of arms; historical account of lineage cited.

10:86 *Burke's Genealogical and Heraldic History of the Peerage, Baronetage, and Knightage.* Ed. by Peter Townend. London: Burke's Peerage. First ed., 1826; frequent eds.

Reproduces coats of arms; includes historical accounts of lineage. Titles of different editions vary slightly.

10:87 Fox-Davies, Arthur Charles. *A Complete Guide to Heraldry.* Rev. and annotated by John Philip Brooke-Little. London: T.C. & E.C. Jack, 1909; reprint, London: Thomas Nelson & Sons, 1969.

Illustrated history of shields, crests, and symbols of heraldry.

10:88 Franklyn, Julian and John Tanner. *An Encyclopaedic Dictionary of Heraldry.* New York: Pergamon Press, 1970.

10:89 Gough, Henry and James Parker. *A Glossary of Terms Used in Heraldry.* Oxford, England: James Parker, 1894; reprint, Detroit: Gale Research, 1966.

10:90 Hieronymussen, Paul. *Orders, Medals and Decorations of Britain and Europe in Colour.* Trans. by Christine Crowley. London: Blandford, 1967.

10:91 Maclagan, Michael. *Heraldry of the Royal Families of Europe.* New York: Clarkson N. Potter, 1981.

Guides to Pronunciation of Names

Most unabridged dictionaries provide pronunciations guides; also see *Academic American Encyclopedia Database* [10:6] and *Current Biography Yearbook* [10:33].

10:92 Greet, William Cabell. *World Words: Recommended Pronunciations.* 2nd ed., rev. New York: Columbia University Press, 1948.

Published for Columbia Broadcasting System; has two sections: good, lengthy discussion of how sounds are pronounced in various countries and list of recommended pronunciations of proper names.

10:93 Kaltenbach, Gustave Emile. *Dictionary of Pronunciation of Artists' Names.* 2nd ed. Chicago: Art Institute of Chicago, 1938; reprint 1989.

Includes more than 1,500 names of artists from western civilization, 13th century to 1930s.

10:94 *Webster's Biographical Dictionary: A Dictionary of Noteworthy Persons With Pronunciations and Concise Biographies.* Springfield, MA: G. & C. Merriam, 1980.

Artistic Styles, Periods, and Cultures: Prehistoric through Gothic

Covering Western European styles and historic periods from the prehistoric through the Gothic, this chapter is divided into resources that survey (1) general art history; (2) ancient and classical cultures; and (3) Early Christian, Byzantine, and Medieval.

General Art History Resources

The following references are divided into (1) art historical surveys, (2) documents, sources, and criticism, (3) art historiography, (4) video documentaries, (5) general art history serials, and (6) cultural/historical surveys.

Art Historical Surveys

Some art historical surveys include discussions of the principle of art, also covered by art appreciation books, annotated in Chapter 28.

11:1 de la Croix, Horst and Richard G. Tansey. *Art Through the Ages,* 8th ed. Orlando, FL: Harcourt Brace Jovanovich, 1986.
 Originally published as Helen Gardner's *Art Through the Ages,* 1926; later editions called *Gardner's Art Through the Ages.*

11:2 Flemming, William. *Arts & Ideas.* 7th ed. New York: Holt, Rinehart & Winston, 1986.

11:3 Hartt, Frederick. *ART: A History of Painting, Sculpture, Architecture.* 3rd ed. Englewood cliffs, NJ: Prentice Hall, 1989.

11:4 Honour, Hugh and John Fleming. *The Visual Arts: A History.* 2nd ed. Englewood cliffs, NJ: Prentice Hall, 1986.

11:5 *Image of the Black in Western Art.* New York: Marrow, 1976+
 Vol. 1: From the Pharaohs to the Fall of the Roman Empire, J. Vercoutter et al, 1976. *Vol. 2: From the Early Christian Era to the "Age of Discovery," Part I: From the Demonic Threat to the Incarnation of Sainthood,* Jean Devisse, *Part II: Africans in the Christian Ordinance of the World (Fourteenth to Sixteenth Century),* Jean Devisse and Michel Mollat, 1979. Vol. 3:

Africa and Europe (Sixteen to the Eighteenth Century), to be published. *Vol. 4: From the American Revolution to World War I, Part I: Slaves and Liberators,* Hugh Honour, *Part II: Black Models and White Myths,* Hugh Honour, 1989.

11:6 Janson, H.W. *The History of Art.* 3rd ed. Englewood Cliffs, NJ: Prentice Hall, 1986.

11:7 Phipps, Richard and Richard Wink. *Invitation to the Gallery: An Introduction to Art.* Dubuque, IA: Wm. C. Brown, 1987.

11:8 Slatkin, Wendy. *Women Artists in History: From Antiquity to the 20th Century.* Englewood cliffs, NJ: Prentice Hall, 1985.

Documents, Sources, and Criticism

11:9 Crofton, Ian. *A Dictionary of Art Quotations.* New York: Scribner, 1989.
 Quotes on painting, drawing, and sculpture with sections on architecture and photography; concerned only with the Western tradition. Arranged alphabetically by topic; index to artists, authors, subjects.

11:10 Edwards, Edward. *Anecdotes of Painters Who Have Resided or Been Born in England with Critical Remarks on Their Productions.* London: Luke Hansfard & Sons, 1808; reprint ed., London: Cornmarket, 1970.
 Conceived as continuation and completion of Walpole's *Anecdotes of Painting* [11:14]; anecdotes for over 190 artists.

11:11 Friedenthal, Richard. *Letters of the Great Artists.* Trans. by Daphine Woodward et al. London: Thames & Hudson, 1963.
 Vol. 1: From Ghiberti to Gainsborough. Vol. 2: From Blake to Pollock.

11:12 Goldwater, Robert and Marco Treves, eds. *Artists on Art: From the XIV to the XX Century.* New York: Pantheon, 1945.

11:13 Venturi, Lionello. *History of Art Criticism.* Trans. by Charles Marriott. New York: W. P. Dutton, 1936, reprint 1964.

11:14 Walpole, Horace. *Anecdotes of Painting in England with Some Account of the Principal Artists and Incidental Notes on Other Arts Collected by the Late Mr. George Vertue and*

Now Digested and Published from His Original Mss. by Mr. Horace Walpole. Strawberry Hill, England: Thomas Farmer, 1762–71; reprint of 1937 ed., New York: Arno, 1969. 4 vols.

Chapters on painters, masons, and sculptors; includes anecdotes for about 500 artists. Several editions, varying from 3 to 5 volumes.

Art Historiography

Art historiography—the theories and techniques of art based upon evaluation and critical examination—includes many types of theories, such as Wölfflin's formalist theories [11:36] and the iconographical and iconological studies of Mâle [29:114 & 115] and Panofsky [29:117 & 118]. For a discussion of historiography, read the essay in the *Encyclopedia of World Art* [10:2] as well as the books by Eugene W. Kleinbauer [11:29 and 11:30].

11:15 Ackerman, James S. "A Theory of Style." *Journal of Aesthetics & Art Criticism* 20(Spring 1962): 227–37.

11:16 Arnheim, Rudolf. *Visual Thinking.* Berkeley: University of California, 1977.

Discusses images of thought, concepts of shape, symbols, abstraction, and art and thought.

11:17 Barasch, Moshe. *Theories of Art: From Plato to Winckleman.* New York: New York University, 1985.

11:18 Berenson, Bernhard B. *Rudiments of Connoisseurship: Study and Criticism of Italian Art.* New York: Schocken, 1962.

Paperback edition of *The Study and Criticism of Italian Art,* 1902. Last chapter, "Rudiments of Connoisseurship," details ways to establish artist of work.

11:19 Broude, Norma and Mary D. Garrard, eds. *Feminism and Art History: Questioning the Litany.* New York: Harper & Row, 1982.

11:20 Creedy, Jean, ed. *The Social Context of Art.* London: Tavistock, 1970.

11:21 Gombrich, E.H. *Art and Illusion.* New York: Bollingen, 1960.

11:22 ———. *Meditations on a Hobby Horse and Other Essays on the Theory of Art.* London: Phaidon, 1963; reprint, Chicago, University of Chicago, 1985.

11:23 Hollander, Anne. *Moving Pictures.* New York: Alfred Knopf, 1989.

Links Northern European paintings to modern cinema; discusses relationships between original works and prints and high and popular art.

11:24 Holly, Michael Ann. *Panofsky and the Foundations of Art History.* Ithaca, NY: Cornell University, 1984.

11:25 Hauser, Arnold. *The Social History of Art.* Trans. by Stanley Godman. New York: Alfred A. Knopf, 1951; reprint, New York: Vintage Books, 1957–58. Original ed. in 2 vols; reprint in 4 books.

11:26 Hegel, Georg Wilhelm Friedrich. *Hegel: On the Arts.* Trans. by Henry Paolucci. New York: Frederick Ungar, 1979.

Selections from Hegel's *Aesthetics or the Philosophy of Fine Art.*

11:27 Irwin, David. *Writings on Art by Johann Winckelmann.* London: Phaidon, 1972.

11:28 Jansen, Charles R. *Studying Art History.* Englewood Cliffs, NJ: Prentice Hall, 1986.

11:29 Kleinbauer, W. Eugene. *Modern Perspectives in Western Art History: An Anthology of 20th-Century Writings on the Visual Arts.* New York: Holt, Rinehart & Winston, 1971; reprint, Toronto: Toronto University, 1989.

Reprints articles illustrating intrinsic perspectives and extrinsic perspectives.

11:30 ——— and Thomas P. Slavens. *Research Guide to the History of Western Art.* Chicago: American Library Association, 1982.

11:31 Podro, Michael. *The Critical Historians of Art.* New Haven, CT: Yale University, 1982.

11:32 Read, Herbert. *Art and Society.* London: Faber and Faber, 1946.

11:33 Rees, A.L. and Frances Borzello. *The New Art History.* London: Thames & Hudson, 1986.

11:34 Roskill, Mark. *What is Art History?* New York: Harper & Row, 1976.

11:35 Schapiro, Meyer, "Style," reprinted in several anthologies: *Anthropology Today,* ed. by A.L. Kroeber, Chicago: University of Chicago Press, 1953 and *Aesthetics Today,* ed. by Philipson Morris. Cleveland: Meridan, 1961.

11:36 Wölfflin, Heinrich. *Principles of Art History.* Trans. by M.D. Hottinger. New York: Dover, 1932; reprint, 1950.

First German edition, 1915.

Video Documentaries

Art of the Western World. The Annenberg/CPB Collection, 1989

1. *The Classical Ideal: Greece and Rome, 600 B.C.–350 A.D.*
2. *A White Garment of Churches: Romanesque and Gothic*
3. *The Early Renaissance: Italy and Northern Europe*
4. *The High Renaissance: Rome and Venice*
5. *Realms of Light: The Baroque*
6. *An Age of Reason, An Age of Passion*
7. *A Fresh View: Impressionism and Post-Impressionism*
8. *Into the 20th Century*
9. *In Our Own Time*

Serials

These general serials cover all kinds of art—especially paintings, drawings, and sculpture—over a wide period of artistic time.

Apollo 1925+
Art Bulletin, College Art Association of America 1913+ (Cumulative Indices for 1913–1948 and 1949–73)
Art History 1978+
Art Journal, College Art Association of America 1941+ (Titled *College Art Journal* 1941–1960)
The Art Journal, London 1839–1912//
Art Quarterly, Detroit 1938–74//
Artibus et Historiae: An Art Anthology 1980+
ARTnews 1902+ (Titled *American Art News* 1902–23)
Bollettino d'arte 1907+ (Titled *Le Arti* 1938–47)
Burlington Magazine 1903+ (Titled *Burlington Magazine for Connoisseurs* 1903–47) (Cumulative Indices for 1903–62, 1963–72, and 1973–82)
Connaissance des arts 1952+
Connoisseur 1901+
Drawing: The International Review, New York, The Drawing Society 1979+
Gazette des beaux-arts 1859+
Hafnia 1970+
Hoogsteder-Naumann Mercury, 1985+
Journal of the Warburg and Courtauld Institutes 1937+
Kunstchronik 1948+
Das Kunstwerk 1946+
Marsyas: Studies in the History of Art, New York University, Institute of Fine Arts 1941+
Master Drawings 1963+
l'Oeil 1955+
Old Master Drawings 1926–40// (Vol. 16 has cumulative index; Collector's Editor reprinted all volumes in 1970.)

Oud-Holland 1883+ (Indices in vols. 40 and 50)
Oxford Art Journal 1978+ (Index for vols. 1–10, 1987)
Pantheon 1928+
Revue de l'art 1968+
Sculpture Review 1982+
Simiolus: Netherlands Quarterly for the History of Art 1966/67+
Storia dell'arte 1969+
Die Weltkunst 1927+ (entitled *Kunstauktion* 1927–30)
Zeitschrift für Kunstgeschichte 1932+

Cultural/Historical Surveys

11:37 Anderson, Bonnie S. and Judith P. Zinsser. *A History of Their Own: Women in Europe from Prehistory to the Present.* New York: Harper & Row, 1988/89. 2 vols.

11:38 Burns, Edward McNall, Robert E. Lerner, and Standish Meacham. *Western Civilizations: Their History and Their Culture.* 10th ed. New York: W. W. Norton, 1984. 2 vols.

11:39 Clapp, Jane. *Art Censorship: A Chronology of Proscribed and Prescribed Art.* Metuchen, NJ: Scarecrow, 1972.
 Chronological account, from 3400–2900 B.C. until 1971 A.D., of censorship of art. News items—all of which are reprinted in the text—are derived from 641 references listed in bibliography. Includes extensive index: excludes censorship of photography and motion pictures.

11:40 Cooke, Jean et al. *History's Timeline.* London: Grisewood & Dempsey, 1981.
 Published in London as *History Factfinder.*

11:41 Cunningham, Lawrence and John Reich. *Culture and Values: A Survey of the Western Humanities.* New York: Holt, Rinehart & Winston, 1982. 2 vols.

11:42 de Mause, Lloyd, ed. *The History of Childhood.* New York: Psychohistory Press, 1974.
 Survey from 9th through 19th centuries of European treatment of children.

11:43 Giele, Janet Zollinger and Audrey Chapman Smock. *Women: Roles and Status in Eight Countries.* New York: John Wiley, 1977.
 Covers from Middle Age to present.

11:44 Grun, Bernard. *The Timetables of History: A Horizontal Linkage of People and Events.* Updated ed. New York: Touchstone, 1982.
 Based upon Werner Stein's *Kulturfahrplan,* 1946.

11:45 Gurney, Gene. *Kingdoms of Europe: An Illustrated Encyclopedia of Ruling Monarchs from Ancient Times to the Present.* New York: Crown, 1982.

11:46 Kedourie, Elie, ed. *The Jewish World: History and Culture of the Jewish People.* New York: Harry N. Abrams, 1979.

11:47 Kinder, Hermann and Werner Hilgemann. *The Anchor Atlas of World History.* Trans. by Ernest A. Menze. New York: Anchor, 1974.
 Vol. 1: From the Stone Age to the Eve of the French Revolution. Vol. 2: From the French Revolution to the American Bicentennial. Provides numerous historical maps and an outline of history.

11:48 Steinberg, S.H. *Historical Tables, 58 BC-AD 1985.* 11th ed. updated by John Paxton. New York: Garland, 1986.

Ancient and Classical Cultures

Because the countries sponsoring excavations frequently retained some outstanding works, ancient art and artifacts are widely scattered in museum collections. But the best selection is often in the country where the excavating took place. For instance, the most extensive collection of Egyptian art is in Cairo's Egyptian Museum; for Greek antiquities, Athens's National Archaeological Museum. But many institutions with encyclopedic collections have outstanding works from these cultures, among these are the British Museum, Le musée du Louvre, and the Metropolitan Museum of Art.

The literature in this field jumps from simplified overviews for the novice to detailed descriptions for the scholar. Included here are only a few of the more scholarly resources, such as the published catalogues of archaeological libraries and the journals of professional associations. From these resources, other works can be located. For some thoughts on recent research, consult Brunilde Sismondo Ridgway's "The State of Research on Ancient Art," *Art Bulletin* 68 (March 1986): 7–23 and the essays and bibliographies in *Encyclopedia of World Art* [10:2]: Volume 16, "Prehistory: Europe and North Africa," "The Primitive World, Egypt, Ancient Near East," and "The Classical World," and in Volume 17, "Origins of Art and the Ancient World."

Dictionaries

Also see mythological books listed in Chapter 29.

11:49 Avery, Catherine B., ed. *New Century Classical Handbook.* New York: Appleton-Century-Crofts, 1962.

11:50 Avi-Yonah, Michael and Israel Shatzman. *Illustrated Encyclopaedia of the Classical World.* New York: Harper & Row, 1975.

11:51 Bray, Warwick and David Trump. *Penguin Dictionary of Archaeology.* 2nd ed. Harmondsworth, England: Penguin, 1982.

11:52 Daniel, Glyn, ed. *An Illustrated Encyclopedia of Archaeology.* New York: Thomas Y. Crowell, 1977.

11:53 Devambez, Pierre, ed. *Praeger Encyclopedia of Ancient Greek Civilization.* New York: Frederick A. Praeger, 1967.

11:54 *Dictionary of Ancient Greek Civilization.* London: Methuen, 1967.

11:55 *Enciclopedia dell'arte antica.* Rome: Instituto dell'enciclopedia italiana, 1958–66. 7 vols. Supplement contains an Atlas.

11:56 Hammond, N. G. L. and H.H. Scullard, eds. *The Oxford Classical Dictionary.* 2nd ed. Oxford: Clarendon, 1977; reprint, 1984.

11:57 Lurker, Manfred. *The Gods and Symbols of Ancient Egypt.* Trans. by Barbara Cummings. New York: Thames & Hudson, 1980.

11:58 Nash, Ernest. *Pictorial Dictionary of Ancient Rome.* New York: Frederick A. Praeger, 1962; reprint, New York: Hacker, 1980. 2 vols.
 Numerous plans and photographs of individual buildings. Includes old prints and photographs of buildings and individual bibliographies for discussed structures.

11:59 Pauly, August F. *Paulys Real-Encyclopädie der classischen Altertumswissenschaft.* 2nd ed. Stuttgart: J. B. Metzler, 1894–1974. 34 vols. in 29 books plus supplement of 15 vols. in 14 books.
 Detailed articles on persons, monuments, and sites. Partially indexed by John P. Murphy's *Index to the Supplements and the Supplemental Volumes of Pauly-Wissowa's R. E.* (Chicago: Ares, 1976).

11:60 Stillwell, Richard, ed. *The Princeton Encyclopedia of Classical Sites.* Princeton, NJ: Princeton University, 1976.
 Covers about 3,000 sites of remains of cities, towns, and other settlements of classical era, 750 B.C. to 565 A.D. Area maps keyed to each site. Includes brief history of classical era, listing of present Greek and Roman remains, indication of present locations of artifacts found at sites, and bibliographical references, which include ancient sources.

11:61 Travlos, John. *Pictorial Dictionary of Ancient Athens.* New York: Praeger, 1971; reprint, Hacker, 1980.

Art Historical Surveys

See *Renaissance Artists and Antique Sculpture* [12:9] and *Taste and the Antique* [12:19]; both discuss classical sculpture.

11:62 *Arts of Mankind.* André Malraux and George Salles, general eds. New York: G. Braziller, Odyssey Press, and Golden Press, 1961–1973.

Well-illustrated with glossaries, floor plans, maps, chronological tables, and extensive bibliographies.

.1 *Sumer: The Dawn of Art,* by André Parrot, 1961.

.2 *Arts of Assyria,* André Parrot. 1961.

.3 *Persian Art: The Parthian and Sassanian Dynasties 249* B.C.–A.D. *651,* Roman Ghirshman, 1962.

.4 *The Arts of Ancient Iran: From Its Origins to the Time of Alexander the Great,* Roman Ghirshman, 1964.

.5 *The Birth of Greek Art,* Pierre Demargne, 1964.

.6 *Rome: The Center of Power, 500* B.C. *to* A.D. *200,* Ranuccio Bianchi Bandinelli, 1970.

.7 *Archaic Greek Art 620* B.C.-*480* B.C., Jean Charbonneaux, Roland Martin, and François Villard, 1971.

.8 *Rome: The Late Empire,* A.D. *200–400,* Ranuccio Bianchi Bandinelli, 1971.

.9 *Classical Greek Art (480–330* B.C.*),* Jean Charbonneaux, Martin Roland, and François Villard, 1972.

.10 *Hellenistic Art 330* B.C.-*50* B.C., Jean Charbonneaux, Roland Martin, and François Villard, 1973.

11:63 Becatti, Giovanni. *Art of Ancient Greece and Rome: From the Rise of Greece to the Fall of Rome.* Englewood Cliffs, NJ: Prentice Hall, 1968.

11:64 Boardman, John. *Athenian Black Figure Vases.* New York: Thames & Hudson, 1974.

11:65 ———. *Athenian Red Figure Vases: The Archaic Period.* New York: Thames & Hudson, 1975.

11:66 ———. *Greek Art.* Rev. ed. New York: Thames & Hudson, 1985.

11:67 ———. *Greek Sculpture: Archaic Period.* New York: Thames & Hudson, 1985.

11:68 ———. *Greek Sculpture: Classical Period.* New York: Thames & Hudson, 1985.

11:69 ———. *Pre-Classical: From Crete to Archaic Greece. Style and Civilization Series.* Baltimore, MD: Penguin Books, 1967.

11:70 Brilliant, Richard. *Roman Art from the Republic to Constantine.* London: Phaidon, 1974.

11:71 British Museum Publications. London: British Museum.

Written for a popular audience; brief overviews of ancient cultures. Some co-published by Harvard University Press.

.1 *Egyptian Sculpture,* T.G.H. James and W.V. Davies, 1983.

.2 *Egyptian Mummies,* Carol Andrews, 1984.

.3 *Egyptian Life,* Miriam Stead, 1986.

.4 *Egyptian Painting and Drawing,* 1985.

.5 *Assyrian Sculpture,* Julian Reade, 1983.

.6 *The Elgin Marbles,* B.F. Cook, 1984.

.7 *Greek Vases,* Dyfri Williams, 1985.

.8 *Greek and Roman Life,* Ian Jenkens, 1986.

.9 *Prehistoric Britain,* I.H. Longworth, 1986.

.10 *Roman Britain,* T.W. Potter, 1983.

11:72 *Corpus antiquitatum Aegyptiacarum.* Mainz: P. von Zabern, 1977+

Fascicles on Egyptian collections in various museums. Such as *Corpus antiquitatum Aegyptiacarum: Museum of Fine Arts, Boston,* 1978.

11:73 *Corpus vasorum antiquorum.* Munich: C.H. Beck and Berlin: Akademie, 1959+

Fascicles on collections of Greek vases, such as the *Corpus vasorum antiquorum: United States of America: J. Paul Getty Museum, Malibu,* fascicle 23 by A.J. Clark, (New York: Oxford University, 1988).

11:74 Frankfort, Henri. *The Birth of Civilization in the Near East.* New York: Barnes & Noble, 1968.

11:75 Groenewegen-Frankfort, Henriette A. and Bernard Ashmole. *Art of the Ancient World: Painting, Pottery, Sculpture, Architecture,* Englewood Cliffs, NJ: Prentice- Hall, 1972.

Covers Egypt and Mesopotamia through the Roman Empire.

11:76 Higgins, Reynold A. *Minoan and Mycenaean Art.* New York: Praeger, 1967.

11:77 Marinatos, Spyridon. *Crete and Mycenae.* New York: Abrams, 1960.

11:78 Murnane, William J. *The Penguin Guide to Ancient Egypt.* Harmondsworth, Middlesex: Penguin, 1983.

11:79 Pallottino, Massimo. *Etruscans.* Trans. by J. Cremona. Rev. and enlarged ed. by David Ridgway. London: Allen Lane, 1974.

11:80 *Pelican History of Art.* Nikolaus Pevsner and Judy Nairn, joint eds. Baltimore, MD: Penguin, 1953+

Scholarly texts, bibliographical footnotes, glossaries, and extensive bibliographies.

Revised editions being prepared. Other volumes cited under art period discussed.

.1 *Prehistoric Art in Europe,* Nancy K. Sandars, 1975.

.2 *Art and Architecture of the Ancient Orient,* 4th rev. ed., Henri Frankfort, 1970.

.3 *Art and Architecture of Ancient Egypt,* rev. ed., W. Stevenson Smith, 1981.

.4 *Arts in Prehistoric Greece,* Sinclair Hood, 1978.

.5 *Greek Architecture,* Arnold W. Lawrence, rev. ed., 1984.

.6 *Etruscan and Roman Architecture,* Axel Boethius and John Ward-Perkins, 1970.

.7 *Etruscan Art,* Otto J. Brendel, 1979.

.8 *Roman Art,* Donald Strong, 1980.

.9 *Roman Imperial Architecture.* 2nd ed., John B. Ward-Perkins, 1981.

.10 *Ancient Iraq,* 2nd ed. by Georges Roux, 1985.

11:81 Pollitt, Jerry Jordan. *Art in the Hellenistic Age.* New York: Cambridge University, 1986.

11:82 Richter, Gisela. *A Handbook of Greek Art.* 9th ed. Jersey City, NJ: DaCapo Press, 1987.

11:83 Ridgway, Brunilde Sismonde. *The Archaic Style in Greek Sculpture.* Princeton, NJ: Princeton University, 1977.

11:84 Robertson, D. S. *Greek and Roman Architecture.* 2nd ed. New York: Cambridge University, 1969.

11:85 Strong, Donald E. *Roman Imperial Sculpture: An Introduction to the Commemorative and Decorative Sculpture of the Roman Empire Down to the Death of Constantine.* London: Tiranti, 1961.

Bibliographies

11:86 *Catalogues of The Berenson Library of the Harvard University Center for Italian Renaissance Studies at Villa I Tatti (Florence, Italy).* Boston: G. K. Hall, 1973. 4 vols.

Classical art, Near Eastern archaeology, medieval illuminated manuscripts, and Italian painting from late Middle Ages to the Renaissance.

11:87 *Catalog of The Warburg Institute Library* 2nd ed. Boston: G. K. Hall, 12 vols. *First Supplement,* 1971. One vol.

Library concerned with classical antiquity, its survival and revival, in European civilizations. Organizes books and articles according to (1) political and social history; (2) religion, history of science, philosophy; (3) literature; and (4) art and archaeology including numerous works on iconography.

Locates difficult-to-find material. Vol. 12 records reference works in Reading Room and includes serial list. For computer project, see 19:15.

11:88 Coulson, William D.E. and Patricia N. Frelert. *Greek and Roman Art, Architecture, and Archaeology: An Annotated Bibliography.* 2nd ed. rev. New York: Garland, 1987.

11:89 Heizer, Robert F., Thomas R. Hester, and Carol Graves. *Archaeology: A Bibliographical Guide to the Basic Literature.* New York: Garland, 1980.

11:90 University of Chicago. *Catalog of the Oriental Institute Library.* Boston: G. K. Hall, 1970. 16 vols.

Sections on classical art, Near Eastern archaeology, and medieval illuminated manuscripts as well as Italian painting from late Middle Ages to the Renaissance.

Documents and Sources

11:91 *Sources and Documents in the History of Art Series.* Englewood Cliffs, NJ: Prentice-Hall.

.1 *Art of Greece: 1400–31* B.C., Jerry Jordan Pollitt. 1965.

.2 *Art of Rome: c. 753* B.C.–*337* A.D., Jerry Jordan Pollitt, 1966; reprint, New York: Cambridge University, 1983.

11:92 Jones, Henry Stuart, ed. *Select Passages from Ancient Writers Illustrative of the History of Greek Sculpture.* Ed. and trans. by Henry Stuart Jones. New York: Macmillan, 1895; reprint, with introduction, bibliography, and index by Al. N. Oikonomides, Chicago: Argonaut, 1966.

Organized in 2 columns: original Greek and translation. Introduction, which gives historical account of ancient writers whose works are quoted, and indices of new edition are valuable additions. Indices to ancient artists, ancient and modern authors, geographical locations, and subjects.

11:93 Pliny, the Elder. *Historia Naturalis.* Trans. by K. Jex-Blake. Chicago: Argonant, 1968. 10 vols.

Roman Pliny the Elder (23–79 AD) wrote this first encyclopedia; sections on history of art and his observations of nature, which influenced the medieval Bestiaries. Numerous translations and editions.

11:94 Wren, Linnea H. and David J. Wren. *Perspectives on Western Art: Source Documents and Readings from the Ancient Near East through the Middle Ages.* New York: Harper & Row, 1987.

Translations of historical documents connected with art objects from proto-Neolithic Jericho to Gothic.

Video Documentaries

The television series of Nova and the National Geographic often have programs on archaeology.

Ancient Lives, Humanities, 1980s
Crete and Mycenae, Museum Without Walls, Kartes, 1986.
Greek Temple, Museum Without Walls, Kartes, 1986
Heritage of the Pharoahs, International Adventure Video, 1983.
In Search of the Trojan War, BBC, 1985
Pyramids, Unicorn, 1988.
Stonehenge, Horizon, 1989.

Indices

11:95 *Archäologische Bibliographie.* Berlin: W. de Gruyter, 1913+
Title varies; now an annual. Continues the bibliographies published in the *Jahrbuch des Deutsches Archäologisches Institut,* 1886–88 and *Archäologischer Anzeiger, Beiblatt zum Jahrbuch des Archäologischen Instituts,* 1889–1912.

11:96 Brooklyn Museum. *Egyptology Titles.* Cambridge, England: Aris & Phillips, 1962+
Small pamphlet issued quarterly in cooperation with Faculty of Oriental Studies, University of Cambridge. Replaces *Wilbour Library of Egyptology Acquisitions Lists,* published from 1962 to 1972 (19 issues).

11:97 *Nestor.* Bloomington: Indiana University, 1957+
Bibliography of Minoan and Mycenaean archaeology.

Serials

Art Index is the only English-language index to cover ancient Egyptian, Greek, and Roman art. *Répertoire d'art et d'archéologie* begins coverage with about 200 AD; *RILA,* the 4th century AD. Many serials cited below highlight a specific association or museum's expeditions and research.

American Journal of Archaeology, Archaeological Institute of America 1885+
The Antiquaries Journal, Society of Antiquaries, London 1921+
Archaeologia, Society of Antiquaries of London 1773+
Archaeological Journal, Royal Archaeological Institute of Great Britain and Ireland 1844+
Archaeology, Archaeological Institute of America 1948+
Expedition: The University Museum of Archaeology/Anthropology, University of Pennsylvania 1958+
Hesperia, American School of Classical Studies at Athens 1932+
Journal of Hellenic Studies, Council of the Society for the Promotion of Hellenic Studies, London 1880+

Journal of Egyptian Archaeology, Egypt Exploration Society, London 1914+
Journal of Roman Studies, Society for the Promotion of Roman Studies, London 1911+
Revue archéologique, Centre National de la Recherche Scientifique 1844+
Rotunda: The Magazine of the Royal Ontario Museum 1968+

Cultural/Historical Surveys

11:98 *Atlas Series.* New York: Facts on File.
.1 *Atlas of Ancient Egypt,* John Baines and Jaromir Malek, 1980.
.2 *Atlas of the Greek World,* Peter Levi, 1984.
.3 *Atlas of the Roman World,* Tim Cornell and John Matthews, 1982.
.4 *Atlas of the Jewish World,* Nicholas de Lange, 1984.

11:99 *Cambridge Ancient History.* 3rd ed. Cambridge: Cambridge University, 1970. 17 vols.

11:100 Durant, Will. *The Story of Civilization.* New York: Simon & Schuster *Part I: Our Oriental Heritage,* 1954.. *Part II The Life of Greece,* 1939. *Part III: Caesar and Christ,* 1944.

11:101 *A History of Private Life. Volume I: From Pagan Rome to Byzantium.* Paul Veyne, ed. Trans. by Arthur Goldhammer. Cambridge, MA: Belknap Press, 1987.

11:102 Hodges, Henry. *Technology in the Ancient World.* Baltimore: Penguin Books, 1970.
Important source for understanding development of art and architecture, prehistoric to 5th century A.D.

11:103 Mylonas, George E. *Mycenae and Mycenaean Age.* Princeton, NJ: Princeton University, 1966.

11:104 Oppenheim, A. Leo. *Ancient Mesopotamia: Portrait of a Dead Civilization.* Rev. ed. completed by Erica Reiner. Chicago: University of Chicago, 1964.

11:105 *Oxford History of the Classical World,* ed. by John Boardman, Jasper Griffin, and Oswyn Murray. New York: Oxford University, 1986.
Vol. 1: *Greece and the Hellenistic World;* Vol. 2: *The Roman World.*

Early Christian, Byzantine, and Medieval

For some thoughts on recent research, consult Herbert L. Kessler's "On the State of Medieval Art History," *Art Bulletin:* 70(June 1988): 166–87 and the essays and bibliographies in the *Encyclopedia of World Art* [10:2]: Volume 9, "Late Antique and Early Christian Art;" Volume 16, "The Middle Ages in the West," "Eastern Christianity," and

"Islam;" and in Volume 17, "The Middle Ages in the West and Eastern Christendom." Since much of this art was concerned with architecture, remember to check the architectural resources cited in Chapter 21.

Dictionaries

See *Dictionnaire des Eglises de France* [21:2] and *Buildings of England* [21:39].

11:106 Dahmus, Joseph. *Dictionary of Medieval Civilization.* New York: MacMillan, 1984.

11:107 Strayer, Joseph R., ed.-in-Chief. *Dictionary of the Middle Ages,* New York: Charles Scribner's, 1982–85. 12 vols.

11:108 Grabois, Aryeh. *The Illustrated Encyclopedia of Medieval Civilization.* NY: Mayflower, 1980.

11:109 *Oxford Dictionary of Byzantine Civilization.* New York: Oxford, to be published, 1991. 2 vols.

Art Historical Surveys

11:110 *Arts of Mankind Series.* New York: G. Braziller, Odyssey Press, and Golden Press.
 .1 *The Golden Age of Justinian: From the Death of Theodosius to the Rise of Islam,* André Grabar, 1967.
 .2 *Early Christian Art: From the Rise of Christianity to the Death of Theodosius,* André Grabar, 1969.
 .3 *Europe of the Invasions,* Jean Hubert, Jean Porcher, and W. F. Volbach, 1969.
 .4 *The Carolingian Renaissance,* Jean Hubert, Jean Porcher, and W. F. Volbach, 1970.

11:111 Beckwith, John. *The Art of Constantinople: An Introduction to Byzantine Art 330–1453.* New York: Phaidon, 1961.

11:112 Calkins, Robert G. *Illuminated Books of the Middle Ages.* Ithaca, NY: Cornell University, 1983.

11:113 ———. *Monuments of Medieval Art.* Oxford: Phaidon, 1979.

11:114 *Corpus della scultura altomedievale.* Spoleto: Centro Italiano di Studi sull'Alto Medioevo, 1959+
 Fascicles on sculpture, reliefs, and church decoration for various areas and cities of Italy, such as *Le Diocese Aquileia,* 1981.

11:115 *Corpus vitrearum medii aevi.* Fascicles have different publishers, 1956+
 Fascicles for different churches, such as Peter A. Newton's *The County of Oxford* (Oxford University, 1979).

11:116 Demus, Otto. *Byzantine Art in the West.* New York: New York University, 1970.

11:117 Grabar, André. *Byzantine Painting: Historical and Critical Study.* Geneva: Skira, 1953.

11:118 Hearn, M. F. *Romanesque Sculpture: The Revival of Monumental Stone Sculpture in the Eleventh and Twelfth Centuries.* Ithaca, NY: Cornell University Press, 1981.

11:119 Kitzinger, Ernst. *Early Medieval Art.* Bloomington: Indiana University, 1964.

11:120 Mâle, Emile. *Religious Art in France.* Princeton, NJ: Princeton University.
 .1 *The Twelfth Century: A Study of the Origins of Medieval Iconography,* 1978.
 .2 *The Thirteenth Century: A Study of Medieval Iconography and its Sources,* 1984.
 .3 *The Late Middle Ages: A Study of Medieval Iconography and its Sources,* 1986.

11:121 Milburn, Robert. *Early Christian Art and Architecture.* Berkeley, CA: University of California, 1988.

11:122 *La nuit des temps Series.* Paris: Zodiaque.
 More than 60 individual books on Romanesque art and architecture in various regions of Europe. Titles usually are for feudal areas, such as *Bourgogne romane.*

11:123 *Oxford History of Art Series.* London: Oxford University.
 Vol. 2: English Art 871–1100, David Talbot Rice, 1952; *Vol. 3: English Art 1100–1216,* T.S.R. Boase, 1953. *Vol. 4: English Art 1216–1307,* Peter Brieger, 1957.

11:124 *Pelican History of Art.* Baltimore, MD: Penguin.
 .1 *Early Christian and Byzantine Art,* John Beckwith, 1970.
 .2 *Early Christian and Byzantine Architecture,* Richard Krautheimer, 1965.
 .3 *Painting in Europe 800–1200,* Charles Dodwell, 1971.
 .4 *Ars Sacra 800–1200,* Peter Lasko, 1972.
 .5 *Carolingian and Romanesque Architecture: 800–1200,* rev. ed., Kenneth John Conant, 1974.
 .6 *Painting in Britain: The Middle Ages,* Margaret Josephine Rickert, 2nd ed., 1965.
 .7 *Sculpture in Britain: The Middle Ages.* Margaret Whinney and John Physink. 2nd ed. 1988.
 .8 *Architecture in Britain: The Middle Ages,* Geoffrey F. Webb, 2nd ed., 1965.
 .9 *Art and Architecture in Italy: 1250–1400,* John White, 2nd ed., 1987.
 .10 *Gothic Architecture,* Paul Frankl, 1963.

.11 *Art and Architecture of Islam,* Richard Ettinghausen, 1987.

11:125 Pope-Hennessy, John. *An Introduction to Italian Sculpture. Part 1: Italian Gothic Sculpture,* see 12:24.

11:126 Post, Chandler Rathfon. *A History of Spanish Painting.* Cambridge, MA: Harvard University Press, 1930–66; reprint, New York: Kraus, 1970. 14 vols. in 18 books.
Spanish art from Pre-Romanesque to late Renaissance in Castille.

11:127 Rice, David Talbot. *Byzantine Painting: The Last Phase.* New York: Dial, 1968.

11:128 Snyder, James. *Medieval Art: Painting, Sculpture, Architecture, 4–14th Century.* Englewood Cliffs, NJ: Prentice-Hall, 1989.

11:129 Stoddard, Whitney S. *Art and Architecture in Medieval France.* New York: Harper & Row, 1972.

11:130 Stokstad, Marilyn. *Medieval Art.* New York: Harper & Row, 1986.

11:131 *Style and Civilization Series.* Baltimore, MD: Penguin.
.1 *Byzantine Style and Civilization,* Steven Runciman, 1975.
.2 *Early Medieval,* George Henderson, 1972.
.3 *Gothic,* George Henderson, 1967.

11:132 Weitzmann, Kurt et al. *The Icon.* New York: Alfred Knopf, 1982.

11:133 Wieck, Roger S. *Time Sanctified: The Book of Hours in Medieval Art and Life.* New York: Braziller/Walters Art Gallery, 1988.

11:134 Zarnecki, George. *Art of the Medieval World: Architecture, Sculpture, Painting, The Sacred Arts.* Englewood Cliffs, NJ: Prentice-Hall, 1975.

Bibliographies

See *Catalog of Warburg Institute* [11:87].

11:135 Allen, Jelisaveta S. *Literature on Byzantine Art, 1892–1967.* London: Mansell, 1973–76. 2 vols in 3 books.
Published for Dumbarton Oaks Center for Byzantine Studies; includes all pertinent entries listed semi-annually in *Byzantinische Zeitschrift,* vols. 1–60.

11:136 Crosby, Everett U. and C. Julian Bishko and Robert L. Kellogg. *Medieval Studies: A Bibliographical Guide.* New York: Garland, 1983.

11:137 *Dumbarton Oaks Bibliographies.* London: Mansell, 1973 +
Based upon *Byzantinische Zeitschrift.*

11:138 *G. K. Hall Art Bibliographies Series.* Boston: G. K. Hall.
.1 *Anglo-Saxon and Anglo-Scandinavian Art: An Annotated Bibliography,* Robert Deshman, 1984.
.2 *Art and Architecture in the Balkans: An Annotated Bibliography,* Slobodan Curcic, 1984.
.3 *Dugento Painting: An Annotated Bibliography,* James H. Stubblebine, 1983.
.4 *French Romanesque Sculpture: An Annotated Bibliography,* Thomas W. Lyman with Daniel Smartt, 1987.
.5 *From Justinian to Charlemagne, European Art, 567–787: An Annotated Bibliography,* Lawrence P. Nees, 1985.
.6 *Insular Art: An Annotated Bibliography,* Martin Werner, 1984.
.7 *Italian Romanesque Sculpture: An Annotated Bibliography,* Dorothy F. Glass, 1983.
.8 *Mosan Art: An Annotated Bibliography,* Gretel Chapman, 1988.
.9 *Villard de Honnecourt—The Artist and His Drawings: A Critical Bibliography,* Carl F. Barnes, Jr., 1982.

11:139 *Dictionary Catalogue of the Byzantine Collection of the Dumbarton Oaks Research Library.* Boston: G. K. Hall, 1975. 12 vols.
Besides Byzantine includes Greco-Roman world, early and medieval Islam, and world of Orthodox Slavs.

11:140 Rounds, Dorothy. *Articles on Antiquity in Festschriften.* Cambridge, MA: Harvard University, 1962.

11:141 School of Classical Studies, Athens. *Catalogue of the Gennadius Library.* Boston: G. K. Hall, 1968. 7 vols. *First Supplement,* 1973. One vol.
Concerned with Greece from antiquity to present; emphasis on medieval period and modern times to 1900. Includes works on beginnings of classical archaeology, 1750–1825.

11:142 *Zeitschrift für Kunstgeschichte.* Berlin: Deutscher Kunstverlag, 1932 +
November/December issue includes bibliography covering art from 500 A.D. to 1850. Suspended publication 1944–48.

Documents, Sources, and Facsimiles

See *Perspectives on Western Art* [11:94].

11:143 *Sources and Documents in the History of Art Series.* Englewood Cliffs, NJ: Prentice-Hall; reprints, Toronto: University of Toronto.
.1 *Early Medieval Art: 300–1150,* Caecila Davis-Weyer, 1971; reprint 1986.

.2 *Gothic Art: 1140-c. 1450,* Teresa Frisch, 1971; reprint 1987.

.3 *Art of the Byzantine Empire, 312–1453,* Cyril A. Mango, 1972.

11:144 Holt, Elizabeth Gilmore, ed.. *A Documentary History of Art. Volume I: The Middle Ages and Renaissance,* Garden City, NY: Doubleday 1957.

11:145 *Masterpieces of Manuscript Painting.* New York: George Braziller.
More than 10 volumes covering different historical periods. Each book has color reproductions from about 40 pages of various manuscripts. Includes *Late Antique and Early Christian Book Illumination,* Kurt Weitzmann, 1977 and *The Decorated Letter,* J.J.G. Alexander, 1978. Braziller also publishes excellent illuminated manuscript facsimiles, such as *The Hours of Catherine of Cleves,* 1966, and *Le Belles Heures of Jean, Duke de Berry,* 1974.

Indices to Works of Art

11:146 *Gothic Sculpture in American Collections.* Dorothy Gillerman, ed. New York: Garland, 1989+ Proposed 3 vols.
Vol. 1: New England Museums reprints census of Gothic art published in *Gesta.* Organized by museums; illustrated scholarly entries.

11:147 *Romanesque Sculpture in American Collections.* Walter Cahn, ed. New York: B. Franklin, 1979+
Vol. 1: New England Museums reprints census of Romanesque art published in *Gesta.* Organized by museums; illustrated scholarly entries.

Video Documentaries

Castles, Unicorn, 1985.

The Day the Universe Changed, James Burke, Series of 10 programs, some of which cover the medieval age, BBC, book on the series published by London Writers Ltd., 1985.

The Frozen World, Civilization Series, BBC, 1970.

Serials

Bulletin Monumental, Société Francaise d'Archéologie 1834+

Byzantinische Zeitschrift, affiliated with Akademie der Wissenschaften 1892+

Cahiers archéologiques 1945+

Cahiers de civilization médiévale, Université de Poitiers 1958+

Congrès Archéologique de France, Société Française d'Archéologie 1834+

Dumbarton Oaks Papers, Dumbarton Oaks Research Library of Harvard University 1941+

Gesta, International Center of Medieval Art, 1963+

Speculum: A Journal of Medieval Studies, Medieval Academy of America 1926+

Cultural/Historical Surveys

11:148 Alexander, Jonathan and Paul Binski. *Age of Chivalry: Art in Plantagenet England 1200–1400.* London: Royal Academy of Arts, 1987.

11:149 *Atlas Series.* New York: Facts on File.
.1 *Atlas of the Christian Church,* ed. by Henry Chadwick and G.R. Evans, 1987.
.2 *Atlas of Medieval Europe,* Donald Matthew, 1983.

11:150 Bouquet, A.C. *Everyday Life in New Testament Times.* New York: Scribner's, 1953.

11:151 *Cambridge Medieval History.* 2nd ed. Cambridge: Cambridge University, 1924; reprint, 1964. 8 vols. in 9 books.
From Constantine to the 15th century.

11:152 Chambers, Edmund K. *The Medieval Stage.* Oxford: Clarendon, 1903. 2 vols.
Discussions of minstrels, folk drama, and religious drama, plus essay on rise and development of 15th-century theater. Vol. 2 has subject index.

11:153 Duby, Georges, ed. *A History of Private Life. Volume II: Revelations of the Medieval World.* Cambridge, MA: Belknap Press, 1988.

11:154 Durant, Will. *The Story of Civilization. Part IV: The Age of Faith.* New York: Simon & Schuster, 1950.

11:155 Gies, Frances and Joseph Gies. *Marriage and the Family in the Middle Ages.* New York: Harper & Row, 1987.

11:156 Holmes, George, ed. *The Oxford Illustrated History of Medieval Europe.* Oxford: Oxford University, 1988.

11:157 Lafontaine-Dosogne, Jacqueline. *Histoire de l'art byzantin et chrétien d'Orient.* Louvain-la-neuve, Belgium: Université Catholique de Louvain, 1987.

11:158 Metzger, Therese and Mendel Metzger. *Jewish Life in the Middle Ages: Illuminated Hebrew Manuscripts of the Thirteenth to the Sixteenth Centuries.* New York: Alpine, 1982.

11:159 *Oxford Illustrated History of Medieval Europe,* ed. by George Holmes. Oxford: Oxford University, 1988.

11:160 Young, Karl. *The Drama of the Medieval Church.* Oxford: Clarendon, 1933; reprint ed., Oxford University Press, 1962. 2 vols.
Discusses history and development of liturgy of Roman Catholic Church and various ecclesiastical related dramatizations. Source for Latin versions of numerous medieval tropes and liturgical plays.

Artistic Styles and Historic Periods: Renaissance to Contemporary

Covering Western European styles and historic periods, this chapter is divided into (1) Italian and Northern European Renaissance; (2) 17th- and 18th-century art; (3) 19th-Century art; and (4) 20th-Century art. Some styles cover more than one period; be sure to check resources for all centuries during which the style was popular.

Italian and Northern European Renaissance

For some thoughts on recent research, consult *Art Bulletin* 68(December 1986): Larry Silver's "The State of Research in Northern European Art of the Renaissance Era," pp. 518–535 and Sandra Hindman's "The Illustrated Book: An Addendum to the State of Research in Northern European Art," pp. 536–542. Also see the essays and bibliographies in the *Encyclopedia of World Art* [10:2], Volume 16, "Renaissance and Mannerism in Italy" and "Renaissance and Mannerism in Northern Europe," and Volume 17, selections from "The Modern Era."

Dictionaries

12:1 Avery, Catherine B., ed. *The New Century Italian Renaissance Encyclopedia.* New York: Appleton-Century-Crofts, 1972.

12:2 Bergin, Thomas Goddard. *Encyclopedia of the Renaissance.* New York: Facts on File, 1987.

12:3 Hale, J. R. *A Concise Encyclopaedia of the Italian Renaissance.* New York: Oxford University, 1981.

12:4 Rachum, Ilan. *The Renaissance: An Illustrated Encyclopedia.* New York: Mayflower, 1980.

Biographical Dictionaries

12:5 Mander, Carel van. *Dutch and Flemish Painters.* Trans. by Constant van de Wall. New York: McFarlane, Warde, McFarlane, 1936.

Earliest biographies of Northern European painters; first published as *Het Schilder-boeck,* 1604.

12:6 Vasari, Giorgio. *Lives of the Most Eminent Painters, Sculptors, and Architects.* Trans. by Gaston du C. de Vere. London: Macmillan, 1912–15. 10 vols.

One of the first art historians, Vasari discussed 175 artists in his first publication of two volumes in 1550. The 2nd edition of 1568 of 250 artists is the one usually translated. In the 1568 edition, woodcut portraits of artists were added. Covers 300 years, from Cimabue to Michelangelo. Numerous editions and abridgements.

Art Historical Surveys

See *History of Spanish Painting* [11:126].

12:7 Antal, Frederick. *Florentine Painting and Its Social Background.* London: K. Paul, 1948; illustrated reprint, Cambridge, MA: Harvard University, 1986.

12:8 *Arts of Mankind.* André Malraux and George Salles, general eds. New York: G. Braziller, Odyssey Press, and Golden Press.
 .1 *The Flowering of the Italian Renaissance,* Andre Chastel, 1965.
 .2 *Studios and Styles of the Italian Renaissance,* Andre Chastel, 1966.

12:9 Bober, Phyllis and Ruth Rubenstein. *Renaissance Artists & Antique Sculpture: A Handbook of Visual Sources.* Oxford, Oxford University, 1986.
 Based upon the Warburg's "Census of Antique Works of Art Known to Renaissance Artists," [19:15], this book includes similar data for 200 ancient sculptures.

12:10 Crowe, J. A. and G. B. Cavalcaselle. *A History of Painting in Italy, Umbria, Florence and Siena from the Second to the Sixteenth Century,* ed. by Langton Douglas. 2nd ed. London: J. Murray, 1903–14. 6 vols.

12:11 Cuttler, Charles D. *Northern Painting From Pucelle to Bruegel: Fourteenth, Fifteenth, and Sixteenth Centuries.* New York: Holt, Rinehart, Winston, 1968.

12:12 Edgerton, Samuel Y., Jr. *The Renaissance Rediscovery of Linear Perspective*. New York: Harper & Row, 1975.

12:13 Fine, Elsa Honig. *Women and Art: A History of Women Painters and Sculptors from the Renaissance to the 20th Century*. Montclair, NJ: Allanheld & Schram, 1978.

12:14 Friedlander, Max J. *Early Netherlandish Painting*. Heinz Trans. by Norden. New York: Phaidon, 1967–76. 14 vols. in 16 books.
 Covers from van Eyck to Bruegel; catalogue entries for each artist's works. Contains bibliographical footnotes; profusely illustrated. Topographical index. Translation of *Die altniederlandische Malerei*, 1924–37.

12:15 Friedlaender, Walter. *Mannerism and Anti-Mannerism in Italian Painting*. New York: Schocken Books, 1965.

12:16 Gilbert, Creighton *History of Renaissance Art: Painting, Sculpture, Architecture Throughout Europe*. Englewood Cliffs, NJ: Prentice-Hall, 1973.

12:17 Harris, Ann Sutherland and Linda Nochlin. *Women Artists: 1550–1950*. Los Angeles: Los Angeles County Museum, 1976.

12:18 Hartt, Frederick. *History of Italian Renaissance Art: Painting, Sculpture, Architecture*. 3rd ed. Englewood Cliffs, NJ: Prentice-Hall, 1987.

12:19 Haskell, Francis and Penny Nicholas. *Taste and the Antique: The Lure of Classical Sculpture 1500–1900*. New Haven, CT: Yale University, 1981.
 Part 1 discusses influences on artistic changes during these centuries. Part 2 is illustrated scholarly catalogue of more than 90 celebrated classical statues; lengthy bibliographies.

12:20 Marle, Raimond van. *The Development of the Italian Schools of Painting*. The Hague: M. Nijhoff, 1923–38; reprint, New York: Hacker, 1970. 19 vols.
 Well-illustrated history of Italian painting from 6th century through Renaissance; each volume has geographical index, index of artists, and bibliographical footnotes. Vol. 6 is iconographical index to first 5 volumes. General index in last volume is divided into artists' names and places where paintings were located when Marle's work was published.

12:21 Offner, Richard. *A Critical and Historical Corpus of Florentine Painting*. New York: New York University, 1930+
 Individual fascicles, such as *The Fourteenth Century: The Painters of the Miniaturist Tendency*, Milk'os Boskovits (Florence: Giunto Barbera, 1986).

12:22 *Oxford History of Art Series*. London: Oxford University.
 Vol.5: English Art 1307–1461, Joan Evans, 1949. *Vol.7: English Art 1553–1625*, Eric Mercer, 1962.

12:23 *Pelican History of Art*. Baltimore, MD: Penguin.
 .1 *Art and Architecture in Italy: 1250–1400*, John White, 2nd ed. 1987.
 .2 *Sculpture in Italy: 1400–1500*, Charles Seymour, Jr., 1966.
 .3 *Architecture in Italy: 1400–1600*, Ludwig Heydenreich and Wolfgang Lotz, 1974.
 .4 *Sculpture in the Netherlands, Germany, France, and Spain: 1400–1500*, Theodor Muller, 1966.
 .5 *Painting in Italy: 1500–1600*, Sydney Joseph Freeberg, 1971.
 .6 *Painting and Sculpture in Germany and the Netherlands: 1500–1600*, by Gert von der Osten & Horst Vey, 1969.
 .7 *Art and Architecture in Spain and Portugal and Their American Dominions: 1500–1800*, George Kubler and Martin Soria, 1959.
 .8 *Art and Architecture in France: 1500–1700*, Anthony Blunt, 4th ed., 1981.
 .9 *Painting in Britain: 1530–1790*, Ellis K. Waterhouse, 4th ed., 1978.
 .10 *Architecture in Britain: 1530–1830*, rev. ed. John N. Summerson, 1963.

12:24 Pope-Hennessy, John. *An Introduction to Italian Sculpture*. New York: Phaidon Press. 3 vols.
 Part 1: Italian Gothic Sculpture, 2nd ed., 1972.
 Part 2: Italian Renaissance Sculpture, 2nd ed., 1971.
 Part 3: Italian High Renaissance and Baroque Sculpture, 2nd ed., 1970.
 Biographical data and extensive bibliography given after each artist's name in section, "Notes on the Sculptors and on the Plates." Contains indices to places and sculptors.

12:25 Smart, Alastair. *The Dawn of Italian Painting, 1250–1400*. Ithaca, NY: Cornell University, 1978.

12:26 Snyder, James. *Northern Renaissance Art: Painting, Sculpture, The Graphic Arts from 1350 to 1575*. New York: Abrams, 1985.

12:27 *Style and Civilization Series*. Baltimore, MD: Penguin.
 .1 *Early Renaissance*, Michael Levey, 1967.

.2 *High Renaissance*, Michael Levey, 1975.

.3 *Mannerism*, John Shearman, 1967.

12:28 White, John. *The Birth and Rebirth of Pictorial Space*. 3rd ed. Cambridge, MA: Harvard University, 1987.

Bibliographies

See Berenson Library catalogue[11:86].

12:29 *G. K. Hall Art Bibliographies Series*. Boston: G. K. Hall.

.1 *Art and Architecture in Central Europe, 1550–1620: An Annotated Bibliography*, Thomas DeCosta Kaufmann, 1988.

.2 *Art and the Reformation: An Annotated Bibliography*, Linda B. Parshall and Peter W. Parshall, 1986.

.3 *Central Italian Painting, 1400–1465: An Annotated Bibliography*, Martha Levine Dunkelman, 1986.

.4 *Fifteenth-Century Italian Sculpture: An Annotated Bibliography*, Sarah Blake Wilk, 1986.

.5 *Fifteenth-Century North Italian Painting and Drawing: An Annotated Bibliography*, Charles M. Rosenberg, 1986.

.6 *Flemish Painting Outside Bruges, 1400–1500: An Annotated Bibliography*, Barbara G. Lane, 1986.

.7 *Hieronymus Bosch: An Annotated Bibliography*, Walter Gibson, 1983.

.8 *Painting in Bruges 1470–1550: An Annotated Bibliography*, E. James Mundy, 1985.

.9 *Royal French Patronage of Art in the Fourteenth Century: An Annotated Bibliography*, Carla Lord, 1985.

12:30 Studing, Richard and Elizabeth Kruz. *Mannerism in Art, Literature, and Music: A Bibliography*. San Antonio, TX: Trinity University, 1979.

Documents and Sources

12:31 *Sources and Documents in the History of Art Series*. Englewood Cliffs, NJ: Prentice-Hall

.1 *Italy and Spain: 1600–1750*, Robert Enggass and Jonathan Brown. 1970.

.2 *Italian Art 1400–1500*, Creighton Gilbert, 1980.

.3 *Italian Art: 1500–1600*, Robert Klein and Henri Zerner, 1966.

.4 *Northern Renaissance Art: 1400–1600*, Wolfgang Stechow, 1966.

12:32 Holt, Elizabeth Gilmore, ed. *A Documentary History of Art*. Garden City, NY: Doubleday.

Vol. 1: The Middle Ages and Renaissance, 1957. *Vol. 2: Michelangelo and the Mannerists: The Baroque and the Eighteenth Century*, 1958.

12:33 Muehsam, Gerd, ed. *French Painters and Paintings from the Fourteenth Century to Post-Impressionism*. New York: Frederick Ungar, 1970.

Critiques and comments concerning about 100 artists. Brief survey of art criticism and bibliography of art criticism and art critics.

Video Documentaries

The Day the Universe Changed, James Burke, Series of 10 programs, some of which cover the Renaissance, BBC. Book on the series published by London Writers Ltd., 1985.

El Greco: Spirit of Toledo, RM Arts, 1982.

Giotto and the Pre-Renaissance, Museum Without Walls, Kartes, 1986.

Leonardo: To Know How to See, National Gallery of Art, 1972.

Raphael, three films—The Apprentice Years, The Prince of Painters, Legend and Legacy—ARTS/BBC, c. 1983.

The Renaissance: Its Beginnings in Italy, Britannica Films, 1957.

Return to Glory: Michelangelo Revealed, Nippon TV, Crown, 1986.

Tintoretto: The Yellow Gash, RM ARTS, 1984.

Serials

Renaissance Quarterly, Renaissance Society of America 1948+ (Titled *Renaissance News* 1948–1966)

Sixteenth Century Journal, Foundation for Reformation Research and 16th Century Studies Conference 1972+

Cultural/Historical Surveys

12:34 Becker, Marvin B. *Florence in Transition*. Baltimore: Johns Hopkins, 1967. 2 vols.

12:35 Braudel, Fernand. *Civilization and Capitalism 15th–18th Century*. Trans. by Sian Reynolds. New York: Harper & Row.

Vol. 1: The Structures of Everyday Life: The Limits of the Possible, 1981. *Vol. 2: The Wheels of Commerce*, 1982. *Vol. 3: The Perspective of the World*, 1984.

12:36 ———. *The Mediterranean and the Mediterranean World in the Age of Philip II*. Trans. by Sian Reynolds. New York: Harper & Row, 1973. 2 vols.

12:37 Brucker, Gene A. *Renaissance Florence*. New York: Wiley, 1969.

12:38 Burke, Peter. *The Italian Renaissance: Culture and Society in Italy*. Princeton, NJ: Princeton University, 1986.

12:39 Durant, Will. *The Story of Civilization*. New York: Simon & Schuster.

Vol. 5: The Renaissance, 1953. *Vol. 6: The Reformation*, 1957.

12:40 *A History of Private Life.* Cambridge, MA: Belknap.
Vol. 2: Revelations of the Medieval World, Georges Duby, ed., 1988. (Covers 11th through 15th century). *Vol. 3: Passions of the Renaissance.* Roger Chartier, ed. Trans. by Arthur Goldhammer, 1989.

12:41 Holmes, George. *Florence, Rome, and the Origins of the Renaissance.* New York: Oxford University, 1986.

12:42 Larner, John. *Culture and Society in Italy, 1290–1420.* New York: Scribner, 1971.

12:43 Mullins, Edwin. *The Painted Witch, Female Body: Male Art: How Western Artists Have Viewed the Sexuality of Women.* London: Secker & Warburg, 1985.

12:44 *New Cambridge Modern History.* Cambridge: Cambridge University, 1957–79. 14 vols.
Covers from 1493–1945.

12:45 *Oxford Illustrated History of Medieval Europe,* ed. by George Holmes. Oxford: Oxford University, 1988.
Covers from 400 to 1500.

17th and 18th Centuries

For some thoughts on recent research, consult (1) *Art Bulletin* 69(December 1987): Egbert Haverkamp-Begemann's "The State of Research in Northern Baroque Art," pp. 510–19 and Elizabeth Cropper and Charles Dempsey's "The State of Research in Italian Painting of the Seventeenth Century," pp. 494–509. See also Barbara Maria Stafford's "The Eighteenth-Century: Towards an Interdisciplinary Model," *Art Bulletin* 70(March 1988): 6–24 and the essays bibliographies in the *Encyclopedia of World Art* [10:2]: Volume 16, "Southern Baroque," "Northern Baroque," and "18th Century in Europe and the United States" and Volume 17, selections from "The Modern Era."

Biographical Dictionaries

12:46 Bernt, Walther. *The Netherlandish Painters of the Seventeenth Century.* Trans. by P. S. Falla from 3rd German ed., 1969. London: Phaidon, 1970. 3 vols.
Gives brief biographical and bibliographical data on 800 Dutch and Flemish artists; facsimiles of artists' signatures. Well illustrated; Vol. 3 has list of artists with their teachers, pupils, and other artists who used similar style.

12:47 Hofstede de Groot, Cornelis. *A Catalogue Raisonné of the Works of the Most Eminent Dutch Painters of the Seventeenth Century: Based on the Work of J. Smith.* Trans. and ed. by Edward G. Hawke. London: MacMillian, 1908–1927. 8 vols.
This early catalogue raisonné is indispensable in compiling provenance of certain works. Table provides identifying works described by John Smith [12:48] whose catalogue raisonné it updates. The original German version, *Beschreibendes und kritisches Verzeichnis der Werke des hervorragendsten holländischen Maler des XVII. Jahrhunderts,* published in 10 volumes, 1907–28, included 10 artists deleted from English text. There is also a reduced-format facsimile published in 1976. No illustrations.

12:48 Smith, John. *A Catalogue Raisonné of the Works of the Most Eminent Dutch, Flemish, and French Painters.* London: Smith & Son, 1829–42; reprint, London: Sands, 1908. 8 vols. in 9 books.
Earliest catalogue raisonné compiled; valuable for establishing provenance of certain works. Sales prices are usually provided. Includes 40 artists: 33 Dutch, 4 Flemish, and 3 French.

Art Historical Surveys

See *Taste and the Antique* [12:19], *Women Artists* [12:17], and *Women and Art* [12:13].

12:49 Boime, Albert. *Art in an Age of Revolution, 1750–1800.* Chicago: University of Chicago, 1987.

12:50 Crow, Thomas E. *Painters and Public Life in Eighteenth-Century Paris.* New Haven, CT: Yale University, 1985.

12:51 Freedberg, S. J. *Circa Sixteen Hundred: A Revolution of Style in Italian Painting.* Cambridge, MA: Harvard University, 1986.

12:52 Held, Julius S. and Donald Posner. *17th and 18th Century Art: Baroque Painting, Sculpture, and Architecture.* Englewood Cliffs, NJ: Prentice-Hall, 1971.

12:53 Hess, Thomas B. and Linda Nochlin, eds. *Women as Sex Object: Studies in Erotic Art, 1730–1970.* New York: Newsweek, 1972.

12:54 Martin, John Rupert. *Baroque. Style and Civilization Series.* Baltimore, MD: Penguin Books, 1977.

12:55 *Oxford History of Art Series.* London: Oxford University.
Vol. 8: English Art 1625–1714, Margaret Whinney, and Oliver Millar, 1957. *Vol. 9: English Art 1714–1800,* Joseph Burke, 1975.

12:56 *Pelican History of Art.* Baltimore, MD: Penguin.
 .1 *Art and Architecture in Spain and Portugal and Their American Dominions: 1500–1800,* George Kubler and Martin Soria, 1959.
 .2 *Art and Architecture in France: 1500–1700,* 4th ed., Anthony Blunt, 1981.
 .3 *Art and Architecture in Italy: 1600–1750,* rev. ed., Rudolf Wittkower, 1973.
 .4 *Art and Architecture of the Eighteenth Century in France,* Wend G. Kalnein and Michael Levey, 1973.
 .5 *Painting in Britain: 1530–1790,* 4th ed., Ellis K. Waterhouse, 1978.
 .6 *Sculpture in Britain: 1530–1830,* Margaret D. Whinney, 1964.
 .7 *Art and Architecture in Belgium: 1600–1800,* Horst Gerson and E. H. ter Kuile, 1960.
 .8 *Dutch Art and Architecture: 1600–1800,* 3rd ed., Jakob Rosenberg, Slive Seymour, and E. H. ter Kuile, 1977.
 .9 *Baroque Art and Architecture in Central Europe,* Eberhard Hempel, 1965.
 .10 *England in the Eighteenth Century,* John Harold Plumb, 1963.

12:57 *Painting and Sculpture in Europe: 1780–1880,* Fritz Novotny, 1960. See 12:84.1.

12:58 Pevsner, Nikolaus. *Academies of Art Past and Present.* New York: Macmillan, 1940; reprint ed., 1973.

12:59 Rosenblum, Robert. *Transformations in Late 18th Century Art.* Princeton, NJ: Princeton University, 1967.

12:60 *Style and Civilization Series.* Baltimore, MD: Penguin.
 .1 *Neo-Classicism,* Hugh Honour, 1968.
 .2 *Romanticism,* Hugh Honour, 1979.

Documents and Sources

See *French Painters and Paintings* [12:33].

12:61 Holt, Elizabeth Gilmore, ed. *A Documentary History of Art.* Garden City, NY: Doubleday.
 Volume II: Michelangelo and the Mannerists: The Baroque and the Eighteenth Century, 1958.

12:62 *Sources and Documents in the History of Art Series.* Englewood Cliffs, NJ: Prentice-Hall.
 .1 *Neo-classicism and Romanticism: 1750–1850,* Lorenz Eitner, 1970. 2 vols.
 .2 *Italy and Spain: 1600–1750,* Robert Enggass and Jonathan Brown, 1970.

Video Documentaries

Eighteenth-Century Women, Metropolitan Museum of Art, 1982.

Rembrandt and Velasquez: Two Faces of the Seventeenth Century, Metropolitan Museum of Art, 1986.
Joshua Reynolds, Home Video, 1987.

Cultural/Historical Surveys

See *New Cambridge Modern History* [12:44] and *The Painted Witch* [12:43].

12:63 Braudel, Fernand. *Civilization and Capitalism 15th–18th Century.* Trans. by Sian Reynolds. New York: Harper & Row.
 Vol. 1: *The Structures of Everyday Life: The Limits* of the Possible, 1981. Vol. 2: *The Wheels of Commerce,* 1982. Vol. 3: *The Perspective of the World,* 1984.

12:64 Durant, Will. *The Story of Civilization.* New York: Simon & Schuster.
 Vol. 7: The Age of Reason Begins, 1961. *Vol. 8: The Age of Louis XIV,* 1963. *Vol. 9: The Age of Voltaire,* 1965.

12:65 Haskell, Francis. *Patrons and Painters: A Study in the Relations Between Italian Art and Society in the Age of the Baroque.* Rev. ed. New Haven, CT: Yale University, 1980.
 Discussion of patronage of popes and nobility; lengthy bibliography.

12:66 Johnson, E. D. H. *Paintings of the British Social Scene from Hogarth to Sickert.* New York: Rizzoli, 1986.

12:67 Kennedy, Emmet. *The Cultural History of the French Revolution.* New Haven, CT: Yale University, 1989.

12:68 McManners, John. *Death and the Enlightenment: Changing Attitude to Death in Eighteenth-Century France.* New York: Oxford University, 1985.

12:69 Schama, Simon. *The Embarrassment of Riches: An Interpretation of Dutch Culture in the Golden Age.* Berkeley: University of California, 1988.

19th Century

For some thoughts on recent research, consult Richard Shiff's "Art History and the Nineteenth Century: Realism and Resistance," *Art Bulletin* 70(March 1988): 25–48. Also see the essays and bibliographies in the *Encyclopedia of World Art* [10:2]: Volume 16, "19th Century in Europe and the United States" and Volume 17, selections from "The Modern Era."

Dictionaries

12:70 Bridgeman, Harriet and Elizabeth Drury. *The Encyclopedia of Victoriana.* New York: Macmillan, 1975.

12:71 Clement, C. E. and L. Hutton. *Artists of the Nineteenth Century and their Works*. St. Louis: North Point, 1885, rev. ed., 1969.

12:72 Harambourg, Lydia. *Dictionnaire des peintres paysagistes français aux XIX^em siècle*. Neuchatel, Switzerland: Ides et Calendes, 1985.

12:73 *Phaidon Encyclopedia of Series*. London: Phaidon.
 .1 *Phaidon Encyclopedia of Impressionism*, Maurice Serullaz, trans. by E.M.A. Graham, 1978.
 Short history of style, glossary of terms and techniques, brief biographical sketches of artists and those who defended them.

12:74 Scheen, Pieter A. *Lexicon Nederlandse beeldende Kunstenaars*, The Hague: P.A. Scheen. *Vol. 1: 1750–1950*, 1970. *Vol. 2: 1750–1880*, 1981.

12:75 Wood, Christopher. *Dictionary of Victorian Painters*. Woodbridge, Suffolk: Antique Collector's Club, 2nd ed., 1978.
 Biographical dictionary of over 11,000 artists working during Victoria's reign, 1837–1901. Facsimiles of artists' monograms and indices to monograms and artists.

Art Historical Surveys

See *Women Artists* [12:17], *Women and Art* [12:13], and *Taste of the Antique* [12:19].

12:76 Boime, Albert. *The Academy and French Painting of the 19th Century*. London: Phaidon, 1971.
 Discusses establishment of French Academy and Ecole des Beaux-Arts, ateliers, importance of sketches, and academic copy.

12:77 Canaday, John. *Mainstreams of Modern Art*. 2nd ed. New York: Holt, Rinehart & Winston, 1981.

12:78 Clark, T. J., *The Absolute Bourgeois: Artists and Politics in France, 1848–1851*. Princeton, NJ: Princeton University, 1982.

12:79 Eitner, Lorenze. *An Outline of 19th Century European Painting: From David Through Cezanne*. New York: Harper & Row, 1988.

12:80 Hamilton, George Heard. *19th and 20th Century Art: Painting, Sculpture, Architecture*. Englewood Cliffs, NJ: Prentice-Hall, 1970.

12:81 Haskell, Francis. *Past and Present in Art and Taste: Selected Essays*. New Haven, CT: Yale University, 1980.

12:82 Harding, James. *Artistes Pompiers: French Academic Art in the 19th Century*. New York: Rizzoli, 1979.

12:83 *Oxford History of Art Series*. London: Oxford University.
 Vol. 10: English Art 1800–1870, T. S. R. Boase, 1959. *Vol. 11: English Art 1870–1940*, Denis Farr, 1979.

12:84 *Pelican History of Art*. Baltimore, MD: Penguin.
 .1 *Painting and Sculpture in Europe: 1780–1880*, Fritz Novotny, 1960.
 .2 *Painting and Sculpture in Europe: 1880–1940*, 3rd ed., George Heard Hamilton, 1981.
 .3 *Architecture: 19th and 20th Centuries*, 3rd ed. Henry Russell Hitchcock, 1971.

12:85 Rewald, John. *History of Impressionism*. 4th ed. rev. New York: Museum of Modern Art, 1973.

12:86 ———. *Post-Impressionism From van Gogh to Gauguin*. 3rd ed. New York: Museum of Modern Art, 1978.

12:87 Rosenblum, Robert and H. W. Janson. *19th Century Art*. New York: Abrams, 1984.

12:88 Selz, Peter Howard. *Art Nouveau: Art and Design at the Turn of the Century*. Rev. ed. New York: MoMA, 1975.

12:89 Stevens, Mary Anne, ed. *The Orientalists: Delacroix to Matisse: European Painters in North Africa and the Near East*. London: Royal Academy of Arts, 1984.

12:90 *Style and Civilization Series*. Baltimore, MD: Penguin.
 .1 *Neo-Classicism*, Hugh Honour, 1968.
 .2 *Romanticism*, Hugh Honour, 1979.
 .3 *Realism*, Linda Nochlin, 1971.

12:91 Trustees of the Tate Gallery. *The Pre-Raphaelites*. London: Penguin Books, 1984.

12:92 Ulrich, Finke. *German Painting From Romanticism to Expressionism*. London: Thames & Hudson, 1985.

12:93 Varnedoe, Kirk. *Northern Light: Realism and Symbolism in Scandinavian Painting, 1880–1910*. New York: Brooklyn Museum, 1982.

12:94 Vaughn, William. *German Romantic Painting*. New Haven, CT: Yale University, 1980.

12:95 Watkinson, Raymond. *Pre-Raphaelite Art and Design*. London: Studio Vista, 1970.

Bibliographies

12:96 *Catalog of the Library of the Museum of Modern Art* Boston: G. K. Hall, 1976. 14 vols. *Annual Bibliography of Modern Art*, 1986+
 MoMA, as the Museum of Modern Art is called, was founded in 1929. Special

strengths are its analytical cataloguing, late-19th and early-20th century resources, and indication of "Scrapbook" or "Artist File," meaning works are available at MoMA or on microfiche [13:69 & 70]. Includes book collection of Department of Photography and some material from the Architecture Study Center and Film Study Center. With the supplements, Latin American material and the Performance Archive are integrated with rest of collection.

12:97 Kemplon, Richard. *Art Nouveau: An Annotated Bibliography.* Los Angeles: Hennessey & Ingalls, 1977.
All kinds of art; includes some material from 1903 to 1910.

12:98 Parsons, Christopher and Martha Ward. *A Bibliography of the Salon Criticism in Second Empire Paris.* Cambridge, Cambridge University, 1986.

12:99 Weisberg, Yvonne and Gabriel Weisberg. *Japonisme: An Annotated Bibliography on the Japanese Influence on Western Art, 1854–1910.* New York: Garland, 1987.

12:100 ———. *The Realist Debate: A Bibliography of French Realist Painting, 1848–1885.* New York: Garland, 1984.

Documents and Sources

12:101 *Sources and Documents in the History of Art Series.* Englewood Cliffs, NJ: Prentice-Hall
.1 *Neo-classicism and Romanticism: 1750–1850,* Lorenz Eitner, 1970. 2 vols.
.2 *Realism and Tradition in Art: 1848–1900,* Linda Nochlin, 1966.
.3 *Impressionism and Post-Impressionism: 1874–1904,* Linda Nochlin, 1966.

12:102 Holt, Elizabeth Gilmore, ed. *A Documentary History of Art.*
Vol.3: From the Classicists to the Impressionists: A Documentary History of Art and Architecture in the 19th Century. Garden City, NY: Doubleday, 1966.

Art Criticism

See *French Painters and Paintings* [12:33] .

12:103 Brookner, Anita. *The Genius of the Future: Studies in French Art Criticism.* New York: Phaidon, 1971.

12:104 *Connoisseurship, Criticism, and Art History in the 19th Century Series: A Selection of Major Texts in English,* Sydney J. Freedberg, ed. New York: Garland, 1978.

12:105 Holt, Elizabeth Gilmore, ed. *The Triumph of Art for the Public: The Emerging Role of Exhibitions and Critics.* Garden City, NY: Anchor, 1979.
Covers exhibitions from 1785 to 1848 in France, England, Italy, and Germany. Has short introduction to history of criticism and art exhibitions.

12:106 ———, ed. *The Art of All Nations, 1850–73: The Emerging Role of Exhibitions and Critics.* Princeton, NJ: Princeton University, 1981.
Covers exhibitions held in France, England, Germany, Italy, and Austria. Index to artists, critics, painting titles, associations, patrons, and political figures mentioned in text.

12:107 ———, ed. *The Expanding World of Art: Universal Expositions & State Sponsored Fine Arts Exhibitions 1874–1902.* New Haven, CT: Yale University, 1988+
Vol. 2, which is in progress, will document exhibitions arranged by independent groups and societies, art dealers, and individual artists.

12:108 Lochhead, Ian J. *The Spectator and the Landscape in the Art Criticism of Diderot and His Contemporaries. Studies in the Fine Arts: Art Criticism Series.* Ann Arbor, MI: U.M.I. Research, 1982.

12:109 Olmsted, John Charles, ed. *Victorian Painting: Essays and Reviews.* New York: Garland, 1983–85.
Vol. 1: 1832–1848, Vol. 2: 1849–1860, Vol. 3: 1861–1880. Includes introductory survey of art scene, essays on criticism, and reviews for exhibitions, such as the Royal Academy and the British Institution.

12:110 Warner, Eric and Graham Hough, eds. *Strangeness and Beauty: An Anthology of Aesthetic Criticism 1840–1910.* New York: Cambridge University Press, 1983. 2 vols.
Vol. 1: Ruskin to Swinburne. Vol. 2: Pater to Symons.

Video Documentaries

The following is just a sampling of the numerous videos on this period of art history.

American Light: The Luminist Movement, 1850–1875, National Gallery of Art, 1984.
Pierre Bonnard and the Impressionist Vision, Minneapolis Institute of Arts, 1982.
Paul Cézanne: The Man and His Mountain, RM/ARTS, 1985.
David: The Passing Show, RM/ARTS/BBC, 1986.
A Day in the Country: Impressionism and the French Landscape, Holiday, 1984.
Degas, Metropolitan Museum, 1988.

Degas: The Unquiet Spirit, RM/ ARTS/BBC, 1980.
Delacroix: The Restless Eye, RM/ ARTS/BBC, 1986.
Paul Gauguin: The Savage Dream, National Gallery of Art, 1988.
Goya, Museum Without Walls, Kartes, 1986.
Gericault: Men and Wild Horses, RM/ ARTS/BBC, 1982.
The Hague School, RM ARTS, 1983.
Hudson River and Its Painters, Metropolitan Museum, 1987.
Ingres: Slaves of Fashion, RM/ ARTS/BBC, 1982.
Edouard Manet: Painter of Modern Life, Metropolitan Museum, 1983.
In a Brilliant Light: Van Gogh in Arles, Metropolitan Museum, 1984.

Serials

Some 19th-century serials—such as *The Art Journal* (London 1839–74// and *Gazette des beaux-arts* 1850+—cited in Chapter 11 discussed artists, exhibitions, and the art of the period. For 19th-century American serials, see Chapter 13.

Cultural/Historical Surveys

See *The Painted Witch* [12:43].

12:111 Durant, Will. *The Story of Civilization.* New York: Simon & Schuster.
 Vol. 10: Rousseau and Revolution, 1967.
 Vol. 11: The Age of Napoleon, 1975.

12:112 Haskell, Francis. *Rediscoveries in Art: Some Aspects of Taste, Fashion, and Collecting in England and France.* 2nd ed. Ithaca, NY: Cornell University Press, 1979.
 Discusses influences on changes in artistic taste from about 1780 to 1870; excellent bibliography.

12:113 Robertson, Priscilla. *An Experience of Women: Pattern and Change in Nineteenth Century Europe.* Philadelphia: Temple University Press, 1982.
 Covers English, French, German, and Italian women; includes data on 18th as well as 19th century.

12:114 Strong, Roy. *And When Did You Last See Your Father? The Victorian Painter and British History.* London: Thames & Hudson, 1978.

20th Century

Some resources cited under "American Studies" in Chapter 13 also cover this period. For an analysis of recent research, study Jack Spector's "The State of Psychoanalytic Research in Art History," *Art Bulletin* 70(March 1988):49–76 and the essays and bibliographies in the *Encyclopedia of World Art* [10:2]: Volume 16, "20th Century Painting and Sculpture" and "20th Century Architecture" and Volume 17, "The Twentieth Century and Problems of Contemporary Criticism." The *AICARC: Bulletin of the Archives and Documentation Centers for Modern and Contemporary Art,* cited below with the serials, contains special issues on art, criticism, and documentation in various countries For instance, Number 1, 1983 was on Scandinavia; Number 2, 1983, Latin America; Number 1, 1984, Greece; Number 2, 1985, Belgium. Some issues list contemporary serials; others provide data on local museums.

Dictionaries

For current information on artists' galleries and their addresses, see summer issue of *Art in America.*

12:115 Berckelaers, Ferdinand Louis (Michel Seuphor). *Dictionary of Abstract Painting: With a History of Abstract Painting.* Trans. by Lionel Izod et al. New York: Tudor, 1957.

12:116 Comanducci, Agostino Mario. *Dizionario illustrato dei pittori, disegnatori, e incisori italiani moderni e contemporanei.* Amplified by Luigi Pelandi and Luigi Servolini. 3rd ed. Milan: Leonilde M. Patuzzi Editore, 1962. 4 vols.
 Biographical dictionary of Italian painters, designers, and engravers of the 19th and 20th centuries.

12:117 *Index of Twentieth Century Artists 1933–1937.* New York: Harper & Row, 1937; reprint, New York: Arno Press, 1970. 4 vols.
 Includes painters, graphic artists, and sculptors.

12:118 Lake, Carlton and Robert Maillard, general eds. *Dictionary of Modern Painting.* Trans. by Lawrence Samuelson et al. 3rd ed., rev. New York: Tudor, 1964.

12:119 Lucie-Smith, Edward. *Lives of the Great Twentieth Century Artists.* New York, Rizzoli, 1986.
 Divided by style, then has material on from 2 to 10 artists.

12:120 Marks, Claude. *World Artists 1950–1980.* New York: H. W. Wilson, 1984.

12:121 *Oxford Companion to Twentieth-Century Art,* ed. by Harold Osborne. New York: Oxford University, 1981.

12:122 Petteys, Chris with assistance of Hazel Gustow, Ferris Olin, Verna Ritchie. *Dictionary of Women Artists: An International Dictionary of Women Artists Born Before 1900.* Boston: G.K. Hall, 1985.

12:123 *Phaidon Dictionary of Twentieth-Century Art.* New York: Phaidon, 1973.

12:124 *Phaidon Encyclopedia Series.* London: Phaidon.
 .1 *Phaidon Encyclopedia of Expressionism,* Lionel Richard, trans. by Stephen Tint, 1978.
 .2 *Phaidon Encyclopedia of Surrealism,* Rene Passeron, trans. by John Griffiths, 1978.
 Short histories of style, glossary of terms and techniques, brief biographical sketches.

12:125 Thomas, Karin and Gerd de Vries. *DuMont's Künstler Lexikon von 1945 bis zur Gegenwart.* Cologne: DuMont, 1981.

12:126 Walker, John Albert. *Glossary of Art, Architecture, and Design Since 1945: Terms and Labels Describing Movements, Styles, and Groups Derived from the Vocabulary of Artists and Critics.* 2nd ed. rev. London: Clive Bingley, 1977.

12:127 Walters, Grant M. *Dictionary of British Artists 1900–1950.* Eastbourne, England: Eastbourne Fine Arts, 1975. 2 vols.

Art Historical Surveys

See Hamilton [12:80 and 12:84.2], Hitchcock [12.84.3], *Women Artists* [12:17], *Women and Art* [12:13], and *Oxford History of Art* [12.55]. Some of the references cited below are concerned with only one movement, as are many of the books cited under "Criticism"; check both lists.

12:128 Arnason, H. H. *A History of Modern Art.* 3rd ed. Englewood Cliffs, NJ: Prentice-Hall, 1986.

12:129 Ashton, Dore. *Life and Times of the New York School.* New York: Viking, 1972.

12:130 Barr, Alfred H., Jr. *Cubism and Abstract Art.* New York: Museum of Modern Art, 1936; reprint, Cambridge, MA: Belknap, 1986.

12:131 ———. *Defining Modern Art: Selected Writings of Alfred H. Barr,* ed. by Irving Sandler and Amy Newman. New York: Abrams, 1986.

12:132 Farr, Denis. *Oxford History of Art Series.* London: Oxford University, 1979.
 Vol. 11: English Art 1870–1940.

12:133 Golding, John. *Cubism: A History and An Analysis, 1907–1914.* 3rd ed. Cambridge, MA: Belknap, 1988.

12:134 Goldwater, Robert. *Primitivism in Modern Art.* Enlarged ed. Cambridge, MA: Belknap, 1986.

12:135 Haftmann, Werner et al. *Art Since Mid-Century: The New Internationalism.* Greenwich, CT: New York Graphic Society, 1971. 2 vols.

12:136 ———. *Paintings in the Twentieth Century.* Trans. by R. Manheim. 2nd ed. New York: Praeger, 1965. 2 vols.

12:137 Hertz, Richard. *Theories of Contemporary Art.* Englewood Cliffs: Prentice-Hall, 1985.

12:138 Leymarie, Jean. *Fauvism: Biographical And Critical Study.* New York: Skira, 1959.

12:139 Lucie-Smith, Edward. *Symbolist Art.* London: Thames & Hudson, 1972.

12:140 Nochlin, Linda and Ann Sutherland Harris. *Women, Art, and Power and Other Essays.* New York: Harper & Row, 1988.

12:141 Preziosi, Donald. *Rethinking Art History: Meditations on a Coy Science.* New Haven, CT: Yale University, 1989.

12:142 Rickey, George. *Constructivism: Origins and Evolution.* New York: G. Braziller, 1967.

12:143 Rosen, Randy II et al. *Making Their Mark: Women Artists Move into the Mainstream, 1970–85.* New York: Abbeville, 1989.

12:144 Rubin, William, ed. *Primitivism in 20th Century Art: Affinity of the Tribal and the Modern.* New York: Museum of Modern Art, 1984.

Bibliographies

See MoMA's catalog [12:96].

12:145 Bell, Doris L. *Contemporary Art Trends 1960–1980: A Guide to Sources.* Metuchen, NJ: Scarecrow, 1981.
 Divided as to art trends—such as air art, mail art, street art—and countries. Includes definitions and scopes of trends.

12:146 Spalek, John M. et al. *German Expressionism in the Fine Arts: A Bibliography.* Los Angeles: Hennessey & Ingalls, 1977.

Documents and Sources

12:147 *Contemporary Documents: A Series of Comprehensive Resource Books for the New Art.* Carl E. Loeffler, general ed. San Francisco: Contemporary Arts Press.
 .1 *Correspondence Art: A Source Book for the Network of International Postal Art Activity,* ed. by Michael Crane and Mary Stofflet, 1984.
 .2 *Performance Anthology: Source Book for a Decade of California Performance Art,* ed. by Carl E. Loeffler, 1980.

12:148 Diamonstein, Barbaralee. *Inside New York's Art World.* New York: Rizzoli, 1979.
Interviews made between 1975 and 1978 with 27 artists, dealers, critics, museum directors, and designers.

12:149 Fry, Edward F. *Cubism.* London: Thames & Hudson, 1966.

12:150 Jaffe, Hans. *De Stijl.* New York: Harry N. Abrams, 1971.

12:151 Motherwell, Robert, general ed. *The Documents of 20th-Century Art.* New York: Viking and Boston: G. K. Hall.
 .1 *Apollinaire on Art: Essays and Reviews, 1902–1918.* LeRoy C. Breunig, ed. Trans. by Susan Suleiman, 1971.
 .2 *Arp on Arp: Poems, Essays, Memories,* Jean Arp. Marcel Jean, ed. Trans. by Joachim Neugroschel, 1972.
 .3 *Art As Art: The Selected Writings of Ad Reinhardt.* Barbara Rose, ed., 1975.
 .4 *Blaue Reiter Almanac.* Wassily Kandinsky and Franz Marc, ed. Trans. by Henning Falkenstein, 1974.
 .5 *Dada: Performance, Poetry, and Art,* John Erickson, 1984.
 .6 *Dialogues With Marcel Duchamp,* Pierre Cabanne. Robert Motherwell, ed. Trans. by Ron Padgett, 1971.
 .7 *Flight Out of Time: A Dada Diary,* Hugo Ball. John Elderfield, ed. Trans. by Ann Raimes, 1974.
 .8 *Functions of Fernand Leger.* Edward F. Fry, ed. Trans. by Alexandra Anderson, 1973.
 .9 *Futurist Manifestos.* Umbro Apollonio, ed. Trans. by Robert Brian et al., 1973.
 .10 *Henry Moore on Sculpture.* Philip James, ed., 1971.
 .11 *Joan Miro: Selected Writings and Interviews,* Margit Rowell, ed. Trans. by Paul Auster and Patricia Mathews, 1986.
 .12 *Marcel Duchamp, Notes.* Paul Matisse, ed., 1983.
 .13 *Memoirs of a Dada Drummer,* Richard Huelsenbeck. Hans J. Kleinschmidt, ed. Trans. by Joachim Neugroschel, 1974.
 .14 *My Galleries and Painters,* Daniel-Henry Kahnweiller and Francis Cremieux. Trans. by Helen Weaver, 1971.
 .15 *My Life in Sculpture,* Jacques Lipchitz with H. H. Arnason, 1972.
 .16 *New Art, The New Life: The Collected Writings of Piet Mondrian.* Harry Holtzman and Martin S. James, eds. 1986.
 .17 *New Art of Color: The Writings of Robert and Sonia Delaunay,* 1978.
 .18 *Picasso on Art: A Selection of Views.* Dore Ashton, ed., 1972.
 .19 *Russian Art of the Avant-Garde: Theory and Criticism 1902–1934,* ed. and trans. by John E. Bowlt, 1976.
 .20 *Tradition of Constructivism.* Stephen Bann, ed., 1974.
 .21 *Kandinsky: Complete Writings on Art.* Kenneth C. Lindsay and Peter Vergo, eds., 1980, 2 vols.
 .22 *The Dada Painters and Poets: An Anthology,* 2nd ed. by Robert Motherwell and Jack D. Flam, with rev. bibliography by Bernard Karpel, 1981.
 .23 *The Autobiography of Surrealism.* Marcel Jean, ed., 1980.

12:152 Robertson, Jack. *Twentieth-Century Artists on Art: An Index to Artists' Writings, Statements, and Interviews.* Boston: G.K. Hall, 1985.
Covers 5,000 artists; includes books, serials, and group exhibition catalogues.

12:153 Seldon, Rodman. *Conversations with Artists.* New York: Devin, 1957.

Art Criticism

12:154 *Art Criticism Series.* Ann Arbor: U.M.I. Research Press,
Many volumes are on individual critics. Only books covering criticism for a particular style are cited here.
 .1 *Art Critics and the Avant-Garde,* Arlene Rita Olson, 1980.
 .2 *Critics of Abstract Expressionism,* Stephen C. Foster, 1980.
 .3 *Cubist Criticism,* Lynn Gamwell, 1980.
 .4 *Feminist Art Criticism: An Anthology,* Arlene Raven et al., eds., 1988.
 .5 *Metaphor of Painting: Essays on Baudelaire, Ruskin, Proust, and Pater,* Lee McKay Johnson, 1980.
 .6 *Modernism in the 1920s: Interpretations of Modern Art in New York from Expressionism to Constructivism,* Susan Noyes Platt, 1985.
 .7 *The New Subjectivism: Art in the 1980s,* Donald Kuspit, 1988.
 .8 *Pop Art and the Critics,* Carol Anne Mahsum, 1987.
 .9 *Postminimalism into Maximalism: American Art, 1966–1986,* Robert Pincus-Witten, 1987.
 .10 *Roger Fry and the Beginnings of Formalist Art Criticism,* Jacqueline Victoria Falkenheim and Roger Eliot Fry, 1980.

12:155 Battcock, Gregory, ed. New York: Dutton.
 .1 *The Art of Performance A Critical Anthology,* 1981.
 .2 *Minimal Art A Critical Anthology,* 1968.

.3 *The New Art A Critical Anthology*, rev.
ed. 1973.
.4 *Super Realism A Critical Anthology*,
1975.

12:156 *Calligram: Essays in New Art History from France*. Norman Bryson, ed. New York: Cambridge University, 1988.

12:157 Foster, Hal, ed. *The Anti-Aesthetic: Essays on Postmodern Culture*. Seattle: Bay Press, 1983.

12:158 ———, ed. *Discussions on Contemporary Culture*. Dia Art Foundation. Seattle: Bay Press, 1987.

12:159 ———, ed. *Vision and Visuality*. Dia Art Foundation. Seattle: Bay Press, 1988.

12:160 Frascina, Francis, ed. *Pollock and After: The Critical Debate*. New York: Harper & Row, 1985.

12:161 ——— and Charles Harrison, eds. *Modern Art and Modernism: A Critical Anthology*. New York: Harper & Row, 1982.

12:162 Greenberg, Clement. *Clement Greenberg: Collected Essays and Criticism*. Chicago: University of Chicago, 1986.
Vol. 1: *Perceptions and Judgements, 1939–40; Vol. 2: Arrogant Purpose, 1945–49.*

12:163 Kuspit, Donald Barton. *The Critic is Artist: The Intentionality of Art*. Ann Arbor, MI: UMI, 1984.

12:164 ———. *Clement Greenberg: Art Critic*. Madison, WI: University of Wisconsin, 1979.

12:165 Lippard, Lucy R. *Changing: Essays in Art Criticism*. New York: Dutton, 1971.

12:166 ———. *Six Years: The Dematerialization of the Art Object from 1966 to 1972*. New York: Praeger, 1973.

12:167 Rosenberg, Harold. *The Anxious Object: Art Today and Its Audience*. New York: Horizon, 1964.

12:168 ———. *Art on the Edge: Creators and Situations*. New York: McMillan, 1975.

12:169 ———. *The De-definitions: Action Art to Pop to Earthworks*. London: Secker and Warburg, 1972.

12:170 Steinberg, Leo. *Other Criteria: Confrontations with Twentieth-Century Art*. New York: Oxford, 1972.

12:171 Wallis, Brian, ed. *Blasted Allegories: An Anthology of Writings by Contemporary Artists*. New York: The New Museum of Contemporary Art, 1987. 2 vols.
Vol. 2 entitled *Art After Modernism: Rethinking Representation.*

Video Documentaries

See Video Data Bank of the School of the Art Institute of Chicago [26:51], the Program for Art on Film [26:47], and the Oral History Program of the Archives in American Art [13:62]. The following is just a sampling of the numerous videos on this period of art history.

Francis Bacon, RM ARTS, 1985.
George Bellows: Portrait of an American Artist, Smithsonian, 1982.
Pierre Bonnard: In Search of Pure Color, Home Video, 1984.
Burchfield at the Met, Lutheran, 1985.
Christo's Islands, Maysles, 1983.
Christo's Running Fence, Maysles, 1978.
The Cubist Epoch, Museum Without Walls, Kartes, 1986.
Germany-Dada, Museum Without Walls, Kartes, 1986.
Red Grooms Talks About Dali Salad, Minneapolis Institute of Arts, 1987.
Jack Levine: Feast of Pure Reason, David Sutherland, 1986.
The Mystery of Henry Moore, CBC Enterprises, 1985.
Picasso: War, Peace, Love, Museum Without Walls, Kartes, 1986.
The Frescos of Diego Rivera, Detroit Institute of Arts, 1986.
The Real World of Andrew Wyeth, RM ARTS, 1980.

Serials

The following is a sampling of 20th-century publications. Many foreign-language serials have English articles, translations, or summaries. Most are profusely illustrated. Some early 20th-century serials are available on microfilm.

Art in America 1913+
Art International, Lugano 1956+
Art international aujourd'hui, 1929–30// (microfilm)
L'Art libre, 1919–22// (microfilm)
Art Press International 1973+
Artforum 1962+
Arts et metiers graphiques 1927–39// (microfilm)
Arts Magazines 1926+
artscribe: The International Magazine of New Art 1976+
Artspace: A Magazine of Contemporary Art 1976+
Broom: An International Magazine of the Arts Published by Americans in Italy 1921–24// (microfilm)
C Magazine 1983+
Le Ciel bleu 1945// (microfilm)
Cimaise: Present Day Art/Arts Actuels 1954+
Du 1929+ (Titled *Du Atlantis* 1964–66)
Flash Art International 1967+ (Variations on title)
FUSE Magazine 1976+ (Titled *Centerfold* 1976–78)
Jonge Holland 1985+
Leonardo 1968+
Modern Painters, 1988+

Opus International: revue d'art 1967+
La Plume 1904–05// (microfilm)
RACAR: Revue d'art canadienne/Canadian Art Review 1974+
Siksi, 1986+ (Covers Nordic countries; Finnish title for "that's why")

Studio International: Journal of Contemporary Art, 1893+ (Title has varied)
Third Text: Third World Perspectives on Contemporary Art and Culture, 1987+
Vanguard, 1972+

North American Studies

This chapter annotates reference works for North America: (1) America and (2) Canada. Although most resources cited in Chapters 11 and 12 are for Western European art, they frequently contain information on U.S. and Canadian art. Additional data may be located in the research materials annotated in Part IV in the chapters on different media.

American Studies

Many U.S. institutions have notable collections of American art, such as the Metropolitan Museum of Art, Boston's Museum of Fine Arts, Philadelphia Museum of Art, Cleveland Museum of Art; Art Institute of Chicago; Detroit Institute of Arts; Virginia Museum of Fine Arts, City Art Museum of St. Louis; and Los Angeles County Museum of Art. A number of museums have extensive collections of American Indian art, such as the Heard Museum in Phoenix and the The Indian Museum in Wichita. But there are also institutions devoted only to American art and culture: the National Museum of American Art, the National Portrait Gallery, the Whitney Museum of American Art, the Winterthur Museum, and the Amon Carter Museum. The libraries of these institutions, as well as the Archives of American Art, reflect their collection policies.

The numerous American cultural and historical surveys are outside the scope of this book; ask the reference librarian for assistance in finding publications pertinent to the study. For some thoughts on recent research in this area, consult Wanda M. Corn's "Coming of Age: Historical Scholarship in American Art," *Art Bulletin* 70(June 1988): 188–207 and the essays in Volumes 16 & 17 of the *Encyclopedia of World Art* [10:2].

Biographical Dictionaries

The general biographies, annotated in Chapter 10, also include Americans.

13:1 *American Art Annual.* New York: R. R. Bowker. 1898+
 Published irregularly. Name changed to *American Art Directory* after Volume 37

(1945/48). Publication separated into *American Art Directory* [20:1] and *Who's Who in American Art* [10:50] after 1952. Early volumes had numerous types of information, including brief biographical data on artists and sometimes a directory of architects.

13:2 *American Artists: An Illustrated Survey of Leading Contemporary Americans.* Les Krantz, ed. New York: Facts on File, 1985.

13:3 *American Painters Born Before 1900: A Dictionary and Database.* Brookline Village, MA: Vose Archive, to be completed 1993.
 Biographical and bibliographical data for more than 40,000 artists.

13:4 Baigell, Matthew. *Dictionary of American Art.* New York: Harper Row, 1979.

13:5 *The Britannica Encyclopedia of American Art.* Chicago: Encyclopedia Britannica Educational, 1973.

13:6 Cederholm, Theresa Dickason. *Afro-American Artists: A Biobibliograhical Directory.* Boston: Trustees of the Boston Public Library, 1973.
 About 2,000 artists from 18th century to present.

13:7 Cummings, Paul, ed. *Dictionary of Contemporary American Artists.* New York: St. Martin's, 5th ed., 1988.
 Over 900 painters, sculptors, and printmakers. Lists one-person and group exhibitions, important collections containing artists' works, special commissions, and bibliographies. Revised every 5 years.

13:8 Dawdy, Doris Ostrander. *Artists of the American West: A Biographical Dictionary.* Chicago: Sage Books, 1979–85. 3 vols.
 Entries for more than 2,700 artists born before 1900.

13:9 *Dictionary of American Artists: 19th & 20th Century,* ed. by Alice Coe McGlauflin. New York: American Art Annual, 1930; reprint, Poughkeepsie, NY: Apollo, 1982.
 Artists active 1850–1950.

13:10 Fielding, Mantle. *Dictionary of American Painters, Sculptors and Engravers.* Enlarged ed. by Genevieve C. Doran. Green Farms, CT: Modern Books & Crafts, 1975.

Reissue of Fielding's original 1926 publication with addition of over 2,500 more American artists. Various editions and revisions available. See 13:13.

13:11 Graham, Mary and Carol Ruppe. *Native American Artist Directory*. Phoenix: Heard Museum, 1985.

13:12 Groce, George C. and David H. Wallace. *New York Historical Society's Dictionary of Artists in America 1564–1860*. New Haven, CT: Yale University, 1957.

Biographical dictionary of about 10,000 American painters, draftsmen, sculptors, engravers, lithographers, and allied artists; brief bibliographies.

13:13 *Mantle Fielding's Dictionary of American Painters, Sculptors, and Engravers*, 2nd ed rev., enlarged, updated by Glenn B. Opitz. Poughkeepsie, NY: Apollo, 1986.

13:14 Samuels, P. and H. Samuels. *Samuels' Encyclopedia of Artists of the American West*. 2nd ed. Secaucus, NJ: Castle, 1985.

13:15 ———. *Contemporary Western Artists*. New York: Doubleday, 1982.

13:16 Snodgrass, Jeanne O. *American Indian Painters: A Biographical Directory*. New York: Museum of American Indian, Heye Foundation, 1968.

13:17 Tuckerman, Henry Theodore. *Book of the Artists: American Artist Life Comprising Biographical and Critical Sketches of American Artists: Preceded by an Historical Account of the Rise and Progress of Art in America*. 2nd ed. New York: James F. Carr, 1966.

Reprint of Tuckerman's 1867 publication. Appendix lists works found in some public and private American collections in 19th century.

13:18 *Who Was Who in American Art*, compiled by Peter H. Falk. Madison, CT: Sound View, 1985.

Contains data on artists active 1898–1947; compiled from 34 volumes of *American Art Annual* [13:1] and *Who's Who in America* [10:50].

13:19 *Women Artists in America: 18th Century to the Present (1790–1980)*, rev. ed. by Glenn B. Opitz and Jim Collins. Poughkeepsie, NY: Apollo, 1980.

Data on more than 5,000 women.

13:20 Young, William. *A Dictionary of American Artists, Sculptors and Engravers: From the Beginning through the Turn of the Twentieth Century*. Cambridge, MA: William Young, 1968.

Art Historical Surveys

13:21 Baigell, Matthew. *A Concise History of American Painting and Sculpture*. New York: Harper & Row, 1984.

13:22 Brown, Milton W. *American Painting From the Armory Show to the Depression*. Princeton, NJ: Princeton University, 1955.

13:23 ——— et al. *American Art: Painting-Sculpture-Architecture-Decorative Arts-Photography*. Englewood Cliffs, NJ: Prentice-Hall, 1987.

13:24 Coe, Ralph T. *Lost and Found Traditions: Native American Art 1965–1985*. Seattle: University of Washington, 1986.

13:25 Davidson, Abraham A. *Early American Modernist Painting 1910–1935*. New York: Harper & Row, 1981.

13:26 Dockstader, Frederick J. *Indian Art in America: The Arts and Crafts of the North American Indian*. 3rd ed. Boston: New York Graphic, 1966.

13:27 Driskell, David C. et al. *Harlem Renaissance: Art of Black America*. New York: Abram, 1987.

13:28 Dunlap, William. *A History of the Rise and Progress of the Arts of Design in the United States*. New York: George P. Scott, 1834; reprint, New York: Dover, 1969. 2 vols. in 3 books.

Early survey by painter Dunlap who knew many artists to whom he refers personally. Also biographical data on 289 American architects, sculptors, painters, and engravers. Another 161 artists mentioned briefly in appendix. 1969 edition added new notes, 394 illustrations, and index.

13:29 Feder, Norman. *American Indian Art*. New York: Abrams, 1971.

13:30 Feest, Christian F. *Native Arts of North America*. New York: Oxford University, 1980.

13:31 Hunter, Sam and John Jacobus. *American Art of the 20th Century: Painting, Sculpture, Architecture*. New York: Abrams, 1973.

13:32 Mathey, Francois. *American Realism: A Pictorial Survey from the Early Eighteenth Century to the 1970s*. 2nd ed. New York: Crown, 1987.

13:33 Novak, Barbara. *Nature and Culture: American Landscape and Painting 1825–1875*. New York: Oxford University, 1980.

13:34 Rose, Barbara. *American Painting: The Twentieth Century*. Geneva: Skira, 1969.

13:35 Rubenstein, Charlotte Streifer. *American Women Artists: The First Complete Story of the Lives and Art of Hundreds of Women Artists Who Have Enriched Our Heritage Since the Beginnings of American History.* Boston: G.K. Hall, 1982.

13:36 Sandler, Irving. *Triumph of American Painting: A History of Abstract Expressionism.* New York: Praeger, 1970.

13:37 Seitz, William. *Abstract Expressionist Painting in America.* Cambridge, MA: Harvard University, 1983.

13:38 Taft, Robert. *Photography and the American Scene: A Social History.* New York: Macmillan, 1938.

13:39 Taylor, Joshua. *America As Art.* New York: Harper & Row, 1976.

13:40 Wade, Edwin L., ed. *The Arts of the North American Indian: Native Traditions in Evolution.* New York: Hudson Hills Press, 1986.

13:41 Wilmerding, John. *American Art. Pelican History of Art Series.* Baltimore, MD: Penguin Books, 1976.

Bibliographies

Some bibliographies cited under "Ancient and Classical Cultures" in Chapter 11 will assist in archaeological studies. Moreover, material annotated under "Latin American Studies" may also be useful. See MoMA's catalogue [12:96].

13:42 *American Folk Art: A Guide to Sources.* Simon J. Bronner, ed. New York: Garland, 1984.

13:43 *Art and Architecture Information Guide Series.* Sydney Starr Keaveney, general ed. Detroit: Gale Research, 1974.
Annotated bibliographies; includes individual artists.
.1 *American Drawing.* Lamia Doumato, ed., 1979.
.2 *American Painting.* Sydney Starr Keaveney, ed., 1974.
.3 *American Sculpture.* Janis Ekdahl, ed., 1977.

13:44 *Arts in America: A Bibliography,* ed. by Bernard Karpel. Washington, D.C.: Archives of American Art, Smithsonian Institution, 1979. 4 vols.
The most comprehensive annotated bibliography of American art; contains almost 25,000 entries written by 20 scholars. There are 21 divisions: art of native Americans; architecture; decorative arts; design—19th and 20th century; sculpture; art of west; painting—17th and 18th, 19th, plus 20th century; graphic arts—17th–19th and 20th century; graphic artists, 20th century; photography; film; theater; dance; music. There are sections on serials; dissertations and theses; and visual resources. Includes general references, works on artistic styles and techniques, bibliographical data for individual Americans, geographical studies, and critical reviews of serials. Numerous annotations for references on artists; for instance, "Sculpture" by William B. Walker contains material for 368 sculptors, including multi-media artists, such as Larry Rivers and Jasper Johns. Each chapter has special features, such as trade catalogues in "Decorative Arts," pattern books under "Architecture," and references on international exhibitions and world fairs in "Design: Nineteenth Century" and "Sculpture." Comprehensive index in Vol. 4 also includes access to artists and subjects in the annotations.

13:45 *Bancroft Library, University of California, Berkeley: Catalog of Printed Books.* Boston: G. K. Hal , 1964. 22 vols. *First Supplement,* 1969. 6 vols. *Second Supplement,* 1974. 6 vols. Author-subject catalogue of Western North America and Pacific Islands.

13:46 *Catalog of the Library of the Whitney Museum of American Art.* Boston: G. K. Hall, 1979; microfilm reprint, 1984. 2 vols.
Emphasis on 20th-century American art.

13:47 *Catalog of the Yale Collection of Western Americana.* Boston: G. K. Hall, 1961. 4 vols.

13:48 Davis, Lenwood G. and Janet Sims. *Black Artists in the United States: An Annotated Bibliography of Books, Articles and Dissertations on Black Artists 1799–1979.* Westport, CT: Greenwood Press, 1980.

13:49 Dawdy, Doris. *Annotated Bibliography of American Indian Painting.* New York: Museum of the American Indian, Heye Foundation, 1968.

13:50 *Dictionary Catalog of the Edward E. Ayer Collection of Americana and American Indians.* Boston: G. K. Hall, 1961. 16 vols. *First Supplement,* 1970. 3 vols.

13:51 Jacknis, Ira. *Northwest Coast Indian Art: An Annotated Bibliography, G. K. Hall Art Bibliographies Series.* Boston: G.K. Hall, to be published in 1990.

13:52 New York Public Library. *Dictionary Catalog of the History of the Americas Collection.* Boston: G. K. Hall, 1961. 28 vols. *First Supplement,* 1974. 9 vols.

13:53 Smith, Ralph Clifton. *A Biographical Index of American Artists*. New York: Williams and Wilkins, 1930; reprint ed., Detroit: Gale Research, 1976.
 Covers about 4,700 artists.

13:54 Tufts, Eleanor. *American Women Artists, Past and Present: A Selective Bibliographical Guide*. New York: Garland, 1984.
 Covers about 500 women.

13:55 *The Winterthur Museum Libraries Collection of Printed Books and Periodicals*. Wilmington, Delaware: Scholarly Resources, 1974. 9 vols.
 Museum displays works of art made or used by Americans between 1600 and 1840; library reflects this interest. Author-subject index to collection emphasizing decorative arts. Vol. 8 lists rare books; Vol. 9, rare books and auction catalogues.

Documents and Sources

13:56 *American Art: 1700–1960*, by John W. McCoubrey, *Sources and Documents in the History of Art Series*. Englewood Cliffs, NJ: Prentice-Hall, 1965.

13:57 *American Diaries: An Annotated Bibliography of American Diaries and Journals*. Detroit: Gale Research, 1983.
 Vol. 1: 1492–1844; Vol. 2: 1845–1980.

13:58 Johnson, Ellen H., ed. *American Artists on Art from 1940 to 1980*. New York: Harper & Row, 1982.
 Reprints about 55 articles; organized by stylistic areas.

13:59 Rose, Barbara, ed. *American Art Since 1900: A Documentary Survey*. New York: Frederick A. Praeger, 1968.

Archives

There are archives of American art located in various U.S. institutions. Finding the most significant ones is the challenge. This section discusses a noteworthy source, the Archives of American Art, and the directories which help researchers find other pertinent archives. See National Museum of American Art [19:29 & 45], National Portrait Gallery [19:52], and Prints and Photograph Division of the Library of Congress discussed in Chapter 22.

Archives of American Art

Begun in the 1940s, the Archives of American Art collects primary and secondary research material on American painters, sculptors, and craftsmen. Any artist who was born in America or immigrated here is considered an American artist. Presently has more than 3,000,000 items: letters, clippings, journals, and scrapbooks, plus 3,000 rolls of microfilm. Most of the original material, which is continually being microfilmed, is available through interlibrary loans, which are coordinated out of the Detroit office. For addresses of the various offices, see Chapter 30.

Besides collecting archival and ephemeral material, the Archives has several other projects. The *Collection of Exhibition Catalogs* [15:37] is an index to the more than 20,000 catalogues dating from the early 19th century to the 1960s, which the Archives photographed. "American Auction Catalogues on Microfilm" [18:39] consists of copies of 15,000 sales catalogues published in America between 1785 and 1960. There is also an oral-history program of taped interviews with more than 1,200 people in the art world [13:62]. In addition, this national research institute, which became a bureau of Smithsonian Institution in 1970, publishes the *Archives of American Art Bulletin*, which irregularly publishes "The Graduate Research Projects in American Art," a listing of dissertation topics, both completed and in progress, which updates the list in Karpel's *Arts in America* [13:44].

13:60 Breton, Arthur; Nancy Zembala; and Anne Nicastro; compilers. *A Checklist of the Collection*. Washington, D.C.: Archives of American Art, 1975.

13:61 *The Card Catalogue of the Manuscript Collections of the Archives of American Art*. Wilmington, DE: Scholarly Resources, 1980. 10 vols. *First Supplement*, 1985.
 Covers more than 5,000 collections of papers, parts of collections, and individual items. Indexing is primarily by personal names; there is none for subjects. Provides such data as kind and quantity of material as well as dates covered.

13:62 *Card Catalog of the Oral History Collections of the Archives of American Art*, ed. by Liza Kirwin. Wilmington, DE: Scholarly Resources, 1984.
 Contains 2,500 cards describing tape recordings; mostly for interviews. Includes panel discussions, symposia, lectures, and funeral orations.

13:63 McCoy, Garnett. *Archives of American Art: A Directory of Resources*. New York: R. R. Bowker, 1972. One vol.

Locating U.S. Archives and Oral History Programs

These resources can be used to discover primary material for various people and subjects. Most provide information on types of documents and locations of files or oral history projects. Remember to check the Archives of American Art Oral History Program [13:62].

13:64 *Directory of Archives and Manuscript Repositories in the United States.* 2nd ed. Phoenix, AZ: Oryx, 1988.
> Includes all 50 states plus U.S. territories and districts. Organized by state, city, and institution; gives holdings of total volumes and description of archives.

13:65 *Directory of Oral History Collections.* Allen Smith, ed. Phoenix, AZ: Oryx, 1988.
> Index to almost 500 U.S. collections of audios and videos featuring people in all kinds of professions.

13:66 *National Inventory of Documentary Sources in the United States.* Alexandria, VA: Chadwyck-Healey, 1983+
> *Part 1: Federal Records* (Including the National Archives, Presidential Libraries, and the Smithsonian Institution); *Part 2: Manuscript Division, Library of Congress; Part 3: State Archives, State Libraries, State Historical Societies, Academic Libraries and Other Repositories.* Abbreviated NIDS, this finding aid to these collections describes the contents of boxes or folders in the archives. List of collections and index to names and subjects.

13:67 *National Union Catalog of Manuscript Collections*
> Abbreviated NUCMC; usually published annually; cumulative indices. Under name of manuscript collection gives description of contents and location of material. Can be used to find papers of artists and patrons and architectural drawings. Use with 13:68.

13:68 *Index to Personal Names in the National Union Catalog of Manuscript Collection 1959–1984.* Alexandria, VA; Chadwyck-Healey, 1988. 2 vols.

Vertical Files

An important new development in art research is the microfilming of material in major vertical file collections, thus preserving it as well as making it available to a greater public. Includes such items as reproductions of entire small exhibition catalogues, pages from sales catalogues, exhibition reviews, entries from magazines and New York newspapers, brief award notices, obituaries, photographs of works of art, letters from artists, invitations to gallery and exhibition openings, and illustrated advertisements. These files cover people from all geographic locations and often a wide spectrum of time.

13:69 *Museum of Modern Art Artists Scrapbooks.* Alexandria, VA: Chadwyck-Healey, 1986.
> Covers 44 artists—including such artists as Degas, Giacometti, Matisse, Picasso, van Gogh—and 3 multi-artist collections.

13:70 *Museum of Modern Art Artists Vertical Files.* Alexandria, VA: Chadwyck-Healey, in preparation; to be published.
> Expected to include about 25,000 to 30,000 contemporary international artists.

13:71 *New York Public Library: The Artists File.* Alexandria, VA: Chadwyck-Healey, 1989.
> Covers 90,000 architects, artists, designers, collectors, historians, museum directors, dealers, and others associated with art. Includes people from all geographic locations as well as all periods of art history, from 5th-century Greek sculptors to contemporary artists. Earliest published material dates from around 1895, but emphasis is on items from 1930s through 1970s. The New York Public Library's Print Division Vertical Files for graphic artists is now being filmed; see 22:54.

Index for Nineteenth-Century American Serials

13:72 Schmidt, Mary M., ed. "Index to Nineteenth Century American Art Periodicals." In preparation; publication c. 1991. Probably 3 vols.
> When finished, will cover 35 to 40 American art journals published 1840s to 1909. There will be about 40,000 articles indexed on the format used by *RILA* [16:7]. Topics include reviews of art museum and academy exhibitions, art collectors and museums, individual artists, and the aesthetic concerns of the period. Printouts of the 28 serials and 8,400 articles that have been indexed are available at the New York Public Library, the Avery Library at Columbia University, Metropolitan Museum of Art, Boston Public Library, and Marquand Library at Princeton University.

Available on microfiche, 11 serials indexed by Schmidt have been published by Chadwyck-Healey:

American Art Union Bulletin, New York 1847–53//
Art Collector 1889–99//
Art Journal, New York, (illustrated) 1875–87//

Beck's Journal of Decorative Art, New York 1886–88//

Brush and Pencil, Chicago (illustrated) 1897–1907//

Collector and Art Critic, New York 1899–1907//

Connoisseur, Philadelphia 1886–89//

Illustrated Magazine of Art, New York (illustrated) 1853–54//

Magazine of Art, London, Paris, New York (illustrated) 1878–1904//

Monthly Illustrator/Home and Country, New York (illustrated) 1893–95//

New Path, New York 1863–65//

Serials

In addition to the art indices, remember to use *America: History and Life* [16:15]. For Indian cultures, see the resources cited under "Latin American Studies" in Chapter 14.

American Art Journal 1969+

American Heritage, 1954+

American Indian Art Magazine 1975–77, 1986+

Archives of American Art Journal 1960+

Smithsonian Studies in American Art 1987+

Winterthur Portfolio: A Journal of American Material Culture 1964+

Canadian Studies

There are several extensive collections of Canadian art, especially those at the Art Gallery of Ontario in Toronto and the National Gallery of Canada in Ottawa, which in 1987 began publishing a series of museum collection catalogues. Already published are *European and American Painting, Sculpture, and Decorative Arts, 1300–1800,* two volumes, and the first volume of *Canadian Art,* a projected five-volume set. For native Canadians, there is The Canadian Museum of Civilization, which opened in 1989 in Hull, Quebec. A major international architectural research center is Montreal's Centre Canadien d'Architecture/ Canadian Centre for Architecture, which has extensive holdings of architectural drawings and photographs.

For exhibition information, see *Royal Canadian Academy of Arts* [15:34] and *Montreal Museum of Fine Arts* [15:30]. Also consult the entries for the Canadian Museum Association [20:36] and *Canadian Art Sales Index* [18:8]. Remember that Canadian artists are frequently listed in U.S. references. Many of the following resources are written in both French and English, because Canada is a bilingual country.

Biographical Dictionaries

The word—Inuit—is now used to describe the people who inhabit the Canadian Arctic. For people living in Alaska, Greenland, and Siberia, the anthropological term—Eskimo—is still used. For biographical summaries of artists, consult *Art Gallery of Ontario: The Canadian Collection* (Toronto: McGraw-Hill, 1970) and the National Gallery of Canada's *Canadian Art.*

13:73 *Biographical Dictionary of Architects in Canada 1800–1950,* compiled and ed. by Robert G. Hill. Toronto: University of Toronto Press, in preparation.

13:74 *Biographies of Inuit Artists.* 3rd ed. Mississauga, Ontario: Tuttavik, 1988. 4 vols.

13:75 Harper, J. Russell. *Early Painters and Engravers in Canada.* Toronto: University of Toronto, 1970.
Data on artists born before 1867.

13:76 Kobayashi, Terry and Michael Bird. *A Compendium of Canadian Folk Artists.* Erin, Ontario: Boston Mills Press, 1985.

13:77 MacDonald, Colin S. *A Dictionary of Canadian Artists.* Ottawa: Canadian Paperbacks, 1967+
Includes bibliographies; 6 vols. (A to Rakine) issued by 1982; volume 7 (R to Z) is in preparation.

13:78 McMann, Evelyn de R. *Canadian Who's Who Index 1898–1984.* Toronto: University of Toronto Press, 1986.

Art Historical Surveys

13:79 Bringhurst, Robert et. al., eds. *Visions: Contemporary Art in Canada.* Vancouver: Douglas & McIntyre, 1983.

13:80 Cawker, Ruth and William Bernstein. *Contemporary Canadian Architecture.* Markham, Ontario: Fitzhenry & Whiteside, 1988.

13:81 Ede, Carol Moore. *Canadian Architecture 1960–70.* Toronto: Burns & MacEachern, 1971.

13:82 Gowans, Alan. *Building Canada: An Architectural History of Canadian Life.* Rev. ed. Toronto: University of Toronto, 1966.

13:83 Greenhill, Ralph and Andrew Birrell. *Canadian Photography 1839–1920.* Toronto: Coach House, 1979.

13:84 Harper, J. Russell. *Painting in Canada: A History.* Rev. ed. Toronto: University of Toronto, 1977.

13:85 Lessard, Michel and Huguette Marquis. *Encyclopedie de la Maison Quebecoise*. Montreal: Les éditions de l'homme, 1972.

13:86 Macrae, Marion and Anthony Adamson. *The Ancestral Roof: Domestic Architecture of Upper Canada*. Toronto: Clare, Irwin & Co., 1963.
　　　One of a series of regional histories on early Canadian architecture.

13:87 McKendry, Blake. *Folk Art: Primitive and Naive Art in Canada*. Toronto: Methuen, 1983.

13:88 Reid, Dennis. *A Concise History of Canadian Painting*. 2nd ed. Toronto: Oxford University, 1988.

13:89 Robert, Guy. *Art actuel au Quebec depuis 1970*. Quebec: Iconia, 1983.

13:90 ———. *L'art au Quebec depuis 1940*. Ottawa: La Press, 1973.

13:91 Swinton, George. *Sculpture of the Eskimo*. Toronto: McClelland and Stewart, 1972.

Bibliographies

13:92 *Art and Architecture in Canada/Art et Architecture au Canada*, ed. by Loren Singer and Mary Williamson. Toronto: University of Toronto, to be issued 1990. 2 vols.
　　　This will be a major resource for the documentation of Canadian art. Vol. 1 contains about 9600 annotated entries for books, articles, exhibition catalogues, and dissertations; Vol. 2 has English and French indices and author index. Covers painting, sculpture, architecture, graphic arts, decorative arts and fine crafts, photography, and native arts. Provides historical data for almost 75 annual Canadian art exhibitions and 75 Canadian serials.

13:93 Blodgett, Jean, "A Bibliography of Contemporary Canadian Inuit Art," *About Arts and Crafts*. 5(1982): 2–34.
　　　Covers art from 1948 to 1981.

13:94 *Catalogue of the Library of the National Gallery of Canada*. Boston: G.K. Hall, 1973. 8 vols. *Supplement*, 1981. 6 vols.
　　　Since 1968, has descriptive cataloguing of French-language publications in that language; all of the publications are catalogued in English. Under "ARTISTS," lists individual artists represented in the 8 vols. "Documentation (CA)" indicates material on artist is in the vertical files; see "Vertical Files" below.

13:95 Chamberlain, K. E. *Design in Canada 1940–1987*. Richmond, British Colombia: K.E. Chamberlain, 1988.
Access to bibliographical information on commercial and industrial design and designers.

13:96 *Dictionary Catalogue of the Library of the Provincial Archives of British Columbia: Victora*. Boston: G.K. Hall, 1971. 8 vols.
　　　Dating from 1893, this is the oldest archival institution in Western Canada.

13:97 *Index des périodiques d'architecture canadiens/Canadian Architectural Periodicals Index 1940–1980*, Claude Bergeron. Quebec: Les presses de l'université Laval, 1986.
　　　Indexes 9 Canadian architecture and building serials. First section covers individual buildings organized under 12 headings, such as religious architecture. Indices to architects, building types, place names, and authors. Second section indexes miscellaneous subjects.

13:98 *Inuit Art Bibliography*. Ottawa: Inuit Art Section, Indian and Northern Affairs Canada, 1986.

Vertical Files

There are numerous Canadian vertical files which contain important material on artists and subjects. The largest collection is at the National Gallery of Canada Library which maintains *Artists in Canada* [13:100] on the national museums collections database, *CHIN (Canadian Heritage Information Network)*.

13:99 Metropolitan Toronto Reference Library. *Canadian Artist Files on Microfiche*. Toronto: Metropolitan Toronto Reference Library.
　　　Files available on microfiche; covers art 1962–1980.

13:100 National Gallery of Canada. Library. *Artists in Canada: A Union List of Artist' Files*. Ottawa: National Gallery Library, 1988.
　　　An alphabetical listing of 40,000 artists' names, who are represented in the vertical files of the National Gallery Library plus 23 other Canadian institutions. Most of the artists are painters, sculptors, or printmakers. Begun in the 1920s, the Gallery's vertical files now include about 30,000 files on Canadian artists and another 10,000 files on Canadian art subjects. Microfiche copies of selected documentation are available to other libraries. The Gallery staff also takes written and phone requests.

13:101 *Directory of Vertical File Collections on Art and Architecture Represented by ARLIS M/O/Q*. Montreal:ARLIS/MOQ, 1989.
　　　Covers libraries in Montreal, Ottawa, and Quebec. Information on kinds of serials

clipped; indices to subjects and names. This provides wider coverage than 13:100, but for a smaller area.

Indices

Remember to use *The Concordia University Art Index to Nineteenth-Century Canadian Periodicals* [16:26] and *Canadian Architectural Periodicals Index* [13:97]. *DataTimes Database* [16:49] covers 15 Canadian newspapers.

13:102 *Canadian Magazine Index.* Toronto: Micromedia, 1985+
　　　　Monthly with annual cumulation; covers about 15 Canadian art serials.

13:103 *Canadian News Index.* Toronto: Micromedia, 1977+
　　　　Monthly with annual cumulation; continues *Canadian Newspaper Index.* Covers 7 Canadian daily newspapers, all of which are on microfilm in the National Library of Canada, Ottawa, and are available through interlibrary loans. Data on art auctions, galleries and museums, and art reviews.

　　　　Canadian Business and Current Affairs Database, DIALOG, File 262, files from July 1980, updates monthly. Covers 500 Canadian business serials and 10 newspapers.

13:104 *Canadian Periodical Index: Index de Periodiques Canadiens: An Author and Subject Index.* Toronto: Info Globe, 1920+
　　　　Monthly author/subject index to 34 arts/culture serials; includes book review data.

Serials

Many of these serials will be indexed in the regular art indices; otherwise check the indices cited above. For Canadian serials having an international scope, see Chapter 12, under 20th-century.

Applied Arts Quarterly 1986+
Camera Canada, National Association for Photographic Art/L'Association nationale d'art photographique 1969+
Canadian Architect 1955+
Artscanada 1940–82// (titled *Maritime Art,* 1940–43; *Canadian Art,* 1943–66)
Espace: Sculpture 1982+
Inuit Art Quarterly 1986+
Journal of Canadian Art History/Annales d'histoire de l'art canadien 1974+
Parachute 1975+
RACAR: Revue d'art canadienne/Canadian Art Review 1974+
The Studio Magazine 1983+
Vie des arts 1956+

Cultural/Historical Surveys

13:105 *The Canadian Encyclopedia.* 2nd ed. Edmonton: Hurtig, 1988. 4 vols.
　　　　Includes entries for individual artists as well as for subdivisions of the arts.

13:106 *The Illustrated History of Canada,* ed. by Craig Brown. Toronto: Lester & Orpen Dennys, 1987.

13:107 Story, Norah. *The Oxford Companion to Canadian History and Literature,* Toronto: Oxford University, 1967. *Supplement,* 1973.

CHAPTER 14

Other Geographic Locations

This chapter annotates reference works for studies of art according to country or region: (1) Latin America including Mexico, (2) Asia, (3) Africa, and (4) the Pacific, including Australia and New Zealand. Chapter 13 covers North American art. Chapter 28 lists myths relating to these various countries.

Latin American Studies

Remember that many American resources include South American artists, especially those who have exhibited or sold their work in the U.S. For instance, *The Catalog of the Library of the Museum of Modern Art* [12:96] lists the contents of its Latin American Archive. There is also material in the New York Public Library's *Artists File* [13:71].

Dictionary

14:1 Muser, Curt. *Facts and Artifacts of Ancient Middle America: A Glossary of Terms and Words Used in the Archaeology and Art History of Pre-Columbian, Mexico, and Central America.* New York: E.P. Dutton, 1978.
Maps for archaeological sites and pronunciation guide.

Art Historical Surveys

14:2 Ades, Dawn. *Art in Latin America: The Modern Era, 1820–1980.* New Haven, CT: Yale University, 1989.

14:3 Bayon, Damian. *Latin America and Its Arts.* New York: Holmes & Meier, 1982.

14:4 Catlin, Stanton Loomis. *Art of Latin America Since Independence.* New Haven, CT: Yale University, 1966.

14:5 Chase, Gilbert. *Contemporary Art in Latin America: Painting, Graphic Art, Sculpture, Architecture.* New York: Free Press, 1970.

14:6 Coe, Michael D. *The Maya.* 3rd ed. London: Thames & Hudson, 1984.

14:7 ———. *Mexico.* Rev. and enlarged ed. London: Thames & Hudson, 1984.

14:8 Dockstader, Frederick J. *Indian Art in Middle America: Pre-Columbian and Contemporary*

Arts and Crafts of Mexico, Central America, and the Caribbean. Boston: New York Graphic, 1964.

14:9 ———. *Indian Art in South America: Pre-Columbian and Contemporary Arts and Crafts.* Boston: New Graphic, 1967.

14:10 Kubler, George. *The Art and Architecture of Ancient America: the Mexican, Maya and Andean Peoples.* 3rd ed. rev. *Pelican History of Art Series.* Baltimore, MD: Penguin, 1984.

14:11 Stierlin, Henri. *Art of the Maya: From the Olmecs to the Toltec-Maya.* Trans. by Peter Graham. New York: Rizzoli, 1981.

14:12 *Studies in Pre-Columbian Art and Archaeology Series.* Washington, D.C.: Dumbarton Oaks, 1966+
Monographic series on various subjects, such as *An Early Stone Pectoral from South Eastern Mexico,* Michael D. Coe, 1966.

Bibliographies and Handbooks

There are numerous bibliographies on specific cultures, such as Katalin Harkanyi's *The Aztecs* (San Diego, CA: California State University, 1972). See also catalogues of the Tozzer Library [17:16].

14:13 Berlo, Janet Catherine. *Art of Pre-Hispanic Mesoamerica: An Annotated Bibliography, G. K. Hall Art Bibliographies Series.* Boston: G.K. Hall, 1985.

14:14 *Catalog of the Latin American Library of the Tulane University Library.* Boston: G.K. Hall, 1970. 9 vols. *First Supplement,* 1973. 2 vols. *Second Supplement,* 1975. 2 vols. *Third Supplement,* 1978.

14:15 *Catalog of the Latin American Collection of the University of Texas.* Boston: G.K. Hall, 1969, 31 vols. *First Supplement,* 1971. 5 vols. *Second Supplement,* 1973. 3 vols. *Third Supplement,* 1975. 8 vols.

14:16 *Catalogue of the Library of the Hispanic Society of America.* Boston: G.K. Hall, 1962. 10 vols. *First Supplement,* 1970. 4 vols.
Author-subject list of holdings in Hispanic field including Spain, Portugal, and Hispanic America.

14:17 Findlay, James A. *Modern Latin American Art: A Bibliography*. Westport, CT: Greenwood, 1983.
> Organized by countries followed by media. Includes serials and exhibition catalogues, but not individual artists. Index gives cross references to double names.

14:18 *Handbook of Latin American Art: A Bibliographic Compilation*. Joyce Waddell Bailey, general ed. Santa Barbara, CA: ABC-CLIO, 1984+ Proposed 3 vols.
> *Vol. 1: General References and Art of the Nineteenth and Twentieth Centuries. Part I: North America. Part II: South America.* Excludes U.S.; includes monographic studies listed under artist's name. *Vol. 2: Art of the Colonial Period,* has index to authors, artists, and Hispanic art in the U.S. Vol. 3 to be bibliography of art for ancient cultures, plus subject bibliography organized by geographic regions.

14:19 *Handbook of Latin American Studies.* Gainesville: University of Florida, 1935+
> Since Vol. 26 (1964) has alternated bibliographic coverage between humanities and social studies, which include anthropology and archaeology. Since Vol. 38 (1976) has covered film and filmakers. Some issues have special sections: Volume 46 on folklore, Vol. 39 on Cuba, Vol. 44 on Brazil.

14:20 *Handbook of Middle American Indians.* Austin: University of Texas, 1964–73. Plus *Supplements.*
> Includes archaeology, ancient cultures, linguistics, guide to ethnohistorical sources, and annotated bibliography.

14:21 Magee, Susan Fortson. *Mesoamerica Archaeology: A Guide to the Literature and Other Information Sources.* Austin: University of Texas, Institute of Latin American Studies, 1981.

14:22 Metropolitan Museum of Art. *Catalog of the Robert Goldwater Library of Primitive Art.* Boston: G.K. Hall, 1982. 4 vols.
> African, Pre-Columbian, native American, and Pacific art. Author-title-subject catalogue arranged by geographic locations followed by country and tribe. About 50% of entries are for serial articles.

14:23 *Inter-American Review of Bibliography: Revista Interamericana de Bibliografia.* Washington, D.C.: Organization of American States, Pan American Union, 1957–71.

Serials
Americas, Organization of American States, Washington, D.C. 1941+
Latin American Art, 1989+

Cultural/Historical Surveys
14:24 *Cambridge History of Latin America.* Leslie Bethell, ed. Cambridge: Cambridge University, 1984. 5 vols.
> Vols. 1–2 cover Colonial period; vol. 3, Independence to 1870; vols. 4–5, 1870–1930.

14:25 Coe, Michael et al. *Atlas of Ancient America.* New York: Facts on File, 1986.

14:26 *Everyday Life Series.* London: Batsford.
> .1 *Everyday Life of the Aztecs,* Warwick Bray, 1968; reprint, London: Dorset, 1987.
> .2 *Everyday Life of the Maya,* Ralph Whitlock, 1987.

14:27 *Life of Series.* Geneva: Minerva/Liber.
> .1 *Life of the Aztecs in Ancient Mexico,* Pierre Soisson and Janine Soisson. Trans. by David Macrae, 1987.
> .2 *Life of the Incas in Ancient Peru,* Jesus Rome and Lucienne Rome. Trans. by Peter J. Tallon, 1987.

Asian Studies

There are a number of fine collections of Asian art in such cities as Boston, New York, Chicago, Cleveland, Kansas City, and San Francisco. Two Washington, D.C. museums devoted to Far Eastern culture are the Freer Art Gallery and the Arthur M. Sackler Gallery for Asian Art. If possible, study these institutions' collections and publications. In addition, read Itsuo Okubo's "Problems in Art History Documentation in Japan," *Art Libraries Journal* 5(Winter 1980): 25–33.

A major problem in Asian studies is that of language. Unless this linguistic barrier is hurdled, the research will be limited. Romanization is the process by which Oriental characters—used in such languages as Chinese and Japanese—are changed into the Latin alphabet in order that words and names can be read by people from Western nations. The first romanization of Japanese characters, for instance, was developed in the 16th century by Jesuit missionaries. Since this system was based upon Portuguese, other foreign countries developed different types of romanization. Because words

and names can vary widely from one system to the other, students must be aware of what system is being used. Only English-language sources are listed here.

General Dictionaries and Encyclopedias

14:28 Beale, Thomas William. *An Oriental Biographical Dictionary.* Rev. and enlarged by Henry George Keene. London: W. H. Allen, 1894; reprint, New York: Kraus, 1965.
Excludes Chinese and Japanese.

14:29 Acharya, Prasanna Kumar. *Dictionary of Hindu Architecture.* New York: Oxford University, 1927; reprint New Delhi: Oriental Books, 1981.

14:30 *Encyclopaedia of Indian Temple Architecture,* ed. by Michael W. Meister, M.A. Dhaky, and Krishna Deva. Princeton, NJ: Princeton University, 1988. 2 vols.

14:31 *Heibonsha Survey of Japanese Art.* Tokyo: Heibonsha, 1971–80. 31 vols.

14:32 *Kodansha Encyclopedia of Japan.* New York: Kodansha International, 1983. 9 vols.
Sections on art and architecture written by noted scholars; bibliographies include both Western-language and Japanese reference works. Index includes Japanese characters with proper nouns.

14:33 Medley, Margaret. *A Handbook of Chinese Art for Collectors and Students.* New York: Horizon, 1964.

14:34 Munsterberg, Hugo. *Dictionary of Chinese and Japanese Art.* New York: Hacker, 1981.

14:35 Papinot, Edmond. *Historical and Geographical Dictionary of Japan.* New York: Ungar, 1964. 2 vols.

14:36 Shoten, Kadokawa, ed. *A Pictorial Encyclopedia of the Oriental Arts.* New York: Crown, 1969. 7 vols.
Compiled from *Encyclopedia of World Art* [10:2]; includes China, Japan, and Korea.

Chinese Biographical Dictionaries

For Chinese artists, data must first be collected on the artists' dates, dynasties under which they lived, and the variations of their names. Chinese names are particularly difficult, because a person used several: (1) his "T" or "Tzu" style or courtesy name which may have been adopted in his youth; (2) his "H" or "hao" style or fancy or literary name, which the person either adopted or was given to him; (3) his Western or romanized version; and (4) sometimes, a posthumous name. A person also had a *hsing* or family name and a *ming* or given name. Until the 1950s Chinese names were romanized by the Wade-Giles System developed in 1859 by Thomas Francis Wade and revised by Herbert Allen Giles in 1892. For a copy of the modified Wade-Giles system, consult the revised edition of the *Chinese-English Dictionary,* by R.H. Matthew (Harvard-Yenching Institute, 1943). Some references still use this system.

Chinese names can also be romanized according to Pinyin, the official system employed by the People's Republic of China. The differences are great. For example, the city of Pei-ching or Pei-p'ing (Wade-Giles) is called Beijing (Pinyin); the dynasty Ch'ing becomes Qing. The Pinyin system has largely supplanted Wade-Giles in geographic names as well as in most references. For instance, *Allgemeines Künstler Lexikon* [10:25], which is now being published, uses the Pinyin system with cross references from the Wade-Giles version. For the conversion of this later system consult *Reform of the Chinese Written Language* (Peking: Foreign Languages Press, 1958)

Owners of Chinese paintings added signatures and seals to their works of art indicating their ownership. In "Seals and Authentication," Wang [14:39] provides a historical discussion of these important imprints, stating that collectors' seals were probably first used in the T'ang dynasty, 618–907 A.D., becoming popular during the Northern Sung dynasty, 960 to 1127. These seals are used to authenticate Chinese paintings. If a Ming scroll seal needs identifying, check the book by Contag and Wang [14:39] for the artist's name. *Dictionary of Ming Biography 1368–1644* [14:41] can then be consulted. Both references will be needed in order to have some biographical information on the artist.

14:37 *Biographical Dictionary of Republican China.* Howard L. Boorman, ed. New York: 1967–71. 4 vols.

14:38 Cahill, James. *An Index of Early Chinese Painters and Paintings: T'ang, Sung, and Yuan.* Berkeley: University of California, 1980.
Provides locations of paintings in public and private collections, worldwide.

14:39 Contag, Victoria and Chi-ch'ien Wang. *Seals of Chinese Painters and Collectors of the Ming and Ch'ing Periods.* Rev. ed. with supplement. Hong Kong: Hong Kong University, 1966.
First edition, published in 1940 as *Maler- und Sammler-Stempel aus der Ming und Ch'ing Zeit,* reproduced more than 9,000

seals used in stamping documents. Under romanized names, provides surnames and given names, Tzu and Hao names, birth and death data, subjects of artists, stylistic characteristics. Brief discussion of Chinese seals and indices to painters and collectors by their stroke count, alphabetized romanized names, and Tzu names. Biographical data in German; see Publishers Note for translations and explanations. Reproduces all seals which each artist used. Supplement provides seals found in American public and private collections.

14:40 Giles, Herbert A. *A Chinese Biographical Dictionary*. London: B. Quaritch, 1898; reprint ed., Taipei, Chin Ch'eng Wen, 1977.
Alphabetized by romanized name with Chinese characters given; no bibliographical data. Indices to Tzu and Hao names.

14:41 Goodrich, L. Carrington and Chaoying Fang, eds. *Dictionary of Ming Biography 1368–1644*. New York: Columbia University, 1976. 2 vols.
Under romanized names, provides brief biographical data. Bibliographies use cross references—such as 2/3/5 meaning 2nd book, 3rd *chüan* or section, and 5th page—to the list of "Eighty-Nine Collections of Ming Dynasty Biographies," all of which are written in Chinese. Gives Tsu, Hao, and Pth (posthumous) names. Includes maps; list of Ming Dynasty Emperors with dates, temple names and titles of reigns; and indices to names, books, subjects.

14:42 Hansford, S. Howard. *A Glossary of Chinese Art and Archaeology*. London: The China Society, 1954; reprint, New York: Beekman, 1972.
Entries are cited under Chinese characters, but definitions are in English. Index lists anglicized version of Chinese terms.

14:43 Hummel, Arthur, ed. *Eminent Chinese of the Ch'ing Period (1644–1912)*. Washington, D.C.: U.S. Government Printing Office; reprint, Taipei, China: Ch'eng Wen, 1970.
Under romanized names, provides Tzu and Hao names, brief biographical data, and short bibliographies—most of which use same notations as 14:41, but to "Thirty-three Collections of Ch'ing Dynasty Biographies." Indices to names, books, and subjects plus chronological list of names.

14:44 Mayers, William Frederick. *The Chinese Reader's Manual: A Handbook of Biographical, Historical, Mythological, and General Literary Reference*. Shanghai: American Presbyterian Mission, 1874; reprint, Detroit: Gale Research, 1968.

Biographical material on more than 1,000 persons: Part 1 lists individual names; Part 2, those in multiple categories. Entries include Chinese characters for person's name. Chronological tables to Chinese Dynasties and index of Chinese characters.

14:45 Seymour, Nancy N. *An Index-Dictionary of Chinese Artists, Collectors, and Connoisseurs*. Metuchen, NJ: Scarecrow, 1988.
Brief biographies covering from T'ang Dynasty through Modern Period. Index to alternate and additional names.

Japanese Biographical Dictionaries

Although the romanization of Japanese characters began in the 16th century, the scheme used in many English-language references—such as the *Kodansha Encyclopedia of Japan* [14:32] and the *Allgemeines Künstler Lexikon* [10:25]—is the Hepburn system. In the 19th century, a group of Japanese and interested foreigners developed this romanization formula. American missionary and physician James Curtis Hepburn (1815–1911) was one of their advisors. When he published this newly devised procedure in his Japanese-English dictionary, the system became associated with his name. For the modified Hepburn system, also called Hyōjun or Standard, consult Kenkyusha's *New Japanese-English Dictionary* (1954). This is the method endorsed by the Rōmaji-kai or Romanization Association.

14:46 Fister, Patricia. *Japanese Women Artists 1600–1900*. New York: Harper & Row, 1989.
Covers 27 women.

14:47 Roberts, Laurance P. *A Dictionary of Japanese Artists: Painting, Sculpture, Ceramics, Prints, Lacquer*. New York: John Weatherhill, 1976.
Alphabetized under western names of Japanese artists, some biographical entries include bibliographical citations and lists of museums possessing artists' works. Lists Japanese art organizations and institutions; art periods of Japan, Korea, and China; Japanese provinces and prefectures plus glossary, extensive bibliography, index of other names by which artist may be known, and index to artists' names as written in Japanese characters.

14:48 Society of Friends of Eastern Art. *Index of Japanese Painters*. Tokyo: Institute of Art Research, 1940; reprint, Rutland, VT: Charles E. Tuttle, 1958.
About 600 brief biographies; artists' names given in English and Japanese. Explanations of various schools.

14:49 Tazawa, Yutaka, ed. *Biographical Dictionary of Japanese Art*. Tokyo: Kodansha International; New York: International Society for Educational Information, 1981.
Covers all categories of art plus 50 charts of artistic lineages and families; glossary and bibliography.

14:50 *Who's Who Among Japanese Artists*. Tokyo: Print Bureau, Japanese Government, 1961.
Includes bibliography on Japanese contemporary art.

Art Historical Surveys

14:51 *Chronological Table of Japanese Art*, ed. by Shigehisa Yamasaki. Tokyo: Geishinsha, 1981.
Covers work in various genres from 6th century to the present; includes all works designated Japanese National Treasures. "Index of Personal Names" contains brief biographical data.

14:52 Coomaraswamy, Ananda K. *History of Indian and Indonesian Art*. New Delhi: Munshiram Manaharla, 1972.

14:53 Goetz, Hermann. *The Art of India: Five Thousand Years of Indian Art*. 2nd ed. New York: Crown, 1964.

14:54 Gray, Basil, ed. *The Arts of India*. Ithaca, NY: Cornell University, 1981.

14:55 *History of World Architecture Series*. New York: Abrams.
.1 *Islamic Architecture*, by John D. Hoag, 1977.
.2 *Oriental Architecture*, by Mario Bussagli et al., 1975.

14:56 Huntington, Susan L. *The Art of Ancient India: Buddhist, Hindu, Jain*. New York: Weatherhill, 1985.

14:57 *Japanese Arts Library*. Tokyo: Kodansha, 1980+
Continues series of books in English which are translations of the quarterly serial, *Nihon no bijutsu*. Each volume has an annotated bibliography.

14:58 Kidder, J. Edward. *The Art of Japan*. New York: Crown, 1985.

14:59 Kramrisch, Stella. *The Art of India*. 3rd ed. London: Phaidon, 1965.

14:60 ———. *Indian Sculpture*. London: Oxford University, 1933.

14:61 Lee, Sherman E. *Chinese Landscape Painting*. 2nd ed. Cleveland: Cleveland Museum of Art, 1962.

14:62 ———. *History of Far Eastern Art*. 4th ed. New York: Henry N. Abrams, 1982.

14:63 ———. *Japanese Decorative Style*. New York: Harper & Row, 1972.

14:64 ———. *Past, Present, East and West*. New York: Braziller, 1983.

14:65 Rawson, Jessica. *Ancient China, Art and archaelolgy*. London: British Museum, 1980.

14:66 *Pelican History of Art*. Baltimore, MD: Penguin.
.1 *Art and Architecture of India: Buddhist, Hindu, Jain*, 3rd ed. rev. by Benjamin Rowland, 1967.
.2 *Art and Architecture of China*, rev. ed. by Laurence Sickman and Alexander Soper, 1971.
.3 *Art and Architecture of Japan*, rev. ed. by R. T. Paine and Alexander Soper, 1974.

14:67 Rogers, Howard and Sherman Lee. *Masterworks of Ming and Qing Paintings from the Forbidden City*. Lansdale, PA: International Arts Council, 1988.

14:68 Rosenfield, John M. and Shujiro Shimada. *Traditions of Japanese Art*. Cambridge, MA: Harvard University, 1970,

14:69 Sirén, Osvald. *Chinese Painting: Leading Masters and Principles*. London: Ernest Benn, 1928; reprint, New York: Hacker, 1973. 7 vols.
First 3 volumes cover first millennium of Chinese art, divided into historical periods with names of artists for whom brief biographies and lists of works of art are cited. Vol. 2 has bibliography and indices to Chinese names and terms, Japanese names and terms, and Western names. Vol. 3 consists of reproductions of art works. Following same format, next 3 volumes cover later periods of Chinese painting.

14:70 ———. *Chinese Sculpture from the Fifth to the Fourteenth Century: Over 900 Specimens in Stone, Bronze, Lacquer, and Wood Principally from Northern China*. London: Ernest Benn, 1925; reprint, New York: Hacker, 1970. 4 vols. in 2 books.
Includes chapters on general characteristics, evolution of styles, and iconography.

14:71 ———. *A History of Later Chinese Painting*. London: Ernest Benn, 1938; reprint, New York: Hacker, 1970.

14:72 Stanley-Baker, Joan. *Japanese Art*. New York: Thames & Hudson, 1984.

14:73 Sullivan, Michael. *The Arts of China*. 3rd ed. Berkeley: University of California, 1984.

Bibliographies

Some of these bibliographies are also indices to the periodical literature.

14:74 *Bibliography of Asian Studies.* Ann Arbor, MI: Association for Asian Studies, 1956+
Beginning with the September 1970 issue, this bibliography was issued independent of the *Journal of Asian Studies.* Organized by country—Korea, Vietnam—or region—Soviet Far East, East Asia—with subdivisions for subjects, such as Anthropology & Sociology, Arts, History, Literature. Lists European-language monographs, serial articles, and *Festscriften.* Art section includes architecture, bronzes, calligraphy, ceramics, folk arts, painting, prints, sculpture, and textile. Has lists of authors, journals, and books analyzed. No attempt is made at standardizing the spelling of names; Chinese names are enter as they are used on a title page. Has time lag; the 1982 *Bibliography of Asian Studies* was published in 1987. For cumulative volumes, see 14:77.

14:75 *Bibliography of Indian Art, History and Archaeology,* compiled by Jagdish Chandra. Delhi:Delhi Printers Prakashan, 1978+

14:76 *Bulletin signalétique 526: Art et archéologie: Proche-Orient. Asie, Amerique.* Centre National de la Recherche. Scientifique. Paris: Centre de Documentation Sciences Humaines. Vol. 1(1970)+
Quarterly, using same format as 16:6, covers Near Eastern archaeology, Far Eastern art, and Pre-Columbian art and archaeology.

Art and Archeology: Near East, Asia, America, QUESTEL, File 526 of *Francis-H Database,* data from 1972; updates 8 times a year.

14:77 *Cumulative Bibliography of Asian Studies, 1941–1965.* Boston: G.K. Hall, 1970. 4 vols. *Supplement, 1966–1970,* 1973. 3 vols.
Cumulates part of the bibliographies published in various editions of the Association for Asian Studies serial, which was titled *Lists by American Council of Learned Societies Devoted to Humanistic Studies Committee on Far Eastern Studies,* 1934–35; *Bulletin of Far Eastern Bibliography,* 1936–40; *Far Eastern Quarterly,* 1941–55; *Journal of Asian Studies* since 1956. See 14:74.

14:78 *Catalogue of the Rubel Asiatic Collection, Harvard University Fine Arts Library.* New York: K.G. Saur, 1989.
Deals with arts of Far East, Southeast Asia, and the Indian Subcontinent.

14:79 *Classified List of Books in Western Languages Relating to Japan.* Tokyo: University of Tokyo, 1965.

14:80 Creswell, Keppel A. C. *A Bibliography of the Architecture, Arts, and Crafts of Islam to 1st Jan. 1960.* Cairo: American University at Cairo, 1961.

14:81 *Dictionary Catalog of the Library of the Freer Gallery of Art.* Boston: G.K. Hall, 1967. 6 vols.
Art and culture of Far East, Near East, Indo-China, and India. Analyzes serial articles, as most of them are not found in standard indices. Four volumes are for works in Western languages, two for Oriental works.

14:82 *Index Islamicus.* Cambridge: W. Heffer and London: Mansell. 1906–55. Plus Supplements: 1956/60, 1961/65, 1966/70, 1971/72 annually through 1974/75.

14:83 *Review bibliographique de sinologie.* Paris: Editions de l'Ecole des hautes 'etudes en sciences sociales, 1955+ Annual.
Art and archaeology; indexes literature in Western and Asian languages.

14:84 *The T.L. Yuan Bibliography of Western Writings on Chinese Art and Archaeology.* London: Mansell, 1975.

14:85 University of California. *East Asiatic Library: Author-Title Catalog.* Boston: G. K. Hall, 1968. 13 vols. *First Supplement,* 1973. 2 vols. *East Asiatic Library: Subject Catalog.* Boston: G. K. Hall, 1968. 6 vols. *First Supplement,* 1973. 2 vols.

14:86 University of Chicago. *Catalogs of the Far Eastern Library.* Boston: G.K. Hall, 1973. 18 vols.

14:87 University of Chicago. *Catalog of the Oriental Institute Library.* Boston: G.K. Hall, 1970. 16 vols.
Near East, Ancient Mesopotamia, Egypt, Palestine, Anatolia, and Iran.

14:88 Webb, Herschel. *Research in Japanese Sources: A Guide.* New York: Columbia University, East Asian Institute, 1965.

Documents and Sources

14:89 *Introductions to Oriental Civilizations.* William Theodore De Bary, ed. New York: Columbia University, 1958–60.
 .1 *Sources of Indian Tradition.*
 .2 *Sources of Chinese Tradition,* with Wing-tai Chan and Burton Watson.
 .3 *Sources of the Japanese Tradition,* Ryusaku Tsunoda et al.

Published Picture Collections

14:90 *Collections from the British Museum: Department of Japanese Antiquities.* Bath, England: Mindata. To be published 1989.
Photographs of Japanese wood-block prints.

14:91 *South Asian Art: Photo Collection on Microfiche.* Leiden, Netherlands: Inter Documentation Company, n.d.
Several large private and institutional South Asian collections were photographed; includes *Part 1: Kushan Period, Caves, and Gupta Period; Part 2: Gandhara.*

Indices to Art Collections

Although texts are written in Chinese characters, these sources contain black-and-white identification photographs and can be used to locate specific paintings.

14:92 *Comprehensive Illustrated Catalog of Chinese Paintings,* comp. by Kei Suzuki. Tokyo: University of Tokyo, 1982. 5 vols.
Vol. 1: America and Canada, Vol. 2: Southeast Asia and Europe, Vol. 3: Japan I, Vol. 4: Japan II, Vol. 5: Index. Gives sources for purchasing reproductions—prints or slides.

14:93 *Illustrated Catalogue of Selected Works of Ancient Chinese Painting and Calligraphy.* Bejing: Cultural Relics, 1986+

14:94 *Oriental Ceramics: The World's Great Collections.* Tokyo: Kodansha, 1976–78. 12 vols. Second issue, 1980. 11 vols.
Color illustrations of key pieces in major museums.

14:95 Roberts, Laurance P. *The Connoisseur's Guide to Japanese Museums.* 2nd ed. Rutland, VT: C.E. Tuttle, 1978.

Serials

Art Index [16:1] is the only English-language art index to cover Asian art. See bibliographies cited above.

Archives of Asian Art, Asia Society 1967+ (Supersedes *Archives of the Chinese Art Society of America* 1945/46–1965)
Ars Orientalis, Freer Gallery of Art, University of Michigan 1954+
Artibus Asiae, 1925/26+
Arts asiatiques, Musée Guimet, Musée Cernuschi 1954+ (Supersedes *Revue de arts asiatiques,* 1924–42)
Arts of Asia 1971+
Asian Art, Arthur M. Sackler Gallery 1988+
Journal of Asian Studies, Association for Asian Studies 1934+ (for title changes see 14:77).

Oriental Art 1948–51, 1955+
Orientations: The Monthly Magazine for Collectors and Connoisseurs of Oriental Art 1970+

Cultural/Historical Surveys

There are a number of atlases for individual countries, such as *The Times Atlas of China.* (London: Times Newspapers, 1974) which cover Asian countries.

14:96 Blunden, Caroline and Mark Elvin. *Cultural Atlas of China.* Oxford: Equinox, 1983.

14:97 *Cambridge Encyclopedia of China.* Brian Hook, general ed. London: Cambridge University, 1982.
Entire section on art and architecture; chapter on symbolism in art. Covers such areas as anthropology, literature, geography, culture, economy, philosophy, and historical periods from "Legendary Prehistory" through "The Peoples' Republic."

14:98 Collcut, Martin et al. *Cultural Atlas of Japan.* Oxford: Equinox, 1988.

14:99 Dunn, Charles J. *Everyday Life in Traditional Japan.* Rutland, VT: C.E. Tuttle, 1977.

14:100 *Encyclopedia of Asian History.* Ainslie T. Embree, Ed.-in-Chief. New York: Scribner's, 1988. 4 vols.

14:101 Frëdëric, Louis. *Encyclopaedia of Asian Civilizations.* New ed. Villecresnes, France: L. Friederic, 1987. 11 vols. in 10 books.

14:102 Lowe, Michael. *Everyday Life in Early Imperial China.* London: B.T. Batsford, 1968; reprint, New York: Dorset, 1988.

14:103 Myers, Bernard S. and T. Copplestone. *History of Asian Art.* Rev. ed. New York: Exeter Books, 1987.

14:104 Robinson, Francis. *Atlas of Islamic World Since 1500.* Oxford: Equinox, 1982; reprint, New York: Facts on File, 1984.

14:105 Saletore, Rajaram Narayan. *Encyclopaedia of Indian Culture.* New Delhi: Sterling, 1981–85. 5 vols.

African Studies

An important aspect of African studies is to locate the various names by which the area has been known as well as which tribes are associated with this land. Although published in 1959, George Peter Murdock's *Africa: Its Peoples and Their Culture History* [14:110] is still a good source for finding tribal names and maps to tribal territory. There are

a number of African art collections, but two outstanding ones are the Goldwater Collection at the Metropolitan Museum of Art and the National Museum of African Art in Washington, D.C. For ancient Egyptian studies, see Chapter 11.

Dictionaries

14:106　Berman, Esmé. *Art and Artists of South Africa: An Illustrated Biographical Dictionary and Historical Survey of Painters, Sculptors, and Graphic Artists Since 1875.* Cape Town, South Africa: A.A. Balkema, 1983.

14:107　*Dictionary of Black African Civilization,* ed. by Georges Balandier and Jaques Maquet. New York: L. Amiel, 1974.

Art Historical Surveys

14:108　Corbin, George A. *Native Arts of North America, Africa, and the South Pacific:* An Introduction. New York: Harper & Row, 1988.

14:109　Leiris, Michel and Jacqueline Delange. *African Art, Arts of Mankind Series.* Trans. by Michael Ross. New York: Golden Press, 1968.

14:110　Murdock, George Peter. *Africa: Its Peoples and Their Culture History.* New York: McGraw-Hill, 1959.
　　　　Includes index of tribal names as well as maps to tribal territory.

14:111　Vansina, Jan. *Art History in Africa: An Introduction to Method.* New York: Longman, 1984.
　　　　Discusses identification of objects, African society, media and techniques, style, interpretation of icons, culture and art, the creative process, and foreign input.

14:112　Wassing, Rene S. *African Art: Its Background and Traditions.* New York: Portland House, 1988.

14:113　Willett, Frank. *African Art: An Introduction.* New York: Oxford University, 1971; reprint 1985.

14:114　Williams, Denis. *Icon and Image: A Study of Sacred and Secular Forms of African Classical Art.* New York: New York University, 1974.

Bibliographies

The Goldwater Library [14:22] includes African art.

14:115　*Africa South of the Sahara: Index to Periodical Literature, 1900–1970.* Boston: G.K. Hall, 1971. 4 vols. *First Supplement,* 1973.

One vol. *Second Supplement,* 1982. 3 vols. *Third Supplement.* Washington, D.C.: U.S. Government Printing Office, 1985. One vol.

14:116　Biebuyck, Daniel P. *Arts of Central Africa: An Annotated Bibliography, G. K. Hall Art Bibliographies Series.* Boston: G.K. Hall, 1987.

14:117　*Catalog of the Melville J. Herskovits Library of African Studies, Northwestern University Library (Evanston, Illinois) and Africana in Selected Libraries.* Boston: G.K. Hall, 1972. 8 vols. *Supplement,* 1978. 6 vols.

14:118　Davies, Mary Kay. *Snake Symbolism in African Art: A Selected Bibliography of Sources in the National Museum of African Art.* Washington, D.C.: Smithsonian Libraries, 1983.

14:119　Gaskin, L. J. P. *A Bibliography of African Art.* London: International African Institute, 1965.

14:120　*International African Bibliography: Current Books, Articles, and Papers in African Studies.* David Hall, ed. London: Mansell, 1971+
　　　　Quarterly with large classifications by regions and subject categories. In 1982 published a cumulative edition for 1973–78.

14:121　Pokornowski, Ila M. et a. *African Dress II: A Select and Annotated Bibliography.* East Lansing, MI: African Studies Center, Michigan State University, 1985.

14:122　Sieber: Roy. *African Textiles and Decorative Arts.* New York: Museum of Modern Art, 1972.

14:123　Stanley, Janet L. *African Art: A Bibliographic Guide.* New York: Africana, 1985.

14:124　———. *Arts in Africa: An Annotated Bibliography.* Atlanta: Crossroads Press, African Studies Association.
　　　　Vol. 1 (1986–87)+

14:125　Western, Dominique. *A Bibliography of the Arts of Africa.* Waltham, MA: Brandeis University, 1975.

Series

14:126　*Traditional Arts of Africa Series.* Bloomington: Indiana University.
　　.1 *An Annotated Bibliography of the Visual Arts of East Africa,* Eugene C. Burt, 1980.
　　.2 *Art and Death in a Senufo Village,* Anita J. Glaze, 1981.
　　.3 *Mbari, Art and Life among the Owerri Igbo,* Herberrt M. Cole, 1982.

.4 *Gëlëde: Art and Female Power Among the Yoruba,* Henry John Drewal and Margaret Thompson Drewal, 1983.

.5 *The Mande Blacksmiths: Knowledge, Power, and Art in West* Africa, Patrick R. McNaughton, 1988.

Serials

See Janet Stanley's "African Art Periodicals," *Art Documentation* 3(Fall 1984): 93–95. See also *National Geographic Magazine* 1888+

African Arts, African Studies Center, University of California 1967+

Arts d'afrique noire, 1971+ (Use with Index for vols. 1–57, 1971–86. Plus supplements such as *Arts du Gabon,* 1979; *Introduction aux arts d'afrique noire* by Marie-Louise Bastin, 1984.)

Cultural/Historical Surveys

14:127 *Cambridge History of Africa.* Cambridge: Cambridge University, 1975–86. 8 vols.
Vol. 1 covers from earliest times to c. 500 B.C.; Vol. 2, 500 B.C.–1050 A.D.; Vol. 3, 1050–1600; Vol. 4, 1600–1790; Vol. 5, 1790–1870, Vol. 6, 1870–1905, Vol. 7, 1905–1940, Vol. 8, 1940–1975.

14:128 *Cultural Atlas of Africa.* Jocelyn Murray, ed. New York: Facts on File, 1981.

14:129 UNESCO. *General History of Africa.* J. Ki-Zerbo, general ed. Berkeley: University of California, 1981+ Projected 8 vols.
Vol. 1 covers methodology and African prehistory; Vol. 2, ancient African civilizations; Vol. 3, 7th–11th century; Vol. 4, 12th–16th century, Vol. 5, 16th–18th century; Vol. 6, 19th century-1880, Vol. 7, foreign domination, 1880–1935, Vol. 8, since 1935.

Pacific Studies, Including Australia and New Zealand

Encyclopedias and Dictionaries

14:130 Germaine, Max. *Artists and Galleries of Australia and New Zealand.* Dee Why West, New South Wales: Lansdowne, 1979.

14:131 McCulloch, Alan. *Encyclopedia of Australian Art.* New York: Frederick A. Praeger, 1968.

14:132 Scarlett, Ken. *Australian Sculptors.* West Melbourne, Victoria: Thomas Nelson Australia, 1980.

Art Historical Surveys

See Corbin's book on native arts [14:108].

14:133 Berndt, Ronald, ed. *Australian Aboriginal Art.* New York: Macmillan, 1964.

14:134 Buck, Peter Henry. *Arts and Crafts of Hawaii,* by Te Rangi Hiroa. Honolulu: Bishop Museum Press, 1957.

14:135 Buhler, Alfred, Terry Barrow, and Charles P. Mountford. *The Art of the South Sea Islands, Including Australia and New Zealand.* New York: Crown, 1962.

14:136 Clark, Jane and Bridget Whitelaw. *Golden Summers: Heidelberg and Beyond.* Rev. ed. Sydney: International Cultural Corporation of Australia, 1986.

14:137 Guiart, Jean. *The Arts of the South Pacific, Arts of Mankind Series.* New York: Golden Press, 1963.

14:138 Smith, Bernard William. *Australian Painting, 1788–1970.* 2nd ed. Melbourne: Oxford University, 1971.

14:139 ———. *Place, Taste and Tradition: A Study of Australian Art Since 1788.* 2nd ed. rev. Melbourne: Oxford University, 1979.
Development of Australian art in relationship to European culture.

14:140 Sutton, Peter, et al. *Dreamings: The Art of Aboriginal Australia.* New York: The Asian Society Galleries, 1988.

Bibliographies

Remember that the Goldwater Library [14:22] includes native arts of these regions.

14:141 Choate, Ray, ed. *A Guide to Sources of Information on the Arts in Australia.* Sydney: Pergamon, 1983.
Covers arts in painting and drawing, prints, sculpture, architecture, the decorative arts, and Aboriginal arts.

14:142 Hanson, Louise and F. Allan Hanson. *Art of Oceania: A Bibliography. G.K. Hall Art Bibliographies Series.* Boston: G.K. Hall, 1984.
Includes Polynesia, Melanesia, Micronesia, and Australia. Has indices to personal names, titles, subjects and lists of sales catalogues.

14:143 McDonald, Jan. *Australian Artists' Index: A Biographical Index of Australian Artists, Craft Workers, Photographers and Architects.* Sydney: ARLIS/ANZ, 1986.
Available from Katherine Cummings, Sydney College of the Arts, P.O. Box 226, Glebe 2037, New South Wales, Australia.

14:144 Taylor, C. R. H. *A Pacific Bibliography: Printed Matter Relating to the Native Peoples of Polynesia, Melanesia, and Micronesia*. 2nd ed. Oxford: Clarendon, 1965.

Australia excluded; covers all aspects of culture. Has list of names of islands in the three groups cited above.

Index and Serial

14:145 *Australian Art Index Database*. Canberra: Australian National Gallery, 1982+

Covers art in Australia and the work of Australian artists overseas.

Art and Australia 1963+

Museum Collection and Exhibition Information

Museum publications—museum collection catalogues, exhibition catalogues, and serials—contain some of the most significant research that is being done. These resources frequently provide excellent illustrations, documentation on art objects, and pertinent articles on various artistic styles. This chapter annotates resources concerned with museum publications and exhibition information. It is divided into (1) resources on permanent museum collections, (2) tools for discovering exhibition information, and (3) serials published by museums. Chapters 3 and 6 discuss these resources.

Resources on Permanent Collections

In order to obtain detailed information on specific works of art, researchers should consult the catalogues of institutions that own them. Most museums publish only brief guides or summary catalogues to their collections. Only a few have compiled scholarly catalogues. Among these are the British Museum, the National Gallery, the Tate Gallery, Victoria and Albert Museum, and Wallace Collection, London; the Kunsthistorisches Museum, Vienna; the Bayerische Staatsgemäldesammlungen, Munich; the National Gallery of Canada, Ottawa; the Metropolitan Museum of Art and the Frick Collection, New York City; and the Samuel H. Kress Foundation. The National Gallery of Art, Washington, D.C., has inaugurated a series of systematic scholarly catalogues on its collection; when finished, there will be about twenty-four volumes. The first publication was *Early Netherlandish Painting*, John Oliver Hand and Martha Wolff (New York: Cambridge University, 1986).

Museum catalogues can be located through the library's catalogue system or through indices to museum collection catalogues. Most entries are accessed through the name of the museum. But if there is no catalogue, similar data can often be found in well-illustrated references published for more popular audiences. This section consists of (1) references that index museum catalogues, (2) well-illustrated books on art museum collections, (3) inventories of private collections, and (4) computerized programs for museum collections.

Indices of Museum Collection Catalogues

These references provide access to the catalogues that have been published by museums on their collections. Also check *Art Books* [17:2] which gives dates, prices, and publishers for more than 3,300 museum collection catalogues. See also *Old Master Paintings in Britain* [19:33] and *Paintings in Dutch Museums* [19:34] which list catalogues for museums in those countries.

15:1 *Catalog of Museum Publications and Media.* 2nd ed. Detroit: Gale Research, 1980.

15:2 *World Museum Publications: A Directory of Art and Cultural Museums, Their Publications, and Audio-Visual Materials.* New York: R. R. Bowker, 1982.
 Organized by museums; has indices to authors and titles.

Well-Illustrated Publications on Art Museum Collections

Although not official art museum catalogues, most of these resources include brief histories of the institutions, numerous color reproductions, and basic information on the museum's masterpieces. Other important paintings may be reproduced in a diminutive size in black and white. Most titles of works of art are translated into English. In addition, some museums publish books that have excellent color reproductions of their collections for a more popular audience. Only the series from the Metropolitan Museum of Art is listed here.

15:3 *Great Galleries of the World Series.* Ettore Camesasca, general ed. New York: Arco Publishing, 1973. 6 vols.
 .1 *The Alte Pinakothek of Munich and the Castle of Schleissheim and Their Paintings,* ed. Edi Baccheschi, 1974.

.2 *The National Gallery of London and Its Paintings,* ed. Marina Anzil, 1974.

.3 *The National Gallery of Washington and Its Paintings,* ed. Mia Cinotti, 1975.

.4 *The Prado of Madrid and Its Paintings,* ed. Mia Cinotti, 1974.

.5 *The Rijksmuseum of Amsterdam and Its Paintings,* ed. Paolo Lecaldano, 1974.

.6 *The Uffizi of Florence and Its Paintings,* ed. Sergio Negrini, 1974.

15:4 *Masterpieces of the World's Great Museums.* New York: Gallery Books, 1988. Covers 10 U.S. and European museums. Brief histories and floor plans of the buildings.

15:5 *Metropolitan Museum of Art At Home Series.* New York: Metropolitan Museum of Art, 1987–89.

.1 *Egypt and the Ancient Near East*
.2 *Greece and Rome*
.3 *Europe in the Middle Ages*
.4 *The Renaissance in Italy and Spain*
.5 *The Renaissance in the North*
.6 *Europe in the Age of Monarchy*
.7 *Europe in the Age of Enlightenment and Revolution*
.8 *Modern Europe*
.9 *The United States of America*
.10 *Asia*
.11 *The Islamic World*
.12 *The Pacific Islands, Africa, and the Americas*

15:6 *Museums Discovered Series.* Ft. Lauderdale: Woodbine Books.

.1 *Museums Discovered: The Calouste Gulbenkian Museum,* Rona Goffen, 1982.

.2 *Museums Discovered: The Isabell Stewart Gardner Museum,* Rollin van N. Hadley, 1981.

.3 *Museums Discovered: The Oskar Reinhart Collections,* Franz Zelger, 1981.

.4 *Museums Discovered: The Phillips Collection,* Eleanor Green, 1981.

.5 *Museums Discovered: The Wadsworth Atheneum,* Gerald Silk, 1982.

15:7 *Newsweek: Great Museums of the World Series.* Carlo Ludovico Ragghianti and Henry A. La Farge, general eds. New York: Newsweek, 1967–1982.

.1 *Brera, Milan,* 1970.
.2 *British Museum, London,* 1967.
.3 *Egyptian Museum, Cairo,* 1978.
.4 *Hermitage, Leningrad,* 1980.
.5 *Louvre, Paris,* 1967.
.6 *Metropolitan Museum of Art, New York,* 1978.
.7 *Museum of Art, Sao Paulo,* 1981.
.8 *Museum of Fine Arts, Boston,* 1969.

.9 *Museum of Fine Arts, Budapest,* 1982.
.10 *Museums of Cracow,* 1981.
.11 *Museums of Egypt,* 1980.
.12 *Museums of the Andes,* 1981.
.13 *Museums of Yugoslavia,* 1977.
.14 *National Archaeological Museum, Athens,* 1979.
.15 *National Gallery, London,* 1969.
.16 *National Gallery, Washington,* 1968.
.17 *National Museum of Anthropology, Mexico City,* 1970.
.18 *National Museum, Tokyo,* 1968.
.19 *Paintings Gallery, Dresden,* 1979.
.20 *Picture Gallery of the Art History Museum, Vienna,* 1970.
.21 *Pinakothek, Munich,* 1969.
.22 *Pompeii and Its Museums,* 1979.
.23 *Prado, Madrid,* 1968.
.24 *Rijksmuseum, Amsterdam,* 1969.
.25 *Uffizi, Florence,* 1968.
.26 *Vatican Museums, Rome,* 1968.

15:8 *World of Art Library: Galleries Series.* London: Thames and Hudson; New York: Harry N. Abrams; Paris: Editions Aimery Somogy, 1964–73.

.1 *The Art Institute of Chicago,* John Maxon, 1970.

.2 *The Berlin Museum: Paintings in the Picture Gallery, Dahlem-West Berlin,* Rüdiger Klessmann, 1971.

.3 *The Dresden Gallery,* by Henner Menz, 1962.

.4 *The Hermitage,* rev. ed., Pierre Descargues, 1967.

.5 *Impressionists in the Louvre,* Germain Bazin, 1958. (sometime called *French Impressionist Paintings in the Louvre*)

.6 *The Louvre,* rev. ed., Germain Bazin, 1966.

.7 *The Munich Gallery, Alte Pinakothek,* Wolf-Dietter Dube, 1970.

.8 *The National Gallery, London,* Philip Hendy, 1960.

.9 *The National Gallery of Art, Washington, D.C.,* rev. ed., John Walker, 1984.

.10 *The National Gallery of Victoria,* Ursula Hoff, 1973.

.11 *The Prado,* rev. ed., F. J. Sanchez-Canton, 1966.

.12 *The Rijksmuseum and Other Dutch Museums,* Remmett Van Luttervelt, 1967.

.13 *The School of Paris in the Musée d'Art Moderne,* Bernard Dorival, 1962.

.14 *The Tate Gallery,* rev. ed., John Rothenstein, 1963.

.15 *Treasures of the British Museum,* ed. by Frank Francis, 1971.

.16 *The Uffizi and Pitti,* Filippo Rossi, 1967.

Inventories of Private Collections

The history of private collecting is long and involved. Due to the many ways in which art works can be purchased, sold, given away, lost, or destroyed makes the individual works in a collection difficult to trace. Scholars look for inventories or a list of the works of art at specific periods of time. Locating a particular list, if one has been created, can be difficult, if not impossible. Sometimes these inventories were made when an estate was settled or when it was sold. Or the collector might have compiled a catalogue and privately published it.

There are several sources for these inventories. They might be in an archive, especially in the city where the collector lived. Although not a complete listing of a specific collection, auction catalogues report the art that the collector wished to sell. These catalogues can be traced through the various references annotated under "Union Lists for Sales Catalogues" in Chapter 18, such as *SCIPIO* [18:48] and Frits Lugt's *Répertoire des catalogues de ventes publiques* [18:47].

In addition, there are some resources which contain accounts of famous collections. For instance, George Redford's *Art Sales* [18:33] includes historical accounts of some of the great collections sold in England. Francis Haskell's *Patrons and Painters* [12:65] provides information on Italian Baroque collections. Some of the privately published catalogues may be located through the major art libraries.

15:9 Foster, Susan, "Paintings and Other Works of Art in Sixteenth-Century English Inventories." *Burlington Magazine* 123(May 1981): 273–82.

15:10 UNESCO. *Illustrated Inventory of Famous Dismembered Works of Art.* New York: K.G. Saur, 1974.
 Although not an inventory of a specific collector, this book does illustrate how art pieces are often dismembered and sold in sections.

15:11 Lavin, Marilyn Aronberg. *Seventeenth-Century Barberini Documents and Inventories of Art.* New York: New York University, 1975.

Computerized Programs for Museum Collections

Many museums are beginning to computerize their collection records. Various levels of data are being added, from lists to detailed entries. For some institutions, this is mostly a location device to keep the registrar's office informed of what is where. But some museums are planning computer projects to record scholarly catalogue entries. Currently, this is for in-house use only, but this may change in the near future. For instance, at the Museum of Fine Arts, Boston, information on the European paintings is available to the public through a computer that provides data found on the object's label as well as the exact location of the work in the museum.

In 1988, the Metropolitan Museum of Art displayed most of its American collection, either in the galleries or in a study area. Some objects, such as watercolors, could not be exhibited due to conservation concerns. Computers containing information on locations, artists, media, and subjects are available to the public. Called AWARE (American Wing Art Research), this public-access system is an abbreviated automated collection catalogue. There may be more of these computer projects available to the public in the future.

Exhibition Information

This section is divided into (1) indices that provide information on exhibitions held since the 1960s, (2) indices that provide information on past exhibitions, and (3) reprints of catalogues. For a discussion of this material, see chapters 3, 6 and 8.

Indices to Catalogues of Exhibitions Held Since the 1960s

These references can be used to discover (1) in which exhibitions particular artists displayed their works and (2) if there have been any exhibitions on specific subjects. The actual exhibition catalogue must then be obtained and studied in order to verify the data. Art abstracting and indexing services, such as *ARTbibliographies MODERN* [16:2], *Répertoire d'art et d'archéologie* [16:6], and *RILA* [16:7] provide access to bibliographical data on exhibition catalogues. *Art Index* [16:1] reports exhibition reviews. Online databases are available for all four resources. The newspaper indices listed in Chapter 16 often give information on the most recent exhibitions, especially if one of the online databases are used.

15:12 *Art Exhibition Catalogs Subject Index: Collection of the Arts Library, University of California at Santa Barbara.* New York: Chadwyck-Healey, 1978+ Microfiche.
 Provides material on museum and gallery catalogues in the UCSB Library, many of which are available for interlibrary loans.

Reports (1) name and city of exhibiting institution; (2) catalogue title; (3) subject terms used to describe or clarify contents; (4) exhibition year; (5) data such as number of pages and illustrations and inclusion of bibliographies, chronologies, and bibliographical footnotes; and (6) authors. Subject category has names of up to 5 individual artists per catalogue. Frequently adds notations, such as if artist's comments are in the catalogue. There are indices to exhibiting institutions and subject categories. Has indexed retrospectively; includes catalogues sold by Knoedler Galleries, Chadwyck-Healey, and Worldwide Books. In 1989 had more than 67,000 catalogues. Updated every 6 months. This data may be added to the RLIN database in the future.

15:13 *Worldwide Art Catalogue Bulletin* and *Worldwide Art Catalogue Bulletin: Annual Index*. Margaret Prescott, ed. Ithaca, NY: Worldwide Books, Volume I (1963) +

Providing reviews of catalogues, this quarterly has included since 1969 an annual index. Culls catalogues from about 3,500 different museums and galleries and chooses from 700 to 900 catalogues for commercial distribution. Over the years, catalogues from over 2,000 art museums in 51 different countries have been sold. Each bulletin reviews around 200 catalogues. Under country followed by city where museum or gallery is located, entry includes title; compiler; place and date of exhibition; number of pages, illustrations, and plates; price and size; review of material; and language in which catalogue is written. Each bulletin has indices to (1) titles; (2) names of artists who are either subjects of monographic catalogues or whose works figure significantly in texts or in illustrative material; (3) Western Art, subdivided by periods of art history and geographical locations and then categorized by media; (4) Non-Western Art; (5) special media—architecture, ceramics and glass, environmental/land art, manuscripts and book design, medals and coins, metalwork, mixed media, photography, textile/fiber art, and video/film/ performance; and (6) topical items such as commercial and industrial design, conceptual art, decorative arts and design, illustration, poster, and women artists. Annual index has same indices. In recent editions, index to museums and galleries whose catalogues are listed has been added. For illustration of types of information disseminated by these brochures, see Example 6. A cumulative index, *The Worldwide Bibliography to Art Exhibition Catalogues, 1963–1987,* will be published by

Kraus International about 1990. There will be (1) a monographs sections, which will be organized by artists' names, (2) a subject bibliography, which will use the *Bulletin's* headings, and (3) a complete title index. Reviews will not be included.

Indices to Past Exhibitions

Because researchers are often looking for specific exhibitions at which a particular artist's work was displayed, the following indices have been divided according to country and date of exhibitions: (1) British, 18th and 19th centuries; (2) North American, 19th and 20th centuries; and (3) European 20th Century. Under an artist's name, the references usually provide the art works' titles, dates, and dimensions; galleries where works were exhibited; dates of exhibitions; and, often, the names of the works' owners, if someone other than the artists possessed them.

Many of these exhibitions were international, remember that artists from all over the world—U.S., Canada, or Europe—may have exhibited in any of the exhibitions. Moreover, some 19th-century serials not only reviewed exhibitions but also published engravings, and later photographs, to illustrate them.

England, Scotland, Ireland: 18th and 19th Centuries

15:14 *The British Institution 1806–1867: A Complete Dictionary of Contributors and Their Work from the Foundation of the Institution,* compiled by Algernon Graves. London: George Bell and Sons, 1908; reprint, West Orange, NJ: Albert Saifer, 1969.

Contains index to portraits, which were chiefly in sculpture.

15:15 *A Century of Loan Exhibitions 1813–1912,* compiled by Algernon Graves. London: H. Graves, 1913–15; reprint ed., New York: Burt Franklin, 1965. 5 vols originally; some reprints in 3 books.

Covers important English and Scottish exhibitions. Indices to portraits and owners.

15:16 *A Dictionary of Artists Who Have Exhibited Works in the Principal London Exhibitions from 1760 to 1893,* compiled by Algernon Graves. 3rd ed. London: H. Graves, 1901; reprint, New York: Burt Franklin, 1970.

Records artists who exhibited in shows of 16 societies; includes the Society of Artists, Royal Academy, British Institution, and Grosvenor Gallery. Entries state number of times artists exhibited with each society. No titles of works listed.

15:17　*Norwich Society of Artists 1805–1833: A Dictionary of Contributors and Their Work,* compiled by Miklos Rajnai for the Paul Mellon Center for Studies in British Art. Norfolk, England: Norfolk Museum Service, 1976.

15:18　*Royal Academy of Arts: A Complete Dictionary of Contributors and Their Work from Its Foundation in 1769 to 1904,* compiled by Algernon Graves. London: H. Graves, 1905–06; reprint, New York: Burt Franklin, 1970. 8 vols in 4 books.

　　　　The serials—*Academy Notes* and *Royal Academy Illustrated*—contain reproductions for some displayed works. For 20th century exhibitions, see 15:36.

15:19　*Royal Hibernian Academy of Arts: Index of Exhibitors 1826–1979,* compiled by Ann M. Stewart. Dublin: Manton, 1985–87. 3 vols.

　　　　Begins with the first annual exhibition in Dublin.

15:20　*Royal Society of British Artists,* compiled by Maurice Bradshaw. Leigh-on-Sea, England: F. Lewis Publishers.

　　　　Vol. 1: Members Exhibiting 1824–1892, 1973. *Vol. 2: Members Exhibiting 1893–1910,* 1975. *Vol. 3: Members Exhibiting 1911–1930,* 1975. *Vol. 4: Members Exhibiting 1931–1946,* 1976. *Vol. 5: Members Exhibiting 1947–1962,* 1977. Some volumes indicate prices artists placed on exhibited works.

15:21　*Royal Society of British Artists 1824–93,* compiled by Jane Johnson. Woodbridge: Antique Collector's Club, 1975. 2 vols.

　　　　Also listed as *Works of Art Exhibited at the Royal Society of British Artists 1824–1893 and the New English Art Club 1888–1917.* Gives addresses and prices for which items sold.

15:22　*Royal Scottish Academy 1826–1916,* under direction of Frank Rinder. Glasgow: Maclehose & Sons, 1917; reprint, Bath, England: Kingsmead, 1975.

15:2〔　*The Society of Artists of Great Britain 1760–1791: The Free Society of Artists 1761–1783: A Complete Dictionary of Contributors and Their Work from the Foundation of the Societies to 1791,* compiled by Algernon Graves. London: G. Bell & Sons, 1907; reprint, Bath, England: Kingsmead Reprints, 1969.

　　　　Brief history of societies and portrait index.

North American, 19th and 20th Centuries

Check the Archives of American Art's *Collection of Exhibition Catalogs* [15:37], which lists one-person exhibitions by artist's name. For graphic art, see *Index of American Print Exhibitions, 1882–1940* [22:45].

15:24　*American Academy of Fine Arts and American Art-Union,* by Mary Bartlett Cowdrey. New York: New York Historical Society, 1953. 2 vols.

　　　　Lists works exhibited 1816–1852; states artist's status of membership plus some sales prices.

15:25　*The Annual Exhibition Record of the Pennsylvania Academy of the Fine Arts,* ed. by Peter Hastings Falk. Madison, CT: Sound View, 1988. Reprint with revisions of 15:28.

　　　　Includes Society of Artists, 1810–14 and Artists' Fund Society, 1835–45.

15:26　"Art Gallery of Ontario: Sixty Years of Exhibitions, 1906–1966," by Karen McKenzie and Larry Pfaff. *RACAR* 7(1980): 62–91.

15:27　*Boston Athenaeum Art Exhibition Index 1827–1874,* compiled by Robert F. Perkins, Jr. and William J. Gavin, III, Boston: Library of the Boston Athenaeum, 1980.

　　　　More than 1,500 artists from 133 catalogues.

15:28　*Cumulative Record of Exhibition Catalogues: The Pennsylvania Academy of the Fine Arts 1807–1870; The Society of Artists 1800–1814; The Artists' Fund Society 1835–1845,* edited by Anna Wells Rutledge. Philadelphia: American Philosophical Society, 1955.

　　　　Lists 69 exhibition catalogues of painting and sculpture; indices to artists, owners, and subjects.

15:29　*A History of the Brooklyn Art Association with an Index of Exhibitions,* compiled by Clark S. Marlor. New York: James F. Carr, 1970.

　　　　Index to exhibitions, from 1859 to 1892. Chronology of exhibitions and catalogues. An asterisk indicates additional information is in the original catalogue; an *f* means that the work was for sale.

15:30　*Montreal Museum of Fine Arts: Formerly Art Association of Montreal: Spring Exhibitions 1880–1970/Musée des beaux arts du Montreal: Salons du printemps 1880–1970,* compiled by Evelyn de Rostaing McMann. Toronto: University of Toronto, 1988.

　　　　Over 3,000 artists.

15:31　*National Academy of Design Exhibition Record 1826–1860.* New York: New York Historical Society, 1943. 2 vols.

　　　　Covers the first 35 annual exhibitions; provides membership status. Includes index of artists, owners, subjects, and places.

15:32 *National Academy of Design Exhibition Record 1861–1900,* compiled by Maria Naylor. New York: Kennedy Galleries, 1973. 2 vols.

15:33 *National Museum of American Art's Index to American Art Exhibition Catalogues: From the Beginning through the 1876 Centennial Year,* compiled by James L. Yarnall and William H. Gerdts. Boston: G. K. Hall, 1986. 6 vols.

Provides multiple access to detailed information from 900 catalogues of exhibitions held in U.S. and Canada in both major and smaller cities, such as Albany, St. Louis, Louisville, and New Orleans. Exhibitions were all held before 1877 and include private collections, galleries, clubs, and fairs. Excludes exhibitions which have previously been subject of publication, such as American Academy of the Fine Arts [15:24], Boston Athenaeum [15:27], Brooklyn Art Association [15:29], National Academy of Design [15:31 & 32], and Pennsylvania Academy of Fine Arts [15:25 & 28]. Has an extensive subject index. For information on obtaining copies of these catalogues, contact the Office of Research Support, National Museum of American Art, Washington, D.C.

15:34 *Royal Canadian Academy of Arts/Academie royale des arts du Canada: Exhibitions and Members 1880–1979,* compiled by Evelyn de Rostaing McMann. Toronto: University of Toronto Press, 1981.

Indexes more than 3,000 artists. Provides biographical data, Academy status, and, where available, present location of work.

European: 20th Century

See *Royal Academy of Arts* [15:18], *Royal Hibernian Academy of Arts* [15:19], *Royal Society of British Artists* [15:20], and *Royal Scottish Academy* [15:22].

15:35 *Modern Art Exhibitions 1900–1916: Selected Catalogue Documentation,* compiled by Donald E. Gordon. Munich: Prestel-Verlag, 1974. 2 vols.

Lists works displayed by 426 painters and sculptors in 851 exhibitions of modern art from 1900 to 1916 in 15 countries and 82 cities whose catalogues were owned by 52 libraries. Many are inaccessible catalogues: 89 in Russia, 36 in Hungary, and 20 in Czechoslovakia. Vol. 1 has chronological list of exhibition catalogues consulted, over 1,900 small black-and-white illustrations of works by 272 artists, and index to artists. Vol. 2 lists exhibition catalogues and contains index to cities and exhibitors.

15:36 Royal Academy of Arts. *Royal Academy Exhibitors 1905–1970: A Dictionary of Artists and Their Work in the Summer Exhibitions of the Royal Academy of Arts.* Wakefield, Yorkshire, England: E. P. Publishing, 1973–82. 6 vols. in 5 books.

For earlier exhibitions, see 15:18.

Reprints of Exhibition Catalogues

Access to earlier exhibition catalogues has been made possible by the number of reprints which have been made of these important research tools. Frequently published in sets, individual titles are not always added to a library's catalogue system, thus making it difficult to know exactly what catalogues are in each set. In addition, some of them are issued on microforms which may be located in a separate section of the library. When searching for a specific exhibition catalogue, ask the reference librarian for assistance.

15:37 The Archives of American Art. *Collection of Exhibition Catalogs.* Boston: G. K. Hall, 1979. Microfilm.

Index to more than 20,000 exhibition catalogues dating from early 19th century to 1960s. Arranged by gallery, museum, and personal names. By artist's name, cites one-person shows or exhibitions of no more than 3 people. Also includes many group exhibitions and annual group exhibits listed by gallery. Available through interlibrary loans; see "Archives" in Chapter 13.

15:38 *Art Exhibition Catalogues on Microfiche.* New York: Chadwyck-Healey, n.d. Microfiche.

Reprints of more than 3,100 important exhibitions: London—Arts Council of Great Britain 1940–1979, Fine Arts Society 1878–1976, Royal Academy of Arts Winter Exhibitions 1852–1976, and Victoria and Albert Museum 1862–1974—and Paris—French Salon Catalogues 1673–1925, Musée des Arts Decoratifs 1904–1976, and National Museums of France 1885–1974. Also a wide range of catalogues for North American exhibition: Chicago Museum of Contemporary Art 1967–1976, Los Angeles County Museum of Art 1932–1976, and in New York—American Federation of Arts 1929–1975, Buchholz Gallery-Curt Valentin 1937–1955, Galerie Chalette 1954–1970, Sidney Janis Gallery 1950–1976, and Solomon R. Guggenheim Museum 1953–1972.

15:39 *Catalogues of the Paris Salon 1673 to 1881.* Horst Woldemar Janson, compiler. New York: Garland, 1977. 60 vols.

Facsimile edition of all 101 livrets issued by Paris Salon, official French art exhibition sponsored by Academie Royale de Peinture et de Sculpture until 1789 and then by Direction des Beaux-Arts.

15:40 *Encyclopédie des arts décoratifs et industriels modernes au XXème siècle.* Wolfgang M. Freitag, advisory ed. New York: Garland, 1977. 12 vols.

Facsimile edition of official publication of 1925 Paris exhibition; includes over 1,100 full-page illustrations.

15:41 *Exhibition Catalogues from the Fogg Art Museum.* New York: Garland, 1977. 10 vols.

Reprint of 10 catalogues from Fogg Art Museum of Harvard University.

15:42 *The Knoedler Library of Art Exhibition Catalogues on Microfiche.* New York: Chadwick-Healey, Knoedler Gallery, 1970s. Microfiche.

Collection from library of M. Knoedler and Company, one of oldest art galleries in New York City, of more than 5,200 catalogues from various institutions. Although not every series is complete, includes most catalogues from Royal Academy of Arts Winter Exhibitions from 1870 to 1927 and British Institute Exhibitions 1813 to 1867. Also Paris Salons, 1673–1939; Salon d'Automne, 1905–1970; Société des Artistes Français, 1885–1939; individual European exhibition catalogues; and other major national and international expositions and world fairs, as well as Knoedler Galleries catalogues. The holdings of catalogues of American exhibitions—which include the National Academy of Design, 1832–1918 and the Pennsylvania Academy, 1812–1969—are extensive.

15:43 *Modern Art in Paris, 1855 to 1900,* selected and organized by Theodore Reff. New York: Garland, 1981. 47 vols.

Reproduces 200 diversified exhibition catalogues; includes 8 Parisian World's Fairs, 1855–1900; the 3 Salon of the Independants, 1884–91; French Salons 1884–99; the 4 Salons of the Refusals, including famous one in 1863; all 8 of the Impressionist Exhibitions in one book entitled *Impressionist Group Exhibitions;* the Post-Impressionist shows, 1889–97; Society of Printmakers; Rosicrucian Salons; Salons des Cent; Art Nouveau; and numerous other exhibition catalogues. Sometimes, these individual works are difficult to find, because they are not always listed separately in a library's catalogue system and because book titles do not always reveal names of exhibitions.

15:44 *National Gallery of Canada Exhibition Catalogues on Microfiche, 1919–1959.* Toronto: McLaren Micropublishing, 1980. Microfiche.

Reproduces 167 catalogues on architecture, photography, prints, and book illustrations. For an index, see Garry Mainprize's "The National Gallery of Canada: A Hundred Years of Exhibitions, List and Index," *RACAR* 11(1984): 3–78. Entries taken from the title page, thus includes artists in one-person shows, collectors, associations, galleries, museums, and exhibition titles.

Serials Published by Museum

This section lists some museum journals and bulletins that report details concerning various aspects of an institution's collection. Most of the articles are scholarly and substantive. The publications are usually covered by the five major art indices. To locate museum titles, consult the *Historical Bibliography of Art Museum Serials from the United States and Canada,* edited by Sheila M. Klos and Christine M. Smith [20:78.5]. Remember, titles have varied over the years and some annuals are provided call numbers and placed on the shelves.

Allen Memorial Art Museum Bulletin, Oberlin College, Ohio 1938+
Bonner Jahrbücher des Rheinischen Landmuseums in Bonn 1842+
Boston Museum of Fine Arts Bulletin 1903+
British Museum Quarterly 1926–73//
British Museum Society Bulletin 1969+
British Museum Yearbook 1976+
Brooklyn Museum Annual 1958+
Brooklyn Museum Bulletin 1939–51//
Chicago Art Institute, Museum Studies 1966+
Cleveland Museum of Art, Bulletin 1914+
Dresden, Staatliche Kunstsammlungen, Jahrbuch 1959+
J. Paul Getty Museum, Journal 1974+
Jahrbuch der Berliner Museen 1959+
Jahrbuch der Hamburger Kunstsammlungen 1948+
Journal of the Warburg and Courtauld Institutes 1937+
Marburger Jahrbuch für Kunstwissenschaft 1924+
Metropolitan Museum of Art, Bulletin 1905–42, new series 1942+
Metropolitan Museum of Art, Journal 1968+
Münchener Jahrbuch der bildenden Kunst 1906+
Musées de France 1929+ (Titled *Bulletin des musées de France,* 1929–47; suspended publication 1939–45)
National Gallery Technical Bulletin (London) 1970+

Oberlin College. Dudley Peter Allen Memorial Art Museum, Bulletin 1938+

Philadelphia Museum of Art Bulletin 1903+

Record of the Art Museum, Princeton University 1941+

La Revue du Louvre et des musées de France 1921+ (Titled *Musées de France* 1921–51; *La Revue des arts* 1951–60)

St. Louis City Art Museum Monographs 1968+

Studies in the History of Art, The National Gallery of Art, Washington, D.C., 1967+ (Originally called *Report and Studies in the History of Art*, 1967–69, jumps in volume numbers, from volume 18(1986) to volume 23(1987); sometimes placed in the Government Documents section library.)

Wallraf-Richartz Jahrbuch, Cologne 1924+

Walters Art Gallery, Baltimore, Journal 1938+

Wiener Jahrbuch für Kunstgeschichte, Vienna 1921+

Indexing and Abstracting Resources and Databases

Indexing and abstracting services, many of which also have online databases and CD-Rom formats, are important to find both contemporary and retrospective material. This chapter is divided into the services that cover: (1) art and design, (2) dissertations and theses, (3) *Festschriften,* (4) humanities and social studies, (5) serials published before the 1970s, (6) anthropology, (7) book reviews, (8) newspapers, and (9) citations. Indices that cover particular countries, styles, or special disciplines are annotated under the appropriate chapters. The numbers cited below are approximate, since publications vary slightly from issue to issue. For a discussion of these reference tools, see Chapters 3 through 5.

Art and Design Indices

16:1 *Art Index.* New York: H. W. Wilson.
 Vol. 1(1929)+
 One of first references to which art researchers turn, this quarterly publication with an annual cumulation covers some 235 serials, of which about 74% are published in English, 9% in French, and 9% in German. Most widely used art index in the U.S.; it indexes all forms and periods of art, including Egypt, the classical periods of Greece and Rome, Islam, the Orient, Asia, and primitive societies. Exhibition catalogues and books are mentioned only if reviewed in serials. Titles of reproduced works of art reported under artist's name. Includes some film publications. Since 1975 all book reviews listed in separate section at end of each vol. In 1977 began subheading "Influence." See Example 7.

 Art Index Database, WILSONLINE, files from October 1984; updates twice a week. Available on CD-ROM.

16:2 *ARTbibliographies MODERN.* Santa Barbara, CA: American Bibliographical Center-Clio Press. Vol. 1(1969)+
 Semi-annual publication provides abstracts or brief annotations for references from some 330 serials, of which about 63% are in English, 9% in French, and 11% in German. Screens more than 500 serials, books, and dissertations for pertinent material. Indices to authors and to museums and galleries. Covers about 385 art museums and galleries in Europe and North America; each issue reports around 400 exhibition catalogues. All titles of books, articles, and catalogues are listed in their original language with English translation added. Separate entires are provided for relevant essays in *Festschriften.* First three volumes, 1969–1971, published annually under title, *LOMA: Literature of Modern Art.* Prior to 1989, indexed wide range of material covering art of the 19th and 20th centuries with inclusion of architecture only from historical aspect. Starting in 1989, subject coverage begins with the 20th century or 1900, although artists and movements of late 19th century influencing or important to the 20th century are included. Architecture has been dropped; photography has no cut off date. Concentration is now on all aspects of art, design, and photography. These changes make a database search even more advantageous, since researchers do not have to remember specific coverage of particular years. For efficient searches, use the cumulative indices and the database. See Example 9.

 Artbibliographies MODERN Five-Year Index: 1969–1974, 1975. Cumulative index published every 5 years.

 ARTbibliographies MODERN Database, DIALOG, File 56, data from 1974; updates semi-annually.

16:3 *BHA: Bibliographie d'Histoire de l'Art/Bibliography of the History of Art.* Williamstown, MA: Sterling and Francine Clark Art Institute. First issue to be published mid 1990. This quarterly with annual cumulation is the merger of the two abstracting references—*RILA* [16:7] and *Répertoire d'art et d'archéologie* [16:6]. Although the indices and subheadings will be printed in both languages, the abstracts will be in the language of the person who writes the entry. Upwards to 4,000 serials will be covered; the publication, which will follow the scope

and format of *RILA,* will have about twice the citations of *RILA.* Excluded are prehistoric, ancient, Far Eastern, Indian, Islamic, African, Oceanic, and ancient and native American art. Media of all types will be included; in addition to the Fine Arts (architecture, sculpture, painting, drawing, and prints) there will be coverage for all contemporary media (such as performance and video art), photography, popular art, folk art, industrial art and design, and all objects of material culture. About 4,000 serials will be perused as well as many museum publications. Thus if contemporary fashion or industrial technology were the subjects of museum exhibitions, they would be included in *BHA.*

Database: Will be available on DIALOG; title uncertain.

16:4 *Design and Applied Arts Index.* Gurnleys, Burnwash, Etchingham, East Sussex: Design Documentation, 1987+
Issued semiannually.

16:5 *Design International: An Information and Bibliographic Data Base.* Haslemere, Surrey: Emmett Publishing, 1984+ Microfiche.
Covers 26 design fields including ceramics, fashion, furniture, interior design, jewelry, metalwork, film, textiles, packaging, wallpaper, lighting, and typography and printing. Indexes international material on post-1850 subjects. Both current and retrospective bibliographic data.

16:6 *Répertoire d'art et d'archéologie.* Under direction of Comite Français d'Historie de l'Art. Paris: Centre de Documentation Sciences Humaines. Vol. 1(1910)+
Published since 1910; covers about 420 serials in each issue, although it scans more than 1,750 annually. Includes exhibition catalogues and *Festschriften.* Covering a period from about 200 A.D. to the present, excludes Islamic, Far Eastern, and primitive art as well as post-1940 works of art and artists born after 1920. This international publication, which includes brief abstracts, has a high percent of Western and Eastern European art serials. Approximately 21% of the serials covered are published in English, 22% in French, and 26% in German. No annual cumulations, but has cumulated index to serials, artists, subjects, and authors. This publication will cease with Volume 25(1989) when it is merged with *RILA* to form *BHA;* see 16:3.

Répertoire includes (a) *"Liste des revues depouillees"* (magazines covered in that issue); (b) *"Liste des recueils collectifs"* (index to individual essays and articles in *Festscriften* and reports of congresses); (c) *"Index"* subdivided into "artistes" and "Matières" (Subjects), and "Liste des codes de pays utilisés dans l'index des matières" (list of abbreviations used); and (d) *"Table des auteurs"* (index to authors). Exhibition catalogues are reported under *"Index des matières,"* which is subdivided into *"Expositions"* and *"Salon."*

Originally difficult to use and not readily accessible in most libraries, the format was changed in 1973, thus increasing the usefulness of this French art index. Titles are cited in the languages in which the articles are written, except those from Scandinavia and Eastern European countries where a French translation is added. This is the only indexing service that has covered art serials since 1910; the pre-1973 issues are still important for older material. For details on how to use them, see Alexander Ross's "The New *Répertoire d'art et d'archéologie,"* *ARLIS/NA Newsletter* 2(Summer 1974): 57–61. See Example 10.

Repertory of Art and Archeology: Paleochristian Period to 1939, QUESTEL, File 530 of *Francis-H Database,* data from 1973; updates 8 times a year.

16:7 *RILA: International Repertory of the Literature of Art, A Bibliographic Service of The J. Paul Getty Trust.* Williamstown, MA: Sterling and Francine Clark Art Institute. *Demonstration Issue,* 1973; Vol. 1(1975)+
Semi-annual publication abstracting articles from core of about 400 journals; includes books, museum and exhibition catalogues, *Festschriften,* congress reports, and dissertations. Covers art from Late Antiquity of the 4th century to present. About 48% of the serials are written in English, 9% in French, and 11% in German. Consists of (1) journal index; (2) abstracts divided into 7 principal categories, such as Medieval Art and Modern Art (1945 to present); (3) "Exhibition List" provides cross references to main entries in abstract section. (4) author index in which asterisk denotes review of author's book and numbers refer to main entries in abstract section; (5) subject index which includes individual artists, places, and terms; and (6) list of *RILA* abbreviations. Arrangement of abstracts into broad categories— subdivided into such sections as architecture, sculpture, pictorial arts, decorative arts, as well as artists, architects, and photographers—allows researchers to browse for material within their own interests. Most

of the principal categories for the abstracts are for periods and styles of Western art.

Contains listings under "General Works: Collected Works to *Festschriften*" and conference and colloquium reports. Since 1975, *Festschriften* are listed under person honored. Table of Contents are reported with title and author of each entry provided; numbers in parentheses refer to the article's abstract. Reviews of *Festschriften* are recorded. Includes as many as 1,200 exhibition catalogues a year. Book reviews are listed following the main entry for the book in the subject index of *RILA*. Quickest way to find material is to use the cumulative indices or a database search. See Example 8.

About 1990, the merger of *RILA* and *Répertoire d'Art et d'Archéologie* will be complete. *RILA* will cease publication with Volume 15(1989). The new publication, called *BHA: Bibliographie d'Histoire de l'Art/Bibliography for the History of Art,* [16:3], will be issued quarterly with an annual cumulative index.

RILA Cumulative Subject Index. Since the volume covering 1975–1979 was issued in 1980, a cumulative index has been published for 1980–1984. There will also be one for the final volumes, 1985–1989.

Art Literature International (RILA) Database, DIALOG, File 191, data from 1973; updates semi-annually. The merged publications of *RILA* and *Répertoire d'art et d'archéologie* will have a database available on DIALOG; the database name may be changed.

Dissertation and Thesis Indices

Dissertations can often be obtained through Dissertation Abstracts [16:9]. Moreover some are published by UMI Press and Garland Press. The latter issues several series: *Outstanding Dissertations in the Fine Arts, Outstanding Theses in the Fine Arts from British Universities,* and *Outstanding Theses from the Courtauld Institute of Art.* Read Chapter 5 for details on these references. *RILA* [16:7] and *ARTbibliographies MODERN* [16:2] also access dissertations.

16:8 "Dissertations and Theses on the Visual Arts," by William Innes Homer, published in *Arts in America: A Bibliography,* ed. by Bernard Karpel [13:44].
Lists 1,361 titles concerned with American art. List kept current at the Archives of American Art; see Chapter 13.

16:9 *Dissertation Abstracts International: Abstracts of Dissertations Available on Microfilm or as Xerographic Reproductions.* Ann Arbor, Michigan: University Microfilms. Vol. 1(1938)+
Issued monthly with cumulative author index for each section; receives abstracts from 285 universities. Entitled *Dissertation Abstracts* until Vol. 30(1970) at which time it began to include dissertations from European universities. With Vol. 27(1966–67), was divided into (A) Humanities and (B) Sciences. About 6 principal words—used in titles of dissertations and also used to describe subject matter of dissertations—are chosen as keywords to be used in indexing. Most words are nouns, verbs, or adjectives that introduce important concepts. Each keyword lists all dissertations having that word in their titles. Entries cite titles, authors, dates degrees granted, schools conferring degrees, abstracts of dissertations, and order numbers if copies available. Dissertations without order numbers are usually available at the universities granting the degrees.

Comprehensive Dissertation Index, 1861–1972, 1973. 37 vols. *Comprehensive Dissertation Index Supplement.* Annual Index to more than 417,000 dissertations listed in *Dissertation Abstracts International, American Doctoral Dissertations,* and the catalogues of Library of Congress. Vol. 17 covers social sciences; Vol. 20–24, education; Vol. 28, history; Vol. 31, communications and the arts; and Vols. 33–37, authors index.

Dissertation Abstracts Online Database, DIALOG, File 35 and BRS, File DISS, covers from 1861 to present; updated monthly. Includes information from *Dissertation Abstracts International, American Doctoral Dissertations, Comprehensive Dissertation Index,* and *Masters Abstracts.* In 1988 began including British dissertations. Available on CD-ROM.

Festschriften Indices

Read Chapter 5 for information on these resources. See Julia J. Bewsey's "Festschriften Bibliographies and Indexes," *Bulletin of Bibliography,* 42(1985): 193-202. *RILA* [16:7] and *Répertoire d'art et d'archéologie* [16:6] access *Festschriften.*

16:10 Leistner, Otto. *International Bibliography of Festschriften.* Osnabruck, Germany: Biblio Verlag, 1976.

Arranged by name of person or institution honored and by subjects. Does not list individual authors and titles of essays. Appendices contain used terms with both German and English translations and general abbreviations.

16:11 Lincoln, Betty Woelk. *Festschriften in Art History, 1960–1975: Bibliography and Index.* New York: Garland, 1988.
Indexes 4,676 essays in 344 *Festschriften.* Under "Bibliography," has listing of *Festschriften* indexed under name of honoree providing table of contents with authors and essay titles. Indices to subjects, authors, and honorees. Good sources for works issued prior to publication of *RILA* [16:7].

16:12 New York Public Library. *Guide to Festschriften.* Boston: G. K. Hall, 1977.
Vol. 1: The Retrospective "Festschriften" Collection of the New York Public Library: Material Cataloged Through 1971, more than 6,000 *Festschriften.* Entries under editor, institution, and title. Honored persons not listed. *Vol.2: A Dictionary Catalog of "Festschriften" in the New York Public Library (1972–1976) and the Library of Congress (1968–1976),* has entries to titles and honoree.

16:13 Rave, Paul Ortwin. *Kunstgeschichte in Festschriften.* Berlin: Verlag Gebr. Mann, 1962.
"Verzeichnis der Festschriften," main entries under honored person; "Aufgliederung der beiträge nach sachgebieten," listing of articles by subjects subdivided by country; and "Register festschriftensachtitel Verfasser der beiträge Künstler- und andere personennamen länder und orte," authors of essays.

Humanities/Social Studies Indices

These resources frequently include art subjects as well as information on the various influences on art.

16:14 *Academic Index Database.* Foster City, CA: Information Access Company. DIALOG, File 88; BRS file ACAD. Called *InfoTrac* in CD-ROM format.
Accesses more than 400 serials over a wide spectrum of disciplines. Includes *Architectural Record, Art Bulletin, Art in America, Art Journal, Art News, Artforum, Arts Magazine, Advertising Age, Current Biography, Time, Newsweek, The New York Times Magazine,* and *The New York Times Book Review.* Most files date from 1985 or 1987. Online files updated monthly.

16:15 *America: History and Life.* Santa Barbara, CA: ABC-Clio. Vol. 1(1964)+
Abstracts articles from over 2,000 serials plus monographs and U.S. and Canadian dissertations. Originally part of *Historical Abstracts* [16:17]. Covers U.S. and Canada.

America: History and Life Database, DIALOG, File 38, covers from 1964; updated three times a year.

16:16 *British Humanities Index.* London: Library Association. Vol. 1(1962)+
Quarterly with annual cumulations. Superseded *The Subject Index to Periodicals* [16:35], published 1915–61, with exception of 1923–25. Indexes about 360 English serials including the *London Times Literary Supplement.*

16:17 *Historical Abstracts.* Santa Barbara, CA: ABC-Clio. Vol. 1(1955)–Vol. 16(1970). *Part A: Modern History Abstracts (1450–1914)* Vol. 17(1971)+ *Part B: Twentieth-Century Abstracts (1914 to the Present)* Vol. 17(1971)+
Covers about 2,000 serials from 90 countries in 30 languages. Quarterly with 4th volume being cumulative index; since 1969, excludes material on U.S. and Canada. See *America: History and Life* [16:15]. Five-year cumulative indices are available.

Historical Abstracts Database, DIALOG, File 39, files from 1973; updated quarterly. Covers both Parts A & B or material dating from 1450 to the present.

16:18 *Humanities Index.* New York: H. W. Wilson. Volume 28 (April 1974-March 1975)+
Quarterly with annual cumulation. Author-subject index to about 300 serials; includes archaeology, drama, film, history, literature, and philosophy. Previously titled *International Index* [16:19].

Humanities Index Database, WILSONLINE, covers from May 1984; updated twice a week. Available on CD-ROM.

16:19 *International Index: A Guide to Periodical Literature in the Social Sciences and Humanities.* New York: H. W. Wilson. Vol. 1(1907–1915) to Vol. 18(April, 1964–March, 1965).
Covers serials in such fields as anthropology, history, economics, literature, and sociology. In 1965, name changed to *Social Sciences and Humanities Index* Vol. 19(1965–1966) to Vol. 27(April, 1973–March, 1974). With Volume 28, divided into *Social Sciences Index* [16:25] and *The Humanities Index* [16:18].

16:20 *Internationale Bibliographie der Zeitschriftenliteratur aus allen Gebieten des Wissens (IBZ)*. Osnabruck, West Germany: Felix Dietrich Verlag, 1896 +

International in scope, semiannual index to about 7,000 serials, few of which are written in English. Difficult to use, *IBZ* is useful for finding data on German subjects. For how to use this index, see Patrick C. Boyden's "Metamorphosis of the *IBZ* Bibliographic Index," *RSR* 15(Spring 1987): 81–85.

16:21 *Magazine Index Database,* Foster City, CA: Information Access. DIALOG, File 47 and BRS, File MAGS

About 480 popular magazines, including those indexed by *Reader's Guide to Periodical Literature* [16:23]. Some files include material from 1959 to 1970 and from 1973 to the present. Those dating since 1977 are more inclusive. Indexes 14 art, architecture, and crafts serials plus 7 film and photography publications. Includes *Current Biography, New York Times Book Review, Time,* and *Newsweek.* Updated monthly.

16:22 *MLA International Bibliography of Books and Articles on the Modern Languages and Literature.* New York: Modern Language Association. Vol. 1(1919) +

About 3,000 serials. Includes data on recently published books and *Festschriften.* From 1919–35, called *American Bibliography.*

MLA Bibliography Database, DIALOG, File 71, covers from 1970, updated annually.

16:23 *Reader's Guide to Periodical Literature: An Author and Subject Index.* New York: H. W. Wilson. Vol. 1(1900–1904) +

Author-subject index to over 180 serials; now published semi-monthly—September to January and March to June, monthly—February, July, and August. Annual cumulation. Cinema reviews under "MOTION picture reviews." Covers wide variety of magazines, such as *American Artists, Atlantic, Ceramics Monthly, Craft Horizons, Film Quarterly, National Geographic, New Yorker, Newsweek,* and *Time.*

Readers' Guide Database, WILSONLINE, files from 1983; updates twice a week. Available on CD-ROM.

16:24 *Religion Index Database,* DIALOG, File 190. Files date from 1975; Covers more than 200 journals plus 300 multiple authors' works. Updates monthly.

16:25 *Social Sciences Index.* New York: H. W. Wilson. Volume 28 (April, 1974–March, 1975) +

Quarterly with annual cumulation. Author-subject index to about 300 serials; includes anthropology, geography, psychology, and sociology. Originally titled *International Index* [16:19].

Social Sciences Index Database. WILSONLINE, covers from April 1983, updates twice a week. Available on CD-ROM.

Indices for Serials Published Prior to 1970s

This section is divided into art indices and humanities/social studies indices. For 19th-century American serials and index, see 13:72.

Art Indices

Art Index [16:1] began indexing with 1929 material; *Répertoire d'art et d'archéologie* [16:6] has been published since 1910.

16:26 *The Concordia University Art Index to Nineteenth-Century Canadian Periodicals.* Hardy George, ed. Montreal: Concordia University, 1981.

Covers 26 journals published from 1830 to 1900.

16:27 *The Courtauld Institute of Art Periodicals Subject Index.* Bath, England: Mindata, 1989. Microfiche.

Author-subject index to about 200 serials issued 1930 to 1983. Includes fine arts, architecture, and the decorative arts. Separate author index.

16:28 *The Frick Art Reference Library Original Index to Periodicals.* Boston: G. K. Hall, 1983. 12 vols.

Compiled between 1923 and 1969; author-subject index to 27 serials, mostly from the first issue. Emphasis on Western European and American painting, drawing, and sculpture and some decorative arts from 11th century to 1860. Includes *Art Bulletin,* 1913–59; *L'Arte,* 1899–1952; *Burlington Magazine,* 1903–59; *Bollettino d'arte,* 1907–60; *Gazette des Beaux-Arts,* 1859–1959; *Old Master Drawings,* 1926–40.

16:29 *Index to Art Periodicals Compiled in Ryerson Library, The Art Institute of Chicago.* Boston: G. K. Hall, 1962. 11 vols. *First Supplement,* 1974. One vol.

Begun in 1907, includes subject entries with particular emphasis on 19th- and 20th-century painting, decorative art, Oriental art, and Chicago architecture. Indexes about 350 serials. *Scrapbook* indicates articles preserved from Chicago newspapers; photocopies can be obtained through interlibrary loans.

Humanities/Social Studies Indices

Most of these indices are difficult to use, because of the broad subject headings. But the indexed articles often provide insight into the thoughts and tastes of the 19th century.

16:30 *Annual Magazine Subject Index*. Boston: Boston Book, 1907–1918 and Boston: F. W. Faxon, 1919–1948; reprint ed., divided into two sections, both published Boston: G. K. Hall. *Cumulated Magazine Subject Index, 1907–1949: A Cumulation of the F. W. Faxon Company's Annual Magazine Subject Index*, 1964. 2 vols. *Cumulated Dramatic Index, 1909–1949: A Cumulation of The F. W. Faxon Company's Dramatic Index*, 1965. 2 vols.
Annual index covering articles in 140 to 160 English and American serials. Specialized in history, art, geography, and travel. First issue, called *Magazine Subject-Index*, covered 79 serials.

16:31 *Cumulative Author Index for Poole's Index to Periodical Literature 1802–1906*. C. Edward Wall, ed. Ann Arbor, MI: Pierian, 1971.
Index to authors whose works are included in Poole's 6 subject indices; see *Poole's Index to Periodical Literature* [16:33].

16:32 *Nineteenth-Century Reader's Guide to Periodical Literature 1890–1899, With Supplementary Indexing 1900–1922*. Helen Grant Cushing and Adah V. Morris, eds. New York: H. W. Wilson, 1944. 2 vols.
Author-subject index to 51 serials published in 1890s; 14 are indexed beyond 1890–99.

16:33 *Poole's Index to Periodical Literature*. William Frederick Poole and William I. Fletcher, compilers. 3rd ed. Boston: J. R. Osgood, 1882; reprint ed., Gloucester, MA: Peter Smith, 1957. One vol. plus 5 supplements.
About 250 serials from 1802 to 1881. Supplements index material: 1882–1887, 1887–1892, 1892–1896, 1897–1902, and 1902–1906. Titles of articles not recorded. Use *Transfer Vectors for Poole's Index to Periodical Literature* compiled by Vinton A.

Dearing (Los Angeles: Pison Press, 1967.) Use with *Cumulative Author Index* [16:31].

16:34 *Wellesley Index to Victorian Periodicals 1824–1900*. Walter E. Houghton, ed. Toronto: University of Toronto Press, 1966–79. 3 vols.
No general index. Since volumes include from 8 to 15 different English 19th-century magazines, each volume must be searched. Organized under magazine title, provides brief history of serial followed by table of contents for each issue. "Bibliographies of Contributors" lists authors who had articles in the serials covered by that volume. Corrections and additions to all volumes found in Vol. 3.

16:35 *The Subject Index to Periodicals*. London: Library Association, 1915–1961.
Published from 1915 to 1961, except for 1923 to 1925. Originally an annual; issued quarterly from 1954 to 1961 when it was superseded by *The British Humanities Index* [16:16]. Divided into subject index and author index; covers over 285 English periodicals.

Anthropological Indices

16:36 *Abstracts in Anthropology*. Westport, CT: Geenwood Press, 1970+
Quarterly.

16:37 *Anthropological Index to Current Periodicals in the Museum of Mankind Library*. London: Royal Anthropological Institute, 1963+ Also on microfilm.
Organized by continents including Europe and North America. Where appropriate, cites general references, physical anthropology, archaeology, cultural anthropology, ethnography, and linguistics. Bibliographies, biographical notes and obituaries of authors and researchers are placed in the general category. List of new serials indexed, serial title changes, and publications which have ceased. In 1983 became a quarterly; also incorporates the former Royal Anthropological Institute Library holdings.

16:38 *Anthropological Literature: An Index to Periodical Articles and Essays*. Pleasantville, NY: Redgrave, 1979–83. 5 vols.
Compiled by the Tozzer Library, formerly called the Peabody Museum of Archaeology and Ethology, Harvard University. For holdings of library, see *Bibliographic Guide to Anthropology* [17:16].

16:39 *Bulletin signalétique 529: Ethnologie.* Centre National de la Recherche. Scientifique. Paris: Centre de Documentation Sciences Humaines. Vol. 1(1986)+

Covers Africa and Central America as well as the American Indian.

16:40 *Ethnoarts Index.* Seattle, WA: Data Arts, 1987+

Coverage of Africa, the Pacific, Latin America, and the American Indian. Titled *Tribal Art Review,* 1984–86.

Book-Review Sources

Most of the abstracts and indices listed in this chapter also include book reviews; be sure to consult them. Remember to check more that one index, since they each cover different serials.

16:41 *Book Review Digest.* New York: H. W. Wilson. Volume I (1905)+

Issued monthly, except February and July, plus annual cumulation. Abstracted material is indexed by book's author. Each reviewed book must have been published or distributed in U.S. or Canada; non-fiction reviews printed within 18 months following book's issue, and book must have had at least two reviews in more than 80 indexed magazines. Contains subject and title index.

Book Review Digest: Author/Title Index, 1905–1974, 1976. 4 vols. and *1975–1984,* 1986.

Book Review Digest Database, WILSONLINE, files from July 1984, updates twice a week.

16:42 *Book Review Index.* Detroit: Gale Research. Vol. 1(1965)+

Bimonthly with 3 cumulations; covers about 460 serials.

Book Review Index Database, DIALOG, File 137, files from 1969; updates three times a year.

16:43 *British Book News.* London: British Council. Vol. 1(1940)+

Provides about 240 book reviews in each monthly publication; covers only books published in the U.K. Annual index to titles, subjects, and authors.

16:44 *Combined Retrospective Index to Book Reviews in Humanities Journals, 1802–1974.* Woodbridge, CT: Research Publications, 1982. 10 vols.

Citations for 500,000 reviews in 150 serials.

16:45 *Combined Retrospective Index to Book Reviews in Scholarly Journals, 1886–1974.* Arlington, VA: Carrollton, 1979. 15 vols.

16:46 *Index to Book Reviews in the Humanities.* Williamston, MI: Phillip Thomson. Vol. 1(1960)+

Published annually. Scans over 700 serials; includes about 435 each year, one of which is London *Times Literary Supplement.*

16:47 *National Library Service Cumulative Book Review Index 1905–1974.* Princeton, NJ: National Library Service, 1975. 6 vols.

Indexes all reviews from *Book Review Digest* [16:41] 1905–74, *Library Journal* 1907–74, *Saturday Review* 1924–74, and *Choice* 1964–74.

16:48 *New York Times Book-Review Index, 1896–1970.* Wingate Froscker, ed. New York: New York Times, 1973. 5 vols.

Almost 800,000 entries in 5 vols. See *The Times Thesaurus of Descriptors* [16:56].

Newspaper Indices

Since 1970s, selective newspaper indexing has been available through various databases, many of which provide full-text service. This section is divided into (1) indices of selected newspapers and (2) indices for individual newspapers. This is an expanding market; newspapers are added continuously. Ask the reference librarian for the latest information. Also see the *Canadian Business and Current Affairs Database* [13:103]. Many large newspapers, remember, are published on microfilm.

Indexing of Selected Newspapers

16:49 *DataTimes Database.* Oklahoma City: DataTimes.

Covers numerous international newspapers which can be searched individually or as a group. Includes local papers in such states as Arizona, Arkansas, California, Florida, Georgia, Illinois, Kentucky, Louisiana, Minnesota, New Jersey, Oklahoma, Pennsylvania, Texas, and Washington. Provides access to about 15 Canadian papers, *The Times* and *The Sunday Times* of London, *The Daily Telegraph,* and even a newspaper in Australia. Although a few files date from 1979, the majority date from about 1985. Full-text service available.

16:50 NEXIS Service. Dayton, OH: MeadData Central.

Covers more than 100 international and national news, trade, and professional publications: *Boston Globe* (since 1988), *Chicago Tribune* (1988), *Los Angeles Times* (1985), *New York Times* (1980), *Washington Post* (1977) plus such magazines as *Newsweek* (1975), *Time* (1981), and *U.S. News & World Report* (1975). The trade journals include *Advertising Age* (1986), *ADWEEK* (1984), and *Women's Wear Daily* (1983). Covers the English newspapers *Daily Telegraph/Sunday Telegraph* and *Manchester Guardian Weekly.* Individual files can be searched separately. Full-text files; updated daily.

16:51 *National Newspaper Index Database,* DIALOG, File 111 and BRS, File NOOZ, updates monthly.

Since January, 1979 indexes the *New York Times, Wall Street Journal,* and *Christian Science Monitor.* In 1982 began indexing *Washington Post* and *Los Angeles Times.* Supplemented by *Newsearch Database* [16:53].

16:52 *Newspaper Abstracts Database,* DIALOG, File 603, files from 1984, updates weekly.

Comprehensive indexing for 19 major regional, national, and international newspapers. Includes papers from Atlanta, Boston, Chicago, Denver, Detroit, Houston, Los Angeles, New Orleans, New York, St. Louis, San Francisco, and Washington, D.C. as well as London and Moscow. Also covers the *Wall Street Journal.*

16:53 *Newsearch Database,* DIALOG, File 211 and BRS, File DALY, files for current month only, updates daily.

Covers 2,000 newspapers, magazines, and periodicals. At end of month, files transferred to other databases, such as *Magazine Index* [16:21], *National Newspaper Index* [16:51], and *Trade and Industry Index* [16:54].

16:54 *Trade & Industry Index Database,* DIALOG, File 148, data from 1981, updates monthly.

Selective coverage of newspapers covered by *National Newspaper Index Database* [16:51] plus more than 300 trade publications and 1,200 others. Includes advertising, apparel-fashions, marketing, construction, and interior design periodicals. Indexes *Advertising Age* and *Women's Wear Daily* (full-text). More than 85 of the journals have full-text service.

Individual Newspaper Indices

More and more individual newspapers are available through online databases, see DataTimes [16:49] and NEXIS [16:50].

16:55 *Chicago Tribune,* DIALOG, File 632.
Coverage since January 1988; updates daily. Full-text service.

16:56 *The New York Times* published since 1851.

New York Times Index. New York: New York Times. Vol. 1 (September, 1851–1862) to Vol. 15(1912); new series not listed as vol. numbers. First issue (1913)+

Sunday sections of newspaper are identified by Roman numerals following date. No cumulative index for entire paper, but for film reviews [26:59], book reviews [16:48], and obituary notices, see below. Indexed in *Nexis Service Database* [16:50], *National Newspaper Index Database* [16:51], *Newsearch Database* [16:53], and *Newspaper Abstracts Database* [16:52].

New York Times Obituaries Index New York: New York Times. *Vol. 1: 1858–1968,* 1970. *Vol. 2: 1969–78,* 1980. Each entry cites year person died plus date, page, and column of obituary.

The New York Times Thesaurus of Descriptors: A Guide for Organizing, Cataloguing, Indexing, and Searching Collections of Information on Current Events. 2nd ed. New York: New York Times, 1968.

16:57 *The Times* (London) published since 1790.

Index of the Times. Reading, England: Newspaper Archive Departments. First issue (1906)+

Originally published annually, now every two months. No cumulative index; includes *The Times, The Sunday Times, The Sunday Times Magazine, The Times Literary Supplement, The Times Educational Supplement,* including Scottish edition, and *The Times Higher Education Supplement.* For indexing of articles in earlier editions use *Palmer's Index to The Times, Newspaper (London),* published quarterly from 1790–95, to 1940–41 and reprinted by Kraus Reprint, 1965–66. Indexed by *DataTimes* [16:49] *Obituaries From The Times 1961–1970.* Reading England: Newspaper Archive Developments, 1975. Reprints of the full obituary of 1,500 personalities; 61% are British.

16:58 *The Washington Post Online,* DIALOG, File 146.
Coverage since April 1983; updated daily. Electronic version of the newspaper.

Citation Index

16:59 *Arts & Humanities Citation Index*. Philadelphia: Institute for Scientific Information. Volume 1(1979)+

 Multivolume work covers 1,300 arts and humanities journals plus relevant material from 5,000 other serials. Citations alphabetized under names of authors or artists.

Indexes books and serials that have cited a person's work; specific titles for works of art are listed.

Arts & Humanities Search Database, DIALOG, File 439 and BRS, File AHCI, covers from 1980; updates every 2 weeks.

Bibliographies for Art Research

Bibliographies, which provide a list of books and articles relating to a specific subject, range from mere lists to highly selective annotated compendiums providing detailed data on references. The latter are appended to most scholarly references. Students must learn to examine bibliographies, not only the ones cited in this chapter, but those in the books they examine. Bibliographies are essential for successful research. This chapter is divided into (1) bibliographies for general art material, (2) published catalogues of library holdings, and (3) a methodological approach for completing bibliographical data. Chapter 5 discusses these resources. Most bibliographies have an LC classification of Z and are usually shelved in a special reference section of the library.

Guides to General Art Reference Material

Specialized bibliographies are cited in the appropriate chapters of this book. For current information, regularly peruse the reviews in *Art Documentation* and the section "Bibliographies" in *Art Libraries Journal*. See also Freitag's *Art Books: A Basic Bibliography of Monographs on Artists* [10:72].

17:1 Arntzen, Etta and Robert Rainwater. *Guide to the Literature of Art History.* Chicago: American Library Association, 1980.
Known simply as *Arntzen & Rainwater,* this scholarly work is divided into large categories: (1) general reference sources, subdivided into bibliography, directories, sales records, visual resources, dictionaries and encyclopedias, and iconography; (2) general primary and secondary sources—historiography and methodology, sources and documents, plus histories and handbooks; (3) particular arts—architecture, sculpture, drawings, paintings, prints, photography, plus decorative and applied arts; and (4) serials—periodicals and books in series. Under "Series" provides a selective list of scholarly works on a wide-range of subjects, such as the A.W. Mellon Lectures in

the Fine Arts, Princeton Monographs in Art and Archaeology, and the Wrightsman Lectures; records only samples of individual titles. Indices to authors-titles and subjects. More than 4,000 entries, most published prior to 1977. Continues Chamberlin's work [17:4] and updates about 40% of works cited by Chamberlin.

17:2 *Art Books.* New York: R. R. Bowker.
.1 *1876–1949: Including an International Index of Current Serial Publications,* 1981.
.2 *1950–1979: Including an International Directory of Museum Permanent Collection Catalogs,* 1980.
.3 *1980–1984 Including an International Directory of Museum Permanent Collection Catalogs,* 1985.
Contains indices to subjects, authors, titles, and books in print. Lists permanent museum collection catalogues arranged under institution's name.

17:3 *Bibliographic Index: A Cumulative Bibliography of Bibliographies.* Marga Franck and Ann Massie Case, editors, New York: H.W. Wilson, Volume 1 (1937–1942)+
Quarterly with cumulative volume; subject index to special bibliographies published in books, pamphlets, and about 2,600 serials. From 1960–1962 to 1966–1968, volumes were issued every two years; in 1969, became annual.

Bibliographic Index Database, WILSONLINE, files from November 1984.

17:4 Chamberlin, Mary W. *Guide to Art Reference Books.* Chicago: American Library Association, 1959.
First major English-language art bibliography. Includes 2,565 annotated entries; cites many foreign-language works. Especially good for older materials and for following changes in serial titles. Updated by *Arntzen & Rainwater* [17:1].

17:5 Ehresmann, Donald L. *Fine Arts: A Bibliographic Guide to Basic Reference Works, Histories, and Handbooks.* 3rd ed. Littleton, CO: Libraries Unlimited, 1989.
Annotates about 2,000 works; excludes dissertations and exhibition catalogues. Extensive list of topography handbooks.

17:6 *G.K. Hall Art Bibliographies Series.* Boston: G. K. Hall.

 .1 *Erotic Art: An Annotated Bibliography with Essays,* Eugene C. Burt, 1989. Individual annotated bibliographies are planned for various artistic styles and periods, such as Medieval Art & Architecture, Art of Northern Europe, Northern Baroque and Rococo. Titles are listed under the appropriate chapters in this guide, except for the general work cited here.

17:7 Muehsam, Gerd. *Guide to Basic Information Sources in the Visual Arts.* Santa Barbara, CA: Jeffrey Norton Publishers/ABC Clio, 1978. Useful for discussion of styles and media.

17:8 Rare Book Dealer Catalogues. Book Dealer Catalogues are the listings for out-of-print and rare books that firms compile on limited subjects. Because these can be valuable bibliographies, some libraries keep them on file. Ars Libri, which sells a wide range of art books, has catalogues on such subjects as *Art History Festschriften, German Art Before 1800, Iconography,* and *Renaissance and Baroque Monographs on Artists.* Charles B. Wood III's catalogues—covering architecture, photography, and the illustrated book—include extensive annotations providing brief histories of the publications.

17:9 Schlosser, Julius Magnino von. *La letteratura artistica: manuale delle fonti della storia dell'arte moderna.* Trans. by Filippo Rossi. 3rd ed. Florence: La nuova Italia, 1964. Originally published as *Die Kunstliteratur* (Vienna, 1924). First Italian ed. was in 1935; 2nd ed. was reprint with additional bibliography by Otto Kurz; 3rd ed. brings the bibliography up through 1963. Covers from late antiquity through the early 19th century with emphasis on the Renaissance. Noted for inclusion of primary source material.

17:10 Sheehy, Eugene P., ed. *Guide to Reference Books.* 10th ed. Chicago: American Library Association, 1986. Good source for finding resources in any field. Bibliographies organized by general references, humanities, social and behavioral sciences, history and area studies, and science, technology, and medicine. Cites references basic to general and scholarly research.

Published Library Catalogues

Published catalogues of libraries consist of reproductions of cards in the catalogue files of those institutions. Some libraries now include their records in bibliographical databases, in which case there will be no additional hardbound supplements. This does not diminish the usefulness of the earlier catalogues, since they will continue to be needed for in-depth research and older resources. This section is divided into (1) general art libraries (2) anthropological libraries, and (3) national libraries. Specialized catalogues—such as MoMA's [12:96] and the Library of the National Gallery of Canada [13:94]—are listed under the art period or geographical area on which they concentrate.

General Art Libraries

17:11 *Catalogue of the Harvard University Fine Arts Library, the Fogg Art Museum.* Boston: G. K. Hall, 1971. 15 vols. *Catalogue of Auction Sales Catalogues,* 1971. One vol. *First Supplement,* 1975. 3 vols. Author-subject catalogue of one of world's largest university art libraries. Excellent listings of literature on Romanesque sculpture, Italian primitives, Dutch 17th-century art, and master drawings. For sales catalogues, see 18:45.

17:12 *Library Catalog of the Metropolitan Museum of Art.* 2nd ed. Boston: G. K. Hall, 1980. 48 vols. *First Supplement,* 1982. One vol. *Second Supplement,* 1985. 4 vols. *Third Supplement, 1983–1986,* 1987. One vol. Author-subject catalogue of one of world's major art museum libraries. Covers entire history of art; special emphases on the Near and Far East, classical period, European and American art, and Pre-Columbian period. Also available on microform. Sales catalogues—listed under subjects, names of collectors, and auction houses—are no longer included after 1982; they are now added to *SCIPIO Database* [18:48].

17:13 New York Public Library. *Dictionary Catalog of the Art and Architecture Division.* Boston: G. K. Hall, 1975. 30 vols. Annual supplements published under title *Bibliographic Guide to Art and Architecture,* 1975+ Author-subject catalogue of one of world's largest research collections in fine and applied arts.

17:14 Victoria & Albert Museum. *National Art Library Catalogue: Author Catalogue.* Boston: G. K. Hall, 1972. 10 vols. *Catalogue of Exhibition Catalogues,* 1972. One vol.

Specializes in works on design and applied and fine arts; 10th volume records works published before 1890. Lists over 50,000 exibition catalogues from past 150 years. Access is by author; lack of subject indexing limits its usefulness; see 17:15.

17:15 *The Victoria and Albert Museum Library: Subject Catalogue.* London: Mindata. Microfiche.

More than 1.5 million entries; index to artists and broad subject categories, such as Archeology, Bronzes, and Sculpture. Includes pertinent serials and exhibition catalogues.

Anthropological Libraries

17:16 Harvard University. Tozzer Library. *Author and Subject Catalogues of the Tozzer Library formerly the Library of the Peabody Museum of Archaeology and Ethnology, Harvard University.* 2nd ed. enlarged. Boston: G.K. Hall, 1988. Microfiche.

Covers prehistoric archaeology, cultural anthropology, and the practice of historical and industrial archaeology. Latin American references are one of its many strengths. Contains books, serials, pamphlets, microforms, maps, and films. This is the 2nd edition of *Author and Subject Catalogues of the Library of the Peabody Museum of Archaeology and Ethnology,* 1963, which had four supplements. Use with *Index to Anthropological Subject Headings.* 2nd ed. rev. Boston: G.K. Hall, 1981. Updated by *Bibliographic Guide to Anthropology,* 1988+

17:17 Smithsonian Institution. National Museum of Natural History. National Anthropological Archives. Washington, D.C. *Catalog of Manuscripts at the National Anthropological Archives.* Boston: G.K. Hall, 1975. 4 vols.

National Libraries

Many national libraries publish catalogues of their holdings. Four are included here: The British Library, London; the Bibliothèque Nationale, Paris; the National Library of Canada, Ottawa; and the Library of Congress, Washington, D.C. Only a representative group of their publications has been cited. These catalogues can be used to complete bibliographical data and discover information about various editions as well as the locations of the works.

17:18 LONDON, THE BRITISH LIBRARY (Formerly The British Museum Library)

General Catalogue of Printed Books to 1955. London: Trustees of British Museum, 1956–65. 263 vols. Regular 5-year supplements; some on microfiche. England's depository library.

17:19 PARIS, BIBLIOTHEQUE NATIONALE

Catalogue general des livres imprimes de la Bibliothèque Nationale. Paris: Paul Catin, 1897–1981. 231 vols. Author catalogue of works published before 1960.

Catalogue general des livres imprimes: Auteurs, Collectivites-Auteurs, Anonymes 1960–1964. Paris: Bibliothèque Nationale, 1965–1967. 12 vols. Author catalogue. Vol. 11 lists works in Cyrillic; Vol. 12, works in Hebrew.

17:20 OTTAWA, CANADA, NATIONAL LIBRARY OF CANADA/BIBLIOTHEQUE NATIONALE DU CANADA

Canadiana, 1951+ Issued 10 months of the year with annual cumulation. Emphasis on works of Canadian interest. Supersedes *Canadian Catalogue of Books Printed in Canada, About Canada, as Well as Those Written by Canadians.* Cumulative indices for 1950–1962, 2 vols.; 1963–67, 3 vols.; 1968–72, 6 vols. The National Library of Canada participates in the Library of Congress publications; see below.

17:21 WASHINGTON, D.C., LIBRARY OF CONGRESS

Extensive publications of Library of Congress, or LC as it is called—which are available on microfiche, hardbound copies, and databases—include various catalogues, such as

(1) *National Union Catalogs,* abbreviated *NUC,* whose entries are indexed by authors
(2) *Books: Subjects*
(3) *Films and Other Materials for Projection,* formerly entitled *Motion Pictures and Filmstrips*
(4) *Monographic Series*
(5) *Music, Books on Music, and Sound Recordings,* previously called *Music and Phonorecords*
(6) *National Register of Microform Masters*
(7) *National Union Catalog of Manuscript Collections,* for accessing archival material
(8) *Newspapers in Microform,* subdivided into those of U.S. and those of foreign countries

For catalogues pertaining to motion pictures and filmstrips, consult 26:40–42; for the Library of Congress Prints and Photographs Collection, Chapter 22. Also see *National Union Catalog of Manuscript Collections* [13:67].

The National Union Catalog: Pre-1956 Imprints. Chicago: The American Library Association, 1968–1981. 754 vols.

> Retrospective author catalogue of books published before 1956. Includes listing of holdings of about 650 U.S. and 50 Canadian participating libraries.

Library of Congress and National Union Catalog Author Lists, 1942–1962: A Master Cumulation. Detroit: Gale Research, 1969. 152 vols.

> Since 1955, cards represent those catalogued by LC and other libraries contributing to this cooperative program; hence additional name, National Union, by which it will hereafter be called.

The National Union Catalog: Books: Author List. Various publishers. *1956 through 1967,* 125 vols. *1968–1972,* 128 vols. *1973–77,* 150 vols. *1978–82,* annual cumulations.

> Printed in 9 monthly issues, 3 quarterly cumulations, and in annual and quinquennial cumulations, *National Union Catalog* contains facsimiles of LC printed cards for books, pamphlets, maps, atlases, periodicals, and other serials that were issued during inclusive dates of catalogue. Author index to reference works owned by LC and 600 other North American libraries; generally excludes doctoral dissertations and works, such as music books and films, reported in other LC publications. Contains abbreviations identifying participating U.S. and Canadian libraries that own the material. After December 1982, ceased publication as hardbound copy. Available on microfiche and computer tape; also see *LC MARC-Books Database* below.

Library of Congress Catalog: Books: Subjects. various publishers.

> Published in 3 quarterly issues, plus annual and quinquennial cumulations from 1950 through 1982, uses categories outlined in *LC Subject Headings.* Ceased publication in 1982; as of January 1983, merged with *NUC: Author List* into *NUC Books.*

Library of Congress Subject Headings. 12th ed. Washington, D.C.: Library of Congress, 1989. 3 vols. Thesaurus for LC.

NUC Books. Washington, DC: Cataloguing Distribution Service, 1983+

COM catalogue combining:
(1) *National Union Catalog: Author List*
(2) *Library of Congress Subject Catalog*
(3) *Library of Congress Monographic Series*
(4) *Library of Congress Chinese Cooperative Catalog*

NUC Books consists of (1) Register, providing main entry organized by author or corporate entry and (2) indices to names, titles, subjects, and names of series of works. Cumulated each month or quarter and provides cross references to main entry in Register. List of libraries having copies of works are now in separate COM catalog entitled *The NUC Register of Additional Locations.*

> Databases for LC Catalogued Materials include OCLC, RLIN, *LC MARC,* and *REMARC.*

LC MARC-Books Database, DIALOG, File 426. Computer tapes of English-language monographic works processed by LC since 1968. For foreign-language works, the following dates apply: 1973, French; 1975, German, Portuguese, Spanish; 1976–77, other Roman alphabet languages; 1979, South Asian and Cyrillic alphabet languages in romanized form; and 1980, Greek in romanized form. Updated monthly, files differ from printed version in that individual library holdings are not included.

REMARC Database, DIALOG, File 421 for Pre-1900 and undated material; File 422, 1900–1939; File 423, 1940–59; File 424, 1960–69; File 425, 1970–80. Provides access to catalogued collections of LC from 1897 to between 1968 and 1980, depending upon language of work; see above listing.

Completing Bibliographical Book Data

During the research process, students may have trouble deciphering abbreviated bibliographical references or collecting sufficient data on resources. Often art reference works do not provide either the first names of authors or the names of book publishers. There are several references to help students discover this information. The bibliographic utilities, such as OCLC and RLIN, are efficient means for completing bibliographical data, but not all students have access to these computer files. Particularly useful are the materials published by the U.S. Library of Congress [17:21]: (1) *The National Union Catalog,* (2) *NUC Books,* and (3) the two databases—*LC MARC-Books* and *REMARC.*

For older works, check *The National Union Catalog: Pre-1956 Imprints,* which consists of 754 vols. If a work was published between 1956 and 1983, it may be located through one of the volumes of the *National Union Catalog: Author Lists.* Usually, the entries can only be found if the author or corporate entry is known. Published since 1983, *NUC Books* accesses bibliographical material through (1) author's name, (2) book's title, (3) subject, and (4) name of series. But the easiest method of locating bibliographical data is through a database search of either *LC MARC-Books* or *REMARC.*

If bibliographical entries cannot be located through the LC catalogues, consult one of the catalogues of holdings of libraries, especially an institution whose collection reflects the same subject as the research topic, such as MoMA's catalogue [12:96] for 20th-century artists. If the title is needed, amd only the publisher, subject, and approximate date of issue are known, check the books-in-print references and the publishers' trade lists, annotated in Chapter 20. The former lists books available in a specific country in a particular year by titles, authors, and sometimes subjects. The latter, which are collections of publicity brochures that publishing firms in a particular country issue to sell their books, are alphabetized by the company's name. These references will also pinpoint recently published books.

Sales Information

This chapter is divided into (1) auction catalogues, (2) information on auction sales, (3) reprints of sales catalogues, (4) union lists of sales catalogues, (5) references on appraisals, (6) sources for monetary conversion rates, and (7) serials that publish auction information. For a discussion on how to use the following resources, consult Chapter 5. For additional background, see Caroline Backlund, "Art Sales—Sources of Information," *ARLIS/NA Newsletter* 6 (Summer 1978): 65–72 and such works as *Auction Companion*, Daniel J. and Katharine Kyes Leab (New York: Harper and Row, 1981); *Auction: A Guide to Bidding, Buying, Bargaining, Selling, Exhibiting, and Making A Profit*, William C. Ketchum, Jr. (New York: Sterling Publishing, 1980); and John Marion's "Games Auctioneers Play," *Art & Antiques* 6 (November 1989): 101–113.

Auction Catalogues

To advertise forthcoming sales, all larger auction houses publish sales catalogues which give estimates of the sale prices for the works of art. After the auction, a postsale price list of the actual hammer price is published. Libraries have these lists attached to their catalogues. Sales catalogues can be purchased separately or on an annual basis. This section discusses (1) Sotheby's and Christie's catalogues, including the historical changes in their names and some categories of their sales catalogues and (2) auction firms' publications which review the season.

Sotheby's and Christie's Sale Catalogues

Because they dominate the market, Sotheby's and Christie's are discussed in this section. Although they both have numerous branch offices, only the London and New York locations are cited.

18:1 Christie, Manson & Woods, 8 King Street, St. James's, London SW1Y 6QT and 502 Park Avenue, New York, NY 10022.

 Founded in 1766 by James Christie, the London auction house originally sold a great variety of items, including 72 loads of meadow hay and a coffin. In 1977 the firm established a branch office in New York City. In addition to the sales catalogues, the firm publishes *Christie's Review of the Season* [18:3], *Auction News from Christie's*, and *Christie's International: The Auction Magazine*.

 Sale items are placed in such categories as American Paintings, Drawings, Watercolors and Sculpture (circa 1945); Contemporary Art, Excluding Prints; Impressionist and Modern Paintings; Latin American Paintings; Nineteenth Century European and Sporting Paintings; Old Master and 19th Century European Drawings and Watercolors; Old Master Paintings (circa 1800); and Prints.

 Other categories include Chinese Works of Art, Japanese Works of Art and Prints, Russian Works of Art, Jewelry, Costumes and Textiles, Porcelain, Glass and Paperweights, Books and Stamps, and Photographic Images and Equipment. There are also five classifications for Decorative Arts and Furniture.

18:2 Sotheby's, 34 & 35 New Bond Street, London W1A 2AA and 72nd Street and York Avenue, 1334 York Avenue, New York, NY 10021.

 Founded in London in 1744, Sotheby's was headed by the bookseller Samuel Baker, who was the sole proprietor until 1767 when G. Leigh became his associate, an arrangement that lasted until 1778. On that date, Mr. Baker's nephew John Sotheby became a member of the firm which was then called Leigh & Sotheby and later changed to Sotheby's. In 1964, when the English company purchased the New York firm of Parke Bernet the name was changed to Sotheby Parke Bernet. The history of Parke-Bernet Galleries is also complicated. The parent company, American Art Association, was founded in 1883 and in 1929 merged with Anderson Galleries, which had originated in 1900 with John Anderson, book auctioneer; from 1903 to 1915, the firm was called Anderson Auction Company. In 1937, American Art Association-Anderson Galleries was renamed Parke-Bernet Galleries. In 1964 this company became affiliated with Sotheby & Company of London. From 1972 to 1984, the New York auction house was called Sotheby Parke Bernet. In 1984, all

of the branches of the firm were called Sotheby's. For a brief history of the auction house, see Thomas E. Norton's *100 Years of Collecting in America: The Story of Sotheby Parke Bernet* [18:5] The company issues *Art at Auction: The Year of Sotheby's* [18:6], *Sotheby's Newsletter,* and *Sotheby's Preview,* which includes articles concerned with aspects of art history and collecting.

Sotheby's sales categories include Old Master Paintings and Drawings, 14th to early-19th century; 19th Century European Paintings and Drawings; Impressionist and Modern Paintings, Drawings, and Sculpture (circa 1870–1950); Contemporary Paintings, Drawings, and Sculpture (since circa 1950); American Paintings, Drawings, and Sculpture (18th to 20th century); Mexican and Other Latin American Paintings, Drawings, Sculpture and Prints; Prints: European and American; and Photographs and Photographic Literature.

There are also categories for Antiquities (work prior to circa 1200); Pre-Columbian Art; Ethnographic Art; Japanese Works of Art, Prints, and Paintings; Russian Works of Art; Chinese Ceramics, Works of Art, and Furniture; Silver; Judaica and Related Art; Jewelry; Oriental Rugs and Carpets; Books and Coins; and Musical Instruments. There are four classifications for Furniture and Decorative Arts. Not all collecting areas have departments in both London and New York.

Reviews of the Auction Seasons

All are profusely illustrated.

18:3 Christie, Manson and Woods, London. *Christie's Review of the Season.* London: Weidenfeld and Nicolson. Annual.
 Titled *Christie's Season,* 1928–1961; *Christie's Review of the Year* from 1962–63 to 1970–71. Signed articles on various aspects of objects sold at Christie's auction house.

18:4 *Drouot: l'art et les encheres en France.* Paris: Compagnie des commissaires-Priseurs de Paris, 1988. Annual.
 Year-end review for the Hôtel Drouot in Paris.

18:5 Norton, Thomas E. *100 Years of Collecting in America: The Story of Sotheby Parke Bernet.* New York: Harry N. Abrams, 1984.
 Brief history of the company, year-by-year illustrated review of sales, and interesting comparison of sales prices for each decade from 1880 to 1982.

18:6 Sotheby Parke Bernet, New York. *Art at Auction: The Year of Sotheby's.* London: Sotheby Parke Bernet. Annual.
 Signed articles on various classifications of works auctioned. Various titles: *The Ivory Hammer: The Year at Sotheby's, Sotheby's 216 Season 1959–60,* and *Art at Auction 1965–66.*

Information on Auction Sales

After the auction has taken place, the catalogues are still valuable research tools, since they contain pertinent data and illustrations. To access this material, indices of auction sales should be used. These indices provide standard information on the sold object, such as sales prices in English pounds and U.S. dollars; sales data of dates, auction houses, and lot numbers; plus titles, dimensions, media, and whether or not works are signed and dated. An *R* indicates an illustrated work. If a sale was negotiated in another currency, the information is often noted. Moreover, a complete list of monetary abbreviations and currency exchange rates for that year are usually included. Some indices list auction houses and their addresses. Most indices began publication in the 1970s and thus provide data only since this date. For information concerning earlier auctions, other tools must be used. Because auction indices cover only one or two media, such as painting and drawing or prints, the annotations must be carefully noted. This section has been divided into (1) indices covering sales since 1970 and (2) indices for pre-1970 auctions.

Auctions Since 1970

This section is divided as to indices that cover (1) paintings, drawings, and sculpture; (2) prints; (3) photographs; and (4) decorative arts, small statues, and collectibles. See 18:20 for a monthly report on many kinds of art.

Paintings, Drawings, Sculpture

18:7 *Art Sales Index.* Richard Hislop, ed. 1 Thames Street, Weybridge, Surrey, KT13 8JG England: Art Sales Index. First edition covered 1968/69 season+ 2 vols.
 Originally covered paintings only, but in 1975/76, began including drawings; and in 1983/84, sculpture, bronzes, and 3-D works of art. Covers sales of about 400 international auction houses in 20 different countries. Includes only sales of works bringing a certain price, a monetary value which has

changed over the years. Includes chronological list of sales. Originally published as *Connoisseur Art Sales Annual,* then *The Annual Art Sales Index.* Since all information is computer based, various services are available. For current information, write the company. See Example 17.

Auction Prices of American Artists, published biennially since 1978. Cumulates information from annual and provides essays analyzing American art market; includes both North and South American artists.

ArtQuest: The Art Sales Index Database, files date from October 1970; updated continuously. Entries for some 1,000,000 works from about 90,000 artists; adds 1,000 to 2,000 new artists' names per year.

18:8 *Canadian Art Sales Index.* Vancouver, B.C.: Westbridge Publications, 1977/80+
First issue covers three years; now an annual. Includes oil paintings, watercolors, drawings, prints and etchings, sculpture, Native art, and art books by Canadian artists. Covers 20 to 22 auction houses in Canada and United Kingdom. Reports Canadian societies and associations to which artists belong.

18:9 *Kunstpreis-Jahrbuch.* Munich: Weltkunst Verlag. Annual. One of few sales indices to cover a wide range of objects, including paintings and drawings, prints, photographs, decorative arts, and sculpture. Many entries illustrated with small black-and-white reproductions. Covers only auctions considered important by the editors. Previously there was an English edition titled *European Art Prices Annuary* 1945/46–1951/52 and *Art-Price Annual,* 1952/53–1978/79 (London: Art & Technology Press). Since 1980 issued only in German.

18:10 *Leonard's Index of Art Auctions.* Susan Theran, ed. Newton, MA: Auction Index, 1980+
Index to paintings, drawings, mixed media, and sculpture sold at American auction houses. No minimum price for objects reported. Since it reports low-priced items, many artists whose names would not appear in other indices are included. Reports if catalogue records provenance, literature, or reproduction. Asterisk indicates that 10% buyer premium has been included in price. Glossary of terms and abbreviations.

18:11 *Lyle Official Arts Review.* Tony Curtis, ed. Glenmayne, Galashiels, Scotland: Lyle, 1975+
Organized by artists, provides photograph of painting, watercolor, or print sold. Covers about 40, mostly English, auction houses including Christie's and Philips but not Sotheby's. No notation as to why certain auctions and works are included.

18:12 Mayer, Enrique. *International Auction Records: Engravings, Drawings, Watercolors, Paintings, Sculpture.* Paris: Editions Enrique Mayer. First English edition (1967) +
Covers engravings, drawings, watercolors, paintings, and sculpture. Most titles translated into English. Chronological listing of sales. Translation of *L'annuaire international des ventes;* first English edition entitled *The International Yearbook of Sales.*

18:13 *Values of Victorian Paintings: Price Review.* Woodbridge, England: Antique Collectors Club, 1979+
Originally issued as supplement to Christopher Wood's 1971 *Dictionary of Victorian Painters* [12:75]; then issued as *Dictionary of Victorian Painters: Price Review,* 1972–77/78.

18:14 *World Collectors Annuary.* Voorburg: Repro-Holland BV. Volume 1 (1946–49) +
Covers paintings, watercolors, pastels, and drawings. Anonymous works listed at end of volume. Entries sometimes record exhibitions, literary references, and provenances. Use with *World Collectors Index 1946–1972,* 1976.

18:15 Zellman, Michael David, ed. *American Art Analog.* New York: Chelsea House Publishers, 1986. 3 vols. *Blue Book* Annual supplement, 1987+
Brief biographies of 820 American artists and price information on works sold between 1975 and 1985. Vol. 1 has artists born 1688–1842; Vol. 2, 1842–1874; Vol. 3, 1874–1930. Reports number of paintings sold, record sales, and ten-year chart illustrating changes in value. Essays on various art subjects—folk art, seascapes, still-life painting, genre.

Prints

Some of the indices cited above also include prints.

18:16 *Gordon's Print Price Annual.* Thomas Wolf, ed. New York: Martin Gordon. Volume 1 (1972)+
Most important source for print sales. Covers about 19 European and U.S. auction houses. Includes edition numbers, condition of print, and signature data. Cross index to publications on auctioned prints; index by artist's name to catalogue number

by which many prints are identified; extensive bibliography. Listing of auction houses reporting dates of sales and commissions charged.

Gordon's In Print Database files since 1972, updates daily.

Photographs

Some of the indices cited above also include photographs.

18:17 *Artronix: Photographs at Auction,* ed. by Bhupendra Karia. New York Artronix Data, Distributed by Ars Libri, 1986.
Not an annual but a retrospective documentation of the photography market. Organized by subjects, such as photographers, firms, collectors, photography serials. Contains chronologies of photo-chemical and photo-mechanical processes. Entries for photographs differentiate as to chemical or mechanical process. Includes publisher's identification, historical notes, provenance, full-text of inscriptions, and signatures. Indices to the chronology and subjects, chronological list of auctions, and statistical overview of selected sales.

18:18 *Photographic Art Market.* New York: Photographic Arts Center. First issue, 1980/81+
Only comprehensive guide to photography market.

Decorative Arts, Small Sculptures, and Collectibles

18:19 *Collectibles: Market Guide & Price Index to Limited Edition Plates, Figurines, Bells, Graphics, Steins & Dolls,* ed. by S. K. Jones. Grand Rapids, MI: Collectors Info Bureau, 1985+

18:20 *International Art Market: A Monthly Report on Current World Market Prices of Art, Antique Furniture, and Objects d'Art.* New York: Art in America. Volume 1 (March 1961–February 1962)+
Provides prices on paintings, drawings, prints, posters, antiquities, art nouveau, clockmakers, furniture, objects of art, Orientalia, paperweights, photographs, pottery, porcelain, rugs and carpets, plus silver. This monthly report, which is bound with annual index in some libraries, has regular feature, "Thoughts on the Art Market." Often includes B.I. or Bought-In price. Back issues are available on microfilm.

18:21 Kovel, Ralph M. and Kovel, Terry H., compilers. *The Complete Antiques Price List: A Guide to the Market for Professionals, Dealers, and Collectors.* New York: Crown Publishers. First issue (1969)+
Only lists items in general way.

18:22 *Lyle Official Antiques Review.* Glenmayne, Galashiels, Scotland: Lyle, 1971+
Includes photographs of items sold.

18:23 *Miller's International Antiques Price Guide,* ed. by Judith and Martin Miller. New York: Viking, 1985.
Based upon 1984 sales, has 10,000 illustrations with price ranges and detailed descriptions of objects.

18:24 *Price Guide Series.* Woodbridge, England: Antique Collectors' Club.
Various publications covering decorative arts and collectibles, such as *The Price Guide to Antique Furniture,* 2nd ed. by John Andrews, 1978; *The Price Guide to 19th Century European Furniture 1830–1910,* Christopher Payne, 1981; *The Price Guide to Jewellery, 3000* BC–1950AD, Michael Poynder, 1976; and *Price Guide to Antique Silver,* Ian Harris, 1969. Also series for small statues: *The Barye Bronzes: A Catalogue Raisonné,* Stuart Pivar, 1974 and *Bronze Sculptures of 'Les Animaliers': Reference and Price Guide,* Jane Horswell, 1971. They include price information, frequently for earlier sales. Sometimes updated by price lists.

18:25 *Sotheby's International Price Guide.* New York: Vendome, 1987+.
First issue was for objects sold in 1984; in 1986 titled *Sotheby's World Guide to Antiques and Their Prices.*

Pre-1970s Auction Information

These references provide retrospective sales records and sometimes an analysis of the market. Some references cited above began coverage before 1970, check them. *American Art Annual* [13:1] reported sales information on American auctions, 1898–1945, including prices and buyers' names. In addition, check Bénézit's dictionary [10:27].

18:26 *Art Prices Current: A Record of Sale Prices at the Principal London, Continental, and American Auction Rooms.* London: William Dawson & Sons. 1907/08–1972/73//.
Still important for pricing early works of art. Part A covers sales of paintings, drawings, and miniatures; Part B, engravings, etchings, lithographs, and prints. No volumes 1917–1920.

18:27　Bérard, Michele. *Encyclopedia of Modern Art Auction Prices.* New York: Arco Publishing, 1971.

Covers paintings and drawings, sold from 1961 to 1969. Includes about 275 artists whose works sold for $2,000 or more. Short biographies of artists plus data on sold works.

18:28　Graves, Algernon. *Art Sales from Early in the Eighteenth Century to Early in the Twentieth Century (Mostly Old Master and Early English Pictures).* London, 1918–21; reprint ed., New York: Burt Franklin, 1970. 3 vols.

Important source for early paintings sold at English auction houses. Reports standard sales data plus purchasers' names and sales prices in English pounds.

18:29　*The Index of Paintings Sold in the British Isles during the Nineteenth Century,* ed. by Burton B. Fredericksen. Santa Barbara, CA: ABC-CLIO, 1989+ Volume I: 1801–1805

The Provenance Index of the Getty Art History Information Program, as it is also called, will be published over the next 20 years, one volume covering 5 years annually. Organized into chronological index of sales, index to paintings listed under artists' names, and index of owners. Analyzes each sale according to contents; has added names of owners and buyers plus sales prices from annotated catalogues, many of which were the original auctioneer's copy. The introduction is an informative discussion of the 19th-century European art market. A database is being formed that has additional information, such as indication of subject using *Iconclass* [19:14] and subsequent provenance of individual works of art.

18:30　Keen, Geraldine. *The Sale of Works of Art: A Study Based on the Times-Sotheby Index.* London: Thomas Nelson & Sons, 1971.

Analyzes art market, 1951 to July, 1969.

18:31　Mireur, Hippolyte. *Dictionnaire des ventes d'art faites en France et à l'étranger pendant les XVIII^me et XIX^me siècles: tableaux, dessins, estampes, aquarelles, miniatures, pastels, gouaches, sépias, fusains, émaux, éventails peints, et vitraux.* Paris: Maison d'éditions d'œuvres artistiques, chez de Vincenti, 1911–12. 7 vols.

Especially good source for 18th- and 19th-century sales in France. Covers paintings, drawings, prints, watercolors, pastels, and enamels. Under artist's name provides standard sales data plus seller and sale price in French francs.

18:32　Moulin, Raymonde. *The French Art Market: A Sociological View.* Trans. by Arthur Goldhammer. New Brunswick, NJ: Rutgers University, 1987.

Concentrates on contemporary painting in France, 1950s and 60s.

18:33　Redford, George. *Art Sales: A History of Sales of Pictures and Other Works.* London: Redford, 1888. 2 vols.

Excellent provenance source. Vol. 1 has historical account of sales of great collections as well as many lesser ones. Vol. 2 cites sales prices under individual artist's names and sales information on works obtained by (1) the National Gallery of London from 1824 through 1887, (2) the National Gallery of Ireland, and (3) Houghton Gallery owned by Sir Robert Walpole. Provides sales information, including sellers, purchasers, and sales prices. Metropolitan Museum of Art has a manuscript covering 1887–1918, which was never published; one volume is for the British School, another for the foreign school.

18:34　Reitlinger, Gerald. *The Economics of Taste, 1961–1970.* New York: Holt, Rinehart, and Winston.

.1　*The Rise and Fall of the Picture Market 1760–1960,* 1961.

.2　*The Rise and Fall of the Objets d'Art Market Since 1750,* 1963.

.3　*The Art Market in the 1960's* (London: Barrie and Jenkins, 1970.

Prices for individual paintings, sculpture, and decorative arts. Analyzes art market; all prices in English pounds.

18:35　Rush, Richard H. *Art As an Investment.* Englewood Cliffs, NJ: Prentice-Hall, 1961.

Analyzes price market for paintings from all periods of art history.

18:36　――― *Antiques As an Investment.* Englewood Cliffs, NJ: Prentice-Hall, 1968.

Provides historical data as well as analyses of market prices for various important styles of furniture from Italian Renaissance to Victorian. Includes chapters on value of antiques, methods of determining authenticity, and antique dealers.

18:37　―――. and eds. of U.S. News and World Report Books. *Investments You Can Live With and Enjoy.* Washington, D.C.: U.S. News & World Report, 1974.

18:38　Savage, George, ed. *International Art Sales.* New York: Crown, 1961–62. 2 vols.

Includes "Notable Sales and Prices Realized," "Price Trends in the Principal Categories," plus index to artists and works of art.

Sales Catalogues Reprinted on Microforms

Because they are published to advertise auctions, sales catalogues were usually not saved. Few libraries will have a backlog of the thousands of catalogues that have been issued. Microform reprints, therefore, are especially important. Although most of them have no index to artists, the correct catalogue can often be located through the indices of auctions sales or the union lists of these catalogues; see Chapter 5 for the methodology.

18:39 Archives of American Art. "American Auction Catalogues on Microfilm."
About 15,000 sales catalogues published in America between 1785 and 1960 have been filmed. Available at the Archive or through interlibrary loans; in ordering, use catalogue numbers in Lancour's *American Art Auction Catalogues* [18:46]. See Chapter 13.

18:40 *Art Sales Catalogues, 1600–1825.* Leiden, Netherlands: Inter Documentation Company, 1989+ Microfiche.
Reprints of sales catalogues based on Lugt's *Répertoire* [18:47]. Set 1 consists of 4,451 sales catalogues: 3,831 are cited in Lugt's first volume and 187 catalogues not in Lugt. Some sales catalogues have been copied twice due to different annotations and translated editions. Project will microfilm all catalogues cited by Lugt from 1600 to 1825.

18:41 *Christie's Pictorial Archive.* London: Mindata, 1980+ Microfiche.
Photographs from Christie's files or from pages of sales catalogues are reproduced. Organized by individual artists, there are several different publications:
 .1 *Painting and Graphic Art* covers works sold at London, 1890–1979;
 .2 *Decorative and Applied Art:* furniture, silver, ceramics, Oriental, other decorative objects sold at London, 1890–1979;
 .3 *Impressionist & Modern Art:* works sold at London 1885–1973;
 .4 *New York 1977–1985:* paintings and decorative arts sold at New York City;
 .5 *Christie's Pictorial Sales Review:* works sold at London, 1980–1985.
 .6 *Christie's Pictorial Sales Review:* both London and New York sales, 1985/86+ annual
The first two publications excluded sales dates and prices, greatly diminishing their usefulness.

18:42 *The Knoedler Library Sales Catalogues* New York: Knoedler Gallery, 1970s. Microfiche.
Knoedler Art Gallery's collection of approximately 13,000 sales catalogues, many of which were annotated by the Knoedler staff, thus providing additional data, such as buyers and sales prices. Sales catalogues—which are organized by country, auction house, then date—are for 14 countries, including the U.S., Great Britain, France, Germany, Italy, Switzerland, Sweden, and Hungary. Earliest auction catalogue dates from 1744. Strength of collection is in late 19th- and early 20th-century publications, particularly those of France and the U.S. Includes Christie's of London and Parke Bernet of New York, but not London Sotheby's. No printed index. The University of California at Santa Barbara Arts Library is indexing these sales catalogues for *SCIPIO Database* [18:48].

18:43 *Sotheby & Co.: Catalogues of Sales.* Ann Arbor, Michigan: University Microfilms, 1973. Microfilm.
More than 15,000 sales catalogues issued at Sotheby's London auction house from the first brochure in 1734 through 1970. Filmed from auctioneers' annotated copies; includes sales prices and purchasers' names. Sales of all types of art—prints, drawings, painting,s art objects, antiquities—as well as such items as autographed letters, manuscripts, books, and coins. Arranged chronologically; no index.

Union Lists of Sales Catalogues

Because artists' estate sales are sometimes cited, an index to owners can be important for locating data on artists. Some published catalogues of art libraries also include listings of sales catalogues; see *Library Catalog of the Metropolitan Museum of Art* [17:12] and *The Winterthur Museum Libraries Collection of Printed Books and Periodicals* [13:55]. For information concerning various names of Sotheby's and Christie's and categories for their auction catalogues, see above.

18:44 Bibliothèque Forney, Paris. *Catalogue des Catalogues de Ventes d'Art* (*Catalog of the Catalogs of Sales of Art*). Boston: G. K. Hall, 1972. 2 vols.
Lists about 14,000 sales catalogues, 1778–1971, arranged under collectors, places of sales, and dates of auctions.

18:45 Harvard University, Cambridge, MA. *Catalogue of Auction Sales Catalogues.* Boston: G. K. Hall, 1971.

Additional sales catalogues are listed in 1975 supplement to the Harvard University's catalogue [17:11].

18:46 Lancour, Harold. *American Art Auction Catalogues 1785–1942: A Union List.* New York: New York Public Library, 1944.
List of 7,317 sales catalogues owned by 21 libraries. Recorded chronologically by auction dates; entries cite names of owners, auction houses, descriptive titles of sales catalogues, and their present locations. Index to owners of sold objects. Covers all forms of art sales. Numbers assigned to entries are used as a reference by other publications. Updated to 1960 on microfilm; available through Archives of American Art [18:39].

18:47 Lugt, Frits. *Répertoire des catalogues de ventes publiques intéressant l'art ou la curiosité, tableaux, dessins, estampes, minatures, sculptures, bronzes, émaux, vitraux, tapisseries, céramiques, objets d'art, meubles, antiquités, monnaies, autographes, médailles, camées, intailles, armes, instruments, curiosités naturelles, etc.* The Hague: Martinus Nijhoff, 1938–87. 4 vols.
Vol. 1: Première période vers 1600–1825, 1938; *Vol. 2: Deuxième période 1826–1860,* 1953; *Vol. 3: Troisième période 1861–1900,* 1964; *Vol. 4: Quatrozième période 1901–1925,* published under the direction of the Fondation custodia in association with the J. Paul Getty Trust, (Paris: Fondation custodia, 1987). Gives location of sales catalogues in international libraries, many of which are in the U.S. Vol. 1 lists over 11,000 sales catalogues; Vol. 2, 14,900; Vol. 3, 32,800; and Vol. 4, more than 89,500. Listed chronologically by sales dates, entries record places of sales, owners, kinds of sale items, total number of items, auction houses, and institutions owning catalogues. Index to collectors of sold works. Numbers assigned to entries are used as references by other publications. Some of the catalogues listed in Vol. 1 are available on microfilm, see 18:40.

18:48 *SCIPIO (Sales Catalog Index Project Input Online) Database* available through RLIN and printed union list.
Computer index of sales catalogues project initiated in 1980 by the Art Institute of Chicago, the Cleveland Museum of Art, and the Metropolitan Museum of Art. By 1989, the project had been joined by 5 additional participants: the National Gallery of Art, the Getty Center for the History of Art and the Humanities, the Nelson-Atkins Museum of Art, the Sterling and Francine Clark Art Institute, and the University of California at Santa Barbara. This is a union list of the holdings of these participating libraries. Reported is the information found on the title page of each sales catalogue, such as title, sale year and date, auction house, and collectors' names. The contents of the catalogue are not analyzed. In 1989 provided access to more than 90,000 current and retrospective sales catalogues; up to 9,000 titles added annually. Also includes reprints of sales catalogues of past auctions. Each reprint catalogue is provided a separate classification number plus Lugt's number [18:47]. Eventually this database will include most of the sales catalogues cited in this section. For a discussion of this resource, see Chapter 5.

Index of Art Sales Catalogs, 1981–1985: A Union List from the SCIPIO Database. Boston: G.K. Hall, 1987. 2 vols.
Chronological listing of sales catalogues and index to large general subjects, such as Modern Art and Old Master Drawings. No index to collectors.

References on Appraisals

In the art market, just like any other commercial situation, the buyer must beware. The best way to make wise art purchases is either to know a great deal about what is being bought or to obtain the advice of an art expert. Since the art of connoisseurship demands years of study, an expert opinion is usually worth the price charged. Such opinions can be sought from reputable art dealers, auction houses, or accredited appraisers. For an informative article on the subject, read Lee Rosenbaum's two-part article, "Appraising Appraisers," *ARTnews* 82(November and December 1983).

18:49 *Appraisal and Valuation Resource Manuals.* Washington, D.C.: American Society of Appraisers, 1955+
Eight volume set covering various kinds of appraisals.

18:50 Babcock, Henry A. *Appraisal Principles and Procedures.* Washington, D.C.: American Society of Appraisers, 1968.

18:51 *Bibliography of Appraisal Literature.* Washington, D.C.: American Society of Appraisers, 1974.
Covers all kinds of appraisals, including personal property which includes fine arts and antiques.

18:52 *Professional Appraisal Services Directory.* Washington, D.C.: American Society of Appraisers. Annual

Sources for Monetary Conversion Rates

Comparing prices over a period of years or centuries is extremely risky, because there are so many variables. The annual indices to auction sales provide the monetary conversion rates for each year, but there are few conversion tables which cover an extended period of time. In front of the first volume of Bénézit's dictionnaire [10:27] is a table providing the French franc equivalents to U.S. and British currency from 1901 to 1973. For additional data, see *Statistical Abstract of U.S* [18:53], which includes the Consumer Price Index that was used by Thomas Norton who compares the dollar with what it could purchase in his *100 Years of Collecting in America* [18:5]. For foreign monetary abbreviations, see Appendix E.

18:53 *Statistical Abstract of U.S.* Washington, D.C.: U.S. Government Printing Office, 1878+
 Compiled by the Bureau of Statistics, Treasury Department, until 1938 when it was issued from the Bureau of the Census. Contains foreign exchange rates over a period of years. In 1988 had tables starting with 1970.

Serials

A number of serials carry extensive advertisements for auctions as well as provide reviews of the sales. Some of these serials, such as *Print Collector's Newsletter* and *Antiques,* are cited in the appropriate sections. The July/August issue of *Art & Auction* provides an international directory for collectors including a calendar of auctions and fairs.

American Society of Appraisers Newsline, American Society of Appraisers (P.O. Box 17265, Washington, D.C. 20041) 1970s+

Art & Auction 1979+

Art Sales Index 1984+

Auction News from Christie's 1983+

Christie's International, The Auction Magazine, 1984+

Connaissance des Arts 1952+

Connoisseur 1901+ (Formerly *International Studio*)

Gazette de l'Hôtel Drouot 1891+

Kunst und Antiquataten 1976+

Sotheby's Newsletter (New York Sales) 1972+

Sotheby's Preview (international) 1981+

Visual Resources and Subject Indexing Projects

This chapter has annotations for (1) published picture collections and (2) subject indexing projects for visual resources. For a discussion of visual resources, see Chapter 5.

Published Picture Collections

Published picture collections reproduce enormous quantities of visual material. In this section, they are cited under those which reproduce (1) art from more than one media and (2) paintings and drawings. Picture collections for one specific media, such as architecture or costumes, are reported in the appropriate chapters of Part V. Because microfiche cards carry various numbers of images that must be magnified, knowing how many images are included is a better indication of a collection's size than the number of fiche. Image statistics are provided.

Several Media

19:1 *The Alinari Photo Archive* (Fratelli Alinari Fotografi Editori). Florence, Italy.

Begun in 1854 by Leopoldo Alinari and his brothers, this firm systematically photographed all major Italian art works in private and public collections. Other collections were purchased, and the photographing continued, both in and out of Italy, until today there are about 220,000 photographic plates, not all of which have been catalogued. The media within these several collections—such as Alinari, Brogi, Anderson, Manelli, and Fiorentini—include architecture, sculpture, paintings, and miscellaneous works of art. Alinari photographs can be located in the following:

.1 *Alinari Photographic Archives.* Some libraries have purchased photographs directly from Alinari Archives and thus have collections the size of the microform publication cited below. Individual photographs can also be ordered through the U.S. distributor: Art Resource Incorporated, 65 Bleecker Street, 9th Floor, New York, NY 10012.

.2 *Alinari Photo Archive on Microfiche.* Zug, Switzerland: Inter Documentation Company, 1983. Microfiche. The various Alinari collections—such as Brogi, Anderson, and Manelli—are kept separate and must be searched individually. The photographs are classified topographically with the Italian region—such as Toscana, Piemonte, or Umbria—cited first, followed by town, then museum or street, title of work, and name of artist. The finding aids are not for the whole collection. Published on microfiche are detailed lists of the Alinari, Brogi, and Anderson collections as well as subject and name indices for only the Alinari Collection. In addition, there is a separate printed finding aid for Italian cities and villages which gives the provinces in which they are situated. Total of about 119,070 images.

.3 *Early Alinari Photographic Archives.* London: Mindata, 1980. Microfiche. Arranged topographically, these photographs, which were mainly taken in the 19th century, are from the collection at the Victoria & Albert Museum, London. About 7,000 images.

19:2 *Bibliothèque Nationale: Archaeology and Exploration.* Paris: Studios Photographiques Harcourt, n.d. Microfiche.

Series of 19th-century photographs of ancient antiquities.

19:3 *The Conway Library, The Courtauld Institute of Art, The University of London: Photographic Research Library for Art History.* Haslemere, Surrey: Emmett Publishing, 1987. Microfiche.

Consists of (1) French and Italian architecture, medieval to the 20th century; (2) architecture from the same period for the rest of Europe, Asia, Africa, and South America; (3) architectural drawings, from the 14th century to the present; (4) sculpture, from the 15th century to the present; (5) medieval arts, including sculpture, metalwork, ivories, panel paintings, and Byzantine monuments; and (6) Western,

Byzantine, and Eastern Christian manuscripts, from the 4th to the 18th century. Printed finding aid to contents of microfiche available. Sets may be purchased separately; prints may be ordered from the Conway Library. See also 19:4. Estimated 800,000 images. A *Five Year Update* will be published in 1992 with an additional 100,000 new photographs.

19:4 *Courtauld Institute Illustration Archives.* London: Harvey Miller. (1976/77)+ Microfiche and Printed editions.

This reproduction project of the extensive photographic collections of the Conway Library of the Courtauld Institute is issued in sets, called Archives. Published quarterly, 4 sets of illustrated volumes are presently being issued: *Archive 1: Cathedrals and Monastic Buildings in the British Isles, Archive 2: 15th and 16th Century Sculpture in Italy, Archive 3: Medieval Architecture and Sculpture in Europe,* and *Archive 4: Late 18th and 19th Century Sculpture in the British Isles.* A companion text was issued for Archive 1 on Laon Cathedral in 1983. For a more extensive reproduction of the Conway Library's collection, see 19:3.

19:5 *Index of Ancient Art & Architecture,* ed. by the Deutsches Archaologisches Institut, Rome. Munich: K.G. Saur, 1988+ Microfiche.

Photographic collection of Greek and Roman classical art and architecture with additional illustrations for Egypt and the Near East as well as architecture and fine arts of the Middle Ages and the modern era. Photographs are organized by types of monuments and topography. No index has been announced. When finished, there will be more than 300,000 images.

19:6 *Index Photographique de l'Art en France.* Munich: K.G. Saur, 1981. Microfiche.

Organized by city or town followed by various buildings and monuments; covers 8th century through the present. Especially good for medieval architecture and collections in small French museums. There is no index. Based upon Richard Hamann's photographic collection, which was edited by the Bildarchiv Foto Marburg [19:7]. About 95,000 images.

19:7 *Marburger Index: Photographic Documentation of Art in Germany.* Munich: K. G. Saur, 1976+ Microfiche.

Owned by the Bildarchiv Foto Marburg and Rheinisches Bildarchiv in Cologne, the photographs cover material dating from the Middle Ages to the present. Contains all types of western and non-western art—architecture, painting, sculpture, prints, and decorative arts and crafts. Exterior and interior views are provided as well as photographs—taken between 1850 and 1976—of art objects owned by German museums, churches, and institutions. Germany is defined as the country in 1937; consequently, monuments and art in such cities as Dresden, which is today in the Deutchland Democratic Republic, are included.

Three separate sections: Set I contains approximately 480,000 images, published 1978–82; Set II, about 300,000, issued 1983–87; and Set III, 150,000, completed in 1990. Each section covers similar material, but photographs are of different views or depict additional monuments or works of art. Organized topographically. Begins with municipal architecture, followed by sacred and secular architecture, and ends with museums followed by individual works of art owned by those institutions. Microfiche frames illustrate works of art and provide names of artists, titles of works, probable dates, and dimensions. About 930,000 total images.

One of the most important aspects of this collection is the extensive subject index which includes:

(1) "Objeckt-Inventar" (Object Inventory) provides catalogue entry for each photograph

(2) "Künstler-Œuvre-Katalog" (Artists-Œuvre Catalog), arranged alphabetically by artists' names, lists works of art that are illustrated, divided as to authentic works, questionable attributions, workshop pieces, and imitations and copies

(3) "Primare Ikonographie" (Primary Iconography) uses *Iconclass* [19:14] numbers, but with added division of 0 for abstract or non-representational art

(4) "Sekundare Ikonographie" (Secondary Iconography)

(5) "Portrat-Katalog Alphabetisch" (portraits)

(6) "Allegorie und Symbol metaphorische Darstellungen" (representations of allegories and symbols)

(7) "Topographische Ikonographie" (topography)

(8) "Katalog der anonymen Werke" (anonymous works)

(9) "Katalog der dislozierten Werke" (displaced works of art), includes some art destroyed during World War II

19:8　*Photographic Archives of the Caisse Na-*
tionale des Monuments Historiques et des
Sites, Paris. (Fine and Decorative Arts in
France), London: Mindata, 1983. Microfiche.
Also called *Art in France: The French State*
Photographic Archives. Established by
French Ministry of Culture in 19th cen-
tury, this collection has photographs, dating
from 1851, of paintings, drawings, prints,
sculpture, decorative arts, antiquities, and
illuminated manuscripts from 200 French
museums and galleries. There are 8 sets,
such as *Paintings in the Louvre,* with 9,000
images; *Paintings in Provincial and Other*
Museums, with 8,500 images. There is a
printed index to artists in the fine arts col-
lections and a microfiche index to all 8 sets.
Total of more than 70,000 images.

19:9　*Portraits of Americans.* Teaneck, NJ:
Chadwyck-Healey, n.d. Microfiche.
Representing wide range of media, in-
cluding photographs, reproduces 1,926
portraits from the National Portrait Gal-
lery, Washington, D.C. For index see 19:53.

Paintings and Drawings

19:10　*Courtauld Institute Survey of British*
Private Collections. London: Courtauld
Institute, 1950s+
The Institute is systematically photo-
graphing works of art, mostly paintings with
some sculpture, in private collections in
England, Wales, and Ireland. More than
400 collections have been photographed.
Sometimes includes views of interiors and
exteriors of houses surveyed. About 20,000
images; adds about 800 to 1,000 annually.

19:11　*Gernsheim Corpus Photographicum of*
Drawings. Helmut Gernsheim, 1956+
Photographs of mostly Old Master draw-
ings from European, U.S., and Australian
museums and private collections. Contains
about 120,000 photographs; adds about
3,900 annually.

19:12　*Royal Library, Windsor Castle: The Royal*
Collection of Drawings and Watercolors.
London: Mindata, 1983. Microfiche.
Over a period of 40 years, 15 scholarly cat-
alogues of more than 20,000 Old Master
drawings have been published by Phaidon
Press, such as *The Bolognese Drawings of*
the XVII and XVIII Centuries in the Col-
lection of Her Majesty the Queen, by Otto
Kurz, 1955 and *The German Drawings in*
the Collection of Her Majesty the Queen
at Windsor Castle by Edmund Schilling,
1971. This microfiche set reproduces the
Master drawings discussed in these printed
volumes.

19:13　*Witt Library Photo Collection on Micro-*
fiche. London: Courtauld Institute of Art,
1978. Microfiche.
One of the largest picture collection of its
kind in the world, the Witt Library of Lon-
don's Courtauld Institute of Art collects re-
productions of drawings and paintings by
European and American artists who lived
from about 1200 to the present. Filmed be-
tween 1978 and 1981, this microfiche pub-
lication covers about 50,000 artists, many
of whom are obscure 19th- and 20th-cen-
tury painters. Printed index to names: *A*
Checklist of Painters c. 1200–1976 Rep-
resented in the Witt Library, Courtauld In-
stitute of Art, London (London: Mansell
Information, 1978). The Witt Library has
developed a computerized index for the
American School of Painting [19:24]. In
North America some museums have the
complete microfiche collection: The Na-
tional Gallery of Canada, Ottawa; Na-
tional Gallery of Art, Washington, D.C.;
Frick Art Reference Library, New York
City; and Getty Center for Art and Hu-
manities, Santa Monica. The Yale Center
for British Art, which owns only the section
on British artists, has a computer subject-
access project [19:17]. Complete micro-
fiche collection contains more than
1,200,000 images.

Subject Indexing Projects
for Visual Resources

This section discusses (1) *Iconclass,* a subject-
indexing tool, and (2) references indexing works of
art. The latter will assist researchers in locating re-
productions of artists' works as well as specific ob-
jects that illustrate a particular subject.

Iconclass

A subject classification system, *Iconclass* is uti-
lized in a growing number of projects, such as *Mar-*
burger Index [19:7], *DIAL* [19:25], *Iconographic*
Index to Old Testament Subjects [19:37], *Icon-*
class Indexes [19:39], and the Witt Computer
Index Project [19:24]. Even researchers who are
not using the published microform picture collec-
tions should learn about this system, since *Icon-*
class can be used to outline scenes of certain
subjects; see Chapter 5. In addition to under-
standing this system, researchers should utilize the
bibliographies that constitute an important part of
Iconclass.

19:14 Waal, H. van de. *Iconclass: An Iconographic Classification System, Completed and Edited by L. D. Couprie.* Amsterdam: North-Holland, 1973–1984. 17 vols.

Iconclass—a word derived from the first four letters of the phrase, iconographic classification—was developed at the University of Leiden in the Netherlands by H. van de Waal and completed and edited by L. D. Couprie. The volumes were published over a span of 10 years, 1973–1983. *Iconclass* consists of 7 system volumes covering 9 divisions and reporting detailed numbers assigned to each person or term. Within each division are subdivisions utilizing letters and Arabic numbers to provide individual notations for complex ideas. In addition to the numbering system, *Iconclass* includes extensive bibliographies, in which an *F* indicates a *Festschrift*. Each section has a different cut-off date for the bibliographical citations. The 9 sections are:

Division 1 (Religion and Magic), classification for the supernatural. Subdivision 10 is used for symbolic representations; 11, for the Christian religion; 12, for non-Christian religions; 13, for magic and supernaturalism; 14, astrology. Since there is a major division for the Christian Bible, the classifications in this section are for non-biblical, reverent topics. Bibliography: pre-1979 publications.

Division 2 (Nature), the physical world; bibliography: pre-1969.

Division 3 (Human Being, Man in General); bibliography: pre-1969.

Division 4 (Society, Civilization, Culture); bibliography: pre-1972.

Division 5 (Abstract Ideas and Concepts), a classification system using double letters for juxtaposition of opposites. For example, the number for good behavior is *57 A*; for bad behavior, *57 AA*. Because of the importance of Cesare Ripa's *Iconologia* [29:128], more than 800 of Ripa's descriptions have been used in the system; these are reported in a special Ripa Index. Bibliography: pre-1976 publications.

Division 6 (History), for depictions of real historical people and events since the time of Constantine the Great (306–337). Other history is classified under division 7 (Bible) or 9 (ancient history). Bibliography: pre-1976.

Division 7 (Bible), the largest division, includes numbers for scenes derived from the Bible. Subdivisions include 71 for the Old Testament and the Apocrypha; 72, typology; and 73, the New Testament. There is also an index to the Gospels; scriptural references are from the *Revised Standard Version of the Bible*. Biblical books are not placed in strict chronological order; events recorded in more than one place in the Bible are consolidated into one subdivision. Apocryphal events and stories have an asterisk; some non-biblical narrations are incorporated

in this division; others are found under Division 1. For instance, under Mary in Division 1 will be found representations of the Madonna and her devotion, but depictions of her birth and youth, which are not even mentioned in the Bible, are found under Division 7. Bibliography: pre-1979.

Division 8 (Literature), Western literature not classified in other divisions. The name of the specific person is added in parentheses. There is also an index to literary characters. Bibliography: pre-1977.

Division 9 (Classical Mythology and Ancient History) consists of such subdivision as 91 for creation myths; 95, Greek heroic legends; 96, Roman gods and legends; and 98, classical history. Bibliography: pre-1977.

Each division is subdivided into minute detailed headings, for a total of about 20,000 different iconographical classifications. In addition to regular numbers, there are other signs allowing for more detailed classifications. For instance, for depictions of ancient historical persons, certain additions pinpoint the type of illustration. For instance, *98 B(Caesar Augustus) +5* indicates a portrait bust. If *+55* had been added, it would have been a full length view. Moreover, certain relationships can be shown by placing two numbers together connected by a colon. The first number is the major idea. For example, in *73 D 62: 42 B 74*, the first number—*73 D 62*—represents the crucifixion; the latter, a family portrait. In this case, the crucifixion is more dominant in the work of art than the secondary theme of donors.

The cumulative index is an additional research tool. For instance, by looking up an attribution, the saint's name can be learned. Because it is language neutral, *Iconclass* provides no translation difficulties. This system is basically concerned with Christianity and classical mythology. Moreover, the subject classification for illustrative material depends upon the expertise of the person assigning the numbers. For many researchers who do not need a topic to be so narrowly defined, the more general classification is all that is necessary. For an update of the material, see Roelof van Straten and Leendert D. Cuprie's "Corrections of the ICONCLASS System," *Visual Resources* 5(1988): 123–34.

Indices to Works of Art

The following resources index works of art which either (1) are reproduced in various formats—slides, microform, books—or (2) are owned by specific museums. Access is through the artist's name unless otherwise indicated. Projects that reproduce the visual material are noted. Remember

that computer indexing projects can retrieve various types of information, such as artists, titles, subject matter, media. For a discussion, see Chapter 4. The following indices are divided into (1) several media, such as architecture, paintings, and sculpture; (2) only paintings, drawings, and prints; (3) illuminated manuscripts; (4) sculpture; and (5) portraits.

Several Media

19:15 Census of Antique Works of Art Known to Renaissance Artists, Warburg Institute of London.

Photographic computer project concentrating on antiquities known by artists before the sack of Rome in 1527. This census of classical art studied by artists between 1400 and 1527 utilizes and augments the photographic collections at the Warburg Institute. For individual works of art, data similar to that in a catalogue raisonné is added plus information on the state of the piece during the Renaissance and the reasons it was known at this time. In 1981, the scope of the computer project increased to include architecture from the photographic collections at Bibliotheca Hertziana in Rome and extended in time to mid-16th century. Presently, there are about 12,000 photographs in Rome and the same number in London. It is estimated that there will be about 30,000 by the time this computer project is finished. Presently available only at the Warburg Institute; *Renaissance Artists and Antique Sculpture* [12:9] is based upon the census.

19:16 Clapp, Jane. *Art in Life.* New York: Scarecrow, 1959. *Supplement* 1965.

Reproductions of paintings and graphic art—plus selective group of photographs of architecture, sculpture, and decorative arts—published in *Life Magazine* from first issue, November 23, 1936, through 1956. Supplement covers 1957–1963.

19:17 Computerized Index of British Art 1550–1945. New Haven, CT: Yale Center for British Art, Photo Archive.

Census of British art in North American collections; computer index of paintings, drawings, watercolors, sculpture, and prints by British artists and foreigners working in Britain. The 6,000 drawings owned by the Huntington Library in San Marino have been catalogued. Each photograph is provided a catalogue entry and up to 5 subject access points. Locations are known for most of the works. Available only at the Yale

Center; answers most telephone or written requests. Consists of some 45,000 photographs representing about 5,000 artists.

19:18 Havlice, Patricia Pate. *Art in Time.* Metuchen, NJ: Scarecrow, 1970.

Reproductions in *Time Magazine,* from the first issue in 1923 through 1969.

19:19 Hewlett-Woodmere Public Library. *Index to Art Reproductions in Books.* Metuchen, NJ: Scarecrow, 1974.

Covers paintings, sculpture, graphic art, photography, and architecture published in 65 books, issued 1956–71. Indices to artists and titles.

19:20 *The Index of Christian Art.* Princeton University.

Begun in 1917 at Princeton University by Charles Rufus Morey, the Index of Christian Art is an open-ended system to which cards are continuously being added. Under about 25,000 subject headings, catalogue cards are arranged by media, such as fresco, illuminated manuscript, ivory, metal, mosaic, painting, and sculpture. Notations concerning the original placement and the present location are included.

Composed of (1) Subject File, consisting of almost 700,000 cards indexing subjects in Early Christian and Medieval works of art up to 1400, (2) Photograph File containing illustrations of varying quality, (3) Bible and Apocrypha File, (4) Bibliography File, (6) Illuminated Manuscripts Index, and (7) Topographical File. Besides original collection at Princeton University, there are two other complete photographic copies in North America: Dumbarton Oaks Research Library, Washington, D.C. and Art Library of University of California at Los Angeles.

19:21 Parry, Pamela Jeffcott. *Contemporary Art and Artists: An Index to Reproductions.* Westport, CT: Greenwood, 1978.

All media, except architecture; covers books issued 1940 to mid-1970s.

19:22 *Where Is It? Series.* London: Frederick Warne, 1981.

Under artists' names, provides titles of works and their European and North American locations. Includes topographical index.

.1 *Paintings and Sculptures of the 15th Century,* Catherine Reynolds.
.2 *British Paintings—Hogarth to Turner,* Catherine Gordon.
.3 *Dutch and Flemish Paintings of the 17th Century,* Christopher Wright.

.4 *Italian, French, and Spanish Paintings of the 17th Century,* Christopher Wright.

.5 *European Paintings of the 18th Century,* M. A. Morris.

.6 *British Paintings of the 19th Century,* Catherine Gordon.

.7 *European Paintings of the 19th Century,* Caroline Bugler.

.8 *Twentieth Century Paintings—Bonnard to Rothko,* Christine Lindey.

Paintings, Drawings, and Prints

19:23 *Census of Pre-Nineteenth-Century Italian Paintings in North American Public Collections,* compiled by Burton B. Fredericksen and Federico Zeri. Cambridge, MA: Harvard University, 1972.

Divided into indices to Italian artists, subjects, and collections. Under artist's name, provides data on works in various institutions. Includes titles and, if known, locations of reproductions in books and journals. Index to subjects has 5 sections: religious works, secular subjects, portraits and donors, unidentified subjects, and fragments. Appendices include register of places listed by states.

19:24 Computerized Index of the American School of Paintings. London: The Witt Library, Courtauld Institute of Art, 1989.

Using *Iconclass* [19:14] plus a few additional notations, this pilot program provides subject access to illustrations for the paintings of American artists owned by this collection. Has computerized all information printed on the mounted photographs, which number about 20,000. British School is now being indexed. Presently, the computer files are only available in London. For additional information, see 19:13 and Chapter 5.

19:25 *DIAL: A Decimal Index to the Art of the Low Countries.* The Hague, Netherlands: Rijksbureau voor Kunsthistorische Documentatie. Ceased publication 1982/83.

Set of small black-and-white illustrations of Dutch and Flemish art—drawings, prints, and paintings from the photographic archive in the Rijksbureau voor Kunsthistorische Documentatie. Organized by subject; cards have artist's name plus medium, dimensions, and work's location. Utilized *Iconclass* [19:14], but because *DIAL* was begun long before *Iconclass* was finished, not all numbers correspond to published numbers. Some librarians have renumbered the cards; most have not. Even so, it is not difficult to find specific entries. Until 1980s, files increased annually by about 500 cards. Has about 14,000 cards. No index to artists' names. Copies of *DIAL* are available at about 20 U.S. libraries, such as Cleveland Museum, Institute of Fine Arts of New York University, University of California at Los Angeles, Harvard University, the University of Texas, and the National Gallery of Art, Washington, D.C.

19:26 *Dutch Art in America,* compiled by Peter C. Sutton. Grand Rapids, MI: Wm. B. Eerdmans, 1986.

Index to Dutch works of art owned by 74 U.S. museums; brief histories of institutions.

19:27 Havlice, Patricia Pate. *World Painting Index.* Metuchen, NJ: Scarecrow, 1977. 2 vols. *First Supplement 1973–1980,* 1982. 2 vols.

References to reproduction in 1,167 books and catalogues, issued from 1940 to 1975. Supplement covers additional 617 reference works.

19:28 *Index Iconologicus.* Sanford, NC: Microfilming Corporation of America, 1980. Microfiche.

Basically covers 16th- and 17th-century prints cited in Adam von Bartsch's *Le peintre graveur* [22:9]. Divided into (1) chronological listing of bibliographic sources, and (2) black-and-white illustrations, organized by proper names, places, works, concepts, objects, and themes, including secular, mythological and religious. Some literary references provide meaning of symbols. About 60,000 images.

19:29 The Inventory of American Painting Executed Before 1914. Washington, D.C.: National Museum of American Art.

Bicentennial computer project begun in 1976; information on about 252,000 paintings. Covers about 20,000 artists; includes almost 85,000 photographic reproductions. Records title of work, its statistics, and present owner or last known sale. Indices to artists, owners or locations, and subject classifications. Available only at the National Museum of American Art, but inquiries answered.

19:30 Korwin, Yala H. *Index to Two-Dimensional Art Works.* Metuchen, NJ.: Scarecrow, 1981. 2 vols.

Covers 250 books published 1960–77.

19:31 Monro, Isabel Stevenson and Kate M. Monro. *Index to Reproductions of American Paintings: A Guide to Pictures Occurring in More than Eight Hundred Books.* New York: H. W. Wilson, 1948; reprint 1966. *First Supplement,* 1964.

Index to artists, titles of works of art, and various broad subjects reproduced in about 500 books and 300 exhibition catalogues. Supplement covers 400 more works. Locations are reported when known.

19:32 ——. *Index to Reproductions of European Paintings: A Guide to Pictures in More than Three Hundred Books.* New York: H. W. Wilson, 1956; reprint 1967.

Same format as 19:31; covers 328 books.

19:33 *Old Master Paintings in Britain: Index of Continental Old Master Paintings Executed before c. 1800 in Public Collections in the United Kingdom,* compiled by Christopher Wright. New York: Sotheby Parke Bernet, 1976.

Provides names of 233 British museums that own works by 1,750 artists; gives titles and references to any catalogues in which they are reported. Lists museum collection catalogues.

19:34 *Paintings in Dutch Museums: An Index of Oil Paintings in Public Collections in The Netherlands by Artists Born before 1870,* compiled by Christopher Wright. New York: Sotheby Parke Bernet, 1980.

Same format as 19:33; includes over 3,500 artists and 350 institutions.

19:35 *Paintings in German Museums: Gemalde in Deutschen Museen,* compiled by Hans F. Schweers. Munich: K. G. Saur, 1981. 2 vols.

Indexes about 10,000 artists in more than 350 German museums.

19:36 Parry, Pamela Jeffcott and Kathe Chipman. *Print Index: A Guide to Reproductions.* Westport, CT: Greenwood, 1983.

Access to works of 2100 printmakers.

19:37 Roberts, Helene E. *Iconographic Index to Old Testament Subjects Represented in Photographs and Slides of Paintings in the Visual Collections, Fine Arts Library, Harvard University.* New York: Garland, 1987.

Utilizing *Iconclass* [19:14], provides subject access to Old Testament and Apocrypha scenes. Works of art subdivided by nationality and schools of art: Early Medieval and Byzantine, Dutch, Flemish, Italian, Spanish, German, British, Swiss, and Mexican. Reports artists' names, titles, dates, and locations. If reproduction came from sales catalog, date and auction house are provided.

19:38 Smith, Lyn Wall and Nancy D. W. Moure. *Index to Reproductions of American Paintings: Appearing in More than 400 Books, Mostly Published Since 1960.* Metuchen, NJ: Scarecrow, 1977.

Same format as Monroe's book [19:31] which it updates; indexes 400 books.

19:39 Straten, Roelof van. *Iconclass Indexes: Italian Prints.* Doornspijk, The Netherlands: Davaco, 1987+

Organized by *Iconclass* [19:14], lists prints depicting specific subjects. These indices can be used to trace the influence of artists through the prints made of their works. For instance, Raimondi, who based much of his work on Raphael, is credited with helping to spread this artist's name and style throughout Europe. And Tempesta produced almost 1,500 different prints, made between 1575 and 1625, based upon famous artists' works. Other volumes are planned: first ones index Bartsch and Hind's works; others will cover Dutch prints and drawings, early Netherlandish paintings, and German prints.

Vol. 1: Early Italian Engravings: An Iconographic Index to A. M. Hind, "Early Italian Engraving," London, 1938–1948, 1987. Includes artists active the second half of the 15th century. See 22:16.

Vol. 2: Marcantonio Raimondi and His School: An Iconographica Index to A. Bartsch, "Le Peinture-Graveur," vols. 14, 15, and 16, 1988. See 22:9.

Vol. 3: Antonio Tempesta and His Time: An Iconographic Index to A. Bartsch, "Le Peinture-Graveur," vols. 12, 17, and 18, 1987. See 22:9.

Illuminated Manuscripts

19:40 *Index of Jewish Art: Iconographical Index of Hebrew Illuminated Manuscripts,* ed. by Bezalel Narkiss and Babrielle Sed-Rajna. New York: K. G. Saur, 1978+

Conceived as a complement to the Princeton Index of Christian art [19:20], this international compilation will have 4 divisions: (1) archives of ancient Jewish Art; (2) Hebrew illuminated manuscripts; (3) synagogues and ritual art, applied arts, and ethnography; and (4) fine arts, mainly modern. Publication began with subjects and iconographic representations depicted in 9th- to 16th-century Hebrew manuscripts. The 6" by 8" object cards provide black-and-white reproductions, approximate dates and origns of manuscripts, bibliography, exact quotes or inscriptions in both Jewish and English translations, and present locations. The subject cards describe the subjects and report the literary references for the Hebrew Scriptures, Midrash, and liturgical texts. The computer

program for this project is located at the Center for Jewish Art in Jerusalem. Photographs can be ordered.

19:41 Ohlgren, Thomas H. *Illuminated Manuscripts: An Index to Selected Bodleian Library Color Reproductions.* New York: Garland, 1977. *Supplemental Index,* 1978.
Subject index to individual illuminated folios or pages in works owned by Bodleian Library, Oxford University, one of world's most comprehensive illuminated-manuscript collections. Based upon Bodleian Library color filmstrips, which some libraries convert into slides, this index has material dating from the first to the 20th century, but most are from 11th through 16th. Includes title, provenance, date executed, artist or school, scribe, type of manuscript, and subject of each illustrated manuscript page. Has 13 separate indices, to such items as: manuscript titles, provenance, dates executed, languages in text, artists or schools, authors, scribes, and subjects, many of which are very detailed. There are also entries for typology. Purdue University has facilities for viewing slides of complete manuscript collection in their Audio-Visual Center.

19:42 ———— et al. *Insular and Anglo-Saxon Illuminated Manuscripts: An Iconographic Catalogue c. A.D. 625 to 1100.* New York: Garland, 1986.
Similar format to the one above.

Sculpture

For classical sculpture, see 19:15.

19:43 Clapp, Jane. *Sculpture Index.* Metuchen, NJ: Scarecrow, 1970. 2 vols. in 3 books.
Vol. 1: Sculpture of Europe and the Contemporary Middle East
Vol. 2: Sculpture of the Americas, the Orient, Africa, the Pacific Areas and the Classical World.
Covers about 950 books; indexes subjects, artists, and historic persons represented in sculpture. Often provides location of works.

19:44 Janson, H. W. with Judith Herschmann. *Iconographic Index to Stanislas Lami's Dictionaire des Sculpteurs de l'école française au dix-neuvième siècle.* New York: Garland, 1983.
Subject index for the 19th-century French sculpture discussed in Stanislas Lami's *Dictionnaire des sculpteurs de l'école française* [10:62]. Locations given when known.

19:45 An Inventory of American Sculpture. Washington, D.C.: National Museum of American Art.
Now being developed; similar to the painting inventory [19:29].

Portraits

In the following indices, access is primarily through the person depicted. Some biographical data on these people is usually provided; often there is an index to the artists who created the works. Also see *Sculpture Index* [19:43].

19:46 American Library Association. *A.L.A. Portrait Index: Index to Portraits Contained in Printed Books and Periodicals.* William Coolidge Lane and Nina E. Browne, eds. Washington, D.C.: American Library Association, 1906; reprint, New York: Burt Franklin, 1965. 3 vols.
Alphabetical listing of names of famous sitters, giving their dates, and occupation. Indexes more than 1,000 titles of serials and books.

19:47 Art Institute of Chicago. *European Portraits 1600–1900 in the Art Institute of Chicago,* ed. by Susan Wise. Chicago: Art Institute of Chicago, 1978.
For 50 portraits, provides scholarly entries for works of art and biographies of sitters.

19:48 Cirker, Hayward and Blanche Cirker, eds. *Dictionary of American Portraits: 4045 Pictures of Important Americans from Earliest Times to the Beginning of the Twentieth Century.* New York: Dover, 1967.
Provides dates of sitters and occupations; no biographies. Sometimes gives locations of works of art. Many illustrations are only identification photographs.

19:49 Fletcher, C. R. L. *Historical Portraits.* Oxford: Clarendon, 1909.
Vol. 1: Richard II to Henry Wriothesley 1400–1600. Vol. 2: 1600–1700. Vol. 3: 1700–1800. Vol. 4: 1800–1850; Index.

19:50 Lee, Cuthbert. *Portrait Register.* Baltimore: Baltimore Press, 1968.
Listing of portraits owned in U.S. Includes (1) sitters' names with dates followed by painter's name and work's location and (2) list of painters with artists' years followed by portraits mentioned in book.

19:51 National Portrait Gallery, London. London: Her Majesty's Stationery Office.
.1 *Tudor and Jacobean Portraits,* Roy C. Strong, 1969. 2 vols.

.2 *Early Georgian Portraits,* John F. Kerslake, 1977. 2 vols.
Biography of person plus section on iconography of work. Indices to artists, engravers, and collections.

19:52 National Portrait Gallery, Washington, D.C. Catalog of American Portraits.
Established in 1966, project collects photographs and documents on historically prominent Americans as well as portraits by noteworthy American artists. Arranged alphabetically by subjects' names with cross references to artists who did the likenesses. Paintings, sculpture, drawings, miniatures, and silhouettes included. This nation-wide census is continuing; the records are being put into a computer database. Available only at the museum; written requests answered. Presently about 80,000 portraits.

19:53 ———. *Portraits of Americans: Index to the Microfiche Edition,* ed. by Sandra Shaffer Tinkham. Teaneck, NJ: Chadwyck-Healey,
Printed index to 1,926 portraits from the National Portrait Gallery's collection, published on microfiche [19:9]. Wide range of media, including photographs.

19:54 New York Historical Society. *Catalogue of American Portraits in the New York Historical Society.* New Haven, CT: Yale University, 1975. 2 vols.
Catalogues more than 2,240 portraits; provides biographical data on sitters.

19:55 The Royal Society. *The Royal Society Catalogue of Portraits,* by Norman H. Robinson. London: The Royal Society, 1980.
Biographical sketches and illustrations. Includes information on works of art and index to artists.

Other Resources

This chapter is divided into (1) marketing aids, (2) writers' aids and style guides, (3) legal aspects of art, (4) location directories, (5) research and grants, (6) locating books, (7) locating serials, and (8) reference works for librarians. The multilingual glossary of proper names, found in Appendix D, should be used with the international location directories.

Marketing Aids

This section is divided into (1) guides, (2) handling and shipping works of art, and (3) suppliers.

Guides

20:1 *American Art Directory.* New York: R. R. Bowker, 1898+ Biennial
 Covers museums, art organizations, and art schools in U.S., Canada, and foreign countries. Lists art magazines, newspapers reporting art editors and critics, art scholarships and fellowships, booking agents for traveling exhibitions, and open exhibitions. For the publication's history, see [13:1].

20:2 *Artist's Market.* Cincinnati: Writer's Digest. 1974+
 Guide on how to sell art work; includes alphabetical listing of associations, glossary of terms, copyright information, and notes on marketing art work. Reproduces typical commission agreement and sample model's release.

20:3 Chamberlain, Betty. *The Artist's Guide to His Market.* Rev. ed. New York: Watson-Guptill, 1983.
 Covers business terms and agreements, pricing and selling, copyright and royalties. Includes sample contract forms, bills of sales, and payment receipts.

Handling and Shipping Works of Art

See also books by Dudley [28:41], Fall [28:43], and Keck [28:45].

20:4 Keck, Caroline K. *Safeguarding Your Collection in Travel.* Nashville, TN: American Association for State and Local History, 1970.

20:5 McCann, Michael. *Health Hazards Manual for Artists.* 3rd rev. and augmented ed. New York: Nick Lyons, 1985.
 Supplemented by the newsletter *Art Hazard News,* issued from McCann's New York office.

20:6 Newman, Thelma R., Jay Hartley Newman, and Lee Scott Newman. *The Frame Book: Contemporary Design With Traditional and Modern Methods and Materials.* New York: Crown, 1974.
 Includes historical account of frames and how-to-do section for mounting, matting, and framing works of art.

20:7 United Nations Educational, Scientific and Cultural Organization. *Temporary and Travelling Exhibitions.* Paris: UNESCO, 1963.
 How to pack, send, and insure fine art. Includes sample insurance policy for fine arts coverage.

Suppliers

20:8 *Graphic Arts Encyclopedia.* George A. Stevenson, compiler. 2nd ed. New York: McGraw-Hill, 1979.
 Tables of comparable sizes and weights.

20:9 *MacRae's Blue Book: Materials, Equipment, Supplies, Components.* Charles A. Burton, Jr., ed. Chicago: MacRae's Blue Book. 5 vols. 1893+ Irregular annual
 Lists suppliers, trade or brand names. In 1929 superseded *Hendricks Commercial Register* published since 1893.

20:10 *Thomas Register of American Manufacturers and Thomas Register Catalog File.* New York: Thomas Publishing. Annual, since 1905+
 Subject index to producers and suppliers. Reprints sales catalogues of listed companies.

The Thomas Register, 1905–1938: Guide to the Microfilm Collection. Woodbridge, CT: Research, 1982.

Thomas Register Online Database, DIALOG, File 535, covers current year, annual reload.

Writers' Aids and Style Guides

20:11 American Psychological Association. *Publication Manual of American Psychological Association.* 3rd ed. Washington, D.C.: American Psychological Association, 1983.

20:12 Barnet, Sylvan. *A Short Guide to Writing About Art.* 3rd ed. Glenview, IL: Scott, Foresman, 1989.

20:13 Barzun, Jacques and Henry F. Graff. *The Modern Researcher.* 4th ed. New York: Harcourt, Brace, Jovanovich, 1985.
Discusses changes in calendar.

20:14 *Chicago Guide to Preparing Electronic Manuscripts for Authors and Publishers.* Chicago: University of Chicago, 1987.

20:15 *The Chicago Manual of Style for Authors, Editors, and Copywriters.* 13th ed. rev. and expanded. Chicago: University of Chicago, 1982.
With this edition changed title from *The Manual of Style.* Sections on manuscript preparation and rights and permissions to republish or quote. Provides sample request forms to reprint material.

20:16 Gibaldi, Joseph and Walter S. Achtert. *The MLA Handbook: For Writers of Research Papers, Theses, and Dissertations.* 3rd. ed. New York: Modern Language Association, 1988.

20:17 *Literary Market Place.* New York: R. R. Bowker. Annual.
Lists books and serial publishers. Subject index to book publishers; lists photo and picture resources and US agents of foreign publishers.

20:18 Sayre, Henry M. *Writing About Art.* Englewood Cliffs, NJ: Prentice Hall, 1989.

20:19 Turabian, Kate L. *A Manual for Writers of Term Papers, Theses, and Dissertations.* 5th ed, rev. and expanded by Bonnie Birtwistle Honigsblum. Chicago: University of Chicago, 1987.
Based upon *Chicago Manual of Style* [20:15].

20:20 ———. *Students' Guide for Writing College Papers.* 5th ed. Chicago: University of Chicago, 1987.

20:21 Van Til, William. *Writing for Professional Publication.* 2nd ed. Boston: Allyn and Bacon, 1986.

20:22 *The Writer's Manual.* 2nd ed. Palm Springs, CA: ETC Publications, 1979.

20:23 *Writer's Market.* Cincinnati, OH: Writer's Digest. Annual.
Annotated list of publishers and manuscript requirements.

Legal Aspects of Art

Most of these references discuss copyright, rights of the artist, contracts, obscenity, publishing, and income taxation. Many have sample legal forms for contracts and sales agreements, commission agreements, releases, print documentation, and deeds of gift. When laws change, so must these books; always seek the latest edition.

20:24 Chernoff, George and Hershel Sarbin. *Photography and the Law.* 5th ed. Garden City, NY: American Photographic, 1978.
Covers right of privacy, ownership of pictures, loss or damage to film, nudes in photography, copyright, and libel. Reproduces standard forms.

20:25 Crawford, Tad. *Legal Guide for the Visual Artist: The Professional's Handbook.* Rev. ed. New York: Madison Square Press, 1987.
Includes video-art works, fine prints, and artists' estates.

20:26 Feldman, Franklin and Stephen E. Weil. *Art Law: Rights and Liabilities of Creators and Collectors.* Boston: Little Brown, 1986. 2 vols. *Supplement,* 1988.
Explains many complicated laws governing art world. Essays written by various experts on *droit de suite,* rights to reproduce works of art, purchase and sale of art objects, statutes of limitation, insurance, tax aspects, civil and criminal liabilities, and private ownership and public trust. Numerous case studies; reproduces forms and agreements.

20:27 Hodges, Scott. *Legal Rights in the Art and Collector's World.* Dobbs Ferry, NY: Oceana, 1986.

20:28 Malaro, Marie C. *A Legal Primer on Managing Museum Collections.* Washington, D.C.: Smithsonian, 1985.

20:29 Merryman, John Henry and Albert E. Elsen. *Law, Ethics, and the Visual Arts.* 2nd ed. Philadelphia: University of Pennsylvania, 1987. 2 vols.
Discusses stolen art, limits of artistic freedom, copyright, the collector, museum, and artist.

20:30 Milrad, Aaron and Ella Agnew. *The Art World: Law, Business, and Practice in Canada.* Toronto: Merritt, 1980.

20:31 Phelan, Marilyn. *Museums and the Law.* Nashville, TN: American Association for State and Local History, 1981.

20:32 Pinkerton, Linda F. and John T. Guardalabene. *The Art Law Primer: A Manual for Visual Artists.* New York: Nick Lyons, 1988.

20:33 Sweet, Justin. *Legal Aspects of Architecture, Engineering, and the Constructions Process.* 3rd ed. St. Paul, MN: West, 1985.

Location Directories

The section is divided into (1) art museums and art schools, (2) corporate art collections, (3) auction houses, (4) art libraries, (5) associations and art organizations, and (6) city directories. Europeans write the number seven, 7, which resembles the capital F; this provides a clear distinction between the numbers one and seven.

Art Museums and Art Schools

Include such data as addresses, personnel, types of museum collections and library specializations. See *American Art Directory* [20:1].

20:34 American Association of Museums. *The Official Directory of Museums.* Washington, D.C.: A.A.M., 1971+ Biennial

20:35 *Art Museums of the World.* Virginia Jackson, ed.-in-chief. Westport, CT: Greenwood, 1987. 2 vols.
Includes brief histories and selected bibliography of their publications.

20:36 Canadian Museums Association/Association des musées canadiens. *The Official Directory of Canadian Museums and Related Institutions/ Repertoire officiel des musées canadiens et institutions connexes.* Ottawa: CMA, 1968+ Every 3 yrs.

20:37 *The Directory of Museums and Living Displays.* Kenneth Hudson and Ann Nicholls, eds. 3rd ed. London: Macmillan, 1985.

20:38 *Guide to American Art Schools,* ed. by John D. Werenko. Boston: G.K. Hall, 1987.

20:39 *International Directory of Arts: Internationales Kunst-Addressbuch.* Frankfurt-am-Main: Verlag Muller G.M.B.H. 2 vols. Biennial
Important for current, hard-to-find material. Divided by museums and art galleries; universities, academies, colleges; associations; artists (painters, sculptors, engravers); collectors; art and antique dealers; galleries; auctioneers; art publishers; art periodicals; book-sellers; and restorers.

20:40 *Museums and Galleries in Great Britain and Ireland.* London: Index Publications. Annual

20:41 *Museums of the World: Museen der Welt.* 4th ed. New York: K.G. Saur, 1986.

20:42 *The World of Learning.* Detroit: Gale Research, 1947+ 2 vols. Annual
Lists learned societies and research institutes, libraries and archives, museums, universities, colleges, schools of art and architecture, and international organizations.

Corporate Art Collections

20:43 *ARTnews International Directory of Corporate Art Collections.* Shirley Reiff Howarth, ed. New York: ARTnews, 1988.

Auction Houses

See *International Directory of Arts* [20:39].

20:44 *International Art & Antiques Yearbook: A Worldwide Dealers' and Collectors' Guide to the Art and Antiques Trade.* London: National Magazine, Annual
Includes antiques and art dealers, packers and shippers, and auctioneers and salesrooms. For each country has specialist index, map, and often glossary of important terms. Lists antique dealers' associations, antique and art serials, and international antique fairs.

Art Libraries

For locating U.S. manuscript collections, see Chapter 14. Also *The World of Learning* [20:42].

20:45 *American Library Directory: A Classified List of Libraries in the United States and Canada with Personnel and Statistical Data.* New York: R. R. Bowker. 1908 +

20:46 *ARLIS/NA Directory.* Tuscon, AZ: ARLIS/NA. Annual.

20:47 *Directory of Art Libraries and Visual Resource Collections in North America.* Judith A. Hoffberg and Stanley W. Hess, eds. New York: Neal-Schuman, 1978. *Addendum,* 1979.

20:48 *Directory of Special Libraries and Information Centers in the U.S. and Canada.* 8th ed. Detroit: Gale Research, 1988. 2 vols.

20:49 National Library of Canada. *Research Collections in Canadian Libraries.* Ottawa: Information Canada, 1972+ #6: *Fine Arts Library Resources in Canada,* 1978. 2 vols.

20:50 Viaux, Jacqueline. *IFLA Directory of Art Libraries.* New York: Garland, 1985.

Associations

For art organizations, see *International Directory of Arts* [20:39] and *The World of Learning* [20:42].

20:51 *Encyclopedia of Associations*. Detroit: Gale Research. Annual

Encyclopedia of Associations Database, DIALOG, File 114, current edition, updates annually.

City Directories

20:52 *City Directories of the United States in Microform*. Woodbridge, CT: Research Publications
Published in 4 divisions: Segment 1, from the earliest known directories through 1860, based upon Dorothea N. Spear's Bibliography of *American Directories Through 1860* (Worcester, Massachusetts, American Antiquarian Society, 1961); Segment 2, 1861–1881; Segment 3, 1882–1901; Segment 4, 1902–1935. Actual city directories of major cities are reproduced.

Research and Grants

20:53 *Foundation Grants Index,* DIALOG, File 27, updates bimonthly.
Records from "Foundation Grants Index Section" of bimonthly *Foundation News.*

20:54 *Grants and Funding Sources Series*. Phoenix, AZ: Oryx. Annuals
.1 *Directory of Grants in the Humanities.*
.2 *Directory of Research Grants.*
.3 *Funding For Museums, Archives and Special Collections.*
.4 *Sponsored Research in the History of Art,* National Gallery of Art. *Vol. 5: 1980–1986, Cumulative Record; Vol. 6: 1985– 1986 and 1986–1987; Vol. 7: 1987–1988.*

Grants Database, DIALOG, File 85, updates monthly.

Locating Books

Books can also be located through the many publications of the Library of Congress; see 17:21.

20:55 *Books in Print*. New York: R. R. Bowker. 9 vols. Annual.
Separate volumes for titles, authors, subjects. Sometimes includes foreign books when there is an American distributor. End of Vol. 6 is key to publishers' abbreviations and directory of publishers.

Books in Print Database, DIALOG, File 470, and BRS, File BBIP, current year, updates monthly.

20:56 *Books in Series*. 4th ed. New York: R. R. Bowker, 1985. 6 vols.

20:57 *Canadian Books in Print*. Toronto: University of Toronto, 1987+ 2 vols.

20:58 *Cumulative Book Index: A Word List of Books in the English Language*. New York: H. W. Wilson. First issue (1928) +
Since 1969 published 11 months a year plus quarterly and annual cumulations. Authors, titles, and subject headings interfiled.

Cumulative Book Index, WILSONLINE, files since January 1982, updates monthly.

20:59 *Les Livres disponibles*. Paris: Cercle de la Librairie. Biennial.
Books-in-print reference with volumes for authors, titles, and subjects. Also available on microfiche.

20:60 *The Publishers' Trade List Annual*. New York: R. R. Bowker. Annual.
Publicity brochures from American publishing houses.

20:61 *Whitaker's Books in Print*. London: J. Whitaker and Sons. 4 vols. Annual.
Formerly called *British Books in Print.*

British Books in Print Database, DIALOG, File 430, updates monthly.

Locating Serials

Serials are infamous for changing titles, volume numbers, and publication frequency. For assistance, in sorting out these publications, see Katz's *Magazines for Libraries* [20:70], Chamberlin [17:4], *Arntzen & Rainwater* [17:1], and the third edition of *Union List of Serials* [20:77] and its supplement, *New Serial Titles* [20:72]. Also see Singer/Williamson's *Art and Architecture in Canada* [13:92]. Karpel's *Arts in America* [13:44] has section on "Serials and Periodicals on the Visual Arts," see Volume 3. *Art Books 1980–1984* [17:2] has listing of serials with indices to subjects, titles, and cessations. For a listing of contemporary serials, see Bell's *Contemporary Art Trends 1960–1980* [12:145].

The methodology for completing a serial entry is similar to a book, only the tools are different. For a discussion on serials, see Chapter 3; for a list of resources, Chapter 20. For instance, as illustrated in Example 4, there are four articles reported in the

Caillebotte entry in *Thieme/Becker* [10:47]: (1) Ch. Ephrussi, *Gaz. d. B.-Arts,* 1880; (2) *Le Temps,* v. 3, 1894; (3) *Chron. des Arts,* 1894; and (4) J. Bernac, *The Art Journ.,* 1895. Since this dictionary does not provide an abbreviations list, students must complete the titles.

For older material, check the abbreviation lists of the indices to periodical literature. If *Art Index* [16:1] is consulted, an entry is found for *Chron, Egypte.* And although the researcher would know that this was not the correct publication, the problem of what *Chron.* represents would be solved, since the entry relates that *Chron.* stands for *Chronique.* Further research my indicate that the Caillebotte article was published in a magazine entitled *Chronique des arts.* The first volume of *Art Index* also has a listing for *Gaz. Beaux-Arts* stating that it represents the French magazine, *Gazette des Beaux-Arts.* Since *Le Temps* is probably a French publication, the compilation of the *Bibliotheque Nationale* might be perused. *Catalogue collectif des périodiques du début du XVIIe siècle à 1939* [20:66] lists 18 publications beginning with the word *Temps,* the French word for time. Moreover, there is an entry for a serial *Le Temps* which began publication in 1860. Further research, may establish this as the correct title.

Armed with the probable titles of the four magazines—*Gazette des Beaux-Arts, Le Temps, Chronique des arts,* and *The Art Journal,* consult (1) the library's catalogue system or computer print-out sheets that indicate the library's serial holdings or (2) a union list of periodicals to verify the title of the serial and to locate a library which has the particular volume required. Most libraries have copies of the *Art Journal,* and the computer printout sheet or union list will indicate the first date of issue. In this case, the *Art Journal,* published by the College Art Association, has been issued since 1942, too late to be the needed periodical. By consulting the *Union List of Serials* [20:77], its supplements *New Serial Titles* [20:72], Chamberlin [17:4], or *Arntzen & Rainwater* [17:1], the mysteries would be solved. *Gazette des Beaux-Arts* has been issued from Paris since 1859. *Chronique des arts et de la curiosite,* which was a supplement to *Gazette des Beaux-Arts,* was published in Paris from 1859 through 1922. *The Art Journal* was published in London 1839 through February 1912. Although there are numerous entries for *Le Temps,* the exact serial indicated by *Thieme/Becker* would require obtaining various publications and checking for the entry. Completing bibliographical entries can be a challenge worthy of the greatest detectives.

Special care must be taken to notice the first issue date and the publishing company. For instance, the two magazines—*Revue de l'Art* and *Revue des Arts*—are very similar. But the former is issued by Flammarion; the latter by the Conseil des Musées Nationaux. Locating and completing bibliographical entries for pre-1900 serials can be a challenge, because the references are often abbreviated and difficult to decipher. Sometimes this kind of information can be found by checking the list of abbreviations used in the indices of periodical literature annotated in Chapter 16. For additional information on serials, see below.

20:62 *Art Serials: Union List of Art Periodicals and Serials in Research Libraries in the Washington D.C. Metropolitan Area.* Carolyn S. Larson, ed. Washington, D.C.: Washington Art Library Resources Committee, 1981.

20:63 *The Art Press: Two Centuries of Art Magazines.* London: Art Book, 1976.

20:64 *British Union-Catalogue of Periodicals: A Record* of the *Periodicals of the World, from the Seventeenth Century to the Present Day, in British Libraries.* New York: Academic Press, 1955–58. 4 vols. Regular supplements until 1980.

20:65 *British Union-Catalogue of Periodicals: Incorporating* World *List of Scientific Periodicals: New Periodical Titles* 1960–1968. London: Butterworth, 1970. Regular supplements until 1980.
 Union list of serial publications in some major British libraries. Supplements include serials that commenced publication, altered titles, or began a new series. Some newspapers cited.

20:66 *Catalogue collectif des périodiques du début du XVII siècle à 1939.* Paris: Bibliothèque Nationale, 1967–81. 5 vols.
 A union list of serial publications owned by some of the major libraries of France: B.N. refers to the Bibliothèque Nationale.

20:67 Gurney, Susan R., "A Bibliography of Little Magazines in the Arts in the U.S.A." *Art Libraries Journal* 6(Autumn 1981): 12–55.

20:68 *Irregular Serials and Annuals: An International Directory.* New York: R. R. Bowker, 1967+ Irregular
 Companion volume to *Ulrich's International Periodicals Directory* [20:75].

20:69 Jones, Linda Marilyn. *Preliminary Checklist of Pre-1901 Canadian Serials*. Ottawa: Canadian Institute for Historical Microreproductions, 1986. 3 vols. Microfiche.

20:70 Katz, William Armstrong. *Magazines for Libraries for the General Reader and School: Junior College, College, and Public Libraries*. 5th ed. New York: R. R. Bowker, 1986.

> Annotated list of serials arranged by subjects; includes art, architecture, archaeology, and interior decoration. Gives titles, publishers, addresses, editors' names, first publication dates, subscription rates, where indexed, whether or not book reviews are included, intended audience, and kinds of articles published.

20:71 McKenzie, Karen and Mary F. Williamson, eds. *The Art and Pictorial Press in Canada: Two Centuries of Art Magazines*. Toronto: Art Gallery of Ontario, 1979.

20:72 *New Serial Titles: A Union List of Serials Commencing Publication After December 31, 1949: 1950–1970 Cumulative*. New York: R. R. Bowker, 1973. 4 vols.

> *New Serial Titles: A Union List of Serials Commencing Publication After December 31, 1949: 1971–1975 Cumulation*. Washington, D.C.: Library of Congress, 1976. 2 vols. Regular updates.

> Issued in 8 monthly issues, 4 quarterlies and annual, 5- and 10-year cumulations. Supplements *Union List of Serials* [20:77]. Entries cite serial titles, various title changes, and frequency of publication.

20:73 Pindell, Howardena, "Alternate Space: Artists' Periodicals," *The Print Collector's Newsletter* 8(September/October 1977): 96–121.

20:74 Roberts, Helene E., *American Art Periodicals of the Nineteenth Century*. Rochester NY: Rochester University, 1964.

20:75 ———. "British Art Periodicals on the Eighteenth and Nineteenth Centuries," *Victorian Periodicals Newsletter* 9(1970).

20:76 *Ulrich's International Periodicals Directory: A Classified Guide to Current Periodicals, Foreign and Domestic*. New York: R. R. Bowker, 1932+ Irregular

> Lists in-print serials issued more than once a year and usually at regular intervals. Alphabetized under such general headings as "Art" and "Art Galleries and Museums." Cites titles, addresses, dates of first publication, subscription prices, and indices covering them. Cessation list, index to publications of international organization, index to new serials, and title index.

Ulrich's International Periodical Directory Database, DIALOG File 480, Ulrich's plus *Irregular Serials and Annuals* [20:68], updated every 6 weeks.

Bowker's International Serials Database, BRS, File ULRI, same as above.

20:77 *Union List of Serials in Libraries of the United States and Canada*. 3rd ed. New York: H. W. Wilson, 1965. 5 vols.

> Gives first publication, title changes, years publication ceased, serials superseding another serial, and which of the more than 900 cooperating libraries own copies. Supplemented by *New Serial Titles* [20:72].

Reference Works for Librarians

This is divided into (1) manuals and texts, (2) visual resource manuals, (3) picture resources, and (4) associations and their publications.

Manuals and Texts

20:78 Art Libraries Society/North America. Occasional Papers. Tucson, AZ: ARLIS/NA.

> Papers on space planning and grantsmanship are in progress.

> .1 *AACR 2 Goes Public*, 4 essays by ARLIS/NA members, 1982.
> .2 *Standards for Art Libraries and Fine Arts Slide Collections*, established by ARLIS/NA Standards Committee, 1983.
> .3 *Current Issues in Fine Arts Collection Development*, 5 essays by ARLIS/NA members, 1984.
> .4 *Reference Tools for Fine Arts Visual Resources Collections*. Christine Bunting, ed., 1984.
> .5 *Historical Bibliography of Art Museum Serials from the United States and Canada*. Sheila M. Klos and Christine M. Smith, eds. 1987.
> .6 *Authority Control Symposium: Papers Presented During the Fourteenth Annual ARLIS/NA Conference, New York, New York, February 10, 1986*. Karen Muller, ed., 1987.
> .7 *Procedural Guide to Automating an Art Library*. Patricia J. Barnett and Amy E. Lucker, eds., 1987.

20:79 Baxter, Paula. *The International Bibliography of Art Librarianship: An Annotated Compilation*. IFLA Section of Art Libraries. New York: G.K. Saur, 1987.

20:80 Jones, Lois Swan and Sarah Scott Gibson. *Art Libraries and Information Services: Development, Organization, and Management.* Library and Information Science Series. Orlando, FL: Academic Press, 1986.
Chapters on art libraries as information centers, the library collection, information services, and collection development and library management. Includes an excerpt from a collection development policy, an annual report, and a selection from a building-program profile.

20:81 Keaveney, Sydney Starr. *Contemporary Art Documentation and Fine Arts Libraries.* Metuchen, NJ: Scarecrow, 1986.

20:82 Larsen, John C., ed. *Museum Librarianship.* Hamden: Shoe String, 1985.

20:83 McKenzie, Karen. "Art Librarianship in Canada," *Art Libraries Journal.* 8(Spring 1983): 73–79.

20:84 Pacey, Philip, ed. *Art Library Manual: A Guide to Resources and Practice.* New York: R. R. Bowker, 1977.

20:85 ———. ed. *A Reader in Art Librarianship.* New York: K.G. Saur, 1985.

Visual Resource Manuals

20:86 Evans, Hilary. *Picture Librarianship.* New York: K.G. Saur, 1980.

20:87 Harrison, Helen P.,ed. *Picture Librarianship,* Phoenix, AZ: Oryx Press, 1981.
Essays on photography and printing, picture sources, selection, processing, preservation and storage, arrangement and indexing, and copyright in artistic works.

20:88 Irvine, Betty Jo with P. Eileen Fry. *Slide Libraries: A Guide for Academic Institutions and Museums.* 2nd ed. Littleton, CO: Libraries Unlimited, 1979.
All aspects of slide librarianship.

20:89 Shaw, Renata V. *Picture Searching: Techniques and Tools.* New York: Special Libraries Association, 1973; reprint on microform, 1984.

20:90 Visual Resource Association. See below for address. Libraries Unlimited, Littleton, CO, published last two books.
.1 *Guide to Equipment for Slide Maintenance and Viewing,* Gillian Scott, 1978.
.2 *Guide for Photograph Collections.* Nancy Schuller and Susan Tamulonis, eds., 1978.
.3 *Guide to Copy Photography for Visual Resource Collections.* Rosemary Kuehn and Arlene Zelda Richardson, eds., 1980.

.4 *Introduction to Visual Resource Library Automation.* Arlene Zelda Richardson and Sheila Hannah, eds., 1981.
.5 *Special Bulletin # 1: British Artists Authority List from the Yale Center for British Art, Photograph Archive,* Anne-Marie Logan and Kerry Sullivan, 1987.
.6 *Special Bulletin # 2: Standard Abbreviations for Image Descriptions for Use in Fine Arts Visual Resources Collections,* Nancy Shelby Schuller, 1988.
.7 *Special Bulletin # 3: Conservation Practices for Slide and Photograph Collections,* Christine L. Sundt, 1989.
.8 *Special Bulletin # 4: Selected Topics in Cataloging Asian Art,* Eleanor Mannikka, 1989.
.9 *Management for Visual Resources Collections,* 2nd ed., Nancy Shelby Schuller, 1989.
.10 *Slide Buyers Guide: An International Directory of Slide Sources for Art and Architecture.* 6th ed. by Norine D. Cashman, due 1990.

Picture Resources

These handbooks, which are directories of institutions that have illustrative material, provide names and addresses of distributing institutions, materials and services available, and procedures to follow to obtain material.

20:91 Evans, Hilary, and Mary Evans, and Andra Nelki. *The Picture Researcher's Handbook: An International Guide to Picture Sources and How to Use Them.* 3rd ed. Wokingham, Berkshire: Van Nostrand Reinhold, 1986.
Indices to subjects, geographical sites, specialized subjects, and to cited sources. Most museum and gallery sources have been excluded.

20:92 *Picture Sources 4: Collections of Prints and Photographs in the U.S. and Canada* ed. by Ernest H. Robl. New York: Special Libraries Association, 1983.
Brief introduction on techniques of picture research; indices to sources and major collections.

Associations and Professional Publications

For all art and visual resource librarians, these informative publications are indispensable. Most report on current professional developments and have extensive book review sections that provide detailed and analytical critiques on art reference works.

Archives and Documentation Centers for Modern and Contemporary Art, AICARC-Center, Swiss Institute for Art Research, Schweizerisches Institut fur Kunstwissenschaft, Waldmannstrasse 6/8, P.O. Box CH-8024 Zurich, Switzerland.

> *AICARC: Bulletin of the Archives and Documentation Centers for Modern and Contemporary Art,* published under the auspices of the International Association of Art Critics with the assistance of UNESCO, 1974+ (Originally called *AICARC Bulletin*)

ARLIS/NA (Art Libraries Society/North America), Pamela Parry, Executive Director, 3900 E. Timrod St., Tucson, AZ 85711.

> *ART Documentation: Bulletin of the Art Libraries Society* of *North America.* (Replaces *ARLIS/NA Newsletter* Volume 1 (November 1972–October 1973)-Volume 10 (December 1981)//), 1982+

ARLIS/UK (Art Libraries Society/United Kingdom), Philip Pacey, ed., Lancashire Polytechnic Library, St. Peter's Square, Preston PR1 2TQ, United Kingdom.

> *Art Libraries Journal* (Formerly titled *ARLIS Newsletter*) 1976+

Slide and Photograph Curators of Visual Arts in Canada, Brenda MacEachern, Slide Curator, Visual Arts Department, University of Western Ontario, London, Ontario N68 5B7.

> *Positive: A Newsletter for Slide and Photograph Curators of Visual Arts in Canada,*

Visual Resources Association, Christine L. Sundt. Architecture and Allied Arts Library, Slide and Photo Collection, University of Oregon, Eugene, OR 97403.

> *Visual Resources: An International Journal of Documentation,* 1980+

> *Visual Resources Association Bulletin* (Titled *MA-CAA Slides and Photograph Newsletter,* 1974–79); *International Bulletin for Photographic Documentation of the Visual Arts: The Journal of the Visual Resources Association,* 1974–88) 1974+

PART V

Specialized Resources
for Various Media and Disciplines

The following chapters discuss and annotate some essential research tools for specific disciplines. Chapter 21 covers architecture; Chapter 22, prints; Chapter 23, photography; Chapter 24, decorative arts and crafts; Chapter 25, fashion, costume, and jewelry; Chapter 26, film; Chapter 27, commercial design; and Chapter 28, museum studies and art/museum education. Although a few works concerned with the planning, making, or selling of art have been added, basic how-to-do books are excluded. Moreover, general business books are beyond the scope of this guide.

In the following chapters, serials are listed for U.S. and Canadian professional organizations accompanied by their addresses. Reading these publications is essential for keeping up in the field. All professionals should support their appropriate associations.

Architecture

This chapter, which cites the special resources needed for architectural research, are organized by (1) dictionaries, encyclopedias, and guides; (2) biographical dictionaries; (3) architectural surveys; (4) cost guides, standards, and technical references for practicing architects; (5) architecture bibliographies; (6) indices to research materials, (7) published picture collections, (8) published architectural archives, (9) video documentaries, (10) indices, and (11) serials. Most general references listed in other chapters also include architecture. Historic preservation is an important aspect of architectural research; these resources are annotated in Chapter 28. For architecture and the law, see *Legal Aspects of Architecture* [20:33].

Moreover, some resources listed in Chapter 24 on the decorative arts are also pertinent for architecture. For instance, those restoring houses may need to use the trade catalogues which were published by firms selling such items as architectural building plans as well as mirrors, furniture, ceramics, glassware, and wall coverings. For browsing, use the LC classification of NA; the Dewey Decimal, 720s. For a discussion of architectural research, see Chapter 9.

Two exceptional resource centers—the Avery Memorial Library, Columbia University, New York City and the Royal Institute of British Architects, known as RIBA, in London—continuously publish their library catalogues and provide detailed indexing to architectural serials. Other extensive collections include the Centre Canadien d'Architecture/Canadian Centre for Architecture, Montreal, and the American Institute of Architects, known as the AIA, Washington, D.C. The AIA has local offices in many cities in all fifty U.S. states. Their four bookstores—Washington, D.C.; Boston; Dallas; and Atlanta—not only carry important architectural resources but are often one of the few places that sell an extensive array of books on local and state building codes.

Dictionaries, Encyclopedias, and Guides

The references in this section are organized by (1) dictionaries and encyclopedias, (2) references concerned with construction terms and reading building plans, and (3) topographical guides and travel books. For archaeology and classical antiquities dictionaries, see Chapter 11.

Dictionaries and Encyclopedias

21:1 Baumgart, Fritz Erwin. *A History of Architectural Styles.* Trans. by Edith Kustner and J. A. Underwood. New York: Praeger, 1970.
Covers major styles; cites general characteristics, materials, major architects, and examples. Glossary and indices of personal names and buildings.

21:2 *Dictionnaire des Eglises de France,* Ed.-in-Chief, Jacques Brosse. Paris: Robert Laffont, 1966. 5 vols.
All styles and periods of French churches, divided by geographic location. Vol. 1 contains essays on church construction, stained glass, church furniture, religious iconography and symbolism, church liturgy, and five centuries of vandalism. Extensive dictionary of architectural terms.

21:3 *Encyclopedia of Architecture: Design, Engineering, and Construction.* Joseph A. Wilkes, Ed.-in-Chief. New York: John Wiley & Sons, 1988+ Projected 5 vols.
Terms, styles, and people.

21:4 *Encyclopedia of 20th Century Architecture.* New York: Abrams, 1987.

21:5 Fletcher, Sir Banister Flight. *A History of Architecture on the Comparative Method for Students, Craftsmen, and Amateurs.* 19th ed. rev. by J. C. Palmes. New York: Charles Scribner's Sons, 1987.
Architectural styles analyzed; includes influences, architectural characteristics, examples, comparative analyses, and list of references. Profusely illustrated; glossary. First edition 1896.

21:6 Harris, Cyril M. *Dictionary of Architecture and Construction.* New York: McGraw-Hill, 1975.

21:7 Hunt, William Dudley, *Encyclopedia of American Architecture*. New York: McGraw-Hill, 1980.
 Types and styles of architecture, construction materials, and elements, about 45 famous architects, and related material, such as Ecole des Beaux Arts, criticism, and ecology.

21:8 Pevsner, Nikolaus; John Fleming; and Hugh Honour. *Dictionary of Architecture*. Revised and enlarged. Baltimore: Penguin, 1975.
 Dictionary of terminology; includes brief biographies on architects. Hardcover edition of *The Penguin Dictionary of Architecture*.

21:9 ———. *An Outline of European Architecture*. rev. ed. Baltimore: Penguin, 1970.
 Covers from 6th century to present. Glossary of technical terms.

21:10 ———. *Studies in Art, Architecture, and Design*. New York: Walker and Company, 1968.
 Vol. 1: From Mannerism to Romanticism. Vol. 2: Victorian and After; reprint, 1982.

21:11 Polon, David D., ed. *Dictionary of Architectural Abbreviations, Signs, and Symbols*. New York: Odyssey, 1965.
 Includes signs for drawings, abbreviations on maps, graphic symbols depicted on structural drawings, and silhouettes used in rendering landscape architecture and city planning.

21:12 Stierlin, Henri. *Encyclopaedia of World Architecture*. New York: Facts on File, 1977. 2 vols.
 Architectural plans from ancient Egypt to the 1960s.

21:13 Sturgis, Russell. *A Dictionary of Architecture and Building: Biographical, Historical, and Descriptive*. New York: Macmillan, 1902; reprint, Detroit: Gale Research, 1966. 3 vols.
 Short biographies plus entries on terminology, famous buildings, and sites.

21:14 Whiffen, Marcus. *American Architecture Since 1780: A Guide to the Styles*. Cambridge, MA: M.I.T. Press, 1969.

Construction Terms and Building Plans

21:15 Brooks, Hugh. *Encyclopedia Dictionary of Building and Construction Terms*. Englewood Cliffs, NJ: Prentice-Hall, 1983.

21:16 *Construction Dictionary: Construction Terms & Tables*. rev. ed. Phoenix, AZ: National Association of Women in Construction, 1989.

21:17 *Elsevier's Dictionary of Building Tools and Materials: In Five Languages, Multi-lingual Glossary of Terms in English with French, Spanish, German and Dutch Translations*. New York: Elsevier Scientific, 1982.

21:18 Huntington, Whitney Clark, et al., *Building Construction Materials and Types of Construction*. 5th ed. New York: John Wiley & Sons, 1981.

21:19 Muller, Edward J. *Reading Architectural Working Drawings*. Englewood Cliffs, NJ: Prentice-Hall, 1988.
 Vol. 1: Basics, Residential, and Light Construction; Vol. 2: Commercial Construction.

21:20 O'Connell, William J. *Graphic Communications in Architecture*. Champaign, IL: Stipes, 1972.

21:21 Putnam, R. E. and G.E. Carlson. *Architectural and Building Trades Dictionary*. Chicago: American Technical Society, 1974; reprint, Reston, VA: Reston Publishing, 1984.
 Sections on legal terms and material sizes.

21:22 Schuler, Stanley. *Encyclopedia of Home Building and Decorating*. Reston, VA: Reston, 1975.

21:23 Schwicker, Angelo C. *International Dictionary of Building Construction: English, French, German, Italian*. New York: McGraw-Hill, 1972.

21:24 Stein, J. Stewart. *Construction Glossary: An Encyclopedic Reference and Manual*. New York: John Wiley & Sons, 1980.
 Organized by 16 divisions, such as site work, concrete, finishes, and electrical. Tables of abbreviations for scientific, engineering, and construction terms and of weights and measures.

21:25 Watson, Don A. *Construction Materials and Processes*. 3rd ed. New York: McGraw-Hill, 1986.

21:26 Weidhaas, Ernest. *Reading Architectural Plans for Residential and Commercial Construction*. 3rd ed. Boston: Allyn & Bacon, 1989.

Topographical Guides and Travel Books

Topographical guides and travel books that cover buildings and monuments in particular regions and countries are important to the study of architectural history. Changes in boundary lines and national affiliations frequently influenced the concepts

and building techniques of monuments. Many nations have financed or encouraged historical surveys. The Historical American Building Survey (HABS) [21:118 through 121] and the *Historic Buildings in Britain* [21:122] are cited below under the "Published Architectural Archives." For an extensive list of other topographical handbooks, see Ehresmann's *Fine Arts* [17:5]. This section is divided into (1) travel books and (2) atlases and maps.

Travel Books

Travel books, such as Baedeker and the Michelin Guide Series, often describe the appearance and condition of buildings, thus providing needed historic notations on which to determine alterations and restorations that might have taken place. Michelin adds detailed maps for locating difficult-to-find works. A representative list of some publishers who issue numerous guidebooks are cited below. The various countries and editions are not reported, but included is the date of earliest publication, which will assist researchers wishing to study specific changes in works of art before and after certain catastrophic events. Most of these publishers are still issuing new editions. There are other guidebooks, such as the ones from the various automobile clubs; these are not cited here.

21:27 Baedeker, Karl. *Baedeker Guides.* Leipzig: Baedeker, 1843 +
Individual books on cities, regions, and countries, especially of Europe. Special issues, such as *Guide to the Public Collections of Classical Antiquities in Rome,* trans. by Wolfgang Helbig, 1895.

21:28 *Companion Guide Series.* New York: Harper & Row; London: Collins.
Historical discussions of the art and architecture in specific localities. Detailed street maps provided.
.1 *Companion Guide to Paris,* Vincent Cronin, 1963.
.2 *Companion Guide to The South of France,* Archibald Lyall, 1963.
.3 *Companion Guide to Rome,* Georgina Masson, 1965.
.4 *Companion Guide to Venice,* Hugh Honour, 1966.
.5 *Companion Guide to Florence,* Eve Borsook, 1966.
.6 *Companion Guide to Tuscany,* Archibald Lyall, 1973.
.7 *Companion Guide to Southern Italy,* Peter Gunn, 1969.

.8 *Companion Guide to Umbria: Assisi, Perugia, Spoleto,* Maurice Rowdon, 1969.
.9 *Companion Guide to Greek Islands,* Ernie Bradford, 1963.
.10 *Companion Guide to Jugoslavia,* J. A. Cuddon, 1968.
.11 *Companion Guide Madrid and Central Spain,* Alastair Boyd, 1974.
.12 *Companion Guide to Southern Spain,* Alfondso Lowe, 1973.
.13 *Companion Guide to London,* David Piper, 1964.
.14 *Companion Guide to East Anglia,* John Seymour, 1970.
.15 *Companion Guide to the Coast of Northeast England,* John Seymour, 1974.
.16 *Companion Guide to The West Highlands of Scotland,* W. H. Murray, 1968.

21:29 *Historic Houses, Castles, & Gardens in Great Britain and Ireland.* London: Index Publishers, 1961 + Annual.

21:30 *Historic Houses, Castles, & Gardens of France.* Paris: Ministere de la Culture, 1975 + Annual

21:31 John Murray. *Handbooks.* London: John Murray, 1842 +
Individual books on European countries and India as well as a number of English shires.

21:32 *Michelin Guides.* Paris: Michelin, 1919 +
Green guides are to various regions in France as well as to international countries. In 1919 published book on areas of France during and after WW I.

21:33 Muirhead, Findlay, ed. *Muirhead Guide-Books.* London: Macmillan, 1920–30s.
Books on Europe and sections of France.

21:34 Murray, Peter and Stephen Trombley, eds. *Modern British Architecture Since 1945.* London: Frederick Muller, 1984.

21:35 *Nagel's Encyclopedia Guide.* Geneva: Nagel, 1967 +

21:36 *The National Register of Historic Places 1966–1988.* Nashville, TN: American Association of State & Local History, 1989.
Listing by state, followed by city or town, of all National Landmarks.

21:37 The National Trust, England, publishes books such as:
.1 *The National Trust Book of British Castles,* Paul Johnson. New York: G. P. Putnam's Sons, 1978.

.2 *The National Trust Book of Great Houses of Britain,* Nigel Nicolson. London: David R. Godine, 1978.

21:38 National Trust for Historic Preservation, United States. *America's Forgotten Architecture,* by Tony P. Wrenn and Elizabeth D. Mulloy. New York: Pantheon, 1976.

21:39 Pevsner, Nikolaus, ed. *Buildings of England.* London: Penguin, 1951–74. 46 vols.
> Arranged by shires or cities, volumes are usually classified individually by title— Cornwall, North Devon, Hampshire, Hertfordshire, London. Each volume consists of site by site travel guide to area. Provides historic background, maps, some photographs and floor plans, glossary, and selected reading list.

21:40 Smith, George Kidder. *The Architecture of the United States.* Garden City, NY: Anchor, 1981. 3 vols.
> Arranged by state, each chapter has map locating structures, listing of cities and buildings followed by entries providing location, name of architect, sometimes literary citations, and illustration of structure.

21:41 *Smithsonian Guide to Historic America Series.* New York: Stewart, Tabori, & Chang, 1989–90.
.1 *Virginia and the Capital Region,* Henry Wiencek
.2 *Southern New England,* Henry Wiencek
.3 *Mid-Atlantic States,* Michael Durham
.4 *Northern New England,* Vance Muse.
.5 *The Deep South,* William Bryant Logan
.6 *Great Lakes States,* Suzanne Winckler
.7 *Pacific States,* William Bryant Logan
.8 *Rocky Mountain States,* Jerry Dunn
.9 *Carolinas and the Appalachian States,* Patricia L. Hudson
.10 *Desert States,* Michael Durham
.11 *Texas and the Arkansas River Valley,* Alice Gordon
.12 *Plains States,* Suzanne Winckler

Atlases and Maps

See *Anchor Atlas of World History* [11:47]. Cultural atlases are cited under the appropriate chapters.

21:42 *Harper Atlas of World History.* New York: Harper & Row, 1987.

21:43 McEvedy, Colin. *Penguin Atlas Series.* Harmondsworth, Middlesex.
.1 *Penguin Atlas of Ancient History,* 1967.
.2 *Penguin Atlas of Medieval History,* 1961.
.3 *Penguin Atlas of Modern History (to 1815),* 1972.
.4 *Penguin Atlas of Recent History: Europe Since 1815,* 1982.

21:44 *Rand McNally Atlas of World History.* Chicago: Rand McNally, 1987.
> Revision of *Hamlyn Historical Atlas* (London: Hamlyn, 1981).

21:45 Reader's Digest Association. *Guide to Places of the World.* London: Reader's Digest Association, 1987.

21:46 Sachar, Brian. *An Atlas of European Architecture.* New York: Van Nostrand Reinhold, 1984.

21:47 *Sanborn Maps.* Pelham, New York: Sanborn Map Company.
> Dating from 1867 to present, maps provide street-by-street information for commercial, industrial, and residential districts of 12,000 cities and towns in U.S., Canada, and Mexico. *Fire Insurance Maps in the Library of Congress* (U.S. Government Printing Office, 1981) is checklist for holdings of some 11,000 volumes of Sanborn maps owned by L.C. Some maps are available on microfilm from L.C.

Biographical Dictionaries

Many of the references listed in Chapter 10 also include architects. This section is organized by (1) contemporary architects, (2) historically prominent architects, and (3) indices to biographical data on architects.

Contemporary Architects

21:48 American Institute of Architects. *Pro File: Professional File Architectural Firms.* Topeka, KA: Archimedia, 1983+ Annual until 5th ed. (1987/88) Now biennial.
> Official AIA Directory of firms and individual members. Includes addresses, types of organizations, years firms established, principal architects with professional affiliations and responsibilities, and numbers of personnel by disciplines—architects, interior designers, landscape architects, and engineers.

21:49 *Contemporary Architects,* 2nd ed. by Muriel Emanuel. New York: St. Martin's Press, 1987.
> Data on more than 400 internationally famous architects who worked from 1920 to 1980.

21:50 *Macmillan Encyclopedia of Architects,* ed. by Adlof Placzek. New York: Macmillan, 1982. 4 vols.
> Excellent biographical reference for 2,450 architects, planners, engineers, designers, landscape architects, and firms. Discussions of architects and their works; lists works with dates and locations. Covers from

ancient Egypt to persons born before 1931 or already deceased. Chronological table of architects and glossary of architectural terms.

Historically Prominent Architects

See *Macmillan Encyclopedia of Architects* [21:50].

21:51 Colvin, Howard Montagu. *A Biographical Dictionary of English Architects, 1660–1840.* London: John Murray, 1954. Rev. ed. includes Scotland and Wales, New York: Facts on File, 1980.
More than 1,000 architects; entries provide biographical data, lists of major architectural and design works, and brief bibliographies.

21:52 Harvey, John. *English Mediaeval Architects: A Biographical Dictionary Down to 1550, Including Master Masons, Carpenters, Carvers, Building Contractors, and Others Responsible for Design.* 2nd ed. Gloucester, England: Sutton, 1987.
Biographical entries relate some payments for work done and list bibliographical references. Includes (1) key to architects' Christian names; (2) tables of monetary remuneration; (3) topographical index; (4) indices to English counties, Welsh counties, and foreign countries; (5) chronological table; and (6) subject index of buildings.

21:53 Madden, Diane. *Master Builders: A Guide to Famous American Architects.* Washington, D.C.: National Trust for Historic Preservation, 1985.

21:54 Pehnt, Wolfgang, ed. *Encyclopedia of Modern Architecture.* Trans. rev. ed. by Barry Bergdoll. London: Thames & Hudson, 1986.
Originally published in 1963 as *Knaurs Lexikon der modernen Architektur*, ed. by Gerd Hatje.

21:55 Richards, James M., ed. *Who's Who in Architecture: From 1400 to the Present.* New York: Holt, Rinehart and Winston, 1977.
Consists of 50 long articles on prominent architects plus 450 shorter entries for less prominent people.

21:56 Sharp, Dennis. *Sources of Modern Architecture: A Critical Bibliography.* 2nd ed. Westfield, NJ: Eastview Editions, 1981.
Biographical and bibliographical references for about 125 architects.

21:57 Sturgis, Russell. *A Dictionary of Architecture and Building: Biographical, Historical, and Descriptive.* New York: Macmillan, 1902; reprint, Detroit: Gale Research, 1966. 3 vols.

21:58 Withey, Henry F. and Elsie Rathburn Withey. *Biographical Dictionary of American Architects (Deceased).* Los Angeles: Hennessey & Ingalls, 1965; reprint, 1970.
Entries for 2,000 architects living between 1740–1952; some literature references.

Indices to Biographical Data

See Vol. 1 of *Arts in America* [13:44] and Freitag's *Art Books* [10:72].

21:59 *Avery Obituary Index of Architects.* 2nd ed. Boston: G. K. Hall, 1980. One vol.
Covers about 17,000 people from 19th and 20th centuries; cites deceased's dates and serial where obituary published. Clipping file at Avery Library contains actual newspaper obituaries; copies may be requested.

21:60 Wodehouse, Laurence. *American Architects from the Civil War to the First World War: A Guide to Information Sources.* Detroit: Gale Research, 1976.
Annotated bibliographical references sometimes report locations of archival material.

21:61 ———. American *Architects from the First World War to the Present: A Guide to Information Sources.* Detroit: Gale Research, 1977.

21:62 ———. British *Architects 1840–1976: A Guide to Information Sources.* Detroit: Gale Research, 1979.

Architectural Surveys

For thoughts on recent research in this area, read Marvin Trachtenberg's "Some Observations on Recent Architectural History," *Art Bulletin* 70(June 1988): 208–41. Remember to check Chapters 11 and 12 for references on pertinent styles and Chapters 13 and 14 for those on special geographic areas. The various books in the *Pelican History of Art Series* are in those chapters.

21:63 Blaser, Werner, ed. *Drawings of Great Buildings.* Boston: Birkhauser, 1983.
Plans and elevations; all drawn to the same scale.

21:64 Davey, Norman. *A History of Building Materials.* London: Phoenix House, 1961.
Relates the development of building materials and construction techniques through the centuries. Section on building tools.

21:65 Harris, Cyril M. *Illustrated Dictionary of Historic Architecture Sourcebook.* New York: Dover, 1983.
Reprint of 1977 *Historic Architecture Sourcebook*

21:66 Harris, John and Jill Lever. *Illustrated Dictionary of Architecture, 850–1914.* London: Faber, 1989.
 Enlargement of 1967 *Illustrated Glossary of Architecture, 850–1830.*

21:67 Kostof, Spiro. *A History of Architecture: Settings and Rituals.* New York: Oxford University, 1985.

21:68 *History of World Architecture Series.* Pier Luigi Nervi, general ed., New York: Harry N. Abrams, 1971–1980. 14 vols.
 Well illustrated: good bibliographies. Contain synoptic tables and brief biographies.
 .1 *Primitive Architecture,* Enrico Guidoni, 1978.
 .2 *Ancient Architecture: Mesopotamia, Egypt, Crete, Greece,* Seton Lloyd, Hans Wolfgang Muller, and Roland Martin, 1975.
 .3 *Roman Architecture,* J. B. Ward-Perkins, 1977.
 .4 *Byzantine Architecture,* Cyril A. Mango, 1975.
 .5 *Romanesque Architecture,* Hans Erich Kubach, 1975.
 .6 *Gothic Architecture,* Louis Grodecki, 1978.
 .7 *Oriental Architecture,* Mario Bussagli et al., 1974.
 .8 *Pre-Columbian Architecture of Mesoamerica,* Paul Gendrop and Doris Heyden, 1975.
 .9 *Islamic Architecture,* John D. Hoag, 1977.
 .10 *Renaissance Architecture,* Peter Murray, 1971.
 .11 *Baroque Architecture,* Christian Norberg-Schulz, 1971.
 .12 *Late Baroque and Rococo Architecture,* Christian Norberg-Schulz, 1974.
 .13 *Neoclassical and 19th-Century Architecture,* Robin Middleton and David Watkin, 1980.
 .14 *Modern Architecture,* Manfredo Tafuri and Francesco Dal Co, 1979.

21:69 Pevsner, Nikolaus. *A History of Building Types.* Princeton, NJ: Princeton University, 1976.
 Discussion of 19th-century buildings for various uses—national monuments, government buildings, townhalls and law courts, theaters, libraries, museums, hospitals, prisons, hotels, banks, warehouses and office buildings, railway stations, exhibition halls, department stores, and factories.

21:70 Pierson, William. *American Buildings and Their Architects.* New York: Anchor, 1976.

21:71 Salzman, L. F. *Building in England Down to 1540: A Documentary History.* Oxford: Clarendon, 1952; reprint ed., 1967.
 History of building materials and processes. Appendix A, medieval writers on buildings, 675 AD to 1526; Appendix B, building contracts for 14th to 16th centuries provides notes on medieval English terms. Indices to persons and places and to subjects.

21:72 *World Atlas of Architecture.* Rev. and expanded. Boston: G.K. Hall, 1984.
 Translation of *Le Grand Atlas de l'Architecture,* 1981. Organized by architectural styles; some floor plans, synoptic tables of civilizations and architecture, and glossary.

Cost Guides, Standards, and Technical References

Only a few resources are cited here; for more information, ask the reference librarian for assistance.

21:73 American Institute of Architects. 1735 New York Avenue, N.W.; Washington, D.C. 20006. Publishes numerous works to assist practicing architects. Write for Member Resource Catalog for complete listing. These references include such items as *The Architects Handbook of Professional Practice, Architect's Handbook of Energy Practice,* and *Guide to Historic Preservation.*

21:74 ———. *Architectural Graphic Standards,* ed. by Robert T. Packard. 8th ed. New York: John Wiley & Sons, 1988.
 Emphasizes conservation of energy, designs for handicapped, environmental protection, anthropometric data, and metric system.

21:75 ———. *Problem Seeking: An Architectural Programming Primer,* 3rd ed. by William Pena, Washington, D.C.: AIA, 1989.

21:76 *Building Estimator's Reference Book,* 23rd ed. by R. Scott Siddens. Lisle, IL: Frank R. Walker, 1989.

21:77 *Craftsman Annuals.* Carlsbad, CA: Craftsman.
 .1 *Building Cost Manual,* 13th ed. by Susan Gibson, 1989.
 .2 *Electrical Construction Estimator: Current Labor and Material Cost Estimates for Residential, Commercial, and Industrial Work,* Edward J. Tyler, 1989.

21:78 DeChiara, Joseph. *Time-Saver Standards for Building Types.* 2nd ed. New York: McGraw-Hill, 1980.

Basic data on functional requirements of wide variety of building types. Criteria presented in graphic form, floorplans, sections, and charts.

21:79 *Dodge Building Cost Calculator and Valuation Guide.* Calculator, VA; Rosoff. Annual
Title has varied, once called *Dow Building Cost Calculation.* Cost figures are at low- to mid-range of competitive bidding. By choosing similar building to proposed project, and multiplying base cost of this type of construction by floor area of proposed structure, base cost can be figured. By then using "Local Building Cost Multipliers" index to find appropriate cost factor for city in which structure will be constructed and multiplying this number by base cost, approximate dollar amount for building can be calculated. Examples of older buildings are included.

21:80 *Dodge Manual for Building Construction Pricing and Scheduling.* Princeton, NJ: McGraw-Hill Information Systems, 1968+ Annual
Used to determine costs and man-hours required for projects. Organized into 16 subject divisions, such as site work, masonry, finishes, and furnishings. Productivity data derived from information from 20 large cities. Unit costs represent average.

21:81 Neufert, Ernest. *Architects' Data.* 2nd International English ed. New York: Halsted Press, 1980.
Concerned with spatial needs of people in buildings. Arranged under types of community and commercial type buildings, provides outline of uses for structure accompanied by floor plans, elevations, and technical diagrams concerned with human scale and design practices. Units of measurements vary; be sure to read explanations carefully. Uses mixture of British and American terms, but all British spellings. Index to terms plus extensive bibliography. More than 30 Germany editions; translated into 9 languages.

21:82 *Sweet's Catalog File.* New York: McGraw-Hill Information Systems, 1943+ Annual
Numerous volumes organized under specific titles, such as *Products for General Building, Products for Industrial Construction and Renovation and Renovation Extension, Products for Light Residential Construction, Products for Interiors, Products for Engineering,* and *Products for Canadian Construction.* All contain producers color advertising brochures. Lists of firms, products, and trade names.

21:83 Reznikoff, S.C. *Interior Graphic and Design Standards.* New York: Watson-Guptill, 1986.

21:84 *Time-Saver Standards for Architectural Design Data,* John Hancock Callender, ed.-in-chief. 6th ed. New York: McGraw-Hill, 1982.
Useful compilation of wide variety of standards and statistical information required in design process. Charts, tables, and schematic drawings are provided on such subjects as solar, angles, floor framing systems, skylights, and fire alarm systems.

21:85 *Wiley Series of Practical Construction Guides,* New York: John Wiley & Sons, 1973+
Publishes more than 20 books concerned with construction. Series includes such helpful guides as *Construction Measurements* by B. Austin Barry, *Construction Specification Writing* by Harold J. Rosen, and *Construction Bidding for Profit* by William R. Park. See *Architectural Graphic Standards* [21:74].

Architecture Bibliographies

This section is divided into (1) specialized bibliographies and (2) published architecture library catalogues. The bibliographies annotated in Chapters 11 through 14 usually include architecture.

Specialized Bibliographies

See *Arts in America: A Bibliography* [13:44]; Vol. 1 includes "Architecture." which contains sections on building types and bibliographical entries for pattern books and references on 18th- and 19th-century building materials and methods.

21:86 American Association of Architectural Bibliographers. *Papers.* Charlottesville: University Press of Virginia; New York: Garland. Paper 1 (1965)-Paper 13 (1979)//
References on various architects from 17th century to present. Some volumes are on one individual architect. Paper XI (1974) is cumulative index for Papers 1–10.

21:87 American Institute of Architects. AIA Library Bibliographies.
More than 300 bibliographies available on various subjects.

21:88 *Art and Architecture Information Guide Series.* Sydney Starr Keaveney, general ed. Detroit: Gale Research.
.1 *American Architecture and Art,* David M. Sokol, 1976.
.2 *American Architects from the Civil War to the First World War,* Lawrence Wodehouse, 1976.

.3 *American Architects from the First World War to the Present,* Lawrence Wodehouse, 1977.

.4 *British Architects, 1840–1976,* Lawrence Wodehouse, 1979.

.5 *Historic Preservation,* Arnold L. Markowitz, 1980.

.6 *Indigenous Architecture Worldwide,* Lawrence Wodehouse, 1980.

21:89 Ehresmann, Donald L. *Architecture: A Bibliographic Guide to Basic Reference Works, Histories, and Handbooks.* Littleton, CO: Libraries Unlimited, 1983.

21:90 *G.K. Hall Art Bibliographies Series.* Boston: G. K. Hall.

.1 *Andrea Palladio: An Annotated Bibliography,* by Carolyn Kolb, to be published

.2 *Byzantine Architecture: An Annotated Bibliography,* by W. Eugene Kleinbauer, to be published

.3 *Chartres Cathedral: An Annotated Bibliography,* by Jan van der Meulen, 1989.

21:91 *Garland Bibliographies of Architecture and Planning Series.* Arnold Markowitz, general ed. New York: Garland.

.1 *Frank Lloyd Wright: A Research Guide to Archival Sources,* Patrick J. Meehan, 1983.

.2 *Alvar Aalto: An Annotated Bibliography,* William C. Miller, 1984.

.3 *Ada Louis Huxtable: An Annotated Bibliography,* Lawrence Wodehouse, 1981.

.4 *Le Corbusier: An Annotated Bibliography,* Darlene Brady, 1985.

21:92 Hitchcock, Henry Russell. *American Architectural Books: A List of Books, Portfolios, and Pamphlets on Architecture and Related Subjects Published in America Before 1895.* Minneapolis: University of Minnesota, 1962.
Lists builders' guides, house pattern books, and other architectural books published in America before 1895. Most books listed have been reproduced in their entirety on microfilm; the set, entitled *American Architectural Books (Woodbridge, CT: Research Publications),* is available at some large libraries.

21:93 Holmes, Michael. *The Country House Described: An Index to the Country Houses of Great Britain and Ireland.* Winchester, England: St. Paul's Bibliographies, 1986.
More than 4,000 houses, and some royal palaces, in England, Wales, Scotland, and Ireland.

21:94 Kamen, Ruth H. *British and Irish Architectural History: A Bibliography and Guide to Sources of Information.* London: Architectural Press, 1981.
Annotated reference to societies, institutions, libraries, guides to architectural literature, and printed sources of architects and buildings.

21:95 Roos, Frank John, Jr. *Bibliography of Early American Architecture: Writings on Architecture Constructed Before 1860 in Eastern and Central United States.* Chicago: University of Illinois, 1968.
Includes 4,377 references divided as to general, colonial, Early Republican, New England, Middle Atlantic States, Southern States, North Central States, Architects—both general and about 40 specific architects and bibliographies of architectural references.

21:96 *Vance Architectural Bibliographies.* Monticello, IL: Vance Bibliographies.
More than 2,100 brief bibliographies—narrowly focused and of mixed quality—on all architectural subjects.

Published Architecture Library Catalogues

21:97 *The Burnham Index to Architectural Literature.* New York: Garland, 1989. 10 vols.
Begun in 1919 at the Art Institute of Chicago, indexes over 600 monographs and 200 serials; emphasis on Midwestern material. *Inland Architect* completely indexed; includes references to material in *Scrapbooks*—maintained 1920s–1960s—and microfilm archives, which was started in 1950s for important Midwestern projects and Midwest architects. Clippings available from library.

21:98 *Catalog of The Avery Memorial Architectural Library.* 2nd ed. Boston: G. K. Hall, 1968. 19 vols. *First Supplement,* 1973. 4 vols. *Second Supplement,* 1975. 4 vols. *Third Supplement,* 1977, 3 vols. *Fourth Supplement,* 1980. 3 vols.
Columbia University; covers architecture, archaeology, sculpture, mosaics, stained glass, tapestries, costume design, furniture design, ornament, interior decoration, and city planning. Files now added to *RLIN.*

21:99 *Catalogue of the Library of the Graduate School of Design.* Boston: G. K. Hall & Company, 1968. 44 vols. *First Supplement,* 1970. 2 vols. *Second Supplement,* 1974. 5 vols. *Third Supplement,* 1979, 3 vols.

Harvard University author-subject-title catalogue, covers bound serials and theses in 1968 publication; indexes designers. Covers broad scope of material, such as urban affairs, housing, zoning, pollution, and noise control.

21:100 Fowler, Laurence Hall and Elizabeth Baer. *The Fowler Architectural Collection of The Johns Hopkins University: Catalogue.* Baltimore: Evergreen House Foundation, 1961; reprint microform, Woodbridge, CT: Research Publications, 1982.

Fowler Architectural Collection, donated in 1945, has been supplemented by other gifts and includes 482 works by notable architects up to end of 18th century. Texts of all titles now available on microfilm from Research Publications.

21:101 *Catalogue of the Royal Institute of British Architects Library.* London: Royal Institute of British Architects, 1937–1938; reprint, London: Dawsons of Pall Mall, 1972. 2 vols.

Covers architecture and archaeology as well as such subjects as sculpture, mosaics, stained glass, tapestries, costume design, furniture design, ornament, interior decoration, and city planning. Since 1984, new book titles added to the RIBA Library are included in *Architecture Database* [21:126]. See 21:102 & 108.

21:102 *Royal Institute of British Architects.* London: World Microfilm, n.d. Microfilm.

Film of individual books, drawings, and serials in RIBA Library, such as *Comprehensive Index to Architectural Periodicals, 1956–1972; Microfilm Collection of Rare Books; Unpublished Manuscripts; Catalogue of the Great Exhibition, 1851; Transactions and Proceedings 1835–93;* and *Drawings Collection.*

Indices to Research Materials

Frequently, the local Tax or Records Office and the Map and Plat Center can be a profitable resource for architectural research. Often the age and square footage of a building can be located as well as the plot of the land, outline of the building, and owner's deed. Many of the resources cited in Chapter 13 include information on architectural materials; see the sections for archives and vertical files. All works cited below provide names, addresses, telephone numbers, scope of collections, major holdings—often giving names and dates of individual architects, plus institutions' admission policies and hours. COPAR (Cooperative Preservation of Architectural Records) also has a

"National Union Index to Architectural Records," a computerized file of more than 5,000 entries, including all of the material published below, except California. Write or phone for information. COPAR, Prints & Photographs Division, Library of Congress, Washington, D.C. 20540, (202) 707–8867.

21:103 California COPAR. *Architectural Records in the San Francisco Bay Area: A Guide to Research.* New York: Garland, 1988.

21:104 COPAR. *Architectural Research Materials in New York City: A Guide to All Five Boroughs.* New York: COPAR, 1977. Supplemented by *Index to the Architects and Architectural Firms Cited in "Architectural Research Materials in New York City,"* Mary M. Ison, 1981.

21:105 ———. *Architectural Research Materials in Philadelphia.* New York: COPAR, 1980.
Supplemented by *Index to the Architects and Architectural Firms Cited in "Architectural Research Materials in Philadelphia,"* Staff of LC Prints & Photographs Division.

21:106 Cummings, Kathleen Roy. *Architectural Records in Chicago: A Guide to Architectural Research Resources in Cook County and Vicinity,* Chicago: Art Institute of Chicago, 1981.

21:107 Hanford, Sally. *Architectural Research Materials in the District of Columbia.* Washington, D.C.: American Institute of Architects Foundation, 1983.

21:108 *Royal Institute of British Architects: A Guide to Its Archives and History,* Angel Mace. London: Mansell, 1986.

The archives are available only at the RIBA London library. Biography File is a vertical file system covering 10,000 architects and architectural historians; includes clippings from *The Times* of London and correspondence of the individuals. Periodical File Index, which has been kept since 1900, includes illustrations of works by RIBA members.

21:109 Schrock, Nancy Carlson, ed. *Architectural Records in Boston: A Guide to Architectural Research in Boston, Cambridge, and Vicinity.* New York: Garland, 1983.

Published Picture Collections

See published picture collections annotated in Chapter 19, the *Drawings of Robert and James Adam* [24:91], and *Index of American Design* [24:92].

21:110 *Ancient Roman Architecture.* Rome: Fototeca Unione American Academy in Rome. Distributed by University of Chicago, 1982+ Issued in 3 Parts. Microfiche.

Housed at American Academy in Rome, photographs are divided into 3 sections: Rome, Italy, and The Empire. Alphabetized by name of site—except for last section which is arranged by name of modern country followed by site, each photograph is labelled and has a bibliographical reference plus date photograph taken. Prints can be purchased from the American Academy in Rome. Set 1 contains about 14,000 images; Set 2, about 12,000; Set 3, 12,000 images. *Index to Ancient Roman Architecture,* published in 1982.

21:111 *Armenian Architecture: A Documented Photo-Archival Collection on Microfiche.* Zug, Switzerland: Inter Documentation, 1980+ Microfiche.

Five volumes of this quality production are planned to include architecture of Transcaucasia and Near and Middle East covering the historic periods from Medieval to present. Text of Volume I has brief introduction to Armenian architecture; discussions of Armenian language, geographical features of Caucasus and Anatolia, and Armenian history accompanied by historical maps; glossary of Armenian terms; and bibliography. For each building, provides old and recent photographs and engravings, if possible; location map; floor plan; elevation; drawings; plus brief history.

21:112 *Bibliothèque Nationale: Architecture and Early Photography in France.* London: Mindata, n.d. Microfiche.

Includes two collections: (1) *Architecture and Monuments in France,* 17,000 photographs (late 19th-century) alphabetized by French departments with topographical index, and (2) *Paris Views and Early Photography in France,* more than 6,000 photographs.

21:113 *Bibliothèque Nationale: Collections of the Departments of Prints and Photographs.* Paris: Studios Photographiques Harcour, n.d. Microfiche.

This department now has 250,000 images, some of which are reproduced on microfiche and sold in sets, such as *Destailleur Collection: 18th and 19th Century Drawings,* French architectural and sculptural details made by such artists as Hubert Robert and Jongkind. *Topographie de la France* contains architectural surveys dating from 17th century, drawings, engravings, press clippings, and photographs.

21:114 *Royal Institute of British Architects: The Drawings Collection.* London: World Microfilms, 1969+ Microfilm.

Volumes have been issued are on individual architects. Use with *Catalogue of the Drawings Collection of the Royal Institute of British Architects* (London: Gress International, 1969).

21:115 *Victoria and Albert Museum: English Architectural Drawings.* London: Microform, n.d.

More than 4,000 architectural designs by such men as Christopher Wren and Robert Adam.

Published Architectural Archives

Begun in 1933, the Historic American Buildings Survey, called HABS, is one of largest collections of architectural records in the world. Available in books or microforms, as cited below, single prints can be ordered from the Photoduplication Service, Library of Congress, Washington, D.C. 20540. For information on HABS, see Chapter 9; on the LC collection, consult "Library of Congress Prints and Photographs Collection" in Chapter 22. The following publications reproduce the actual material, which usually consists of architects' drawings and plans.

21:116 *Dunlap Society Visual Archives.* Princeton, NJ: Princeton University Press. Microfiche.

Quality production; detailed captions and printed text. Slides or prints can be ordered from The Dunlap Society, Lake Champlain Road, Essex, New York 12936.

.1 *The Architecture of Washington, D.C.* 2 vols.

.2 *The County Court Houses of America.* 2 vols.

21:117 *Garland Architectural Archives Series,* New York: Garland.

.1 *Le Corbusier Archive,* 1982. 32 vols.

.2 *Louis I. Kahn Archive,* 1987. 7 vols.

.3 *Mies van der Rohe Archive: An Illustrated Catalogue of the Mies van der Rohe Drawings in the Museum of Modern Art,*
Part I: 1907–1938, 1986. 4 vols.
Part II: 1938–1969, in progress.

.4 *Holabird & Roche & Holabird & Root: A Catalogue of Works,* 1880–1940, to be published.

21:118 *HABS: Catalog of the Measured Drawings and Photographs of the Survey in the Library of Congress, March 1, 1941.* New York: Burt Franklin, 1941, reprint, 1971.

21:119 *HABS: Virginia Catalog: A List of Measured Drawings, Photographs, and Written Documents from the Survey,* Virginia Historic Landmarks Commission, 1975.

21:120 *Historic American Buildings Survey.* U.S. Library of Congress. New York: distributed by Chadwyck-Healey, 1980s. Microfiche. All states available.

21:121 *Historic American Buildings.* New York: Garland.
Reproduces HABS drawings and includes photographs of many buildings. Published *California,* 4 vols., 1980; *New York (State),* 8 vols., 1979; *Texas,* 2 vols., 1979.

21:122 *Historic Buildings in Britain.* New York: Chadwyck-Healey, 1977. Microfiche.
The Royal Commissions on Historic Monuments in England, Scotland, and Wales was commissioned to inventory all notable buildings recommended for preservation and constructed before 1700, a date later changed to 1850. Although not every area of Britain was covered, 65 volumes on various parishes and cities have been published. These inventories provide detailed descriptions of the monuments as well as visual materials—photographs, line drawings, maps, and floor plans. Divided by parishes, entries are subdivided under prehistoric monuments, Roman monuments, ecclesiastical buildings, secular buildings, and unclassed monuments. Glossaries of heraldic, archaeological, and architectural terms, plus indices to names and subjects. Can be purchased separately by shires.

21:123 *Inigo Jones: Complete Architectural Drawings,* by John Harris and Gordon Higgott. London: Zwemmer, 1989.

21:124 Wren Society. London. *Catalogue of Sir Chr. Wren's Drawings.* Oxford: Oxford University, 1924–43. 20 vols.

Video Documentaries

The American Institute of Architects has more than 100 videotapes for rental, both to members and non-members. Some programs are professionally edited tapes of AIA convention programs. Subjects include (1) individual architects—such as Antonio Gaudi, Mies van der Rohe, Philip Johnson and Richard Meier; (2) architecture—such as *Japan: Three Generations of Avant Garde, Proud Towers,* and *Rousing Home Renovations;* (3) concerns of the discipline—such *The Street, Good Design Means Good Business,* and *Architecture: The 80's and Beyond;* and (4) the business side of the profession—such as *Getting Paid, How to Bid for Design Work,* and *How to Price Design Services.* For videotapes on historic periods, see Chapters 11 and 12.

The Movie Palaces, Smithsonian Institution, 1987.
The Centre Georges Pompidou, Adrian Maben, RM Arts Program, 1987.
Frank Lloyd Wright: Prophet Without Honor, Public Television Library, 1977.

Indices

Most indices cited in Chapter 16 also cover architecture. See *Canadian Architectural Periodicals Index 1940–1980* [13:97]. Avery [21:127] and RIBA [21:126] are discussing collaborating to improve coverage of both services.

21:125 *Architecture Index.* Boulder, CO: Architectural Index, 1950+
Annual index covering 8 to 10 serials, most of which are covered by *Art Index* [16:1].

21:126 *Architectural Periodicals Index.* London: Royal Institute of British Architects, 1973+
Publication of one of world's outstanding architectural libraries. Since 1933, British Architectural Library of the Royal Institute of British Architects, known as RIBA, has published an index to architectural serials. From 1933 until 1972, data was published in quarterly, *RIBA Library Bulletin.* In 1967 *RIBA Annual Review of Periodical Articles* was published. Vol. 1 (1965–66) recorded all references listed in volume 20 of the *RIBA Library Bulletin.* In 1972, index changed to present name and given new volume numbers. Published quarterly with cumulative last issue. Prior to 1978, only cumulative issues contained index of authors, architects, and planners. Since 1978, cumulative edition has topological index to names of buildings. Indexes more than 500 international serials; covers engineering and construction.

The Architecture Database, DIALOG, File 179, files since 1978, for this periodical index; since 1984, the book catalogue [21:101] entries have also been included.

21:127 *Avery Index to Architectural Periodicals.* 2nd ed. Boston: G.K. Hall, 1973. 15 vols. One vol. supplements +
Avery Library contains one of world's finest architectural collections. Begun in 1934; indexed some serials from first publication date: *American Architect,* 1876; *Architectural Forum,* 1892; *Architectural Record,* 1891; *Progressive Architecture,* 1920.

On-line Avery Index to Architectural Periodicals Database, RLIN, files since 1977.
Avery Index to Architectural Periodicals Database, DIALOG, File 178, files since 1977.

21:128 *Engineering Index: Engineering's First and Most Comprehensive Collection of Time Saving Abstracts on Worldwide Developments in All Related Disciplines.* New York: Engineering Index. Volume 1 (1884–1891)+
Monthly publication with annual cumulation; 1975 annual edition (Volume 74) composed of four books. A subject index to about 2,000 serials and 1,000 conference reports Use *Thesaurus of Engineering and Scientific Terms* (New York: Engineers Joint Council, 1967).

COMPENDEX Database, DIALOG, Files from 1970, updates monthly. BRS, File (COMP) from 1976, updates monthly.

Serials

Remember to check the list of publications under the various styles and cultures listed in Chapters 11 through 14. Below are some of the important architectural serials, many of which are covered by the major art abstracting and indexing services.

American Architect 1876–1938// (Titled *American Architect's Building News* 1876–1908 and *American Architect and the Architectural Review*, 1921–24; merged with *Architectural Record*, 1938).
Architect 1854–1980//
Architectura 1971+
Architectural Digest 1925+
Architectural Forum 1892–1974//
Architectural History, Society of Architectural Historians of Great Britain 1958+
Architectural Record 1891+ (Merged with *American Architect*, 1938)
Architectural Review 1896+
Architecture, American Institute of Architects 1944+
Architecture Canada, Royal Architectural Institute of Canada (328 Somerset Street West, Ottawa, Ontario K2P OJ9), 1924–73// (Titled *RAIC Journal* 1924–66)
Architecture Concept 1945+ (Titled *Architecture-Batiment-Construction* 1945–68)
L'Architecture d'aujourd'hui 1930+
The Canadian Architect 1955+ (Absorbed *Royal Architectural Institute of Canada Bulletin*)
Inland Architect 1957+
Japan Architect 1925+
Journal of the Society of Architectural Historians, Society of Architectural Historians (1232 Pine Street, Philadelphia, PA 19107) 1941+
Lotus International 1964/65 (Titled *Lotus* 1964/65–1974)
Palladio 1937+
Progressive Architecture 1920+

CHAPTER 22

Prints and the Art of the Book

This chapter is divided into (1) biographical dictionaries and directories, (2) historical surveys and books on techniques, (3) index to American print exhibitions, (4) references on watermarks which can be used to date prints and drawings, (5) a guide to marketing current work, (6) bibliographies of prints and artists' books, (7) Library of Congress Prints and Photographs Collection, (8) published print collections, and (9) print serials. The documentation of fine art prints is to a large degree provided by exhibition and museum collection catalogues. These catalogues are not included in this guide; however, for sources for locating them, see Chapter 3. For graphic arts encyclopedias, see Chapter 27. Some subject-indexing projects cited in Chapter 19 cover the graphic arts; see *DIAL* [19:25], *Index Iconologicus* [19:28], *Print Index* [19:36], and *Iconclass Indexes* [19:39]. For a detailed listing of references on print of various countries, see *Arntzen & Rainwater* [17:1]. For browsing, use the LC classification number NE; Dewey Decimal, 760s.

Biographical Dictionaries and Directories

In order to compile an adequate chronology, a number of references cited below will need to be consulted, because most resources provide only brief biographical entries. Material can also be located in the catalogues of museums with large print collections, such as the Library of Congress [17:21]. Many general references cited elsewhere in this book—such as Mantle Fielding's dictionaries [13:13], *Who's Who in American Art* [10:50] and *Who Was Who in American Art* [13:18]—provide material on prints and graphic artists. Remember to check them. This section is divided into resources on (1) contemporary printmakers, (2) historically prominent printmakers, and (3) a discussion of methods of illustrating and subject accessing the material in Bartsch.

Contemporary Printmakers

The references cited here provide biographical information as well as data on commercial firms. Also see *Artist Biographies Master Index* [10:70], *Contemporary Designers* [10:32], *Who's Who in American Art* [10:50].

22:1 Adams, Clinton. *American Lithographers, 1900–1960: The Artists and Their Printers.* Albuquerque: University of New Mexico, 1983.
Details on national and regional movements, clubs, and techniques.

22:2 American Institute of Graphic Arts. *Membership Directory.* New York: American Institute of Graphic Arts.

22:3 Amstutz, Walter. *Who's Who in Graphic Art: An Illustrated World Review of the Leading Contemporary Graphic and Topographic Designers, Illustrators, and Cartoonists.* Zurich: Amstutz & Herdeg, Graphis Press, 1962.

22:4 ———. *Illustrated World Review of Leading Contemporary Graphic Designers.* Dubendorf, Switzerland: De Clivo, 1982.

22:5 *Printworld Directory of Contemporary Prints and Prices.* Bala-Cynwyd, PA: Printworld, 1982.

Historically Prominent Printmakers

During the 18th century, prints for the first time were systematically classified according to schools and individual artists. Much of this organizational work was devised by the Austrian engraver, Adam von Bartsch, who for over 40 years worked with the print collection in Vienna's Imperial Library. The scholarly catalogues compiled by Bartsch set the standard for subsequent print research. Between 1808 and 1821, Bartsch published *Le peintre-graveur* [22:9], 21 volumes which contained descriptions of Flemish, Dutch, German, and Italian prints—engravings, etchings, and woodcuts. A second edition, which was published in 1854–70,

included some additions and corrections to Bartsch's monumental work. In literature and sales catalogues, Bartsch's print numbers are still used for the identification of specific prints.

Other scholars followed Bartsch's lead; for instance, Robert-Dumesnil's *Le peintre-graveur français, 1835–71* [22:22] is an 11-volume work that follows Bartsch's organizational scheme. Some others are Andresen [22:6 & 7], Passavant [22:19], and Weigel [22:25]. Each of these complement Bartsch's work but cover different countries and time periods. The greatest liability to Bartch's work is the lack of illustrative material. During the 20th century, several projects were initiated to correct this deficiency; they are discussed below under "Illustrated Bartsch." Also remember to consult the works cited under "Designations and Signatures of Artists and Collectors," in Chapter 10, especially Lugt's *Les marques de collections de dessins et d'estampes* [10:80].

22:6 Andresen, Andreas. *Der deutsche Peintre-Graveur; oder, Die deutschen Maler als Kupferstecher nach ihrem Leben und ihren Werken, von dem letzten Drittel des 16. Jahrhunderts bis zum Schluss des 18. Jahrhunderts.* Leipzig: Rudolph Weigel, 1864–78; reprint, New York: Collectors, 1969. 5 vols.
 Covers 140 German engravers working from 1560–1800. Initials used by engravers either precede article or are found at end of volume under "Monogrammel Tafel." Last volume has general index.

22:7 Andresen, Andreas. *Die deutschen Maler-Radirer (peintres-graveurs) des neunzehnten Jahrhunderts., nach ihren Leben und Werken.* Leipzig: von Rudolph Weigel, 1866–70; reprint, New York: Georg Olms, 1971. 5 vols.
 Over 70 German 19th-century engravers.

22:8 Baker, Charles. *Bibliography of British Book Illustrators 1860–1900.* Birmingham, England: Birmingham Bookshop, 1978.
 Includes biographical data.

22:9 Bartsch, Adam von. *Le peintre graveur.* Vienne, France: Degen,1802–21; reprint, Leipzig: Barth, 1854–76; reduced size reprint ed., Nieuwkoop, Holland: B. de Graaf, 1982. 21 vols in 4.
 Covers more than 500 artists working between the 15th and 18th centuries; 200 of whom were either unknown or were known only by initials. Under artist's name has brief biographical sketch and discussion of printmaker's œuvre, with most prints arranged by media and subjects. For each print, there is a description, dimensions in ancient French measurement system, sometimes data inscribed on print, and information concerning states and editions. Prints organized: (1) original prints subdivided by biblical subjects, saints, history and allegories, fictitious subjects, and portraits; (2) prints based upon other artists' works; (3) doubtful attributions; (4) prints made after artist's drawings but engraved anonymously; and (5) prints based upon artist's drawings but engraved by someone else.
 Vols. 1–5, Dutch and Flemish; Vols. 6–11, German; Vols. 12–21, Italian masters plus supplements to other volumes. See "Illustrated Bartsch" below for discussion.

22:10 Baudicour, Prosper de. *Le peintre-graveur français continué, ou Catalogue raisonné des estampes gravées par les peintres et les dessinateurs de l'école française nés dans le XVIIIᵉ siècle, ouvrage faisant suite au Peintre-graveur français de M. Robert-Dumesnil.* Paris: Bouchard-Huzard, 1859–61. 2 vols.
 Covers 60 18th-century French engravers; artists not placed in alphabetical order; use table of contents in front of each volume.

22:11 Beraldi, Henri. *Les graveurs du XIXe siècle: guide de l'amateur d'estampes modernes.* Paris: L. Conquet, 1885–95; reprint, Nogent-le-Roi, France: Jacques Laget L.A.M.E., 1981. 12 vols. in 10 books.

22:12 Delteil, Loys. *Le peintre-graveur illustré (XIX et XX siècles).* Paris: Chez l'auteur, 1906–1930; reprint, New York: Collectors Editions, and DaCapo Press, 1969. 31 vols. *Appendix and Glossary.* Under supervision of Herman J. Wechsler. New York: DaCapo, 1969.
 Illustrations of works by 31 artists; includes chronologies and brief biographical data.

22:13 Engen, Rodney K. *Dictionary of Victorian Engravers, Print Publishers and Their Works.* Teaneck, NJ: Chadwyck-Healey, 1980.

22:14 ———. *Dictionary of Victorian Wood Engravers.* Teaneck, NJ: Chadwyck-Healey, 1985.

22:15 *The German Single-Leaf Woodcut*
 .1 *1500–1550,* by Max Geisberg, rev. & ed. by Walter L. Strauss. New York: Hacker, 1974. 4 vols. Trans. of *Der deutsche Einblatt Holzschnitt, 1923–30.*
 .2 *1550–1600,* by Walter L. Strauss. New York: Abaris, 1975. 3 vols.
 .3 *1600–1700: A Pictorial Catalogue,* by Dorothy Alexander in collaboration with Walter L. Strauss. New York: Abaris, 1977. 2 vols.

22:16 Hind, Arthur M. *Early Italian Engraving: A Critical Catalogue with Complete Reproductions of All the Prints Described.* New York: Knoedler, 1938–48, reprint, Nendeln, Liechtenstein: Kraus, 1970. 7 vols. in 4 books.

22:17 Hollstein, F.W.H. *Dutch and Flemish Etchings, Engravings, and Woodcuts, ca. 1450–1700.* Amsterdam: Menno Hertzberger, 1949+ 32 Vols. have been published.
 Illustrated; includes brief biographies and literary references.

22:18 ———. *German Engravings, Etchings, and Woodcuts, ca. 1400–1700.* Amsterdam: Menno Hertzberger, and A. L. van Gendt, 1954.
 Same format as 22:17.

22:19 Passavant, Johann David. *Le peintre-graveur: Contenant l'histoire de la gravure sur bois, sur métal et au burin jusque vers la fin du XVI. siècle. L'histoire du nielle avec complément de la partie descriptive de l'Essai sur les nielles de Duchesne aîné. Et un catalogue supplémentaire aux estampes du XV. et XVI. siècle du Peintre-graveur de Adam Bartsch.* Leipzig: Weigel, 1860–64; reprint, New York: Burt Franklin, 1970. 6 vols. in 3 books.
 History of engraving through 16th century. Each volume has artist index and facsimiles of monograms.

22:20 Portalis, Baron Roger and Henri Beraldi. *Les graveurs du dix-huitième siècle.* Paris: Morgand et Fatout, 1880–82; reprint, New York: Burt Franklin, 1970. 3 vols.

22:21 Reese, Albert. *American Prize Prints of the 20th Century.* New York: American Artists Group, 1949.

22:22 Robert-Dumesnil, A. P. F. *Le peintre-graveur français, ou Catalogue raisonné des estampes gravées par les peintres et les dessinateurs de l'école française.* Paris: Gabriel Warée, 1835–71; reprint, Paris: F. Nobele, 1967. 11 vols.
 Vol. 11, supplement by Georges Duplessis, contains general index.

22:23 Stauffer, David McNeely and Mantle Fielding. *American Engravers Upon Copper and Steel.* New York: Burt Franklin, 1964. 3 vols.
 Parts 1 and 2 by Stauffer cover about 700 artists and were originally published in 1907. Part 3, by Fielding, is addendum of about 120 artists.

22:24 Strutt, Joseph. *A Biographical Dictionary: Containing an Historical Account of All the Engravers, from the Earliest Period of the Art of Engraving to the Present Time, and a Short List of Their Most Esteemed Works.* London: J. Davis, 1785–86; reprint, Geneva, Switzerland: Minkoff, 1972. 2 vols. in one book.
 Facsimiles of monograms and index to engravers' initials. Last volume has chronological list of principal engravers active from 1450 to 1770.

22:25 Weigel, Rudolph. *Suppléments au peintre-graveur de Adam Bartsch.* Leipzig: Weigel, 1843.

22:26 Zigrosser, Carl. *The Artist in America: Twenty-four Close-ups of Contemporary Printmakers.* New York: Knopf, 1942, microform reprint, 1987.

Illustrated Bartsch

Bartsch's original volumes—and other catalogues based upon his work—contain no illustrations and no subject indices. To rectify this situation, there are several special reference tools: (1) the Warburg Institute project, (2) *The Illustrated Bartsch,* (3) *Index Iconologicus* [19:28], and (3) *Iconclass Indexes* [19:39]. The last two resources, which can be used as subject indices to Bartsch's volumes, are discussed in chapter 7.

In the 1950s, London's Warburg Institute [11:87] and the Institute of Fine Arts, New York City, photographed prints which were owned by the British Museum and the Metropolitan Museum of Art to create illustrations for Bartsch's work. Each reproduction is a 4 3/4" by 6 1/2" glossy photograph. Many North American and European institutions, which subscribed to this project, filed their reproductions according to Bartsch's original organizational scheme. The Warburg Institute created 2 files: one using Bartsch's order; the other, a key-word subject classification scheme. The Institute of Fine Arts also used a subject approach. For more information, read Evelyn Samuel "The Illustrated Bartsch: Approaches to the Organization of Visual Materials," *Visual Resources* 1(Spring 1980): 60–66.

22:27 *The Illustrated Bartsch: Le Peintre-Graveur Illustre.* Walter L. Strauss and John Spike, general eds. New York: Abaris Books, 1979+
 Multi-volume work of projected 175 books, which when completed will provide reproductions for all 20,000 European prints discussed in Bartsch and supplement and update his material. There are also supplementary books which cover artists omitted by Bartsch or active after his death.

A comprehensive index has been publicized; but until it is published *Index Iconologicus* [19:28], and *Iconclass Indexes* [19:39] provide limited subject indexing to Bartsch's volumes.

Illustrated Bartsch is organized into (1) the illustration volumes or Picture Atlases and (2) the corresponding Commentary volumes. The former reproduce the prints described in Bartsch. The latter provide detailed entries for each print. The prints in the Picture Atlases correspond to Bartsch's work in organization and entry numbers, but Bartsch's original broad subject headings are not reprinted. For each illustration there is a brief caption, such as

"2 (11) Moses with the Tablets of the Law (Moyse et les tables de la loi) 1583 [SG. 168] 574 × 423. Haarlem, New York (MM), Rotterdam."

The 2 is the Bartsch's number; (11) refers to the page number in Bartsch's publication. The English title is followed by the original French one; the print was made in 1583. The [SG. 168] is the number this print has in Walter Strauss' 1977 publication, which is explained at the beginning of the volume. All sizes—in this case the 574 x 423—are in millimeters, height before width. The last references are institutions which own impressions of the print, one of which is the Metropolitan Museum in New York City.

In the Commentary volumes, there are brief biographical sketches. For works no longer attributed to the artists, the numbers are placed in brackets. Prints not cited by Bartsch are inserted in the proper iconographic sequence: Old Testament, Christ, the Virgin, Holy family, Saints, Classical and mythological subjects, landscapes, portraits, and coats of arms. Commentary Volumes include such items as reproductions of watermarks, chronological tables, concordances of Bartsch's numbers to other publications, and indices to subjects and people. The numbers of the volumes of *Illustrated Bartsch* have expanded beyond the numbers used by Bartsch. There has been published criticism of the scholarship of a few volumes in this momentous undertaking. See V. Birke's "Towards a Tempesta Catalogue," *Print Quarterly* 2(1985): 205–18 and the 3rd volume of *Iconclass Indexes* [19:39].

Historical Surveys and Techniques

22:28 Bland, David. *A History of Book Illustration.* 2nd ed. London: Faber & Faber, 1969.

22:29 Castleman, Riva. *Prints of the Twentieth Century: A History.* Rev. and enlarged. New York: Thames & Hudson, 1988.
Important print survey of various 20th-century styles, such as Expressionism, Cubism, non-objective art, Dada and Surrealism, Pop Art, as well as Op, Kinetic, Concrete, Conceptual.

22:30 Eichenberg, Fritz. *The Art of the Print: Masterpieces, History, Techniques.* New York: Abrams, 1976.
Encyclopedic reference covering every technique from 15th-century Far Eastern prints to those of the present.

22:31 Gascoigne, Bamber. *How to Identify Prints: A Complete Guide to Manual and Mechanical Processes from Woodcut to Jet Ink.* New York: Thames and Hudson, 1986.
Print vocabulary in appendix refers to examples in text.

22:32 Harthan, John. *A History of the Illustrated Book: The Western Tradition.* New York: Thames & Hudson, 1981.

22:33 Hind, Arthur Mayger. *A History of Engraving and Etching: From the 15th Century to the Year 1914.* 3rd ed. revised. Boston: Houghton, Mifflin, 1923; reprint, New York: Dover, 1963.
Illustrated history with extensive bibliography, index of monographs on famous engravers, and list of engraving collections accompanied by a list of their catalogues. Includes classified list of engravers arranged chronologically under various geographic locations.

22:34 ———. *An Introduction to a History of Woodcut With a Detailed Survey of Work Done in the Fifteenth Century.* Boston: Houghton Mifflin, 1935; reprint, New York: Dover, 1963.
Vol. 1: The Primitives, Single Cuts, and Block-Books. Vol. 2: Book-Illustration and Contemporary Single Cuts. Illustrated history with extensive bibliographies. Indices to designers and engravers, printers and publishers, books illustrated with woodcuts, and subjects.

22:35 Hirth, George. *Picture Book of the Graphic Arts 1500–1800.* Munich: Knorr & Hirth, 1882–90; reprint, New York: Benjamin Blom, 1972. 6 vols.

22:36 Ivins, William M., Jr. *How Prints Look: Photographs With a Commentary.* New York: Metropolitan Museum of Art, 1943; rev. ed. by Marjorie B. Cohn. Boston: Beacon, 1987.

22:37 Johnson, Una E. *American Prints and Printmakers.* Garden City, NY: Doubleday, 1980. Covers from 1900.

22:38 Lumsden, Ernest S. *The Art of Etching: A Complete and Fully Illustrated Description of Etching, Drypoint, Soft-Ground Etching, Aquatint and Their Allied Arts, Together with Technical Notes upon Their Own Work by Many of the Leading Etchers of the Present Time.* London: Seeley Service, 1924; reprint, New York: Dover, 1962.

22:39 Mayor, Alpheus Hyatt. *Prints and People: A Social History of Printed Pictures.* New York: Metropolitan Museum of Art, 1971; reprint, Princeton, NJ: Princeton University, 1980.

22:40 Museum of Fine Arts, Boston. *The Artist & the Book: 1860–1960 in Western Europe and the United States.* Boston: Museum of Fine Arts, 1961; reprint, 1972.
Extensive bibliography.

22:41 Saff, Donald and Deli Sacilotto. *Printmaking: History and Process.* New York: Holt, Rinehart and Winston, 1978.

22:42 Watrous, James. *American Printmaking: A Century of American Printmaking, 1880–1980.* Madison: University of Wisconsin, 1984.

22:43 Wilder, F. L. *How to Identify Old Prints.* London: G. Bell and Sons, 1969.

22:44 Zigrosser, Carl and Christa M. Gaehde. *A Guide to the Collecting and Care of Original Prints.* New York: Crown, 1965.

Index to American Print Exhibitions

22:45 Wilson, Raymond L. *Index of American Print Exhibitions, 1882–1940.* Metuchen, NJ: Scarecrow Press, 1988.
Arranged by exhibiting organization followed by artist's name and works displayed. Covers New York Etching Club, Chicago Society of Etchers, California Society of Etchers, Printmakers Society of California, Brooklyn Society of Etchers, Fine Prints of the Year, Fifty Prints of the Year, Panama-Pacific International Exposition, Victoria & Albert Museum, and New York World's Fair. Not all institutions had annual exhibitions. Index to artists.

Watermarks

Watermarks are impressed or incorporated into sheets of paper to designate their markers or manufacturers. These help determine the location and approximate dates of works on paper.

22:46 Briquet, Charles Moise. *Les filigranes: Dictionaire historique des marques du papier des leur apparition vers 1282 jusqu'en 1600.* 2nd ed. Paris: A. Picard & Fils, 1907; reprint, New York: Hacker Art Books, 1985. 4 vols.
Over 16,000 facsimiles of watermarks used from 13th through 15th century. Entries for each watermark are listed under descriptions of watermarks, such as "Tête de Boeuf," "Sphere," "Pot à une anse," and "Cercle." At end of each volume are line drawings of the watermarks. Fourth volume contains indices to principal subjects, paper makers, paper manufacturers, and names of papers.

22:47 Churchill, William Algernon. *Watermarks in Paper in Holland, England, France, etc., in the XVII and XVIII Centuries and Their Interconnection.* Amsterdam: Menno Hertzberger & Company, 1935; reprint, Meppel, Netherlands: Krips Reprint, 1967.
Reproduces 578 watermarks used from 1635 to 1800. Brief history of European watermarks and papermakers during 17th and 18th centuries.

22:48 Hunter, Dard. *Papermaking: The History and Technique of an Ancient Craft.* 2nd ed. rev. and enlarged. New York: Alfred A. Knopf, 1947.
Chronology of paper ranging from 2700 B.C. to 1945; bibliographical footnotes. Chapter on famous case histories in which watermarks were used to detect forgeries.

Guide to Marketing

22:49 Davis, Sally Prince. *The Graphic Artist's Guide to Marketing and Self-Promotion.* Cincinnati, OH: North Light Books, 1987.

Bibliographies

See *Arts in America* [13:44], Volume 2: Elaine Johnson's "Graphic Arts: Seventeenth-Nineteenth Century," which lists 176 artists, and "Graphic Artists: Twentieth Century," with 105 artists.

22:50 Karpinski, Caroline. *Italian Printmaking, Fifteenth and Sixteenth Centuries: An Annotated Bibliography. G. K. Hall Art Bibliographies Series.* Boston: G. K. Hall, 1987.

22:51 Ludman, Joan and Lauris Mason. *Fine Print References: A Selected Bibliography of Print-Related Literature.* Millwood, NY: Kraus International, 1982.
 Citations to about 2,500 international books and exhibition catalogues.

22:52 Mason, Lauris and Joan Ludman. *Print Reference Sources: A Selected Bibliography 18th–20th Centuries.* 2nd ed. Millwood, NY: Kraus International, 1979.
 Has bibliographical but no biographical data on about 1,800 printmakers.

22:53 Mason, Lauris, Joan Ludman, and Harriet P. Krauss. *Old Master Print References: A Selected Bibliography.* White Plains, NY: Kraus International, 1986.
 Covers about 900 artists from 15th through late 18th century.

22:54 New York Public Library. *Dictionary Catalog of the Prints Division.* Boston: G. K. Hall, 1975. 5 vols.
 Collection covers history of Western printmaking from 15th century to the present, and Japanese printmaking from 10th century to the 20th. Includes titles of reference works on history, subjects, terms, and techniques of printmaking and book illumination as well as biographical material on printmakers. Notations for "Catalogues and other pamphlet material" indicates that there is a vertical file on the printmaker. Organized in 1903, the Print Division has extensive vertical files for nearly 35,000 artists. It will be reproduced on microfiche by Chadwyck-Healey and published in 1991/92.

22:55 Phillpot, Clive, ed. "An ABC of Artists' Books Collections," *Art Documentation* 1(December 1982): 169–181.
 Written by various experts, the article includes a discussion of the subject, a list of artists' presses, and a bibliography compiled by Janet Dalberto.

22:56 Riggs, Timothy A., compiler. *The Print Council Index to Œuvre-Catalogues of Prints by European and American Artists.* Millwood, NY: Kraus, 1983.
 Covers over 9,500 artists from 15th century to present.

Library of Congress Prints and Photographs Collection

Organized in 1896, the Prints and Photographs Division of the Library of Congress houses 12 million graphic items, consisting of about:

1. 110,000 woodcuts, engravings, etchings, lithographs, silkscreens, and other graphic media dating from the 15th century to the present including both Old Master and contemporary prints
2. 40,000 prints documenting the 18th and 19th centuries
3. 70,000 American and foreign posters dating from 1850s to the present
4. 9,000,000 original still photographic exposures documenting social, cultural, and political history form 1850 to 1970
5. 4,000 original images by noted photographers
6. 600,000 items on architecture, design, and engineering including HABS [21:118–121], the Pictorial Archives of Early American Architecture, the Carnegie Survey of the Architecture of the South, and the Seagram County Court House Archives

In 1982, the Library of Congress initiated a Non-Print Optical Disk Pilot Program, by which visual materials are put on analog laser videodisks. This process conserves the material and increases research possibilities by linking the visual material to additional data. For details on this program, read Elisabeth Betz Parker's "The Library of Congress Non-Print Optical Disk Pilot Program." *Information Technology and Libraries* (December 1985): 289–299.

22:57 *American Prints in the Library of Congress: A Catalog of the Collection,* compiled by Karen F. Beall. Baltimore: Johns Hopkins, 1970.
 Gives brief outline of biographical data and lists of works citing titles, dates, media, dimensions, number in edition, signature data, and acquisition information. Indices to subjects and geographical locations depicted in works of art and to names.

22:58 Prints and Photographs Division, Library of Congress. Washington, D.C.: Library of Congress.

 .1 *Guide to the Special Collections of Prints & Photographs in the Library of Congress,* Paul Vanderbilt, 1955.

.2 *The American Revolution in Drawings and Prints: A Checklist of 1765–1790 Graphics in the Library of Congress,* Donald H. Cresswell, 1975.

.3 *Graphic Sample,* Renata V. Shaw, 1979.

.4 *A Century of Photographs, 1846–1946, Selected from the Collections of the Library of Congress,* Renata V. Shaw, 1980.

.5 *Graphic Materials: Rules for Describing Original Items and Historical Collections,* Elisabeth W. Betz, 1982.

Published Collections of Prints

22:59 *Bibliothèque Nationale: Collections of the Department of Prints and Photographs.* Paris: Studios Photographiques Harcourt, n.d. Microfilm.

Created in 1667 by Louis XIV, this is the oldest such department in the world. Since 1689 it has been the official print repository for all of France. Comprises 14,000,000 items. Microfilming, which began in 1981, continues. Contains several sets, such as *The de Vinck Collection: The Revolution of 1830 and the July Monarchy,* showing life in France during 1830s through prints.

22:60 *British Museum: Historical Prints.* London: Mindata, n.d. Microfiche.

More than 10,000 prints representing European history from 15th to 20th century. Arranged chronologically by events depicted; prints are captioned and can be ordered singly.

Serials

Artist's Proof 1961–72//

Journal of the Print World 1978+

Print 1940+

Print Collector's Newsletter 1970+

Print-Collector's Quarterly 1911–1950// (Merged with *Print,* Winter 1950/51)

Print Connoisseur 1920–32//

Print Quarterly 1984+

Print Review 1961–85// (Titled *Artist's Proof* (1961–1971)

Prints 1930–38//

Tamarind Technical Papers 1974–78//

Photography

The photographs discussed in this section are fine arts photographs and differ from those that document works of art, which were discussed in Chapter 19 under "Published Picture Collections." This chapter is divided into (1) dictionaries and encyclopedias, (2) references that provide biographical information, (3) historical surveys and books on techniques, (4) guides to marketing, (5) bibliographies, (6) documents and sources, (7) published photographic archives, (8) a guide to archival material, (9) indices to photographic collections, (10) indices to reproductions of photographs in books, (11) indices to photographic literature, and (12) serials. Many of the general references cited elsewhere in this book—such as the *Encyclopedia of World Art* [10:2], *Art Index* [16:1], and *RILA* [16:7]—provide information on photographs. For sales data, see Chapter 18. For browsing purposes, use LC classification of TR; Dewey Decimal of 770s. some libraries use the alternate LC classification of NH.

Dictionaries and Encyclopedias

23:1 Morgan, Willard D., ed. *Encyclopedia of Photography*. New York: Greystone, 1974. 20 vols.
 Originally published as *The Complete Photographers* in 1943.

23:2 Pinkard, Bruce. *The Photographer's Dictionary*. London: B.T. Batsford, 1982.
 Terminology, photographers, and societies.

Information on Photographers

There is often only a brief biographical entry in these references; a number of them will need to be consulted in order to compile an adequate chronology of a photographer's life. Also check under "Photographers" in *Who's Who in American Art* [10:50]. For additional brief biographical data, see the other references cited in this chapter. This section is divided into (1) biographical dictionaries and (2) the books that advertise photographers' works.

Biographical Dictionaries

The following resources provide brief biographical data, lists of exhibitions, some bibliographical citations, and sometimes illustrations of the photographers' works.

23:3 Auer, Michele and Michel Auer. *Photographers Encyclopedia International 1839 to the Present*. Hermance, Switzerland: Camera Obscura, 1985. 2 vols.
 Covers 1,600 photographers.

23:4 Beaton, Cecil and Gail Buckland. *The Magic Image: The Genius of Photography from 1839 to the Present Day*. Boston: Little, Brown & Co., 1975.

23:5 *Contemporary Photographers*. Colin Naylor, ed. 2nd ed. Chicago: St. James, 1988.
 Best source for contemporary people; about 750 photographers of 20th century; lists exhibitions, collections, and publications.

23:6 International Center of photography. *Encyclopedia of Photography*. New York: Crown, 1984.

23:7 Lucie-Smith, Edward. *The Invented Eye: Masterpieces of Photography, 1839–1914*. New York: Paddington, 1975.

23:8 Lyons, Nathan. *Photography in the Twentieth Century*. New York: Horizon, 1967.

23:9 *Macmillan Biographical Encyclopedia of Photographic Artists and Innovators*. Turner Browne and Elaine Partnow, eds. New York: Collier Macmillan, 1983.
 About 2,000 photographers, fine arts and commercial, as well as others involved in the media.

23:10 Mathews, Oliver. *Early Photographs and Early Photographers: A Survey in Dictionary Form*. New York: Pitman, 1973.

23:11 Naggar, Carole. *Dictionnaire des Photographes*. Paris: Editions du Seuil, 1982.
 Includes 400 biographies.

23:12 Newhall, Beaumont and Nancy Newhall, eds. *Masters of Photography*. New York: George Braziller, 1958.

23:13 Stroebel, Leslie and Hollis N. Todd. *Dictionary of Contemporary Photography*. New York: Morgan & Morgan, 1974.

23:14 Welling, William. *Collectors' Guide to Nineteenth-Century Photographs.* New York: Macmillan, 1976.

23:15 Willis-Thomas, Deborah. *Black Photographers, 1840–1940: An Illustrated Bio-Bibliography.* New York: Garland, 1985.
About 70 photographers.

23:16 Witkin, Lee D. and Barbara London. *The Photograph Collector's Guide.* Boston: New York Graphic Society, 1979.
Material on more than 230 photographers. Essays on collecting, care, and restoration of photographs; glossary; chronology of photography; and listing of museums, galleries, auction houses, and exhibition spaces.

Illustrated Directories

These books contain color illustrations of works by commercial photographers; includes their addresses. Many are annuals.

23:17 *American Society of Magazine Photographers Membership Directory.* New York: Watson Guptill.

23:18 *Art Directors Index to Photographers.* Mies, Switzerland: Rotovision, SA, 1989.
Part 1 includes North, Central, and South America plus Asia and Australia; Part 2, Europe.

23:19 *The Creative Black Book.* New York: The Creative Black Book, 1981 + Biennial. 2 vols.
Covers photographers and suppliers.

23:20 *Photography American Showcase.* New York: American Showcase. New York: Watson-Guptill, 1989.

Historical Surveys and Books on Techniques

23:21 Doty, Robert, ed. *Photography in America.* New York: Random House, 1974.

23:22 Freund, Gisele. *Photography and Society.* Boston: David R. Godine, 1982.

23:23 Gernsheim, Helmut. *Origins of Photography.* London: Thames and Hudson, 1982.
Revised edition of his *History of Photography from the Camera Obscura to the Beginning of the Modern Era.* (2nd ed., New York: McGraw Hill, 1969.) with new chapter, "The Origins of Photography in Italy," by Daniela Palazzoli.

23:24 Green, Jonathan. *American Photography: A Critical History, 1945 to the Present.* New York: Abrams, 1984.

23:25 Hall-Duncan, Nancy. *History of Fashion Photography.* Rochester, NY: International Museum of Photography at the George Eastman House, 1979.

23:26 Greenough, Sarah et al. *On the Art of Fixing a Shadow: One Hundred and Fifty Years of Photography.* Washington, D.C.: National Gallery of Art, 1989.

23:27 Jammes, Andre and Eugenia Parry Janis. *The Art of the French Calotype: With a Critical Dictionary of Photographers.* Princeton, NJ: Princeton University, 1983.

23:28 Newhall, Beaumont. *The Daguerreotype in America.* 3rd rev. ed. New York: Dover, 1976.

23:29 ———. *The History of Photography: From 1839 to the Present Day.* Rev. ed. New York: Museum of Modern Art, 1982.

23:30 Pollack, Peter. *The Picture History of Photography: From the Earliest Beginnings to the Present Day.* Rev. and enlarged. New York: Abrams, 1969.

23:31 *Professional Photographic Illustration Techniques.* Rochester, NY: Eastman Kodak, 1978.

23:32 Rosenblum, Naomi. *A World History of Photography.* New York: Abbeville, 1984.

23:33 Scharf, Aaron. *Art and Photography.* Baltimore: Penguin Books, 1968.

23:34 ———. *Pioneers of Photography: An Album of Pictures and Words.* New York: Abrams, 1975.

23:35 Taft, Robert. *Photography and the American Scene: A Social History, 1839–1889.* New York: Macmillan, 1938; reprint, New York: Dover, 1964.

23:36 *Time-Life Library of Photography Series.* New York: Time, 1970–72.
Well-illustrated individual books on such topics as theory, history, and conservation.

23:37 Weaver, Mike, ed. *The Art of Photography, 1839–1989.* New Haven, CT: Yale University, 1989.

Guides to Marketing

23:38 Perrett, Thomas I. *Gold Book of Photography Prices.* Carson, CA: Photography Research Institute Carson Endowment, 1989.
Covers how to price photography work.

23:39 *Photographer's Market: Where to Sell Your Photographs.* Cincinnati, OH: Writer's Digest Books. Annual
Lists companies which purchase photographs. Gives tips on selling work. Lists professional associations and annual workshops.

Bibliographies

See *Arts in America* [13:44], Vol. 3, Beaumont Newhall's "Photography," lists 170 photographers; *Catalogue of the Library of the Museum of Modern Art* [12:96], see "Photographers," which is subdivided as to century and geographical location; and *Worldwide Art Catalogue Bulletin* [15:13], under "Photography" lists exhibition catalogues.

23:40 Barger, M. Susan. *Bibliography of Photographic Processes in Use Before 1880: Their Methods, Processing, and Conservation.* Rochester, NY: Rochester Institute of Technology, 1980.

23:41 Boni, Albert. *Photographic Literature: An International Bibliographical Guide to General and Specialized Literature on Photographic Processes, Techniques, Theory, Chemistry, Physics, Apparatus, Materials, and Applications, History, Biography, Aesthetics, etc.* New York: Morgan & Morgan, 1962. *First Supplement: 1960–1970, 1972.*
 Comprehensive in coverage.

23:42 Columbia University. *A Catalogue of the Epstean Collection on the History and Science of Photography and Its Applications Especially to the Graphic Arts.* New York: Columbia University, 1937.

23:43 Heidtmann, Frank. *Die Deutsche Photoliterature, 1839–1978: Theorie-Technik-Bildleistungen.* Munich: K.G. Saur, 1980.

23:44 International Museum of Photography. *Library Catalog of the International Museum of Photography at George Eastman House.* Boston: G.K. Hall, 1982. 4 vols.
 Author-title-subject dictionary of this outstanding library. Includes citations for books, articles, and exhibition catalogues as well as special entries for 19th-century books illustrated by photographs.

23:45 New York Public Library. *Photographica: A Subject Catalog of Books on Photography.* Boston: G.K. Hall, 1984.
 Collection is especially rich in 19th-century works.

23:46 *Photography Magazine Index, 1978–1983,* ed. by Stu Berger. Santa Rosa, CA: Paragon, 1984. Supplemented by annual loose leaf, 1984–1985.
 First issued irregularly, 1978–1983, then as cumulation; indexes about 10 popular serials.

23:47 Stark, Amy. *Researching Photographers.* Tucson, AZ: Center for Creative Photography, University of Arizona, 1984.

Documents and Sources

23:48 Danziger, James and Barnaby Conrad. *Interviews with Master Photographers.* New York: Paddington, 1977.

23:49 Diamonstein, Barbaralee. *Visions and Images: American Photographers on Photography.* New York: Rizzoli, 1981.

23:50 Dugan, Thomas. *Photography Between Covers.* Rochester: Light Impressions, 1983.

23:51 Hill, Paul and Thomas Cooper. *Dialogue with Photography.* New York: Farrar, Straus, Giroux, 1979.

23:52 Howard, David. *Perspectives.* San Francisco: San Francisco Center for Visual Studies, 1978.

23:53 Lyons, Nathan. *Photographers on Photography: A Critical Anthology.* Englewood Cliffs, NJ: Prentice-Hall, 1966.

23:54 Mitchell, Margaretta K. *Recollections: Ten Women of Photography.* New York: Viking, 1979.

Published Photographic Archives

See also the general published picture collections cited in Chapter 19 and the *Bibliothèque Nationale: Collections of the Department of Prints and Photographs* [22:59], which includes collections of individual photographers.

23:55 *Royal Archives at Windsor Castle: Victorian Photographic Collection.* London: World Microfilms Publication, n.d.
 More than 7,000 photographs, mostly made from 1845 to 1901.

23:56 *Victoria and Albert Museum: Early Rare Photographic Collection, 1843–1915.* London: World Microfilms, 1980.

Guide to Archival Material

23:57 *Guide to Archival Materials of the Center for Creative Photography,* compiled by Roger Myers. Tuscon: University of Arizona, 1986.
 Founded in 1975, Center has more than 40,000 photographs, covering the history of photography as an art form. Individual chapters describe 76 archive groups. See 23:62.

Indices to Collections of Photographs

One of the outstanding collections of photographs is owned by the Library of Congress; see Chapter 22. For other institutions with photograph collections, check *American Art Directory* [20:1], *International Directory of Arts* [20:39], and the *Official Directory of Museums* [20:34].

23:58 *Directory of British Photographic Collections,* ed. by John Wall. New York: Camera/Graphic Press, 1977.
 Index to 1,600 collections and about 1,000 photographers.

23:59 *Guide to Canadian Photographic Archives/Guide des archives photographicques canadiennes,* 2nd ed. by Christopher Seifried. Ottawa: Public Archives, 1984.
 The 8,631 entries represent collections owned by 139 archives.

23:60 *Index to American Photographic Collections,* ed. by James McQuaid. Boston: G. K. Hall, 1982.
 Indices to 458 American photographic collections and to about 19,000 photographers; cross references to collections that own their works.

23:61 International Museum of Photography at George Eastman House. *Index of Photographers.* Rochester, NY: George Eastman House, 1979. Microfiche.
 Lists photographers whose work is owned by George Eastman House. Search by photographers, geographic regions in which they worked, or photographic format used.

23:62 Myers, Roger. *Guide to Archival Materials of the Center for Creative Photography.* Tuscon, AZ: University of Arizona, 1986.
 Founded in 1975, the Center has more than 40,000 master photographs, 10,000 volumes, and 500 videotapes on photography.

23:63 Pearce-Moses, Richard. *Photographic Collections in Texas: A Union Guide.* College Station, TX: Texas A & M University, 1987.
 Index to about 350 collections, with more than 100,000 photographs.

Indices to Reproductions of Photographs in Books

23:64 Moss, Martha, *Photography Books Index: A Subject Guide to Photo Anthologies.* Metuchen, NJ: Scarecrow, 1980. *Photography Books Index II,* 1985.
 Vol. 1 covers 22 publication; Vol. 2, 28. Both have sections for photographers, subjects, and portraits.

23:65 Parry, Pamela Jeffcott. *Photography Index: A Guide to Reproductions.* Westport, CT: Greenwood, 1979.
 Covers about 90 books which reproduce photographs made from 1820 to 1920; indexes by photographer, subjects of prints, and titles of works. Chronological index to anonymous photographers.

Indices

Indexing of photography serials has been erratic; some which have ceased publication are cited under "Bibliographies." Also see *Art Index* [16:1], *ARTbibliographies MODERN* [16:2], and *RILA* [16:7]. Under photographer's name, *Arts & Humanities Citation Index* [16:59] includes titles of photographs used as illustrations. In addition, remember to use the indices to newspapers and more popular magazines to locate information.

23:66 *International Photography Index.* William S. Johnson, ed. Boston: G. K. Hall, 1983+
 Indexes books, articles, and exhibition reviews; covers more than 2,000 photographers. Irregularly issued from 1977–81. Titled *Index to Articles on Photography* 1977–1978 published by Visual Studies Workshop, Rochester, New York.

23:67 *Photohistorica: Literature Index of the European Society for the History of Photography.* Antwerp: European Society for the History of Photography, 1980+ Irregular.
 Covers about 80 international serials; includes subject heading on iconography.

Serials

Afterimage 1972+
American Photographer 1978+
Aperture 1952+
British Journal of Photography 1854+
Camera (Switzerland) 1967–81//
Camera 35 1957–82// (Titled *Camera 35,* 1973–78 and 1979–82; in between called *Camera 35 Photo World* or variation thereof)
Camera Work: A Photographic Quarterly 1903–17//
Creative Camera 1963+
Fotomagazine 1949+ (Titled *Photo Magazine* 1949–60)
History of Photography 1977+
Image (International Museum of Photography at George Eastman House 1952+
Photographic Journal, Royal Photographic Society of Great Britain, 1953+
Photography 1897 + (Titled *Camera* 1897–1949, absorbed *Photographic Journal of America,* 1932 and *Bulletin of Photography,* 1931; continued as *Camera Magazine* 1949–53 when changed to present name)

CHAPTER 24

Decorative Arts and Crafts

Visiting historic houses—such as Thomas Jefferson's Monticello—or restored villages—such as Williamsburg, Virginia—is an excellent way to study original furniture and historical room arrangements. Some museums, such as the Metropolitan Museum of Art and the Philadelphia Museum of Art, have period rooms where authentic pieces are displayed in appropriate surroundings. For a listing of historic places, see "Topographical Guides and Travel Books" in Chapter 21. To locate museums with historical rooms, see the subject index of *American Art Directory* [20:1]. For decorative arts libraries, there are such centers as the Winterthur Museum in Wilmington, Delaware, the Cooper-Hewett Museum in New York City, and the Victoria and Albert Museum in London.

This chapter is divided into (1) general dictionaries, encyclopedias, histories, (2) furniture, (3) ceramics, (4) silver, pewter, and goldware, (5) tapestries, (6) textiles, (7) decorative arts bibliographies, (8) published picture collections, (9) trade catalogues, (10) video documentaries, and (11) serials. For sales and price information, see Bibliothèque Forney [24:82.2] and Chapter 18; for directories of antique dealers, Chapter 20. For browsing purposes, use LC classification of NK, Dewey Decimal of 740s.

General Dictionaries, Encyclopedias, Histories

Many of these resources include definitions of terms, brief biographies of craftsmen, and bibliographies.

24:1 Anscombe, Isabelle and Charlotte Gere. *Arts and Crafts in Britain and America.* New York: Rizolli, 1978.

24:2 Boger, Louise Ade and H. Batterson Boger, eds. *The Dictionary of Antiques and the Decorative Arts: A Book of Reference for Glass, Furniture, Ceramics, Silver, Periods, Styles, Technical Terms, etc.* 2nd ed., enlarged. New York: Charles Scribner's Sons, 1967.

24:3 Bridgeman, Harriet and Elizabeth Drury. *The Encyclopedia of Victoriana.* New York: Macmillan, 1975.
Furniture, pottery, porcelain, metalwork, photographs, textiles, and wallpaper.

24:4 Comstock, Helen, ed. *The Concise Encyclopedia of American Antiques.* New York: Hawthorn, 1958. 2 vols.

24:5 Edwards, Ralph and L. G. G. Ramsey, eds. *The Connoisseur's Complete Period Guides to the Houses, Decoration, Furnishing, and Chattels of the Classic Periods.* New York: Bonanza, 1968. 6 vols.
From Tudor Period 1500–1603 through Early Victorian Period 1830–1860; includes architecture and interior design, furniture, paintings, sculpture, silver, ceramics, textiles, jewelry, portrait miniatures, and printing.

24:6 Fleming, John and Hugh Honour. *The Penguin Dictionary of Decorative Arts.* London: Allen Lane, 1977.
In U.S. published as *Dictionary of Decorative Arts.* Dictionary of styles, technical terms, materials, biographies, and brief histories of notable factories. Ceramic marks, hallmarks on silver, and makers marks on silver and pewter.

24:7 Garner, Philip, ed. *Phaidon Encyclopedia of Decorative Arts 1890–1940.* London: Phaidon, 1978; reprint, 1988.

24:8 Hardy, William et al. *Encyclopedia of Decorative Styles, 1850–1935.* Oxford: Phaidon, 1978; reprint, Secaucus, NJ: 1988.

24:9 Harling, Robert, ed. *Studio Dictionary of Design and Decoration.* New York: Viking, 1973.

24:10 Jervis, Simon. *The Facts On File Dictionary of Design and Designers.* New York: Facts On File, 1984.
In England, published as *The Penguin Dictionary of Design and Designers.*

24:11 Kovel, Ralph and Terry Kovel. *Know Your Antiques: How to Recognize and Evaluate Any Antique—Large or Small—Like An Expert.* 3rd ed. New York: Crown, 1981.

24:12 Lewis, Philippa and Gillian Darley. *Dictionary of Ornament*. New York: Pantheon, 1986.

24:13 Lucie-Smith, Edward. *The Story of Craft: The Craftsman's Role in Society*. New York: Cornell University Press, 1982; reprint, New York: Van Nostrand Reinhold, 1984.

24:14 Newman, Harold. *An Illustrated Dictionary of Glass*. Lodnon: Thames & Hudson, 1977.

24:15 Osborne, Harold, ed. *The Oxford Companion to the Decorative Arts*. London: Oxford University Press, 1975.
 Some fashion terms and lengthy article on costumes.

24:16 Pegler, Martin. *The Dictionary of Interior Design*. New York: Crown, 1966. Fairchild, 1983.

24:17 Phillips, Phoebe, ed. *The Collectors' Encyclopedia of Antiques*. New York: Crown, 1973.
 Arms and armour, bottles and boxes, carpets and rugs, ceramics, embroidery and needlework, furniture, glass, jewelry, metalwork, and pewter. Covers techniques, repairs and maintenance, how to distinguish fakes and forgeries, and museums having outstanding collections.

24:18 Phipps, Frances. *The Collector's Complete Dictionary of American Antiques*. Garden City, NY: Doubleday, 1974.

24:19 Praz, Mario. *An Illustrated History of Furnishing: From the Renaissance to the 20th Century*. New York: Braziller, 1964.

24:20 Ramsey, L. G. G., ed. *The Complete Color Encyclopedia of Antiques*. 2nd ed. New York: Hawthorn, 1975.
 Furniture, jewelry, pottery and porcelain, prints and drawings, needlework and embroidery, glass, carpets and rugs, sculpture and carvings, books and bookbindings, painting, metal work, and silver. Adapted from *The Concise Encyclopedia of Antiques* [24:21] and his *Concise Encyclopaedia of American Antiques*. Includes museums having particularly good examples.

24:21 ———. *The Concise Encyclopedia of Antiques*. New York: Hawthorn, 1955–61. 5 vols.

24:22 *Random House Collector's Encyclopedia: Victoriana to Art Deco*. Introduction by Roy Strong. New York: Random House, 1974.
 Terminology, techniques, craftsmen, and designers working from 1851 to 1939. Facsimiles of ceramic and silver hallmarks.

24:23 Savage, George. *Dictionary of Antiques*. 2nd ed. New York: Praeger, 1978.

24:24 Ware, Dora and Maureen Stafford. *An Illustrated Dictionary of Ornament*. New York: St. Martin's Press, 1974.

24:25 Wilson, Jose and Arthur Leaman. *Decorating Defined: A Dictionary of Decoration and Design*. New York: Simon and Schuster, 1970.

Furniture

Some references above include furniture and cabinetmakers. For contemporary designers, see Chapter 10.

24:26 Aronson, Joseph. *The New Encyclopedia of Furniture*. 3rd ed. New York: Crown, 1967.
 List designers and craftsmen.

24:27 Beard, Geoffrey and Christopher Gilbert, ed. *Dictionary of English Furniture Makers 1660–1840*. London: Furniture History Society, 1986.
 Includes commissions and data on signed or documented pieces.

24:28 Bjerkoe, Ethel Hall. *The Cabinetmakers of America*. 2nd ed. Exton, PA: Schiffer, 1978.
 Data on cabinetmakers working from 1680–1900; glossary.

24:29 Boger, Louise Ade. *The Complete Guide to Furniture Styles*. Enlarged ed. New York: Charles Scribner's Sons, 1969, reprint, 1982.

24:30 Corkhill, Thomas. *The Complete Dictionary of Wood*. New York: Stein & Day, 1980.
 Terms for all phases of working in wood. Discussions of tree species and their uses as well as wood-working equipment and techniques.

24:31 Edwards, Ralph. *Dictionary of English Furniture From the Middle Ages to the Late Georgian Period*. London: Antique Collectors, 1983. 3 vols.
 Definitions of terminology and styles; brief biographical entries for about 180 cabinetmakers and designers. Occasionally includes bibliographical references.

24:32 Fregnac, Claude, ed. *French Cabinetmakers of the Eighteenth Century*. Paris: Hachette, 1965.
 Discusses evolution of taste and manufacturing techniques.

24:33 Gloag, John. *Guide to Furniture Styles: English and French, 1450 to 1850*. New York: Scribner, 1972.

24:34 ———. *A Short Dictionary of Furniture: Containing Over 2,600 Entries that Include Terms and Names Used in Britain and the United States of America.* Revised and enlarged ed. London: George Allen and Unwin, 1969.

Covers furniture design. Chronology from 1100 to 1950 citing types of furniture, construction methods, materials, and craftsmen; biographical section on British and American designers and cabinetmakers; and dictionary of terms and styles.

24:35 Honour, Hugh. *Cabinet Makers and Furniture Designers.* London: Hamlyn, 1972.

Biographical data on about 50 designers from 16th century to present. Literature references are listed under "Bibliography."

24:36 Lockwood, Luke Vincent. *The Furniture Collectors' Glossary.* New York: Walpole Society, 1913; reprint, New York: Da Capo Press, 1967.

24:37 Macquoid, Percy. *A History of English Furniture.* London: Lawrence and Bullen, 1904–08; reprint, London: Antique Collectors, 1987. 4 vols.

Vol. 1: The Age of Oak, 1500–1660; Vol. 2: The Age of Walnut, 1660–1720; Vol. 3: The Age of Mahogany, 1720–1770; Vol. 4: The Age of Satinwood, 1770–1820.

Ceramics

Most of these resources include brief biographies and reproduce hallmarks.

24:38 Boger, Louise Ade. *The Dictionary of World Pottery and Porcelain.* New York: Charles Scribner's, 1971.

24:39 Burton, William and Robert Lockhart Hobson. *Handbook of Marks on Pottery and Porcelain.* London: Macmillan and Company. 1909; reprint ed. see 24:56.

Chronological listing of marks under particular geographic locations.

24:40 Cameron, Elizabeth. *Encyclopedia of Pottery and Porcelain: 1800–1960.* New York: Facts-on-File, 1986.

24:41 Chaffers, William. *Marks and Monograms on European and Oriental Pottery and Porcelain.* 15th rev. ed. London: William Reeves, 1965. 2 vols.

24:42 Charleston, Robert J. *World Ceramics: An Illustrated History.* New York: McGraw-Hill, 1968.

Glossary of hallmarks.

24:43 Dodd, Arthur Edward. *Dictionary of Ceramics: Pottery, Glass, Vitreous Enamels, Refractories, Clay Building Materials, Cement and Concrete, Electroceramics, Special Ceramics.* New York: Philosophical Library, 1964.

Dictionary of technical terminology.

24:44 Evans, Paul E. *Art Pottery of the United States: An Encyclopedia of Producers and Their Marks.* New York: Charles Scribner's, 1974.

Hallmarks of pottery firms and geographic listing of art potteries.

24:45 Fournier, Robert. *Illustrated Dictionary of Pottery Form.* New York: Van Nostrand Reinhold, 1981.

24:46 Godden, Geoffrey A. *Illustrated Encyclopaedia of British Pottery and Porcelain Marks.* New York: Crown, 1966.

Alphabetized by pottery firms; entries cite addresses and reproduce hallmarks. Indices to monograms and to signs and devices.

24:47 ———. *Encyclopaedia of British Porcelain Manufacturers.* London: Barrie & Jenkins, 1988.

24:48 Haggar, Reginald G. *The Concise Encyclopedia of Continental Pottery and Porcelain.* New York: Hawthorn, 1960.

24:49 Hamer, Frank. *The Potter's Dictionary of Materials and Techniques.* London: Pitman, 1975.

24:50 Hillier, Bevis. *Pottery and Porcelain, 1700–1914.* New York: Meredith, 1968.

24:51 Honey, William Bowyer. *European Ceramic Art from the End of the Middle Ages to About 1815: A Dictionary of Factories, Artists, Technical Terms, et cetera.* 2nd ed. London: Faber and Faber, 1963 2 vols.

Biographical and bibliographical data, facsimile of signatures, and index to marks.

24:52 Kovel, Ralph and Terry Kovel. *Kovel's New Dictionary of Marks: Pottery and Porcelain.* New York: Crown, 1986.

Alphabetical listing of hallmarks. Indices to hallmarks and manufacturers.

24:53 ———. *The Kovels' Collector's Guide to American Art Pottery.* New York: Crown, 1974.

Entries on pottery firms provide historical background, bibliographical data, and hallmarks used.

24:54 Lehner, Lois. *Lehner's Encyclopedia of U.S. Marks on Pottery, Porcelain & Clay.* Collector Books, 1988.

24:55 Mankowitz, Wolf and Reginald G. Haggar. *The Concise Encyclopedia of English Pottery and Porcelain.* New York: Frederick A. Praeger, 1968.
 List of engravers for pottery and porcelain.

24:56 Paul, Ethel and A. Petersen, eds. *Collector's Handbook to Marks on Porcelain and Pottery.* Green Farms, CT: Modern Books & Crafts, 1974. See Burton [24:39].

24:57 Penkala, Maria. *European Pottery: A Handbook for the Collector.* 3rd ed. Schiedam, Netherland: Interbook International, 1980.

24:58 ———. *European Porcelain: A Handbook for the Collector.* 3rd ed. Schiedam, Netherland: Interbook International, 1980.

24:59 Savage, George and Harold Newman. *An Illustrated Dictionary of Ceramics.* New York: Van Nostrand Reinhold, 1974.
 List, compiled by John Cushion, of principal European ceramic factories and facsimiles of their hallmarks.

Silver, Pewter, and Goldware

Most of these reference works reproduce hallmarks.

24:60 Brett, Vanessa. *Sotheby's Directory of Silver 1600–1940.* London: Sotheby's, 1986.

24:61 Clayton, Michael. *The Collectors' Dictionary of the Silver and Gold of Great Britain and North America.* 2nd ed. New York: World, 1985.
 Terms and artisans; bibliographical references.

24:62 Cotterell, Howard H. *Old Pewter: Its Makers and Marks in England, Scotland, and Ireland.* London: B.T. Batsford, 1929, reprint, 1964.

24:63 Culme, John. *The Directory of Gold and Silversmiths: Jewellers & Allied Traders 1838–1914.* London: Antique Collectors' Club, 1981.
 Vol. 1: The Biographies; Vol. 2: The Marks.

24:64 Fallon, John P. *Marks of London Goldsmiths and Silversmiths (c. 1697–1837).* Rev. ed. Newton Abbot, England: David & Charles, 1988.

24:65 Grimwade, Arthur. *London Goldsmiths 1697–1837: Their Marks and Lives from the Original Registers at Goldsmith's Hall and Other Sources.* London: Faber and Faber, 1976.
 London goldsmiths, provincial English goldsmiths, and unregistered hallmarks.

24:66 Jackson, Charles James. *English Goldsmiths and Their Marks: A History of the Goldsmiths and Plate Workers of England, Scotland, and Ireland.* 2nd ed. London: Macmillan, 1921; reprint, New York: Dover, 1964.
 Chapters divided by various cities in British Isles; lists goldsmiths who lived from 1090 to 1850. Covers legislation concerned with goldsmiths and historical survey.

24:67 ———. *Jackson's Silver and Gold Marks of England, Scotland, and Ireland,* rev. ed. by Ian Pickford. Woodbridge, England: Antique Collectors Club, 1989.

24:68 Kovel, Ralph and Terry Kovel. *A Dictionary of American Silver, Pewter, and Silver Plate.* New York: Crown, 1961.
 Under name of companies and artisans, reproduces hallmarks and cites dates and geographic locations. Index to initials used as hallmarks.

24:69 Newman, Harold. *An Illustrated Dictionary of Silverware: 2,373 Entries Relating to British and North American Wares, Decorative Techniques and Styles, and Leading Designers and Makers, Principally from c. 1500 to the Present.* London: Thames & Hudson, 1987.

24:70 Rainwater, Dorothy T. *Encyclopedia of American Silver Manufacturers.* New York: Crown, 1975.
 List of trade names; key to unlettered trademarks, glossary of terms, and table of equivalents of troy and silver standards weights.

24:71 Turner, Noel D. *American Silver Flatware 1837–1910.* South Brunswick, NJ: A. S. Barnes, 1972.
 Dictionary of firms that produced flatware silver; glossary.

24:72 Wyler, Seymour B. *The Book of Old Silver: English, American, Foreign, with All Available Hallmarks Including Sheffield Plate Marks.* 2nd ed. New York: Crown, 1937.
 Reproduces hallmarks of gold- and silversmiths in North America plus Great Britain, France, Germany, and other European countries.

Tapestries

24:73 Jarry, Madeleine. *World Tapestry: From Its Origins to the Present.* New York: G.P. Putnam's Sons, 1969.
 Large section on 20th-century tapestries.

24:74 Thompson, W. G. *A History of Tapestry from the Earliest Times Until the Present Day.* 3rd ed. rev. London: Hodder & Stoughton, 1973. Checklist of weaver's marks, glossary, and list of museums with major holdings.

Textiles

To locate textile collections, see 24:77.

24:75 Geijer, Agnes. *A History of Textile Art.* New York: Sotheby Parke Bernet, 1979.

24:76 Linton, George E. *The Modern Textile and Apparel Dictionary.* 4th ed. rev. Plainfield, NJ: Textile Book Service, 1973.

24:77 Lubell, Cecil, ed. *Textile Collections of the World.* New York: Van Nostrand Reinhold, 1976. 3 vols.

24:78 Jaques, Renate and Ernst Flemming. *Encyclopedia of Textiles: Decorative Fabrics from Antiquity to the Beginning of the 19th Century Including the Far East and Peru.* New York: Frederick A. Praeger, 1958.

24:79 Montgomery, Florence M. *Textiles in America 1650–1870.* New York: W. W. Norton, 1984.

24:80 Wingate, Isabel B. *Fairchild's Dictionary of Textiles.* 6th ed. New York: Fairchild, 1979. Terms of fiber construction and finishes.

Decorative Arts Bibliographies

See *Arts in America* [13:44], Winterthur Museum's catalog [13:55], as well as the architectural bibliographies listed in Chapter 21, such as Harvard University's Graduate School of Design [21:99], and the general library catalogues of famous libraries, cited in Chapter 17, especially the Victoria and Albert Museum library [17:15].

24:81 *Art and Architecture Information Guide Series.* Sydney Starr Keaveney, general ed. Detroit: Gale Research.
 .1 *American Decorative Arts and Old World Influences,* ed. by David M. Sokol, 1980.
 .2 *Color Theory,* ed. by Mary Buckley, 1974.
 .3 *Pottery and Ceramics,* ed. by James E. Campbell, 1978.
 .4 *Stained Glass,* ed. by Darlene A. Brady and William Serban, 1980.

24:82 Bibliothèque Forney, Paris.
 For sales catalogues, see 18:44.
 .1 *Catalogue d'articles de périodiques: Arts décoratifs et beaux-arts (Catalog of Periodical Articles: Decorative and Fine Arts).* Boston: G. K. Hall, 1972. 4 vols. Subject index to over 1,300 articles from 245 French magazines and 80 other serials.
 .2 *Catalogue matières: Arts-décoratifs, beaux-arts, métiers, techniques.* Paris: Société des Amis de la Bibliothèque Forney, 1970. 4 vols. *Supplément,* 1979. Subject catalogue.

24:83 Ehresmann, Donald L. *Applied and Decorative Arts: A Bibliographic Guide to Basic Reference Books, Histories, and Handbooks.* Littleton, CO: Libraries Unlimited, 1977.
 Over 1,200 annotated entires covering ceramics, enamels, furniture, glass, ivory, leather, metalwork, textiles, arms and armor, clocks, costume, jewelry, lacquer, medals and seals, musical instruments, and toys and dolls.

24:84 Franklin, Linda Campbell. *Antiques and Collectibles: A Bibliography of Works in English, 16th Century to 1976.* Metuchen, NJ: Scarecrow, 1978.

24:85 *G. K. Hall Art Bibliographies Series.* Boston: G. K. Hall.
 .1 *Stained Glass Before 1540: An Annotated Bibliography,* by Madeline Harrison Caviness, 1983.
 .2 *European Decorative Arts, 1400–1600: An Annotated Bibliography,* by Patrick de Winter, 1988.

24:86 *IDEC Comprehensive Bibliography for Interior Design,* ed. by Betty McKee Treanor and John Garstka. Richmond, VA: Interior Design Educators Council, 1984.

24:87 Romaine, Lawrence B. *The Guide to American Trade Catalogs: 1744 through 1900.* New York: R. R. Bowker, 1960; reprint: Salem, NH: Ayer, 1976.
 Chapter on building materials lists over 300 trade catalogues on building materials and indicates library owning catalogue. Other chapters cite catalogues on ornamental ironwork, fences, and plumbing.

24:88 Semowich, Charles J. *American Furniture Craftsmen Working Prior to 1920: An Annotated Bibliography.* Westport, CT: Greenwood, 1984.

24:89 Strong, Susan R. *History of American Ceramics: An Annotated Bibliography.* Metuchen, NJ: Scarecrow, 1983.

24:90 Weidner, Ruth Irwin, compiler. *American Ceramics Before 1930: A Bibliography.* Westport, CO: Greenwood Press, 1982.

Published Picture Collections

Some of the collections listed in Chapter 19 also include decorative arts.

24:91 *The Drawings of Robert and James Adam in the Sir John Soane's Museum.* New York: Chadwyck-Healey, 1979. Microfilm.

Reproductions of more than 10,000—2,000 in color—drawings of architecture, interiors, ornaments, ceilings, furniture, woodwork, and textiles. More than 360 buildings depicted. *Catalogue of the Drawings of Robert and James Adam in Sir John Soane's Museum,* a hardbound book compiled by Walter L. Spiers, 1979, contains brief descriptions for each drawing plus names of buildings, clients, and types of subjects. Includes indices to buildings, clients, and objects.

24:92 *The Index of American Design.* New York: Chadwyck-Healey, 1979. Microfiche.

Part of Federal Art Project of the 1930s, this was a visual survey consisting of objects of decorative, folk, and popular arts made in America up to about 1900. There are 10 sets which can be purchased as a group or separately: Textiles, Costume, and Jewelry; Art and Design of Utopian and Religious Communities; Architecture and Naive Art; Tools, Hardware, Firearms; Domestic Utensils; Furniture and Decorative Accessories; Wood Carvings and Weathervanes; Ceramics and Glass; Silver, Copper, Pewter, and Toleware; plus Toys and Musical Instruments. The printed, *Catalog to the Index of American Design,* contains 4 separate indices: to renderers (the ones who did the drawings), to owners; to craftsmen, designers, and manufacturers; and to subjects. The original renditions are kept at the National Gallery of Art, Washington, D.C.

Reprints of Trade Catalogues

Trade literature is the advertising published in brochures, journals, and newspapers by manufacturers of such items as furniture, bricks, and clothing, and by the people who supplied services, such as the stone masons and carpenters. For a bibliography of these catalogs, see Romaine's book [24:87].

24:93 *Architectural Trade Catalogues from Avery Library.* New York: Clearwater, 1988. Microfiche.

Reproduces 2,300 architecture and building-related catalogues, the majority of which were issued between the 1860s and the 1950s.

24:94 Reprints of Trade Literature. Research Publications.

.1 *Victorian Shopping: Harrod's Catalogue 1895,* 1972.

.2 *Montgomery Ward & Company, Catalog and Buyers Guide No. 57,* (reprint of Spring and Summer 1895 catalogue), 1969.

.3 Sears Roebuck & Company, *The Great Price Maker, Catalog No. 117: 1908,* 1969.

24:95 Sears, Roebuck, and Company. *The 1902 Edition of the Sears Roebuck Catalogue.* New York: Crown, 1970.

Source material for furnishings and finishes available then.

24:96 *Trade Catalogues at Winterthur.* New York: Clearwater, 1984. Microfiche.

Reproduces 1,885 catalogues covering the period from 1750 to 1980. Sold in sets by subject or by state. Use with the printed volume: *Trade Catalogues at Winterthur: A Guide to the Literature of Merchandising 1750 to 1980* by E. Richard McKinstry. (New York: Garland, 1984).

24:97 *Trade Catalogues in the Victoria & Albert Museum 1762–1939.* London: Mindata, 1986. Microfiche.

British and European trade catalogues from the 18th to the 20th century.

24:98 *Victoria and Albert Museum: Liberty's Catalogues: Fashion, Design, Furnishings 1881–1949.* London: Mindata, 1985. Microfiche.

24:99 *Victoria and Albert Museum: The Department Collections.* London: Mindata, n.d. Microfiche.

Reprints of photographs in various departments: Architecture and Sculpture, Ceramics, Furniture and Woodwork, Metalwork, and Textiles. Can be purchased by department; photographs can be ordered from museum.

Video Documentaries

A History of Textiles, Kax Wilson, 1979.
Story of English Furniture, BBC, 1986.
Part 1 covers from Middle Ages to 18th century; Part 2, late 18th century to present.
Treasure Houses of Britain, National Gallery of Art, 1985 (three cassettes), 1986 (one cassette).

Serials

American Craft, New York, American Craft Council 1941+ (Titled *Craft Horizons* 1941–1978)
Antiques 1922+ (*Antiques Cumulative Indexes, Volumes I-LX,* 1922–1951. New York: Editorial, 1952.)

Antiques Journal 1946–1981//
Art and Antiques 1984+
Contract Interiors 1940+ (Titled *Interiors* 1940–77)
Design Quarterly 1946+ (Titled *Evertday Art Quarterly* 1946–1953)
Domus 1928+
Furniture History, Furniture History Society, 1965+
Interior Design 1950+

Journal of Decorative and Propoganda Arts, 1986+
L'Oeil 1955+
Textile Museum Journal, Textile Museum, Washington, D.C., 1962+ (Originally titled *Textile Museum Workshop Notes*)
Victoria and Albert Museum Yearbook 1965+
Winterthur Portfolio 1964+

CHAPTER 25

Fashion, Costumes, and Jewelry

There are several outstanding U.S. libraries for this field: The Fashion Institute of Technology in New York City, The Costume Institute at the Metropolitan Museum of Art in New York City, and The Fashion Institute of Design and Merchandizing in Los Angeles. In addition, London's Victoria & Albert Museum is noted for its collection. The libraries of these institutions have (1) extensive holdings of difficult to locate 18th and 19th-century fashion journals; (2) extensive photographic archives for fashion designers, regional costumes, and couture firms, which can be used to browse for design ideas; (3) numerous video documentaries; (4) costume exhibition catalogues; and (5) vertical files on designers and commercial firms. Vertical file material in libraries not in the researcher's area can sometimes supply pertinent data. By writing the Fine Arts Librarian, students may discover if a vertical file exists on a specific subject and the price for photocopying some of the material. Fashion vertical file material may be reproduced on microfiche in the future.

This chapter is divided into (1) references on fashion and dress construction, (2) biographical dictionaries, (3) historical surveys of fashion and costume, (4) historical surveys on jewelry and gems, (5) fashion forecasting, (6) bibliographies, (7) published picture collections, (8) indices to reproductions of costumes, (9) social history books, (10) fashion documentaries, (11) an index, and (12) serials and associations. Some fashion designers have created clothing for the film industry; see Chapter 26. Trade catalogues, reproduced on microform, usually include fashion; they are annotated in Chapter 24. For browsing the book section of the library, use the L.C. classification of GT; Dewey Decimal, 391.

References on Fashion and Dress Construction

Most of these resources include glossaries and bibliographies; many are illustrated. See *Oxford Companion to the Decorative Arts* [24:15], *Encyclopedia of Victoriana* [24:3] and *Collectors' Encyclopedia of Antiques* [24:17].

25:1 Calasibetta, Charlotte Mankey. *Fairchild's Dictionary of Fashion.* 2nd ed. New York: Fairchild, 1988.
Biographical data on fashion designers.

25:2 Cunnington, Cecil Willett; Phillis Cunnington; and Charles Beard. *A Dictionary of English Costume, 900 to 1900.* New York: Barnes and Noble, 1968; reprint, London: Adam C. Black, 1976.
Lists obsolete color names.

25:3 Houck, Catherine. *The Fashion Encyclopedia: An Essential Guide to Everything You Need to Know about Clothes.* New York: St. Martin's, 1982.

25:4 Kybalová, Ludmila; Olga Herbenová; and Milena Lamarová. *The Pictorial Encyclopedia of Fashion.* Trans. by Claudia Rosoux. New York: Crown, 1968.

25:5 Leloir, Maurice. *Dictionnaire du costume et de ses accessoires, des armes et des étoffes des origines à nos jours.* Paris: Gründ, 1951.

25:6 Linton, George E. *The Modern Textile and Apparel Dictionary.* 4th ed. rev. Plainfield, NJ: Textile Book, 1973.

25:7 O'Hara, Georgina. *Encyclopedia of Fashion.* New York: Harry N. Abrams, 1986.
Biographical data.

25:8 Payne, Blanche. *History of Costume: From the Ancient Egyptians to the Twentieth Century.* New York: Harper & Row, 1965.
Section on pattern drafts.

25:9 Picken, Mary Brooks. *The Fashion Dictionary: Fabric, Sewing, and Dress as Expressed in the Language of Fashion.* Rev. and enlarged. New York: Funk & Wagnalls, 1973.
Original 1939 publication titled *The Language of Fashion.* Gives pronunciation of many terms.

25:10 Waugh, Norah. *The Cut of Women's Clothes, 1600–1930.* New York: Theatre Arts, 1968.

25:11 Wilcox, Ruth Turner. *The Dictionary of Costume.* New York: Charles Scribner's Sons, 1969; reprint, New York: MacMillan, 1986.

25:12 Yarwood, Doreen. *The Encyclopedia of World Costume.* New York: Scribner, 1978.
Biographical data.

Biographical Dictionaries

A database search is an efficient method for discovering recent information on fashion designers. See *Newsearch Database* [16:53], *Magazine Index* [16:21], and *Trade and Industry Index* [16:54], which since 1981 has covered *Women's Wear Daily*. Some references, such as *Current Biography Yearbook* [10:33], cited in Chapter 10 include fashion designers. See also *Fairchild's Dictionary of Fashion* [25:1], *Encyclopedia of Fashion* [25:7], and *Encyclopedia of World Costume* [25:12].

25:13 Lambert, Eleanor. *World of Fashion: People, Places, Resources.* New York: R. R. Bowker, 1976.
Organized by continents and subdivided into chapters representing countries. Biographical sketches of fashion designers, lists of persons who influenced fashion, fashion trade associations and organizations, fashion educational institutions, costume and fashion archives, and titles of fashion publications. Under "Hall of Fame," gives brief biographical sketches on deceased fashion designers. Appendix lists Coty Award winners, 1943–1973.

25:14 Lynam, Ruth, ed. *Couture: An Illustrated History of the Great Paris Designers and Their Creations.* Garden City, New York: Doubleday, 1972.
History of couture system; biographical chapters on a few designers.

25:15 McDowell, Colin. *McDowell's Directory of Twentieth Century Fashion.* Englewood Cliffs: NJ: Prentice Hall, 1985.
More than 350 major fashion designers, illustrators, photographers, and fashion editors. Includes glossary, bibliography of designer autobiographies, fashion awards, organizations, and schools.

25:16 Milbank, Caroline Rennolds. *Couture: The Great Designers.* New York: Steward, Tabori & Chang, 1985.

25:17 Stegemeyer, Anne. *Who's Who in Fashion.* 2nd ed. New York: Fairchild, 1988.

Historical Surveys of Fashion and Costumes

This section is divided into (1) general references on costumes covering an extensive period of time, (2) fashion resources from early civilizations to the Renaissance, (3) fashion resources from the Renaissance to the present, (4) children's dress, (5) wedding and ceremonial dress, (6) ecclesiastical and military dress, (7) working and sport clothing, and (8) regional and ethnic dress.

General References

25:18 Black, J. Anderson and Madge Garland. *A History of Fashion.* rev. ed. New York: William Morrow, 1980.

25:19 Boucher, Francois. *20,000 Years of Fashion: The History of Costume and Personal Adornment.* Expanded ed. New York: Harry N. Abrams, 1987.
Profusely illustrated history; general bibliography and glossary. Translation of *Histoire du costume en Occident.*

25:20 Contini, Mila. *Fashion: From Ancient Egypt to the Present Day.* New York: Odyssey, 1965.

25:21 Corson, Richard. *Fashions in Makeup From Ancient to Modern Times.* New York: Universe, 1972.

25:22 Gaudriault, Raymond. *La Gravure de Mode Femine en France.* Paris: les éditions de l'amateur, 1983.
List of French fashion periodicals up to 1959, providing titles, dates, formats, and characteristics.

25:23 Russell, Douglas A. *Costume History and Style.* Englewood Cliffs, NJ: Prentice-Hall, 1983.
Comprehensive textbook; chapter bibliographies include both art and fashion citations.

25:24 Wilton, Mary Margaret, Countess of. *The Book of Costume, or, Annals of Fashion (1846).* Annotated and trans. by Pieter Back. Longon: Henry Colburn, 1846; reprint, Lopez Island, WA: R. L. Shep, 1986.
Covers Europe 12th–19th centuries.

Early Civilizations to the Renaissance

25:25 Boehn, Max von. *Modes and Manners.* Tran. by Joan Joshua. Philadelphia: J. B. Lippincott, 1932; reprint, New York: B. Blom, 1971. 4 vols. in 2 books.
Vol. 1: From the Decline of the Ancient World to the Renaissance.

25:26 Brooke, Iris. *English Costume in the Early Middle Ages: The Tenth to the Thirteenth Centuries.* London: A. & C. Black, 1936; reprint, Chester Springs, PA: Dufour, 1987.

25:27 Cunnington, Cecil Willett and Phillis Cunnington. *Handbook of English Medieval Costume.* 2nd ed. London: Faber & Faber, 1969.

Renaissance to the Present

25:28 Boehn, Max von. *Modes and Manners.* Trans. by Joan Joshua. Philadelphia: J. B. Lippincott, 1932; reprint, New York: B. Blom, 1971. 4 vols. in 2 books.
> *Vol. 2: The Sixteenth Century. Vol. 3: Seventeenth Century. Vol. 4: Eighteenth Century*

25:29 ———. *Modes and Manners: Ornaments: Lace, Fans, Gloves, Walking-sticks, Parasols, Jewelry, and Trinkets.* New York: Dutton, 1929; reprint titled *Ornaments,* New York: B. Blom, 1970.

25:30 ———. *Modes and Manners of the Nineteenth Century as Represented in the Pictures and Engravings of the Time.* Trans. by Oskar Fischel and M. Edwardes. New York: Dutton, 1927. 4 vols. Reprint, New York: B. Blom, 1970. 4 vols in 2 books.
> *Vol. 1: 1790–1817. Vol. 2: 1818–1842. Vol. 3: 1843–1878. Vol. 4: 1879–1914.*

25:31 Braun-Ronsdorf, Margarete. *Mirror of Fashion: A History of European Costumes 1789–1929.* Trans. by Oliver Coburn. New York: McGraw-Hill, 1964.
> Using paintings and illustrations from fashion magazines, describes costumes of period. Brief bibliography includes list of 35 fashion magazines.

25:32 Brooke, Iris. *English Costume of the Later Middle Ages: The Fourteenth and Fifteenth Centuries.* New York: Barnes & Noble, 1935; reprint, Chester Springs, PA: Dufour, 1987.

25:33 ———. *English Costume in the Age of Elizabeth: The Sixteenth Century.* 2nd ed. London: A. & C. Black, 1950; reprint, London: A. & C. Black, 1977.

25:34 ———. *English Costume of the Seventeenth Century.* New York: Barnes & Noble, 1958; reprint, 1970.

25:35 ———. *English Costume of the Eighteenth Century.* London: A. & C. Black, 1931; reprint, London: A. & C. Black, 1977.

25:36 ———. *English Costume of the Nineteenth Century.* London: A. & C. Black, 1929; reprint, London: A. & C. Black, 1977.

25:37 ———. *English Costume 1900–1950.* London: Methuen, 1951.

25:38 Cunnington, Cecil Willett and Phillis Cunnington. *Handbook of English Costume.* London: Faber & Faber, 1970–72.
> *Vol. 1: In the Sixteenth Century,* rev. ed. *Vol. 2: In the Seventeenth Century,* 3rd ed. *Vol. 3: In the Eighteenth Century,* rev. ed.

25:39 ——— and Phillis Cunnington. *Handbook of English Costume in the Nineteenth Century.* 3rd ed. London: Faber & Faber, 1970.
> Series continued by 24:38.

25:40 Davenport, Millia. *The Book of Costume.* New York: Crown, 1948; reprint, 1979. 2 vols. in one book.
> Photographs of works of art depicting costumes. Entries cite dates and locations of objects. Often includes information concerning sitter.

25:41 Mansfield, Alan and Phillis Cunnington. *Handbook of English Costume in the 20th Century 1900–1950.* Boston: Plays, 1973.

25:42 McClellan, Elisabeth. *Historic Dress in America 1607–1870.* New York: B. Blom, 1967. 2 vols. in one book.
> Reprint of *Historic Dress in America, 1607–1800,* 1900 and *Historic Dress in America, 1800–1870,* 1910.

25:43 Norris, Herbert. *Costume & Fashion.* New York: E.P. Dutton, 1924–38.
> *Vol. 1: Evolution of European Dress Through the Earlier Ages, Vol. 2: Senlac to Bosworth 1066–1485, Vol. 3: Part 1: The Tudors 1485–1547, Part 2: The Tudors 1547–1603; Vol. 6: Nineteenth Century.*

25:44 Saisselin, Remy. *The Bourgeois and the Bibelot.* New Brunswick: Rutgers University, 1984.
> English edition called *Bricabracomania: The Bourgeois and the Bibelog.*

25:45 Victoria & Albert Museum. *Costume Illustration: The Nineteenth Century.* London: The Ministry of Education, 1947.

25:46 Warwick, Edward; Henry C. Pitz; and Alexander Wyckoff. *Early American Dress: The Colonial and Revolutionary Periods.* New York: Benjamin Blom, 1965.

25:47 Wilcox, Ruth Turner. *The Mode in Costume.* New York: Charles Scribner's, 1958; reprint, 1983.

25:48 ———. *Five Centuries of American Costume.* New York: Charles Scribner's, 1963; reprint, New York: MacMillan, 1988.

Children's Dress

25:49 Brooke, Iris. *English Children's Costume Since 1775.* London: A. & C. Black, 1930.

25:50 Cunnington, Phillis and Anne Buck. *Children's Costume in England 1300–1900: From the Fourteenth to the End of the Nineteenth Century.* New York: Barnes & Noble, 1965.

25:51 Ewing, Elizabeth. *History of Children's Costume: From Medieval to Present.* New York: Charles Scribner's, 1977.

Wedding and Ceremonial Dress

25:52 Cunnington, Phillis and Catherine Lucas. *Costumes for Births, Marriages, and Deaths.* New York: Harper & Row, 1972.

Information on the customs, rites, and ceremonies of funerals, marriages, and births in England.

Ecclesiastical and Military Dress

25:53 Drobna, Zoroslava and Jan Durdik. *Medieval Costume, Armour, and Weapons (1350–1450),* ed. by Eduard Wagner. Trans. by Jean Layton. London: Andrew Dakers, 1957; reprint, London: Hamlyn, 1972.

25:54 "Ecclesiastical Vestments of the Middle Ages: An Exhibition." *The Metropolitan Museum of Art Bulletin.* 29(March 1971): 285–317.

25:55 Knotel, Richard, et al. *Uniforms of the World 1700–1937.* New York: Charles Scribner's, 1980.

25:56 Mayo, Janet. *A History of Ecclesiastical Dress.* New York: Holmes & Meier, 1984.

Working and Sport Clothing

25:57 Barsis, Max. *The Common Man Through the Centuries: A Book of Costume Drawings.* New York: Frederick Unger, 1973.

25:58 Cunnington, Phillis and Catherine Lucas. *Charity Costumes of Children, Scholars, Almsfolk, Pensioners.* New York: Harper & Row, 1978.

25:59 ———. and Catherine Lucas. *Occupational Costume in England: From the Eleventh Century to 1914.* New York: Barnes & Noble, 1967.

25:60 ———. and Alan Mansfield. *English Costume for Sports and Outdoor Recreation: From the Sixteenth to the Nineteenth Centuries.* London: A. & C. Black, 1969.

25:61 Lister, Margo. *Costumes of Everyday Life: An Illustrated History of Working Clothes.* Boston: Plays, 1972.

Covers European clothing from 900 to 1910.

25:62 William-Mitchell, Christobel. *Dressed for the Job: The Story of Occupational Costume.* Poole, Dorset, England: Blanford Press, 1982.

Regional and Ethnic Dress

There are numerous books on costumes of specific countries; only a few are cited here.

25:63 Minnich, Helen Benton with Shojiro Nomura. *Japanese Costume and the Makers of Its Elegant Tradition.* Rutland, VT: Charles E. Tuttle, 1963.

25:64 Rubens, Alfred. *A History of Jewish Costume.* Rev. and enlarged. London: Peter Owen, 1981.

25:65 Scarce, Jennifer. *Women's Costume of the Near and Middle East.* London: Unwin Hyman, 1987.

From Byzantium and the Ottoman Inheritance to the 19th-century Arab world.

Historical Surveys of Jewelry and Gems

25:66 Mason, Anita. *An Illustrated Dictionary of Jewellery.* New York: Harper and Row, 1974.

25:67 Rainwater, Dorothy T. *American Jewelry Manufacturers.* West Chester, PA: Schiffer, 1988.

25:68 British Museum: *Jewellery Through 7000 Years.* London: British Museum, 1976.

Photographs of about 500 actual jewelry with scholarly catalogue entries; traces history from 5000 B.C. to mid-19th century.

25:69 Evans, Joan. *A History of Jewellery, 1100–1870.* 2nd ed. London: Faber & Faber, 1970.

25:70 ———. *Magical Jewels of the Middle Ages and the Renaissance, Particularly in England.* Oxford: Clarendon, 1922; reprint, New York: Dover, 1976.

25:71 Gregorietti, Guido. *Jewelry Through the Ages.* Trans. by Helen Lawrence. New York: American Heritage, 1969.

Includes (1) list of gems with their hardness, coloring, countries with large deposits, varieties, and historic period of greatest use and (2) chronological bibliography.

25:72 *Jewelry: Ancient to Modern.* New York: Viking, 1980.

Glossary of foreign jewelry terms.

25:73 Laufer, Berthold. *Jade: A Study in Chinese Archaeology and Religion.* Chicago: Field Museum of Natural History, 1912; reprint, New York: Dover, 1974.

Historical, symbolic, and ornamental uses of jade. Appendices include "Jade in Buddhist Art" and "The Nephrite Question of Japan."

25:74 Newman, Harold. *An Illustrated Dictionary of Jewelry.* London: Thames & Hudson, 1981.

Definitions and data on principal designers and makers; covers antiquity to the present.

25:75 Steingraber, Erich. *Antique Jewelry.* New York: Frederick A. Praeger, 1957.

List 20 gems citing color, chemical composition, crystal system, degree of hardness, and countries of origin.

Fashion Forecasting

There are fashion forecasting companies that publish reports on future fashion trends for the next six months to two years. The fashion design houses and some fashion institutes subscribe to these services, which predict silhouette, color, and fabric for apparel and accessories for men, women, and even children. These forecasters include The Fashion Service (TFS), IM International, Stylists' Information Service (SIS), Here & There, SIR International, Design Intelligence, and the Tobe Report. Access to these expensive forecasts may be restricted.

Bibliographies

The Fashion Institute of Technology Library, New York City, has a wide range of bibliographies on such topics as Books on Accessories, Textiles, Apparel Design Technology, Cosmetics & Toiletries, Fur, Fashion Buying & Merchandising. Copies are often available on request.

25:76 Anthony, Pegaret and Janet Arnold. *Costume: A General Bibliography*, rev. and enlarged by Janet Arnold. London: Victoria & Albert Museum, 1974.

25:77 Colas, René. *Bibliographie générale du costume et de la Mode.* Paris: Librairie René Colas, 1933; reprint, New York: Hacker, 1969. 2 vols.
 Historical literature of the field.

25:78 Costume Society of America. *Bibliography: Of Recent Publications and Reprints Relating to Aspects of Dress,* compiled by Adele Filene and rev. by Polly Willman, 1974/79. *Bibliography,* compiled by Polly Willman, 1983.
 Purchase through Costume Society of America; see "Serials and Associations" below.

25:79 Gaudriault, Raymond. *La Gravure de Mode Femine en France.* Paris: les éditions de l'amateur, 1983.
 List of French fashion periodicals up to 1939; provides title, dates, formats, characteristics.

25:80 Hiler, Hiliare and Meyer Hiler. *Bibliography of Costume: A Dictionary Catalog of about Eight Thousand Books and Periodicals.* New York: H.W. Wilson, 1939; reprint, New York: B. Blom, 1967.

25:81 Kesler, Jackson. *Theatrical Costume: A Guide to Information Sources.* New York: Gale Research, 1979.

25:82 Lipperheide, Franz Joseph. Katalog der Lipperheideschen Kostümbibliotek. Berlin: Mann, 1965. 2 Vols.

25:83 Prichard, Susan Perez. *Film Costume: An Annotated Bibliography.* Metuchen, NJ: Scarecrow, 1981.

Fashion and Costume Picture Collections

25:84 *Bibliothèque Nationale: Collections of the Department of Prints and Photographs.* Paris: Studios Photographiques Harcourt, n.d. Microfilm.
 .1 *Costumes de Regne de Louis XIV,* 17th-century engravings made of the then contemporary fashions.
 .2 *Costumes du XVIII^{eme} Siècle,* engravings made between 1778 and 1785 by Parisian firm of Esnault and Rapilly, of then current fashions and manners.
 .3 *"La Mésangère" Parisian Costumes, 1797–1839,* drawings made by Mesangere and others for *Journal des Dames et des Modes,* that depicted contemporary society.

25:85 *Victoria and Albert Museum.* Haslemere, Surrey, England: Emmet Microform. Color microfiche.
 .1 *Jewellery Gallery,* 1983.
 .2 *Local and Traditional Costumes,* 1987.
 .3 *Paquin Worth Fashion Drawings: 1865–1956,* 1982.
 .4 *Schiaparelli,* 1984.
 .5 *Swinging Sixties: Fashion in Britain,* 1985.
 .6 *Theatre Costume Designs,* 1984.
 .7 *Visual Catalogue of Fashion and Costume,* 1981

25:86 *Victoria and Albert Museum: The House of Worth: Fashion Designs, A Photographic Record 1895–1927.* London: Mindata, 1983. Microfiche.
 Reproduces 7,000 photographs of fashions created by Charles Frederick Worth, an Englishman pre-eminent in the world of fashion.

Indices to Reproductions of Costumes

These indices indicate serials and books that have reproductions of various costumes and dress for particular periods and countries; usually color illustrations are indicated.

25:87 Greer, Roger C. *Illustration Index*. Metuchen, NJ: Scarecrow, 1973.
Indexes 14 books and serials issued between July, 1963 and December, 1971. Costume illustrations emphasized.

25:88 Monro, Isabel Stevenson and Dorothy E. Cook, eds. *Costume Index: A Subject Index to Plates and Illustrative Text*. New York: H. W. Wilson, 1937. Also available from Ann Arbor, MI: Xerox University Microfilms.
Index to 942 volumes; *National Geographic Magazine* is only serial included.

25:89 ———— and Kate M. Monro, eds. *Costume Index Supplement*. New York: H. W. Wilson, 1957.
Indexes 347 books. Costumes of 19th and 20th centuries indexed under century and subdivided by decades rather than separate countries.

25:90 Vance, Lucile E. and Esther M. Tracey. *Illustration Index*. 3rd ed. New York: Scarecrow, 1973.
Lists reproductions published in 24 magazines from 1950 through June, 1963.

Social History

Also see the history books cited in Chapters 12 through 14 and Boehn's *Modes and Manners* [25:25, 28–30].

25:91 Adburgham, Alison. *A Punch History of Manners and Modes 1841–1940*. London: Hutchinson, 1961.

25:92 Batterberry, Michael and Ariane Batterberry. *Mirror, Mirror: A Social History of Fashion*. New York: Rinehart & Winston, 1977.

25:93 Bentley, N. *The Victorian Scene, 1837–1901*. London: Weidnfeld & Nicolsn, 1968.

25:94 Canter Cremers-Van der Does, Eline. *The Agony of Fashion*. Poole, Dorse, England: Blandford Press, 1980.
Translation of *Onze Lijne Door De Tijd*, 1975. Relates discomfort in dress from time of ancient Egyptians to date.

25:95 Chamberlin, Russell. *Everyday Life in the Nineteenth Century*. Lexington, MA: Silver, Burdett & Ginn, 1983.

25:96 *Everyday Life Series*. London: B.T. Batsford, reprints by New York: Dorset.
.1 *Everyday Life in the Old Stone Age*, Marjorie & C. H. B. Quennell, 2nd ed., 1926.
.2 *Everyday Life in Babylonia and Assyria*, H.W.F. Saggs, 1965, reprint 1987.
.3 *Everyday Life of the Etruscans*, Ellen Macnamara, 1973, reprint, 1987.
.4 *Everyday Life in Roman and Anglo-Saxon Times*, Marjorie & C. H. B. Quennell, 1959; reprint, 1987.
.5 *Everyday Life of the Barbarians: Goths, Franks, and Vandals*, Malcolm Todd, 1972; reprint, 1988.
.6 *Everyday Life in the Viking Age*, Jacqueline Simpson, 1967; reprint, 1987.
.7 *Everyday Life in Byzantium*, Tamara Talbot Rice, 1967; reprint, 1987.
.8 *Everyday Life in Medieval Times*, Marjorie Rowling, 1968; reprint, 1987.
.9 *Everyday Life in Ottoman Turkey*, Raphaela Lewis, 1971; reprint, 1988.
.10 *Everyday Life in Renaissance Times*, E. R. Chamberlin, 1965; reprint, New York: Perigee, 1980.
.11 *Everyday Life of the North American Indians*, Jon Manchip White, 1979; reprint, 1988.

25:97 *Everyday Things in Series*. London: B. T. Batsford.
.1 *Everyday Things in Archaic Greece*, Marjorie & C. H. B. Quennell, 1937.
.2 *Everyday Things in Classical Greece*, Marjorie & C. H. B. Quennell, 1932.
.3 *Everyday Things in Homeric Greece*, Marjorie & C. H. B. Quennell, 1929.
.4 *History of Everyday Things in England*, Marjorie & C. H. B. Quennell. London: B.T. Batsford.
Vol. 1: 1066–1499, 1918. *Vol. 2: 1500–1799*, 1919. *Vol. 3: 1733–1851*, 1933. *Vol. 4: 1851–1934*, 1934.

25:98 Fussell, G. E. and K. R. Fussell. *The English Countryman: His Life and Work From Tudor Times to the Victorian Age*. London: Andrew Melrose, 1955; reprint, London: Bloomsbury, 1985.

25:99 ————. *The English Countrywoman: Her Life in Farmhouse and Field From Tudor Times to the Victorian Age*. London: Andrew Melrose, 1953; reprint, London: Bloomsbury, 1985.

25:100 Grant, Neil. *Everyday Life in the Eighteenth Century*. Lexington, MA: Silver, Burdett & Ginn, 1983.

25:101 Hawke, David F. *Everyday Life in Early America*. New York: Harper & Row, 1988.

25:102 Heston, E.W. *Everyday Life in Old Testament Times*. New York: Scribner, 1977.

25:103 Hiler, Hilaire. *From Nudity to Raiment: An Introduction to the Study of Costume*. New York: Marshall, 1929; reprint, New York: Gordon Press, 1974.

25:104 Hollander, Anne. *Seeing Through Clothes.* New York: Viking, 1975.
Discusses drapery, nudity, undress, costume, dress, and mirrors and their impact on artists and viewers.

25:105 James, Edwin Oliver. *Marriage Customs Through the Ages.* New York: Collier, 1965.

25:106 Langner, Lawrence. *The Importance of Wearing Clothes.* New York: Hastings House, 1959, microform reprint, 1982.

25:107 Langdon, William. *Everyday Things in American Life.* New York: Scribner's, 1937–41; reprint 1981. 2 vols.
Vol. 1 covers how Americans lived from 1607–1776, Vol. 2, from 1776–1876.

25:108 Laver, James. *The Age of Illusion: Manners and Morals 1750–1848.* New York: David McKay, 1972.

25:109 ———. *Manners and Morals in the Age of Optimism 1848–1914.* New York: Harper & Row, 1966.

25:110 ———. *Modesty in Dress.* London: William Heinemann, 1969.

25:111 *Life in Series.* Geneva: Minerva.
.1 *Life in Egypt in Ancient Times,* Bernard Romant, trans. by J.Smith, 1986.
.2 *Life in Greece in Ancient Times,* Paul Werner, trans. by David Macrae, 1986.
.3 *Life in Rome in Ancient Times,* Paul Werner, trans. by David Macrae, 1978.
.4 *Everyday Life in the Middle Ages,* Suzanne Comte, trans. by David Macrae, 1978.

25:112 Middleton, Haydn. *Everyday Life in the Sixteenth Century.* Lexington, MA: Silver, Burdett, & Ginn, 1983.

25:113 Ribeiro, Aileen. *Dress and Morality.* London: B.T. Batsford, 1986.

25:114 Selz, Peter. *Art in Our Times: A Pictorial History 1890–1980.* New York: Harcourt, Brace, Jovanovich, 1981.

25:115 Squire, Geoffrey. *Dress and Society, 1560–1970.* New York: Viking, 1974.

25:116 Taylor, Laurence. *Everyday Life in the Seventeenth Century.* Lexington, MA: Silver, Burdett & Ginn, 1983.

25:117 *Time-Life Books: This Fabulous Century: Sixty Years of American Life.* New York: Time Life Books, 1969. 7 vols.
Vols. 1–6, each cover a decade; *Vol. 7: Prelude 1870–1900.*

25:118 Wildeblood, Joan and Peter Brinson. *The Polite World: A Guide to English Manners and Deportment from the Thirteenth to the Nineteenth Century.* London: Oxford University, 1965.

Fashion Documentaries

Of utmost importance to the fashion world are the seasonal showings of the couturier collections; these receive international press coverage. A few libraries have videotapes made by various coutures of their showings. These videos are not for sale or rent, but can be viewed at the institution's library. *Fashion Update* is a record of the international couturier collections using single photographs of the events. For information on the video collection at the Fashion Institute of Design and Merchandising, which has more than 1,400 titles, see "The International Fashion Video Library: Documenting the Globalization of Fashion for the Future," by Maryhelen Garrett and Kaycee Hale, *Art Libraries Journal* 13(1988): 17–20.

A recent development is the video magazine concept; this, provides moving views of how specific fashions work with the human body. Seeing a model move in a dress provides insight into how the construction influenced the achieved look. Video magazines illustrate the important international couturier shows, have pictorial essays on various aspects of the clothing industry, and interview designers, models, and others involved in fashion.

25:119 *Fashion Update.* Haslemere, Surrey, England: Emmet Microform 1983+ Color microfiche.
Issued 4 times a year; about 1,400 reproductions of clothes of about 120 designers from Milan, London, Paris, and New York. Includes menswear.

25:120 Videofashion Network. Jersey City, NJ: Speier Enterprises. Videotape.
Established in 1976, there are four serials: *Videofashion Monthly, Videofashion News, Videofashion Men,* and *Videofashion Specials.* These are half-hour videotapes with no advertising; all are produced each month, except men's fashions which is produced every 3 months. The *Videofashion Specials* have included *The Art of Dressing, The Making of a Model,* and reports on designers in such cities as Milan, Paris, and London.

Chanel, Chanel, Home Vision, 1986.
Eighteenth-Century Women. New York: Metropolitan Museum of Art, 1982. Video Cassette
Story of Fashion, Home Vision, 1986.

Index

See *Reader's Guide to Periodical Literature* [16:23] and *Magazine Index* [16:21]. *Trade and Industry Index Database* [16:54] includes *Women's Wear Daily*.

25:121 *The Clothing & Textile Arts Index.* Monument, CO: Clothing and Textile Arts Index. 1970+ Annual.

Originally called *Clothing Index.* Cumulations for 1970–1979 and 1980–1984. Textile artists, clothing designers, costume and textile historians, theatrical costumers; includes summary or description of articles. Since 1989, available on CD-ROM.

Serials and Associations

For a new format in serials, see *Videofashion* [25:120], which is both a documentary and a serial. Several other serials are also using this format. For regional dress, consult *National Geographic Magazine,* 1888+

California Apparel News 1974+

Costume: The Journal of the Costume Society 1967/68+ (Costume Society, Department of Textiles, Victoria and Albert Museum, London, SW7, England)

Costume Society of America Newsletter 1975+ (Costume Society of America, 55 Edgewater Drive, PO Box 73, Earleville, MD 21919.) See also *Dress.*

Costume Society of Ontario Newsletter Costume Society of Ontario Newsletter 1971+

Dallas Apparel News 1981+

Dress, The Journal of the Costume Society of America 1975+

Elle 1945+

Fashion and Craft 1967+

Gentleman's Quarterly, 1931+

Harper's Bazaar 1867+

M: The Civilized Man, 1977+ (Titled *Men's Wear,* 1977–83)

Officiel de la Couture et de la Mode de Paris 1921+

Ornament 1979+

Style: The Canadian Women's Wear Newspaper 1888+

Textile History 1968+

Textile Museum Journal, Textile Museum, Washington, D.C., 1962+ (Originally titled *Textile Museum Workshop Notes*)

Vogue 1892+ (Numerous spin offs, such as *Vogue Italia, Manner Vogue, Vogue British, Vogue Pelle, Vogue Hommes, Vogue Paris,* L'Uomo Vogue. In 1982, Mindata published *British Vogue 1916–1939* on microfiche.)

Women's Wear Daily 1927+ (Since 1976, titled *WWD,* but literature still refers to it by its original title. Past issues available on microfilm)

Film and Video

Research on film has grown in importance in the art world; films—whether on reels, discs, or tapes—have become an integral part of most museum programs. Contemporary artists frequently experiment and produce in this medium. And without photography and film, there would be no documentation of conceptual and performance art. In addition, there is the field of video art, originating in video technology. Although a detailed discussion of these fields is beyond the scope of this book, this chapter does list and annotate a few essential research tools for both Hollywood-oriented and documentary films. The chapter is divided into (1) film resources, (2) bibliographies, (3) Library of Congress film holdings, (4) indices to video and film, (5) film reviews, (6) indices, and (7) serials. In this guide, the word video is used to encompass both videotapes and videodiscs. For browsing, use PN for facts about films and TR for film technology in the LC classification system; 791.43 for Dewey.

Any serious research on films requires viewing them. Frequently the film can be seen at a movie house or on television. Sometimes the film will be in a videotape or videodisc format and can be rented. Remember that the new video releases include both new and old movies. For films which have yet to be converted, researchers must visit one of the motion picture and video libraries, such as The Pacific Film Archive at the University of California in Berkeley, The UCLA Film Archive at the University of California at Los Angeles, the Margaret Herrick Library of the Academy of Motion Picture Arts and Sciences and Academy Foundation in Beverly Hills, the Museum of Modern Art, the Museum of Broadcasting in New York City, the International Museum of Photography at George Eastman House in Rochester, and The Motion Picture, Broadcasting, and Recorded Sound Division and the Motion Picture Section of the Library of Congress in Washington, D.C., as well as The National Film Archive in London.

Film Resources

Many of these volumes provide data on individual films, such as production company, film type, release date, number of reels and feet, cast credits, synopsis of movie story, screen writers, and motion picture awards.

26:1 Academy of Motion Picture Arts and Sciences. *Who Wrote the Movie and What Else Did He Write? An Index of Screen Writers and Their Film Works 1936–1969.* Los Angeles: Academy of Motion Picture Arts and Sciences and Writers Guild of America, West, 1970.

26:2 American Film Institute. *American Film Institute Catalog of Motion Pictures Produced in the United States.* New York: R. R. Bowker, 1984; Berkeley: University of California.
Feature Films 1: 1911–1920, 1988. 2 vols.
Feature Films 2: 1921–1930, Kenneth W. Munden, 1971. 2 vols.
Feature Films 6: 1961–1970, 1976. 2 vols.
Project will include, decade by decade, catalogues of American produced films: features, shorts, and newsreels.

26:3 Bawden, Liz-Anne, ed. *The Oxford Companion to Film.* New York: Oxford University, 1976.
International coverage of terms, styles, and people associated with films.

26:4 Beaver, Frank E. *Dictionary of Film Terms.* New York: McGraw-Hill, 1983.

26:5 Bessy, Maurice and Jean-Louis Chardans. *Dictionnaire du cinéma et de la télévision.* Paris: Jean-Jacques Pauvert, 1965–71. 4 vols.

26:6 Boussinot, Roger, ed. *L'encyclopédie du cinéma.* Paris: Bordas, 1967.

26:7 Cawkwell, Tim and John M. Smith, associate eds. *The World Encyclopedia of Film.* London: Studio Vista, 1972.
Biographical entries.

26:8 Daisne, Johan. *Dictionnaire filmographique de la littérature mondiale. (Filmographic Dictionary of World Literature.)* Ghent, Belgium: Story-Scientia PVBA, 1971–78. 2 vols.

26:9 Geduld, Harry M. and Ronald Gottesman. *An Illustrated Glossary of Film Terms.* New York: Holt, Rinehart and Winston, 1973.

26:10 Gifford, Denis. *The British Film Catalogue 1895–1970.* New York: McGraw-Hill, 1973; reprint, New York: Garland, 1987.

26:11 Halliwell, Leslie. *The Filmgoer's Companion.* 7th ed. rev. and enlarged. New York: Scribner, 1989.

26:12 ———. *Film and Video Guide.* 5th ed. New York: Scribner, 1987.

26:13 Katz, Ephraim. *The Film Encyclopedia.* New York: Thomas Crowell, 1979.

26:14 Lacalamita, Michele, ed. *Filmlexicon degli autori e delle opere.* Rome: Bianco e Nero, 1958–67. 7 vols.

26:15 Low, Rachael. *The History of the British Film.* London: George Allen and Unwin and Winchester, MA: Unwin Hyman.
 Vol. 1: 1896–1906, with Roger Manvell, 1948; *Vol. 2: 1906–1914,* 1949; *Vol. 3: 1914–1918,* 1950; *Vol. 4: 1918–1929,* 1971. Continued by: *Films of Comment and Persuasion of the 1930s,* 1979; *Documentary and Educational Films of the 1930s,* 1979; and *Film Making in Nineteenth Thirties Britain,* 1985.

26:16 Magill, Frank N., ed. *Magill's Survey of Cinema: English Language Films.* Englewood Cliffs, NJ: Salem Press. 1980–82, reprint, 1987. 3 vols.
 First Series, 1980. 4 vols., films released from 1927 to 1980. *Second Series,* 1981, 6 vols., films, 1928–81. *Silent Films,* 1982, 3 vols., films, 1902–1936. *Foreign Films,* 1985. *Title Index: All Series,* 1985.

26:17 Manchel, Frank. *Film Study: A Resource Guide.* Rev. & enlarged. Rutherford, NJ: Fairleigh Dickinson University, 1987.
 Chapters on film literature, representation of genre in film, stereotyping in film, thematic approach to movies, and comparative film literature. Glossary; list of film critics and film periodicals.

26:18 Manvell, Roger, general ed. *The International Encyclopedia of Film.* New York: Crown, 1972; reprint, New York: Bonanza, 1975.

26:19 Michael, Paul, ed.-in-chief. *The American Movies Reference Book: The Sound Era.* Englewood Cliffs, NJ: Prentice-Hall, 1969.

26:20 Nash, Jay Robert and Stanley Ralph Ross. *The Motion Picture Guide.* Chicago: Cinebooks, 1985–87. 12 vols.

Under movie title, cites data on 50,000 English-speaking and notable foreign films from 1827–83/84. Major entries volumes 1–9; Vol. 10 lists more than 3,000 major silent films, 1910–36 compiled by Robert Connelly. Last 2 volumes are indices to alternate titles, series, awards, and names.

26:21 Pickard, R. A. E. *Dictionary of 1,000 Best Films.* New York: Association Press, 1971.

26:22 Pickard, Roy. *Who Played Who in the Movies.* New York: Schocken, 1981.

26:23 Sadoul, Georges. *Dictionary of Film Makers.* Trans. and ed. by Peter Morris. Berkeley: University of California, 1972.

26:24 ———. *Dictionary of Films.* Trans. and ed. by Peter Morris. Berkeley: University of California, 1972.

26:25 Shale, Richard. *Academy Awards.* New York: Frederick Unger, 1978.
 Includes costume design, art direction, and cinematography.

26:26 Thomson, David. *A Biographical Dictionary of Film.* 2nd ed, rev. New York: William Morrow, 1981.

Bibliographies

See *Arts in America* [13:44] Volume 3, George Rehrauer's "Film" lists 300 actors, directors, and producers.

26:27 Batty, Linda. *Retrospective Index to Film Periodicals 1930–1971.* New York: R. R. Bowker, 1975.
 Indexes 19 serials.

26:28 *Catalogue of the Book Library of the British Film Institute.* Boston: G. K. Hall, 1975. 3 vols.
 Covers virtually all English-language books on cinema. Institution originally called National Film Library.

26:29 *Film Index: A Bibliography.* White Plains, NY: Kraus International, 1985.
 Compiled by the Writers' Program of the W.P.A. in New York City in the 1930s; Vol. 1, *Film As Art,* first published in 1941. Vol. 2: *The Film as Industry* and Vol. 3: *The Film in Society* have never been issued previously.

26:30 Gerlach, John C. and Lana Gerlach. *The Critical Index: A Bibliography of Articles on Film in English, 1946–1973.* New York: Teachers College Press, 1974.
 Items from 22 film journals and 60 general serials.

26:31 Leonard, Harold, ed. *Film Index: A Bibliography*. New York: Museum of Modern Art Library & H. W. Wilson, 1941; reprint ed., New York: Arno, 1966; reprint, New York: Kraus, 1988.

26:32 Los Angeles, University of California, Theater Arts Library. *Motion Pictures: A Catalog of Books, Periodicals, Screenplays and Production Stills*. 2nd ed. Boston: G.K. Hall, 1976. 2 vols.

26:33 MacCann, Richard Dyer and Edward S. Perry. *New Film Index: A Bibliography of Magazine Articles in English, 1930–1970*. New York: E. P. Dutton, 1975.
 Supplements *Film Index* [26:29]. Covers 60 serials.

26:34 Prichard, Susan Perez. *Film Costume: An Annotated Bibliography.* Metuchen, NJ: Scarecrow, 1981.
 Has more than 3,600 entries; indices for subjects and designers.

26:35 Rehrauer, George. *Cinema Booklist*. Metuchen, NJ: Scarecrow, 1972. *Supplement One*, 1974. *Supplement Two*, 1977.

26:36 ———. *The Macmillan Film Bibliography: A Critical Guide to the Literature of the Motion Picture*. New York: Macmillan, 1982. 2 vols.

26:37 Schuster, Mel. *Motion Picture Directors: A Bibliography of Magazine and Periodical Articles, 1900–1972*. Metuchen, NJ: Scarecrow, 1973.
 Indexes 340 serials.

26:38 ———. *Motion Picture Performers: A Bibliography of Magazine and Periodical Articles, 1900–1969*. Metuchen, NJ: Scarecrow, 1971. Supplement No. 1: 1970–1974, 1976.
 Indexes 140 serials.

26:39 Slide, Anthony. *The Idols of Silence: Stars of the Cinema Before the Talkies*. New York: A.S. Barnes, 1976.

Library of Congress Film Holdings

In September, 1951, librarians at the Library of Congress began issuing printed cards for catalogued motion pictures and filmstrips of educational or instructional value released in the U.S. and Canada. In 1972, cataloguing for records, transparencies, and slides were added. In 1978, title was changed to *LC Catalogs: Audio-Visual Materials;* since 1983, issued on microfiche. Some catalogues are cited below.

26:40 *Library of Congress: Motion Pictures: Catalog of Copyright Entries. Motion Pictures 1894–1912*, by Howard Lemarr Walls, 1953. *Motion Pictures 1912–1939*, 1951; *Motion Pictures 1940–1949*, 1953.

26:41 *The George Klein Collection of Early Motion Pictures in the Library of Congress: A Catalog*, 1980. Titles produced between 1898 and 1926.

26:42 *Motion Pictures from the Library of Congress Paper Print Collection 1894–1912*. Kemp R. Niver, compiler. Los Angeles: University of California, 1967.

Indices to Video and Film

Under film titles, these references sometimes provide such data as film's completion date, country of origin, synopsis of story, type of film—drama, comedy, cartoon, or detective, list of credits—producer, director, author, script writer, choreographer, photographer, and leading players. Some catalogues are for libraries where films can be viewed.

26:43 *Artsamerica Fine Art Film & Video Source Book*. Greenwich, CT: Artsamerica, 1987. *Supplements*, 1988+

26:44 Besemer, Susan P. and Christopher Crosman. *From Museums, Galleries, and Studios: A Guide to Artists on Film and Tape*. Westport, CT: Greenwood, 1986.

26:45 Boyle, Deirdre. *Video Classics: A Guide to Video Art and Documentary Tapes*. Phoenix, AZ: Oryx, 1986.

26:46 British Film Institute. *National Film Archive Catalogue*. London: British Film Institute.
 Part 1: Silent News Films, 1895–1933, 2nd ed., 1965. *Part 2: Silent Non-Fiction Films, 1895–1934*, 1960. *Part 3: Silent Fiction Films, 1895–1930*, 1966. *Part 4: The National Film Archive Catalogue. Volume One: Non-Fiction Films*, 1980.

26:47 "Critical Inventory of Films on Art." Program for Art on Film, 980 Madison Ave., New York City 10021.
 Computerized compilation of data on international films and videos. Established in 1984; stated goal of this joint venture between the Metropolitan Museum of Art and the J. Paul Getty Trust is "to improve the quality of film and video productions about art and to enhance public awareness of the visual arts through film."

26:48 *Educational Film/Video Locator of the Consortium of University Film Centers and R. R. Bowker.* 3rd ed. New York: R. R. Bowker, 1986. 2 vols.

26:49 *Feature Films: A Directory of Feature Films on 16mm and Videotape Available for Rental, Sale, and Lease.* James L. Limbacher, ed. 8th ed. New York: R. R. Bowker, 1985.

26:50 *Film Catalog: A List of Film Holdings in the Museum of Modern Art,* Jon Gartenberg, ed. Boston: G. K. Hall, 1985.
Lists about 5,500 films dating from 1890 to 1980s.

26:51 *On Art and Artists: Video Data Bank.* Chicago: School of the Art Institute of Chicago, Columbus Drive at Jackson Blvd., Chicago, IL 60603, 1984+ Updated periodically.
About 200 programs on contemporary art and artists. Maintains archive of over 2,000 video programs concentrating on ideas central to contemporary art. Many programs combine performance, video, and film.

26:52 *Video Classics: A Guide to Video Art and Documentary Tapes,* Deidre Boyle. Phoenix, AZ: Oryx, 1986.

26:53 *The Video Source Book.* David J. Weiner, ed. 10th ed. Detroit: Gale Research, 1989.

Film Reviews

Also see *Film Literature Index* [26:60], which lists film reviews under individual film titles, and *Reader's Guide to Periodical Literature* [16:23], which includes cinema reviews.

26:54 *American Film Directors.* Stanley Hockman, compiler. New York: Frederick Ungar, 1974.
Quotations from critical reviews of movies of 65 directors.

26:55 *Film Criticism: An Index to Critics' Anthologies.* Richard Heinzkill, compiler. Metuchen, NJ: Scarecrow, 1975.
Relates in which of 40 anthologies review of particular film will be found. All foreign films are listed under an English-translated title.

26:56 *Film Review Index.* Patricia King Hanson and Stephen L. Hanson, eds. Tuscon, AZ: Oryx.
Vol. 1: 1882–1949, 1986; *Vol. 2: 1950–1985,* 1987.

26:57 *Index to Critical Film Reviews in British and American Film Periodicals.* Stephen E. Bowles, compiler. New York: Burt Franklin, 1974. 2 vols.

Lists over 20,000 film reviews and 6,000 reviews of books about cinema. Excludes serials indexed in *Reader's Guide to Periodical Literature* [16:23].

26:58 *Media Review Digest: The Only Complete Guide to Reviews of Non-Book Media.* Ann Arbor, MI: Pierian. 1970–1972 +
First issue was titled *Multi-Media Reviews Index.* Covers films and videotapes, filmstrips, records and tapes, plus miscellaneous media.

26:59 *New York Times Film Reviews.* New York: New York Times Company. Became Biennial.
Vol. 1: 1916–1931; Vol. 2: 1932–1938; Vol. 3: 1939–1948; Vol. 4: 1949–1958; Vol. 5: 1959–1968; Vol. 6: Appendix Index (1913–68). Reprints entire film review.

Indices

Film information is indexed in a number of indices of periodical literature, such as *Art Index* [16:1], which covers such serials as *Film Comment, Film Culture, Film Quarterly, Films in Review.* and the *Reader's Guide to Periodical Literature* [16:23]. Separate indices for current film literature are issued irregularly, therefore, it is especially important to check the books listed above under "Bibliographies," since a number of these references have indexed film serials retrospectively.

26:60 *Film Literature Index.* Albany, NY: Filmdex, 1973+
Quarterly author-subject index to about 200 international serials with annual cumulation.

26:61 National Film Information Service. The Margaret Herrick Library of the Academy of Motion Picture Arts and Sciences and Academy Foundation, 8949 Wilshire Blvd., Beverly Hills, CA 90211.
Founded in 1927, the library has 60,000 films, 13,000 books and pamphlets, 4,000,000 still photographs, and extensive vertical files. Compiles research guides containing detailed bibliographies, which are available for a nominal sum.

Serials

American Cinematographer, American Society of Cinematographers, (1782 North Orange Drive, Hollywood, CA 90028), 1920+
American Film, American Film Institute 1975+

Close Up, American Film Institute (John F. Kennedy Center for Performing Arts, Washington, D.C. 20566), 1982+

Film Comment 1962 + (once titled *Vision*)

Film Culture 1955 +

Film Library Quarterly 1967 +

Film Quarterly 1958 + (Available on microfilm)

Films in Review, National Board of Review of Motion Pictures 1950+

Literature/Film Quarterly 1973+

Sight and Sound 1961–66, 1972–80, 1985+

Sight-Line Magazine, American Film Institute & Video Association (Formerly Educational Film Library Association; address, 920 Barnsdale road, Suite 152, La Grange Park, IL 60525) 1967+

Commercial Design

This chapter is divided into (1) dictionaries; (2) biographical dictionaries, directories, and bibliographies; (3) surveys and techniques; (4) published picture collection; (5) annuals and source books; and (6) serials. Additional material may be located in the Harvard University Graduate School of Design catalogue [21:99]. The Library of Congress has 70,000 American and foreign posters; see Chapter 22. For browsing, use the LC classification of NC or the Dewey of 741.67. Business references, which are outside the scope of this book, can be located with the help of the reference librarian.

Graphic Arts Dictionaries

27:1 Mintz, Patricia Barnes. *Dictionary of Graphic Art Terms: A Communication Tool for People Who Buy Type and Printing.* New York: Van Nostrand Reinhold, 1981.
Includes reprint of *Code of Fair Practice of the Joint Ethics Committee of New York.*

27:2 Snyder, John. *Commercial Artist's Handbook.* New York: Watson-Guptill, 1973.
Covers materials, techniques, terms.

27:3 Stevenson, George A. *Graphic Arts Encyclopedia,* 2nd ed. New York: McGraw-Hill, 1979.
Illustrated dictionary of terms and equipment; includes photographic and commercial print terms. Conversion tables for metric system and paper sizes. Records mathematical symbols.

Biographical Dictionaries, Directories, Bibliographies

Other biographical dictionaries cover these artists, such as *Who's Who in American Art* [10:50], *Contemporary Designers* [10:32], and *Current Biography Yearbook* [10:33]. For a bibliography of Canadian designers, see *Design in Canada: 1940–1987* [13:95]. Some illustrators may be listed with printmakers; see Chapter 22.

27:4 American Institute of Graphic Arts. *Membership Directory.* New York: American Institute of Graphic Arts.

27:5 Amstutz, Walter. *Who's Who in Graphic Art: An Illustrated Book of Reference to the World's Leading Graphic Designers, Illustrators, Topographers, and Cartoonists.* Zurich: Amstutz & Herdeg, Graphis, 1962.

27:6 Baker, Charles. *Bibliography of British Illustrators 1860–1900.* Birmingham, England: Birmingham Bookshop, 1978.

27:7 Castagno, John. *Artists As Illustrators: An International Directory With Signatures and Monograms, 1800-Present.* Metuchen, NJ: Scarecrow, 1989.
Biographical data on 14,000 artists; includes artists' nationalities, dates, and facsimiles of signatures.

27:8 *Contemporary Graphic Artists: A Biographical, Bibliographical, and Critical Guide to Current Illustrators, Animators, Cartoonists, Designers, and Other Graphic Artists.* Detroit: Gale Research, 1987. 2 vols.
Cumulative indices for artists, occupations, and subjects including organizations, important awards, artistic media, and genre.

27:9 *The Design Firm Directory: A Listing of Firms and Consultants in Industry, Graphic, Interior, and Exterior Design.* W. Daniel Wefler, ed. Evanston, IL: Wefler & Associates, 1986+ Annual
Reports more than 1,350 firms in geographical order by state then city. Cites date firm established, number of employees, names of major personnel, services, and clients.

27:10 Houfe, Simon. *The Dictionary of British Book Illustrators and Caricaturists 1800–1914.* Rev. ed. Woodbridge, Suffolk: Antique Collectors Club, 1981.
History of book illustration; brief biographies.

27:11 *Illustrators.* New York: Society of Illustrators, 1959+ Annual

27:12 *N. Y. Gold.* New York: Watson-Guptill, 1987+ Annual.
Directory of services in New York City for photography, illustration, design, film, video, music.

27:13 Peppin, Brigid and Lucy Micklethwait. *Book Illustrators of the Twentieth Century.* New York: Arco, 1984.

27:14 Weill, Alain. *The Poster: A Worldwide Survey and History*. Boston: G.K. Hall, 1984. Brief biographies.

Surveys and Techniques

27:15 Bereswill, Joseph W. *Corporate Design: Graphic Identity Systems*. New York: PBC International, 1987.

27:16 Carter, David E. *Corporate Identity Manuals*. New York: Art Direction Book, 1978.

27:17 ———. *Designing Corporate Identity Programs for Small Corporations*. New York: Art Direction Book Company, 1982.

27:18 CoCoMas Committee. *Corporate Design Systems*. New York: PBC International, 1979.

27:19 ———. *Corporate Design Systems Two*. New York: PBC International, 1985.

27:20 ———. *Design Systems for Corporations.* Tokyo: SANNO Institute Business Administration, 1976–79. 6 vols.

27:21 Davis, Sally Prince. *The Graphic Artist's Guide to Marketing and Self-Promotion*. Cincinnati, OH: North Light Books, 1987.

27:22 *The Illustrators: The British Art of Illustration 1800–1988*. London: C. Beetles, 1988.

27:23 Klineman, Phillip. *International Advertising Design*. New York: PBC International/Rizzoli, 1988.

27:24 Marquand, Ed. *Graphic Design Presentations*. New York: Van Nostrand Reinhold, 1986.

27:25 Pilditch, James. *Communication by Design: A Study in Corporate Identity*. New York: McGraw-Hill, 1970.

27:26 Schmittel, Wolfgang. *Corporate Design International*. Zurich: ABC Verlag, 1984.

27:27 ———. *Process Visual: Development of a Corporate Identity*. Zurich: ABC, 1978.

27:28 Selame, Elinor and Joe Selame. *Developing a Corporate Identity: How to Stand Out in the Crowd*. New York: Lebhar-Friedman, 1975.

27:29 Souter, Nick. *Creative Director's Sourcebook*. London: Macdonald, 1988.

27:30 Wilde, Richard. *Problems: Solutions: Visual Thinking for Graphic Communicators*. New York: Van Nostrand Reinhold, 1986.

27:31 Winters, Arthur A. and Stanley Goodman. *Fashion Advertising and Promotion*. 6th ed. New York: Fairchild, 1984.

Published Picture Collection

A number of trade catalogues—advertising brochures for architecture, decorative arts, and fashion—have been reprinted on microfiche; see Chapter 24.

27:32 *The Henry Dreyfuss Archive*. London: Mindata, 1986. Microfiche.
Reproduces almost 6,000 pages of illustrations and text from the Henry Dreyfuss (industrial designer, worked 1929–1969) Collection at the Cooper-Hewitt Museum.

Advertising Annuals and Source Books

Annuals are the major publications of this discipline. All have extensive color reproductions; many have minimal multilingual texts. International in scope, entries for advertisements give names of firms, art directors, photographers, copywriters, agencies, clients, and dates. Some annuals reproduce international prize winning advertising designs and computer graphics; a few include films. Publications frequently change titles and are issued irregularly.

27:33 *Advertising Design in Japan*. Tokyo: Rikuyo-Sha, 1987+

27:34 *Art Director's Annual*. New York: ADC Publications, 1922+
Name has varied greatly; 1987 edition includes First Annual International Exhibition.

27:35 *Best in Series*. Bethsheba, MD: RC Publications.
.1 *Best in Advertising*, 1977+
.2 *Best in Advertising* Campaigns, 1975+
.3 *Best in Annual Reports*, 1975+
.4 *Best in Covers and Posters*, 1975+
.5 *Best in Environmental Graphics*, 1975+
.6 *Best in Exhibition Design*, 1977+
.7 *Best in Packaging*, 1975+

27:36 *British Design & Art Direction*. London: Designers & Art Directors, 1981+

27:37 *Corporate Photography Showcase*. New York: Van Reinhold, 1982+

27:38 *European Illustration*. New York: Hurst, 1974/75+

27:39 *Graphic Design in Japan*. New York: Kodansha International, 1982+

27:40 *Graphis Series*, Zurich: Amstutz & Herdeg, Graphis Press, Distributed by Lakewood, NJ: Watson-Guptill.

Publishes numerous annuals some of which have altered titles over the years. A representative list is provided.

.1 *Graphis Design Annual, 1987/88+ (Titled Graphis Annual 1953/54–1986/87)*

.2 *Graphis Design USA 1980+*

.3 *Graphis Packaging, 1959+*

.4 *Graphis Posters, 1973+*

.5 *PHOTOGRAPHIS: The International Annual of Advertising and Editorial Photography, 1966+*

27:41 *Illustration in Japan.* Tokyo: Kodansha International, 1982+

27:42 *International Design Yearbook.* New York: Abbeville Press, 1985/86+
Guest edited by famous designer; covers interior designs.

27:43 *International Photography Exposed.* Tokyo: Japan Creators Association, 1985+

27:44 *Letterheads: The International Annual of Letterhead Design.* Ashland, KY: Century Communications Unlimited, 1977+

27:45 *Print Casebooks: The Best in Covers and Posters.* Bethsheba, MD: R.C. Publications, 1975+

27:46 *RotoVision Series.* Geneva: RotoVision.

.1 *Images, 1982+*

.2 *Best of British Illustration and Photography, 1987+*

.3 *Designers Index, 1987+*

Serials

Trade and Industry Index Database [16:54] indexes *Advertising Age* (1981) and *ADWEEK Eastern Edition* and *Western Marketing News* (1989). Nexis Service [16:50] includes *Advertising Age* (1986) and *DWEEK* (1984). *Design International* [16:5], covers packaging and printing.

ADWEEK 1960+ (Various editions: Eastern, Western, Midwest, Southeast, Southwest, New England.)

Advertising Age 1930+

Advertising and Graphic Arts Techniques 1965+ (Entitled *Advertising Art Techniques,* 1965–70 and *Advertising Techniques,* 1970–83)

Art Direction 1949+ (Titled *Art Director and Studio* 1949–55)

Focus 1979+ (Titled *Advertising Age Europe,* 1979–81; *Advertising Age's Focus* 1981–85.)

Graphis: International Bi-Monthly Journal of Graphic Art and Photography 1944+

ID: Magazine of International Design, 1954+ (Titled Industrial *Design* 1954–84)

Museum Studies and Art/Museum Education

This chapter includes references concerned with (1) the interpretation of works of art, (2) conservation and preservation of art and architecture, (3) studies on museums and private collections, and (4) art/museum education. For resources on museum collection and exhibition catalogues, see Chapter 15.

Interpreting Works of Art

In the 5th century B.C., Democritus wrote about the arts in an historical context. Art historians, critics, and art educators have continued this line of investigation and interpretation. For a discussion on analyzing the form and style of works of art, see Chapter 6; for iconographical studies, Chapter 7. This section lists references concerned with (1) art appreciation, (2) analysis of works of art, (3) artists' techniques, (4) migration of art motifs, and (5) fakes and art thefts. For art historiography, see Chapter 11; for iconographical references, Chapter 29.

Art Appreciation

Some of these books also discuss the history of art. Moreover, some of the general art history surveys cover the principles of art; see Chapter 11.

28:1 Arnheim, Rudolf. *Art and Visual Perception: A Psychology of the Creative Eye.* London, Faber & Faber, 1954; reprint, Berkeley: University of California, 1974.
Discusses balance, shape, form, growth, space, light, color, movement, tension, and expression.

28:2 Feldman, Edmund Burke. *Varieties of Visual Experience.* 3rd ed. Englewood Cliffs, NJ: Prentice-Hall, 1987.
Abridged edition of *Art as Image and Idea,* 1967. Divided into functions of art, structure of art, interaction of medium and meaning, and problems of art criticism.

28:3 Gilbert, Rita and William McCarter. *Living With Art.* 2nd ed. New York: Knopf, 1988.
Discusses vocabulary of art, principles of design, and various kinds of media.

28:4 Gombrich, E. H. *The Story of Art.* 15th ed., rev. Englewood Cliffs, NJ: Prentice-Hall, 1989.

28:5 Knobler, Nathan. *The Visual Dialogue: An Introduction to the Appreciation of Art.* 3rd ed. New York: Holt, Rinehart and Winston, 1980.
Explains principles, media, and vocabulary of art.

28:6 Preble, Duane. *Artforms.* 3rd ed. New York: Canfield, 1984. Second edition of *Man Creates Art Creates Man.*

28:7 Taylor, Joshua. *Learning to Look.* Chicago: University of Chicago, 1981.

28:8 Zelanski, Paul and Mary Pat Fisher. *The Art of Seeing.* Englewood Cliffs, NJ: Prentice Hall, 1988.

Analysis of Works of Art

28:9 *Art in Context.* John Fleming and Hugh Honour, eds. New York: Viking, 1972–76. 18 vols.
Illustrated; cover historical aspects of individual works. Also include historical table of events.
.1 *Van Eyck: "The Ghent Altarpiece,"* Elisabeth Dhanens, 1973.
.2 *Turner: "Rain, Steam and Speed,"* John Gage, 1972.
.3 *Edward Munch: "The Scream,"* Reinhold Heller, 1973.
.4 *David, Voltaire, "Brutus," and the French Revolution: An Essay in Art and Politics,* Robert L. Herbert, 1973.
.5 *Leonardo: "The Last Supper,"* Ludwig H. Heydenreich, 1974.
.6 *Monet: "Le déjeuner sur l'herbe,"* Joel Isaacson, 1972.
.7 *Trumbull: "The Declaration of Independence,"* Irma B. Jaffe, 1970.
.8 *Piero della Francesca: "The Flagellation,"* Marilyn Aronberg Lavin, 1972.
.9 *Courbet: "The Studio of the Painter,"* Benedict Nicolson, 1973.

.10 *Watteau: "A Lady at Her Toilet,"* Donald Posner, 1973.

.11 *Fuseli: "The Nightmare,"* Nicolas Powell, 1973.

.12 *Van Dyck: "Charles I on Horseback,"* Roy C. Strong, 1972.

.13 *Poussin: "The Holy Family on the Steps,"* Howard Hibbard, 1974.

.14 *Manet: "Olympia,"* Theodore Reff, 1976.

.15 *Marcel Duchamp: "The Bride Stripped Bare by her Bachelors, Even,"* John Golding, 1973.

.16 *Delacroix: "The Death of Sardanapolus,"* Jack J. Spector, 1974.

.17 *Goya: "The Third of May 1808,"* Hugh Thomas, 1973.

.18 *The Statue of Liberty,* Marvin Trachtenberg, 1976.

28:10 Bouleau, Charles. *The Painter's Secret Geometry: A Study of Composition in Art.* Trans. by Jonathan Griffin. New York: Harcourt, Brace & World, 1963; reprint, New York: Hacker Art, 1980.

28:11 UNESCO. *An Illustrated Inventory of Famous Dismembered Works of Art: European Painting with a Section on Dismembered Tombs in France.* Paris: UNESCO, 1974.

Artists' Techniques

28:12 Cennini, Cennino. *The Craftsman's Handbook.* Trans. by D. V. Thompson. New Haven, CT: Yale, 1932–33; Reprint, New York: Dover, 1954. Vol. 2 of *Il libro dell'arte,* A Treatise by a 14th-Century Tuscan painter.

28:13 Huberts, Kurt. *The Complete Book of Artists' Techniques.* New York: Frederick A. Praeger, 1958.
Covers various kinds of art; appendix includes article on reconstructing historical techniques.

28:14 Mayer, Ralph. *The Artist's Handbook of Materials and Techniques.* 4th ed. rev. and expanded. New York: Viking, 1982.

28:15 Wehlte, Kurt. *Materials and Techniques of Paintings.* New York: Van Nostrand Reinhold, 1967.

28:16 Wittkower, Rudolf. *Sculpture: Processes and Principles.* New York: Harper & Row, 1977.

Migration of Art Motifs

28:17 Evans, Joan. *Pattern: A Study of Ornament in Western Europe from 1180 to 1900.* Oxford: Clarendon, 1931; reprint, New York: Hacker, 1975. 2 vols.

28:18 Glazier, Richard. *A Manual of Historic Ornament: Treating Upon the Evolution, Tradition, and Development of Architecture and the Applied Arts Prepared for the Use of Students and Craftsmen.* 5th ed. revised. New York: Charles Scribner's, 1933; reprint, Detroit: Gale Research, 1972.
Divided into historical accounts and various applied arts. First edition 1899.

28:19 Hamlin, Alfred Dwight Foster. *A History of Ornament.* New York: Century, 1916; reprint, New York: Cooper Square, 1973.
Vol. 1: Ancient and Medieval. Vol. 2: Renaissance and Modern.

28:20 Jairazbhoy, Rafique Ali. *Oriental Influences in Western Art.* New York: Asia Publishing House, 1965.
Traces motifs from Eastern to Western art. Covers decorative use of Arabic lettering, inlay, tournament scenes, hunting scenes, dragon genera, kingship of heroes, zoomorphic frieze, fused and interlocked fauna, lions as guardians, and ascension theme. Includes indices to names, to places, and to subjects.

28:21 Jones, Owen. *The Grammar of Ornament.* New York: J.W. Bouton, 1880; reprint, New York: Van Nostrand Reinhold, 1972.
Describes and traces principal motifs used by various civilizations, such as primitive societies, Egyptian, Grecian, Roman, Arabic, Persian, and Indian, plus motifs used in different periods of art history, such as Middle Ages, Renaissance, and Elizabethan; first edition 1856.

28:22 Mackenzie, Donald A. *The Migration of Symbols and Their Relations to Beliefs and Customs.* New York: Alfred A. Knopf, 1926; reprint, Detroit: Gale Research, 1968.
Traces swastika, spiral, ear symbols, and tree symbols in different cultures.

28:23 Speltz, Alexander. *Styles of Ornament: From Prehistoric Times to the Middle of the Nineteenth Century.* Trans. by David O'Conor from 2nd ed. revised by R. Rhene Spiers. New York: E. Weyhe, 1910; reprint, New York: Dover, 1959.

28:24 Stafford, Maureen and Dora Ware. *An Illustrated Dictionary of Ornament.* New York: St. Martin's, 1974.
Dictionary of terminology associated with ornament; index to persons and places. Lists and illustrates heraldic ornaments.

28:25 Wittkower, Rudolph. *Allegory and the Migration of Symbols.* New York: Thames & Hudson, 1977.

Fakes and Art Theft

28:26 Burnham, Bonnie. *Art Theft: Its Scope, Its Impact, and Its Control.* New York: International Foundation for Art Research, 1978.

28:27 Cescinsky, Herbert, *The Gentle Art of Faking Furniture.* 2nd ed. New York: Dover, 1967.

28:28 Fleming, Stuart J. *Authenticity of Art: The Scientific Detection of Forgery.* New York: Crane, Russak and Company, 1976.

 Covers paintings, ceramics, and metals; appendix covering x-ray fluorescence of Chinese blue-and-white porcelain, radiocarbon analysis, and lead isotope analysis of ancient objects.

28:29 Goodrich, David L. *Art Fakes in America.* New York: Viking, 1973.

 Historical accounts plus chapters on marketplace, fakes in American museums, detection, lawsuits, and prints and sculpture.

28:30 Kurz, Otto. *Fakes.* 2nd ed. rev. and enlarged. London: Faber & Faber, 1948; reprint, New York: Dover, 1967.

 Case histories of fakes on variety of art objects: paintings, sculpture, bronzes, glass, porcelain, furniture, jewelry, drawings, and graphics.

28:31 Minneapolis Institute of Arts. *Fakes and Forgeries.* Minneapolis: Minneapolis Institute of Arts, 1973.

 Data on detecting fakes and extensive bibliography.

28:32 Rieth, Adolf. *Archaeological Fakes.* Trans. by Diana Imber. London: Barrie and Jenkins, 1970.

28:33 Wright, Christopher. *The Art of the Forger.* London; Gordon Fraser, 1984.

28:34 Yates, Raymond Francis. *Antique Fakes and Their Detection.* New York: Harper & Brothers, 1950.

 Illustrated guide to detecting fakes in furniture, glassware, chinaware, silverware, pewter, clocks, jewelry, prints and paintings, and brass.

Conservation and Preservation

This section is divided into (1) historic preservation resources, (2) conservation of art objects, (3) video documentaries, (4) indices and bibliography, and (5) serials and associations.

Historic Preservation Resources

28:35 American Association for State and Local History.

Excellent source for books and technical brochures on preservation. Numerous publications; to name a few:

 .1 *A Bibliography on Historical Organization Practices,* Frederick L. Rath, Jr. and Merrilyn Rogers O'Connell.

 .2 *Historic Preservation in Small Towns,* Arthur P. Ziegler, Jr. and Walter C. Kidney.

 .3 *Local Government Records: An Introduction to Their Management, Preservation, and Use,* H. G. Jones.

 .4 *Furniture Care and Conservation,* 2nd ed., Robert F. McGiffin, due 1990.

 .5 *Exploring Their History Series,* with volumes on *Houses and Homes, Public Places,* and *Places of Worship.*

28:36 Hosmer, Charles B., Jr. *Preservation Comes of Age: From Williamsburg to the National Trust, 1926–1949.* Charlottesville: University Press of Virginia, 1981. 2 vols.

 Discussion of specific preservation projects, local and state preservation programs, U.S. Federal Government programs, and restoration techniques. Chronology for 1920–1953, bibliography, and copious footnotes.

28:37 Insall, Donald W. *The Care of Old Buildings Today: A Practical Guide.* London: Architectural Press, 1972.

 Discusses conservation techniques, administration problems, and case histories.

28:38 Markowitz, Arnold L. *Historic Preservation: A Guide to Information Sources.* Detroit: Gale Research, 1980.

 Serves as guide to various commercial and government publications dealing with historic preservation, including financial, legal, and planning aspects, description and documentation, materials and technology, and renovation and restoration.

Conservation of Art Objects

Write for a list of bulletins from the American Association of Museums and the American Association for State and Local History.

28:39 André, Jean-Michel. *The Restorer's Handbook of Ceramics and Glass.* Trans. by Denise André. New York: Van Nostrand Reinhold, 1976.

28:40 ———. *The Restorer's Handbook to Sculpture,* Trans. by J. A. Underwood. New York: Van Nostrand Reinhold, 1977.

28:41 Dudley, Dorothy H.; Wilkinson, Irma Bezold; et al. *Museum Registration Methods.* 3rd rev. ed. Washington, D.C.: American Association of Museums and Smithsonian Institution, 1979.

Chapters on storage and care of objects, packing and shipping, insurance, and preparing art exhibitions for travel.

28:42 Emile-Mâle, Gilbert. *The Restorer's Handbook of Easel Painting.* Trans. by J. A. Underwood. New York: Van Nostrand Reinhold, 1976.
Includes table indicating kinds of deterioration, causes, and treatments.

28:43 Fall, Freida Kay. *Art Objects: Their Care and Preservation, A Handbook for Museums and Collectors.* La Jolla, CA: Laurence McGilvery, 1973.

28:44 Hours, Madeleine. *Conservation and Scientific Analysis of Painting.* Trans. by Anne G. Ward, New York: Van Nostrand Reinhold, 1976.

28:45 Keck, Caroline K. *A Handbook on the Care of Paintings, for Historical Agencies and Small Museums.* Nashville: American Association for State and Local History, 1965.

28:46 Lewis, Ralph H. *Manual for Museums.* Washington, D.C.: U.S. National Park Service, 1976.
Chapter, "Caring for a Collection," describes some problems encountered from insects, molds, and pollution.

28:47 Plenderleith, Harold James and A.E.A. Werner. *The Conservation* of *Antiquities and Works of Art: Treatment, Repair, and Restoration.* 2nd ed. New York: Oxford University Press, 1971.

28:48 Taubes, Frederic. *Restoring and Preserving Antiques.* New York: Watson-Guptill, 1969.

Video Documentaries

The American Association for State and Local History has a number of videotapes, such as *Marketing and Promoting Interpretive Programs, Basic Deterioration and Preventive Measures for Museum Collections, Interpreting the Humanities through Museum Exhibits,* and *Museum Education: A Tool of Interpretation.*

Lifting a Curtain: Conservation of Rubens' Crowning of St. Catherine, Toledo Museum.
Paper and Silk: The Conservation of Asian Works of Art, Minneapolis Institute of Arts.
Return to Glory: Michelangelo Revealed: The Restoration of the Sistine Chapel, Nippon TV, Crown, 1986.

Indices and Bibliography

Also see brochures from the American Association for State and Local History [28:35].

28:49 *Art and Archaeology Technical Abstracts* (AATA). London: International Institute for Conservation of Museum Objects, 1955+

28:50 *Conservation Information Network Database.* Marina del Rey, CA: The Getty Conservation Institute, 1987.
Consists of (1) *Bibliographic Database,* with about 100,000 citations, covering all volumes of *Art and Archaeology Technical Abstracts* and abstracts of ICCROM's Library holdings; (2) *Materials Database.* which currently has information on such items as adhesives, coatings, and pesticides; and (3) *Suppliers Database,* which has data on international manufacturers, distributors, and retailers of conservation materials. Regular printed publications of subsets of the databases and diskette copies of the information which can be used at local libraries. In addition to the Getty, the participating institutions include the Conservation Analytical Laboratory of the Smithsonian Institution and CCI/ICC and CHIN/RCIP, both of Ottawa. Participants are the IICROM Library in Rome as well as ICOM and ICOMOS, both in Paris.

28:51 New York University, Institute of Fine Arts, *Library Catalog of the Conservation Center.* Boston: G. K. Hall, 1980.

Serials and Associations

Bulletin du Laboratoire du Musée du Louvre, 1956–68//
Historic Preservation, National Trust for Historic Preservation, (1785 Massachusetts Avenue, NW, Washington, D.C. 20036; see also *Preservation News.*) 1949+
History News, American Association for State and Local History, (172 Second Avenue, North, Suite 202, Nashville, TN 37201) 1949+
National Gallery Technical Bulletin (London), 1977+
Preservation News, National Trust for Historic Preservation, 1961+
Studies in Conservation, International Institute for Conservation of Historic and Artistic Works, 1959+

Studies on Museums and Private Collections

This section covers (1) patrons and patronage, (2) museum history, (3) current issues and standards, (4) video documentaries, and (5) serials and associations.

Patrons and Patronage

Consult Haskell's books: *Taste and the Antique* [12:19], *Patrons and Painters* [12:65], *Rediscoveries in Art* [12:112], and *Past and Present in Art and Taste* [12:81].

28:52 Alsop, Joseph Wright. *The Rare Art Traditions: The History of Art Collecting and Its Linked Phenomena Wherever These Have Appeared.* New York: Harper & Row, 1982.

28:53 Bertelli, Sergio, Franco Cardini, and Elvira Garbero Zorzi. *The Courts of the Italian Renaissance.* Trans. by Mary Fitton and Geoffrey Culverwell. New York: Facts on File, 1986.

28:54 Dickens, A. G., ed. *The Courts of Europe: Politics, Patronage and Royalty 1400–1800.* New York: McGraw-Hill, 1977; reprint, New York: Greenwich House, 1984.
Genealogical charts of ruling families.

28:55 *Great Family Collections,* ed. by Douglas Cooper. New York: Macmillan, 1965.

28:56 *Great Private Collections,* ed. by Douglas Cooper. New York: Macmillan, 1963.

28:57 Holst, Niels von. *Creators, Collectors and Connoisseurs: An Anatomy of Artistic Taste from Antiquity to the Present Day.* London: Thames and Hudson, 1967.

28:58 Levey, Michael. *Painting at Court.* New York: New York University Press, 1971.
Royal patronage between 14th and 19th centuries.

28:59 Meyer, Karl Ernst. *The Plundered Past.* New York: Atheneum, 1973.

28:60 Plumb, J. H. and H. U. W. Wheldon *Royal Heritage: The Treasures of the British Crown.* New York: Harcourt Brace Jovanovich, 1977.

28:61 Saarinen, Aline. *The Proud Possessors: The Lives, Times, and Tastes of Some Adventurous American Art Collectors.* New York: Random House, 1958.

28:62 Simpson, Colin. *Artful Partners: Bernard Berenson and Joseph Duveen.* New York: Macmillan, 1986.

28:63 Southorn, Janet. *Power and Display in the Seventeenth Century: The Arts and Their Patrons in Modern and Ferrara.* Cambridge: Cambridge University, 1988.

28:64 Taylor, Francis Henry. *The Taste of Angels: A History of Art Collecting from Rameses to Napoleon.* Boston: Little, Brown, 1948.

28:65 Treue, Wilhelm. *Art Plunders: The Fate of Works of Art in War and Unrest.* Translated by Basil Creighton. New York: John Day, 1961.
Discusses looters of art, which is a form of collecting, from antiquity through World War II. Includes lengthy section on French Revolution and Napoleon.

28:66 Trevor-Roper, Hugh. *Princes and Artists: Patronage and Ideology at Four Habsburg Courts 1517–1633.* New York: Harper & Row, 1976.

Museum History

28:67 Adams, Robert. *The Lost Museum: Glimpses of Vanished Originals.* New York: Viking, 1980.

28:68 Bazin, German. *The Museum Age.* Trans. by Jan van Nuis Cahill. New York: Universe Books, 1967.

28:69 Burt, Nathaniel. *Palaces for the People: A Social History of the American Art Museum.* New York: Little, Brown, 1977.

28:70 Meyer, Karl E. *The Art Museum: Power, Money, Ethics.* New York: William Morrow, 1979.

Current Issues and Standards

For the latest material, consult the American Association of Museums, American Association of State and Local History, and the Canadian Museum Association.

28:71 Alexander, Edward Porter. *Museums in Motion: An Introduction to the History and Functions of Museums.* Nashville, TN: American Association for State and Local History, 1979.

28:72 American Association of Museum Directors. *Professional Practices in Art Museums.* Rev. ed, New York: AAMD, 1981.

28:73 Phelan, Marilyn. *Museums and the Law.* Nashville, TN: American Association for State and Local History, 1982.

28:74 Sandak, Cass R. *Museums: What They Are and How They Work.* New York: Franklin Watts, 1981.

28:75 Weil, Stephen E. *Beauty and the Beasts: On Museums, Art, the Law, and the Market.* Washington, D.C.: Smithsonian Institution, 1983.

Video Documentaries

These are being produced at a prodigious rate, frequently to accompany and advertise special exhibitions. Many are excellent; only a few can be cited here. For locating pertinent videotapes, see resources cited in Chapter 26.

At the Met: Curator's Choice, Metropolitan Museum of Art, 1983.
Centre Georges Pompidou, RM ARTS, ABC Video Enterprise, 1987.
The Grand Museum Series: The Louvre: The Paintings, The Prado, The Vatican Museums, Dorset, nd.
The Jewish Museum, Vineyard Video, 1984.
Masterpieces of the Met, Metropolitan Museum of Art, 1988.
National Gallery of Art, National Gallery, 1984.
Phillips Collection, Checkerboard, nd.
The Treasures of France Series, Kronos, 1983. (Includes *Châteaux of the Loire, The Louvre: A Tour, Mont St. Michel; Versailles; Paris*)
Twentieth Century American Art: Highlights of the Permanent Collection, the Whitney Museum, 1982.
Uffizi: Florence's Treasure House of Art, VPI/AC Video, 1988.

Serials and Associations

Curator, American Museum of Natural History (Central Park West at 79th Street, New York, NY 10024) 1958+
Muse, Canadian Museum Association (280 Metcalfe Street, Suite 400, Ottawa, Ontario K2P 1R7) 1983+
The Museologist, Mid-Atlantic Association of Museums (University of Delaware, Newark, DE 19717) 1935+
Museum, UNESCO 1927+ (Titled *Mouseion: Bulletin de l'office international des musées,* Institute de cooperation intellectuelle de la Société des Nations, Paris, from 1927–1946; became *Museum* in 1948)
Museum News, American Association of Museums, (1225 Eye Street, N.W., Suite 200, Washington, D.C. 20005) 1924+
Museum Quarterly: The Journal of the Ontario Museum Association (38 Charles Street, East, Toronto, Ontario M4Y 1T1) 1983+
Museum Studies Journal, Center for Museum Studies, J.F.K. University, 1983–88//

Art/Museum Education

This section is divided into (1) dictionaries and books of readings, (2) research methods, (3) descriptions of educational programs, (4) references on art education, (5) bibliographies, (6) ERIC materials, (7) other education indices, and (8) serials and associations.

Dictionaries and Books of Readings

28:76 Monroe, Paul. *A Cyclopedia of Education.* New York: Macmillan, 1911–13; reprint, New York: MacMillan, 1970. 5 vols.
Out of date but useful for articles on terminology, historical periods, and educators.

28:77 *Dictionary of Education,* Prepared Under Auspices of Phi Delta Kappa, ed. by Carter V. Good. 3rd ed. New York: McGraw-Hill, 1973.
Educational terminology; lists about 25,000 words. Section for terms that differ from U.S. meanings; includes Canadian, English, and Welsh terms. Other editions (1945, 1959) have sections for word differentiations used in France, Germany, and England.

28:78 *Dictionary of Education,* ed. by P.J. Hills. London: Routledge & Kegan Paul, 1982.

28:79 *The Educator's Encyclopedia,* by Edward W. Smith, et al. Englewood Cliffs, NJ: Prentice-Hall, 1961.
Covers education and measurements, materials and resources, instructional improvement, and student activities. Glossary of educational terms.

28:80 *The Encyclopedia of Education,* editor-in-chief Lee C. Deighton. New York: Macmillan & Free Press, 1971. 10 vols.

28:81 *The Encyclopedia of Educational Research.* American Educational Research Association. New York: Macmillan. 1st ed., Walter S. Monroe, 1940. 2nd rev. ed., Walter S. Monroe, 1950. 3rd ed., Chester W. Harris, 1960. 4th ed., Robert L. Ebel, 1969. 5th ed., Harold E. Mitzel, 1982.
Collection of articles written by eminent scholars. Covers such topics as art, attitudes, and audiovisual communication, articles present critical evaluations, syntheses, and interpretations of pertinent research. Later editions are not revisions but have new subjects and different authors.

28:82 *Handbook on Contemporary Education,* ed. by Steven E. Goodman. New York: R. R. Bowker, 1976.
Signed articles on such topics as educational change and planning, teaching and learning strategies, and some alternatives and opinions in education.

28:83 *Handbook of Research on Teaching: A Project of the American Educational Research Association,* ed. by Nathaniel Lees Gage. Chicago: Rand McNally, 1963.
Analyzes educational research.

28:84 *Second Handbook of Research on Teaching: A Project of the American Educational Research Association,* ed. by Robert M. W. Travers. Chicago: Rand McNally College, 1973.
Includes research on teaching the visual arts.

28:85 *The Teacher's Handbook,* ed. by Dwight W. Allen and Eli Seifman. Glenview, IL: Scott, Foresman, 1971.
Covers such subjects as curriculum, instructional process, teacher, and contemporary issues.

Research Methods

28:86 Allen, George Richard. *The Graduate Students' Guide to Theses and Dissertations: A Practical Manual for Writing and Research.* San Francisco: Jossey-Bass, 1973.

28:87 Beittel, Kenneth R. *Alternatives for Art Education Research: Inquiry into the Making of Art.* Dubuque, IA: William C. Brown, 1973.
Discusses non-statistical kinds of research.

28:88 Best, John W. *Research in Education,* 6th ed. Englewood Cliffs, NJ: Prentice-Hall, 1989.

28:89 Booth, Jeanette Hauck, Gerald H. Krockover, and Paula R. Woods. *Creative Museum Methods and Educational Techniques.* Springfield, IL: Charles C. Thomas, 1982.

28:90 Mager, Robert F. *Goal Analysis.* 2nd ed. Belmont, CA: Lear Siegler/Fearon, 1984.

28:91 ———. *Preparing Instructional Objectives.* 2nd ed. rev. Belmont, CA: Fearon, 1984.

28:92 Van Dalen, Deobold B. *Understanding Educational Research: An Introduction.* 4th ed. New York: McGraw-Hill Book, 1979.

Educational Programs: Descriptions

28:93 Berry, Nancy and Susan Mayer, eds. *Museum Education: History, Theory, and Practice.* Reston, VA: National Art Education Association, 1989.

28:94 Hurwitz Al and Stanley S. Madeja. *The Joyous Vision: A Source Book for Elementary Art Appreciation.* Englewood Cliffs, NJ: Prentice-Hall, 1977.

28:95 Newsom, Barbara Y. and Adele Z. Silver, eds. *The Art Museum as Educator: A Collection of Studies as Guides to Practice and Policy.* Berkeley: University of California, 1978.

28:96 Nichols, Susan K. and Mary Alexander, and Ken Yellis, eds. *Museum Education Anthology 1973–1983,* Washington, D.C.: Museum Education Roundtable, 1984.

28:97 Ott, Robert W. and Al Hurwitz, eds. *International Museums and Art Education,* University Park, PA: Pennsylvania State University, 1984.

Art Education

28:98 Chapman, Laura H. *Approaches to Art in Education.* New York: Harcourt, Brace, Jovanovich, 1978.

28:99 Gaitskell, Charles D. and Al Hurwitz. *Children and Their Art: Methods for the Elementary School.* 4th ed. New York: Harcourt, Brace, Jovanovich, 1982.

28:100 Hubbard, Guy. *Art for Elementary Classrooms.* Englewood Cliffs, NJ: Prentice-Hall, 1982.

28:101 ——— and Charles S. White. *Computers and Education.* New York: MacMillan, 1988.

28:102 *Issues in Discipline-Based Art Education: Strengthening the Stance, Extending the Horizons: Seminar Proceedings, May 21–24, 1987, An Invitation Seminar.* Sponsored by The Getty Center for Education in the Arts. Los Angeles: The Center, 1988.

28:103 Lowenfeld, Viktor and W. Lambert Brittain. *Creative and Mental Growth.* 8th ed. New York: Macmillan, 1987.

28:104 Mattil, Edward L., Project Director. *A Seminar in Art Education for Research and Curriculum Development.* University Park: Pennsylvania State University, 1966.

28:105 Mattil, Edward L. and Betty Marzan. *Meaning in Children's Art: Projects for Teachers.* Englewood Cliffs, NJ: Prentice-Hall, 1981.

28:106 McFee, June King and Rogena M. Degge. *Art, Culture, and Environment: A Catalyst for Teaching.* Belmont, CA: Wadsworth, 1977; reprint, Dubuque, IA: Kendall/Hunt, 1980.

28:107 Parsons, Michael J. *How We Understand Art: A Cognitive Developmental Account of Aesthetic Experience.* Cambridge: Cambridge University, 1987.

28:108 Plummer, Gordon S. *Children's ART Judgment: A Curriculum for Elementary Art Appreciation.* Dubuque, IA: William C. Brown, 1974.

28:109 Silberstein-Storfer, Muriel and Mablen Jones. *Doing Art Together.* New York: Simon and Schuster, 1982.

28:110 Wilson, Brent, Al Hurwitz and Marjorie Wilson. *Teaching Drawing From Art.* Worcester, MA: Davis, 1987.

28:111 Wilson, Brent and Harlan Hoffa, eds. *The History of Art Education: Proceedings from the Penn State Conference.* Reston, VA: NAEA, 1985.

Bibliographies

28:112 Bunch, Clarence, ed. *Art Education: A Guide to Information Sources.* Art and Architecture Information Guide Series. Detroit: Gale Research, 1978.
> Includes all types of topics of interest to art educators, such as research, creativity, exceptional and disadvantaged children, teaching processes and materials, teacher resource materials, financing art education, and children's art books.

28:113 Columbia University. *Dictionary Catalog of the Teachers College Library.* Boston: G. K. Hall & Company, 1970. 36 vols. *First Supplement,* 1971. 5 vols. *Second Supplement,* 1973. 2 vols. *Third Supplement,* 1970. 10 vols. Since 1974 updated by annual editions of *Bibliographic Guide to Education.*
> Author-subject catalogue of over 400,000 works; library receives more than 1,800 serials.

28:114 Feeley, Jennifer, "Museum Studies Library Shelf List." *Museum Studies Journal.* 1(Spring 1983): Insert, pp. i-xvi.

28:115 Kingsley, Brandt. *Children in Museums: A Bibliography.* Washington, D.C.: Smithsonian Institution, 1979.

ERIC Materials

In 1964 the United States Department of Health, Education, and Welfare created the Educational Resources Information Center, called ERIC, for the purposes of collecting, evaluating, abstracting, indexing, and disseminating educational research results, research-related materials, and other resource information. Abstracts of this vast amount of educational data are published in ERIC's monthly journal *Resources in Education,* abbreviated *RIE* [28:118]. Copies of this abstracted material are available in paperback or microfiche from ERIC Document Reproduction Service, EDRS. Since there are more than 700 full collections of ERIC documents owned and maintained by the staffs of libraries and educational institutions, most of which are in the U.S., many libraries will own the ERIC reports.

Due to the vast amounts of educational-related material and because ERIC's *Resources in Education* did not adequately index educational literature, a second index was initiated. Commencing publication in 1969, *Current Index to Journals in Education* [28:116], abbreviated *CIJE,* is a monthly index that covers more than 780 education and educational-related journals. Since *CIJE* uses the same descriptors for subjects as does *RIE,* the *ERIC Thesaurus Descriptors* [28:119] can be used for both journals.

28:116 *Current Index to Journals in Education.* Phoenix, AZ: Oryx, 1969+
> *CIJE* briefly abstracts articles from more than 780 education and educational-related journals. Issued monthly with semi-annual cumulations. Copies of most articles available through University Microfilms International; see volumes for details. Supplement to *RIE* [28:118].

28:117 *ERIC Database,* DIALOG, File 1 and BRS, File (ERIC), files from 1966, updates monthly. Available on CD Rom.
> Computer file of all material in *RIE* [28:118] and *CIJE* [28:116]. Files are from 1966 when *RIE* was initiated. BRS file called *Educational Resources Information Center* (ERIC).

28:118 *Resources in Education.* ERIC, Educational Resources Information Center. Washington, D.C.: U.S. Government Printing Office, 1966+
> Called *RIE;* monthly abstract journal with annual cumulative index. In 1975, changed its name from *Research in Education* to reflect broader scope of material. For computer search discussion, see Chapter 4.

28:119 *Thesaurus of ERIC Descriptors.* Frederick Goodman. compiler. 11th ed. New York: C.C.M. Information Corporation, 1987.

Other Education Indices

28:120 *Education Index: A Cumulative Author-Subject Index to a Selected List of Educational Periodicals, Proceedings, and Yearbooks.* New York: H. W. Wilson, 1930+
> Author-subject index to over 345 serials; lists book reviews. Published 10 times a year with annual cumulation.

Education Index Database, WILSONLINE, files from December 1983, updates quarterly.

28:121 *Ontario Education Resources Information System Database,* BRS, File ONED, Files from 1970, updates quarterly.
> Bilingual; abstracts include educational research, curriculum guidelines, reports and position papers, and learning materials.

28:122 *Psychological Abstracts: Nonevaluative Summaries of the World's Literature in Psychology and Related Disciplines.* Washington, D.C.: American Psychological Association, 1927+

> Now published monthly with annual and three-year cumulations. Scans over 900 journals, and 1,500 books and other scientific documents. Useful for checking psychology of color and shapes, aesthetics, and art education research. Use with *The Thesaurus of Psychological Index Terms,* 3rd ed., published by the American Psychological Association in 1982.

PsycINFO Database, DIALOG, File 11 and BRS, File (PSYC) from 1967, updates monthly.

Serials and Associations

Art Education, National Art Education Association (NAEA, 1916 Association Drive, Reston, VA 22091; also see *Art Teacher* and *Studies in Art Education*) 1948+

Art Teacher, NAEA, 1971–80//

Art Therapy, American Art Therapy Association (505 East Hawley Street, Mundelein, IL 60060) 1983+

Journal of Education in Museums, Group for Education in Museums, (Buckinghamshire County Museum, Church Street, Aylesbury, Bucks, HP20 2QP, England)

Journal of Museum Education, Museum Educational Roundtable (Box 506, Beltsvilles, MD 20705; titled *Roundtable Reports,* 1981–84), 1981+

School Arts 1901+ (Titled *Applied Arts Book,* 1901–03; *School Arts Book,* 1903–12; *School Arts Magazine,* 1912–35)

Studies in Art Education, NAEA, 1959+

Visual Arts Research (Name varied, called *Review of Research in Visual Arts Education* 1975–81) 1975+

PART VI

Iconographical Resources

The following chapter includes references for the study of subjects and symbols in works of art.

References on Subjects and Symbols in Art

This chapter is divided into (1) general references, (2) mythology and folklore, (3) Christian subjects, (4) subjects in art, (5) emblem books, (6) references on animals and beasts, (7) flowers, fruit, and still-life symbolism, (8) musical iconography, (9) resources for other religions and ethics, and (10) a bibliography. For information on how to use these reference works, consult Chapter 7. For subject indexing projects, many of which are for visual resources, see Chapter 19. Also refer to the Princeton Index of Christian Art [19:20]. In addition, the *Catalog of The Warburg Institute Library* [11:87] classifies works by broad subject categories, including iconography.

General References

29:1 Bernen, Satia and Robert Bernen. *Myth and Religion in European Painting 1270–1700: The Stories as the Artists Knew Them*. New York: Braziller, 1973.

29:2 Champeaux, Gerard de and Dom Sebastien Sterckx. *Introduction au monde des Symboles*. 3rd ed. Paris: Zodiaque, 1966.

29:3 Chevalier, Jean, ed. *Dictionnaire des symboles: Mythes, rêves, coutumes, gestes, formes, figures, couleurs, nombres*. Paris: Robert Laffont, 1969.
 Broad concepts emphasized; extensive bibliography.

29:4 Chetwynd, Tom. *A Dictionary of Symbols*. London: Paladin/Grafton, 1982.

29:5 Cirlot, Juan Eduardo. *A Dictionary of Symbols*. Trans. by Jack Sage. 2nd ed. London: Rutledge & Kegan Paul, 1971.
 Broad concepts emphasized; excludes narrative themes.

29:6 Daniel, Howard. *Encyclopaedia of Themes and Subjects in Painting*. London: Thames and Hudson, 1971.
 Early Renaissance to mid-19th century.

29:7 Fingesten, Peter. *The Eclipse of Symbolism*. Columbia, SC: University of South Carolina, 1970.

Art motifs as symbols of life and society, craft of creation, eye of God, smile of Buddha, symbolic or visual presence, symbolism of nonobjective art, symbolism and allegory, a sixfold schema of symbolism, and the eclipse of symbolism.

29:8 Garnier, François. *Thésaurus iconographique: système descriptif des représentations*. Paris: Leopard d'Or, 1984.

29:9 Goldsmith, Elizabeth Edwards. *Ancient Pagan Symbols*. New York: Putnam, 1929; reprint, New York: AMS Press, 1973.
 Lotus, tree of life, cross, serpent, sun, moon, wheel, swastika, birds, animals, triangles.

29:10 Hall, James. *Dictionary of Subjects and Symbols in Art*. 2nd ed. rev. New York: Harper and Row, 1979.
 A comprehensive reference on themes and symbols in European art, commencing with classical Greece. Beginning of book has bibliography of iconographical studies and sources.

29:11 Hangen, Eva Catherine. *Symbols, Our Universal Language*. Wichita, KA: McCormick-Armstrong, 1962.
 Dictionary of symbols from all periods of history and all countries.

29:12 Jobes, Gertrude. *Dictionary of Mythology, Folklore, and Symbols*. New York: Scarecrow, 1961. 3 vols.
 Dictionary of terminology, symbols, deities, and heroes covering every phase of culture since prehistoric times. Third volume is subject index to entries in other volumes; under themes, such as "Destroyer," "Happiness," and "Justice," cites deities and heroes described in other volumes plus listing culture from which they came.

29:13 Jung, Carl G., ed. *Man and His Symbols*. Garden City, NY: Doubleday, 1964.
 Theory of the importance of symbolism, especially those revealed in dreams, by Swiss psychologist, Carl Jung. Chapter on symbolism in visual arts by Aniela Jaffe.

29:14 Morales y Marin, Jose Luis. *Diccionario de Iconologia y Simbologia*. Madrid: Tarus, 1984.

29:15 *Reallexikon zur deutschen Kunstgeschichte.* Otto Schmitt and Karl-August Wirth, general eds. Stuttgart: J. B. Metzlersche and Munich: C. H. Beck'schen, 1937–81.
Signed articles; includes iconographical themes. Each entry has location of works of art depicting the theme and a bibliography.

29:16 Vries, A. B. de. *Dictionary of Symbols & Imagery.* 3rd rev. ed. Amsterdam: North-Holland, 1981.
Limited to Western civilization.

29:17 Waters, Clara Erskine Clement. *A Handbook of Legendary and Mythological Art.* 2nd ed. Boston: Houghton, Mifflin, 1881; reprint, Detroit: Gale Research, 1969.
Dictionary-type index arranged by symbolism in art, legends of saints, legends of places, and ancient myths. Lists some paintings illustrating these themes accompanied by location of these works in the 19th century.

29:18 Whittick, Arnold. *Symbols: Signs and Their Meaning and Uses in Design.* 2nd ed. London: Hill, 1971.
Broad essays relating symbol's history, origins, and meanings.

29:19 Wilhelmi, Christoph. *Handbuch der symbole in der bildenden kunst des 20. jahrhunderts.* Frankfurt: Safari Ullstein, 1980.

Mythology and Folklore

These references are divided as to dictionaries that discuss the subject and some of the literature from which the myths derived.

Mythological Studies

29:20 Allen, Maude Rex. *Japanese Art Motives.* Chicago: A. C. McClurg, 1917.
Chapters on plants, animals and fabulous creatures, deities, symbols and symbolic objects, festivals and ceremonies, garden and flower arrangement, and crests.

29:21 Avery, Catherine B., ed. *The New Century Handbook of Greek Mythology and Legend.* New York: Appleton-Century-Crofts, 1972.
Alphabetical guide to gods, goddesses, heroes, and heroines of ancient Greece; pronunciation guides.

29:22 Beckwith, Martha. *Hawaiian Mythology.* Hartford, CT: Yale University, 1940; reprint, Honolulu: University of Hawaii, 1970.
Divided into sections covering Hawaiian gods, children of gods, chiefs, and heroes and lovers in Hawaiian fiction.

29:23 Bell, Robert E. *Dictionary of Classical Mythology: Symbols, Attributes, & Associations.* Santa Barbara, CA: ABC-CLIO, 1982.

29:24 ———. *Place-Names in Classical Mythology: Greece.* Santa Barbara, CA: ABC-CLIO, 1988.

29:25 Bonnerjea, Biron. *A Dictionary of Superstitions and Mythology.* London: Folk, 1927; reprint, Detroit: Singing Tree, 1969.
Includes non-Christian and Christian superstitions.

29:26 *Bulfinch's Mythology: The Age of Fable, The Age of Chivalry, and Legends of Charlemagne.* New York: Thomas Y. Crowell, 1970.
One of many editions of Thomas Bulfinch's mythological and legendary lore published 1855–1863. This edition includes dictionaries of archaeological sites and of names and terms used in text.

29:27 Davis, F. Hadland. *Myths and Legends of Japan.* New York: Thomas Y. Crowell, 1932.

29:28 Diel, Paul. *Symbolism in Greek Mythology: Human Desire and Its Transformations.* Trans. by Vincent Stuart et al. Boulder, CO: Shambhala, 1980.

29:29 Dorson, Richard M. *Folk Legends of Japan.* Rutland, VT: C. E. Tuttle, 1962.

29:30 ———. *Studies in Japanese Folklore.* Port Washington, NY: Kennikat, 1973.

29:31 Dowson, John. *A Classical Dictionary of Hindu Mythology and Religion, Geography, History, and Literature.* London: Kegan Paul, Trench, Trubner, 1928; reprint, Boston: Milford House, 1974.
Written for those who do not read Sanskrit; index of names in Sanskrit accompanied by their Western equivalents and an explanation of Sanskrit.

29:32 Fox, William Sherwood. *The Mythology of All Races.* Boston: Marshall Jones, 1916. 13 vols.
First volume, *Greek and Roman Mythology,* has number of reprints.

29:33 Frazer, James George. *The Golden Bough: A Study in Magic and Religion.* 3rd ed. rev. London: Macmillan, 1955. 13 vols.
First edition published 1890; study of comparative religions. *Aftermath: A Supplement to the Golden Bough* is 13th volume; originally published in 1936.

29:34 Grant, Michael and John Hazel. *Gods and Mortals in Classical Mythology.* Springfield, MA: G. & C. Merriam, 1973.

Lists Greek and Roman writers mentioned in text. Several genealogical trees of Greek heroes and maps of classical world. English edition of same year entitled *Who's Who in Classical Mythology.*

29:35 Grimal, Pierre. *The Dictionary of Classical Mythology.* Oxford: Blackwell, 1985.

29:36 Hackin, J. et al. *Asiatic Mythology: A Detailed Description and Explanation of the Mythologies of All the Great Nations of Asia.* New York: Crescent, 1963.

29:37 Hinks, R. *Myth and Allegory in Ancient Art.* London: Warburg Institute, 1939; reprint, New York: Kraus, 1976.

29:38 *Lexicon iconographicum mythologiae classicae: (LIMC).* Zurich: Artemis Verlag, 1981+ Proposed 7 double vols: one text, one plates.
Iconography of Greek, Etruscan, and Roman mythology from after Mycenean period down to beginning of Early Christianity. Scholarly articles—in English, German, French, Italian—include bibliographies. In 1988, *Vol. 4: Eros-Herakles* was published.

29:39 *Mythology of the World.* London: Paul Hamlyn; reprints, New York: P Bedrick, 1983+
.1 *African Mythology* by Edward Geoffrey Parrinder, 1967.
.2 *Celtic Mythology* by Proinsias Mac Cana, 1970.
.3 *Chinese Mythology* by Anthony Christie, 1968.
.4 *Christian Mythology* by George Every, 1970; rev. ed., as *Christian Legends,* 1987.
.5 *Dictionary of Greek and Roman Mythology* by Michael Stapleton, 1978; reprinted as *An Illustrated Dictionary of Greek and Roman Mythology.* New York: Peter Bedrick, 1986.
.6 *Egyptian Mythology* by Veronica Ions, 1968.
.7 *European Mythology* by Jacqueline Simpson, 1987.
.8 *Greek Mythology* by John Pinsent, 1969.
.9 *Indian Mythology* by Veronica Ions, 1967; reprint 1984.
.10 *Japanese Mythology* by Juliet Piggott, 1969.
.11 *Jewish Legends* by Juliet Piggott, 1987.
.12 *Mexican and Central American Mythology* by Irene Nicholson, 1967.
.13 *Near Eastern Mythology: Mesopotamia, Syria, Palestine* by John Gray, 1969.
.14 *North American Indian Mythology* by Cottie Burland and Marion Wood, 1968.
.15 *Oceanic Mythology* by Roslyn Poignant, 1967.
.16 *Persian Mythology* by John R. Hinnells, 1973.
.17 *Roman Mythology* by Stewart Perowne, 1969.
.18 *South American Mythology* by Harold Osborne, 1968.
.19 *Scandinavian Mythology* by H. R. Ellis Davidson, 1986.

29:40 *New Larouse Encyclopedia of Mythology.* Felix Guirand, general ed. Trans. by Richard Aldington and Delano Ames. Rev. ed. New York: G. P. Putnam's Sons, 1968.
Illustrated history of various non-Christian beliefs, including Egyptian, Assyro-Babylonian, Phoenician, Greek, Roman, Celtic, Slavonic, Finno-Ugric, Ancient Persian, Indian, Chinese, Japanese, North and South American, Oceanian, and African.

29:41 Norman, Dorothy. *The Hero: Myth/Image/ Symbol.* New York: World, 1969.
Covers numerous cultures—ancient, medieval, modern—and countries—Egypt, Mesopotamia, India, China, Greece—and religions.

29:42 Otto, Alexander F. and Theodore S. Holbrook. *Mythological Japan Or The Symbolism of Mythology in Relations to Japanese Art.* Philadelphia: Drexel Biddle, 1902.

29:43 Parrinder, Edward Geoffrey. *A Dictionary of Non-Christian Religions.* Philadelphia: Westminister, 1971.
Dictionary of deities, beliefs, and practices; discusses some pre-Columbian and African beliefs.

29:44 Werner, Edward Theodore Chalmers. *A Dictionary of Chinese Mythology.* Shanghai: Kelly and Walsh, 1932; reprint, New York: Julian, 1961.
Names given in Chinese characters as well as English. Bibliography is divided into works written in Chinese and those written in Western European languages. List of Chinese dynasties and index to myths.

29:45 Zimmer, Heinrich and Joseph Campbell, eds. *The Art of Indian Asia: Its Mythology.* Princeton, NJ: Princeton University, 1983. 2 vols.

Classical Literature

Most works cited below have had numerous translations and editions; they are recorded only as a reminder of these momentous works.

29:46 Homer. *The Illiad of Homer.* Trans. by Richmond Lattimore. Chicago: University of Chicago, 1951.

29:47 Homer. *The Odyssey of Homer.* Trans. by Ennis Rees. Indianapolis: Bobbs-Merril, 1977.

29:48 Ovid. *The World of Ovid's Metamorphoses,* ed. by Joseph B. Solodow. Chapel Hill: University of North Carolina, 1988.

29:49 Virgil. *Aeneid of Virgil: A Verse Translation,* by Allen Mandelbaum. Berkeley, CA: University of California, 1981.
 Can be spelled both Vergil and Virgil.

Christian Subjects

The literature is so vast that only a small fraction of the references pertaining to this subject can be recorded. This section is subdivided into (1) iconographical works, (2) hagiography, (3) literature, and (4) references to the Christian church. Also see *Christian Mythology* 29:39.4. Some references cited below under "Subjects in Art" also discuss Christian symbolism.

Iconographical Works

29:50 Aurenhammer, H. *Lexikon der christlichen Ikonographie.* Vienna: Hollinck, 1959; reprint, 1967.

29:51 Benson, George Willard. *The Cross: Its History* and *Symbolism.* Buffalo, NY: Private Printing, 1934; reprint, New York: Hacker, 1976.

29:52 Davidson, Gustav. *A Dictionary of Angels, Including the Fallen Angels.* New York: Free, 1967.
 Literary references and lengthy bibliography.

29:53 Didron, Adolphe Napoleon. *Christian Iconography: The History of Christian Art in the Middle Ages.* Trans. by E. J. Millington. London: Henry G. Bohn, 1851–86; reprint, New York: Frederick Ungar, 1965. 2 vols.
 Additions and appendices supplied by Margaret Stokes. Vol. 1 relates history and symbols of Nimbus or Glory and of God. Vol. 2 comprises iconography of Trinity, angels, devils, death, and the soul. Discussion of influence of Christian scheme and Medieval drama on iconography; reprints English translation of "Byzantine Guide to Painting," which may be 10th- or 11th-century version of manuals that described religious scenes to be painted.

29:54 Evans, Joan. *Monastic Iconography from the Renaissance to the Revolution.* Cambridge, England: University of Cambridge, 1970.

Discusses Benedictines, Cistercians, Augustinians, Carthusians, Carmelites, Dominicans, Franciscans, and Jesuits.

29:55 Ferguson, George. *Signs and Symbols in Christian Art.* New York: Oxford University, 1954; reprint, 1967.
 Covers life of Holy Family and saints; meanings of animal, floral, earthly, and human-body symbols; and symbolism of letters, numbers, and religious dress and objects. No sources for information.

29:56 Grabar, André. *Christian Iconography: A Study of Its Origins.* Princeton, NJ: Princeton University, 1968.

29:57 Hulme, F. Edward. *The History, Principles, and Practice of Symbolism in Christian Art.* London: Swan Sonnenschein, 1891; reprint, Detroit: Gale Research, 1969.
 Symbols of signs, animals, and saints.

29:58 Kirshbaum, Engelbert and Wolfgang Braufels, eds. *Lexikon der christlichen Ikonographie.* Rome: Herder, 1968–76.
 Vols. 1–4: *Gemeine Ikonographie;* Vols. 5–8: *Ikonographie des Heiligen.* Scholarly dictionary-type reference with signed entries that have numerous illustrations and bibliographical references. At beginning of 1st and 5th volumes are four lists explaining abbreviations: for terms, museums, cities, and bibliographical references. These lists are especially important since so much information is abbreviated. Vol. 4 includes indices to material in first 4 books: one is in English with German equivalents.

29:59 Metford, J. C. J. *Dictionary of Christian Lore and Legend.* London: Thames & Hudson, 1983.
 Comprehensive reference on themes and symbols in Christian art.

29:60 Pigler, Andor. *Barockthemen: Eine Auswahl von verzeichnissen zur Ikonographie des 17. und 18. Jahrhunderts.* Budapest: Akademiai-Kiadó, 2nd ed., 1974. 3 vols.
 List of works of art depicting Baroque themes used during 17th and 18th centuries, although there are often citations for much earlier and later periods. Vol. 1 covers religious subjects; Vol. 2, profane ones; Vol. 3 has illustrations. Under each theme, such as "Salomo und die Konigin von Saba" (Solomon and the Queen of Sheba), is brief list of references describing scene plus list of artists who depicted it divided as to artists' nationalities. Sometimes accompanied by various information related to art works: media, locations, and sources of reproductions. Everything in outline form; many

words abbreviated. At beginning of 1st volume is explanation of abbreviations; at end of each volume is table of contents.

29:61 Réau, Louis. *Iconographie de l'art chrétien.* Paris: Presses Universitaires de France, 1955–59; reprint, Nendeln, Liechtenstein: Kraus, 1974. 3 vols in 6 books.

Vol. 1, which is general introduction, has articles on sources and evolution of Christian iconography; on animal, human, and liturgical symbolism; and on iconography of saints. Vol. 2 containing iconography of the Bible is divided into 2 books, one covering Old Testament; the other, the New. Vol. 3, iconography of saints, consists of 3 books, last of which has indices to names of saints in various languages; to patronage of various saints; and to attributes of saints. Entries in 3rd volume describe scenes in which saints are depicted in art, often including English title for scene and containing bibliographical data and extensive list of works of art that illustrate saint or symbol discussed; these lists are divided by century and include locations of works of art.

29:62 Schiller, Gertrud. *Iconography of Christian Art.* Trans. by Janet Seligman. Greenwich, CT: New York Graphic, 1971. 2 vols.

Vol. 1: Christ's Incarnation, Childhood, Baptism, Temptation, Transfiguration, Works, and Miracles. Vol. 2: The Passion of Christ. Profusely illustrated with black-and-white reproductions. Each book contains selected bibliography; second volume has general index for both works. Other volumes of *Ikonographie der christlichen Kunst* have not been translated. *Vol. 3: Die Auferstehung und Erhohung Christi* (on the Resurrection and Ascension), 1971. *Vol. 4, Part I: Die Kirche* (The Church), 1976; *Part II: Maria,* 1976. *Registerbeiheft zu den Banden 1 bis 4* (an index), 1980. All of the German-language volumes were published by Verlagshaus Gerd Mohn in Gutersloh, Germany.

29:63 Seibert, Jutta. *Lexikon christlichen kunst: themen, Gestalten, symbole.* Freiburg: Herder, 1980.

29:64 Sill, Gertrude Grace. *A Handbook of Symbols in Christian Art.* New York: Macmillan, 1975.

29:65 Webber, Frederick Roth. *Church Symbolism: An Explanation of the More Important Symbols of the Old and New Testament, the Primitive, the Mediaeval, and the Modern Church.* 2nd ed., rev. Cleveland, OH: J. H. Jansen, 1938; reprint, Detroit: Gale Research, 1971.

Lists important saints accompanied by dates of martyrdom and attributes and glossary of some common symbols. Chapter on many variations of the cross.

Hagiography, Study of Christian Saints

Remember that many books listed in the above section also include data on saints. Also see Chapter 7 and the subject indexing references cited in Chapter 19. For Voragine, Jacobus de, see 29:73.

29:66 Attwater, Donald. *A Dictionary of Saints: Being also an Index to the Revised Edition of Alban Butler's "Lives of the Saints."* 2nd ed. London: Burns, Oates, and Washbourne, 1948; reprint, New York: P. J. Kenedy & Sons, 1958.

29:67 Bles, Arthur de. *How to Distinguish the Saints in Art By Their Costumes, Symbols, and Attributes.* New York: Art Culture, 1925; reprint, Detroit: Gale Research, 1975.

Chronological list of Roman Bishops and Popes to end of 16th century, alphabetized list of emblems relating which saints used them, and alphabetical list of means by which saints were martyred.

29:68 Butler, Alban. *Lives of the Saints.* Ed. and supplemented by Herbert Thurston and Donald Attwater. New York: Kenedy and Sons, 1956. 4 vols.

Standard authoritative reference; includes bibliographical data and footnotes. Each volume covers three months; saints are listed under their feast day. Butler's original work was published between 1756 and 1759.

29:69 Coulson, John, ed. *The Saints: A Concise Biographical Dictionary.* New York: Hawthorn, 1958.

Calendar of feast days listing saints associated with them.

29:70 Drake, Maurice and Wilfred Drake. *Saints and Their Emblems.* London: T. W. Laurie, 1916; reprint, New York: Burt Franklin, 1971.

Divided into biographical dictionary of saints and dictionary of emblems that lists saints associated with them. Appendices to patriarchs and prophets with their emblems; sibyls and their emblems; patron saints of arts, trades, and professions; patron saints of various classifications; and saints envoked for particular reasons. Saint's feast day provided in parentheses beside saint's name.

29:71 Farmer, David Hugh. *The Oxford Dictionary of Saints.* Oxford: Clarendon, 1978.

Although mainly concerned with English saints and saints for whom there was an English cult, includes most famous saints,

except those of the Byzantine Period. Organized by people, rather than feast day. Prior to the 16th century, listing is under Christian name; after that date, surname. Provides bibliographical references. Good introduction to hagiography and 1969 reform of Roman Calendar when some saints' feast days were downgraded.

29:72　Holweck, Frederick George. *A Biographical Dictionary of the Saints: With a General Introduction on Hagiology.* St. Louis: B. Herder, 1924; reprint, Detroit: Gale Research, 1969.

29:73　Jacobus de Voragine. *The Golden Legend or Lives of the Saints, as Englished by William Caxton.* Trans. by William Caxton. London: J. M. Dent, 1900. 7 vols. Reprint ed., trans. and adopted by Granger Ryan and Helmut Ripperger. Salem, NH: Ayer, 1987. 1 vol.
　　First published in Latin in 1275 by Jacobus de Voragine, Archbishop of Genoa. Also spelled Varagine, and in French translations listed as Jacques de Voragine. Edition by Caxton, who died in 1491, is based upon French version of Latin text. Saints are listed by their feast day. There are numerous translations and editions; some in one volume.

29:74　Jameson, Anna Brownell. *History of Our Lord as Exemplified in Works of Art.* 2nd ed. London: Longmans, Green, 1865; reprint: Detroit: Gale Research, 1976. 2 vols.

29:75　————. *Legends of the Madonna As Represented in the Fine Arts.* 3rd ed. London: Longmans, Green, 1864; reprint, Detroit: Gale Research, 1972.
　　Legends and titles of art works in which madonna figures; first edition in 1852; Mrs. Jameson died in 1860.

29:76　————. *Sacred and Legendary Art.* 10th ed. London: Longmans, Green, 1870; reprint, Saint Claire Shores, MI: Scholarly Press, 1972. 2 vols.
　　Legends, history, attributes, and titles of art works in which the saints figured. Second volume includes topographical index; first ed., 1848.

29:77　Kaftal, George. *Iconography of the Saints in Italian Painting from Its Beginnings to the Early XVIth Century.* Florence: Sansoni and La lettere, 1952–85.
　　Vol.1: *Iconography of the Saints in Tuscan Painting,* 1952; reprint, 1986; Vol. 2: *Iconography of the Saints in Central and South Italian Schools of Painting,* 1965; reprint 1986; Vol. 3: *Iconography of the Saints in the Painting of North East Italy,* 1978; and Vol. 4: *Iconography of the Saints in the*

Painting of Northwest Italy, 1985. Covers paintings and frescoes from 2nd to early 16th century. Each volumes contains: Part I, alphabetical listing of saints providing dates, attributes, usual inscriptions found on scrolls they might carry, types of representations and scenes, literary sources, resources for reproductions, and brief hagiographical bibliographies. Part II, indices to attributes, distinctive signs, and scenes; painters; topography providing locations for works; and saints and the Blessed. Many abbreviations; read "Explanatory Note." Numerous black-and-white illustrations.

Literature

This vast body of work includes the Bible; the writings of the Four Latin Fathers—St. Augustine, St. Jerome, St. Gregory, and St. Ambrose; St. Thomas Aquinas; and numerous other theologians and religious philosophers. A few multivolume publications are cited, since some library catalogues have only one notation for the series, not individual entries for each volume. This list is only a small fraction of the available material. Also see Jacobus de Voragine, *The Golden Legend* [29:73].

29:78　Anselm, St. *The Prayers and Meditations of St. Anselm.* Trans. by Sister Benedicta Ward. Harmondsworth, Middlesex: Penguin, 1973.
　　Written by an 11th-century Bishop of Canterbury, these meditative prayers influenced art.

29:79　*The Ante-Nicene Fathers,* ed. by Alexander Roberts and James Donaldson. Trans. by various scholars. Edinburgh: reprint, Grand Rapids, MI: William B. Eerdmans, 1951–68. 10 vols.
　　Vols. 1–8, ecclesiastical authors who wrote prior to 325 A.D.; Vol. 9 is bibliographical synopsis of first 8 volumes and indices to subjects and scripture. Vol. 10 is a supplement of recently discovered documents. Vol. 8 contains some of the *Infancy Gospels.*

29:80　*Biblia Pauperum.*
　　There are several facsimile editions of this work: notes by Elizabeth Soltesz, Budapest: Corvina Press, 1967; ed. by Avril Henry, Ithaca, NY: Cornell University Press, 1987. Consisting of blockprints and very little text, this biblical picture book, often called the Bible of the Poor, became popular with the advent of inexpensive printing. Most facsimile copies consist of prints depicting biblical stories. Each print has three major scenes—2 from the Old

Testament which prefigured one from New Testament. Scenes are accompanied by verses of 4 prophets and brief explanatory text.

29:81 *Fathers of the Church.* New York: Fathers of the Church and Washington, D.C.: Catholic University of America, 1947+
Series of books, 100 are planned; includes works of four Latin Fathers: Augustine (22 volumes on his work alone), Ambrose, Gregory, Jerome.

29:82 Hennecke, Edgar. *New Testament Apocrypha.* Edited by R. McL. Wilson. Trans. by A. J. B. Higgins et al. Philadelphia: Westminster, 1963–66. 2 vols.
Translation based upon 3rd edition of *Neutestamentliche Apokryphen,* edited by Wilhelm Schneemelcher and published in 1959, 8 years after Hennecke's death. First edition was in 1904. Vol. 1 contains *Infancy Gospels* upon which so much Medieval and Renaissance art is based.

29:83 James, Montague Rhodes. *The Apocryphal New Testament: Being the Apocryphal Gospels, Acts, Epistles, and Apocalypses.* Oxford: Clarendon, 1924; reprinted numerous times.
Translations of *Infancy Gospels, Apocryphal Acts of Apostles,* and *Apocryphal Apocalypses.*

29:84 Ludolphus of Saxony. *Vita Christi.*
The 14th-century Carthusian monk is noted for his long meditative writings on the life of Christ, which include passages from more than 100 other writers. The complete *Vita Christi* has not been translated into English. For translation of the 10 chapters on the Passion, see *The Hours of the Passion Taken from The Life of Christ by Ludolph the Saxon,* by Henry James Coleridge, London: Burns and Oates, 1887.

For a translation of all of the prayers given at the end of each chapter of *Vita Christi,* see *Praying The Life of Christ: First English Translation of the Prayers Concluding the 181 Chapters of the Vita Christi of Ludolphus the Carthusian: The Quintessence of His Devout Meditations on the Life of Christ,* by Sister Mary Immaculate Bodenstedt, Salzburg, Austria: Analecta Cartusiana, 1973.

29:85 *Meditations on the Life of Christ: An Illustrated Manuscript of the Fourteenth Century,* ed. by Isa Ragusa and Rosalie B. Green. Trans. by Isa Ragusa. Princeton, NJ: Princeton University, 1961; several reprintings.
Once attributed to Pseudo St. Bonaventura, now believed to have been written by 13th-century Franciscan monk living in Italy. Extensively illustrated; text relates story of Virgin Mary and Christ.

29:86 *The Other Bible: Jewish Pseudepigrapha, Christian Apocrypha, Gnostic Scriptures,* edited by Willis Barnstone. New York: Harper & Row, 1984.

29:87 *Patrologiae Cursus Completus, Series Latina,* ed. by Jacques-Paul Migne, Paris: 1844–82; microform ed., Englewood, CO: Information handling Services. 221 vols.
Called *Patrologia Latina,* this momentous undertaking reprints 2,614 early Latin ecclesiastical authors, writings from end of 2nd century to 1215.

29:88 *Patrologiae Cursus Completus. Series Graeca,* ed. by Jacques-Paul Migne, Paris: 1857–66; microform ed., Englewood, CO: Information handling Services. 166 vols.
Called *Patrologia Graeca,* reprints Latin translations of 800 early Greek ecclesiastical authors.

29:89 *St. Bridget. The Revelations of Saint Birgitta: Edited from the Fifteenth-Century MS. in the Garrett Collection in the Library of Princeton University,* by William Patterson Cumming. London: Oxford University, 1929.
A 14th-century Swedish saint who made a pilgrimage to Bethlehem and while contemplating the grotto where Christ was presumed to be born, had a vision of his birth. For brief version, see *Revelations of St. Bridget On the Life and Passion of Our Lord and the Life of His Blessed Mother,* Rockford, IL: Tan Books, 1984. For additional data, see *Iconography St. Birgitta of Sweden,* by Anthony Butkovich, Ecumenical Foundation of America, 1969.

29:90 *Select Library of the Nicene and Post-Nicene Fathers of the Christian Church,* ed. Philip Schaff. New York: Christian Literature, 1887–95 and Charles Scribner's Sons, 1898–1907; reprint, Grand Rapids, MI: Eerdmans, 1979–83.
First Series, 1886–89, 14 vols. *Second Series,* 1887–92, 14 vols. Vol. 14 is on 7 Church Councils.

29:91 Thomas à Kempis. *The Imitation of Christ.* Trans. by Leo Sherley-Price. New York, 1952; reprint, New York: Dorset, 1986.
Priest Kempis died in 1471; his book influenced art.

References to the Christian Church

29:92 Addis, William Edward and Thomas Arnold. *A Catholic Dictionary.* St. Louis: Herder, 1960. Numerous eds. & revs.

Covers major themes, concepts, rites, ceremonies, councils, and religious orders. First published in 1884.

29:93 *Bible (King James Version) Database.* DIALOG, File 297.
Modern revision of 1769 edition of Thomas Nelson Publishers of the King James Version, a translation ordered by King James I of England in 1604. Includes Old and New Testaments but not the Apocrypha, see Chapter 7.

29:94 Bowden, Henry Warner, ed. *A Century of Church History: The Legacy of Philip Schaff.* Carbondale: Southern Illinois University, 1988.

29:95 Bynum, Caroline W. *Holy Feast and Holy Fast.* Berkeley, CA: University of California, 1987.

29:96 Cabrol, Fernand et al. *Dictionnaire d'archéologie chrétienne et de liturgie.* Paris: Letouzey et Ane, 1903; reprint, 1924–53. 15 vols.

29:97 Davies, J.G. *The New Westminister Dictionary of Liturgy & Worship.* Philadelphia: Westminister, 1986.

29:98 *Encyclopedia of the Lutheran Church,* ed. by Julius Bodensieck. Minneapolis: Augsburg, 1965. 3 vols.

29:99 Hardison, O. B., Jr. *Christian Rite and Christian Drama in the Middle Ages.* Baltimore: Johns Hopkins, 1965.
Discusses the Roman Mass as sacred drama.

29:100 James, E.O. *Seasonal Feasts and Festivals.* New York: Barnes & Noble, 1961.

29:101 Jungmann, Josef Andreas. *The Mass of the Roman Rite: Its Origins and Development (Missarum Sollemnia).* Trans. by Frances A. Brunner. New York: Benziger Brothers, 1951. 2 vols.
Discusses history of rite of mass of Roman Catholic Church from time of primitive church, thus provides reasons for certain changes that were made in religious architecture and liturgical objects. The author is a Jesuit scholar.

29:102 Kelly, J. M. D. *The Oxford Dictionary of the Popes.* Oxford: Oxford University, 1986.

29:103 Mann, Horace K. *The Lives of the Popes in the Early Middle Ages.* 2nd ed. St. Louis: B. Herder, 1925–32; reprint, Nendeln, Liechtenstein: Kraus, 1964–66. 18 vols in 19 books.

Covers St. Gregory the Great to Benedict XI; includes bibliographical footnotes and list of references. Vols. 6–18 have title: *Lives of the Popes in the Middle Ages.*

29:104 McKenzie, John L. *Dictionary of the Bible.* New York: Macmillan, 1965.
One volume providing accounts of books of the Bible, major themes and concepts, persons, and geography. Includes a bibliography.

29:105 *New Catholic Encyclopedia.* New York: McGraw-Hill, 1967. 15 vols.

29:106 Percival, Henry R. *The Seven Ecumenical Councils of the Undivided Church: Their Canons and Dogmatic Decrees.* New York: Charles Scribner's, 1900.
Information on declaration of early church from First Council of Nicea in 325 through Second Council of Nicea in 787.

29:107 Schroeder, Henry Joseph. *Disciplinary Decrees of the General Councils: Text, Translation, and Commentary.* St. Louis: B. Herder, 1937.
Decrees for the 18 ecumenical councils from 325 to 1215.

29:108 Weiser, Francis X. *Handbook of Christian Feasts and Customs: The Year of the Lord in Liturgy and Folklore.* New York: Harcourt, Brace, 1958.
Discusses various Christian feast days, their symbols and customs.

Subjects in Art

The books listed below discuss various subjects depicted in art, for references that index subjects, see "Subject Indexing Projects," Chapter 19.

29:109 Armitage, John. *Man at Play: Nine Centuries of Pleasure Making.* New York: Frederick Warne, 1977.
Covers games and merrymaking from the 12th century to the 20th.

29:110 Cosgrove, Denis. *The Iconography of Landscape.* New York: Cambridge University, 1988.

29:111 Hall, James. *A History of Ideas and Images in Italian Art.* New York: Harper & Row, 1983.
Traces survival of images, changing attitude of Christian church, belief in magical powers of art, and role of patrons in Italy from time of Etruscans to 19th century. Section on Greek and Latin alphabets and inscriptions, glossary, and indices to general subjects, primary sources, and artists and subjects.

29:112 Katzenellenbogen, Adolf Edmund Max. *Allegories of the Virtues and Vices in Mediaeval Art: From Early Christian Times to the Thirteenth Century.* New York: W. W. Norton, 1964; reprint, Toronto: University of Toronto, 1989.

Divided into dynamic representations of the conflict between virtues and vices and static representations of systems of virtues and vices. Bibliographical footnotes and indices to places and to names and subjects.

29:113 Knipping, John Baptist. *Iconography of the Counter Reformation in the Netherlands: Heaven on Earth.* Nieuwkoop, Holland: B. de Graaf, 1974. 2 vols.

Based on *Iconografie van de Contra-Reformatie in de Nederlanden,* 1939–41. Chapters entitled "Humanism," "The New Asceticism," "The New Devotions," "The Bible," "The Saint in Cult and Culture," "Christian Love and Life," "The Militant Church," "Form and Content," and "The Great Stream of Tradition.'"

29:114 Mâle, Emile. *The Gothic Image: Religious Art in France of the Thirteenth Century.* Trans. by Dora Nussey. New York: Dutton, 1913; reprint, New York: Harper and Row, 1958.

Mâle, who is considered one of the great iconographical authorities, wrote 4 books on French medieval iconography: (1) *L'art religieux du XIIᵉ siècle en France,* (2) *L'art religieux du XIIIᵉ siècle en France,* (3) *L'art religieux de la fin du moyen age en France,* (4) *L'art religieux de la fin du XVIᵉ siècle, du XVIIᵉ siècle et du XVIII siècle: Etude sur l'iconographie après le Concile de Trente. Gothic Image,* a translation of *L'art religieux du XIIIᵉ siècle* originally published in 1898, is concerned with the influence upon symbolism by: (1) *Speculum Majus* written by Vincent of Beauvais in 13th century, (2) Bible, (3) *The Golden Legend* by Jacobus de Voragine and published in 1275, and (4) secular history of period. *Religious Art: From the Twelfth to the Eighteenth Century* (New York: Pantheon Books, 1949) has translated sections from all 4 of Mâle's works.

29:115 ———. *Religious Art in France,* ed. by Henry Bober. Trans. by Marthiel Mathews. Princeton, NJ: Princeton University.

Vol. 1: *The Twelfth Century: A Study of the Origins of Medieval Iconography,* 1977; Vol. 2: *The Thirteenth Century: A Study of the Origins of Medieval Iconography,* 1985; Vol. 3: *The Late Middle Ages: A Study of the Origins of Medieval Iconography,* 1987. Illustrated updated editions of 3 of Mâle's books.

29:116 Marle, Raimond van. *Iconographie de l'art profane au Moyen-Âge et à la Renaissance, et la décoration des demeures.* The Hague: Martinus Nijhoff, 1931–32; reprint, New York: Hacker, 1971. 2 vols.

Important source for secular iconography. Vol. 1: *La Vie Quotidienne* covers the nobles, nature, hunting and fishing, war, rural life, and the rapport between the sexes. Vol. 2: *Allegories et symboles* deals with ethical and philosophical allegories plus love and death.

29:117 Panofsky, Erwin. *Studies in Iconology: Humanistic Themes in the Art of the Renaissance.* Cambridge, England: Oxford University, 1939; reprint ed., New York: Harper & Row, 1962.

Covers such subjects as Father Time, blind cupid, the Neoplatonic movement in Florence and North Italy, and the Neoplatonic movement and Michelangelo.

29:118 ———. *Meaning in the Visual Arts: Papers in and on Art History.* Garden City, NY: Doubleday, 1955.

Collection of Panofsky's previously published works. Illustrated articles include subject of human proportion, Abbot Suger of St. Denis, Titian, Vasari, Dürer and Classical antiquity, Poussin, and brief essay on three decades of U.S. art history.

29:119 Paulson, Ronald. *Emblem and Expression: Meaning in English Art of the Eighteenth Century.* Cambridge, MA: Harvard University, 1975.

Chapter titles include "Illustration and Emblem," "The Poetic Garden," "Industry and Idleness," and "The Conversation Piece in Painting and Literature." Special chapters on Hogarth, Reynolds, Watteau and Chardin, Zoffany, Stubbs, Wright of Derby, and Gainsborough.

29:120 *Phaidon Gallery Series.* London: Phaidon, 1979.

.1 *Everyday-Life Painting* by Helen Langdon
.2 *Landscape Painting* by Bo Jeffares
.3 *Mythological Painting* by Michael Jacobs
.4 *Nude Painting* by Michael Jacobs
.5 *Portrait Painting* by Malcolm Warner
.6 *Religious Painting* by Stephanie Brown

29:121 Seznec, Jean. *The Survival of the Pagan Gods: The Mythological Tradition and Its Place in Renaissance Humanism and Art.* Trans. by Barbara F. Sessions. New York: Pantheon, 1953; reprint, New York: Harper and Row, 1961.

Part 1: The Concepts has chapters on the historical, physical, moral, and encyclopedic traditions. Part 2: The Forms includes chapters on metamorphoses of gods and reintegration of gods. Last section covers science of mythology in 16th century, theories regarding use of mythology, and influence of manuals.

29:122 *Studies in Iconography Series.* Linda Seidel, series ed. Ann Arbor, MI: UMI Research.
Series on varied subjects. Some of the titles are as follows:

.1 *Alchemical Imagery in Bosch's "Garden of Delights,"* Laurinda S. Dixon, 1981.

.2 *Political Ideas in Medieval Italian Art: The Frescoes in the Palazzo dei Priori, Perugia,* Jonathan B. Riess, 1981.

.3 *"With Bodilie Eyes": Eschatological Themes in Puritan Literature and Gravestone Art,* David H. Watters, 1981.

.4 *Masks of Wedlock: Seventeenth-Century Dutch Marriage Portraiture,* David R. Smith, 1982.

.5 *How the West was Drawn: American Art and the Settling of the Frontier,* Dawn Glanz, 1982.

.6 *Boerenverdriet: Violence Between Peasants and Soldiers in Early Modern Netherlands Art,* Jane Susannah Fishman, 1982.

.7 *The Child in Seventeenth-Century Dutch Painting,* Mary Frances Durantini, 1983.

.8 *Realism and Politics in Victorian Art of the Crimean War,* Matthew Paul Lalumia, 1984.

.9 *Rise of the Black Magus in Western Art,* Paul H. D. Kaplan, 1985.

29:123 Tervarent, Guy de. *Attributs et symboles dans l'art profane, 1450–1600: Dictionnaire d'un langage perdu.* Paris: E. Droz, 1958. *Supplément et index,* 1964.

29:124 Wind, Edgar. *Pagan Mysteries in the Renaissance.* Rev. and enlarged. New York: W. W. Norton, 1958.
Discusses literature and mythology which influenced Renaissance art. Index of sources subdivided into literary texts used during Renaissance and passages quoted, and secondary sources.

Emblem Books

For information on how these books are used, see Chapter 7. For a listing of earlier publications, see *Arntzen & Rainwater* [17:1], pages 69–70.

29:125 *Emblem Books.* Zug, Switzerland: Inter-Documentation. Microform edition reprinting 354 emblem books.

29:126 Henkel, Arthur and Albrecht Schone. *Emblemata: Handbuch zur Sinnbildkunst des XVI. und XVII. Jahrhunderts.* Stuttgart: J.B. Metzlersche, 1967.
Illustrated dictionary of emblems, including those of elements, plants, animals, people, and myths. Entries are detailed; indices to illustrators, meanings, and notables in "Physiologus Graecus."

29:127 Praz, Mario. *Studies in Seventeenth-Century Imagery.* 2nd ed. Roma: Edizioni di Storia e Letteratura, 1964. Part II: *Addenda and Corrigenda,* 1974.
Discussion of subjects and symbols and Emblem Books. Half of the book is an extensive bibliography of emblem books.

29:128 *The Renaissance and the Gods: A Comprehensive Collection of Renaissance Mythographies, Iconologies,* and *Iconographies,* ed. by Stephen Orgel. New York: Garland, 1979. 55 vols.
This series of 55 volumes reproduces numerous Emblem Books, including variations of Ripa's *Iconologia* and George Richardson's *Iconology* of 1779.

29:129 Ripa, Cesare. *Cesare Ripa: Baroque and Rococo Imagery.* Trans. and commentaries by Edward A. Maser. New York: Dover, 1971.
Translation of the 1758–60 German edition published by Johann Georg Hertel accompanied by full-page scenes designed by Gottfried Eichler, the Younger.

References on Animals and Beasts

For Aesop, see 29:134 & 144. Some works listed below are derived from the bestiary, a compilation of animal stories based upon the *Physiologus.* Developed between the 2nd and 5th century A.D., these popular tales were included in sermons to illustrate the Bible during the Middle Ages. The symbolism of animals in Christian art is often based upon these stories.

29:130 Allen, Judy and Jeanne Griffiths. *The Book of the Dragon.* London: Orbis, 1979.

29:131 *Animals in Archaeology,* ed. by A. Houghton Broderick. London: Barrie & Jenkens, 1972.
From Old Stone Age to Aegean Civilization plus India and China.

29:132 Ball, Katherine M. *Decorative Motives of Oriental Art.* New York: Dodd, Mead, 1927; reprint, New York: Hacker Art, 1969.
Discusses use of animal form.

29:133 Beer, Rudiger Robert. *Unicorn: Myth and Reality.* Trans. by Charles M Stern. New York: Van Nostrand Reinhold, 1977.

29:134 Daly, Lloyd William, translator and ed. *Aesop Without Morals: The Famous Fables and a Life of Aesop.* New York: Thomas Yoseloff, 1961.
Brief history of two works translated into present-day English: (1) Ben Edwin Perry's edition of 10th-century manuscript in Pierpont Morgan Library describing Xanthus the Philosopher and his slave, Aesop, and (2) Aesop's fables based upon Perry's *Aesopica,* published by University of Illinois in 1953. Numbers listed before each fable refer to numbers in Perry's book. Appendix lists moral to each fable.

29:135 Dent, Anthony Austen. *The Horse: Through Fifty Centuries of Civilization.* London: Phaidon, 1974.

29:136 Evans, Edward Payson. *Animal Symbolism in Ecclesiastical Architecture.* London: William Heinemann, 1896; reprint, Detroit: Gale Research, 1969.
Covers animals described in the *Physiologus* as well as satirical and whimsical depictions of animals.

29:137 Friedmann, Herbert. *A Bestiary for Saint Jerome: Animal Symbolism in European Religious Art.* Washington, D.C.: Smithsonian Institution, 1980.

29:138 ———. *The Symbolic Goldfinch: Its History and Significance in European Devotional Art.* Washington, D.C.: Pantheon, 1946.
Lists paintings and their locations.

29:139 Hathaway, Nancy. *The Unicorn.* New York: Viking, 1980.

29:140 Husband, Timothy. *The Wild Man: Medieval Myth and Symbolism.* New York: Metropolitan Museum of Art, 1981.

29:141 Janson, Horst Woldemar. *Apes and Ape Lore in the Middle Ages and the Renaissance.* London: Warburg Institute, University of London, 1952.

29:142 Klingender, Francis Donald. *Animals in Art and Thought to the End of the Middle Ages.,* ed. by Evelyn Antal and John Harthan. Cambridge, MA: M.I.T., 1971.
From prehistoric caves through the Middle Ages; concentrates on stylistic changes.

29:143 Lascault, Gilbert. *Le monstre dans l'art occidental un problème esthétique.* Paris: Editions Klincksieck, 1973.

29:144 Lenaghan, R. T., ed. *Caxton's Aesop.* Cambridge, MA: Harvard University, 1967.
Edition of William Caxton's *Aesop,* which contained 167 fables and life of Aesop. Bibliographical footnotes, glossary to old English terms, index to fables and tales, and reproduces 186 woodcuts that Caxton published in his 15th-century edition.

29:145 Lloyd, Joan Barclay. *African Animals in Renaissance Literature and Art.* Oxford, England: Clarendon, 1971.
Special treatment of the crocodile, chameleon, and elephant.

29:146 McCulloch, Florence. *Mediaeval Latin and French Bestiaries.* Rev. ed. Chapel Hill, NC: University of North Carolina, 1962.
Discusses different manuscripts and how they vary.

29:147 Mode, Heinz Adolph. *Fabulous Beasts and Demons.* London: Phaidon, 1975.
Originally published in 1973 under the title *Fabeltiere und Dämonen in der Kunst.* Includes glossary of monsters.

29:148 Nigg, Joe. *The Book of Gryphons.* Cambridge, MA: Applewood, 1982.

29:149 Rawson, Jessica. *Animals in Art.* London: British Museum, 1977.

29:150 Sheridan, Ronald and Anne Ross. *Gargoyles and Grotesques: Paganism in the Medieval Church.* Boston: New York Graphic Society, 1975.

29:151 Stern, Harold P. *Birds, Beasts, Blossoms and Bugs: The Nature of Japan.* New York: Harry N. Abrams, 1975.

29:152 *Topsell's Histories of Beasts,* ed. by Malcolm South. Chicago: Nelson-Hall, 1981.
Selections from *The History of Four-Footed Beasts,* 1607, and *History of Serpents,* 1608, written by Edward Topsell.

29:153 Varty, Kenneth. *Reynard the Fox.* Leicester, England: Leicester University, 1967.
Lists fox carvings and drawings in England.

29:154 Waterbury, Florence. *Bird-deities in China.* Ascona, Italy: Artibus Asiae, 1952.

29:155 White, Terence Hanbury, ed. *The Bestiary: A Book of Beasts.* New York: G. P. Putnam's Sons, 1960.
Translation of 12th-century Latin Bestiary.

Flowers, Fruit, Still Life Symbolism

Also see Stern's *Bird, Beasts, Blossoms, and Bugs* [29:151].

29:156 Haig, Elizabeth. *The Floral Symbolism of the Great Masters*. London: Kegan Paul, Trench, Trubner, 1913.
> Includes some fruits.

29:157 Lehner, Ernst and Johanna Lehner. *Folklore and Symbolism of Flowers, Plants, and Trees*. New York: Tudor, 1960.
> Brief entries plus illustrations of about 75 plants. Includes flower calendar, which tells which plants were considered representative of various months and index to sentiments and symbolism, that cites under name of plant, what it represented.

29:158 Segal, Sam. *A Prosperous Past: The Sumptuous Still Life in the Netherlands 1600–1700*, ed. by William B. Jordan. The Hague: SDU, 1988.

29:159 Seward, Barbara. *The Symbolic Rose*. New York: Columbia University, 1954.
> Concerned with the Medieval heritage and the symbolism of roses in British poetry.

Musical Iconography

29:160 Fischer, Pieter. *Music in Paintings of the Low Countries in the 16th and 17th Centuries*. Amsterdam: Swets & Zeitlinger, 1975.
> Well-illustrated book on musical instruments and notations in Dutch and Flemish paintings from the 16th and 17th centuries. Index to persons and places.

29:161 Hammerstein, Reinhold. *Diabolus in Musica: Studien zur Ikonographie der Musik im Mittelalter*. Munich: Francke, 1974.
> Discusses dance of demons and mythological tales with music.

29:162 Lang, Paul H. and Otto Bettmann. *A Pictorial History of Music*. New York: W.W. Norton, 1960.
> Extensively illustrated; provides overview.

29:163 Meyer-Baer, Kathi. *Music of the Spheres and the Dance of Death: Studies in Musical Iconology*. Princeton, NJ: Princeton University, 1970.
> From antiquity through Renaissance.

29:164 Mirimonde, Albert P. de. *L'Iconographie Musicale sous les Rois Bourbons: La musique dans les arts plastiques (XVIIᵉ—XVIIIᵉ siècles)*. Paris: A. & J. Picard, 1977. 2 vols.
> Discussion of music depicted in art in 17th and 18th centuries; extensive bibliography.

29:165 *Musical Iconography*. Zug, Switzerland: Microfiche, 1973–79. Microfiche.
> *Series 1: European Musical Instruments on Prints and Drawings. Series 2: Portraits of Composers and Musicians.*
> Reproductions of 600 prints and drawings which date from 16th-19th century from Music Department of the Gemeentemuseum, Den Haag, Netherlands. Index to Series 1 includes complete alphabetical list of prints and drawings according to musical instrument and name of artist. Series 2 contains about 830 prints and drawings.

29:166 Winternitz, Emanuel. *Musical Instruments and Their Symbolism in Western Art: Studies in Musical Iconology*. New York: W. W. Norton, 1967; reprint, New Haven, CT: Yale University, 1979.
> Discusses depictions of musical instruments in works of art; mostly concerned with 15th and 16th centuries.

Resources for Other Religions and Ethics

See listings under "Mythology and Folklore," above, Ball's *Decorative Motives of Oriental Art* 28:132, and Allen's *Japanese Art Motives* [29:20].

29:167 Banerjea, Jitendra Nath. *The Development of Hindu Iconography*. 2nd ed. rev. Calcutta: University of Calcutta, 1956; reprint, Columbia, MO: South Asia, 1974.
> Appendix has English translations of Brhatsamhita and Pratimamanalaksanam and tables of measurements according to Dasatala.

29:168 Bhattacharyya, Benoytosh. *The Indian Buddhist Iconography: Mainly Based on the Sadhanamala and Cognate Tantric Texts and Rituals*. 2nd ed. rev. Calcutta: K. L. Mukhopadhyay, 1958.

29:169 Coomaraswamy, Ananda Kentish. *Elements of Buddhist Iconography*. 2nd ed. New Delhi: Munshiram Manoharlal, 1973.
> First issued in 1935. Part I: "Tree of Life," "Earth-Lotus," and "Word Wheel." Part II: "Place of the Lotus-Throne."

29:170 ———. *The Origin of the Buddha Image*. New Delhi: Munshiram Manoharlal, 1972.

29:171 Edmunds, William H. *Pointers and Clues to the Subjects of Chinese and Japanese Art As Shown in Drawings, Prints, Carvings, and the Decorations of Porcelain and Lacquer*. London: Sampson Law, Marston, 1934; reprint, Geneva: Minkoff, 1974.

Chapter "Pointers and Clues" gives iconographical background of symbols. Biographical entries of Chinese, Buddhist, and Japanese subjects plus glossary of Japanese words.

29:172 *Encyclopaedia of Religion and Ethics,* ed. by James Hastings. New York: Charles Scribner's Sons, 1928; reprint, Edinburgh: T. & T. Clark, 1979–81. 13 vols.
Discussions on broad categories, especially of comparative religions.

29:173 Garrett, John. *A Classical Dictionary of India: Illustrative of the Mythology, Philosophy, Literature, Antiquities, Arts, Manners, Customs of the Hindus.* Madras, India: Higginbotham, 1871, supplement, 1873; reprint, New York: Burt Franklin, 1974.

29:174 Goodenough, Erwin Ramsdell. *Jewish Symbols in the Greco- Roman Period.* New York: Pantheon, 1953–68. 13 vols.
Covers art symbols discovered during excavations of Greco-Roman world. Summary and conclusion in Vol. 12; Vol. 13 includes index to names, subject index, and maps of area.

29:175 Goldsmith, Elizabeth E. *Ancient Pagan Symbols.* New York: Putnam, 1929; reprint ed., New York: AMS, 1973.

29:176 Gopinatha Rao, T. A. *Elements of Hindu Iconography.* Madras, India: Law Printing House, 1914–16; reprint, New York: Paragon, 1968. 2 vols. in 4 books.

29:177 Gordon, Antoinette K. *The Iconography of Tibetan Lamaism.* Rev. ed. Rutland, VT: Charles E. Tuttle, 1959; reprint, New York: Paragon Book, 1972.
Brief Sanskrit-English dictionary and guide to pronunciation of Sanskrit.

29:178 Gupte, Ramesh Shankar. *Iconography of the Hindus, Buddhists, and Jains.* Bombay: D. B. Taraporevala Sons, 1972.

29:179 *The Hindu World: An Encyclopedic Survey of Hinduism.* New York: Praeger, 1968. 2 vols.

29:180 Joly, Henri L. *Legend in Japanese Art: A Description of Historical Episodes, Legendary Characters, Folk-Lore, Myths, Religious Symbolism, Illustrated in the Arts of Old Japan.* New York: Lane, 1908.
Use with *People, Places, and Things in Henri Joly's Legend in Japanese Art: An Analytical Index,* John Barr Tompkins and Dorothy Campbell Tompkins (Alexandria, VA: Kirin, 1978).

29:181 *Maya Iconography,* ed. by Elizabeth P. Benson and Gillett G. Griffin. Princeton, NJ: Princeton University, 1988.

29:182 Moore, Albert C. *Iconography of Religions.* Philadelphia: Fortress, 1977.

29:183 Munsterberg, Hugo. *Symbolism in Ancient Chinese Art.* New York: Hacker, 1986.

29:184 Murase, Miyeko. *Iconography of the Tale of Genji: Genji Monogatari Ekotoba.* New York: Weatherhill, 1983.

29:185 Oort, H. A. van. *The Iconography of Chinese Buddhism in Traditional China.* Leiden: E. J. Brill, 1900. 2 vols.

29:186 Ross, Nancy Wilson. *Three Ways of Asian Wisdom: Hinduism, Buddhism, Zen, and Their Significance for the West.* New York: Simon and Schuster, 1966.
Explanation of the Asian philosophies and of arts that grew from them. Glossary.

29:187 Salmony, Alfred. *Antler and Tongue: An Essay on Ancient Chinese Symbolism and Its Implications.* Ascona: Artibus Asiae, 1954; reprint, 1963.

29:188 Stutley, James and Margaret Stutley. *Harper's Dictionary of Hinduism: Its Mythology, Folklore, Philosophy, Literature, and History.* New York: Harper & Row, 1977.

29:189 Waterbury, Florence. *Early Chinese Symbols and Literature: Vestiges and Speculations.* New York: Weyhe, 1942.

29:190 Williams, Charles Alfred Speed. *Outlines of Chinese Symbolism and Art Motives: An Alphabetical Compendium of Legends and Beliefs as Reflected in the Manners and Customs of the Chinese.* 3rd ed., rev. Shanghai: Kelly and Walsh, 1941; reprint, New York: Dover, 1976.
Dictionary of symbolism includes literary references.

29:191 Zimmer, Heinrich, *Myths and Symbols in Indian Art* and *Civilization,* ed. by Joseph Campbell. New York: Pantheon, 1946; reprint, Princeton, NJ: Princeton University, 1972.
Chapters on eternity and time, mythology of Vishnu, guardians of life, cosmic delight of Shiva, and the Goddess.

Bibliography

Many of the books cited in this chapter have extensive bibliographies, such as Réau's *Iconographie de l'art chrétien* [29:61] and Kirschbaum's *Lexikon der christlichen Ikonographie* [29:58].

There is also coverage in *RILA* [16:7], *Art Index* [16:1], and *Répertoire d'art et d'archéologie* [16:6]. For additional references consult bibliographies in *Iconclass* [19:14], *Arntzen & Rainwater* [17:1], and *Catalogue of the Warburg Institute* [11:87].

29:192 Gibson, Sarah Scott. "Humanist and Secular Iconography, 16th to 18th Centuries, Bibliographic Sources: A Preliminary Bibliography." *Special Libraries* 72 (July 1981): 249–260.

Discussion of subject plus a bibliography.

SECTION C
Research Centers

After the resources of the local public, university, and art museum libraries plus the capabilities of the interlibrary loan service have been exhausted, researchers may need to study some specific material in a faraway institution that does not circulate its holdings. There are some outstanding art research centers in North America and Europe. Included in this section are a few representative ones accompanied by a listing of some of their publications and holdings. Shortened titles are used; numbers in brackets refer to the complete bibliographical citation in Section B.

CHAPTER 30

North American and European Art Research Centers

Some research centers were founded to service a specific body of scholars, such as a museum's curators or a university's students. Often the facilities are limited to certain people, such as scholars or graduate students. In order to use the library, a reservation by letter or phone is sometimes required; proper identification may be requested. A letter, as far in advance as possible, stating what is desired and the day of arrival, saves immeasurable time.

Most large libraries have the closed-shelf system, making it necessary to know exactly what books or articles are needed. If the library has published a catalogue of its collection, this should be consulted. Some institutions use an identification system by which each chair or desk in the reading room has a different number attached to it. Once researchers are seated at a particular place in the reading room, this number is considered to be the researcher's number. At some institutions, there is a limit to the number of books which can be requested at any one time. If a researcher is to work at the library for an extended period, there is usually a place to store the books. Although the charge may be high, most institutions have some kind of photocopy service. Sometimes the request must be made in writing; the photocopying or microfilming may take two to three days.

This chapter—which is divided into research centers in America, Canada, and Europe—lists only a representative group of art libraries. For information on specific institutions and their holdings, see the reference works listed under "Location Directories, Art Libraries" in Chapter 20 of this guide and "Special Collections and Resources" in Chamberlin's *Guide to Art Reference Books* [17:4]. Not all of the following libraries are open to the public; inquire as to the restrictions.

American Art Centers

The following representative list of U.S. art centers is organized by state.

CALIFORNIA, Los Angeles Area

University of California, Los Angeles, Art Library, Second Floor, Dickson Art Center, Los Angeles 90024–1392.

Contains the Elmer Belt Library of Vinciana, the UCLA Artists' Files, Chinese Palace Archives, the Artists' Bookworks Collection, *Alinari* [19:1], *Marburger Index* [19:7], *Index Photographie* [19:6], *DIAL* [19:25], *Princeton Index of Christian Art* [19:20]. Shares copy of *Artists' Files* [13:71] with University of California. Collection of about 200,000 film, television, and radio titles which are accessible to all researchers upon written application to the director. Catalogue of film titles is available.

The Getty Center for the History of Art and the Humanities, Library, 401 Wilshire Boulevard, Suite 400, Santa Monica 90401–1455.

In the future, this is expected to become the largest art library in the world. Specializes in Western European archeology, art, and architecture. Photograph collection is one of the most extensive in the U.S. Includes Douws Photographic Collection of Dutch & Flemish paintings, Berenson/I Tatti Fototeca photographs of Italian paintings, Fototeca Unione (Rome) of Roman Architecture, *DIAL* [19:25], *Witt Photo Library* [19:13], *Christie's Pictorial Archive* [18:41], *Marburger Index* [19:7]. Participating member of *SCIPIO* [18:48].

CONNECTICUT, New Haven

Yale University, Yale University, Box 1605 A, Yale Station, New Haven 06520.

> The Beinecke Rare Book and Manuscript Library contains letters and manuscripts, including those of early American painters, especially John Trumbull and Samuel B. Morse. Includes the Gertrude Stein Collection, the Katherine Dreier Bequest, the Steiglitz Archives, a collection of John Ruskin's manuscript writings as well as medieval manuscripts, Audubon prints, some American Indian material, and the Western Americana collection of early photographs.

> Yale Center for British Art, Box 2120, contains books on British art—excluding decorative arts, medieval art, and architecture. Well represented are travel guides, dissertations on British art, and British literature.

> Yale Center for British Art Photo Archive has extensive picture collection for paintings, drawings, watercolors, and prints by British artists or foreigners working in the U.K. from about 1500 until 1945. Since 1976, has been computerizing the photo archive [19:17] and working towards a census of British art in North American collections. Owns British School Section of *Witt Photo Library* [19:13].

DISTRICT OF COLUMBIA, Washington

American Institute of Architects Library, 1735 New York Avenue, N.W., 20006.

> Librarians compile numerous bibliographies on architectural subjects which are available to interested parties [21:87]. Emphasis on contemporary architects and architecture; numerous videotapes available for rental.

Archives of American Art, Smithsonian Institution, five offices, processing and reference center office is American Art and Portrait Gallery Building, F Street & 8th, 20560.

> Founded in 1954 in Detroit as a national research institute for American art, the Archive became a bureau of the Smithsonian Institution in 1970. Collection of primary, secondary, and printed research material on American painters, sculptors, craftsmen, dealers, critics, collectors, and art societies. Any artist born in America or who immigrated here considered an American artist. More than 8,000,000 items: letters, clippings, journals, and scrapbooks, plus about 5,000 rolls of microfilm and transcripts of 2,000 taped interviews with artists and other

> people. See *Manuscript Collection* [13:61], *Exhibition Catalogs* [15:37], *Oral History Collections* [13:62], American Auction Catalogues on Microfilm [18:39], and *Archives of American Art Journal.* All original source material is microfilmed with copies for branch offices. Interlibrary loans handled out of the Detroit office.

> Other offices include: 1285 Avenue of Americas, New York, NY 10019; 5200 Woodward Avenue, Detroit, MI 48202; 87 Mount Vernon Street, Boston, MA 02108; M. H. de Young Memorial Museum, Golden Gate Park, San Francisco, CA 94118; Huntington Library, 1150 Oxford Road, San Marino, CA 91108.

Dumbarton Oaks Research Library, Harvard University, 1703 32nd Street, N.W., 20007.

> Comprehensive collection of international publications on Byzantine Civilization. Contains Dumbarton Oaks Research Archives, a census of Early Christian and Byzantine art found in American collections, and two bibliographical card files based on entries in the *Byzantinische Zeitschrift*: one arranged by authors, the other by subjects. *Princeton Index of Christian Art* [19:20]. See *Catalogue of Byzantine Collection* [11:139] and *Bibliographies* [11:137].

Freer Gallery of Art and *Arthur M. Sackler Gallery Library,* Sackler Gallery, 1050 Independence Avenue, Washington, D.C. 20560.

> Outstanding collection on Asian studies. See *Dictionary Catalog* [14:81].

Library of Congress, Washington, D.C. 20540.

> Created in 1800 to provide a reference library for U.S. legislators, this is now the largest library in the world. More than 78 million items, of which more than 19 million are books and pamphlets on numerous subjects and in a variety of languages. Open to anyone over high school age. Special study desks are available for researchers.

> Prints and Photographs Division, First St. Between E. Capitol St. & Independence Ave., 20540. See discussion in Chapter 22.

> Motion Picture, Broadcasting and Recording Sound Division Division has custody of the Library's moving-image and recorded sound collections which include 150,000 film and video titles and 1,500,000 sound recordings. Individual viewing and listening facilities available to serious scholars and researchers. Collections date from the 1890s to the present; see discussion Chapter 26.

National Museum of American Art and *the National Portrait Gallery,* Smithsonian Institution, F. Street at Eighth, N.W., 20560.

> Major national resource for American art, this combined library covers paintings, sculpture, portraits, and biographies. Extensive vertical-file material. The Inventory of American Paintings Executed Before 1914 [19:29] was begun as a bicentennial project to celebrate 1976. A file for sculpture is now being formulated [19:45]. The Catalog of American Portraits [19:52] contains photographs and documentation on 80,000 historically important Americans. Photographs and graphic arts are usually excluded. Also see 19:9 and 19:53.

National Gallery of Art, 6th Street and Constitution Avenue, N.W., 20565.

> A major, national research center serving primarily the needs of the museum's staff and the members of the Gallery's Center for Advanced Study in the Visual Arts. Strength is western European and American art; artist monographs; *Festschriften* and dissertations; museum, exhibition, private collection, and sales catalogues; and Leonardo da Vinci material. Special collections of exhibition and sales catalogues and extensive vertical file material for artists, museums, and galleries. Participating member of *SCIPIO* [18:48]. Open to visiting scholars by appointment.
>
> The Photographic Archives is one of the largest in the U.S. Photograph collections of Richter, Gluck, and Huyghe are supplemented by all major art and architecture microform collections, including *Alinari* [19:1], *Witt Photo Library* [19:13], *Gernsheim Corpus Photographicum of Drawings* [19:11], *DIAL* [19:25], *Marburger Index* [19:7], *Christie's Pictorial Archive* [18:41], *Index Photographie* [19:6], *Courtauld Survey British Private Collections* [19:10].

National Museum of African Art, Smithsonian Institution, East Pavilion, 950 Independence Ave., S.W., 20506.

> Traditional and contemporary African arts; extensive vertical file material.

ILLINOIS, Chicago

Chicago Public Library, Art Information Center, Visual & Performing Arts Department, 78 E. Washington Street, Chicago 60602.

> Collection strengths in 19th and 20th century art and architecture, Western painting, photography, decorative arts, costume, and local art and history. Extensive picture collection.

The Ryerson and Burnham Libraries, The Art Institute of Chicago, 37 South Wabash Ave., Chicago 60603.

> Emphasis on 19th- and 20th-century painting, architecture, decorative arts, and Oriental art. Collections of such architects as Louis Sullivan, Daniel Burnham, Frank Lloyd Wright, and Ludwig Hilberseimer plus pre-1922 Chicago architectural drawings. Participating member of *SCIPIO* [18:48]. See *Index to Art Periodicals* [16:29]; *Burnham Index to Architectural Literature* [21:97]. *Museums Studies* 13 (1988) has article devoted to the Library's collections.

MASSACHUSETTS, Boston Area

Boston Museum of Fine Arts, Library, 465 Huntington Avenue, Boston 02115.

> Established in 1879, emphasis on Asian, Classical, Egyptian, early American. *DIAL* [19:25].

Boston Public Library, Art Reference Department, P.O. Box 286, Boston 02117.

> Covers all aspects of art and architecture. Numerous microform sets, including *Marburger Index* [19:7], *Index Photographie* [19:6], *Artists' Files* [13:71].

Harvard University Fine Arts Library, Fogg Museum of Art, Quincy Street, Cambridge 02138.

> Italian Renaissance, Islamic art and architecture, art and history of still photography, conservation, drawings, and graphic arts. Photographs on Italian paintings from Berenson/I Tatti Fototeca and repertory of photographs assembled in Florence at the Biblioteca Berenson of the Harvard Center for Italian Renaissance Studies. *Alinari* [19:1], *Index Photographie* [19:6], *Marburger Index* [19:7]. *DIAL* [19:25]. For other campus libraries, see 17:16, 14:78, and 21:99. See *Catalogue of Fine Arts Library* [17:11] and listings in this Chapter for Dumbarton Oaks, Distric of Columbia, and Biblioteca Berenson, Florence.

NEW YORK CITY AREA

Avery Architectural & Fine Arts Library, Columbia University, New York 10027.

> One of the world's great architectural collections. Special collection of 300,000 architectural drawings. See *Index to*

Periodicals and Database [21:127], *Catalog of Library* [21:98], *Obituary Index* [21:59], *Architectural Trade Catalogues* [24:93]. Owns *Index Photographie* [19:6] and *Marburger Index* [19:7].

Brooklyn Museum Libraries, Brooklyn Museum, 188 Eastern Parkway, Brooklyn, New York 11238.

The Art Reference Library contains a collection of original American designer's sketches, 1900–1950. The Wilbour Library of Egyptology is considered one of the best of its kind in the western hemisphere.

Cooper-Hewitt Museum, Doris and Henry Dreyfuss Study Center, Smithsonian Institution, 2 East 91st Street, New York, New York 10028.

American decorative arts and design. Extensive picture collection pertaining to this field.

The Frick Art Reference Library, 10 East 71st Street, New York 10021.

One of the oldest U.S. art libraries. Emphasis on paintings, sculpture, drawings, and illuminated manuscripts created between 325 and 1930 A.D. in the U.S. and Western Europe. Extensive picture collection of works of art accessed by portrait index by sitter's name and an iconographical index. Reproductions also indexed under name of collection—both public and private—owning the works. Owns *Witt-Photo Library* [19:13], *Alinari* [19:1], *DIAL* [19:25] *Index Photographie* [19:6], *Marburger Index* [19:7]. See *Index to Art Periodicals* [16:28].

Metropolitan Museum of Art Libraries, Fifth Avenue and 82nd Street, New York 10028.

Separately administered libraries open to researchers:

Thomas J. Watson Library is one of oldest U.S. art museum libraries. Long runs of serials and exhibition catalogues. Large collection of European and American sales catalogues, partially indexed by names of collectors. Vertical files on artists and art subjects. *DIAL* [19:25]. Participating member of *SCIPIO* [18:48]. See *Library Catalog* and supplements [17:12].

Robert Goldwater Library was established in 1957; covers art of Africa, Pacific Islands, and Pre-Columbian and Native America. See *Catalog of Library* [14:22].

Irene Lewisohn Costume Reference Library was founded in 1951; emphasis on fashion and costume history.

Cloisters Library in Cloisters in uptown Manhattan devoted to Medieval studies.

The Museum of Modern Art, The Library, 11 West 53rd Street, New York 10019.

Vertical Files on approximately 25,000 to 30,000 artists, mostly living. Special collections on Dada and Surrealism, Latin American Art, Artists' Books, and MoMA publications. Archival papers of Hans Richter, the N.Y. art dealer Curt Valentin, past MoMA directors—Alfred Barr and Rene d'Harnoncourt. See *Catalog of the Library* and *Annual Bibliography* [12:96].

Film Study Center has about 9,000 films, some of which circulate. There is also a collection of screenplays, extensive files of contemporary reviews, newspaper and magazine articles, and publicity material. See *Film Catalog* [26:50].

New York Public Library, The Research Libraries, Fifth Avenue at 42nd Street, New York 10018.

Probably the world's largest public library. Consists of various departments, the collections of which have been published. Extensive vertical files. See *Dictionary Catalog* and *Bibliographic Guide* [17:13]; *Artists' Files* [13:71], *Dictionary Catalog of the Prints Division* [22:54].

OHIO, Cleveland

Cleveland Museum of Art, Ingalls Library, 1150 East Boulevard, Cleveland 44106.

Founded in 1916; strength in Asian art. Suzuki Archive of Chinese Paintings; Bartsch, Berenson, and Hirmer Fotoarchive. Microforms include *Alinari* [19:1]; *Gernsheim's Corpus Photographicum of Drawings* [19:11]; *Christie's Pictorial Archive* [18:41], *DIAL* [19:25], *Marburger Index* [19:7], *Sotheby Catalogues* [18:43]. Participating member of *SCIPIO* [18:48].

TEXAS, Ft. Worth/Dallas Area

Amon Carter Museum, P.O. Box 2365, Fort Worth 76113.

Emphasis on 19th- and early 20th-century American paintings, prints, drawings, sculpture, and photography. American illustrated book collection, extensive art and photography serials, and 7,000 reels of 19th-century American newspapers. *Artists' Files* [13:71], *Knoedler Library on Microfiche,* both exhibition and sales catalogues [15:42 & 18:42], *City Directories* [20:52]. Supplemented by area libraries, such as University of North Texas which has used this books as a buying guide and has *Marburger Index* [19:7] and *Index Photographie* [19:6].

Canadian Art Centers

ONTARIO, Ottawa

National Gallery of Canada Library, 380 Sussex Drive, P. O. Box 427, Station A, Ottawa, K1N 9N4.

> Emphasis on Canadian and Western European art; 40,000 files on Canadian artists and institutions. Witt Photo Library [19:13]. See *Catalogue of the Library* [13:94]; *Artists in Canada* [13:100].

ONTARIO, Toronto

Art Gallery of Ontario, Musée des beaux-arts de l'Ontario, 317 Dundas Street W, Toronto M5T 1G4.

> Founded in 1933; strength in Canadian art. Canadian artist documentation files, 1906 to present.

QUEBEC, Montreal

Centre Canadien d'Architecture/Canadian Centre for Architecture, 1920, rue Baile, Montreal, H3H 2S6.

> Founded in 1979, this international collection contains 5,000 architectural drawings, 47,000 architecture photographs, and archival material of individual architects and firms. Began CARS, an acronym for the Canadian Architectural Records Survey. Numerous publications including *Architecture and Its Image: Four Centuries of Architectural Representation-Works from the Collection of the Canadian Centre for Architecture,* Eve Blau and Edward Kaufman, eds. (Boston: MIT Press, distributor, 1989).

European Art Centers

DEUTSCHLAND (GERMANY)

Berlin

Kunstibibliothek Staatliche Museen Preussischer Kulturbesitz; Jebensstrasse 2; D-1000 Berlin 12.

> Emphasis on Spanish, Portuguese, Anglo-Saxon, and Scandinavian art and culture up to 1900 plus 20th-century architecture and city planning. Includes the Lipperheide Costume Library.

Cologne

Kunst- und Museumsbibliothek im Wallraf-Richartz-Museum; Bischofsgartenstr. 1; D-5000 Köln 1.

> Emphasizes references relating to art in Belgium, Holland, and Luxembourg up to 1900 and all 20th-century art, except architecture. The vast collection of photographs of art in Germany of The Rheinisches Bildarchiv is reproduced on microfiche along with the Bildarchiv Foto Marburg at the Forschungsinstitut für Kunstgeschichte der Philipps-Universität Marburg, to form the *Marburger Index* [19:7].

Munich

Zentralinstitut für Kunstgeschichte Bibliothek/Photothek; Meiserstrasse 10; D-8000 München 2.

> Emphasis on works of French art up to 1900, all art from Eastern European and Southeast European countries, 20th-century art, iconography, art theory, plus the history of criticism and art appreciation. See *Kataloge der Bibliothek des Zentralinstituts für Kunstgeschichte* (Munich: K. G. Saur, microfiche).

Nurnberg

Bibliothek des Germanischen Nationalmuseums; Kartäusergasse 1; Postfach 9580; D-8500 Nürnberg 11.

> Founded in 1852, collects and indexes all literature on Albrecht Dürer. Emphasizes art from German-speaking countries from early Middle Ages through Expressionism.

ENGLAND

London

The British Architectural Library, Royal Institute of British Architects (RIBA); 66 Portland Place; London W1N 4AD.

> Founded in 1834, this is one of the finest architectural libraries in the world. Special collections: pre-1841 works, Manuscript Collection of papers of RIBA architects, and archives of RIBA administrative records. The Drawings Collection, which is housed at 21 Portman Street, London W1H 9HF, is the largest collection of British architectural drawings in the world. Includes works by Palladio. Some of the library materials and papers are being microfilmed and are available at other institutions [21:102]. See *Catalogue of RIBA Library* [21:101], *Architectural Periodicals Index* and *Database* [21:126], *The Drawings Collection* [21:114], *Guide to Archive* [21:108].

The British Library Reference Division (formerly British Museum Library), Great Russell Street, London WC1B 3DG.

> Open to graduate students and researchers not able to find the material elsewhere. A

pass must be secured. For details of application write to the Reader Admissions Office. This is a depository library possessing more than 10,000,000 printed books and periodicals, 83,500 volumes of western European manuscripts, 39,300 volumes of Oriental manuscripts, 100,000 charters and rolls, 18,000 detached seals and casts of seals, 3,000 Greek and Latin papyri, plus a fine collection of Egyptian papyri.

The Conway Library, Courtauld Institute of Art, University of London, Somerset House, Strand, London WC2R 2LS.

Extensive photographic collection of architecture, sculpture, illuminated manuscripts, architectural drawings and publications, medieval wall and panel paintings, mosaics, stained glass and metalwork. Covers Western art from classical Greek period to present day. See *Courtauld Institute Illustration Archives* [19:4] and *The Conway Library* [19:3].

National Art Library, Victoria and Albert Museum, South Kensington, London, S W 7, 2 R L, England.

Covers fine and applied art of all periods and countries. Includes medieval manuscripts, autographed letters, fine European and Oriental bindings, and 20th-century *livres d'artiste.* A pass must be obtained for the use of special material. See *Catalogue* [17:14]; *Subject Catalogue* [17:15], *Periodicals Index* [16:27].

The Warburg Institute Library, Woburn Square, London WC1H OAB.

Concerned with the classical tradition in art, literature, religion, science, and institutions. Extensive collection of photographs on ancient art arranged under subject-matter rather than artist. Most media in the fine and applied arts, from antiquity to the 18th century. Illuminated manuscripts kept separately, arranged by library, indexed by author and subject. The Census of Antique Works of Art Known to the Renaissance (for which architectural monuments are collected by Bibliotheca Hertziana in Rome) is being computerized [19:15]. Prints of engravings illustrating Adam Bartch's *Le peintre-graveur. DIAL* [19:25], *Marburger Index* [19:7]. See *Catalog* [11:87].

Witt Library, Courtauld Institute of Art, University of London, 20 Portman Square, London England. WIH OBE.

As of 1989, more than 1,500,000 reproductions of paintings, drawings, and graphics of European and Western Schools, dating from 1250 to the present. Collection grows by about 25,000 images per year. Presently covers over 60,000 artists. Between 1978 and 1981, collection was filmed; at that time there were more than 1,200,000 images and 50,000 artists. *Witt Library on Microfiche* [19:13] available in North America at The J. Paul Getty Museum; The National Gallery, Washington, D.C.; The National Gallery of Canada, Ottawa; the Frick Art Reference Library, New York; and the Yale Center for British Art, Connecticut (British School only). See *Witt Library. A Checklist of Painters* [19:13]. In addition, the Photographic Survey Department has photographed more than 400 private art collections in England, Wales, and Ireland and has made the photographs available to some 70 subscribers, many in U.S. [19:10]. *DIAL* [19:25], *Marburger Index* [19:7].

The National Film Archive; British Film Institute; 21 Stephen Street, London W1P 1PL.

Begun in 1935 to maintain a British national repository of films of permanent value. See *Catalogue of the Book Library* [26:28], *Film Archive Catalogue* [26: 46], *National Film Archive Catalogue of Viewing Copies,* 1983 (list of 7,000 films which can be seen at the Institute).

Oxford

Bodleian Library, University of Oxford, Broad Street, Oxford, OX1 3BG.

Founded in 1602; contains some 136,000 manuscripts including Medieval manuscripts, topographical and antiquarian collectanea, and Oriental manuscripts. Numerous publications on their illuminated manuscripts, such as *Illuminated Manuscripts in the Bodleian Library* (London: Clarendon, 1966–73, 3 vols.); F. Madan et. al. *Summary Catalogue of Western Manuscripts in the Bodleian Library* (Oxford, 1895–1953, reprint Kraus, 7 vols, in 8 books); I. Hutter, *Corpus Der Byzantinischen Miniaturenhanschriften* (Stuttgart, 1977–82, 3 vols in 4). See Ohlgren's index [19:41].

FRANCE, Paris

Bibliothèque d'Art et d'Archéologie (Fondation Jacques DOUCET); 3, rue Michelet; F-75006 Paris.

Given in 1918 by Jacques Doucet to the University of Paris. Letter of introduction required. See *Bibliothèque d'art et d'archéologie (Fondation Jacques Doucet): Catalogue général périodiques* (Nendeln, Liechtenstein: Kraus-Thomson Organization, 1972).

Bibliothèque Forney; Hôtel des Archevêques de Sens; 1, rue du Figuier; F-75004 Paris.

> Founded in the 19th century as Professional Art Industry Library. Includes references to fine, graphic, and decorative arts; special collections of 19th- and 20th-century drawings of furniture and fabrics and 15,000 French posters dating from 1880–1985. See *Catalogue d'articles de périodiques* [24:82].

Bibliothèque Nationale; 58, rue de Richelieu; F-75002 Paris.

> Manuscript collection numbers over 300,000 volumes. Pass is required. See *Les catalogues* [17:19].

ITALIA (ITALY)

Florence

Biblioteca Medicea-Laurenziana; Piazza San Lorenzo 9; I-50123 Firenze.

> Founded in 1571, contains about 12,000 manuscripts, 4,000 books published in 15th and 16th centuries, 3,000 Greek papyri, and 4,000 illuminated manuscripts.

Biblioteca Berenson, Villa I Tatti, Harvard University, Center for Italian Renaissance Studies; Via di Vincigliata, 26; I-50135 Firenze.

> Covers Renaissance history, art history, literature and music. The Berenson Fototeca consists of about 350,000 black-and-white photographs of works by Italian painters. See *Catalogues* [11:86].

Kunsthistorisches Institut Florenz, Bibliothek; Via G. Giusti, 44; I-50121 Firenze.

> Founded in 1897 by a group of scholars to promote international cooperation in the field of art history, the library contains 300,000 photographs and an index to inscriptions of 15th-century Florentine paintings, index to coats of arms of Florentine families, and special collection of source books on the history of Futurism. Emphasizes works pertaining to all Italian art from the Middle Ages to the present. *Catalog of the Institut for the History of Art, Florence, Italy* (Boston: G. K. Hall, 1964, 9 vols.; two supplements of 2 vols. each, 1968 & 1972).

Rome

Bibliotheca Hertziana; Max-Planck-Institut; Via Gregoriana, 28; I-00187 Roma.

> Opened in 1913 by private foundation Henrietta Hertz; emphasizes works pertaining to Italian art, early Christian period to present. Contains about 400,000 photographs. *Römisches Jahrbuch fur Kunstgeschichte; Römische Forschungen der Bibliotheca Hertziana; Römische Studien der Bibliotheca Hertziana; Kataloge der Bibliotheca Hertziana in Rom.*

NEDERLAND, Den Haag

Rijksbureau voor Kunsthistorische Documentatie, Korte Vijverberg 7, Den Haag ('S-Gravenhage) 2005.

> Special interest: Dutch and Flemish paintings and drawings. Department of Archival Material has documents on Dutch artists and extracts from the A. Bredius Archives. The card index of Dutch and Flemish paintings and drawings was begun by C. Hofstede de Groot. The Topographical Department includes a collection of photographs and reproductions as well as a card index of all painted and drawn identified sites and buildings depicted by artists from the Netherlands. In excess of 1,000,000 photographs and reproductions. The iconographic index of Dutch and Flemish art, DIAL [19:25] is based upon this collection. *Bibliography of the Netherlands Institute for Art History.* (Records books, articles, and exhibition catalogues relating to Dutch and Flemish art, with exception of architecture, to 1830. Short critical comments in English. First volume published by this library in 1946 and covered 1943–1945; supplements cover two years).

Appendices

The terms in these foreign-language dictionaries were culled from art museum catalogues plus biographical and location directories; the definitions reflect their use in these references. A number of adjectives and conjunctions have been included, because it is often these basic words that make translating a title of a work of art difficult. Appendix D contains terms denoting time and number and the names of animals as well as proper names and geographic locations. These words are not repeated in the individual dictionaries of French, German, and Italian words.

French-English Dictionary

Words that are the same or similar to the English equivalents have not been included, such as: *acquisition, addition,* and *âge.* Masculine nouns and adjectives are usually listed; the feminine form is often derived by adding *e* or *ne.* In French many of the adjectives are placed after the noun: *la robe bleue,* the blue dress. The definite articles are *le* (masculine), *la* (feminine), and *les* (plural); the indefinite: *un* (masculine), *une* (feminine), and *des* (plural); the subject pronouns: *je* (I), *tu* (you), *il* (he, it), *elle* (she), *nous* (we), *vous* (you), *ils* (they, masculine) and *elles* (they, feminine). Only the third person singular of the verb is listed; the verb forms are either the past definite (literary past) tense or the past participle.

French	English
à	To, into, by, at, for, from, on
A Bas	Down
Abbaye	Abbey
Abord	Arrival
d'abord	At first, at first sight
Abrégé	Abridged; summary
Abside	Apse
Absidiole	Small apse; chapels
Abstrait	Abstract
Académie	Academy
Académique	Academic
Accentuation	Emphasis
Accessoires	Accessories
Accroupissement	Crouching
Achat	Purchase
Acier chromé	Chrome
Acquis	Acquired
Acteur	Actor
Actif	Active
Adieu	Farewell, parting
Affiche	Poster
Âge d'or	Golden Age
Agonie	Agony of death; the death of Christ on the cross
Agrée	Student ready to apply for membership in the French Academy
Aiguière	Ewer, vessel with handle and spout
Aiguillon	Incentive, spur
Aile	Wing
Ailé	Winged
Ainsi	Thus, in this manner
Ainsi que	In the same way
Albigeois	Albigenses, a French religious sect of the twelfth century
Allongé	Lengthened
Âme	Spirit, soul
Ami	Friend, patron
Amour	Love
Amphore	Amphora
Anatomie	Anatomy
Ancêtres	Ancestors
Ancien	Ancient, old
Ange	Angel
Anneau	Ring, link
Annonciation	Annunciation
Annuaire	Annual, yearbook, directory
Anonyme	Anonymous
Anse	Handle of a pot or of a basket
Antienne	Anthem
Antiquité	Classical Antiquity

French	English
Apocryphe (Les Apocryphes)	Apocryphal (The Apocrypha)
Apôtre	Apostle
Appareil photographique	Camera, camera obscura
Appartenant à	Belonging to, pertaining to
Applique	Ornamental accessories, decoration
Après	After
Aquarelle	Watercolor
Aquatinte	Aquatint
Arbre	Tree
Arc	Arch
Arc outrepassé	Horseshoe Arch
Archaïque	Archaic
Argent	Silver, money
Argile	Clay
Arme	Weapon
Armoire	Large wardrobe with doors
Art décoratif	Decorative arts
Arts graphiques	Graphic art
Assyrien	Assyrian
Atelier	Workshop, studio
Attribué à	Attributed to
Aussi	Also, too, as, so
Autel	Altar
Auteur	Author, creator
Automne	Autumn
Auto-portrait	Self-portrait
Autre	Other, another
Avant	Before
Avant-garde	Leaders for change
Avant-plan	Foreground
Avec	With, by means of, together with
Avertissement	Information, caution
Aveugle	Blind
Avoisinant	Near by, neighboring
Badigeon	Whitewash; a disguise for defects
Baigneur	Bather
Baiser de Judas	Judas kiss
Baptistère	Baptistry
Barbare	Barbarian
Barque	Boat
Bas	Low
Basilique	Basilica
Bataille	Battle
Bâtiment	A structure or building
Beauté	Beauty
Beaux-Arts	Fine Arts
Bénissant	Blessing
Bénitier	Holy water basin
Berceau	Cradle
Berger	Shepherd
Bergère	Upholstered armchair with closed upholstered sides, shepherdess
Bestiaire	Bestiary, book of beasts
Bibliographie	Bibliography
Bibliothèque	Library
Biblique	Biblical
Bienheureux	Happy, blessed
Bijou	Jewel

French	English	French	English
Biographie	Biography	Chemin	Road, way
Blanc, blanche	White	Chevet	The eastern or apsidal end of a church, includes the apse, ambulatory, and chapels.
Bleu	Blue		
Bois	Wood		
Boiserie	Panelling	Chiffre	Amount; figure; monogram
Boîte	Box; chest	Chinoiserie	Object decorated with Chinese motifs
Bol	Bowl, basin		
Bord	Side, edge	Choeur	Choir
Bordure	Border, rim, fringe, edging	Choix	Choice, selection
Bosselé	Dented	Chrétien	Christian
Bouffon	Jester	le Christ	Jesus Christ
Boule	Ball, sphere, globe	Un Christ	Crucifix, depiction of Christ on cross
Boulle	Inlay of tortoiseshell and brass for furniture		
		Chute	Fall, collapse
Boutique	Shop; atelier	Ciel (plural: Cieux)	Heaven, sky
Bras	Arm	Cierge	Church candle
Broderie	Embroidery	Cime	Top
Brosse	Brush	Cinétique	Kinetic
Brume	Haze, fog	Circoncision	Circumcision
Brun	Brown	Cire	Wax
Bruni	Burnished, darkened	Cire-perdue	Lost wax method of casting bronze sculpture
Brut	Rough, raw, unpolished		
		Ciselure	Embossing, chasing, tooling (of leather)
Cabinet des dessins	Drawing department		
Cabriole	Furniture leg inspired by an animal form	Cité	City, town, an ancient nucleus of a town
Caché	Hidden	Clair-obscur	Chiaroscuro, use of lights and darks in paintings
Cadeau de	Gift of		
Cachet	Stamp, seal	Claire-voie	Clerestory, the upper part of the church which has windows that rise above the roof of the aisle and ambulatory
Cadre	Framework; skeleton; design		
Caisse	Chest, box, cashier's office		
Calcaire	Limestone		
Calendrier	Calendar		
Calice	Chalice, communion cup	Clarté	Light
Calvaire	Calvary	Classement	Classification
Camaïeu	Monochrome painting; colorless painting; cameo	Classique	Classical
		Clef	Key
Camée	Cameo; painting done in grey	Clocher	Belfry, steeple
Campagne	Country	Cloisonné	Enamel work in which a vitreous paste of various colors fills the areas defined by cloisons
Canapé	Sofa		
Cannelé	Fluted (column)		
Carré	Square		
Carte	Map; postcard	Cloître	Cloister
Cartouche	Ornamental scroll or shield	Coeur	Heart
Cathares	Albigenses, a French religious sect of the twelfth century	Coffret	Casket
		Colère	Anger
Carton	Cardboard, cardboard box	Collé	Glued, stuck
Cathédrale	Cathedral	Collectionneur	Collector
La Cène	Last Supper, Holy Communion	Colonne	Column
La Cène chez le Pharisien	Supper in house of the Pharisee	Colonne engagée	Engaged column
Centimètre	Centimeter, .3937 inch	Colorant	Coloring, dye
Céramique	Ceramic	Commissaire-priseur	Auctioneer
Chaise	Seat, chair	Commode	A chest of drawers
Chambre	Room	Commun	Common, universal
Champs-Elysées	Elysian Fields; in mythology the place where the good people went after death; place of happiness, a famous street in Paris	Comprit, compris	Understood
		Compte rendu	Review
		Concile	Council
		Concret	Concrete
		Congrès	Congress, general meeting
Chandeleur	Candlemas; celebration of infant Christ's presentation in temple and purification of Virgin Mary; on February 2.	Connaisseur	Connoiseur, a critical judge of works of art
		Connu	Known, discovered, understood, knew
Changement	Change, alteration	Conquête	Conquest, acquisition
Chapelet	Rosary	Consacré	Consecrated
Chapiteau	Capital of a column	Conservateur	Conservationist
Chapitre	Chapter-house	Construit	Constructed, built
Charbon	Charcoal	Contemporain	Contemporary
Chasse	Hunting	Contenu	Contained
Châssis	Framework, case	Contraste	Contrast
Château	Mansion, manor house, medieval fortress	Contrefort	Buttress
		Coquille	Shell
Chaud	Warm	Coran	Koran

French	English	French	English
Corbeau	Raven; corbel in architecture	Directeur	Director
Corne à boire	Drinking horn	Dirigeant	Leader, director, directing
Corniche	Ledge, cornice	Disciple	Follower of
Corps	Body	Disponible	Available, vacant
Côté (à côté de)	Side, direction (beside, by)	Dissimulant	Concealing
Couché	Recumbent, lying in bed	Dit	Called, said
Couche inférieure	Undercoat	Don de	Gift of
Couleur	Color	Donateur	Donor
Coup de pinceau	Stroke of the brush	Donneur, donneuse	Donor, giver
Cour	Court, courtyard	Doré	Gilt
Courbé	Curved, bent	Dot	Dowry
Couronne	Crown	Doute	Doubt
Couronnement	Coronation	Doux	Soft
Cours	Course, studies	Droit	Right
Court	Short, brief	Droit de suite	A copyright system used in some European countries.
Court métrage	Short film		
Coutume	Custom	Dur	Hard
Couture	Sewing, dressmaking	Dynastie	Dynasty
Craie	Chalk		
Crayon	Pencil	Eau	Water
Crayon de fusain	Charcoal crayon	Eau-forte	Etching
Croisade	Crusade	Ebauche	Preliminary painting on a canvas; outline
Croisé	Crossed, crusader		
Croisillon	Cross-bar	Ebène	Ebony
Croix	Cross, crucifix	Ebéniste	Cabinet-maker, usually of verneer or inlay work
Croquis	First sketch, rough draft		
Crosse	Crozier	Ebrasement	Splaying
Crucifiement	Crucifixion	Ecaille	Tortoise shell
Cuir	Leather	Ecaillé	Chipped
Cuit	Cooked, done, ripe	Echantillon	Pattern, sample
Cuivre	Copper	Echauguette	Watch-tower
Curateur	Curator	Echelle	Scale, gradation
		Eclairage	Illumination
D'abord	At first, at first sight	Ecole (de)	School (of)
Dadaïsme	Dada School	Ecolier	Student
Dans	In, into	Ecriture	Scripture, handwriting
Danse macabre	Dance of death	Ecrivain	Author
De	Of	Ecu	Shield, escutcheon, money
Déambulatoire	Ambulatory	Edifice	Building
Décédé	Deceased	Editeurs d'art	Art publishers
Décoloré	Faded	Effet	Effect
Décoratif	Decorative	Egalement	Equally, likewise, uniformily, also
Découpage	Cutting out; decorated surface of object with paper cutouts		
		Eglise	Church
Découvert	Discovered	Elévation de la croix	Raising the Cross
Décret	Decree	Elève	Student, apprentice
Défi	Challenge	Email (plural: émaux)	Enamel
Dehors	Outside, without	Embrassant	Embracing
Déjà vu	Unoriginal; already seen; trite	Emplacement	Location
Dépouilles	Spoils, remains	Emprunt (de)	Loan (on loan)
Depuis	Since, for, after	En	Within, at, to, in
Dernier cri	Latest word (in fashion)	En arrière de	Behind
Derrière	Behind	En aval de	Below
Descente de la croix	Descent from the Cross	Encadrement	Frame; border; margin
Désigné	Appointed, chosen	En passant	By the way
Dessin	Drawing, design, sketch, pattern	En plein	Fully, entirely
		En vente	For sale, in print
Dessin au pastel	Pastel drawing	Enchère	Bid, auction
Dessin à l'échelle	Scale drawing	Encre	Ink
Dessous	Under	Endroit	Place, locality
Détrempe	Distemper, painting using an egg emulsion as a binding medium	Enfant	Child, infant
		Enfer	Hell
		En haut	Up, above
Détruit	Destroyed	Enseignement	Teaching, education, lesson
Devant	Before, in front of	Ensevelissement	Entombment
Diable	Devil	Entendre	Understand, listen, hear
Diamètre	Diameter	Enterrement	Burial
Diaphane	Translucent	Entouré de	Surrounded by
Diapositive	Slide, transparency	Entre	Between, among
Dieu	God	Entre-deux	Partition; space between
Dimensions	Size	Entrelacé	Intertwined
Diptyque	Diptych, two panels or pictures hinged together	Entreprit	Attempted
		Epais	Thick

301

French	English	French	English
Epoque	Epoch, era, time	Fondeur	Founder; caster of metal sculpture
Epouse	Wife, bride	Fontaine	Fountain
Epoux	Husband, bridegroom	Fonts Baptismaux	Baptismal receptacle
Epreuve	Trial; test; proof-sheet	Forme	Form
Erudit	Scholar	Fort	Strong, large, difficult
Escalier	Stair	Fosse	Pit, grave
Esclave	Slave	Fossé	Moat, ditch
Espace	Space	Fou, folle	Insane, mad, foolish
Espérance	Hope	Foudre	Large cask
Esprit de corps	Spirit of closeness developed by people associated with each other	Fouille	Excavation
		Fraise	Strawberry
Esquisse	Sketch; rough plan	Frère	Brother
Essai	Trial, sample	Fresque	Fresco
Est	East, is	Frise	Frieze
Estampe	Print, engraving	Fronton	Pediment
Estampille	Trade mark; stamp of authenticity	Fuite en Egypte	Flight into Egypt
		Fureur Iconoclaste	Iconoclastic Controversy
et	And	Fusain	Charcoal
Etain	Pewter	Fut	Was
Etat	State, circumstances; condition	Fût	Column shaft
Eté	Summer		
Etoile	Star	Galerie	Gallery
Etouffant	Suffocating, close	Garçons	Boys
Etranger	Stranger	Gargouille	Gargoyle, water spout
Etude	Study	Gauche	Left, clumsy
Evangile	Gospel	Gauchi	Warped
Evêque	Bishop	Géant	Giant, gigantic
Exposition	Exhibition	Géminé	Double, twin
Ex-voto	Votive offering, given or offered because of a vow	Genre	Subjects from everyday life; family; race; kind
		Geste	Deed, exploit
Fabrique	Factory	Gisant	Lying; recumbent effigy on tomb
Façade	Front of building		
Faculté	Faculty; ability; power	Glacé	Frozen, glazed, glossy
Faïence	Fine quality glazed earthenware having brightly colored designs	Glaive	Sword
		Gothique	Gothic
		Gouache	Opaque water-color painting
Fauteuil	Arm chair	Gourde	Flask
Faux, fausse	False	Gramme	Gram, 15.432 grains
Femme	Woman	Grand	Large; great; important
Fenêtre	Window	Granit	Granite
Fer	Iron	Graphique	Graphics
Ferme	Farm	Grappe	Cluster of fruit
Fermé	Closed	Gravé	Engraved
Ferronnière	Chain with jewel decorating a woman's head	Graveur	Engraver
		Graveur sur bois	Wood engraver
Fête	Holiday, saint's-day or feast	Grenade	Pomegranate
Fête-Dieu	Corpus Christi Day	Grenier	Attic, loft
Fête-galante	Elegant festival developed by Antoine Watteau	Gris	Grey
		Grisaille	Done in shades of grey
Feu	Fire	Gros, grosse	Large, coarse
Feuille	Sheet of paper	Guérison	Cure, healing
Feuille d'or	Gold leaf	Guerre	War
Figure	Figure, face; form		
Fil	Thread, yarn, wire	Habilité	Skill
Filigrane	Filigree, water-mark on paper; embossing	Hausse	Lift, rise, advance
		Haut	High, loud, upper
Fille	Daughter	Hauteur	Height, elevation
Fils	Son	Héraldique	Heraldry
Fin	End, conclusion	Hérésie	Heresy
Fin de siècle	End of century (of the late 19th century)	Heure	Hour, time
		Histoire	Story, tale
Flâneur, flâneuse	Strolling spectator	Historié	Historiated, decorated with figures that tell a story (as a capital of a column)
Fleur	Flower		
Fleuve	River		
Foi	Faith, creed	Hiver	Winter
Fois	Time	Homme	Man
Fond	Bottom (of the sea or of a container); background	Homogène	Homogeneous
		Hors-concours	Above competition; not competing; in the academy exhibition, not having to be judged in order to have one's work shown
Fondamental	Fundamental		
Fondateur	Founder		
Fondement	Foundation		

French	English	French	English
Hospice	Convent, asylum, refuge for travelers	Litre	Liter, 1.76 pints
		Livre	Book
Hôtel	Town house	Livret	Catalogue
Hôtel de vente	An establishment where auctions are held	Long métrage	Feature film
		Longueur	Length
Hôtel de ville	Town hall	Lumière	Light
Huile	Oil	Lune	Moon
		Lutte	Struggle
Icone	Icon	Lycée	Secondary school
Iconographie	Iconography, study of significance of symbols and themes in art		
		Macramé	Hand-knotted fringe
		Madone	Madonna
Idéaliste	Idealistic	Mages	Magi
Idée	Idea	Main	Hand
Idolâtrie	Idolatry	Maison	House
Il ne fit que	He only did, he only made	Maison natale	Birthplace
Il prit part	He took part	Maître	Master
Il semble que	It seems that	Maître inconnu	Unknown master
Illustré	Pictorial	Majeur	Major
Imitateur de	Imitator of	Malade	Sick
Impressionnisme	Impressionism	Maquette	Small rough model or sketch
Imprimé	Printed	Marbre	Marble
Imprimeur	Printer	Marchand	Merchant, dealer, buyer
Inconnu	Unknown	Marin	Pertaining to the sea, seascape
Incrustation	Inlay	Marque	Mark, imprint
Inférieur	Lower, inferior	Matière	Material, subject, contents
Infini	Infinite	Matière plastique	Plastic material
Inné	Innate, inborn	Matières textiles	Textiles
Inscrit	Inscribed	Maure	Moor
Intaille	Intaglio, incised or sunken design	Melange	Blend, alloy of metals
		Même	Same, self
		Même chose	Same thing, all one
Interne	Internal	Menuisier	Joiner; cabinetmaker of plain or carved pieces
Inventaire	Inventory		
		Mer	Sea
Jardin	Garden	Mère	Mother
Jaune	Yellow	Méridional	Southern, person from southern France
Jeu de Paume	Tennis; name of the small building, which was once an indoor tennis court, now a part of the Musée du Louvre, Paris.		
		Mesure	Measurement
		Métal (plural: métaux)	Metal(s)
		Métier	Craft
Jeune	Young	Métrage	Measurement, film
Joie	Joy	Mètre	Meter, 3.28 feet
Journaux d'art	Art periodicals	Mettre	To put on, place
Jubé	Roodscreen in a church	Meubles	Furniture
Juif	Jew	Mezzo-tinto	Mezzotint
		Le Midi	The south of France
Lait	Milk	Milice	Militia
Laiton	Brass	Milieu	Center
Lancette	Lancet, a high narrow window with a pointed top	Millefleurs	Many different flowers (design on tapestries of 15th and 16th centuries)
Langue	Language		
Lapidaire	Lapidary, stone inscriptions	Millimètre	Millimeter, .039 inches
Laqué	Lacquered, enamelled	Mineur	Minor
Largeur	Width	Mise	Placing, manner of dress, attire
Larron	Robber, thief	Mise en scène	Setting, showing how figures or actors fit into the environment, production
Latérale	Side		
Lavé	Washed		
Légèrement	Lightly, swiftly	Miséricorde	Mercy; a small piece of wood attached to the underneath side of a choir seat upon which a standing singer can rest.
Legs	Legacy, bequest		
Leitmotiv	Themesong, any recurrent theme		
Lentille	Lens of a camera		
Lettre	Letter	Modèle	Model
Leur	Their	Moine	Monk, friar
Libéré	Liberated	Monastere	Monastery
Librairie	Book store	Monastique	Monastic
Libre	Free	Monde	World
Licet	Permission	Montage	Mounting, combining together a number of pictoral elements in one composition
Linéaire	Linear		
Linteau	Lintel		
Lis	Lily	Montagne	Mountain
Lisse	Smooth		

French	English	French	English
Monté	Mounted	Panneau	Panel
Monumentalite	Monumentality	Pape	Pope
Morceau	Piece, work, fragment	Papier	Paper
Mort	Dead	Pâques	Easter
Mosaïque	Mosaic	Parabole	Parable
Mou	Soft	Paradis	Paradise
Mouillé	Wet	Parchemin	Parchment
Moulage	Plaster cast, mold	Parfois	Sometimes
Moule	Mold	Parmi	Among
Moulure	Moulding	Parquet	Inlaid floor, often with geometric shapes
Mourut	Died		
Mouvement	Motion	Part	Share, part, portion, collaboration, concern
Moyen	Medium, middle		
Mur	Wall	Particulier	Particular, private, special
Musée	Museum	Partisan	Believer, supporter
Musée archéologique	Archaeological museum	Pascal	Paschal, pertaining to Easter or the Passover
Musée d'art	Art museum		
Musée des arts et métiers	Museum of crafts or decorative arts	Pâte dure	Hard paste
		Pâte tendre	Soft paste
Mystère	Mystery	Pater	Lord's Prayer
		Pauvre	Poor
N'a pas été restauré	Has not been restored	Pays	Country, land
Nature Morte	Still life	Paysage	Landscape
Né	Born	Péché	Sin
Nef	Nave	Pêche miraculeuse	Miraculous draught of fishes
Négociants d'art et d'antiquités	Art and antique dealers	Pécheur	Sinner
Neige	Snow	Pêcheur	Fisherman
Nettoyé	Cleaned	Peintre	Painter
Neuf, neuve	New, inexperienced	Peinture	Paint, painting
Nicéen	Nicene	Peinture à l'huile	Oil-painting
Nimbe	Halo, nimbus	Peinture au pistolet	Spray-painting
Noces de Cana	Wedding at Cana	Peinture en mosaïque	Mosaic-painting
Noël	Christmas	Pèlerin	Pilgrim
Noir	Black	Pendaison	Hanging
Nom	Name, celebrity, noun	Pendant	Hanging, depending, during
Nom patronymique	Surname	Pendule	Clock
Non reproduit	Not reproduced	Père	Father
Nord	North	Périodique	Magazine, periodical
Notre-Dame	Our Lady	Pentecôte	Pentecost
Nouveau	New, recent	Petit	Small
Nouvelle	News, tidings, new, recent	Peuplade	Tribe, clan
Nu	Nude	Peuple	People, nation, crowd
Nuit	Night	Pied-droit	Jamb of the door, pillar, pier
Numéro	Number	Pied	Foot
		Pierre	Stone
Obélisque	Obelisk	Pinceau	Paint-brush
Obscurité	Darkness, dimness	Pionnier	Pioneer
Occidentale	The West, Europe and the Americas	Pittoresque	Picturesque, painterly
		Placage	Veneering (wood); plating (metal)
Œil	Eye		
Œuf	Egg	Plafond	Ceiling
Œuvre	Works of an artist taken singly or as a whole; production	Plage	Beach
		Plaie	Plague, wound, sore
Ombre	Shade, shadow, darkness	Planche	Plates, illustrations
On	People, they	Plancher	Floor
Onction	Anointing, unction	Plastique	Plastic
Or	Gold	Plâtre	Plaster
Orangé	Orange-colored	Plume	Pen
Ordre	Sequence, order	Pochade	Rough sketch, value study
Orfèvrerie	Gold or silver ware; jewelry	Poids	Weight
Orgues	Organ	(au) Point	In focus
Os	Bone	Poli	Burnished, polished
Ostensoir	Monstrance, a receptacle that holds and exposes the consecrated wafer or Host	Polyptyque	Polyptych, a work of art composed of several hinged panels
Ouest	West		
Outragé	Insulted, outraged	Pomme	Apple
Ouvert	Open	Pont	Bridge
Ouvrage	Work	Pont-levis	Drawbridge
Ove	Egg shaped	Populaire	Popular, folk
		Porcelaine	Porcelain
Païen, païenne	Pagan	Portail	Chief doorway, portal
Paix	Peace, tranquillity	Porte	Door
Palais	Palace	Portefeuille	Portfolio, wallet

French	English	French	English
Portement de la croix	Christ carrying the cross	Religieux, religieuse	One who belongs to a religious order
Possédé	Possessed	Reliquaire	Reliquary
Poterie	Pottery	Relique	Relic
Postérieur	Behind, subsequent	Reliure	Bookbinding
Pouce	Inch; thumb	Remise	Delivery
Pourpre	Purple	Reniement	Denial
Prêché	Preached	Repas	Meal
Précis	Precise	Répertoire	Table, index, catalogue, repertory
Prédécesseur	Predecessor		
Premier	First	Réplique	Replica; rejoinder
Préromane	Pre-Romanesque	Repos	Rest, repose
Près	Near, by	Repoussé	Thin sheet of metal with raised design produced by hammering the back side of the sheet
Prêt	Loan, ready, prepared		
Prêteur, prêteuse	Lender		
Prêtre	Priest		
Prie-dieu	Piece of furniture at which an individual kneels to pray	Ressuscité	Risen
		Restauré	Restored
Prière	Prayer, request	Rétable	Altarpiece
Prieuré	Priory	Rêve	Dream
Primitif	Early; primitive	Rinceau	An ornament composed of scrolls and a floral motif
Printemps	Spring		
Prix	Price; cost; value; prize	Robe	Dress
Prix de Rome	A scholarship awarded annually in France; the recipient receives a stipend to study art in Rome	Roche	Rock
		Roi	King
		Roman	Romanesque
		Rond	Round
Procédé	Process	Roue	Wheel
Proche	Near	Rouge	Red
Profondeur	Depth	Rue	Street
Projet	Project	Ruine	Ruin, decay (of a building)
Prolongé	Elongated		
Prophète	Prophet	Sacré	Holy
Propos (à propos)	Words, remark (apt)	Sage	Wise
Provenance	Origin, source	Saison	Season
Publié	Published	Salière	Salt cellar
Pudeur	Modesty	Salle	Large room, hall, gallery of museum
Puis	Then, next, besides		
Puits	Well; pit	Salon	Exhibition; drawing room
		Sang	Blood
Quart	Quarter, fourth part	Sans	Without
Quatre-feuilles	Quartrefoil	Sarcophage	Sarcophagus, stone coffin
Que (ne . . . que)	Whom, which, that, what, if, as, (only)	Sarrasin	Saracen
		Sauveur	Savior
Quelque	Some; any; a few	Savant	Expert, scholarly
Queue	Tail; end; rear	Sceau	Seal, stamp
Qui (à qui?)	Who, whom, which, that, (to whom)	Scénario	Screen play
		Sculpteur	Sculptor
Quoi	What, which	Sec	Dry
Quotidien	Daily	Seigneurie	Domain of a lord
		Sein	Bosom
Raccourcissement	Foreshortening in art	Séjourna	Stayed, sojourned
Raisin	Grape	Sens	Sense (of touch, sight, direction)
Raison	Reason, judgment		
Rameau	Palm	Sépulcre	Sepulcher, tomb
Rangé	Odered, tidy	Seulement	Only
Rapport	Profit, relation, connection	Signalement	Description
Ravissement	Rape; rapture	Signé	Signed
Réalisme	Realism	Signification	Meaning
Réalité	Reality	Silencieux	Silent
Recherche	Research	Singerie	Representations of monkeys
Reconnu	Recognized, accepted	Socialiste	Socialist
Recto	Front side of a work of art; right-hand page	Société	Association
		Soeur	Sister
Reçu	Recognized, accepted, received	Soleil	Sun
Recueil	Collection, miscellany, selection	Sommaire	Summary
Rédacteur	Writer, editor	Sommeil	Sleep
Réduit	Reduced	Sommet	Top
Refaite	Rebuilt; repaired	Songe	Dream
Réflexion	Reflection	Souci	Care, anxiety
Règne	Reign	Soudé	Welded
Régulièrement	Regularly, exactly	Sourd	Deaf
Reine	Queen		
Rejeté	Rejected		

French	English	French	English
Souriante	Smiling	Trame	Weft and woof in weaving
Sous	Under, below, with, upon, by	Travail (plural: travaux)	Work(s)
Souterrain	Subterranean	Trésor	Treasure
Souverain	Ruler	Triptique	Triptych, three panels or
Squelette	Skeleton		pictures hinged together
Statique	Static	Trompe-l'œil	A painting which at a distance
Stylisé	Stylized		gives an illusion of reality;
Sud	South		deceiving the eye
Suite	Those that follow, series	Trône	Throne
Suivant	Following, next	Trouvé	Found
Suivant de	Follower of	Trumeau	Pier between two doors
Sujet	Subject		supporting the lintel
Supplice	Pain, anguish, torture	Tua	Killed
Sur	On, over, in, about	Tympan	Tympanum
Surmoulage	Process of duplicating a bronze		
	statue	Urne	Urn
Symbole de Nicée	Nicene Creed		
		Valeur	Value
Table des matières	Table of contents	Vécut	Lived
Tableau	Painting, picture, scene	Vélin	Vellum
Tailleur	Tailor, cutter	Vénitien	Venetian
Tapis	Carpet	Vent	Wind
Tapisserie	Tapestry	Vente	Sale
Tard	Late	Vérité	Truth
Tasse	Cup	Vernis	Varnish
Technologie	Technology	Verre	Glass
Teinte	Hue, tint, shade	Verrerie	Glass-works, glassmaking
Tempête	Tempest, storm	Vers	About, toward
Temps	Time	Verso	Reverse side of a work of art
Ténébristes	Tenebrists, users of sharply	Vert	Green
	contrasted light and dark	Vertu	Virtue, chastity
	tones in paintings	Victorien	Victorian
Tentateur	Temptor	Vie	Life
Tentation	Temptation	Vieillard	Old man
Tenture	Hangings, tapestry	Vierge	Virgin
Terme	Term	Vieux, vieil, vieille	Old, ancient
Terre	Earth	Vif, vive	Vivid (colors)
Terre cuite	Terra cotta	Ville	City, town
Tête	Head	Visage	Face, counterance
Théière	Teapot	Viscosité	Viscosity
Tirage	Drawing, hauling	Vitrail (plural: vitraux)	Stained-glass window(s)
Tissage	Weaving	Vivant	Alive
Tissu	Cloth	Voir	To see
Titre	Title, style	Vol	Flight; theft
Titres abrégés	Abridged titles	Volet	Shutter
Toile	Canvas	Voussoir	Wedge-shaped stone of an arch
Toile de Jouy	Finely woven cotton fabric	Voussure	The curve of an arch
	printed with a classical scene	Voûte	Arch, vault
Toile de lin	Linen	Vrai	True, genuine
Toit	Roof	Vue	View
Tombeau	Tomb	Vue aérienne	Aerial view
Tome	Volume	Vue générale	General view, over-all view
Tour	Tower		

German-English Dictionary

The German language forms new words by the continuous additions of terms without any hyphens to assist the reader in their recognition; consequently, if words are separated, their meaning can often be discovered. For instance, in the word, *Phantasiekunst, Phantasie* stands for fantasy or inventiveness; *kunst,* for art. The researcher may need to try to divide some of the longer German words in order to learn their definition.

Words which are the same or similar to the English equivalent have not been included; such as *Allegorie, Archiv,* and *Film.* Most nouns in German form the plural by adding an *n, en, nen, e,* or *er.* The basic definite articles are *der* (masculine), *die* (feminine), *das* (neuter), *die* (plural); while the indefinite articles are *ein* (masculine and neuter), and *eine* (feminine). The subject pronouns are *ich* (I), *du* (you), *er* (he), *es* (it), *sie* (she), *wir* (we), *ihr* (you), *sie* (they), and *sie* (you). The negative is usually formed by placing a form of *kein* (no, not any) before a noun or *nicht* (not) in front of a verb or adverb.

All nouns are capitalized in German, no matter where they are placed in a sentence or a title. An umlauted vowel—ä, ö, ü—is sometimes written with an e—ae, oe, ue. The German script of β has been replaced with a double s in this dictionary.

German	English
Abänderung	Variation, modification
Abbildung	Illustration
Abdruck	Print, reproduction
Abendmahl	Supper
abklären	To clarify
abliefern	To deliver
Abmessung	Dimension
Abnahme	Taking down, decrease
Abrahams Schoss	Abraham's bosom, heaven
Abstrakte	Abstract
Abstraktgëmalde	Abstract painting
Abstufung	Gradation
Abtei	Abbey
Adressbuch	Directory
Ähnlichkeit	Likeness
Akademie	Academy
akademisch	Academic
Akt	Nude model, act
aktiv	Active
Allegorie	Allegory
allgemein	Common, general
alphabetisch	Alphabetical
alt	Ancient, old
Altargëmalde	Altarpiece
Altartafel	Altarpanel
altchristliche	Early Christian
Alter	Age
Ältere	Elder
altertümlich	Archaic
Altertumsforscher	Archaeologist
Anatomie	Anatomy
Anbetung	Adoration, admiration
Anbetung der Könige	Adoration of the Kings
Anblick	Aspect
Andachtsbild	Devotional image
andere	Other
Anerkennung	Acknowledged by, acknowledgment
Anfang	Beginning, origin
Anfänger	Beginner
Angeboren	Inborn, native

German	English
Angevin	Anjou, a province in western France
Anhänger	Disciple
Anleihe	Loan
Anmerkung	Note, comment
Anonym	Anonymous
Anordnung	Arrangement
Anschein	Appearance
Anschluss	Connection
Ansicht	View, opinion
Antiquariat	Antiquarian, dealer in old and rare books
Antiquitäten	Antiques
Antiquitäten-handlungen	Antique dealers
Antritt	Accession; start; entry room
Anzeige	Review
Apfel	Apple
Apokalypse	Apocalypse
Apostel	Apostle
Apsis	Apse
Aquarell	Watercolor
Aquarellmalerei	Watercolor painting
Arabeske	Arabesque
Arbeit	Work
Arbeiter	Worker
Archäolog	Archaeologist
Architekt	Architect
Architektur	Architecture
Archivolte	Archivolt
arm	Poor
Aspekt	Aspect
ästhetisch	Aesthetic
Atelier	Studio
Atmosphäre	Atmosphere
Ätzdruck	Etching
auch	Too, also
auf	In, on, upon, at
Auferstehung	Resurrection
Auflage	Edition of printing, contribution
aufrichten	To raise, to erect
Aufsatz	Article, essay
Aufsteig	Ascension, rise
Auftraggeber	Patron
Auge	Eye
Auktion	Auction
Auktionator	Auctioneer
Ausarbeitung	Elaboration, composition
Ausdruck	Expression, term
Ausführung	Execution
Ausgabe	Expenses
Ausgang	Exit, end
ausgestellt	Display
Auslegung	Interpretation
Ausmass	Scale, measure, degree
Ausschuss	Refuse, waste; best part; choice; committee
ausserhalb	Outside, beyond
aussetzen	To expose, to display
ausstellen	To exhibit
Ausstellung	Exhibition
Ausstellungshaus	Exhibition house
authentisch	Authentic

German	English	German	English
bald	Soon	Bildschnitzer	Wood-carver
Band	Volume	Bildstecher	Engraver
Barbar	Barbarian	Bildstreifen	Reel of film
Barock	Baroque	Bildtafeln	Illustrations
Barockstil	Baroque style	Bildung	Formation, fashion
Basilika	Basilica	Bildunterschrift	Title beneath illustration;
Bau	Building, construction		signature on picture
Bauart	Style of architecture	Biographie	Biography
Baukunst	Architecture	bis	Until, to, up to
Baukünstler	Architect	Bischof	Bishop
Bauleute	Builders	Bischofsmütze	Mitre
Baum	Tree, pole	Blatt	Newspaper, sheet of paper
Baum der Erkenntnis	Tree of Knowledge	blau	Blue
Baum des Lebens	Tree of Life	Bleistift	Pencil
Baumeister	Master builder	Blick	View, look
bedeutend	Important, significant	Blitz	Flash, lightening
bedeutungsvoll	Meaningful, significant	Blumen	Flowers
beendigen	To terminate	Blumenschmuck	Floral decoration
befreien	To liberate	Blumenstrauss	Bouquet of flowers
Begräbnis	Entombment	Blumenstück	Flower painting
Begriff	Concept, notion	Blut	Blood
behandeln	To handle, to manipulate	Boden	Bottom, ground
bei	Near	Bogen	Arch, bend, curve
Beiblatt	Supplement	braun	Brown
beide	Both	Braut	Betrothed
Beifügung	Addition	breit	Broad, flat, wide
beimessen auf	To attribute to	Brennpunkt	Focus
Beispiel	Example, illustration	Broschüre	Brochure, pamphlet
beitragen	To contribute	Bruchstück	Fragment
Beiwerk	Accessories	Brücke	Bridge
bekannt	Known	Bruder	Brother
Beleuchtung	Illumination	Brunnen	Well
bemalen	To paint over	Buch	Book
Bereich	Scope, sphere, area	Buchdeckel	Book cover
Bericht	Report	Bücherkunde	Bibliography
Berg	Mountain	Buchhändler	Bookseller
Beschreibung	Description	Buchhandlung	Bookstore
Beschriftung	Inscription, legend	Buckel	Bulge, bump
Besitz	Possession, property	Bühne	Stage
Bestiarium	Bestiary	buntes Glas	Stained Glass
betiteln	Entitled, name, style	Bürste	Brush
Beton	Concrete	Byzantinisch	Byzantine
Betrug	Fake		
Beweggrund	Motive	Chor	Choir
beweglich	Mobile, movable	Chorhaupt	Chevet; eastern or apsidal end
Beweinung Christi	Lamentation over the Dead		of church
	Christ	Chorumgang	Ambulatory, choir gallery or
Beweisstück	Document		passage
bewundern	To admire	Christfest	Christmas
Bewusstsein	Awareness, knowledge	Christus	Christ
bezeichnend	Significant, characteristic	christlich	Christian
Bibliographie	Bibliography	Chrom	Chrome
Bibliothek	Library		
biblisch	Biblical	Dachboden	Attic
Bild	Picture, image, portrait	damalige	Of that time, then
bilden	To form, fashion, model	Dämon	Demon
bildend	Plastic, graphic	Dankopfer	Thank offering
Bildende Künste	Fine arts	dann	Then, at that time
Bildergallerie	Picture gallery	darbringen	To present, to offer
Bilderhändler	Picture-dealer	Darlegung	Exposition
Bilderhandschrift	Illuminated manuscript	Darstellung	Representation, presentation,
bilderstürmend	Iconoclastic		exhibition
Bildgrösse	Size of image	Darstellung im Tempel	Presentation in the Temple
Bildhauer	Sculptor	daselbst	There
Bildhauerarbeit	Sculptured piece	datiert	Dated
Bildhauerkunst	Sculpture	Datum	Date
bildlich	Pictorial, graphic	Decke	Ceiling, covering
Bildner	Sculptor, molder	Deckel	Cover, lid
Bildnis	Portrait, likeness	dekorativ	Decorative
Bildniskunde	Iconography	Dekoration	Scenery
bildsam	Plastic, adaptive	dekorieren	To decorate, to adorn
Bildsäule	Statue	dem	To whom, to which, to the
Bildsäule zu Pferde	Equestrian Statue		

German	English	German	English
derselbe	Same	Familie	Family
Diapositiv	35 mm. slide	Farbe	Color, hue, paint
Diaverzeichnis	List of slides	Farbstoff	Pigment
Dichter	Poet	Farbwert	Value of color
Diptychon	Diptych	Fassade	Facade
Direktor	Director	fassen	To mount, to grasp
Dom	Cathedral, dome, cupola, vault	Feder	Feather
Dominikaner	Dominican	Fels	Rock, cliff
Doppel	Duplicate, double	Festung	Fortress
dorisch	Doric	Feuer	Fire
Drehbuch	Screen play	Figur	Figure
Dreifaltigkeit	Trinity	Firnis	Varnish
Drucker	Printer	flach	Plane, low, flat
dunkel	Dark, gloomy	Flachbildwerk	Bas-relief
Dunkelkammer	Dark room	Flasche	Flask, bottle
durch	Through, by, across	Flatterhaft	Volatile; fickle
Durchbrochenes	Triforium, something perforated	fliessend	Smooth; flowing
		Flucht nach Ägypten	Flight to Egypt
Durchmesser	Diameter	Flügel	Wing, arm; grand piano
durchscheinen	To shine through	Fluss	River
		Folge	Series
Ebenbild	Image	Forscher	Scholar, researcher
Ebenholz	Ebony	Forschung	Research
echt	Authentic	fortwährend	Continual
Ehebrecherin	Adultress	Franziskanermönch	Franciscan monk
Eichenholz	Oakwood	Frau	Woman; wife
Einblick	Insight	Freiheit	Freedom
einfach	Simple	fremd	Foreign
einfarbig	Monochromatic	Fresko	Fresco
Einfluss	Influence	Freude	Joy
einige	Some, several	Friedhof	Cemetery
Einlegeholz	Veneer	früh	Early
Einlegen	Inlay	Frühling	Spring
Einleitung	Introduction, preface	Frührenaissance	Early Renaissance
einschliesslich	Included	Führer	Guide, guide-book, leader
einschreiben	To inscribe	Führung	Tour, guide
Einsicht	Insight	für	For, instead of, against
einzel	Particular, single	fürbitte	Intercede
Einzelheit	Detail	Furcht	Fear
Eisen	Weapon, sword, iron	Furnier	Veneer
Elfenbein	Ivory	Fuss	Foot
Emaille	Enamel	Futurismus	Futurism
Empfänger	Receiver, recipient		
Engel	Angel	Gabe	Gift, donation
Entarte Kunst	Degenerate Art	Galerie	Gallery
entgegensetzen	To contrast	ganz	Entire, entirely
entwickeln	To develop	Garten	Garden
Entwicklung	Evolution, development	Gärtner	Gardner
Entwurf	Design, sketch	Gastmahl	Banquet, dinner party
Erde	Earth, ground	Gattungsmaler	Genre-painter, one who depicts subjects of everyday life
Erdbeere	Strawberry		
Erfahrung	Experience	Gebäude	Building
Erhöhung	Rising, raising	geboren	Born
Erinnerungsbild	Memory pictures, memorial pictures	Geburt Christi	Nativity
		Geburtsort	Birthplace
Erklärung	Explanation, interpretation	Gedenktafel	Plaque
Erläuterung	Explanation	Gefangenschaft	Captivity
Eroberer	Conqueror	Gefäss	Vessel
Eröffnung	Opening day (of an exhibit)	geflügelt	Winged
erscheinen	To appear	Gefüge	Texture; joining together
erst	First, prime	Gegen	Towards, opposed to, against, about
Erwähnung	Mention		
Erwerb	Acquisition	Gegensatz	Contrast
Erzherzog	Archduke	Gegenstand	Object, subject matter, theme
etwa	About	gegenüberstehen	To oppose
Evangelium	Gospel	Gehalt	Content
Expressionismus	Expressionism	Gehäuse	Case, casing
		gehören zu	To belong to
Fabelwesen	Fabulous creature	Geisselung Christi	The Flagellation
Fabrikat	Artifact	Geist	Spirit, ideas
Fach	Compartment	gelb	Yellow
Fahrt	Journey, trip	Geld	Money
falsch	False	Gelehrter	Scholar

German	English	German	English
Gemälde	Picture, painting	Greis	Old man
Gemäldegalerie	Picture gallery	Grenze	Limit, border
gemäss	Measure	gross	Large, tall
gemein	General, common	Grösse	Size, dimension
Gemetzel	Massacre	grösser	Bigger, higher
genannt	Surnamed, called	Gruft	Vault, tomb
genau	Precise	Gruftkirche	Crypt
Genosse	Partner, associate	grün	Green
Genrebild	Painting of scenes of everyday life	Grund	Ground, basis
		Grundfarben	Primary colors
Genremaler	Painter of scenes of everyday life	grundlegend	Fundamental
		Gründung	Foundation
Genreszenen	Scenes of everyday life	Guss	Pouring out, casting
genug	Enough	gut	Good
Geometrik	Geometric		
geradlinig	Rectilinear	Hafen	Harbour, port
gerecht	Just	Hälfte	Half, middle
Gerechtigkeit	Justice	Haltung	Attitude
gereinigt	Cleaned	Handlung	Action, act (play)
gering	Minor; limited	Handschrift	Manuscript
Gesamtbild	The whole picture	Handwerk	Handicraft
Geschenk	Gift	Handzeichnung	Sketch, drawing
Geschichte	History; story	Hauptfarbe	Primary color
Geschichtlichkeit	Historical relevance, authenticity	Hauptteil	Principal section
		Hauptwerke	Principal work
Geschicklichkeit	Skill	Haus	House
geschnitzelt	Chipped, cut	heilig	Sacred, holy
Gesellschaft	Society	heiliger	Saint
Gesicht	Face	Heim	Home
Gesichtspunkt	View-point	Heimsuchung	Visitation
Gestalt	Form, figure, shape	Heirat	Marriage of
Geste	Gesture	hell	Bright, clear
Gestell	Framework, support, easel	Helldunkel	Chiaroscuro
gestern	Yesterday	Herausforderung	Challenge
gestorben	Died	Herausgeben	Publish, edit
gewaltsam	Violent; powerful	Herausgeber	Editor, publisher
Gewand	Garment	Herkunft	Provenance, origin
Gewebe	Texture, weaving	Herkunftsort	Original location
Gewerbekunde	Technology	Herrschend	Dominant
Gewicht	Weight	Herrscher	Ruler
Gewölbe	Arch, vault	Herz	Heart
Gewölbepfeiler	Buttress	Herzog	Duke
Gewölbestütze	Flying buttress	Himmel	Heaven, sky
gezeichnet	Signed; designed	Himmelfahrt	Ascension
Giebelfeld	Tympanum, pediment	Hindernis	Obstacle
Glanz	Brightness	hinter	After, behind
Glas	Glass	Hintergrund	Background
glasen	To glaze	Hinzufügung	Addition
Glasmalerei	Painting on glass	Hirt	Shepherd
Glasur	Glaze	hoch	High
glatt	Smooth	Hochländer	Highlander
Glaube	Faith	Hochzeit zu Kana	Wedding at Cana
Gleichgewicht	Balance	Hof	Palace, courtyard, farm, country house
Gleichnisse	Parables; similarities		
Glockenspiel	Clock which works with bells and has figures that move	Hoffnung	Hope
		Höhe	Height, elevation, top
Glockenturm	Clock tower	Hölle	Hell
Glossar	Glossary	holperig	Bumpy
Goldenes Zeitalter	Golden Age	Holz	Wood, timber
Goldschmiede-arbeiten	Goldsmith's work	Holzkohle	Charcoal
gotisch	Gothic	Holzmosaik	Wood inlaying
Gott	God	Holzschneider	Wood-carver
Gottähnlich	Devine	Holzschnitt	Woodcut
Gotteshaus	Temple, church, chapel	Horizont	Horizon
Götzenbild	Idol	Humanismus	Humanism
Grab	Tomb	Hunne	Hun
Grablegung	Burial	Hut	Hat
Granatapfel	Pomegranate		
Graphik	Graphics	idealistisch	Idealistic
Graphiker	Graphic artist	Idee	Idea
grau	Grey	Ikon	Icon
Graveur	Engraver	immer	Always
Gravüre	Engraving	Impressionismus	Impressionism

German	English	German	English
Ingenieur	Engineer	Klostergang	Cloister walk
Inhalt	Contents, subject, volume	Klugheit	Prudence
Inszenierung	Setting, actors or sculpture set in an environment	Kluniazensermönch	Cluniac monk
		Knabe	Boy
Intensität	Intensity	Knochen	Bone
Inventar	Inventory	Koje	Stall, berth, cabin
inwendig	Inner	koloriert	Illuminated; colored
irrtümlich	Erroneous	kompliziert	Complex
isoliert	Isolated	Komposition	Composition
		König (Königin)	King (queen)
Jahreszeit	Season	Königreich	Kingdom
Jahrgang	Annual (of a book)	Konzil	Council
Jahrzehnt	Decade	Kopf	Head
jeder	Every, each	Kopie	Copy
jeweils	At any given time	Körper	Body
Jude	Jew	Kostüm	Costume
Jungen	Boys	Kreide	Chalk
Jüngere	Younger	Kreis	Circle; district
Jungfrau	Virgin	Kreuz	Cross, crozier, crucifix
Jüngling	Youth, young man	Kreuzgang	Cloisters
jüngst	Latest, recent; youngest	Kreuzigung	Crucifixion
Juwel	Jewel, gem	Krieg	War
		Kristall	Crystal
Kalender	Calendar	Kritiker	Critic
Kamee	Cameo	Krone	Crown
Kamera	Camera	Krönung	Coronation of
Kampf	Struggle, battle	kubisch	Cubic
Kanne	Jug, tankard, pot	Kubismus	Cubism
Kapelle	Chapel	Kulisse	Scenery for theater
Kapetinger	Capetians, a ruling house of France	Kult	Cult, worship
		Kultur	Culture
Kapitell	Capital	Kulturgeschichte	History of Civilization
Kapselfarbe	Color from a tube	Kulturkreis	Cultural circle
Karikatur	Caricature	Kunst	Art, skill
Karmeliter	Camelite	Kunstakademie	Art school
Karolingisch	Carolingian	Kunstausstellung	Art exhibition
Kartäusermönch	Carthusian monk	Kunstbuchhandlung	Art book store
Karton	Cardboard; box	Kunstdruckerei	Printers of fine art works
Kastchen	Casket	Künste	Art, skill
Katalog	Catalogue	Kunstgewerbe	Practical arts, arts and crafts
Kathedrale	Cathedral	Kunstgewerbemuseum	Museum of crafts or decorative arts
Kauf	Purchase		
Kelch	Chalice	kunsthistorisch	Art historical
Keramik	Ceramics	Kunstkenner	Connoisseur
Kerze	Candle	Künstler	Artist
Kette	Necklace, chain	Künstlerlexikon	Directory of Artists
Keuschheit	Chastity	Kunstmuseum	Art museum
Kind	Child, infant	kunstreich	Artistic
Kinderporträt	Child's portrait	Kunstrichter	Art critic
Kindheit	Infancy	Kunstsammlung	Art collection
Kinematographie	Motion picture	Kunstschule	Art academy
Kino	Cinema, movie house	Kunsttheorie	Art theory
Kirche	Church	Kunstverein	Art Association
Kirchenbann	Excommunication	Kunstverleger	Art publisher
Kirchenchor	Choir	Kunstzeitschriften	Art periodicals
Kirchenfrevel	Sacrilege	Kupferstich	Copper plate engraving
Kirchenfürst	Prelate	Kupferstecher	Engraver
Kirchengerät	Sacred vessels or garments	Kupferstich	Copper engraving
Kirchengesetz	Ecclesiastical canon	Kupido	Cupid
Kirchenglaube	Dogma, creed	Kuppel	Dome
Kirchenlehrer	Early church father	Kurfürst	Elector (in the German states)
Kirchenordnung	Church ritual	Kurve	Curve
Kirchenschiff	Nave	kurz	Short
Kirchenstuhl	Pew		
Kirchenvater	Church father	Lack	Varnish
Kirchhalle	Church porch	Lackarbeit	Lacquered work
Kirchspiel	Parish	Lackfirnis	Lacquer
Kirchturm	Steeple	Lage	Position, location
Kitsch	Rubbish, inartistic trash	Landesmuseum	State museum
klassisch	Classical	Landschaft	Landscape
klein	Small, short	Landschafstmaler	Landscape painter
Kleinkindesalter	Infancy	lang	Lengthy, long
Kleinplastik	Small sculpture		

German	English	German	English
Länge	Length, size	Metall	Metal
lapidarisch	Lapidary, inscriptions on stones	Methode	Method
Laster	Vice	Miniatur, Miniaturbild	Miniature
laut	Loud, noisy; in accordance with	Mirakel	Miracle
Leben	Life, exist	Mirakelspiel	Miracle Play
lebendig	Alive	mit	With, by, as, to
lebensgross	Life size	Mitarbeiter	Assistant, collaborator
lebhaft	Vivid, bright, lively	Mitglieder	Members
Legende	Legend	Mittel	Medium, center, middle, means
Lehrer	Teacher	Mittelalter	Middle Ages
Leidenschaft	Passion	mittelalterlich	Medieval
Leihweise	On loan	Mittelpfeiler	Trumeau, center pier between
Leinen	Linen		two doors supporting the
Leinwand	Canvas		lintel
Leitmotiv	Recurring theme, leading motif	Mitteltafel	Middle panel
letzt	Latest, final, last	Möbel	Furniture
Licht	Light	Modell	Model
licht	Clear, bright	Moderne Kunst	Modern Art
Lichtbild	Photograph	Mohr	Moor, Negro
Liebe	Love, charity	Mönch	Monk
Liebe Frau	Our Lady, Virgin Mary	Mönchskloster	Monastery
Lieferung	Part, issue	Monumentalität	Monumentality
Lilie	Lily	Mosaik	Mosaic
Linie	Line, rank	Münze	Coin, medal
link	Left	Muschel	Shell
Linse	Lens of a camera	Museumsleiter	Museum director
Literatur	Literature	Musik	Music
Lithographie	Lithography	Musikinstrumente	Musical instruments
Lokalfarbe	Natural color	Muster	Design
		Mutter	Mother
Macht	Power	Mysterium	Mystery
Magier	Magi	Mystisch	Mystical
Mahl	Meal		
malen	To paint, portray	nach	After, towards, according to, to
Maler	Painter, artist	Nachahmung	Imitation, forgery
Malerei	Painting, picture	Nachantike	Pre-classical antiquity
Malerfarbe	Paint	Nachbildung	Replica
Malergold	Ormolu, gilded metal	nachdem	After
	emulating gold	Nachdruck	Emphasis, reprint, reproduction
malerisch	Artistic, picturesque	Nachfolge	Imitation of
Malerkunst	Art of painting	Nachfolger	Follower of
Malerleinwand	Canvas	Nachricht	Report, account
Malerpinsel	Paint brush	Nächst	Next
Malerscheibe	Palette	Nächstenliebe	Charity
Malerschule	School of painting or for	Nachtrag	Addendum, supplement
	painters	nackte Figur	Nude
Malerstaffelei	Easel	Namen	Name, title
manchmal	Sometimes	namenlos	Anonymous
Manieriertheit	Mannerism	Narr	Fool
Mann	Man; husband	nass	Wet
Männliches Bildnis	Portrait of a gentleman	Natur	Nature
Manuskript	Manuscript	natürlich	Natural
Marinemaler	Seascape painter	nautisch	Nautical
Marmor	Marble	neben	Beside
Mässigkeit	Temperance	Neigung	Tendency, inclination
masstäbliche Zeichnung	Scale drawing	neu	New, recent
Materie	Matter	Neuerung	Innovation
Mauer	Wall	neutestamentliche	Of the New Testament
Mauergemälde	Mural	neuzeitlich	Modern
Mauerzierat	Wall decoration	nicht	Not
Maurer	Mason	Niederlage	Defeat; warehouse
Medaille	Medal	Niedriger	Lower; inferior
Meeresfelsen	Seacliff	Nonne	Nun
mehere	Several	Nord	North
mehr	More	nötig	Necessary
Meister	Master	Nummer	Number
Meisterstück	Masterpiece	nur	Only
Mensch	Mankind, human being		
Mensur	Measure	oben	On high, above
Merkzeichen	Hallmark	oberhalb	At the upper part, above
Merowinger	Merovingian	Oberteil	Top
Messing	Brass	obige	Above mentioned
Messung	Measurement		

German	English	German	English
Objekt	Object	Produktion	Production
oder	Otherwise, or	Projekt	Project
offen	Open	Prozess	Process
offenbar	Manifest	Prozessionskreuz	Procession of the cross
Offenbarung	Apocalypse; revelation	Publikum	Public
öffentlich	Public	Punkt	Point
Öffnungzeit	Opening time	purpur	Purple
oft	Often	Putz	Ornament, plaster
ohne	Except, without		
Öl	Oil	Quadrat	Square
Ölfarbe	Oil color	Quellen	Sources
Ölgemälde	Oil painting	Quellenmaterial	Source material
Ölmalerei	Oil painting	Querschiff	Transept
optisch	Optical		
Orange	Orange-color	Rad	Wheel
organisch	Organic	Radierung	Etching
organisieren	Organize	Rahmen	Frame
Orgel	Organ	Rand	Border
Orgelchor	Organloft	Rathaus	Town hall
Originell	Original	rauh	Rough
Ort	Place	Raum	Space, room, place
Osmane	Ottoman	Realismus	Realism
Ost	East	Rechnung	Bill, account
Ostasien	Far East	Recht	Right
Ostern, Osterfest	Easter	rechtfertigen	Justify
Ozean	Ocean	Rede	Conversation, speech
		Register	Table of Contents
Palast	Palace	Reich	Empire, state, reign
Paneel	Panel, wainscot	reich	Rich
Papier	Paper	Reihenfolge	Sequence
Pappelholz	Poplar wood	rein, reinlich	Clean
Papst	Pope	Reiter	Rider, horseman
Parabel	Parable	reparieren	Repair
Pastell	Pastel, crayon	Reproduktion	Reproduction
Pastellfarbe	Pastel color	republikanisch	Republican
Pastellgemälde	Pastel painting	Rest	Remains
Pastellmaler	Pastel painter	Restaurator	Restorer
Pastellstift	Crayon	rhythmisch	Rhythmic
Pater	Father	Richtung	Direction, course, tendency
Pergament	Parchment	Riese	Giant
Periode	Period	Rokoko	Rococo
Perspektive	Perspective	romanisch	Romanesque
Pfarrkirche	Parish church	Romanschriftstellar	Novelist
Pfeil	Pillar	Romantik	Romanticism
Pfingsten	Pentecost	Rosenkranz	Rosary, garland of roses
Phantasie	Fantasy, inventiveness	rot	Red
phantastisch	Bizarre	Rückseite	back, reverse side
Phasen	Phases	Ruf	Reputation
philosophisch	Philosophical	rund, rundlich	Round
Photographie	Photograph	Rundschau	Review
physisch	Physical		
Pionier	Pioneer	Sach	subject
Plakat	Poster	sachdienlich	Relevant
Planung	Planning	Sachkundiger	An expert
plastisch	Plastic; formative	Sachregister	Table of Contents, Index to Subjects
platt	Flat		
Platte	Printing or etching plate	Sachwörterbuch	Encyclopedia
Platz	Place	Sage	Fable, myth, saga
polieren	Burnish; polish	Salzfass	Salt-cellar
Polyptychon	Polyptych	Sammler	Collector
Popular	Pop	Sammlung	Collection
Porträt	Portrait	Sankt	Saint
porträtieren	To portray	Sarazene	Saracen
Porträtmaler	Portrait painter	Sättigung	Saturation of color, purity of color
Porzellan	Porcelain		
prächtig	Magnificent	Säule	Column
Prachtseite	Display side	Schabkunst	Messotint
Präraphaelit	Pre-Raphaelite	Schafe	Lamb
Predigt	Sermon	Schäfer	Shepherd
Primitiv	Primitive	Schaft	Shaft, handle, stick
Prinzip	Principle	Schale	Bowl
privat	Private	Schatten	Shade, shadow
Privatsammlung	Private collection	Schatzkammer	Treasury

German	English	German	English
Schatzkästlein	Casket, box	Stellung	Attitude; position
Schau	View, review, exhibition	sterben	Die
Schauspiel	Spectacle, play	Stern	Star
Schauspieler	Actor	Stickerei	Embroidery
scheiden	Separate, part, depart	Stifter	Donor
Schiff	Boat, nave	Stil	Style
Schild	Shield, escutcheon, sign	stilisieren	Stylize
Schlacht	Battle	still	Silent, quiet
Schlaf	Sleep	Stilleben	Still life
schlecht	Bad, poor	Stoff	Cloth
Schliesse	Clasp	Strand	Shore, beach, seashore
Schloss	Palace	Strasse	Street
Schluss	End, conclusion	streben	Strive
Schlüssel	Key	Strebepfeiler	Buttresses
Schneelandschaft	Snow landscape	Streich	Stroke
Schnitzer	Wood-carver	streng	Severe, rough, stiff, sharp
Schnitzwerk	Wood-carving	Struktur	Structure
schön	Beautiful, lovely	Stunde	Hour
Schöne Künste	Fine Arts	Sturm	Storm
Schönfärberei	Dyeing, coloring, embellishment	Sturz	Fall, plunge
		Sturze	Lintel; cover
Schönheit	Beauty	Subjekt	Subject
Schoss	Bosom, lap	Süd	South
Schrein	Cabinet, shrine	Sünder	Sinner
Schriftsteller	Writer	Surrealismus	Surrealism
Schule	School	Symmetrie	Symmetry
Schüler	Pupil	synthetisch	Synthetic
Schützen	Protect	Szene	Scene, stage
Schutzheiliger	Patron saint		
schwarz	Black	Tafel	Tablet, plaque
schwer	Heavy, difficult	Täfelung	Wainscoting
Schwester	Sister	Tagesbericht	Bulletin
schwinden	Fade	täglich	Daily, every day
Seele	soul	Tapete	Hanging, tapestry
Seelenstärke	Fortitude	Tasse	Cup
Sehkraft	Vision	Täter	Doer, author
Seite	Page, side	tätig	Active, employed, engraved
Seitengebäude	Wing of building	Tätigkeit	Occupation, profession; ability
Seitenschiff	Side aisle	Taufe	Baptism
Sekundärfarbe	Secondary color	Taufkapelle	Baptistry
Selbstbildnis	Self-portrait	Tecknik	Technique, depth
selig	Blessed, happy	Teil	Section, piece
Separat	Separate	teilweis	Partial, fractional
Sieg	Triumph, conquest	Tempel	Temple
Siegel	Seal of	Tenebristen	Tenebrists, users of sharply contrasted light and dark tones in paintings
Signatur	Signature		
Silber	Silver		
Sinnbild	Emblem, symbol	Teppich	Carpet
Sinnlich	Sensual	teuer	Expensive
Sintflut	Deluge, flood	Teufel	Devil, demon
Skizze	Sketch, outline	Textilien	Textile
Skizzieren	To make a sketch	Textur	Texture
Skulptur	Sculpture	Thron	Throne
Sohn	Son	Thronender Christus	Enthroned Christ
Sommer	Summer	tiefdruck	Intaglio
sozial	Social	Tiefe	Depth
Sozialist	Socialist	Tierkreis	Zodiac
Spannung	Tension, bracing	Tinte	Ink
spät	Late	Tisch	Table
Spender	Donor	Titel	Title
Sphäre	Sphere	Tochter	Daughter
Spiel	Game, sport	Tod	Death
Sprache	Language	Ton	Clay, tone
Sprichwort	Proverb	Töpfer	Potter
Spur	Mark, trace	Töpferei, Töpferware	Pottery, ceramics
Staatliches Museum	State museum	töricht	Foolish
Stabil	Stable	tot	Dead
Stadt	City	töten	To kill
Stall	Stable	Totentanz	Dance of Death
Standort	Location	Tracht	Costume, fashion
Starb	Died	Tränen	Tears
Stein	Stone	Traum	Illusion, dream
Steindruck	Lithography	Treppe	Stairs
Steingut	Stoneware		

German	English	German	English
Trinkhorn	Drinking horn	Verzerrung	Distortion
Triptychon	Triptych	Verzierung	Ornament
Tugend	Virtue, chastity	verzückung	Ecstacy
Tür	Door	vicktorianisch	Victorian
Turm	Tower	viel	Much
Türpfosten	Door post, jamb of door	viele	Many
Türsturz	Lintel	viereckig	Square
Tuschmanier	Aquatint	Virtuos	Masterly performer
Typ	Type, standard, model	Vogelschau	Bird's-eye view
		Volk	People, nation
über	Over, on, above, upon, about	Völkerkundemuseum	Ethnological museum
überall	Everywhere	vollendet	completed
überarbeiten	To retouch	vollkommen	Entire
Überblick	Survey, general view	Volumen	Volume
Überdruck	Overprint, transfer	von	By, from, of, in, about
Übergang	Transition	vor	Before; ago
Überschreitung	Transgression	Vorbild	Model, pattern
Übersetzung	Translation	Vordergrund	Foreground
um	About, around, near	Vorgänger	Predecessor
Umfang	Size, scope	vorgeschichtlich	Prehistoric
umgeben von	Surrounded by, encircled by	Vorhall	Porch
Umgebung	Environment	Vorhanden	In print; available
Umwelt	Environment, milieu	Vorlesung	Course; lecture
unbekannt	Unknown	Vorliebe	Preference
und	And	Vorrätig	In print
undurchsichtig	Opaque	Vorraum	Narthex
unendlich	Infinite	Vorstellungskraft	Imagination
Unklarheit	Haze; murkiness	Vortragekreuz	Processional cross
unten	Beneath, at the bottom	Vorzeichnung	Preparatory drawing, sign
unter	Under		
Untergrund	Undercoat; underground	Waage	Balance
Unterschied	Difference	Wachs	Wax
Urkunde	Document	Waffe	Weapon
Urne	Urn, casket	Wahrheit	Truth
Ursprung	Origin	wahrnehmen	To perceive, to observe
		Wald	Forest
Vater	Father	Wandgemälde	Wall painting
Verallgemeinerung	Generalization	Wandteppich	Tapestry
Veraltet	Archaic	Wappen	Coat of arms
Veränderung	Change	Wasser	Water
Veranlagung	Assessment, talent	Wasserfarbe	Watercolor
verbergen	To conceal	Wasserspeier	Gargoyle
verdrehen	To warp	Wasserzeichen	Watermark
verehren	To admire	Weberei	Weaving
Verein	Society, club, association	weder . . . noch	Neither . . . nor
Vereinigung	Alliance, union, meeting	wegen	Because of
vergoldet	Gilt, gilded	Weib	Wife, woman
Vergoldung	Gilding	weich	Soft
Vergrösserung	Enlargement	Weid	Chase, hunt
Verhältnis	Proportion, relation	Weihnacht	Christmas
Verkauf	Sale	Weihnachtskind	Christ Child
Verkäuflich	For sale	Weihwasserbecken	Holy water basin
(Marie) Verkündigung	The Annunciation	Weintraube	Grape
Verlag	Publishers, publishing house	weiss	White
Verlängerung	Elongation	Weite	Width
Verleugnung	Denial	Welt	World
Verloren	Lost	wenig	Little, few
Vermächtnis	Legacy, bequest	wenn	If
Vermählung	Marriage	Werk	Work
vermutlich	Probably, likely, presumed	Werkstatt	Workshop
Verschiedenes	Various, miscellaneous	Wert	Value, worth
Verschlag	Partition	Wertschätzung	Appreciation, estimation
Verschlingen	Intertwined	wesentlich	Essential
verschollen	Lost, missing	Wichtigkeit	Importance
Verstehen	Understand	wichtigst	Most important
Versteigerung	Auction	Widmung	Dedication
Versuchung	Temptation; attempt	wieder	Again
Vertrauen	Faith	wiederherstellen	To restore
Verwalter	Curator, administrator	Wiege	Cradle
Verwandtschaft	Relationship	Wiesel	Weasel
verweigern	To refuse	wirken	To produce, to weave, to work
verworfen	Rejected	Wirkung	Effect
Verzeichnis	Index, list, catalogue	Wissenschaft	Knowledge

German	English	German	English
Wollust	Lust	Zerstörung	Destruction
Wort	Word, term	ziehen	To draw, to pull
Wörterbuch	Dictionary	zierend	Ornamental
Wunder	Miracle	Zinn, Zinnern	Tin, Pewter
Wunderbare	Miraculous, amazing	Zinnwaren	Tinware, pewter
Würdigung	Elevation	Zisterziensermönch	Cistercian monk
		Zodiakus	Zodiac
zahlreich	Numerous	Zoll	Inch; customs
zart	Delicate	zu	To, towards, in addition to, for, in, by, towards
Zeichen	Symbol, sign		
Zeichner	Designer	zudem	Besides, in addition
Zeichnungen	Drawings	zufrieden	Content, satisfied
Zeit	Age, time	zugeschrieben	Attributed to
Zeitalter	Era, generation	zurück	Back
zeitgenössisch	Contemporary	Zurückstrahlung	Reflection
Zeitschrift	Magazine	Zusammenarbeit	Cooperation, collaboration
Zeïttafel	Chronology	Zuschreibung	Attribution
zeitweilig	Temporary, current	Zustand	Condition
Zentimeter	Centimeters	zuversichtlich	Confident
Zentrum	Center	Zuwachs	Accession
Zepter	Sceptre	Zweifel	Doubt, suspicion
zerstören	To destroy	zwischen	Between
		Zyklus	Cycle

Italian-English Dictionary

There are only twenty-one letters in the Italian alphabet; *j, k, w, x,* and *y* are only found in words of foreign origin. The plural is usually formed by changing the vowel: *o* to *i* in masculine words, *capitello* (capital) to *capitelli; a* to *e* in feminine words, *donna* (woman) to *donne; e* to *i* in both masculine and feminine words, *pittore* (painter) to *pittori.* The basic indefinite articles are *un, uno* (masculine) and *una* (feminine); the definite ones: *il* (masculine), *la* (feminine), *i* (masculine plural), and *le* (feminine plural). Subject pronouns are: *io* (I); *tu, Lei, voi* (you); *lui* (he); *lei* (she); *esso, essa* (it); *noi* (we); *voi, Loro* (you); *loro* (they). The negative is formed by placing *non* (not, no) before the verb. Adjectives are usually placed after the noun: *affresco secco* (dry fresco). An accent mark is placed on an Italian word to indicate that the stress falls on the final vowel or to differentiate between two words which are pronounced and spelled alike.

Italian	English
Accresciuto	Increased
Acquasantiera	Holy water vessel
Acquerello	Watercolor
Acquisatato	Acquired, purchased
Adorazione	Adoration
Affresco	Fresco
Agiografia	Hagiography, study of the Christian saints
Aiuto	Assistance, aide
Albero	Tree
Alla	On the, to the, at the
Allievo	Student, apprentice
Altare	Altar
Altezza	Height, depth
Alto rilievo	High relief
Altro	Except, next, other
Amanti	Lovers
Amò	Loved
Anche	Even, too, also
Anello	Link, ring
Angelo	Angel
Anno	Year
Annunciazione	Annunciation
Antichità	Antiques
Antico	Ancient
Antiquari	Art and antique dealers
Aperto	Open, opened
Apertura	Opening
Apocalisse	Apocalypse
Arabo	Arab
Arancio	Orange color
Arca	Sarcophagus, tomb, ark
Arcaico	Archaic
Arcare	Arch
Archeologico	Archeological
Architetto	Architect
Arcivescovo	Archbishop
Argenti	Silver
Arma Christi	Instruments of Christ's Passion
Arte antica	Ancient art
Arte moderna	Modern art
Artigiano	Craftsperson
Artista	Artist
Artisti di grafici	Graphic artists
Ascensione	Ascension, Christ's Ascension
Associazioni	Associations
Astratto	Abstract
Attivo	Active
Attore	Actor

Italian	English
Attrice cinematografica	Film actress
Autore	Author
Autunno	Autumn
Avorio	Ivory
Avventura	Adventure
Avvenuto	Happened, occurred
Bacio	Kiss
Bambino	Child
Barca	Boat
Barocco	Baroque
Basso rilievo	Low Relief
Battello	Boat
Battesimo	Baptism
la Beatissima Vergine	The Blessed Virgin
Beato	Blessed
Belle arti	Fine Arts
Bellissima	Beautiful
Benché	However, although
Bianco	White
Biblico	Biblical
Bibliografia	Bibliography
Biblioteca	Library
Bizantino	Byzantine
Blu	Blue
Bottega	Workshop, studio
Braccialetto	Bracelet
Braccio	Arm
Bronzo	Bronze
Calice	Chalice
Camera	Room
Campanile	Bell tower
I Campi Elisi	Elysian Fields
Campione	Trial, sample
Camposanto	Churchyard
Capitello	Capital
Capitolo	Chapter house
Cappella	Chapel
Carattere	Character, mark
Carboncino	Charcoal
Carità	Faith
Carta	Paper
Cartone	Cartoon, cardboard
Casa	House
Casa d'asta	Auctioneer house
Cassone	Large chest, similar to a hope chest
Castello	Castle
Catalogo	Catalogue
Cattedra	Chair, professorship
Cena	Supper
Cerchio	Circle
Che	Whom, who, thing, what
Chiaro	Clearness, light in color
Chiaroscuro	Graduations of lights and darks
Chiave	Key
Chiesa	Church
China	Slope, descent
Chiostro	Cloister
Chuiso	Closed
Cielo	Sky, heaven

Italian	English	Italian	English
Cimitero	Cemetery	Editore	Publisher
Cinematografico	Film, cinematographic	Editori d'arte	Art publishers
Città	Town, city	Edizione	Edition
Classico	Classical	Effemeride	Journal, diary
Classificazione	Classification	Enciclopedia	Encyclopedia
Cofanetto	Casket	Epoca	Epoch, period
Col	With the	Erba	Grass
Collezione	Collection	Eseguito	Executed, accomplished
Collezionisti	Collectors	Esempio	Model, pattern, example
Colonna	Column	Esperto	Expert
Colore	Color	Esposta	Exhibited
Combattimento	Battle	Est	East
Compianto	Lamentation	Estate	Summer
Compiuto	Completed	Estetica	Aesthetics
Con	By, with	Età	Age, epoch
Conchiglia	Shell		
Congresso	Congress, general meeting	Fabbricato	Building
Consacrato	Consecrated	Facciata	Façade, front
Conserva	Store, preserve	Ferro	Iron
Construzione	Construction	Fiasco	Flask, bottle
Conte	Count, earl	Figlio (figlia)	Son (daughter)
Conterraneo	Fellow-countryman	Finestra	Window
Contrafforte	Buttress	Finezza	Politeness, daintiness
Coperchio	Cover	Fino	Thin, fine, until
Coppa	Cup	Fiore	Flower
Corinzio	Corinthian	Firmato	Signed
Corno potorio	Drinking horn	La Flagellazione	Scouraging of Christ, The Flagellation
Coro	Choir	Fonte	Fountain, source
Cortile	Courtyard	Fra	Between, among, brother
Cosiddetto	So-called	Frammento	Fragment
Credenza	Large sideboard	Fratello	Brother
Cristiano	Christian	Fu	Was
Croce	Cross	La fuga in Egitto	Flight to Egypt
Crociata	Crusade		
Crocifisso	Crucifix	Galleria	Gallery
Crocifissione	Crucifixion	Galleria di Chiostro	Cloister walk
Cubismo	Cubism	Gentiluomo	Gentleman
Cuoio	Leather	Genere	Kind, class, everyday subjects depicted in art
Cura	Care, solicitude	Gesso	Plaster, chalk
Dapprima	At first	Giallo	Yellow
Datata	Dated	Giardino	Garden
Deceduto	Dead, deceased	Gioia	Jewel, joy
La Deposizione	Descent of Christ from the Cross	Gioielli	Jewelry
Destinato	Destined, intended	Giornale	Journal, newspaper
Destro	Right side	Giornalmente	Daily
Detto	Called, proverb	Giovane	Young man or woman
Dimensioni	Dimensions	Giù	Down
Dipinto	Painting, picture, scene, mural painting	Gli	The
Direttore	Director, editor	Grafica	Graphic art
Dirigente	Director, directing	Grigio	Grey
Disegnare	To draw, to design	Grossezza	Thickness
Disegnatori	Engravers, designers	Guida	Guide
Disegno	Drawing, design		
Distrutto	Destroyed, ruined	Ha	Has
Dittico	Diptych		
Dizionario	Dictionary	Illustrazione	Illustrations
Donato	Presented, given, donated	Imperatore	Emperor
Donna	Woman	Impressionismo	Impressionism
Doppio	Double	Inchiostro	Ink
Dopo	After, afterwards	Incisione	Engraving
Dorico	Doric	Incisore	Engraver
Dorso	Back	Incoronazione	Coronation
Duca	Duke	Ingresso	Entrance
Ducale	Ducal	Intaglio	Incised or sunken design in carving or engraving
Duro	Hard	Interamente	Entirely
		Internazionale	International
E	And	Intitolare	To dedicate, to name, to call
Ebano	Ebony	Intorno	About, around
Ebreo	Jew	Inverno	Winter
Edificio	Building	Ionico	Ionic

Italian	English	Italian	English
Lapis	Pencil	Ogni	Each, every
Larghezza	Width	Olio	Oil
Latta	Tin	Onice	Onyx
Lato	Side, direction	Opera	Works, opera
Lavoro	Work	Ornato	Decoration, ornamental design
Legge	Law	Oro	Gold
Legno	Wood	Oscuro	Dark, mysterious, dim
Legato	Legacy, bequest	Ottenere	To acquire, to obtain
Lettera	Letter	Ovest	West
Librerie d'arte	Art bookstores		
Libro	Book	Padre	Father
Lido	Beach	Paesaggio	Landscape
Listello	Lintel	Pagina	Page
Litografo	Lithograph	Pala d'Altare	Altarpiece
Luce	Light	Palazzo	Palace
Lumeggiamento	Emphasize, illuminate	Papa	Pope
Lunetta di portale	Tympanum	Participato	Participated
Luogo natio	Birthplace	Particolare	Private, personal
		Pasqua	Easter
Madre	Mother	Pastello	Pastel
Maniera	Manner	Pastori	Shepherds
Manierismo	Mannerism	Peccato	Sin
Manieristico	Manneristic	Peltro	Pewter
Manoscritto	Manuscript	Penitenza	Penance
Marca	Mark	Penna	Pen
Mare	Sea	Perduto	Lost
Marmo	Marble	Pergamena	Parchment
Martirio	Martyrdom	Pergamo	Pulpit
Materiale	Material	Periodico	Periodical
Matto	Insane, mad	Personaggio	Personality, character
Mattone	Tile, brick	Piano	Floor, softly
Medioevo	Middle Ages	Pianterreno	Ground floor
Menzionata	Mentioned	Piazza	Place, square
Metà	Half	Piccolo	Small, little, short
Miracolo	Miracle	Pietra	Stone
Mistico	Mystic	Pinacolo	Pinnacle
Misto	Mixture	Pinacoteca	Picture gallery
Misura	Measure	Pioniere	Pioneer
Mobili	Furniture	Pittore	Painter
Molle	Soft	Pittura	Painting
Molte	Numerous, many	Poi	After, then, later
Monaca	Nun	Polittico	Polyptych
Monastero	Monastery	Ponte	Bridge
Monografia	Monograph	Popolo	People
Monogramma	Monogram	Porcellana	Porcelain
Montaggio	Mounting, assembling, montage	Porpora	Purple
		Portale	Portal, chief doorway
Montagna, monte	Mountain	Possiede	Owns, possesses
Morte	Death	Pozzo	Water well
Morto	Dead, deceased	Predica	Sermon
Mostra	Exhibition, show	Pregio	Value, worth
Museo	Museum	Pregiottesca	Before Giotto
		Preistorico	Prehistoric
Nartece	Narthex	Preraffaelita	Pre-Raphaelite
Nascita	Birth	Presentazione	Presentation
Natale	Christmas	Presso	Near, by, in
Natività	Nativity	Prestatore	Lender
Nativo	Native	Presunta	Presumed
Nato	Born	Prezzi d'asta	Value at public auction, sales prices
Nature morte	Still life		
Navata	Nave	Primavera	Spring
Nel, nella	In the	Probabilmente	Probably
Nero	Black	Produttore	Producer, manufacturer
Nipote	Nephew, niece, grandchild	Proporzione	Scale or proportion
Nome	Name	Prova	Proof, experiment
Nord	North	Pure	Yet, however, still, also
Notevole	Important, remarkable		
Notizia	News, report, information	Quale	Who, what, which, as
Noto	Well-known	Qualità	Quality, attribute, kind, property
Nudo	Nude, naked		
		Questo	This one, this, the latter

Italian	English	Italian	English
Raccolto	Collected	Stipo	Cabinet
Ragazzo	Boy	Stoffa	Fabric
Rame	Copper	Storia	Story, history
Re	King	Storico	Historic, historical
Recente	New, recent	Strada	Street
Regista	Director	Strumenti musicali	Musical instruments
Regina	Queen	Studio	Study
Registro	List	Stupore	Astonished, amazed
Reliquiario	Reliquary	Su	Up
Renana	Rhenish	Sud	South
Restauratore	Restorer		
Resurrezione	Resurrection	Tabernacolo	Tabernacle
Riconoscere	Identify, recognized	Tappeti	Carpets
Rimane	Remains	Tappezzeria	Hangings, tapestry
Rinascenza	Renaissance	Tarsia	Inlaid woodwork
Riposo	Rest	Tartaruga	Tortoise shell
Riposo in Egitto	Rest on Flight to Egypt	Tavola	Panel, index, list, table
La Risurrezione	Resurrection of Christ	Teatrale	Theatrical
Ritratto	Portrait	Teatro	Theater
Riveduta	Revision	Tela	Canvas
Romanico	Romanesque	Tema	Theme, subject
Romanzesco	Romantic	Tema conducente	Themesong, any recurrent theme
Rosso	Red		
		Tempio	Temple
Sacra Famiglia	Holy Family	Tentatore	Temptor
Saggio	Wise	Tentazioni	Temptations
Sala	Room, hall	Tesoro	Treasure
Saliera	Salt cellar	Tessile	Textile
Sanguinare	Bleed	Testa	Head
Sansepolcro	Holy Sepulchre	Tomba	Tomb
Sarcofago	Sarcophagus	Tomo	Volume
Scala	Stairs, musical scale	Tra	Between
Scemo	Retarded	Transetto	Transept
Sceneggiatore	Scenario writer	Triforio	Triforium
Scenico	Scenic	Trittico	Triptych
Scenografo	Scene-painter	Trono	Throne
Scoprimento	Discovered		
Scorcio	Foreshortening	Ultima Cena	Last Supper
Scudo	Coat of arms	Ultima moda	Latest fashion
Scultura	Sculpture	Umido	Wet
Scuola	School	Unico	Unique, only, one
Scultore (scultrice)	Sculptor (sculptress)	Uomo	Man
Secco	Dry		
Secolo	Century	Vecchio	Old, elder
Seduto	Seated	Vedi	See
Sempre	Ever, always	Veduta	View
Sepolcro	Tomb, sepulchre	Velo	Veil
Sepoltura	Entombment	Verde	Green
Si	Yes	Vergine	Virgin
Sigillo	Seal, mark	Vescovato	Bishop's Palace
Sinistro	Left side	Vescovo	Bishop
Soggetto	Subject	Vigne	Vineyards, vines
Solo	Only, alone	Villaggio	Village
Sommario	Summary	Vino	Wine
Sono	I am, they are	Virtù	Virtue
Sopra	On	Visitazione	Visitation
Sorella	Sister	Vista	View
Sotto	Beneath, under	Vita	Life, spirit
Speranza	Hope	Vizio	Vice
Sperone	Jamb	Volta	Arch, dome, canopy, time, direction
Spessore	Thickness		
Sposalizio	Marriage	Volto	Face
Stampa	Print		
Stanza	Room		

Multilingual Glossary of French, English, German, Italian, and Spanish Terms

The following concordance, which is alphabetized according to the French terms, is divided into three sections: (1) proper names, (2) geographic locations, and (3) terms denoting time and number, (4) animals—real and imaginary, and (5) names in Greek and Roman mythology.

Proper Names

French	English	German	Italian	Spanish
Abraham	Abraham	Abraham	Abramo	Abrahán
Agnès	Agnes	Agnes	Agnese	Inés, Inez
Alexandre	Alexander	Alexander	Alessandro	Alejandro
Ambroise	Ambrose	Ambrosius	Ambrògio	Ambrosio
André	Andrew	Andreas	Andrèa	Andrés
Anne	Anne, Ann	Anna	Anna	Ana
Antoine	Anthony	Antonius	Antonio	Antonio
Augustin	Augustine	Augustinus	Agostino	Agustín
Bacchus	Bacchus	Bacchus	Bacco	Baco
Baptiste	Baptist	Täufer	Battista	Bautista
Barthélemy	Bartholomew	Bartholomäus	Bartolomèo	Bartolomé
Benoît	Benedict	Benedikt	Benedetto	Benito
Bernard	Bernard	Bernhard	Bernardino, Bernardo	Bernardo
Caïn	Cain	Kain	Caino	Caín
Catherine	Catherine	Katharina	Caterina	Catalina
Cécile	Cecilia	Cäcilia, Caecilia	Cecilia	Cecilia
César	Caesar	Cäsar	Cesare	César
Charlemagne	Charles the Great	Karl der Grosse	Carlo Magno	Carlomagno, Carlos el grande
Christophe	Christopher	Christophorus	Cristoforo	Cristóbal
Claire	Clare	Clara	Chiara	Clara
Clément	Clement	Klemens, Clemens	Clemente	Clemente
Clovis	Clovis	Chlodwig	Clodovèo	Clodoveo, Clovis
Denis	Denis	Dionysius	Diòniga	Dionisio
Denis	Dionysus, Dionysos	Dionysius	Dionísio	Dionisio
Dorothée	Dorothy	Dorothea	Dorotea	Dorotea
Edouard	Edward	Eduard	Edoardo	Eduardo
Eléanore	Eleanor	Leonore	Eleanòra	Leonor
Elisabeth	Elizabeth	Elizabeth	Elisabetta	Isabel
Esope	Aesop	Äsop	Esopo	Esopo
Etienne	Stephen	Stephan	Stéfano	Esteban
Eustache	Eustace	Eustachius	Eustachio	Eustaquio
Eve	Eve	Eva	Èva	Eva
François	Francis	Franz	Francésco	Francisco
Françoise	Frances	Franziska	Francésca	Francisca
Frédéric	Frederick	Friedrich	Federico	Federico
Gaspar	Jaspar	Kasper	Gàspare	Gaspar
Georges	George	Georg	Giorgio	Jorge
Gérard	Gerard	Gerhard	Gerardo, Gherardo	Gerardo
Gilles	Giles	Ägidius	Egìdio	Gil
Grégoire	Gregory	Gregor	Gregòrio	Gregorio
Guillaume	William	Wilhelm	Guglielmo	Guillermo
Héléne	Helen	Helena	Elena	Elena
Henri	Henry	Heinrich	Enrico	Enrique
Hercule	Hercules	Herkules	Ercole	Hércules
Isaïe	Isaiah	Isaias	Isaia	Isaías

French	English	German	Italian	Spanish
Jacques	James	Jakob	Giacomo	Iago, Diego, Jaime
Saint Jacques le Majeur	St. James, the Greater, the Elder	hl. Jakobus der Ältere, hl. Jacobus Major	San Giacomo, Il Maggiore	Santiago el Mayor
Saint Jacques le Mineur, le Juste	St. James, the Lesser	hl. Jakobus Minor	San Giacomo, Il Minore	Santiago el Menor
Jean-Baptiste	John the Baptist	Johannes der Täufer	Giovanni Battista	Juan Bautista, El Precursor
Jean l'Evangéliste	John the Evangelist	Johannes der Evangelist	Giovanni Evangelista	Juan Evangelista
Jeanne	Jean, Joan	Johanna	Giovanna	Juana
Jéhovah	Jehovah	Jehova	Geova	Jehová
Jérôme	Jerome	Hieronymus	Geròlamo	Jerónimo
Jésus-Christ	Jesus Christ	Jesus Christus	Gesù Cristo	Jesucristo
Job	Job	Hiob	Giobbe	Job
Jonas	Jonah	Jonas	Giona	Jonás
Joseph	Joseph	Joseph	Giuseppe	José
Judas	Judas	Judas	Giuda	Judas
Judith	Judith	Judith	Giuditta	Judit
Julien	Julian	Julianus	Giuliano	Julián
Laurent	Lawrence	Laurentius	Lorenzo	Lorenzo
Lazare	Lazarus	Lazarus	Làzzaro	Lázaro
Léonard	Leonard	Leonhard	Leonardo	Leonardo
Lothaire	Luther	Luther	Lutero	Lutero
Louis	Lewis, Louis	Ludwig	Luigi, Lodovico	Luis
Louise	Louise	Luise	Luisa	Luisa
Lucie	Lucy	Lucia	Lucia	Lucía
Luc	Luke	Lukas	Luca	Lucas
Marc	Mark	Markus	Marco	Marcos
Marguerite	Margaret	Margaretha	Margherita	Margarita
Marie	Mary	Maria	Marìa	María
Marie l'Egyptienne	Mary of Egypt	Maria Ägyptiaca	Marìa Egizïaca	María de Egipto
Marie Madeleine	Mary Magdalene	Maria Magdalena	Marìa Maddaléna	María Magdalena
Mars	Mars	Mars	Marte	Marte
Marthe	Martha	Martha	Marta	Marta
Martin	Martin	Martin	Martino	Martín
Matthieu	Matthew	Matthäus, Matthias	Mattèo	Mateo
Maurice	Morris	Mauritius	Maùrizio	Mauricio
Michel	Michael	Michel	Michèle	Miguel
Moïse	Moses	Moses	Mosè	Moisés
Nicolas	Nicholas	Nikolaus	Nicòla	Nicolás
Patrice	Patrick	Patrick, Patricius	Patrizio	Patricio
Paul	Paul	Paulus	Paolo	Pablo
Philippe	Philip	Philippus	Filippo	Felipe
Pierre	Peter	Petrus	Pietro	Pedro
Praxitèle	Praxiteles	Praxiteles	Prassitele	Praxiteles
Raphaël	Raphael	Raffael	Raffaello	Rafael
Raymond	Raymond	Raimund	Raimóndo	Raimundo
Renaud	Reginald	Reginald	Rainaldo	Reginaldo
Richard	Richard	Richard	Riccardo	Ricardo
Robert	Robert	Rupert	Roberto	Roberto
Rodolphe	Ralph	Rudolf	Rodolfo	Rodolfo
Roger	Roger	Rüdiger	Ruggero	Rogelio, Rogerio
Roland	Roland	Roland	Orlando	Rolando
Sébastien	Sebastian	Sebastian	Sebastiano	Sebastián
Théodore	Theodore	Theodor	Teodoro	Teodoro
Thérèse	Theresa	Theresia	Teresa	Teresa
Thierry	Theodoric	Detrich	Teodorico	Teodorico
Thomas	Thomas	Thomas, Thoma	Tommaso	Tomás
Timothée	Timothy	Timotheus	Timòteo	Timoteo
Titien	Titian	Tizian	Tiziano	Ticiano
Ursule	Ursula	Ursula	Órsola	Úrsula
Vénus	Venus	Venus	Venere	Venus
Véronique	Veronica	Veronika	Verònica	Verónica
Victor	Victor	Viktor	Vittóre	Victor
Vincent	Vincent	Vincenz	Vincenzo	Vicente
Zénobe	Zenobius	Zenobius	Zanobi	Zenobia

Geographic Locations

The italicized word is the spelling the people of the listed city or country use; if it is different from one of the following five languages, it is placed after the English spelling. For instance, the people of Czeckoslovakia call their capital Praha; the anglicized version is Prague; they spell their country Československo. Both of these Czech terms are italicized and are placed after the English version. Some bilingual countries, such as Switzerland, have more than one official spelling. Rivers are listed under their proper names, but all of the seas are placed under *Mer* and the lakes under *lac*.

The German terms usually add *er* to the stem to denote the person of the country and *isch* for the adjective; for instance, Europäer means a person who lives in Europe, and eropäisch, the adjective European. All nouns are capitalized in German; adjectives are written in lower case. The feminine form of the French noun is often formed by adding *e* or *ne*; only the masculine form is given here. In Romance languages the proper nouns are capitalized, but the adjectives deriving from these nouns are written in lower case.

French	English	German	Italian	Spanish
Afrique (africain)	Africa (African)	Afrika (Afrikaner)	Africa (africano)	África (africano)
Aix-la-Chapelle	Aachen	*Aachen*	Aquisgrana	Aquisgrán
Allemagne (allemand)	Germany (German)	*Bundesrepublik Deutschland (Deutscher)*	Germania (tedesco)	Alemania (alemán)
Alsace (alsacien)	Alsace (Alsatian)	Elsass (Elsässer)	Alsàzia (alsaziano)	Alsacia (alsaciano)
Amérique du Nord	North America	Nordamerika	Amèrica del Nord	América del Norte
Amérique du Sud	South America	Südamerika	Amèrica del Sud	América del Sur
Angleterre	*England*	England	Inghilterra	Inglaterra
Anvers	Antwerp	*Antwerpen*	Anvèrsa	Amberes
Arcadie (de l'Arcadie)	Arcadia(n) *Arkadia*	Arkadien (arkadisch)	Arcàdia (arcade, arcadico)	Arcadia (árcade, arcadico)
Asie Mineure	Asia Minor	Kleinasien	Asia Minóre	Asia Menor
Athènes	Athens *Athênai*	Athen	Atène	Atenas
Australie	*Australia*	Australien	Australia	Australia
Autriche	Austria	*Österreich*	Austria	Austria
Babylonie	Babylonia	Babylonien	Babilonese	Babilonia
Bâle	Basle	*Basel*	Basileà	Basilea
Basque	Basque	Baske	Basco	Vasco
Bavière (bavarois)	Bavaria (Bavarian)	*Bayern (Bayer)*	Baviera (bavarese)	Baviera (bávaro)
Belgique	Belgium	*Belgien*	Belgio	Bélgica
Berlin	Berlin	*Berlin*	Berlino	Berlín
Berne	Berne	*Bern*	Bèrna	Berna
Bohême (bohémien)	Bohemia(n) *Čechy*	Böhmen (böhmisch)	Boèmia (boemo)	Bohemía (bohemio, bohemo)
Bourgogne (bourguignon)	Burgundy (Burgundian)	Burgund (Burgunder)	Borgógna (borgognóne)	Borgoña (borgoñón)
Bretagne	Brittany	Bretagne	Bretagna	Bretaña
Bruges	Bruges	*Brügge*	Bruges	Brujas
Bruxelles	Brussels	*Brüssel*	Brusselle	Bruselas
Bulgarie (bulgare)	Bulgaria(n) *Bălgarija*	Bulgare (bulgarisch)	Bulgarià (bulgaro)	Bulgaria (búlgaro)
Caire	Cairo *Misr al-Qàhira*	Kario	Il Cairo	el Cairó
Calédonie	Caledonia, *Scotland*	Kaledonien, Schottland	Scozia	Caledonia, Escočia
Californie	*California*	Kalifornien	Califòrnia	California
Canada	*Canada*	Kanada	Cànada	el Canadá
Carthage	Carthage	Karthago	Cartàgine	Cartago
Castille	Castile	Kastilien	Castìglia	*Castilla*
Celtes	Celts	Kelten	Cèlti	Celtas
Chine (de Chine, chinois)	China (Chinese) *Chung-hua Jen-min Kung-ho Kuo*	China (Chinese, chinesisch)	Cina (cinese)	China (chino)
Chypre (cypriote)	Cyprus (Cypriot) *Kypros*	Zypern (Zyprer)	Cipro (cipriota)	Chipre (chipriota)
Cologne	Cologne	*Köln*	Colonia	Colonia
Copenhague	Copenhagen *Kφbenhavn*	Kopenhagen	Copenaghen	Copenhague
Copte (cophte)	Copt (Coptic)	Kopte (koptisch)	Copti (copta)	Copto (copto)
Corée	Korea *Chôsen*	Korea	Coreà	Corea
Corinthe (corinthien)	Corinth (ian) *Korinthos, Kôritho*	Korinth (korinthisch)	Corinto (corinzio, corintio)	Corinto (corintio)
Cracovie	Cracow *Kraków*	Krakau	Cracòvia	Cracovia
Croatie (croate)	Croatia(n) *Hrvatska*	Kroatien (Kroat)	Croàzia (croato)	Croacia (croata)
Cuba	Cuba	Kuba	Cuba	*Cuba*
Cyclades	Cyclades *Kiklàdhes*	Zykladen	Cicladi	Cíclades
Danemark	Denmark *Danmark*	Dänemark	Danimarca	Dinamarca
Le Danube	Danube River	*Donau*	Danùbio	Danubio
Ecosse (écossais)	*Scotland* (Scot)	Schottland (Schotte)	Scozia (scozzese, scoto)	Escocia (escocés)
Egypte	Egypt *Misr, Masr*	Ägypten	Egitto	Egipto

French	English	German	Italian	Spanish
Espagne	Spain	Spanien	Spagna	*España*
Etats-Unis	*United States*	Vereinigte Staaten	Stati Uniti	Estados Unidos
Ethiopie	Ethiopa *Ityopya*	Äthiopien	Ethiòpia	Etiopía
L'Etna	Etna	Ätna	*Etna*	Ètna
Etrurie (étrusque)	Etruria (Etruscan)	Etrurien (etruskisch)	*Etruschi* (etrusco)	Ètruria (etrusco)
L'Euphrate	Euphrates River *Firāt, al-Furāt*	Euphrat	Eufrate	Eufrates
Europe (européen)	Europe (European)	Europa (Europäer, europäisch)	Europa (europeo)	Europa (europeo)
Extrême-Orient	Far East	Ostasien, Ferne Osten	Asia orientale	Extremo Oriente
Flandre (flamand)	Flanders (Flemish) *Vlaanderen*	Flandern (flämisch)	Le Fiandre (fiamminga)	Flandes (flamenco)
Florence	Florence	Florenz	*Firenze*	Florencia
Fôret-Noire	Black Forest	*Schwarzwald*	Selva Néra	Selva Negra
France (français)	France (French)	Frankreich (französisch)	*Frància* (francese)	Francia (francés)
Galilée	Galilee	Galiläa	Galilèa	Galilea
Gand	Ghent	*Gent*	Gand	Gante
Gascogne	Gascony	Gaskogne	Guascògna	Gascuña
Gaule	Gaul	Gallien	Gallia	Galia
Gênes	Genoa	Genua	*Genova*	Génova
Genève	Geneva	*Genf*	Ginevra	Ginebra
Golfe Persique	Persian Gulf	Persischer Golf	Golfo Persico	Golfo Pérsico
Goth	Goth	Gote	Goto	Godo
La Grande-Bretagne	*Great Britain*	Grossbritannien	La Gran Bretagna	Gran Bretaña
Grèce (de la Grèce, grecque)	Greece (Greek) *Hellas, Ellàdha*	Griechenland (griechisch)	Grècia (greca)	Grecia (griego)
Hambourg	Hamburg	*Hamburg*	Amburgo	Hamburgo
La Haye	The Hague *Den Haag*	Der Haag	L'Aia	La Haya
Hollande	Holland	Holland	Olanda	Holanda
Hongrie	Hungary *Magyar Népköztársaság*	Ungarn	Ungheria	Hungría
Ibérien	Iberian	Iberer	Iberico	Ibero, Ibérico
Indochine	Indo-China	Hinterindien	Indocina	Indochina
Ionie (ionien)	Ionia (Ionian) *Iònia*	Ionien (ionisch)	Iònia (iònico)	Jonia (jónico, jonio)
Irlande (irlandais)	Ireland (Irish) *Eire*	Irland (irisch)	Irlanda (irlandese)	Irlanda (irlandés)
Italie	Italy	Italien	*Itàlia*	Italia
Japon	Japan *Nippon*	Japan	Giappóne	el Japón
Jérusalem	Jerusalem *Al-Quds, Yerūshālayim*	Jerusalem	Gerusalèmme	Jerusalén
La Judée	Judea *Al-Yahūdiyya*	Judäa	Giudèa	Judea
Le lac de Luzerne	Lake Lucerne	Luzerner See, *Vierwaldstätter See*	Lago di Lucerna, Lago dei Quattro Cantoni	Lago de los cuatro cantones
Le lac Léman	Lake Geneva	*Genfer See*	Lago Lemano	Lago Ginebra
Latin	Latin (person)	Lateiner	Latino	Latino
Lituanie	Lithuania *Lietuva*	Litauen	Lituania	Lituania
Lombardie	Lombardy	Lombardei	*Lombardìa*	Lombardía
Londres	*London*	London	Lóndra	Londres
Lorraine	Lorraine	Lothringen	Lorèna	Lorena
Luzerne	Lucerne	*Luzern*	Lucèrna	Lucerna
Le Maroc	Morocco *Al-Maghrib al-Aqsā*	Marokko	Maròcco	Marruecos
La Méditerranée	Mediterranean Sea	Mittelländisches Meer, Mittelmeer	Il mare Mediterraneo	Mar Mediterráneo
La Mer Adriatique	Adriatic Sea	Adria, Adriatische Meer	Adriatico	Mar Adriático
La Mer des Antilles	Caribbean Sea	Karaibishe Meer	Mare dei Caraibi	Mar Caribe
La Mer Baltique	Baltic Sea	Ostsee	Mare Bàltico	Mar Báltico
La Mer Caspienne	Caspian Sea	Kaspisee, Kaspisches Meer	Mare Càspio	Mar Caspio
La Mer Egée	Aegean Sea	Ägaische Meer	Mare Egèo	Mar Egeo
La Mer Morte	Dead Sea	Totes Meer	Mar Morto	Mar Muerto
La Mer du Nord	North Sea	Nordsee	Mare del Nord	Mar del Norte
La Mer Rouge	Red Sea	Rotes Meer	Mare Rosso	Mar Rojo
Meuse	Meuse River	*Maas*	Fiume Mosa	Río Mosa
Mexique	Mexico	Mexiko	Mèssico	*Méjico, México*
Milan (milanais)	Milan (Milanese)	Mailand (mailändisch)	*Milano* (milanese)	Milán (milanés)
Montagnes Rocheuses	*Rocky Mountains*	Felsengebirge	Montagne Rocciose	Montañas Rocosas

French	English	German	Italian	Spanish
Moravie	Moravia *Morava*	Mähren	Moràvia	Moravia
Moscou	Moscow *Moskva*	Moskau	Mósca	Moscú
Munich	Munich	München	Monaco	Munich
Mycènes	Mycenae *Mykênai*	Mykenä, Mykene	Micene	Micenas
Naples	Naples	Neapel	*Napoli*	Nápoles
Les Nations Unies	United Nations	Vereinte Nationen	Nazioni Unite	Naciones Unidas
Nice	Nice	Nizza	Nizza	Niza
Le Nil	Nile River *An-Nîl*	Nil	Nilo	Nilo
Normandie	Normandy	Normandie	Normandia	Normandía
Norvège	Norway *Norge*	Norwegen	Norvègia	Noruega
Nouvelle-Zélande	*New Zealand*	Neuseeland	Nuova Zelanda	Nueva Zelondïa
Nuremberg	Nuremberg	*Nürnberg*	Norimberga	Nuremberg
L'Océan Pacifique	Pacific Ocean	Grosser Ozean, Stiller Ozean	Il Pacifico	Océano Pacifico
Palatinat	Palatinate	*Pfalz*	Palatinato	Palatinado
Palestine	*Palestine*	Palästina	Palestina	Palestina
Paris (parisien)	Paris (Parisian)	Paris (Pariser)	Parigi (di Parigi, parigino)	París (parisiense)
Les Pays-Bas	Low Countries (Holland, Belgium, Luxembourg)	Benelux	Benelùx	Países Bajos
Pays de Galles	*Wales*	Wales	Galles	Gales, País de Gales
Perse (de Perse, persan)	Persia (Persian) *Iran*	Persien (Perser, persisch)	Pèrsia (persiano)	Persia (persa)
péruvien, de Pérou	Peruvian	Peruaner	peruviano	*peruano*
phénicien	Phoenician	Phöniker	fenicio	fenicio, fenicia
Pologne	Poland *Polska*	Polen	Polònia	Polonia
Polynésie	Polynesia	Polynesien	Polinesia	Polinesia
Portugal	*Portugal*	Portugal	Portogallo	Portugal
Prague	Prague *Praha*	Prag	Praga	Praga
Proche-Orient	Near East	Nahe Osten	Il Levante	Próximo Oriente
Prusse	Prussia	*Preussen*	Prùssia	Prusia
Pyrénées	Pyrenees	Pyrenäen	Pirenei	Pirineos
Reims	Rheims	Reims	Reims	Reims
Rhin	Rhine	Rhein	Reno	Rin
Rhénanie	Rhineland	*Rheinland*	Renania	Renania
romain	Roman	römisch	romano	romano
Rome	Rome	Rom	*Roma*	Roma
Royaume-Uni	*United Kingdom*	Grossebritannien und Nordirland	Regno-Unito	Reino Unido
Russie	Russia	Russland	Rùssia	Rusia
Saltzbourg	Salzburg	*Salzburg*	Salisburgo	Salzburgo
Saxe	Saxony	*Sachsen*	Sassonia	Sajonia
Scandinavie	Scandinavia	Skandinavien	Scandinavia	Escandinavia
Sienne	Siena	Siena	*Siena*	Siena
Slave	Slav	Slawe	Slavo	Eslavo
Suède	Sweden *Sverige*	Schweden	Svèzia	Suecia
Suisse	Switzerland	*Schweiz*	Svìzzera	Suiza
La Tamise	*Thames River*	Themse	Tamigi	Támesis
Terre-Neuve	*Newfoundland*	Neufundland	Terranova	Terranova
Thèbes	Thebes	Theben	Tebe	Tebas
Thrace	Thrace *Thrakê*	Thrazien	Tracia	Tracia
Turin	Turin	Turin	*Torino*	Turín
Toscane	Tuscany	Toskaner	*Toscana*	Toscana
Tchécoslovaquie	Czechoslovakia *Ceskoslovensko*	Tschechoslowakei	Cecoslovacchia	Checoslovaquia
Turquie	Turkey *Türkiye Cumhuriyeti*	Türkei	Turchia	Turquía
Tyrol	Tyrol	*Tirol*	Tirolo	El Tirol
Varsovie	Warsaw *Warszawa*	Warschau	Varsavia	Varsovia
Le Vatican	Vatican	Vatikan	Vaticano	*Vaticano*
Venise (vénitien)	Venice (Venetian)	Venedig (venedisch)	*Venezia* (veneziano)	Venecia (veneciano)
Vienne	Vienna	*Wien*	Vienna	Viena
La Vistule	Vistula River	Weichsel	Vistola	Vístula
Zurich	Zurich	*Zürich*	Zurigo	Zurich

Terms Denoting Time

French	English	German	Italian	Spanish
Avant Jesus-Christ, (Avant J-C)	Before Christ, (B.C.)	vor Christi (v.C.)	avanti Christo (a.C.)	Antes de Jesucristo, Antes de Cristo, (A.C.)
Après Jesus-Christ (Après J-C)	Anno Domini, (A.D.)	nach Christi (n.C.)	L'anno di Grazia	Después de Cristo, (D.C.)
siècle	century	Jahrhundert	sècolo	siglo
an, année	year	Jahr	anno	año
mois	month	Monat	mese	mes
semaine	week	Woche	settimana	semana
jour	day	Tag	giorno	día
heure	hour	Stunde	ora	hora
temps	time	Zeit	tempo	tiempo, hora
matin	morning	Morgen	mattina	mañana
après-midi	afternoon	Nachmittag	dopopranzo	tarde
soir	night	Nacht	notte	noche
janvier	January	Januar	gennaio	enero
février	February	Februar	febbraio	febrero
mars	March	März	marzo	marzo
avril	April	April	aprile	abril
mai	May	Mai	maggio	mayo
juin	June	Juni	giugno	junio
juillet	July	Juli	luglio	julio
août	August	August	agosto	agosto
septembre	September	September	settembre	septiembre
octobre	October	Oktober	ottobre	octubre
novembre	November	November	novembre	noviembre
décembre	December	Dezember	dicembre	diciembre
lundi	Monday	Montag	lunedì	lunes
mardi	Tuesday	Dienstag	martedì	martes
mercredi	Wednesday	Mittwoch	mercoledì	miércoles
jeudi	Thursday	Donnerstag	giovedì	jueves
vendredi	Friday	Freitag	venerdì	viernes
samedi	Saturday	Samstag, Sonnabend	sabato	sábado
dimanche	Sunday	Sonntag	domenica	domingo

Numbers

French	English	German	Italian	Spanish
premier, première	first	erst-	primo primario	primero
deuxième	second	zweit-	secondo	segundo
troisième	third	dritt-	terzo	tercero
quatrième	fourth	viert-	quarto	cuarto
cinquième	fifth	fünft-	quinto	quinto
un, une	one	eins	uno, una	uno, una
deux	two	zwei	due	dos
trois	three	drei	tre	tres
quatre	four	vier	quattro	cuatro
cinq	five	fünf	cinque	cinco
six	six	sechs	sei	seis
sept	seven	sieben	sette	siete
huit	eight	acht	otto	ocho
neuf	nine	neun	nove	nueve
dix	ten	zehn	dieci	diez
onze	eleven	elf	undici	once
douze	twelve	zwölf	dodici	doce
treize	thirteen	dreizehn	tredici	trece
quatorze	fourteen	vierzehn	quattordici	catorce
quinze	fifteen	fünfzehn	quindici	quince
seize	sixteen	sechzehn	sedici	dieciséis
dix-sept	seventeen	siebzehn	diciassètte	diecisiete
dix-huit	eighteen	achtzehn	diciotto	dieciocho
dix-neuf	nineteen	neunzehn	diciannove	diecinueve
vingt	twenty	zwanzig	venti	veinte
vingt-cinq	twenty-five	fünfundzwanzig	venticinque	veinticinco
trente	thirty	dreissig	trènta	treinta
quarante	forty	vierzig	quaranta	cuarenta
cinquante	fifty	fünfzig	cinquanta	cincuenta
soixante	sixty	sechzig	sessanta	sesenta
soixante-dix	seventy	siebzig	settanta	setenta
quatre-vingts	eighty	achtzig	ottanta	ochenta
quatre-vingt-dix	ninety	neunzig	novanta	noventa
cent	one hundred	hundert	cento	cien, ciento
mil, mille	thousand	tausend	mille	mil

Animals: Real and Imaginary

French	English	German	Italian	Spanish
abeille	bee	Biene	ape	abeja
agneau	lamb	Lamm	agnello	cordero
aigle	eagle	Adler, Aar	aquila	áquila
âne	ass, donkey	Esel	asino	asno, burro
animal	animal	Tier	animale	animal
araignée	spider	Spinne	ragno	entom
aspic	asp	Aspis	aspide	aspid
autruche, autrice	ostrich	Strauss	struzzo	avestruz
baleine	whale	Wal	balena	ballena
basilic	basilisk	Basilisk	basilisco	basilisco
belette, mostelle	weasel	Wiesel	donnola	comadreja
bélier	ram, male sheep	Widder	montone	morueco
boeuf	ox, beef	Ochse	bue	buey
caille	quail	Wachtel	quaglia	codorniz
canard	duck	Ente	anitra	anade
caster	beaver	Biber	castoro	castor
cerf	deer, stag, hart	Hirsch	cervo	ciervo
chameau	camel	Kamel	cammello	camello
chardonneret	goldfinch	Stieglitz	cardellino	jilguero
chat	cat	Katze	galto	gato
chauve-souris	bat	Fledermaus	pipistrello	murciélago
cheval	horse	Pferd	cavallo	caballo
chèvre	goat	Ziege	capra	cabra
chien	dog	Hund	cane	perro
chimère	chimera	Chimäre	chimera	quimera
cigogne	stork	Storch	cicogna	cigueña
cochon	pig	Schwein	porco	cochino
colombe	dove	Taube	colomba	palomba
coq	cock	Hahn	gallo	gallo
corbeau	raven	Rabe	corvo	cuervo
corneille	crow	Krähe	corvo	ornit
crapaud	toad	Kröte	botta	sapo
crocodile	crocodile	Krokodil	coccodrillo	cocodrilo
cygne	swan	Schwan	cigno	cisne
dauphin	dolphin	Delphin	delfino	deflin
dragon	dragon	Drache	drago, dragone	dragón
écureuil	squirrel	Eichhörnchen	scoiattolo	ardilla
éléphant	elephant	Elefant	elefante	elefante
faucon	hawk, falcon	Falke	falco, falcone	halcón
fourmi	ant	Ameise	formica	hormiga
grenouille	frog	Frosch	rana	rana
griffon	griffin	Greif	grifo	grifo
grue	crane	Kranich	gru	ornit
hérisson	hedgehog	Igel	riccio	erizo
hermine	ermine	Hermelin	ermellino	armiño
héron	heron	Reiher	airone	garza
hibou	owl	Eule	gufo	lechuza
hirondelle	swallow	Schwalbe	rondine	golondrina
hyène	hyena	Hyäne	iena	hiena
homard	lobster	Hummer	aragosta	langosta
lapin	rabbit	Kaninchen	coniglio	conejo
lézard	lizard	Eidechse	lucertola	lagarto
licorne	unicorn	Einhorn	unicorno	unicornio
lièvre	hare	Hase	lepre	liebre
lion	lion	Löwe	leone	léon
loup	wolf	Wolf	lupo	lobo
merle	blackbird	Amsel	merlo	mirlo
mouton	sheep	Schaf	pecora	carnero
oie	goose	Gans	oca	ganso
oiseau	bird	Vogel	ucello	ave
oiseau	fowl	Haushuhn	pollo	ave
ours	bear	Bär	orso	oso
paon	peacock	Pfau	pavone	pavón
papillon	butterfly	Schmetterling	farfalla	mariposa
passereau	sparrow	Sperling	passero	gorrión
pelican	pelican	Pelikan	Pellicano	pelicano
perdrix	partridge	Rebhuhn	pernice	perdiz
perroquet	parrot	Papagei	pappagallo	papagayo
phénix	phoenix	Phönix	fenice	fénix
pigeon	dove, pigeon	Taube	piccione	pichón
poisson	fish	Fisch	pesce	pescado

French	English	German	Italian	Spanish
poule	hen	Henne	gallina	gallina
renard	fox	Fuchs	volpe	zorra
rossignol	nightengale	Nachtigall	usignuolo	ruiseñor
sanglier	wild boar	Wildschwein	cinghiale	jabali
sauterelle	grasshopper	Heuschrecke	cavalletta	langosta
scie de mer	sawfish	Sägefisch	pesce sega	pescado sierra
serpent	snake	Schlange	serpente	serpiente
singe	ape, monkey	Affe	scimmia	mono
sirène	siren	Sirene	sirena	sirena
souris	mouse	Maus	topo	ratón
taupe	mole	Maulwurf	talpa	topo
taureau	bull	Bulle, Stier	toro	toro
tortue	tortoise	Schildkröte	testuggine, tartaruga	tortuga
tortue de mer	turtle	Schildkröte	tartaruga, testuggine	tortuga
tourterelle	turtledove	Turteltaube	tortora	tórtola
vautour	vulture	Geier	avvoltoio	buitre
veau	calf	Kalb	vitello	becerro
verrat	boar, male swine	Eber	verro	verraco

Names in Greek and Roman Mythology

For slightly different spellings of Bacchus, Dionysus, Hercules, and Venus, see listings under "Proper Names."

Greek	Roman
Aphrodite	Venus, Cythera
Ares	Mars
Artemis	Diana, Cynthia
Athena, Athene, Pallas Athena	Minerva
Demeter	Ceres
Dionysus	Bacchus, Dionysos
Eos	Aurora
Eros	Cupid, Amor
Hades	Pluto
Hephaestus	Vulcan
Hera	Juno
Heracles	Herakles, Hercules, Alcides
Hermes	Mercury
Odysseus	Ulysses
Poseidon	Neptune
Zeus	Jupiter, Jove

Terminology

This glossary, which is especially concerned with terminology used in catalogues, explains the following abbreviations and terms: (1) attribution, (2) time, (3) shape and dimension, (4) other words used in catalogues and bibliographies, (5) monetary abbreviations, and (6) the books of the Catholic and Protestant Bibles and the *Apocrypha*.

Terms of Attribution

The artist's name is usually given whenever there is conclusive evidence that the artist was the creator of the piece or whenever there has been many years of substantial scholarly agreement as to the attribution. If any doubt still exists as to whether or not the artist was the creator of the work, a question mark in parentheses or the words *Ascribed to* or *Attributed to* are often added. In most cases, *Studio of* or *Shop of* precedes the artist's name in cases where the artist had a large active *bottega* or studio. The terms signify that the work of art was produced in the artist's studio and that although the degree of the artist's involvement has probably not been determined, the artist's guidance can usually be assumed.

The following terms are used in descending order to suggest the degree of closeness to the style of a particular artist: *Close Follower of, Follower of, Imitator of,* and *Style of.* Whereas the first term may denote a degree of closeness or involvement with the artist, the last term suggests only a vague relationship of one work of art to another. The term *After* usually means a copy of a work of art. Moreover, the copy, which may or may not have variations from the original piece, can be made at any date after the time of the original. The copy date could be a couple of years or several centuries later.

Not all catalogues list attributions the same way. In most catalogues a dubious work of art will be cited under the name of the artist to whom it is attributed together with a statement that the work is an attributed one. Yet, in some catalogues an attributed work may be listed under *anonymous* with a notation that some scholars credit the work to a certain artist. Sometimes the name of the person who attributed the work of art to a particular artist is provided. The date the attribution was made is seldom included, although this latter information could be of the utmost importance, especially if the date of attribution was before a work of art was cleaned or underwent x-ray or infrared study.

Often used with the name of a town or district, the terms *School* and *School of* are sometimes used to distinguish a group of artists who worked in a particular place and used a specific style. For instance, the Utrecht School is the name given to a group of painters who lived in Utrecht, Holland, during the seventeenth century and who were greatly influenced by the realist style of the Italian painter Caravaggio. When the term School of is used with the name of an artist—as for instance, the School of Cellini—the indication is that the artist did not have any involvement with the object, but that the artist's work influenced this particular piece.

Sometimes the artist's name is followed by the initials of the artist's society. Sir Joshua Reynolds, R.A., indicates that Reynolds was a member of the English Royal Academy. A.R.A. stands for Associate member of the Royal Academy; P.R.A. refers to a past president of the organization. R.S.A. signifies a member of the Royal Scottish Academy, whereas N.A. denotes the National Academy of Design in the United States.

Terms of Time

The abbreviations *B.C.* and *A.D.* are not universal. Sometimes *B.C.E.* for *Before Common Era* and *C.E.* indicating *Common Era* are used. The French terms are *Avant Jesus-Christ* and *Après Jesus-Christ;* the German, *vor Christi* and *nach Christi.* The multilingual glossary of Appendix D lists the French, English, German, Italian and Spanish words for periods of time, the months of the year, and the basic cardinal and ordinal numbers.

In designating the years during which some event occurred, the placement of a *c.* or a *ca.,* for *circa,* denotes that the episode took place around that

time. If there is a discrepancy in dates, usually both years, or a range of time, will be given. For instance, Bernard Strigel (1460/61–1528) indicates that Strigel was born either in 1460 or 1461 and died in 1528. Sometimes only the periods during which an artist was producing art are known. These are signified by the term *active,* as for example, Claus Sluter, active 1380–1406.

Terms of Shape and Dimension

Paintings and their frames can be made in various shapes and dimensions. A *tondo* is a circular or round shape. A *diptych* is composed of two panels hinged together along one side which can be opened and closed like a book. This gives two outside and two inside surfaces. For instance, during the fifteenth century, small personal diptychs owned by the aristocracy often had a portrait of a person's patron saint on the top panel, related subjects depicted on the two inside sections, and the coat of arms of the owner on the back of the piece. A *triptych* has three panels usually hinged in order that the two outside pieces—which are each half the width of the center section—fold and cover the third wider panel. A *polyptych* has numerous panels that are hinged so that they can be opened and closed to show various scenes. The terms—diptych, triptych, and polyptych—are sometimes used for works of art that are either stationary parts of an altarpiece or separate related pieces.

A *retable* is a large altarpiece composed of numerous panels. For instance, *The Retable of St. George* in the Victoria and Albert Museum of London measures twenty-two feet by sixteen feet and contains more than fifty small paintings of various sizes. A *predella,* which consists of the small pictures at the bottom of a large altarpiece, usually has five or six panels. The subjects of these works often refer to the larger figures depicted in the main part of the altarpiece. Sometimes the panels of retables and *predelle*—the plural of *predella*—are separated and appear individually in different museums.

In a catalogue entry the dimensions of a piece are always reported. Most measurements, which are written with the height of the object preceding the width, are usually provided for the area of the actual painting. Furniture dimensions are given for height, width, and depth. Sometimes the height of the arm is provided for arm chairs. Bowls and cups can be measured by the height and the diameter of the top, and sometimes the base, of the piece. The diameter of plates and saucers is all that is usually recorded.

The part of the metric system that is most important to the measurement of art objects is composed of the meter, which is slightly over 39 1/3 inches. A tenth part of a *meter* is called a *decimeter;* a hundredth part, a *centimeter;* and a thousandth part, a *millimeter.* These are abbreviated m., dm., cm., and mm. Since the equivalents in the United States measuring system can only be stated in approximate figures, the actual numbers derived may vary somewhat depending upon at what point the number is rounded off. A brief conversion table, based upon the United States system of measurements, follows:

1 meter = 39.37 inches
1 meter = 3.281 feet
1 decimeter = 3.937 inches
1 centimeter = 0.3937 inch
1 millimeter = 0.03937 inch
1 foot = 30.48 centimeters
1 foot = .305 meters
1 inch = 2.54 centimeters
1 liquid quart = 0.946 liter
1 liter = 1.0567 liquid quarts
1 dry quart = 1.101 liters
1 liter = 0.908 dry quart
1 pound = 0.454 kilogram
1 kilogram = 2.205 pounds

The dimensions of a work of art can be used in scholarly detective work. For instance, in a German inventory list, a painting may be recorded: "Selbstbildnis, 1889, 40.5 × 32.5 cm." A painting by the same artist is described in an American auction catalogue: "Self-portrait, 1889, 16 × 13 in." Are the two citations for the same work of art? Since the titles and dates are identical, the question is whether or not 40.5 centimeters is the same as 16 inches and if 32.5 centimeters equals 13 inches?

The following mathematical computation shows the comparison.

Since 1 cm. = .3937 in.
 40.5 cm. = .3937 x 40.5
 = 15.94485
 = 15.945 (rounded off to the nearest thousandth)
 = 15.95 (rounded off to the nearest hundredth)
 = 16.0 in. (rounded off to the nearest tenth or the nearest whole number)

Since 1 cm. = .3937 in.

 32.5 cm. = .3937 x 32.5

 = 12.79525

 = 12.795 (rounded off to the nearest
thousandth)

 = 12.80 (rounded off to the nearest
hundredth or tenth)

 = 13.0 in. (rounded off to the nearest
whole number)

If the measurements were converted from inches into centimeters, the mathematics would be as follows:

 1″ = 2.54 cm.

 16″ = 2.54 x 16 = 40.64 cm.

 1″ = 2.54 cm.

 13″ = 2.54 x 13 = 33.02 cm.

The German catalogue gives the same measurements, even though in centimeters. The dimensions quoted in the U.S. system are probably also of the same painting. Even though 40.5 cm. equaled 16 in. in the conversion from the metric to the U.S. system, and even though a reversal of the procedure produced 16 in. equaling 40.64 cm.; this discrepancy was due to the rounding off of the figures. The same is true for the variance in the other equation—32.5 cm. = 13 in. and 13 in. = 33.02 cm. The conversion numbers will always differ somewhat due to the fact that a meter is slightly over 39 1/3 inches.

Other Terms

Accession numbers are the identifying marks placed on an object in order that the registrar can keep track of the numerous pieces in the museum's collections. Often the numbers indicate the year the work was acquired. For instance, 47.78 means the seventy-eighth work brought into the museum during 1947. The number 1972.47.5 would mean that the object was number five in lot forty-seven which entered the institution in 1972. Some works of art have numerous marks: (a) accession or acquisition numbers that were assigned when the object first entered the collection as well as each time a new registration method was devised and (b) catalogue numbers that sometimes vary in older institutions depending upon which edition of the catalogue is being discussed.

Casting Marks: the German word, *Guss.,* meaning casting or founding, and the French term, *fondeur,* for founder or caster, are often placed on the piece followed by the name of the company that cast the work.

Edition Size and Number —both for bronze castings and prints—are signified by the juxtaposition of two numbers or a number and a letter: 3/4 means the third casting or print out of four; 5/K, the fifth of eleven made, since *K* is the eleventh letter in the alphabet. On prints, *AP* refers to the artist's proof, of which any number can exist.

et al is an abbreviation for the Latin term *et alii,* which means *and others.* If there are more than three authors of a book, sometimes only the first author is listed followed by *et al.*

f. (or *ff.*) represents *the following page (or pages).*

Fecit or Me Fecit, Latin for *he or she made it* is sometimes used with a signature.

Maquette is a small three-dimensional model for either a sculpture or an architectural monument or building. A French term, it can also mean a rough sketch for a painting.

n.d. indicates that no date was available for the reference.

n.p. relates that the publication data was unavailable.

ns. means *new series,* signifying that a serial began a new numbering system.

Pentimento, singular for *pentimenti,* an Italian word meaning to rethink, is the revealing of an earlier form underneath the painting which the artist had painted. Through the course of time the top layer becomes more transparent to disclose the alterations which had been made earlier.

sic is a Latin term meaning *so* or *thus;* it is often written after words or phrases which either appear strange or may be incorrect in spelling or usage but which are quoted verbatim; *sic* is usually enclosed in parentheses or square brackets. For example: "He used a bright vermillion [*sic*]." In this quote the [*sic*] tells readers that the researcher knew the correct spelling of vermilion.

Sides of a piece: recto indicates the right-hand page of a manuscript; *verso,* the opposite side. In a painting or drawing, *recto* means the front or correct viewing side; *verso,* the reverse.

Surmoulage is the process of duplicating a bronze work by making a mould of an existing piece and using this cast, instead of the original one which the artist either made or supervised, to produce an additional work of art.

S.v. stands for the Latin phrase, *sub verbo,* meaning under the heading. It is often used in a bibliographical form to indicatethe name under which the artist will be located. For instance, Charles-Edouard Jeanneret-Gris, the Swiss architect who was known as Le Corbusier, could be located under several names. For some bibliographical forms the entry would be

McGraw-Hill Dictionary of Art, 1969 ed. S.v. "Le Corbusier," by Theodore M. Brown.

Vte. is the abbreviation for *Vente* which means sale or selling. *Vte. X* or *Vente X* indicates an anonymous sale or one where the auction was not limited to one individual collection being sold.

Monetary Abbreviations

In many references, the following monetary abbreviations are used.

England

In the English monetary system, the money is written in this manner: 4/6/3 which represents four pounds, six shillings, and three pence. A pound, £, equals 20 shillings, which is abbreviated s. A guinea, Gns., represents 21 shillings. Before February 1971 when the British government went on the metric system, there were 12 pence to a shilling; now there are five.

France

A French franc can be abbreviated fr., F.F., or F.Fr. Bénézit uses fr. for the franc of pre-1959 and F. for the money after that period when the valuation was changed.

Germany

D.M. stands for the German Deutsches Mark. Prior to 1848, the currency was called a reichsmark.

Italy

An Italian lira is usually L. or I.L.

Belgium

A Belgium franc is F.B. or B.FR.

Denmark

A Danish krone is Dkr. or D.KR.

Holland

A Dutch florin is Fl. or D.Fl.

Switzerland

A Swiss franc is Sfr. or S.FR.

Books of the Old and New Testament and the *Apocrypha:* A Comparison of Catholic and Protestant Bibles

When St. Jerome (c. 340–420 AD) translated the Bible into Latin, the version called the Vulgate, he based some of his work on the *Septuagint,* an early Greek translation of Hebrew writings which contained 14 pieces of literature that were later not incorporated into the official Hebrew Scriptures. In the 16th-century when he translated the Bible into German, Martin Luther decided that only the writings contained in the canonical Hebrew Scriptures should be included. In Luther's Bible, the 14 literary pieces, called the *Apocrypha,* meaning doubtful, were placed between the Old and the New Testaments. The 17th-century English translation, entitled the King James Version of the Bible, retained this format. Later to save printing costs, the *Apocrypha* was often deleted. In most Protestant Bibles, it is missing, but the *Apocrypha* is still incorporated into the text of the Roman Catholic Bible.

The proper names and chapter titles of the approved texts of the Catholic and Protestant Bibles are not always the same. Moreover, deviations in chapter and verse numbers exist within different translations; for example, the last verse of one chapter may be the first verse of the next chapter or verses may be combined so that some chapters of various editions have fewer verses. Even within a specific translation, different printings may include text not found in others. The same is true for the *Apocrypha.* Some of these variations are cited below.

Old Testament

Catholic- Douay-Rheims Version	Protestant- Revised Standard Version	Notes
Genesis	Genesis	First five books also referred to as the Five Books of Moses or the Pentateuch. The first six books called the Hexateuch.
Exodus	Exodus	
Leviticus	Leviticus	
Numbers	Numbers	
Deuteronomy	Deuteronomy	
Josue	Joshua	
Judges	Judges	
Ruth	Ruth	
1 Kings	1 Samuel	
2 Kings	2 Samuel	
3 Kings	1 Kings	
4 Kings	2 Kings	
1 Paralipomenon	1 Chronicles	
2 Paralipomenon	2 Chronicles	
1 Esdras	Ezra	Some *Apocrypha* include verses not found in either approved text
2 Esdras, alias Nehemias	Nehemiah	
Tobias		Tobit (*Apocrypha*)
Judith		Judith (*Apocrypha*), story of Judith & Holofernes
Esther	Esther, less Apocrypha text	Verses 10:4–16:24 (*Apocrypha*)
Job	Job	
Psalms	Psalms	Numbers of the Psalms differ beginning with 9; (ie: Protestant Psalm 23 is Catholic Psalm 22); each contains 150 psalms
Proverbs	Proverbs	
Ecclesiastes	Ecclesiastes	
Canticle of Canticles	Song of Solomon	also called Song of Songs
Wisdom		Wisdom of Solomon (*Apocrypha*)
Ecclesiasticus		Ecclesiasticus or Wisdom of Jesus Son of Sirach (*Apocrypha*)
Isaias	Isaiah	
Jeremias	Jeremiah	
Lamentations	Lamentations	also called Lamentations of Jeremias/Jeremiah
Baruch		Baruch (*Apocrypha*)
Ezechiel		Ezekiel
Daniel	Daniel	*Apocrypha:* Song of Three Children (Dan. 3:24–90), Story of Susanna & Elders (Dan. 13), and Story of Bel & the Dragon (Dan. 14), which includes the Story of Habacuc.
Osee	Hosea	
Joel	Joel	
Amos	Amos	
Abdias	Obadiah	
Jonas	Jonah	
Micheas	Micah	
Nahum	Nahum	
Habacuc	Habakkuk	
Sophonias	Zephaniah	
Aggeus	Haggai	
Zacharias	Zechariah	
Malachias	Malachi	
		Prayer of Manasseh (*Apocrypha*)
1 Machabees		1 Maccabees (*Apocrypha*)
2 Machabees		2 Maccabees (*Apocrypha*)

New Testament

Catholic Dovay-Rheims Version	Protestant-Revised Standard Version	Notes
St. Matthew	Matthew	Referred to as Gospel of Jesus Christ according to
St. Mark	Mark	or Gospel according to:
St. Luke	Luke	
St. John	John	
The Acts of the Apostles	The Acts of the Apostles	
St Paul to the Romans	Romans	Books of Romans through Philemon referred to as
Corinthians	1 Corinthians	Epistle of Paul or Letter of Paul to; Paul generally
2 Corinthians	2 Corinthians	accepted as author of all 12 epistles/letters
Galatians	Galatians	
Ephesians	Ephesians	
Philippians	Philippians	
Colossians	Colossians	
1 Thessolonian	1 Thessalonians	
2 Thessolonians	2 Thessalonians	
1 Timothy	1 Timothy	
2 Timothy	2 Timothy	
Titus	Titus	
Philemon	Philemon	
To the Hebrews	Hebrews	Texts of Catholic and some Protestant Bibles credit this epistle/letter to Paul
St. James	James	Books of James through Jude referred to as
1 St. Peter	1 Peter	Epistles or Letters of:
2 St. Peter	2 Peter	
1 St. John	1 John	
2 St. John	2 John	
3 St. John	3 John	
St. Jude	Jude	
Apocalypse of St. John the Apostle	Revelation to John	Also called Revelation of St. John the Divine by some Protestant texts.

Databases: Their Primary Subjects, and Vendors

This section is divided into (1) a subject index to databases accompanied by the names of their vendor and a reference to their main entry in brackets and (2) a list of vendors accompanied by their addresses and telephone numbers.

Subject Index to Databases

Archaeology
Bulletin Signalétique: Art and Archéology: Near East, Asia, QUESTEL [14:76]

Architecture/Design
The Architecture Database, DIALOG [21:101 & 126]
On-line Avery Index to Architectural Periodicals Database, CLASS and DIALOG [21:127]

Art, General
Art Index Database, WILSONLINE [16:1]
ARTbibliographies MODERN Database, DIALOG [16:2]
Répertory of Art and Archéology, QUESTEL [16:6]
Art Literature International (RILA) Database, DIALOG [16:7]

Art/Sales
ArtQuest, Art Sales Index [18:7]
SCIPIO, CLASS [18:48]

Association Information
Encyclopedia of Associations Database, DIALOG [20:51]

Biography
Biography Master Index Database, DIALOG [10:70]
Biography Index Database, WILSONLINE [10:71]
Marquis Who's Who Database, DIALOG [10:75]

Book Information
Books in Print Database, DIALOG and BRS [20:55]
Cumulative Book Index, WILSONLINE [20:58]
LC MARC [17:21]
REMARC. [17:21]

Book Review
Book Review Digest Database, WILSONLINE [16:41]
Book Review Index Database, DIALOG [16:42]

Conservation/Preservation
Conservation Information Network Database, Getty Conservation Institute [28:50]

Dissertations
Dissertation Abstracts Online Database, DIALOG & BRS [16:9]

Education
Education Index Database, WILSONLINE [28:120]
ERIC Database, DIALOG & BRS [28:117]
Ontario Education Resources Information Database, BRS [28:121]

Encyclopedias
Academic American Encyclopedia, DIALOG & BRS [10:6]
Encyclopedia Britannica 3, NEXIS [10:7]

Engineering
COMPENDEX Database, DIALOG & BRS [21:128]

Grants
Foundation Grants Index Database, DIALOG [20:53]
Grants Database, DIALOG [20:54]

History
America: History and Life Database, DIALOG [16:15]
Historical Abstracts Database, DIALOG [16:17]

Humanities
Arts & Humanities Search Database, DIALOG & BRS [16:59]
Humanities Index Database, WILSONLINE [16:18]
Magazine Index Database, DIALOG & BRS [16:21]
MLA Bibliography Database, DIALOG [16:22]
Readers' Guide Database, WILSONLINE [16:23]

Newspaper Information
Numerous individual newspapers can be searched through one of the following files:

Chicago Tribune, DIALOG [16:55]
DataTimes Database, DataTimes [16:49]
NEXIS Service, MeadData Central [16:50]
National Newspaper Index Database, DIALOG & BRS [16:51]

Newspaper Abstracts Database, DIALOG [16:52]
Newsearch Database, DIALOG & BRS [16:53]
Washington Post Online, DIALOG [16:58]

Psychology

PsycINFO Database, DIALOG and BRS [28:122]

Religion

Bible (King James Version) Database, DIALOG
[29:93]
Religion Index Database, DIALOG [16:24]

Serial Information

Ulrich's International Periodical Directory Database,
DIALOG [20:76]
Bowker's International Serials Database, BRS [20:76]

Social Sciences

Social Sciences Index Database, WILSONLINE
[16:25]

Trade and Industry

Thomas Register Online Database, DIALOG [20:10]
Trade and Industry Index Database, DIALOG [16:54]

Vending Firms

Art Sales Index Ltd., 1 Thames Street, Weybridge, Surrey, KT13 8JG England, telephone 0932–856426.

BRS Information Technologies, 1200 Route 2, Latham, NY 12110, (800) 468–0908 and (518) 783–1161.

CLASS, Special File of RLIN, 1415 Knoll Circle, Suite 101, San Jose, CA 95112–4698, (408) 289–1756.

DataTimes, Parkway Plaza, Suite 450, 14000 Quail Springs Parkway, Oklahoma City, OK 73134, U. S. (800) 642–2525 and (405) 751–6400.

DIALOG Information Services, Inc. Marketing Department, 3460 Hillview Avenue, Palo Alto, CA 94304, U.S. (800) 334–2564, Canada (800) 387–2689.

The Getty Conservation Institute, 4503 Glencoe Avenue, Marina del Rey, CA 90292–6537, (213) 822–2299.

MeadData Central, 9443 Springboro Pike P.O. Box 933, Dayton, OH 45401, U.S. (800) 543–6862, Canada (800) 553–3685.

QUESTEL, Inc. 5201 Leesburg Pike, Suite 603, Falls Church, VA 22041, (703) 845–1133.

WILSONLINE, The H.W. Wilson Company, 950 University Avenue, Bronx, NY 10452, U.S. (800) 367–6770, New York State (800) 462–6060, Canada call collect (212)588–8400.

Index to Publications, Subjects, and Professions

The following criteria were used in developing this index:

1. Page numbers are provided for the main entry and any lengthy discussion or important information on the work.
2. Shortened titles are used in the index, but main entries provide complete bibliographical data.
3. All titles and some data are indexed from the annotations. All serial titles, even previous ones, are included.
4. Specific titles of serials, newspapers, and video documentaries are cited under SERIALS, SPECIFIC TITLES; SERIALS PUBLISHED BY MUSEUMS; NEWSPAPERS; or VIDEO DOCUMENTARIES: SPECIFIC TITLES.
5. Books which are part of a series and which are scattered throughout the book are cited twice in the index: under the title and under the name of the series. Thus, PELICAN HISTORY OF ART SERIES lists all of the book in this group.
6. Numbers are not spelled out, but are alphabetically located: 18th Century rather than Eighteenth Century.
7. There is a listing for PROFESSIONAL ASSOCIATIONS, ADDRESSES and PROFESSIONAL ASSOCIATIONS, PUBLICATIONS.
8. Abbreviations for some associations (AIA) and cities (NYC) are used, but cross references are included to assist the reader.
9. Confusing entries with multiple page numbers have an asterisk to indicate the main entry.
10. Because of the quantity of material for people in specific disciplines of art, the most pertinent sections for the various professions are pinpointed, such as PHOTOGRAPHY. All cultures and styles also have specific entries, such as AFRICAN STUDIES.
11. Sections concerned with research methods have all of the pages recorded regardless of whether or not the particular method or kind of reference is actually found on each page.
12. The book is divided as follows: Discussion of Methodology, pp. 3–105; Entries for the Resource Material, pp. 109–286; and Listing of Research Centers, pp. 287–295. Appendices cover pages 297–336. Index numbers correspond with this organization. For a quick method of finding these sections, turn to the last page in the book for tab references.

Mayer, Susan, 267
Mayers, William Frederick, 152
Mayo, Janet, 246
Mayor, Alpheus Hyatt, 227
Mbari, Art & Life among the Owerri
 Igbo, 156
Me Fecit, 331
Meacham, Standish, 121
MeadData, 336
Meaning in Children's Art, 267
Meaning in Visual Arts, 75, 281
Medals, 118
MEDIA & DISCIPLINES,
 RESOURCES
 Architecture, 211–222
 Art Education, 266–269
 Commercial Design, 257–259
 Decorative Arts and Crafts, 235–241
 Fashion, Costume, Jewelry, 243–250
 Film & Video, 251–255
 Museum Studies, 261–266
 Photography, 231–234
 Prints, 223–229
Media Review Digest, 254
Mediaeval Latin & French Bestiaries,
 283
Medieval, see Early Christian, Byzantine,
 & Medieval STUDIES
Medieval Art, 127
Medieval Costume, Armour, & Weapons,
 246
Medieval Stage, 128
Medieval Studies, 127
Meditations on a Hobby Horse, 120
Meditations on Life of Christ, 79, 279
Mediterranean World, Age of Philip II,
 131
Medley, Margaret, 151
Meehan, Patrick J., 218
Meister, Michael W., 151
Mellon, Paul, 92
Melville J. Herskovits Library of African
 Studies, 156
Memoirs of a Dada Drummer, 138
Menz, Henner, 160
Mercer, Eric, 130
Merger of *RILA & Repertoire,* 30–32,
 167–168
Merryman, John Henry, 202
"La Mesangere" Parisian Costumes, 247
Mesoamerica Archaeology, 150
Metamorphoses, 84
Metamorphoses in 19th-Century
 Sculpture, 116
"Metamorphosis of *IBZ Bibliographic*
 Index", 171
Metaphor of Painting, 138
meter, 330
Metford, J. C. J., 76, 80, 276
Metropolitan Museum, 122, 141, 145,
 150, 156, 160, 161, 189, 225, 235,
 243, 253, 292 000
Metropolitan Museum, *Library*
 Catalogue, 53, 178
Metropolitan Museum of *Art At Home*
 Series, 160
Metropolitan Museum of Art: *Notable*
 Acquisitions, 27
Metropolitan Toronto Reference Library,
 147
Metzger, Mendel, 128
Metzger, Therese, 128
Mexican & Central American
 Mythology, 275

Mexico, 149
Meyer, George H., 117
Meyer, Karl E., 265
Meyer, Valerie D., 114
Meyer-Baer, Kathi, 284
Michael, Paul, 252
Michael Durham, 214
Michelangelo & Mannerists, 131, 133
Michelin Guide Series, 213
Micklethwait, Lucy, 257
Mid-Atlantic Association of Museums,
 266
Mid-Atlantic States, 214
Middle Ages & Renaissance, 131
Middleton, Haydn, 249
Middleton, Robin, 216
Mies van der Rohe Archive, 97, 220
Migne, Jacques-Paul, 80, 279
Migration of Art Motifs, 262
Migration of Symbols, 262
Milbank, Caroline Rennolds, 244
Milburn, Robert, 126
Millar, Oliver, 132
Miller, Judith, 186
Miller, Martin, 186
Miller, William C., 218
Miller's International Antiques Price
 Guide, 186
millimeter, 330
"Millionaire & the Madonna", 27
Milrad, Aaron, 202
ming name, 151
Miniature in Europe, 115
Miniaturists, Biographical Dictionaries,
 115
Minimal Art A Critical Anthology, 138
Minneapolis Institute of Arts, 263
Minnich, Helen Benton, 246
Minoan & Mycenaean Art, 123
Mintz, Patricia Barnes, 257
Minus Sign −, Meaning of 28
Mireur, Hippolyte, 187
Mirimonde, Albert P. de., 284
Miro, Joan, 138
Mirror of Fashion, 245
Mirror Mirror, 248
Mitchell, Margaretta K., 233
Mitchell, Peter, 114
Mitzel, Harold E., 266
MLA Handbook, 202
MLA International Bibliography, 171
Mode, Heinz Adolph, 283
Mode in Costume, 245
Modern Architecture, 216
Modern Art & Modernism, 139
Modern Art Exhibitions, 164
Modern Art in Paris, 165
Modern British Architecture Since 1945,
 213
Modern Europe, 160
Modern History Abstracts, 170
Modern Language Association, 202
Modern Latin American Art, 150
Modern Perspectives in Western Art
 History, 61, 120
Modern Researcher, 202
Modern Textile & Apparel Dictionary,
 239, 243
Modernism in the 1920s, 138
Modes & Manners, 244, 245
Modes & Manners, 19th Century, 245
Modes & Manners: Ornaments, 245
Modesty in Dress, 249
Mollat, Michel, 119

Mollett, John William, 112
MoMA, see Museum of Modern Art
Monastic Iconography, 276
Mondrian, Piet, 138
Monet: "Le dejeuner sur l'herbe", 261
Monetary Evaluations, 69
Money, Foreign Abbreviations, 332
Monogramm Lexikon, 117
Die Monogrammisten, 117
monograph, 23
Monographic Series, 179
Monro, Isabel Stevenson, 196, 248
Monro, Kate M., 196, 248
Monroe, Paul, 266
Monroe, Walter S., 266
Le monstre dans l'art occidental, 283
Montgomery, Florence M., 239
Montgomery Ward & Company, Catalog,
 240
Montreal Museum of Fine Arts, 163
Monuments of Medieval Art, 126
Moore, Albert C., 285
Moore, Henry, 138
Morales y Marin, Jose Luis, 273
Morey, Charles Rufus, 195
Morgan, Willard D., 231
Morris, Adah V., 172
Morris, M. A., 196
Morris, Peter, 252
Mosan Art, 127
Moss, Martha, 234
Motherwell, Robert, 138
Motion Picture Directors, 253
Motion Picture Guide, 252
Motion Picture Performers, 253
Motion Pictures & Filmstrips, 179
Moulin, Raymonde, 187
Mountford, Charles P., 157
Moure, Nancy D. W., 197
Mouseion, 266
Moving Pictures, 120
Muehsam, Gerd, 93, 131, 178
Muirhead, Findlay, 213
Muirhead Guide-Books, 213
Muller, Edward J., 212
Muller, Hans Wolfgang, 216
Muller, Karen, 206
Muller, Theodor, 130
Mullins, Edwin, 132
Mulloy, Elizabeth D., 214
Multi-Media Reviews Index, 254
Mundy, E. James, 90, 131
Munich Gallery, Alte Pinakothek, 160
Munsterberg, Hugo, 151, 285
Murase, Miyeko, 285
Murdock, George Peter, 155, 156
Murnane, William J., 123
Murphy, John P., 122
Murray, Jocelyn, 157
Murray, John, 213
Murray, Linda, 112
Murray, Oswyn, 125
Murray, Peter, 112, 213, 216
Murray, W. H., 213
Muse, 266
Muse, Vance, 214
Musée Cernuschi, 155
Musée des Arts Decoratifs, 164
Musee du Louvre, 68, 122
Musée Guimet, 155
Museen der Welt, 203
Muser, Curt, 149
Museum Age, 265